THE BIRTH OF

ELVIS

PRESLEY

THE ELVIS PRESLEY

BIRTH OF ROCK AND ROLL

ALFRED WERTHEIMER THE PHOTOGRAPHER

TERMINAL

STUDIO

SHOW
STUDIO 50
7. 1956
K CITY

PRESLEY

T. ESLEY

SOUTHERN RAILWAY

JUNE 30th HUDSON NEW YORK

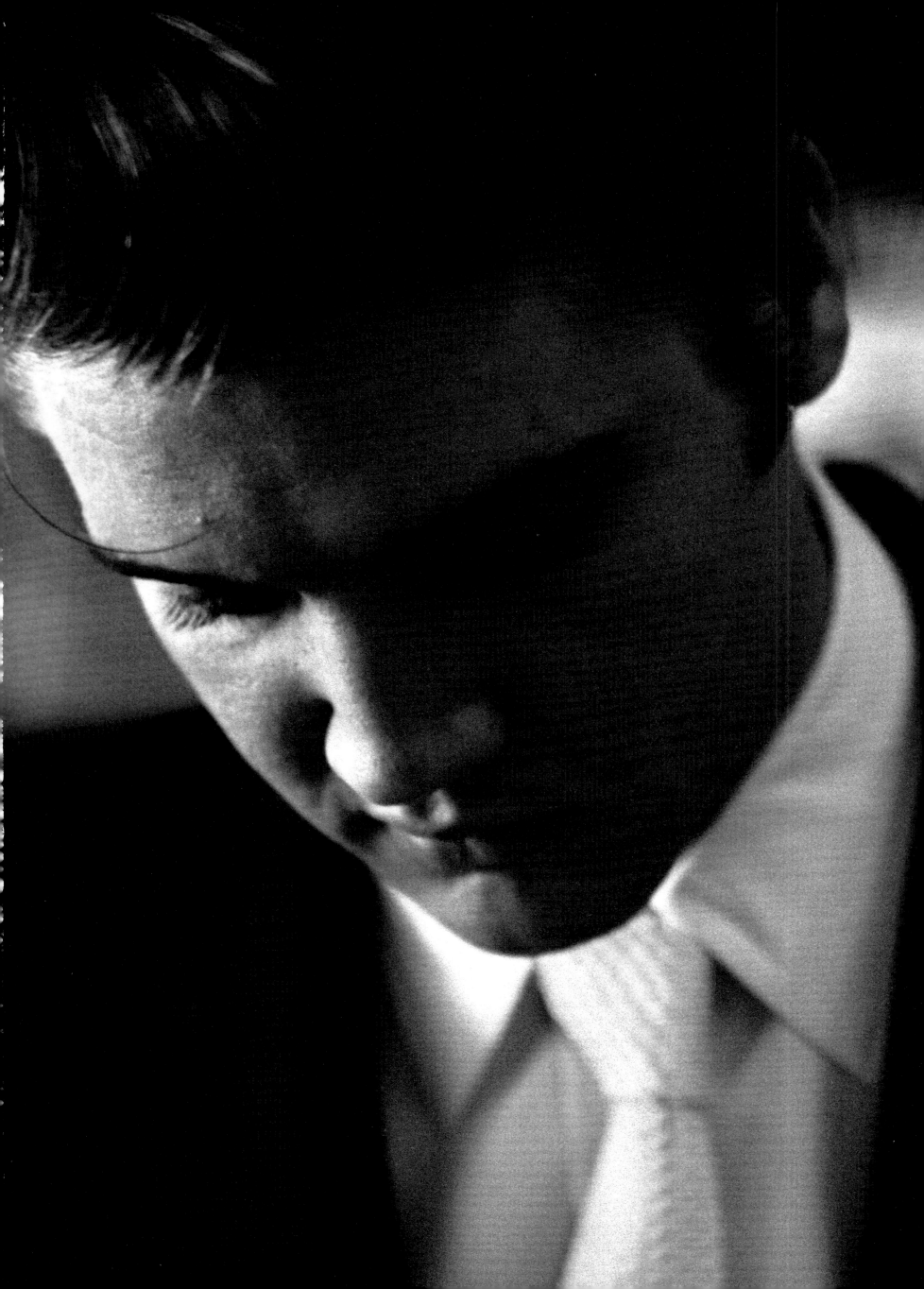

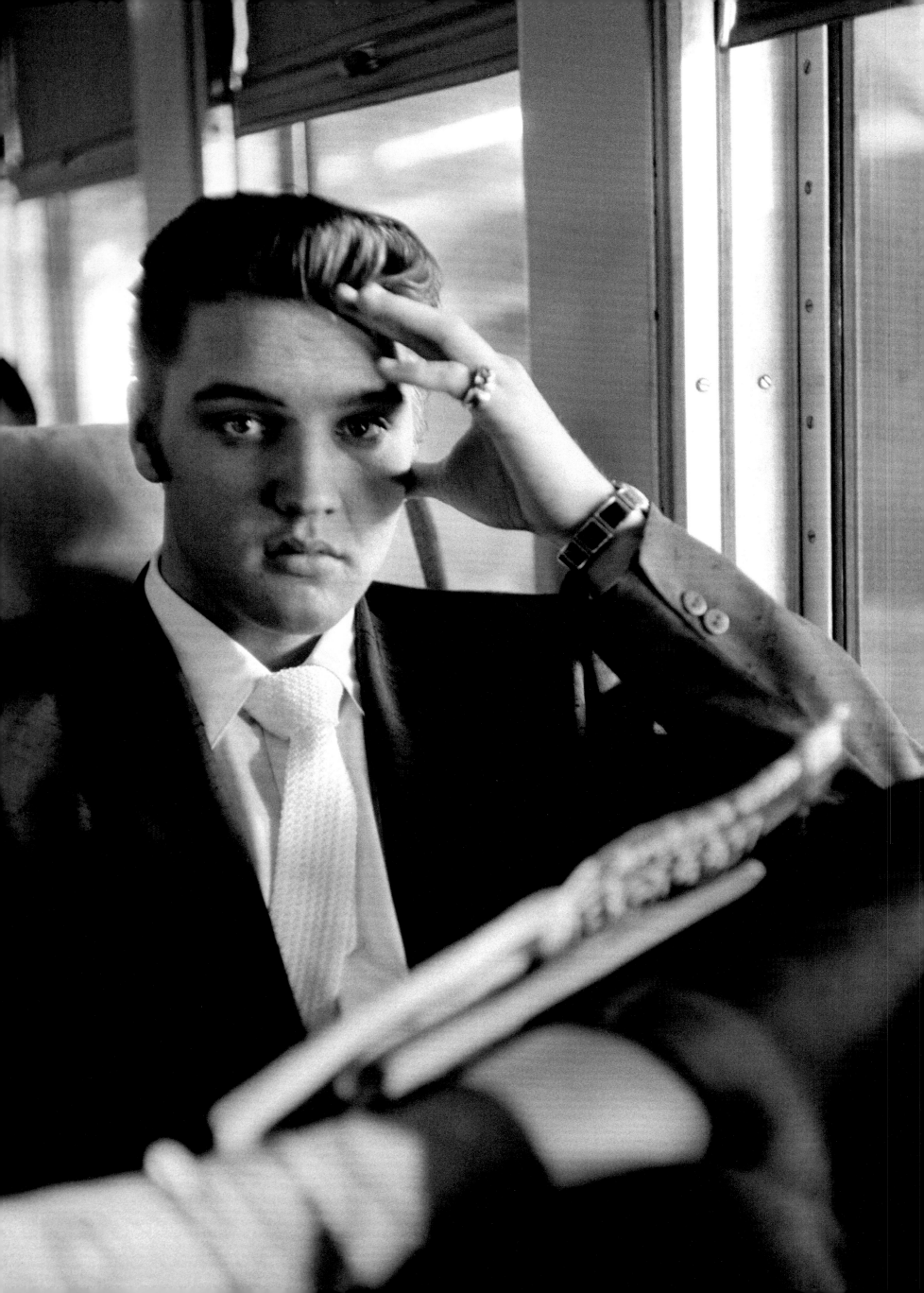

ALFRED WERTHEIMER

ELVIS

AND THE BIRTH OF ROCK AND ROLL

TASCHEN

ALFRED WE

ELN

THE BIRTH OF R

AI

★ ED. BY CHRIS MURRAY ★ ES

TASCHEN ★ ART DIRECTION BY JOS

ERTHEIMER

ND

OCK AND ROLL

SAY BY ROBERT SANTELLI ★

BAKER ★ POSTERS BY ★ *Hatch Show Print*

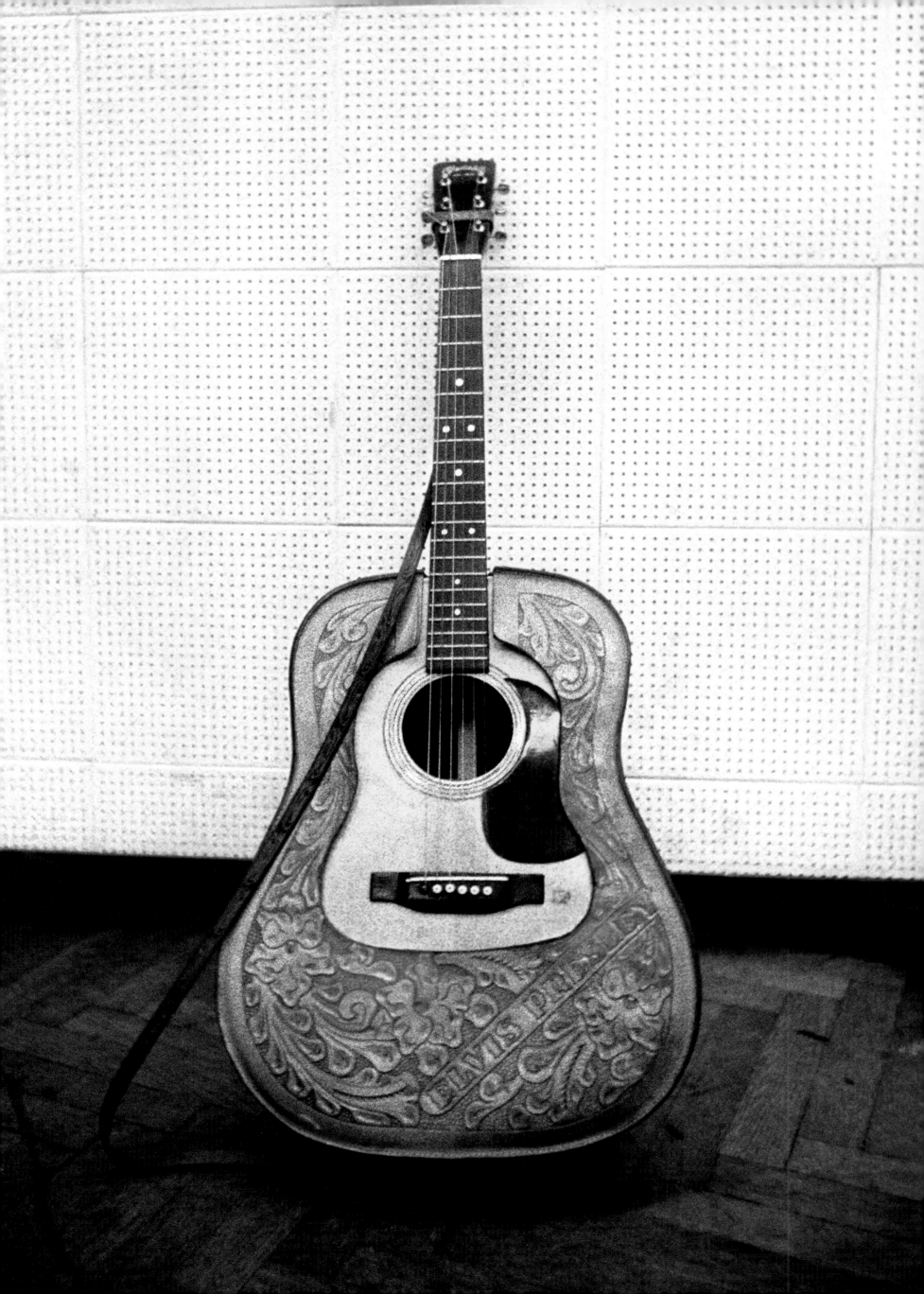

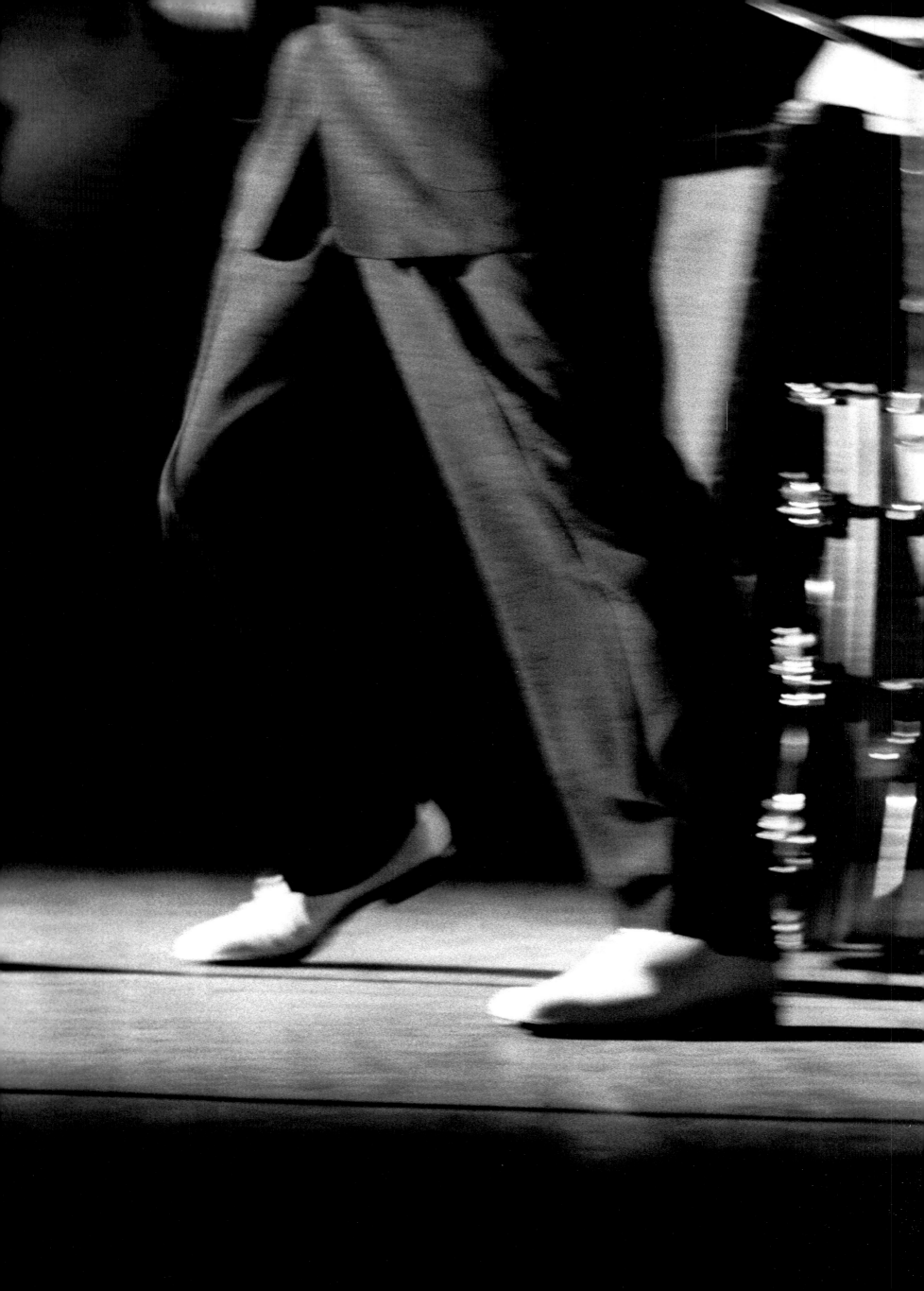

In the Beginning

ALFRED WERTHEIMER

THE YEAR WAS 1956, and I was working as a freelance photographer in New York City when RCA Victor publicist Anne Fulchino hired me to shoot a newly signed singer by the name of Elvis Presley. I remarked, "Elvis who?"

That was one of the last times anyone had to ask that question again. The 21-year-old singer shot to stardom shortly after I photographed him that Saturday night, March 17, on *Stage Show* hosted by Tommy and Jimmy Dorsey. Once I stumbled into that assignment and met Elvis, I felt that this guy had something that was unique, and had an interesting story that had to be told. So I followed him on the road and everywhere else for two weeks, taking over 2,500 photographs of the singer who would later be known to the world as the King of Rock and Roll.

Most of the time, Elvis never even knew I was taking his picture. He was laser-focused on whatever he did, so I would wait until he was engaged—and he was always immersed in being Elvis—whether rehearsing, flirting with women, combing his hair, buying a ring, or talking to his father about why the plumbing wasn't working and they had to fill the pool with a hose from the kitchen sink. Elvis gave me complete access to his life—I would even follow him into the bathroom.

My feeling was that the closer I could come to being a fly on the wall and still produce high-quality work, I didn't necessarily have to worry about what photographer Henri Cartier-Bresson called the "decisive moment." I wanted to be an unobtrusive observer— like a good psychiatrist with a camera. Obviously, the decisive moment is graphically strong, but the moments before and after—those images are unusual and there's often a strangeness involved that I like. And from the thousands of pictures I took of Elvis, what I find most appealing are the immediate pre- and post-decisive moments.

I can recall Elvis busy washing up at the Warwick Hotel in New York—he had a towel over his shoulder, a toothbrush in his hand and toothpaste on the brush, and the water

was running in the sink—and he's ready to stick the toothbrush in his mouth, in a pre-decisive moment that everyone who has ever brushed their teeth has experienced. And I just love that picture of Elvis with a couple of pimples on his back.

There are a lot of iconic images that came out of that bathroom session, pictures I wouldn't have ever captured had I not asked to follow Elvis into his inner sanctum. This was my first year in professional photography, and fortunately I didn't know any better. So as far as I was concerned, everything was fair game if Elvis would allow me in. I was experimenting and making up my rules as I went along, whatever it took to come up with some money shots that could be published.

Here I was with somebody who I didn't know was going to become famous. But I did know two things: I knew that he was not shy—I mean, Elvis was shy in the sense that he was introverted, but he was not shy to the camera. He permitted closeness. And when you get close there is a whole different dynamic to a picture. As I remember Robert Capa saying, "If your pictures are boring, it means you're not close enough." Closeness allows you to capture a certain texture, which creates a presence and makes a photograph interesting. The other thing I knew that Elvis had in his favor was that he made the girls cry.

YOU'RE EITHER A NOTE TAKER, a writer, or, in my case, a photographer—an observer ready to freeze moments that you see and then piece them together. And it's not a simple process, because the subject does not tell you what he's doing. But it's just as well—because the moment it becomes a verbal process, it's no longer a visual process. The main subject does not know what you're going to do, because you do not know what you're going to do. You react to an event as it unfolds without having control over it.

As a photojournalist, the game that I would play with myself was, how can I *not* intrude on what the subject wants to do? And how can I keep the background organized not to interfere too much with foreground? And how can I compose it in such a way where I won't have a lot of ambiguity between the foreground and the background? That was my style, and this is just an example of how those things worked in my mind.

Photographers tend to practically engrave their photographs on their brains, or at least I do with most every image that has any significance. Some things appear in photographs that you don't see with your eyes. I mean photography picks up things that are not reality—they're photo-reality. For example, while shooting the concert at Russwood Park, somebody's flashbulb went off in the audience at the exact moment my shutter opened to photograph the crowd. It created a flare in my lens that produced a magnificent spray of light in front of Elvis and backlit the crowd. It's what Kodak tells you never to do, but it was a wonderful accident, and the photograph *Starburst* was born.

Another moment: On the 27-hour train ride to Memphis, Elvis was bored. In an attempt to entertain himself, he picked up a stuffed panda and put it on his left hip and walked down to the other end of the car. I picked up my camera and followed him. The passengers on the train didn't know what to make of Elvis. I mean, 21-year-old men don't normally walk around with four-foot pandas. But Elvis paid them no mind. Halfway back up the

8 *White Bucks*, onstage at the Mosque Theater, Richmond, Virginia, June 30, 1956.

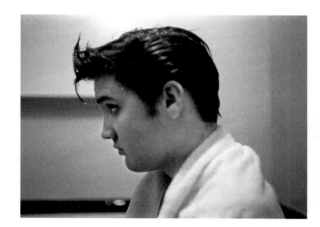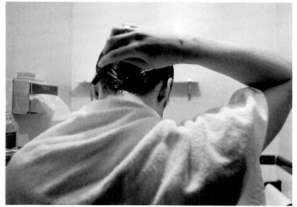

aisle he made a sharp left and looked two teenage girls straight in the eyes, and said, "Are you coming to my concert tonight?" Well, they said, "Who are you…what concert?" He then said, "I'm Elvis Presley, I have got a concert at Russwood Park." Well, they said, "How do we know you're Elvis Presley?" He said, "You see that photographer over there? Do you think he would be taking my picture if I wasn't Elvis Presley?" That whole time I had been standing on one of the seats shooting him chatting it up with the girls and that explanation seemed to satisfy them.

This was the young Elvis, the one who permitted closeness and might have said to himself, "Well, look, how is anybody ever going to know what I am all about if there is no record of me except my music? We're living in photographic times, so why not cooperate? After all, I don't even know when this guy is taking pictures." Every once in a while, if I was in his face, well then he would be aware, but in the whole collection there are only one or two pictures where Elvis was posing. The rest are just Elvis living his life—and all I was doing was recording that life. I wasn't asking him to do anything for me and he couldn't have cared less about somebody following him with a camera. I believe the uniqueness of my photographs of Elvis lies in the fact that I accepted he was the director of his own life.

YOU WILL FIND THAT WHEN people are intensely involved in something that's important to them, they're pretty much oblivious to the camera. That's when you get your best pictures, because your subjects are not hamming it up. If you can get in close and frame it properly with the available light and operate at slow shutter speeds—and manage not to trip over your own feet—you will get what I find to be very interesting photographs.

I used two 35mm split range-finder black Nikon S-2 cameras to shoot Elvis—one with a 105mm lens and the other with a 35mm lens. I think I used supplemental light in only 25 or 30 photographs. I stayed away from using a flash for the most part, because I thought that the flash effect was always so artificial. It kills the mood and the tonality of the lighting that exists. Since I was more or less into the available-light category of photography, I coined the phrase, "available-darkness photography," with the idea that you can find people in their more natural state the darker the place they're in. For example, if

ABOVE Elvis gets the hair perfect for his performance on *Stage Show* in the bathroom of his suite at the Warwick Hotel, New York City, March 17, 1956.

you go into a bar, people will be a lot more themselves than they would in a fluorescent-lit office. It's just the way it is!

I was basically self-taught in photography, except for one class I took from Josef Breitenbach at Cooper Union, during which time I experimented with what I like to call the New York Ashcan School of Photography. Once I had a camera in my hand, I had no shame. I was fearless. Without a camera, I was a milquetoast...

I admired the work of W. Eugene Smith—he was one of my heroes. So were David Douglas Duncan, Margaret Bourke-White, Dorothea Lange, and the whole Stryker group during the WPA (Works Progress Administration) days. I was intrigued by the photographs of Walker Evans, and if you go back a way, certainly Talbot, Daguerre, Mathew Brady, and Muybridge—and by all means the master of them all, whom I didn't discover until years after I got into photography, Erich Salomon. However, it was my good friend Paul Schutzer—another photographer who was killed in the Gaza Strip working for *Life* magazine covering the Six-Day War, who introduced me to Anne Fulchino. She was my connection to Elvis.

In 1956 I was not publishing my work very much, but I did go back to photograph Elvis one last time in September of 1958 when he was in the Army and giving a press conference before shipping out on the troop ship *USS Randall*, from the Brooklyn Port of Embarkation for Germany with 6,000 other soldiers. It was the last time I saw him.

Thereafter, I got into motion picture camera work, where I covered the 1960 John F. Kennedy–Richard Nixon presidential election, was a staff cinematographer for Granada television, and later, a cameraman for the original Woodstock Music Festival. The irony of all this is that I did not get one single phone call for an Elvis Presley photograph for 19 years from the time I last saw him alive until the day he died, on August 16, 1977.

That day I got a call from Robert Pledge of Contact Press Images, a photo agency in New York, who suggested I go see John Durniak at *Time* magazine with my photographs of Elvis. When all was said and done he wanted an exclusive for one week before any other publication would get their hands on my work. For this he was willing to pay what I considered a huge sum of money for 1977. It was more money than I made on all of my Elvis Presley photos in the previous 21 years. I believe when the artist dies, then the public wants to know!

Two years after Elvis's death my first book on the subject was published and my work has been all about Elvis ever since—it's been the longest assignment of my life.

OPPOSITE Elvis returns to the Warwick Hotel between the afternoon rehearsal and evening performance of *Stage Show*, March 17, 1956.

14 Lunch at the counter of the Jefferson Hotel coffee shop, Richmond, Virginia.

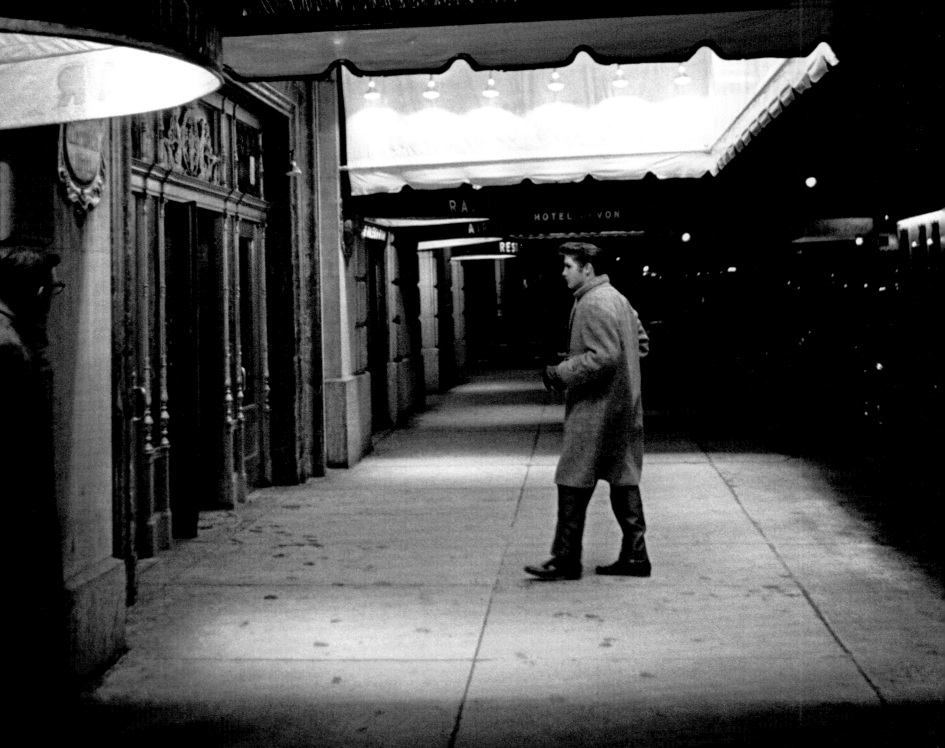

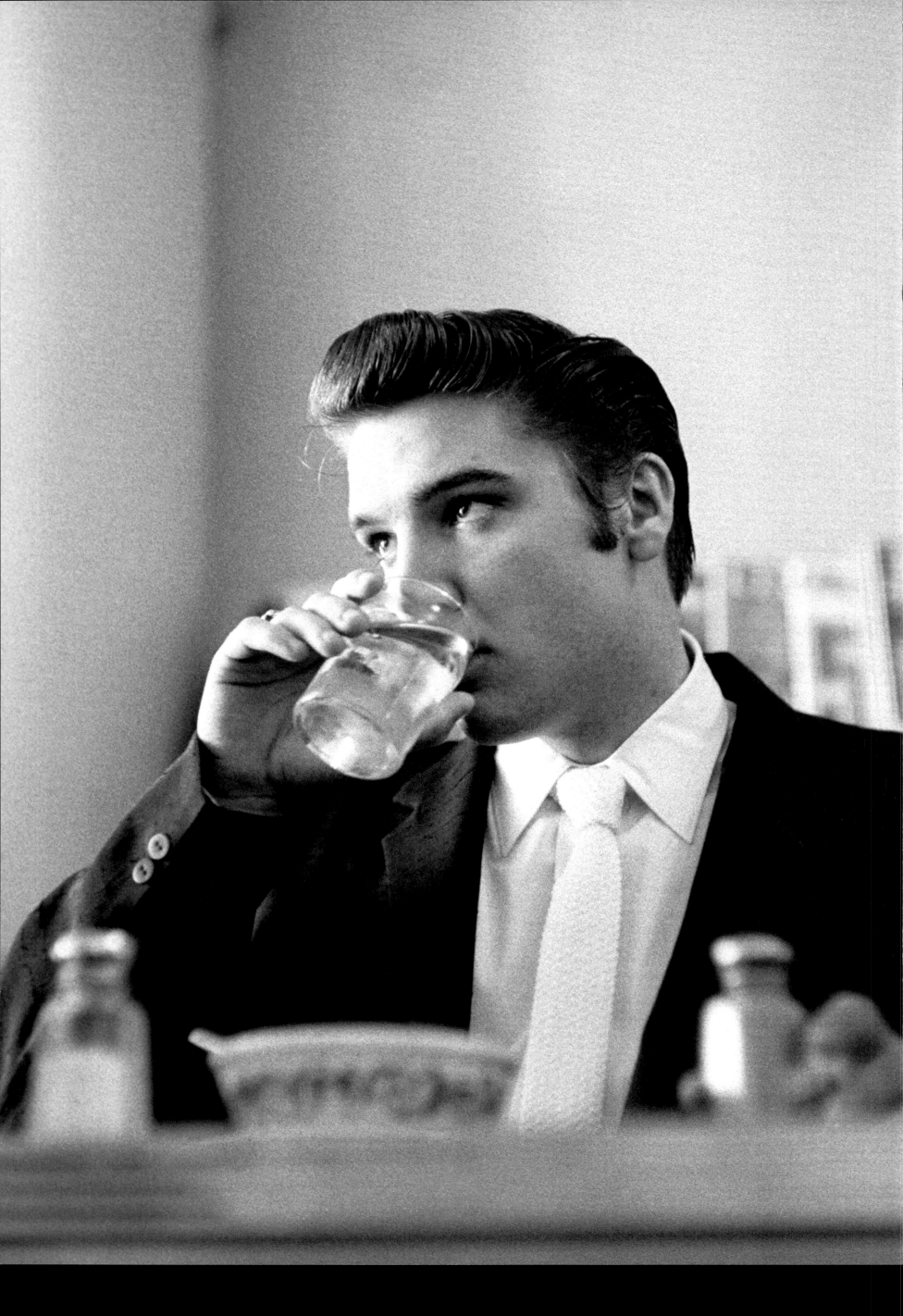

Am Anfang

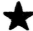

ALFRED WERTHEIMER

MAN SCHRIEB DAS JAHR 1956, und ich arbeitete gerade als freier Fotograf in New York, als Anne Fulchino, die PR-Chefin von RCA Victor, mich beauftragte, einen frisch unter Vertrag genommenen Sänger namens Elvis Presley zu fotografieren. Ich fragte: „Elvis wer?"

Es sollte eines der letzten Male gewesen sein, dass jemand diese Frage stellen musste. Kurz nachdem ich den 21-jährigen Sänger an jenem 17. März bei seinem Auftritt in der Samstagabendsendung *Stage Show* von Tommy und Jimmy Dorsey fotografiert hatte, begann sein kometenhafter Aufstieg. Als ich erst einmal in diesen Auftrag hineingestolpert war und Elvis persönlich kennengelernt hatte, spürte ich, dass dieser Typ etwas hatte, das einzigartig war, und witterte eine interessante Story, die erzählt werden musste. Also folgte ich ihm zwei Wochen lang auf Tour und überall sonst hin und machte dabei über 2500 Aufnahmen von dem Sänger, der später als „King of Rock and Roll" weltbekannt werden sollte.

Die meiste Zeit über wusste Elvis nicht einmal, dass ich ihn fotografierte. Er war auf alles, was er tat, laserscharf fokussiert, also wartete ich, bis er mit etwas beschäftigt war – und er ging grundsätzlich voll und ganz darin auf, Elvis zu sein, ob er nun probte, mit Frauen flirtete, sich frisierte, einen Ring kaufte oder mit seinem Vater darüber diskutierte, warum der Wasserzulauf streikte und dass sie den Pool von der Küchenspüle aus mit einem Gartenschlauch befüllen mussten. Elvis gewährte mir völlig freien Zugang zu seinem Leben – ich folgte ihm sogar bis ins Badezimmer.

Das Gefühl, mit dem ich an den Auftrag heranging, war: Wenn es mir gelänge, wie eine Fliege an der Wand zu sein und dabei immer noch hohe Qualität zu produzieren, bräuchte ich mir nicht zwingend Gedanken über das zu machen, was der Fotograf Henri Cartier-Bresson den „entscheidenden Augenblick" nannte. Ich wollte ein unaufdring-licher Beobachter sein – wie ein guter Psychiater mit Kamera. Dass der entscheidende

Augenblick grafisch stark ist, liegt auf der Hand, aber die Augenblicke davor und danach – solche Bilder sind ungewöhnlich und haben oft etwas Seltsames an sich, das mir gefällt. Und am reizvollsten unter den Tausenden Aufnahmen, die ich von Elvis machte, sind für mich die Momente unmittelbar vor und nach dem entscheidenden Augenblick.

Ich kann mich erinnern, wie Elvis einmal im Warwick Hotel in New York gerade dabei war, sich zu waschen – er hatte ein Handtuch über der Schulter, eine Zahnbürste in der Hand, Zahnpasta auf der Bürste, und der Wasserhahn lief –, und er ist gerade im Begriff, sich die Bürste in den Mund zu schieben; es ist ein Moment vor dem entscheidenden Augenblick, wie ihn jeder, der sich jemals die Zähne geputzt hat, kennt. Und dieses Bild von Elvis mit ein paar Pickeln auf dem Rücken finde ich einfach großartig.

Bei dieser Badezimmer-Session entstanden viele Aufnahmen, die zu Ikonen wurden, Bilder, an die ich nie gekommen wäre, hätte ich nicht darum gebeten, Elvis bis in den privatesten Bereich folgen zu dürfen. Es war mein erstes Jahr als Berufsfotograf, und glücklicherweise wusste ich es nicht besser. Was mich betraf, war alles erlaubt, solange Elvis mich dabei sein ließ. Ich probierte herum und tat, was mir richtig erschien, wichtig war nur, dass am Ende ein paar Aufnahmen heraussprangen, die sich zu Geld machen ließen.

Da war ich nun also mit jemandem zusammen, von dem ich nicht wusste, dass er berühmt werden würde. Aber zwei Dinge gab es, die ich sehr wohl wusste: Ich wusste, dass Elvis nicht schüchtern war – schüchtern im Sinne von introvertiert war er schon, aber nicht kamerascheu. Er ließ Nähe zu. Und wenn man nahe rangeht, bekommt ein Bild eine völlig andere Dynamik. Ich erinnere mich an Robert Capa, der sagte: „Wenn deine Bilder langweilig sind, heißt das, dass du nicht nahe genug dran bist." Nähe erlaubt dir, eine gewisse Stofflichkeit einzufangen, die Präsenz schafft und eine Fotografie interessant macht. Das Zweite, was ich über Elvis wusste und was ihn auszeichnete, war, dass er die Mädels zum Weinen brachte.

MAN IST ENTWEDER EIN PROTOKOLLANT DES GESCHEHENS, ein Schreiber, oder, wie in meinem Fall, ein Fotograf – ein Beobachter, immer bereit, Momente, die er sieht, festzuhalten und dann zusammenzusetzen. Und das ist kein einfacher Vorgang, denn dein Motiv sagt dir nicht, was es gerade tut. Andererseits ist das auch gut so – denn sobald sich ein verbaler Vorgang entwickelt, ist es kein visueller Vorgang mehr. Dein zentrales Motiv weiß nicht, was du tun wirst, weil du es selbst nicht weißt. Du reagierst auf ein Ereignis, während es vor deinen Augen abläuft, ohne dass du Kontrolle darüber hast.

Für mich als Fotojournalisten hieß das Spiel, das ich mit mir selbst spielte: Wie schaffe ich es, dem Motiv bei dem, was es tun will, *nicht* in die Quere zu kommen? Wie kann ich den Hintergrund so unter Kontrolle halten, dass er nicht zu stark in den Vordergrund hineinspielt? Und wie kann ich das Bild so komponieren, dass sich zwischen Vorder- und Hintergrund nicht zu viele Unklarheiten ergeben? Das war mein Stil, und das ist nur ein Beispiel dafür, was ich mir dabei dachte.

Fotografen neigen dazu, sich ihre Bilder praktisch ins Gehirn einzumeißeln, jedenfalls tue ich das mit fast jedem Bild, das in irgendeiner Form von Bedeutung ist. Manchmal

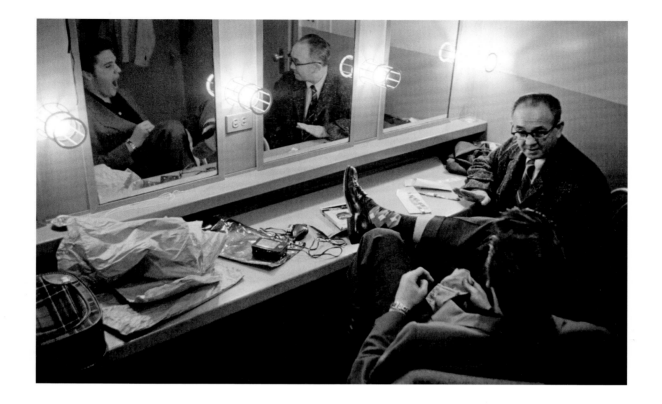

tauchen auf Fotografien Dinge auf, die man nicht mit den Augen sieht. Ich meine damit, Fotografie fängt Dinge ein, die nicht die Realität sind – sie existieren in der Fotorealität. Als ich zum Beispiel das Konzert im Russwood Park fotografierte, ging genau in dem Moment, als ich auf die Zuschauermenge hielt und den Auslöser drückte, im Publikum ein Blitzlicht los. Es warf einen Reflex auf meine Linse, der einen großartigen Strahlenkranz vor Elvis erzeugte, und zeigt die Menge im Gegenlicht. Genau das, was man laut Kodak niemals tun sollte, aber es war ein wunderbarer Unfall, und das Bild *Starburst* war geboren.

Ein anderer Augenblick: Auf der 27-stündigen Zugfahrt nach Memphis wurde Elvis langweilig. Um sich irgendwie zu unterhalten, nahm er einen Pandabären aus Plüsch, setzte ihn sich auf die linke Hüfte und ging damit den Mittelgang hinunter bis ans andere Ende des Wagens. Ich schnappte mir meine Kamera und folgte ihm. Die Fahrgäste im Zug wussten nicht, was sie von Elvis halten sollten. Ich meine, 21-jährige Kerle rennen normalerweise nicht mit metergroßen Plüschpandas herum. Aber Elvis kümmerte sich nicht um sie. Auf dem Rückweg durch den Gang wendete er sich auf halber Strecke abrupt nach links, blickte zwei Mädels direkt in die Augen und sagte: „Kommt ihr heute Abend in mein Konzert?" Und sie sagten: „Wer bist du denn ... welches Konzert?" Er sagte: „Ich bin Elvis Presley, ich gebe ein Konzert im Russwood Park." Darauf die beiden Teenager: „Woher sollen wir wissen, dass du Elvis Presley bist?" Und er: „Seht ihr den Fotografen da drüben? Denkt ihr, er würde mich knipsen, wenn ich nicht Elvis Presley wäre?" Ich hatte während der ganzen Zeit auf einem der Sitze gestanden und ihn beim Plaudern mit den Mädchen fotografiert, und diese Erklärung schien sie zufriedenzustellen.

Das war der junge Elvis, der Nähe zuließ und sich vielleicht gesagt haben mag: „Na schön, wie sollen die Leute jemals erfahren, wer ich überhaupt bin, wenn es nichts anderes

ABOVE A ring salesman delivers a good luck horseshoe ring encrusted with diamonds to Elvis in his dressing room at *Stage Show*.

über mich gibt als meine Musik? Wir leben in Zeiten der Fotografie, warum also nicht kooperieren? Schließlich weiß ich nicht einmal, wann dieser Typ auf den Auslöser drückt." Hin und wieder, wenn ich ihm direkt vor dem Gesicht hing, war ihm das wohl schon bewusst, aber in der ganzen Sammlung gibt es nur ein oder zwei Bilder, auf denen Elvis posierte. Alle übrigen sind einfach nur Elvis, wie er leibte und lebte – und ich tat nichts weiter, als dieses Leben aufzunehmen. Ich bat ihn nie, etwas Bestimmtes zu tun, und dass ihm jemand mit einer Kamera folgte, hätte ihm gleichgültiger nicht sein können. Ich glaube, das Einzigartige an meinen Elvis-Aufnahmen war, dass ich ihn als Regisseur seines eigenen Lebens anerkannte.

WENN MENSCHEN VÖLLIG IN ETWAS VERTIEFT SIND, das ihnen wichtig ist, wird man feststellen, dass sie die Anwesenheit einer Kamera kaum mehr bemerken. Genau dann bekommt man die besten Bilder, weil die Motive nicht schauspielern. Wenn man es schafft, nahe genug ranzukommen und unter den vorhandenen Lichtverhältnissen einen sauberen Ausschnitt zu suchen und mit langen Verschlusszeiten zu arbeiten – und dabei nicht über die eigenen Füße zu stolpern –, bekommt man Bilder, die ich persönlich sehr interessant finde.

Für die Elvis-Aufnahmen benutzte ich zwei schwarze 35-mm-Nikon-S2-Messsucher-kameras mit Mischbild-Entfernungsmesser – die eine mit einem 105-mm-Objektiv, die andere mit einem 35er. Ich glaube, ich habe bei höchstens 25 oder 30 Aufnahmen mit zusätzlicher Beleuchtung gearbeitet. Die meiste Zeit über ließ ich die Finger vom Blitz, weil ich den Blitzlichteffekt immer so künstlich fand. Er zerstört die Stimmung und Tonalität der vorhandenen Lichtsituation. Da ich eher ein Anhänger der „Fotografie mit vorhandenem Licht"-Schule war, prägte ich dafür den Ausdruck „Fotografie mit

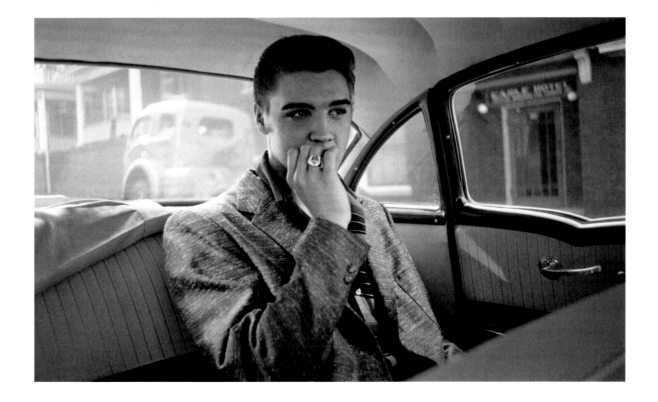

vorhandener Dunkelheit"; die Idee dahinter war, dass sich Menschen umso natürlicher geben, je dunkler der Ort ist, an dem sie sich aufhalten. Wenn man zum Beispiel in eine Bar geht, werden die Leute dort viel mehr sie selbst sein als in einem neonlichthellen Büro. Das ist einfach so!

Das Fotografieren hatte ich mir mehr oder weniger selbst beigebracht, abgesehen von einer Vorlesung bei Josef Breitenbach, die ich an der Cooper Union in New York besuchte, wo ich zu der Zeit auch mit dem herumexperimentierte, was ich gerne die New York Ashcan School der Fotografie nenne. Sobald ich eine Kamera in der Hand hatte, verlor ich jede Scheu. Ich war regelrecht furchtlos. Ohne Kamera dagegen war ich der reinste Hasenfuß …

Ich bewunderte die Arbeit von W. Eugene Smith – er war einer meiner Helden. Genauso wie David Douglas Duncan, Margaret Bourke-White, Dorothea Lange und der ganze Stryker-Trupp, der während des New Deal im staatlichen Auftrag durch Amerika zog, um die Auswirkungen der Wirtschaftskrise in Bildern zu dokumentieren. Mich faszinierten die Fotos von Walker Evans, und wenn man noch etwas weiter zurückgeht, natürlich auch Talbot, Daguerre, Mathew Brady und Muybridge – und auf jeden Fall der absolut Größte von allen, den ich erst Jahre nach meinem Einstieg in die Fotografie entdeckte, Erich Salomon. Jedenfalls war es Paul Schutzer, ein guter Freund von mir und ebenfalls Fotograf – er wurde bei einer Reportage für das *Life*-Magazin während des Sechs-Tage-Kriegs im Gazastreifen getötet –, der mich Anne Fulchino vorstellte. Sie war meine Verbindung zu Elvis.

1956 brachte ich noch nicht viele der Bilder in Publikationen unter, trotzdem machte ich mich im September 1958 noch einmal auf, um Elvis zu fotografieren, als er beim Militär war und eine Pressekonferenz gab, ehe er zusammen mit 6000 anderen Soldaten auf dem Truppentransporter USS Randall vom Verladehafen in Brooklyn Richtung Deutschland auslief. Es war das letzte Mal, dass ich ihn sah.

Danach arbeitete ich als Kameramann beim Film, berichtete unter anderem über den Kennedy-Nixon-Wahlkampf von 1960, gehörte zum festen Drehteam des britischen Fernsehsenders Granada Television und später auch zur Kameracrew des original Woodstock-Dokumentarfilms. Die Ironie bei all dem ist, dass ich 19 Jahre lang keine einzige Anfrage für ein Elvis-Bild bekam – von der Zeit, als ich ihn zum letzten Mal lebend sah, bis zu seinem Todestag am 16. August 1977.

An dem Tag rief mich Robert Pledge von der New Yorker Fotografenagentur Contact Press Images an und gab mir den Tipp, mich mit meinen Elvis-Bildern bei John Durniak vom *Time Magazine* zu melden. Gesagt, getan, wir kamen ins Geschäft, und er verlangte das exklusive Nutzungsrecht für eine Woche. Dafür, dass während dieser Zeit keine andere Publikation an meine Bilder würde herankommen können, war er bereit, eine für 1977 in meinen Augen enorme Summe zu zahlen. Es war mehr Geld, als ich mit all meinen Elvis-Aufnahmen in den 21 Jahren zuvor verdient hatte. Ich glaube, wenn der Künstler stirbt, dann will die Öffentlichkeit alles erfahren!

Zwei Jahre nach Elvis' Tod erschien mein erster Bildband über ihn, und seitdem dreht sich meine Arbeit ständig um das Thema Elvis – es ist der längste Auftrag meines Lebens.

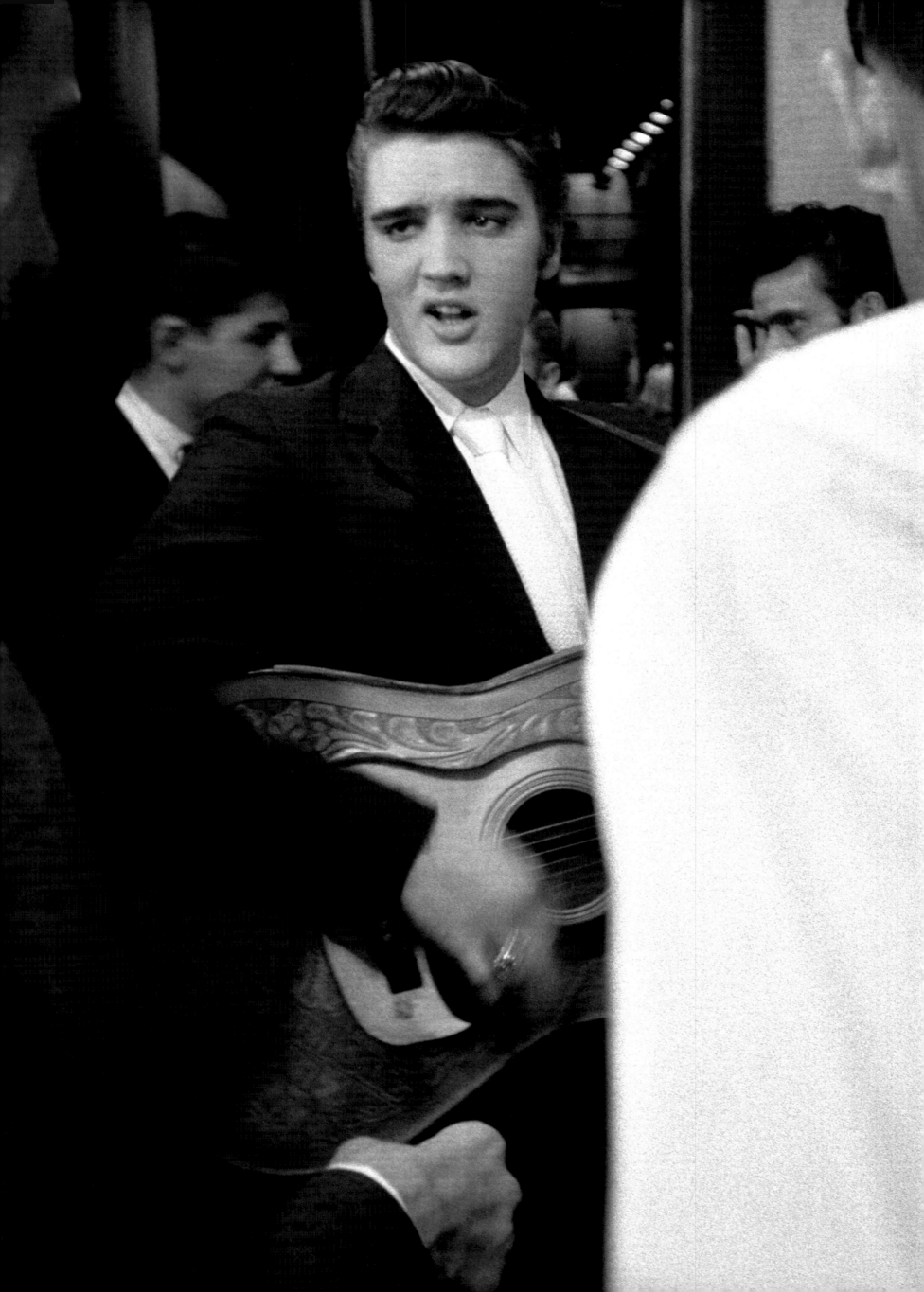

Au commencement...

ALFRED WERTHEIMER

C'ÉTAIT EN 1956. J'étais photographe free-lance à New York quand la responsable de la publicité chez RCA Victor, Anne Fulchino, m'a recruté pour photographier Elvis Presley, un jeune chanteur qu'ils venaient de prendre sous contrat. J'ai demandé: « Elvis qui ? »

C'était sans doute l'une des dernières fois que quelqu'un poserait une telle question. Après que je l'ai photographié ce samedi soir, le 17 mars, lors de sa prestation dans l'émission télévisée de Tommy et Jimmy Dorsey, *Stage Show*, le chanteur de vingt et un ans fut propulsé au firmament des stars. Dès que je l'ai rencontré, j'ai senti qu'il n'était pas comme les autres et qu'il y avait là une histoire à raconter. Je l'ai donc suivi partout pendant deux semaines, prenant plus de 2 500 clichés de celui qui serait bientôt connu dans le monde entier comme le roi du rock'n'roll.

La plupart du temps, Elvis n'était même pas conscient que je le mitraillais. Il était entièrement concentré sur ce qu'il faisait. J'attendais donc qu'il soit occupé (et Elvis était toujours occupé à être Elvis): qu'il soit en train de répéter, de flirter, de se recoiffer, de s'acheter une bague, de discuter plomberie avec son père ou de décider de remplir la piscine de ses parents avec un tuyau relié au robinet de la cuisine. Elvis m'ouvrit grand les portes de sa vie; je pouvais même le suivre dans la salle de bains.

Je considérais que si je parvenais à être comme une petite souris tout en réalisant un travail de grande qualité, je n'avais pas besoin de me préoccuper de ce que le photographe Henri Cartier-Bresson appelait « le moment décisif ». Je voulais être un observateur discret, comme un bon psychiatre avec un appareil photo. Naturellement, le moment décisif donne une image puissante, mais ce sont les instants avant et après qui me plaisent, car ils sont inhabituels et possèdent souvent une qualité étrange. Sur les milliers de photos que j'ai prises d'Elvis, ce sont les moments « pré » et « post » décisifs que je trouve les plus émouvants.

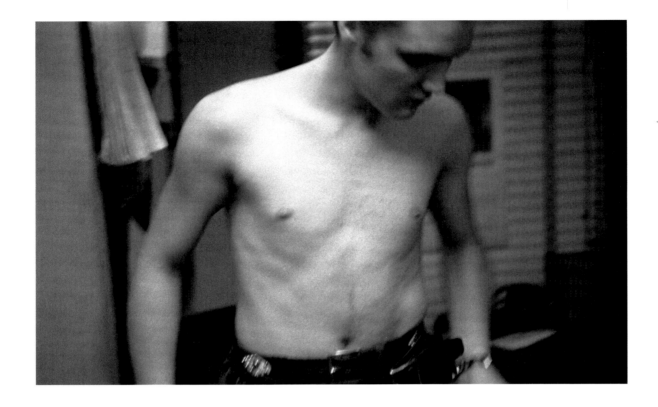

Je me souviens d'Elvis faisant sa toilette dans sa salle de bains à l'hôtel Warwick de New York. Il avait une serviette balancée par-dessus une épaule, une brosse à dents avec une noisette de dentifrice dans la main, et se tenait devant le robinet ouvert. Il s'apprête à mettre la brosse dans sa bouche; c'est un moment «pré-décisif» que tout le monde connaît. J'adore cette image d'Elvis avec quelques boutons d'acné sur le dos.

Il y a de nombreuses photos célèbres dans cette série prise dans la salle de bains, des images que je n'aurais jamais pu prendre si je n'avais pas demandé à Elvis de l'y suivre. C'était ma première année en tant que photographe professionnel et, fort heureusement, je n'étais pas très au fait des usages. Pour moi, tout était permis tant qu'Elvis me laissait faire. J'expérimentais et inventais mes propres règles au fur et à mesure, faisant le nécessaire pour obtenir de bonnes images susceptibles d'être publiées.

J'ignorais alors qu'il deviendrait célèbre, mais je savais deux choses: il n'était pas timide (enfin, disons plutôt qu'il était introverti mais il n'avait pas peur de l'objectif). Il se laissait approcher. Or, quand une photo est prise de près, une autre dynamique s'installe. Robert Capa a dit: «Si tes photos sont ennuyeuses, c'est que tu ne t'es pas approché d'assez près.» La proximité permet de capter une certaine texture qui crée une présence et rend la photo intéressante. L'autre point en sa faveur était qu'il faisait pleurer les filles.

QUE VOUS SOYEZ UN PRENEUR DE NOTES, un écrivain ou, comme dans mon cas, un photographe, vous êtes avant tout un observateur qui isole des moments auxquels il assiste avant de les rassembler. Le procédé n'est pas simple, parce que le sujet ne vous informe pas de ce qu'il fait. D'un autre côté, c'est préférable car, dès lors que le moment est verbalisé, il cesse d'être visuel. Le sujet principal ignore ce que vous allez faire puisque

ABOVE & OPPOSITE RIGHT Street clothes neatly placed on a chair, Elvis prepares to put on his first tuxedo, *The Steve Allen Show*, New York City, July 1, 1956.

22

vous ne le savez pas non plus. Vous réagissez à un événement à mesure qu'il se déroule, sans pouvoir le contrôler.

Mes défis en tant que photojournaliste étaient: comment ne pas m'immiscer dans les activités du sujet? Comment organiser l'arrière-plan afin qu'il n'interfère pas trop avec le premier plan? Et comment composer mes images de sorte qu'il n'y ait pas trop d'ambiguïté entre l'arrière-plan et le premier plan? C'étaient là mes préoccupations majeures à l'époque et ce qui définissait mon style.

Les photographes tendent à imprimer leurs photographies dans leur cerveau, du moins c'est mon cas avec toutes les images qui ont un sens. Les photographies révèlent des détails que vous ne voyez pas à l'œil nu. Elles révèlent des choses qui ne sont pas la réalité mais qui relèvent de la photo-réalité. Par exemple: lors du concert à Russwood Park, un flash a éclaté dans la foule au moment précis où je photographiais la salle, coïncidant avec l'ouverture de mon obturateur, créant un magnifique halo de lumière au-dessus d'Elvis et plaçant le public à contre-jour. C'est ce que Kodak vous recommande d'éviter à tout prix. Néanmoins, ce merveilleux accident a donné naissance à la photo *Starburst*.

Un autre exemple: pendant le long trajet en train de vingt-sept heures vers Memphis, Elvis s'ennuyait. Pour se distraire, il a saisi un panda en peluche géant, l'a calé contre sa hanche et s'est dirigé vers l'autre bout de la voiture. Je l'ai suivi avec mon objectif. Les autres passagers ne savaient pas trop quoi penser de ce jeune homme déambulant avec une peluche de plus d'un mètre de haut, mais Elvis ne leur prêtait aucune attention. En revenant vers moi, il s'est brusquement arrêté à la hauteur de deux adolescentes sur sa gauche, les a regardées dans les yeux et leur a demandé: «Vous venez à mon concert, ce soir?» Elles ont répondu: «Vous êtes qui? Quel concert?» Il leur a dit: «Je suis Elvis Presley et je donne un concert à Russwood Park.» Elles ont alors demandé: «Qui nous dit que vous êtes bien Elvis Presley?» Il m'a montré du doigt: «Vous voyez ce photographe

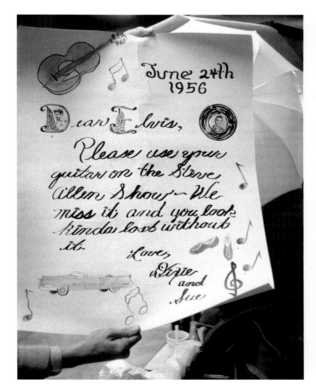

ABOVE LEFT Scroll signed by fans, imploring Elvis to play his guitar on the show.

là-bas? Vous croyez qu'il me prendrait en photo si je n'étais pas Elvis Presley?» Pendant tout ce temps, j'étais perché sur un siège, le mitraillant, et cette explication a semblé satisfaire les deux filles.

Ce jeune Elvis qui permettait une telle proximité se disait sans doute: «Comment les gens sauront-ils vraiment qui je suis s'il n'y a pas d'autres traces de moi en dehors de ma musique? Nous vivons dans une ère photographique, alors pourquoi ne pas coopérer? Après tout, je ne me rends même pas compte que ce type me prend en photo.» De temps en temps, quand j'étais vraiment sous son nez, il prenait conscience de ma présence, mais, dans toute la série, il y a peut-être une ou deux images où il pose. Le reste du temps, c'était simplement Elvis vivant sa vie, et je ne faisais qu'enregistrer son quotidien. Je ne lui demandais pas de faire des choses pour moi et il se souciait comme d'une guigne d'être suivi par quelqu'un avec un appareil photo. Je crois que ce qui fait le caractère unique de ces photos, c'est précisément que j'acceptais qu'il soit l'unique metteur en scène de sa vie.

QUAND LES GENS SONT PROFONDÉMENT CONCENTRÉS sur ce qui leur plaît, ils

oublient facilement l'objectif. C'est à ce moment que l'on obtient les meilleures images, car le sujet ne cabotine pas. Si vous approchez d'assez près, soignez le cadrage avec la lumière naturelle et une vitesse d'obturation assez lente (sans vous prendre les pieds dans le tapis), vous obtenez ce qui, à mon sens, sont des photographies très intéressantes.

Pour photographier Elvis, j'ai utilisé deux appareils Nikon S-2 noirs équipés de stigmomètre, l'un avec un objectif de 35 mm, l'autre un 105 mm. Je n'ai recouru à une lumière supplémentaire que pour environ vingt-cinq ou trente des clichés. J'ai évité en grande partie le flash car il créait un effet trop artificiel. Il casse l'ambiance et écrase la tonalité

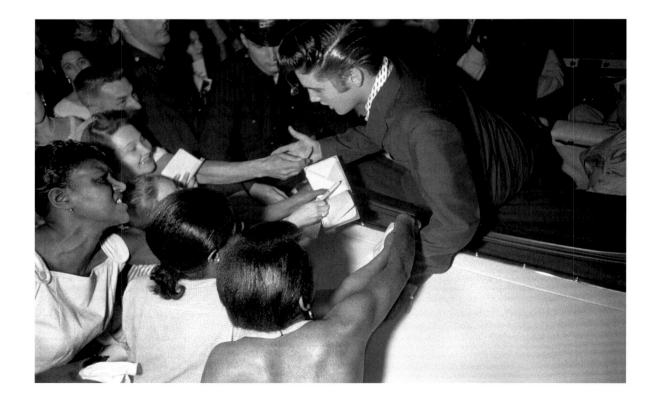

ABOVE Outside *The Steve Allen Show*'s Hudson Theatre, desperate fans reach for an autograph.

24

de la lumière existante. J'appartiens à la catégorie des photographes privilégiant la lumière naturelle et ai inventé l'expression « pénombre naturelle » avec l'idée que, plus l'environnement est sombre, plus les sujets sont à l'aise. Par exemple : les gens dans un bar sont davantage eux-mêmes que sous les néons fluorescents d'un bureau. C'est comme ça.

J'ai appris la photographie plus ou moins tout seul, hormis un cours avec Josef Breitenbach à la Cooper Union à l'époque où je m'intéressais à l'Ashcan School of Photography de New York. Dès que j'avais un appareil entre les mains, plus rien ne m'arrêtait ; je n'avais peur de rien. Sans mon appareil, j'étais une chiffe molle.

J'admirais le travail de W. Eugene Smith, un de mes héros. Ces derniers comptaient également David Douglas Duncan, Margaret Bourke-White, Dorothea Lange et tout le groupe de Roy Stryker de l'époque de la WPA (Works Progress Administration). J'étais intrigué par les photographies de Walker Evans et, en remontant plus loin, par celles de Talbot, de Daguerre, de Mathew Brady et de Muybridge ; sans oublier leur maître à tous, bien que je ne l'aie découvert que des années après avoir commencé la photographie, Erich Salomon. C'est mon vieil ami Paul Schutzer, un autre photographe, tué dans la bande de Gaza alors qu'il couvrait la Guerre des six jours pour le magazine *Life*, qui m'a présenté à Anne Fulchino. C'était elle, mon lien avec Elvis.

En 1956, peu de mes photos furent publiées. Je suis retourné photographier Elvis en septembre 1958 lorsqu'il était dans l'armée. Il donnait une conférence de presse dans le port de Brooklyn avant d'embarquer à bord du *USS Randall* pour l'Allemagne avec 6 000 autres soldats. C'est la dernière fois que je l'ai vu.

Plus tard, je suis passé derrière la caméra et j'ai couvert la campagne présidentielle de 1960 qui opposait John F. Kennedy à Richard Nixon. J'ai ensuite été chef opérateur pour la chaîne de télévision Granada, avant d'être caméraman lors du fameux festival de

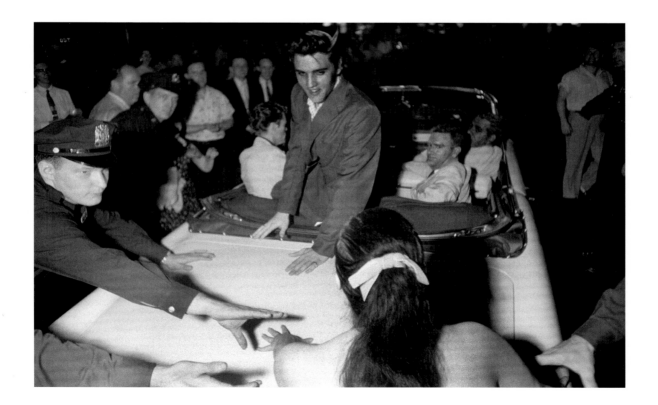

ABOVE Stand back! Police manage fans outside the Hudson Theatre.

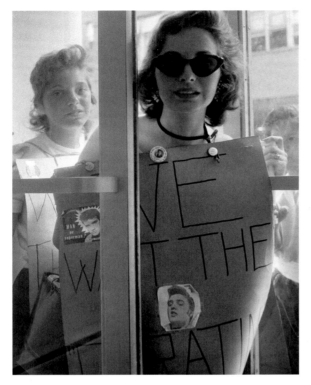

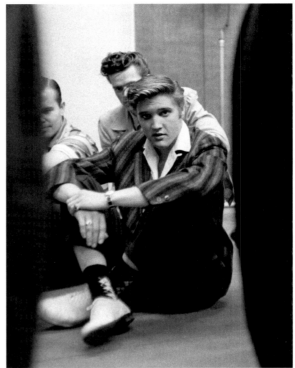

musique de Woodstock. L'ironie du sort fait que, au cours des dix-neuf ans qui se sont écoulés entre la dernière fois où j'ai vu Elvis en chair et en os et le 16 août 1977, date de sa mort, personne ne m'a demandé une de mes images d'Elvis Presley.

Ce jour-là, j'ai reçu un appel de Robert Pledge de Contact Press Images, une agence de photo à New York. Il m'a conseillé d'aller voir John Durniak au magazine *Time* avec mes photos d'Elvis. Ce que j'ai fait. En bref, ce dernier m'a demandé l'exclusivité de mes images pendant une semaine avant qu'une autre publication ne mette la main dessus. Pour ça, il était prêt à me payer ce qui, en 1977, me paraissait une fortune. C'était plus d'argent que tout ce que j'avais gagné avec mes photos d'Elvis au cours des vingt et une années précédentes. Le public ne s'intéresse jamais autant à un artiste que quand il meurt.

Mon premier livre sur Elvis a été publié deux ans après sa mort et, depuis, toute mon activité a tourné autour de lui. Ça a été la plus longue mission de ma vie.

ABOVE LEFT Fans speak out: "We want Elvis on TV with his guitar—not without it."

ABOVE RIGHT & OPPOSITE Elvis and guitarist Scotty Moore between takes at RCA Victor Studio 1, New York City, July 2, 1956.

26

28 Listening to a playback at RCA Victor Studio 1.

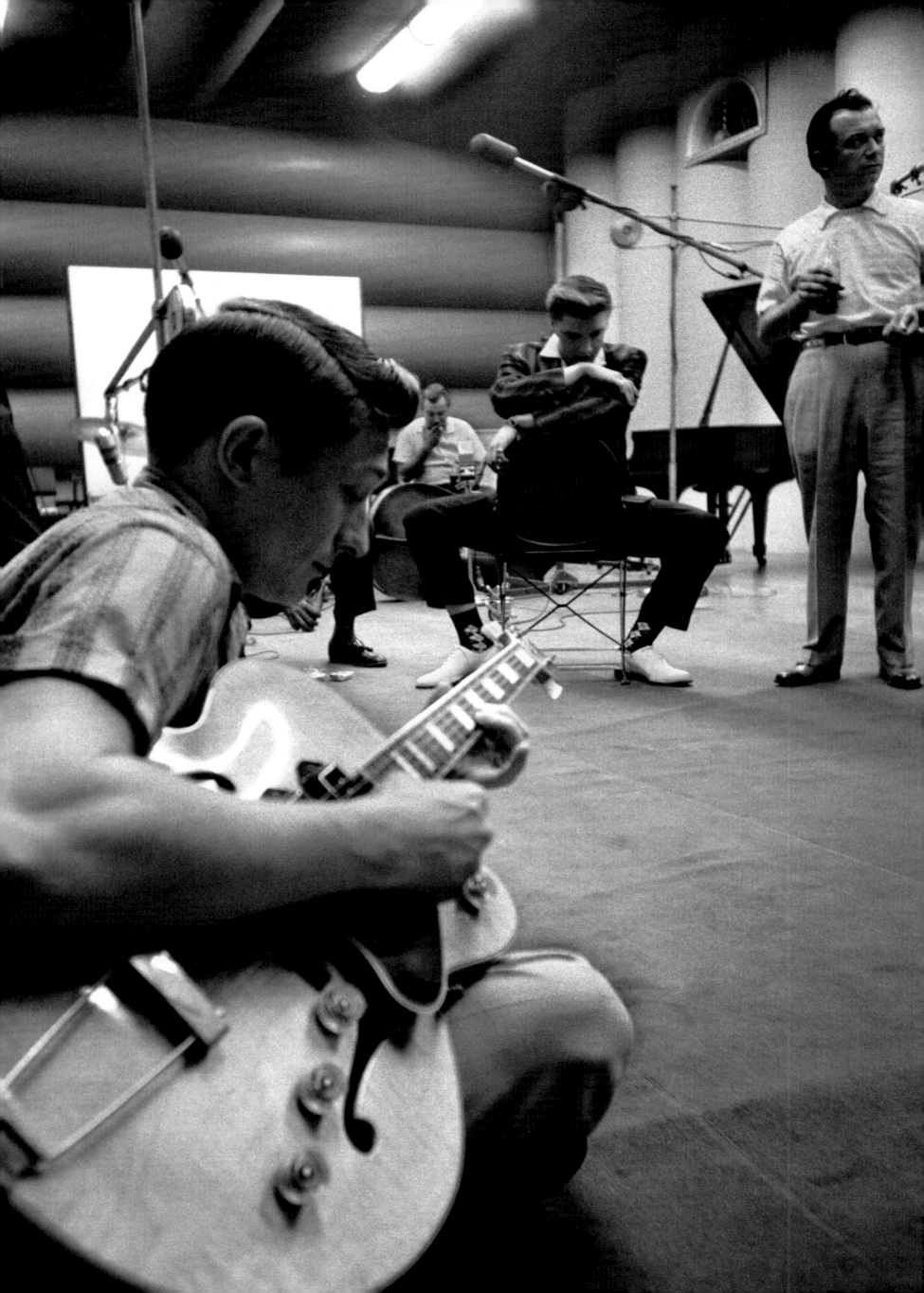

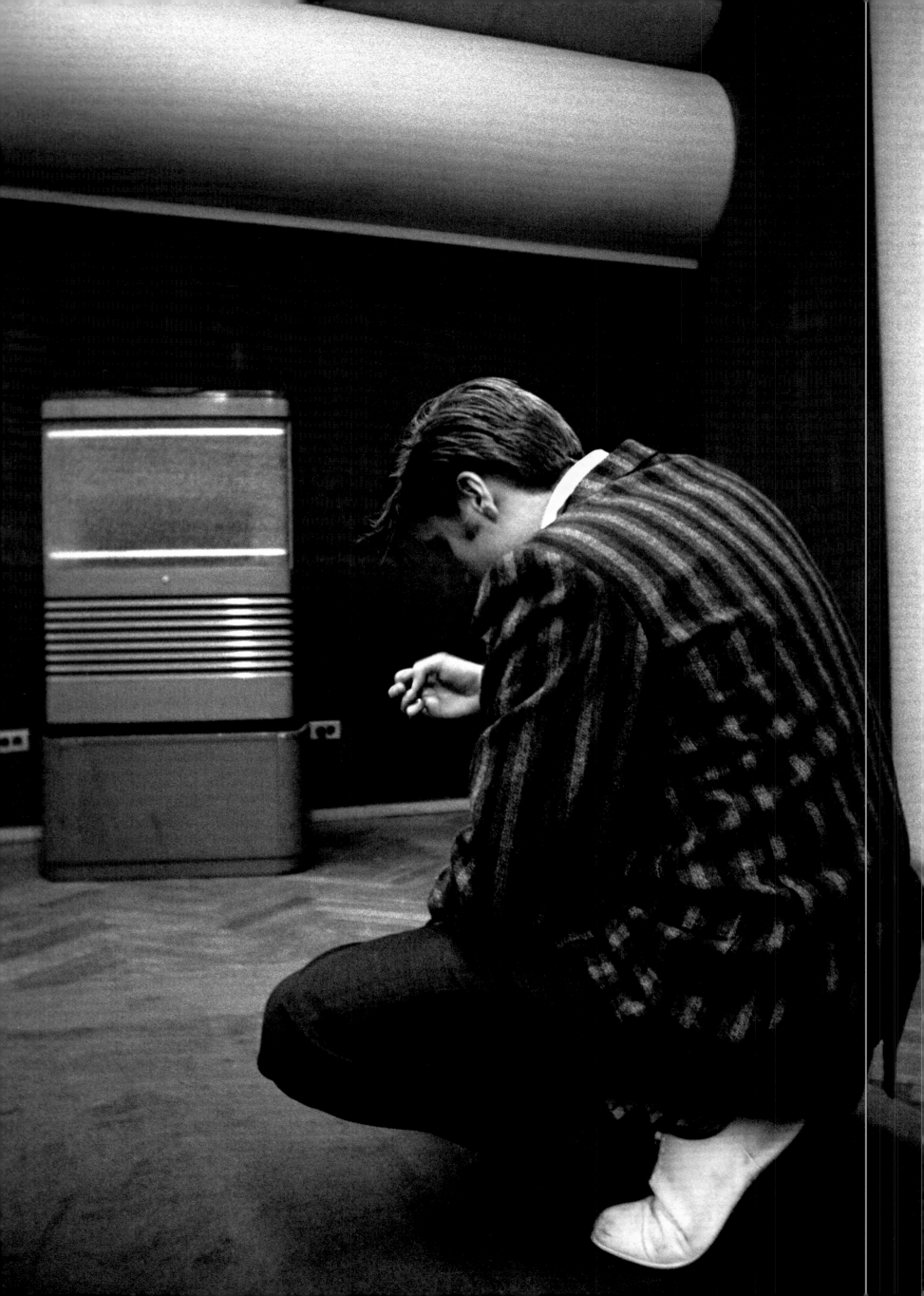

Elvis: The Life and Legacy

ROBERT SANTELLI

THEY CALLED HIM THE KING OF ROCK AND ROLL. Elvis Presley, the young man with the swiveling hips and sexy smile, the one who put the music on the map and unleashed a cultural revolution that changed the world. More a rebel than a royal, he rose up against conformity and sneered at popular convention. He used music to punch a hole through both poverty and prejudice. With those looks, that voice, and a bucking restlessness that made every song he sang an anxious statement about a changing America, he blazed the path we were all bound to follow.

Until 1956 Elvis was hardly known by America outside the South, where for the past couple of years he'd been barnstorming with his band, melting girls' hearts, testing the laws of decency (at least that's what civic leaders and pastors claimed), and generally remaking the arch and angles of American music. In January of that year, RCA Victor Records, the New York–based recording company that now had him under contract, released "Heartbreak Hotel," a shivering, seductive tale of primitive rock-and-roll angst, and with it, The Year of Elvis officially began. Over the ensuing months, RCA released more Presley singles—all of them racking up record sales. Hollywood beckoned and Elvis became a movie star. By year's end, the young singer was a millionaire, rock and roll had taken up residence on the pop charts, and America's youth felt the tug of change and the stirrings of freedom.

There with his camera to capture Elvis's most precious moments—those we'd come to cherish, thanks to the startling pictures he made—was the photographer Alfred Wertheimer. Though he knew next to nothing about this young singer when first assigned the task of taking photos of Elvis—except that he made an exceptional subject to shoot—Wertheimer would document his meteoric rise like no one else. The pictures are beautiful and revealing, historic and artistic. They resonate with Presley's youthful passion, and pose the question: If Elvis had not come along, what would have become of America?

ELVIS PRESLEY WAS BORN POOR IN TUPELO, Mississippi, on January 8, 1935, in the midst of the Great Depression. The only child of Gladys and Vernon Presley, young Elvis loved the gospel, blues, country, and pop sounds he heard as a boy. His family scraped by, its condition made worse when Vernon went to prison for writing bad checks. Young Elvis found solace in the music he heard on the radio and blaring from churches and juke joints. When the Presley family moved to Memphis in 1948, eager for a new start, Elvis took his love of music with him, for now it was deep within his soul, searching for a release.

Elvis took advantage of his new surroundings. Beale Street—where black bluesmen, gamblers, loan sharks, con men, and hookers plied their trades—fascinated him. He graduated from Humes High School in 1953 and got a job driving a truck for Crown Electric. But music was always on his mind. He embraced the blues and rhythm and blues and felt the sacred touch of both black and white gospel. He sang and strummed some simple guitar chords, but he never could have thought or even dreamed of what was to come.

In July 1954, he entered the Memphis Recording Service on Union Avenue, where less than a year earlier he had cut two songs that he made into a record for his mother. Studio owner Sam Phillips took special notice of the handsome, pompadoured young man who was white, but sang black. Phillips, barely making ends meet, thought that just maybe the Presley kid was the ticket for which he'd been hoping. That hot summer, Phillips brought Elvis back to his studio, along with honky-tonk musicians Scotty Moore, who played guitar, and Bill Black, a bass player. Together, the three stumbled upon a sound so rich and new that it couldn't be described in conventional terms. Part blues and part country, with gospel strains running through Elvis's vocals, this hybrid music was like nothing anyone had ever heard before. Sam Phillips had no name for it; neither did Elvis or Scotty or Bill. Not long after, it would be defined as rock and roll, but that July in Memphis it sounded like musical sex.

That historic turn at the Memphis Recording Service was presented to the rest of America when Phillips released Presley's versions of "That's Alright Mama" (written by bluesman "Big Boy" Arthur Crudup) and "Blue Moon of Kentucky" (written by country bluegrass pioneer Bill Monroe) on his small, independent Sun Records label. Prior to Elvis, most of those who recorded for Sun were black blues singers, and the label barely made money. When Elvis sang his special kind of blues with a country twist, the songs shed their earlier identities and simply rocked. There was no other way to put it or say it: They rocked. Things would never be the same.

RCA Victor Records only heard the sound of the cash register ringing when they offered Sam Phillips the then-unheard-of sum of $35,000 for Presley's contract, plus $5,000 more so Elvis could buy a Cadillac for his beloved mother. Everyone benefited. Presley released his first RCA singles in early 1956; by year's end, he had earned a million dollars, his name was on the lips and in the dreams of every American adolescent female, and he was known simply as Elvis. The hits rolled from the recording studio to the radio and finally onto record players across America: "I Want You, I Need You, I Love You"; "Hound Dog"; "Don't Be Cruel"; and "Love Me Tender." They all shot to number one. Elvis performed on *The Ed Sullivan Show*, the Dorsey Brothers' *Stage Show*, and *The Steve Allen Show*. The country buzzed Elvis Presley.

He made his acting debut in the movie *Love Me Tender*. Being on the big screen only elevated his star status. That he couldn't really act mattered little. His part in the film only confirmed what most of teen America already knew: Elvis was a hunk, a heartthrob. Teenage boys wanted to be like him; girls just plain wanted him. Elvis's hits continued in the late '50s, but by this time there were plenty more young rock and roll stars competing for the same spotlight that once shined only on him. Still, Elvis was the King. When he traded his slick-combed jet-black hair for a GI crew cut in 1958 and shipped off to Germany, his fans still got their share of Elvis music, thanks to the shrewd work of his manager, Colonel Tom Parker. Maintaining Elvis's fan base was Parker's priority number one while his boy served Uncle Sam, and he saw to it that Elvis had stockpiled plenty of songs before heading to boot camp.

WHEN PRESLEY BECAME A CIVILIAN AGAIN, rock and roll had changed, and so had he. Rather than regain the music territory he once exclusively ruled, Elvis spent most of his creative time making movies, few of them good. The Beatles, the Rolling Stones, the Beach Boys, Bob Dylan, Motown, and many more had inspired a new generation of music fans to press past Elvis, as "rock and roll" became simply "rock" and fueled a new revolution—one far more potent than anything witnessed in the 1950s.

Elvis returned for one more magical music moment. It occurred on television in 1968, seven years after his last public performance. History calls it the "Comeback Special." It was certainly special; his performance recalled the raw exuberance of his early sound and proved it could still topple giants. Suddenly Elvis was with us again, but he didn't stay, despite three more hit singles the following year: "In the Ghetto," "Suspicious Minds," and "Don't Cry Daddy." His voice was still crisp, but it had lost the magic. He toured the U.S.

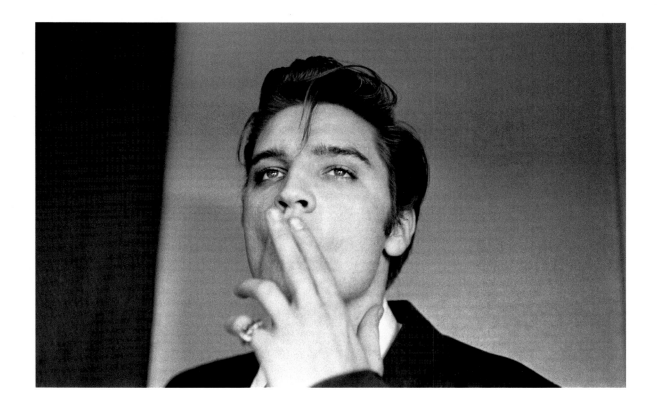

ABOVE Heading back to Memphis from New York City on the Southern Railway, Elvis, in animated pose, tells a long-winded story to sidemen Scotty Moore and Bill Black, July 3, 1956.

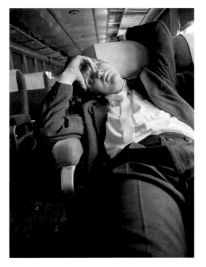 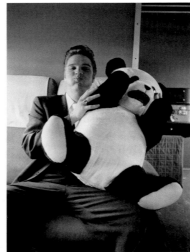 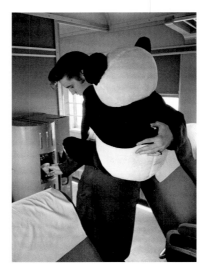

and sold out everywhere, and he even had one more number one album in 1973. But Elvis was more relic than rocker. Fans came for the memories. There was little else Elvis could give them.

On August 16, 1977, he was found dead in a bathroom of his lavish home, Graceland. Congestive heart failure was the official culprit. He was just 42 years old. From that point on, the myth took over. America and the rest of the world grieved, and when the tears dried Elvis was bigger than ever. His records rebounded to the top of the charts, documentaries gave us new insight into the fallen star, and Graceland became the most visited residence in America, other than the White House.

Today when we hear his music or see photographs of him—especially the realism and intimacy found in Wertheimer's photographs of the beginning of Elvis's career in 1956—it brings us back to another place and time. Wertheimer's photographs not only document a crucial year in Elvis's storied career, but they also capture the metamorphosis of pop music and the cultural transformation of America. Rich with raw emotion and uncut honesty, Wertheimer's images show Elvis unguarded and innocent, confident and scared, sexy and silly. We would never see him like that again, and without these photos we'd never have had that inside view of his life at all—and for that we have Al Wertheimer to thank.

ABOVE LEFT *One-Eyed Jack*, July 4, 1956.

ABOVE CENTER & RIGHT & OPPOSITE Hours into the journey, Elvis drifted between sleep, reading, and clowning around with a giant stuffed panda. The 27-hour ride to Memphis, Tennessee, ran from July 3 to July 4, 1956.

34 Back home with his family in Memphis on the Fourth of July, Elvis signs autographs for neighbors while sitting on his Harley-Davidson, 1034 Audubon Drive.

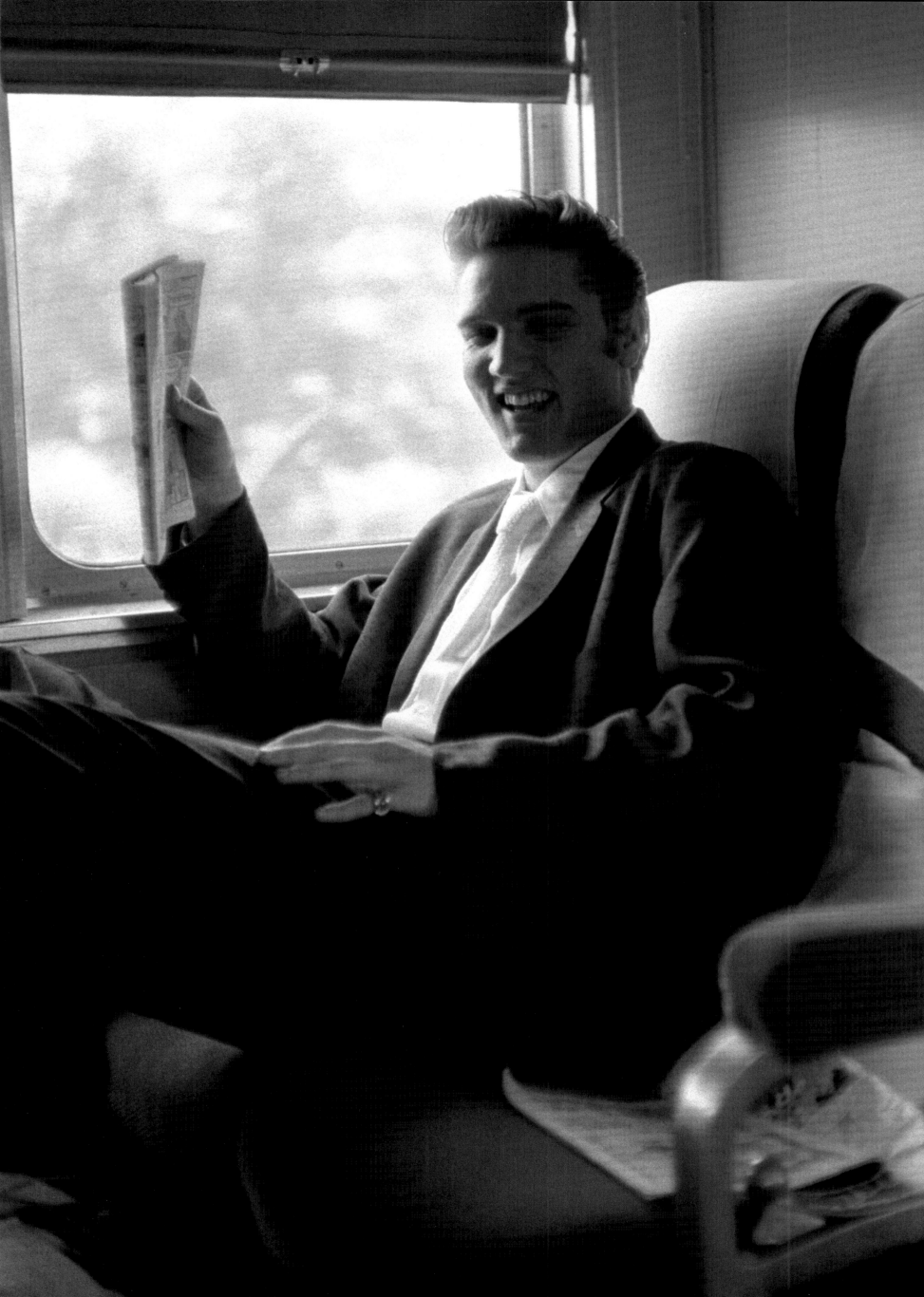

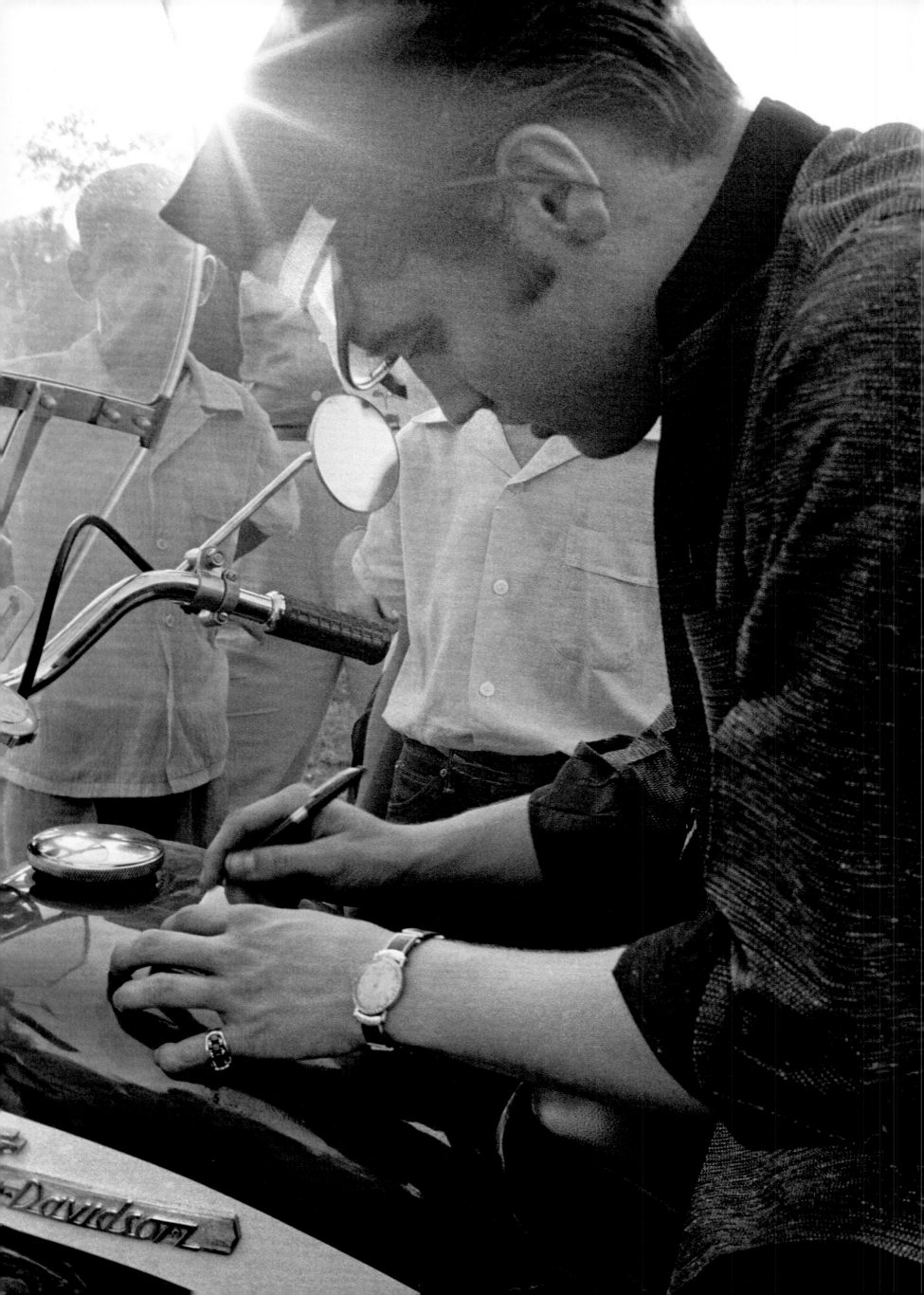

Elvis: Sein Leben, sein Vermächtnis

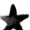

ROBERT SANTELLI

MAN NANNTE IHN DEN KING OF ROCK AND ROLL: Elvis Presley, der junge Mann mit dem Hüftschwung und dem sexy Lächeln, der diese Musik erst bekannt machte und eine Kulturrevolution ins Rollen brachte, die die Welt veränderte. Er war eher ein Rebell als ein König, widersetzte sich jeder Art von Angepasstheit und pfiff auf gängige Konventionen. Er benutzte die Musik, um Armut und Vorurteilen zugleich den Stachel zu ziehen. Mit seinem Aussehen, seiner Stimme und einer nicht zu bändigenden Rastlosigkeit, die jeden Song aus seinem Mund zu einem beunruhigenden Statement über ein Amerika im Wandel machte, machte er den Weg frei, dem wir alle unausweichlich folgen mussten.

Bis zum Jahr 1956 war Elvis in Amerika so gut wie unbekannt, vom Süden abgesehen, wo er bereits seit ein paar Jahren mit seiner Band durch die Provinz tingelte, Mädchenherzen zum Schmelzen brachte, die Grenzen von Sitte und Anstand ausreizte (so jedenfalls die Behauptung von etablierten Bürgern und Kirchenmännern) und ganz allgemein die Koordinaten der amerikanischen Musiklandschaft neu bestimmte. Im Januar dieses Jahres hatte das New Yorker Plattenlabel RCA Victor, bei dem er nun unter Vertrag war, „Heartbreak Hotel" herausgebracht, eine lockende, vor Leidenschaft bebende Ballade voller primitiver Rock-and-Roll-Angst, und mit diesem Song begann das offizielle Elvis-Jahr. Im Lauf der folgenden Monate veröffentlichte RCA weitere Presley-Singles – von denen jede die Verkaufszahlen noch weiter in die Höhe schraubte. Hollywood rief, und Elvis wurde zum Filmstar. Am Ende des Jahres war der junge Sänger Millionär, Rock and Roll hatte sich in den Popcharts etabliert, und Amerikas Jugend spürte den Sog des Wandels und das Gefühl der Freiheit.

Mit seiner Kamera zur Stelle, um Elvis' kostbarste Augenblicke einzufangen – jene, die im Nachhinein auch uns lieb und teuer werden sollten, dank der erstaunlichen Bilder, die er davon machte –, war der Fotograf Alfred Wertheimer. Obwohl er praktisch nichts über diesen jungen Sänger wusste, als er zum ersten Mal vor der Aufgabe stand, ihn zu

fotografieren – außer, dass er ein Ausnahme-Motiv abgab –, gelang es Wertheimer wie keinem anderen, Elvis' kometenhaften Aufstieg zu dokumentieren. Die Fotografien sind wunderschön und aufschlussreich, geschichtsträchtig und kunstvoll. Sie geben Presleys jugendliche Leidenschaft wieder und werfen die Frage auf: Wäre Elvis nicht auf der Bildfläche erschienen, was wäre wohl aus Amerika geworden?

ELVIS PRESLEY KAM IN ARMUT ZUR WELT. Als einziges Kind von Gladys und Vernon

Presley inmitten der Weltwirtschaftskrise am 8. Januar 1935 in Tupelo, Mississippi, geboren, lernte der kleine Elvis die Musik lieben, mit der er aufwuchs – Gospel, Blues, Country und Pop. Die Situation seiner Familie, die gerade so über die Runden kam, verschlechterte sich weiter, als Vernon wegen ungedeckter Schecks im Gefängnis landete. Elvis fand Trost in der Musik, die er im Radio und aus Kneipen und Kirchen schallen hörte. Als die Presleys, getrieben von der Hoffnung auf einen Neuanfang, 1948 nach Memphis zogen, nahm Elvis seine Liebe zur Musik mit, denn nun saß sie tief in seiner Seele und verlangte nach einem Ventil.

Für Elvis war die neue Umgebung eine Bereicherung. Die Beale Street, in der schwarze Bluesmusiker, Zocker, Kredithaie, Hochstapler und Huren ihrem Gewerbe nachgingen, faszinierte ihn. 1953 machte er seinen Abschluss an der Humes High School und nahm einen Job als Lkw-Fahrer bei Crown Electric an. Aber die Musik ließ ihn nicht los. Er sog den Blues und Rhythm and Blues in sich auf und spürte die spirituelle Kraft sowohl schwarzer wie weißer Gospelmusik. Er sang und zupfte ein paar simple Akkorde auf der Gitarre dazu, doch hätte er sich nie träumen lassen, was kommen sollte.

Im Juli des Jahres 1954 betrat er das Aufnahmestudio des Memphis Recording Service in der Union Avenue, wo er vor nicht einmal einem Jahr zwei selbst komponierte Lieder

ABOVE At Elvis's invitation, Wertheimer jumps on the motorcycle, but soon runs out of film.

36

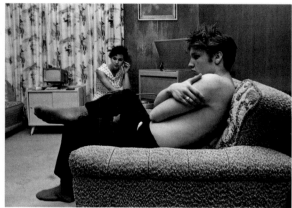

für seine Mutter auf Platte hatte aufnehmen lassen. Dem Betreiber des Studios, Sam Phillips, ging der gut aussehende Junge mit der Schmalztolle, der ein Weißer war, aber wie ein Schwarzer sang, nicht aus dem Sinn. Phillips, der sich damals mit seinem Geschäft kaum über Wasser halten konnte, dachte, dass vielleicht dieser Presley-Knabe das Zugpferd sein könnte, auf das er gehofft hatte. In jenem heißen Sommer holte Phillips Elvis zurück in sein Studio, dazu die Honky-Tonk-Musiker Scotty Moore als Gitarristen und Bill Black, der Bass spielte. Zusammen stießen die drei zufällig auf einen Sound, der so satt und neu klang, dass er mit gängigen Begriffen nicht zu beschreiben war. Teils Blues und teils Country, vermischt mit Gospelanklängen, die Elvis' Gesangsparts durchzogen, war diese Kreuzung aus verschiedenen Musikstilen anders als alles, was man bis dahin gehört hatte. Sam Phillips hatte keinen Namen dafür; ebenso wenig wie Elvis, Scotty oder Bill. Bald darauf sollte der Sound als Rock and Roll definiert werden, doch in jenem Juli in Memphis hörte er sich an wie Sex in Musikform.

Das restliche Amerika erfuhr von dieser historischen Wende, die sich im Aufnahmestudio des Memphis Recording Service vollzogen hatte, als Phillips bei seinem kleinen, unabhängigen Plattenlabel Sun Records eine Single mit Presleys Versionen von „That's Alright Mama" (aus der Feder des Bluesmusikers Arthur „Big Boy" Crudup) und „Blue Moon of Kentucky" (geschrieben von Bill Monroe, einem Country-Bluegrass-Pionier) herausbrachte. Ehe Elvis auftauchte, hatte Sun Records vorwiegend schwarze Bluesmusiker unter Vertrag, und das Label machte kaum Gewinn. Als nun Elvis seinen ganz speziellen Blues mit Country-Einschlag sang, streiften die Songs ihre alte Identität ab und rockten einfach. Es ließ sich schlicht nicht anders sagen: Sie rockten. Nichts würde mehr so sein, wie es einmal war.

Der einzige Sound, den die Leute von RCA Victor im Ohr hatten, als sie Sam Phillips die damals unerhörte Summe von 35 000 Dollar für Presleys Vertrag boten und 5 000 Dollar obendrauf legten, damit Elvis seiner geliebten Mutter einen Cadillac kaufen konnte, war das Klingeln der Registrierkasse. Alle Seiten profitierten. Presley veröffentlichte seine erste RCA-Single Anfang 1956; am Ende dieses Jahres hatte er eine Million Dollar verdient, sein Name war auf den Lippen und in den Träumen jedes amerikanischen Backfischs, und man kannte ihn nur noch als Elvis. Die Hits rollten aus dem Aufnahmestudio über die Radiostationen hinaus bis auf die Plattenteller in ganz Amerika: „I Want You, I Need You, I Love You", „Hound Dog", „Don't Be Cruel" und „Love Me Tender".

ABOVE Scenes from Audubon Drive: Gladys Presley watches her son in the pool and Barbara Hearn, an old flame, visits with Elvis.

Sie alle schossen auf Platz eins der Musikcharts. Elvis trat in der *Ed Sullivan Show*, der *Stage Show* der Dorsey-Brüder und der *Steve Allen Show* auf. Elvis Presley war in aller Munde.

In dem Kinofilm *Love Me Tender* gab er sein Debüt als Schauspieler. Mit seinem Erscheinen auf der Leinwand steigerte sich sein Starstatus nur noch weiter. Dass er eigentlich gar nicht schauspielern konnte, spielte kaum eine Rolle. Seine Filmfigur bestätigte nur, was die meisten amerikanischen Teenager ohnehin schon wussten: Elvis war ein Traumtyp, ein Mädchenschwarm. Die Jungs wollten sein wie er; die Mädels wollten ihn ganz einfach. Elvis' Hitsträhne hielt auch während der späten 1950er-Jahre an, doch nun gab es bereits wesentlich mehr junge Rock and Roller, die um das Scheinwerferlicht kämpften, das einst auf ihn alleine gerichtet war. Aber Elvis war nach wie vor der King. Als er 1958 seine pechschwarze Pomadenfrisur gegen einen soldatisch kurzen Crewcut eintauschte und das Armeeschiff nach Deutschland bestieg, bekamen seine Fans weiterhin ihre musikalische Elvis-Ration, dank der gewieften Vorarbeit seines Managers Colonel Tom Parker. Solange „sein Junge" für Uncle Sam im Einsatz war, lautete Parkers höchste Priorität, Elvis' Fanstamm bei der Stange zu halten, und er sorgte dafür, dass Elvis ausreichend Songs auf Vorrat produzierte, ehe er ins Ausbildungslager einrückte.

ALS PRESLEY WIEDER ZIVILIST WURDE, hatte sich nicht nur der Rock and Roll

verändert, sondern auch er selbst. Anstatt das musikalische Hoheitsgebiet zurückzuerobern, das er einst unangefochten alleine regiert hatte, verschwendete er den größten Teil seiner kreativen Kraft nun auf Filme, unter denen nur wenige gut waren. Die Beatles, die Rolling Stones, die Beach Boys, Bob Dylan, die Motown-Musiker und viele andere hatten eine neue Generation von Musikfans beflügelt, die an Elvis vorbeistürmte, als aus Rock and Roll blanker Rock wurde, der eine neue Revolution befeuerte – eine, die in ihrer Wirkung wesentlich stärker war als alles, was man in den 1950er-Jahren erlebt hatte.

Doch Elvis kehrte für einen weiteren magischen Moment der Musikgeschichte noch einmal zurück. Er ereignete sich 1968, sieben Jahre nach seinem letzten öffentlichen Auftritt. In den Annalen ist er als *Comeback Special* vermerkt – und ein „Special" war dieser Fernsehauftritt allemal, rief er doch die rohe, überbordende Kraft des frühen Elvis-Sounds zurück und bewies, dass dieser Sound immer noch Giganten ins Wanken bringen konnte. Plötzlich war Elvis wieder bei uns, doch er sollte nicht bleiben, trotz dreier weiterer Hit-Singles, die im folgenden Jahr erschienen: „In the Ghetto", „Suspicious Minds" und „Don't Cry Daddy". Seine Stimme war noch immer ausdrucksstark, aber sie hatte ihren Zauber verloren. Er tourte durch die Staaten und trat stets vor ausverkauften Häusern auf, brachte 1973 sogar noch ein Nummer-eins-Album auf den Markt. Doch Elvis war eher Relikt als Rocker. Die Fans kamen der Erinnerungen wegen. Mehr konnte Elvis ihnen kaum geben.

Am 16. August 1977 fand man ihn in einem Badezimmer seines Prunkdomizils Graceland tot auf. Herzinsuffizienz hieß der offizielle Schuldige. Elvis wurde gerade einmal 42 Jahre alt. Das war der Moment, in dem der Mythos Elvis begann. Amerika und der Rest der Welt trauerte, und als die Tränen trockneten, war Elvis größer denn je. Seine

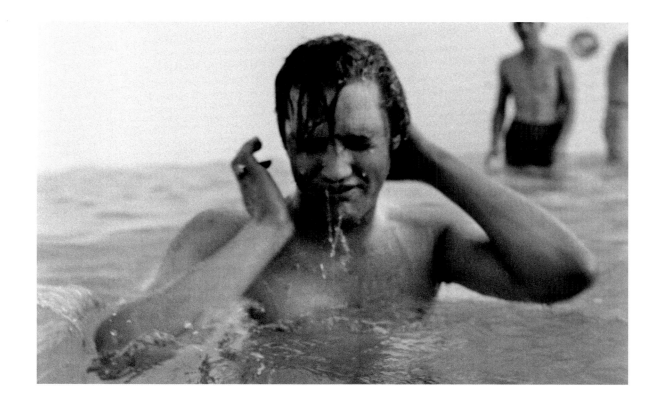

Platten schnellten zurück an die Spitze der Charts, Dokumentationen lieferten uns neue Erkenntnisse über den verblichenen Star, und Graceland wurde zum meistbesuchten Anwesen Amerikas neben dem Weißen Haus.

Wenn wir heute Elvis' Musik hören oder Bilder von ihm sehen – gerade die uninszenierten und intimen Augenblicke, die Wertheimer zu Beginn seiner Karriere im Jahr 1956 einfing –, versetzt uns das zurück an einen anderen Ort und in eine andere Zeit. Wertheimers Aufnahmen dokumentieren nicht nur ein entscheidendes Jahr in Elvis' sagenhafter Karriere, sondern auch die Metamorphose der Popmusik und den kulturellen Wandel Amerikas. Reich an blanken Emotionen und von ungeschliffener Ehrlichkeit, zeigen Wertheimers Bilder Elvis schutzlos und unbedarft, selbstsicher und verschüchtert, aufreizend und albern. Wir sollten ihn nie wieder so sehen, und ohne diese Bilder hätten wir einen derart tiefen Einblick in sein Leben auch niemals erhalten – dafür haben wir Al Wertheimer zu danken.

ABOVE Up for air in the family pool.

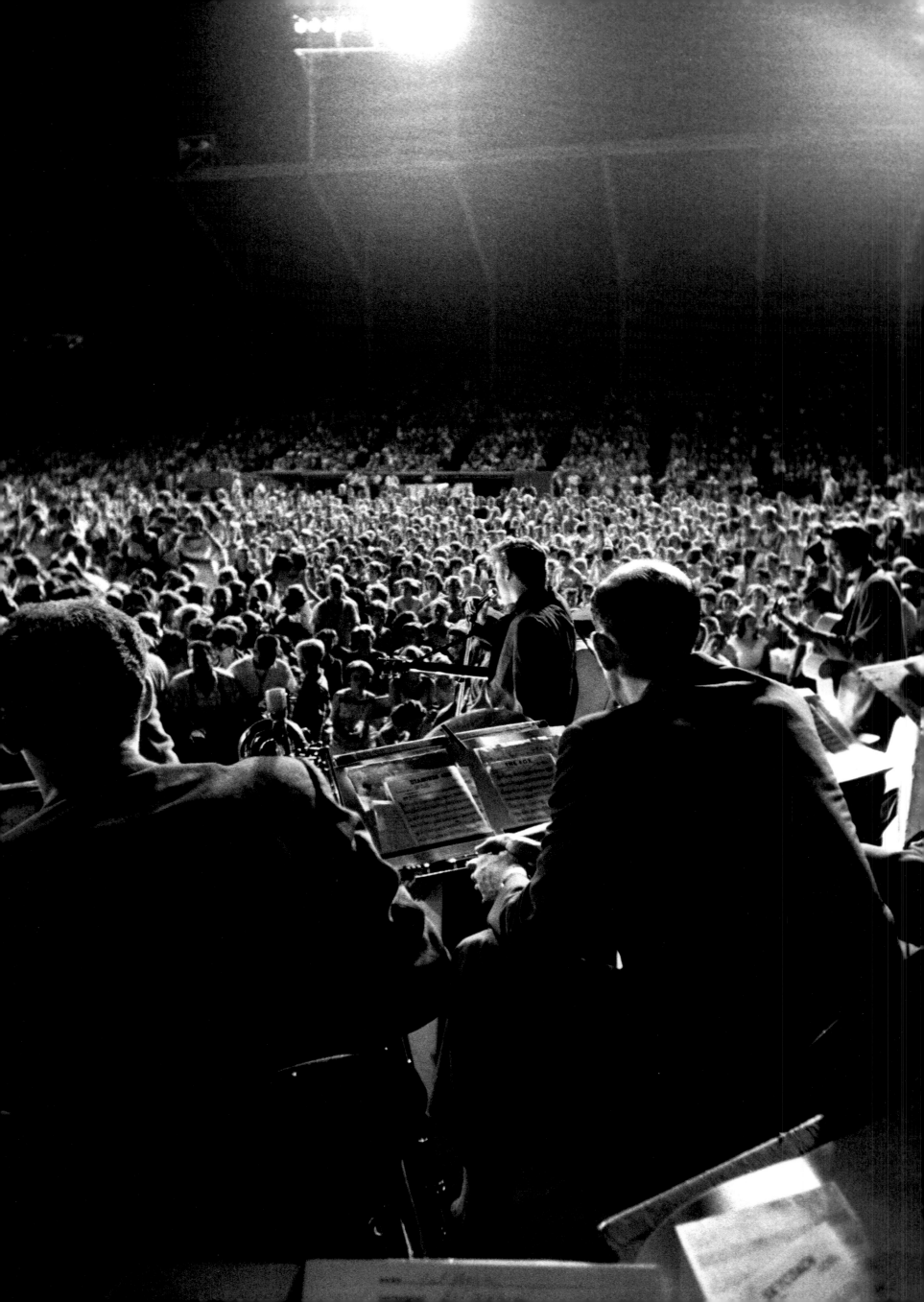

Elvis : sa vie, son héritage

ROBERT SANTELLI

ON L'APPELAIT LE KING. Elvis Presley, le jeune rockeur aux déhanchements provocants et au sourire ravageur, est à l'origine d'une révolution culturelle qui changea le monde. Plus rebelle que royal, il s'érigea contre le conformisme et se moquait des conventions populaires. Il utilisa sa musique comme un coup de poing contre la pauvreté et les préjugés. Armé d'un physique de jeune premier, d'une voix de velours et d'une énergie fébrile qui faisait de chacune de ses chansons le reflet d'une Amérique en pleine mutation, il enfonça une porte par laquelle nous nous sommes tous engouffrés.

Jusqu'en 1956, Elvis était pratiquement inconnu hors des États du Sud où il tournait avec son groupe depuis deux ans, faisant fondre le cœur des filles, repoussant les lois de la décence (de l'avis des bien-pensants et des pasteurs) et réinventant les règles de la musique américaine. En janvier de cette année-là, RCA Victor Records, la maison de disques new-yorkaise qui l'avait pris sous contrat, produisit « Heartbreak Hotel », un envoûtant conte rockabilly chargé d'angoisse existentielle. L'année Elvis était officiellement lancée. Au cours des mois suivants, RCA sortit d'autres singles du chanteur qui battirent tous des records de vente. Hollywood ne tarda pas à le repérer et en fit une star de cinéma. Avant la fin de l'année, Elvis était devenu millionnaire, le rock'n'roll s'était définitivement installé au hit-parade et la jeunesse américaine succombait à l'appel du changement et à l'effervescence de la liberté.

Le photographe Alfred Wertheimer était présent avec son objectif, saisissant ces moments précieux que nous chérissons aujourd'hui en grande partie grâce à ses merveilleux clichés. Lorsqu'on lui commanda un reportage photographique sur le jeune chanteur, il ignorait tout de lui, hormis qu'il ferait un sujet exceptionnel. Personne n'a aussi bien documenté son ascension fulgurante. Ses images sont belles et révélatrices, artistiques et historiques. Elles vibrent de toute la passion juvénile de Presley et posent la question suivante: si Elvis n'était pas apparu, que serait devenue l'Amérique?

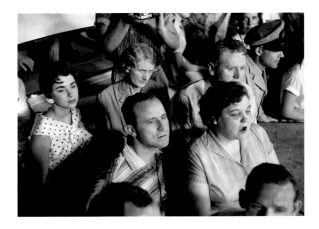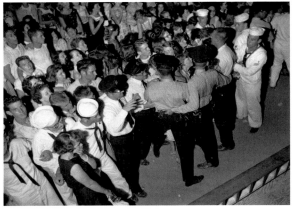

ELVIS PRESLEY EST NÉ PAUVRE À TUPELO, dans le Mississippi, le 8 janvier 1935, au

cœur de la Grande Dépression. Fils unique de Gladys et de Vernon Presley, son enfance
fut bercée par les gospels, le blues, la country et la musique populaire. Sa famille subsistait
tant bien que mal, une situation qui s'aggrava lorsque Vernon fut envoyé en prison pour
des chèques en blanc. Le petit Elvis se réfugiait dans la musique qu'il entendait à la radio,
dans les églises et les juke-joints, ces bars improvisés où l'on jouait du blues. Lorsque les
Presley tentèrent un nouveau départ en déménageant à Memphis en 1948, Elvis emporta
avec lui son amour de la musique. Elle était profondément ancrée en lui, n'attendant qu'à
être libérée.

Elvis s'imprégna de son nouvel environnement musical. L'atmosphère de Beale Street,
notamment, le fascinait. La rue était peuplée de bluesmen noirs, de joueurs, de prêteurs
sur gages, d'escrocs et de prostituées. Lorsqu'il sortit du lycée Humes en 1953, il trouva
un job de chauffeur-livreur pour la Crown Electric Company. Cependant, la musique ne
quittait jamais son esprit. Il aimait le blues, le rhythm and blues et était habité par le
sens sacré des gospels, noirs comme blancs. Il chantait et grattait des accords simples sur
sa guitare, sans pouvoir imaginer ce que le destin lui réservait.

En juillet 1954, il entra dans le bâtiment du Memphis Recording Service sur Union
Avenue. Moins d'un an plus tôt, il avait fait graver deux chansons sur un disque pour
l'offrir à sa mère. Le patron du studio, Sam Phillips, avait remarqué le séduisant jeune
homme coiffé d'une banane qui était blanc mais chantait comme un Noir. Phillips avait
des difficultés financières et s'était dit que le jeune Elvis pourrait être la solution à ses
problèmes. Il lui avait donc demandé de revenir faire des essais avec deux musiciens
locaux: le guitariste Scotty Moore et le contrebassiste Bill Black. À eux trois, ils créèrent
un son si riche et nouveau qu'on ne pouvait le décrire en des termes conventionnels.
Mi-blues mi-country, avec des accents de gospel dans la voix du chanteur, cette musique
hybride ne ressemblait à aucune autre. Sam Phillips n'avait pas de nom pour elle, pas
plus qu'Elvis, Scotty ou Bill. On la baptiserait bientôt rock'n'roll mais, pour le moment,
elle évoquait surtout un coït musical.

Le reste des États-Unis découvrit ce moment historique lorsque le petit label indé-
pendant de Phillips, Sun Records, sortit le premier disque d'Elvis où il chantait «That's
Alright Mama» (écrit par le bluesman Arthur Cudrup «Big Boy») et «Blue Moon
of Kentucky» (du pionnier du bluegrass Bill Monroe). Jusque-là, Sun Records n'avait

enregistré que des chanteurs de blues noirs et le label gagnait à peine de quoi survivre. À travers l'interprétation d'Elvis, une sorte de blues mâtiné d'accents country, ces chansons perdaient leur identité initiale et vous donnaient envie de bouger. Il n'y avait pas d'autres façons de le décrire: ça balançait! Rien ne serait plus pareil.

En rachetant le contrat de Presley à Sam Phillips pour la somme alors mirobolante de 35 000 dollars, plus 5 000 dollars pour qu'Elvis offre une Cadillac à sa chère mère, RCA Victor avait trouvé le pactole. Tout le monde était gagnant. Les premiers singles d'Elvis chez RCA sortirent début 1956. Moins d'un an plus tard, il avait gagné un million de dollars, son nom était sur toutes les lèvres et dans les rêves des adolescentes américaines. Il était devenu simplement «Elvis». Ses tubes, relayés par la radio, se vendirent comme des petits pains aux quatre coins des États-Unis: «I Want You, I Need You, I Love You»; «Hound Dog»; «Don't Be Cruel», et «Love Me Tender». Tous accédèrent directement à la première place du hit-parade. Elvis fut invité à chanter dans le *Ed Sullivan Show*, le *Stage Show* des frères Dorsey et le *Steve Allen Show*. Dans tout le pays, on ne parlait plus que de lui.

Il fit ses débuts au cinéma dans *Love Me Tender*. Le grand écran magnifia encore son statut de star. Le fait qu'il ne sache pas jouer la comédie importait peu; sa prestation ne fit que confirmer ce que la plupart des adolescents savaient déjà: Elvis était sexy, un vrai bourreau des cœurs. Les garçons voulaient lui ressembler, les filles voulaient être dans ses bras. Elvis enchaîna les hits jusqu'à la fin des années cinquante puis, peu à peu, d'autres jeunes stars du rock'n'roll apparurent, rivalisant pour attirer les projecteurs qui, jusque-là, n'avaient été braqués que sur lui. Néanmoins, le King restait indétrônable. En 1958, lorsqu'il troqua ses cheveux noirs lissés en arrière pour une coupe de GI avant d'embarquer pour faire son service militaire en Allemagne, ses admirateurs ne furent pas sevrés grâce au travail habile de son impresario, le colonel Tom Parker. Ce dernier

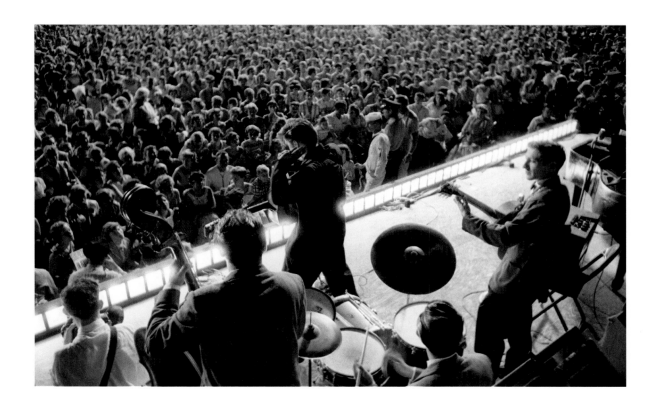

OPPOSITE & ABOVE Russwood Park: In the audience, Elvis's parents, Gladys and Vernon; uncle Vespa; grandmother Minnie Mae; and ex-girlfriend Barbara Hearn watch from the side of the stage, while security guards hold back the fans, July 4, 1956.

était déterminé à ce que son poulain ne soit pas oublié par ses fans pendant qu'il servait sous les drapeaux et lui avait fait enregistrer une réserve de futurs tubes avant son départ.

QUAND ELVIS FUT RENDU À LA VIE CIVILE, le rock'n'roll avait changé, et lui aussi. Plutôt que de tenter de reconquérir le territoire musical sur lequel qu'il avait régné avant son départ, il préféra tourner dans des films, dont une majorité de navets. Entre-temps, les Beatles, les Rolling Stones, les Beach Boys, Bob Dylan, Motown et bien d'autres avaient inspiré une nouvelle génération d'amateurs de musique, les entraînant plus loin qu'Elvis ne l'avait fait. Le «rock'n'roll» était devenu le «rock» et alimentait une autre révolution dont la portée serait beaucoup plus puissante que ce qu'on avait connu dans les années cinquante.

Elvis remonta sur scène pour un dernier moment de grâce. Sept ans après son dernier concert en public, la télévision lui consacra une émission entière, intitulée *Elvis, '68 Comeback Special*. Ce fut un triomphe: Elvis était de retour parmi nous, retrouvant l'exubérance naturelle de ses débuts et démontrant qu'il pouvait encore se hisser parmi les plus grands. Hélas, l'enchantement fut de courte durée, en dépit de trois nouveaux tubes qui sortirent l'année suivante: «In the Ghetto», «Suspicious Minds» et «Don't Cry Daddy». La voix était toujours là, mais il avait perdu la magie. Il continua à effectuer des tournées à guichets fermés dans tous les États-Unis et sortit même un nouvel album qui arriva en tête du hit-parade en 1973. Toutefois, Elvis était plus une relique qu'un rocker. Le public venait pour les souvenirs, et il n'avait pas grand-chose d'autre à lui offrir.

Le 16 août 1977, il fut retrouvé mort dans la salle de bains de sa luxueuse villa, Graceland. Officiellement, il avait succombé à une insuffisance cardiaque congestive. Il avait

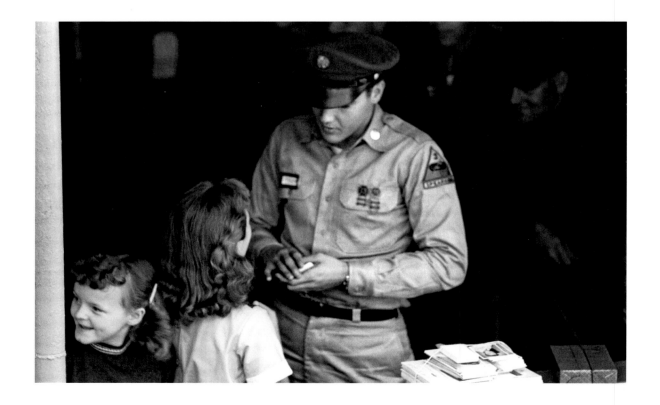

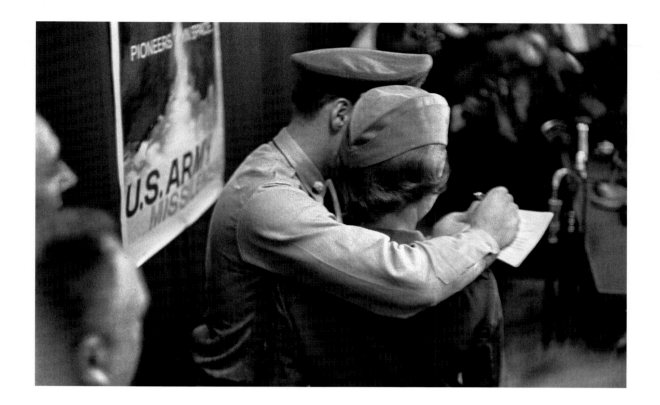

quarante-deux ans. Dès lors, le mythe prit la relève. L'Amérique et le reste du monde pleurèrent sa disparition. Quand les larmes eurent séché, Elvis était plus grand que jamais. Ses disques grimpèrent à nouveau au sommet du Top 50, les documentaires sur l'étoile déchue se multiplièrent et Graceland devint la résidence la plus visitée après la Maison-Blanche.

Aujourd'hui, lorsque nous écoutons sa musique ou regardons des photographies de lui, notamment les images réalistes et intimistes prises par Wertheimer à l'aube de sa carrière en 1956, nous sommes transportés dans un autre temps et un autre lieu. Les clichés de Wertheimer ne se contentent pas de documenter une année cruciale dans la carrière légendaire d'Elvis, elles captent la métamorphose de la musique populaire et la transformation culturelle de l'Amérique. Empreintes d'émotion et d'authenticité, elles nous montrent un Elvis naturel et innocent, sûr de lui et inquiet, sexy et espiègle. Nous ne le verrons plus jamais ainsi et, sans ces images, nous n'aurions pas aujourd'hui cette vision intime de l'homme. Pour cela, nous pouvons être reconnaissants à Al Wertheimer.

OPPOSITE & ABOVE Well-wishers gather to bid an enlisted Elvis farewell during the process of boarding the troop ship *USS Randall*, Brooklyn Port of Embarkation, September 22, 1958.

FOLLOWING PAGE Private Presley waves to the crowd. This would be the last day Wertheimer would see his subject.

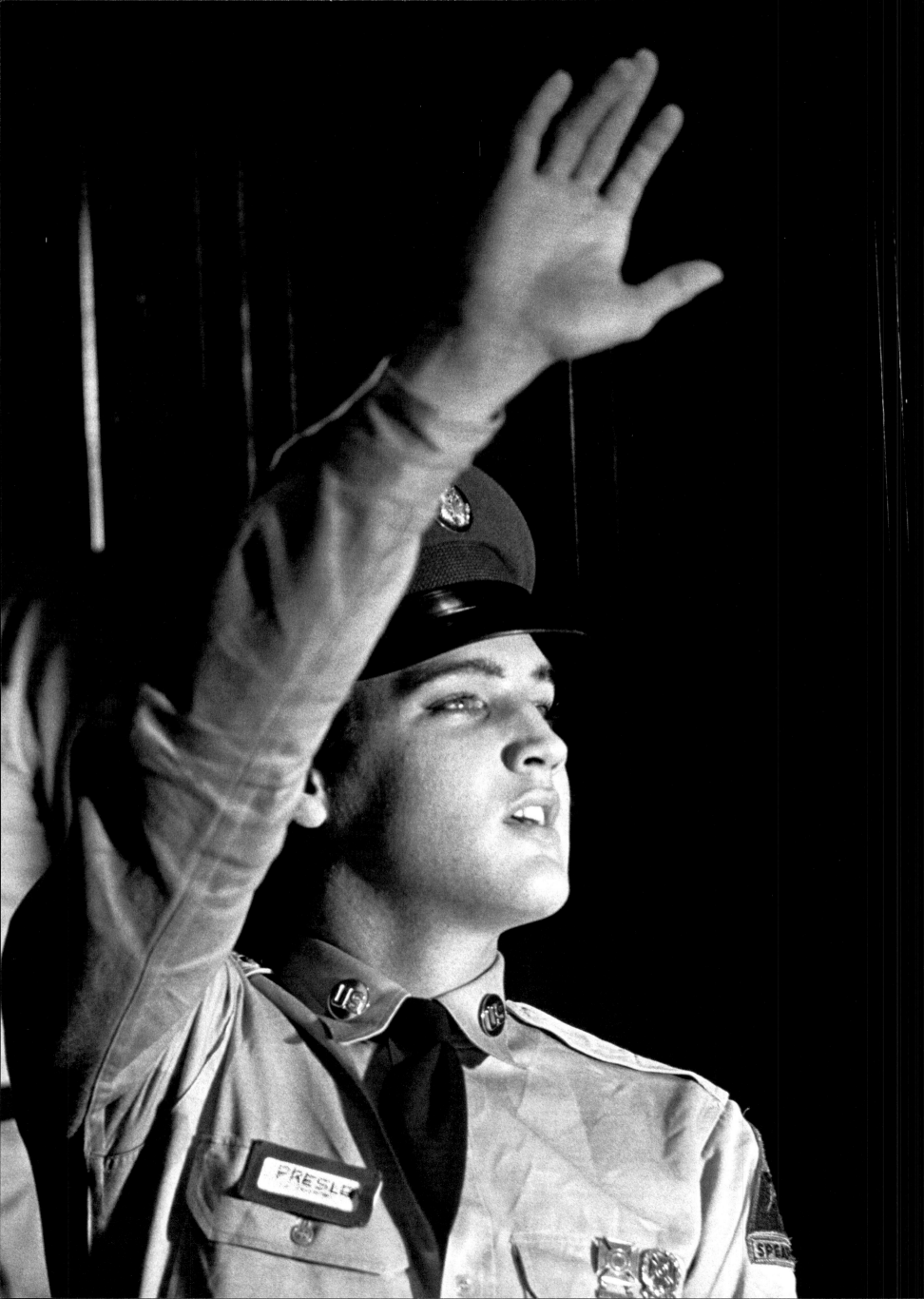

It all happened so fast till I don't know I'm afraid to wake up, afraid it's liable to be a dream, you know.

Es passierte alles so schnell, dass ich, keine Ahnung, Angst habe, aufzuwachen, Angst, dass es wahrscheinlich nur ein Traum ist, wissen Sie?

Tout s'est passé si vite. J'ai peur de me réveiller et de découvrir que ce n'était qu'un rêve.

—ELVIS PRESLEY
Robinson Auditorium, Little Rock,
Arkansas, May 16, 1956

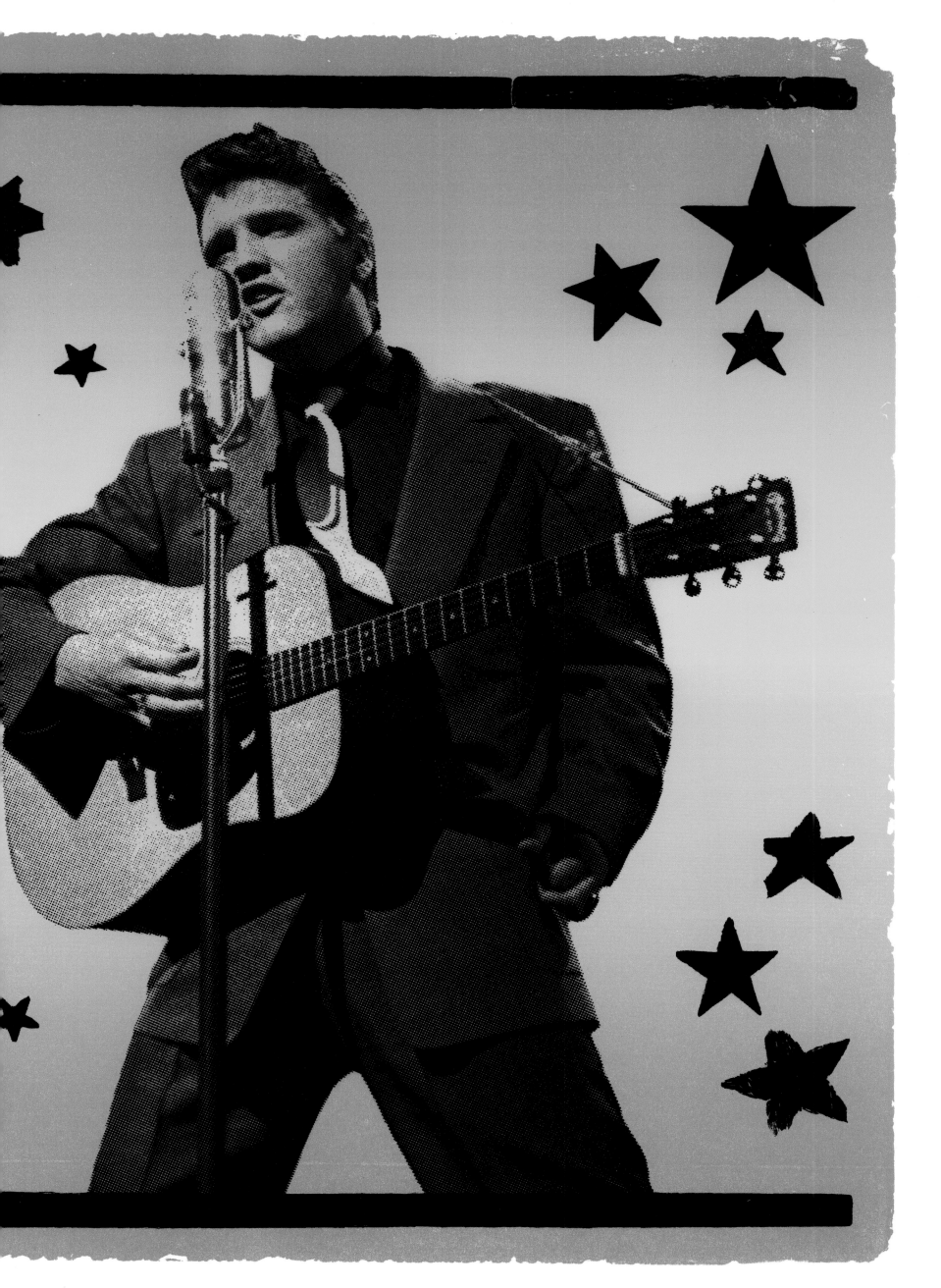

ANNE FULCHINO OF RCA VICTOR'S POP RECORD DIVISION called me to photograph some publicity shots of Elvis Presley during his performance on *Stage Show*, a variety show hosted by Tommy and Jimmy Dorsey. My first words were "Elvis who?" Despite this reaction, I headed down to CBS's Studio 50 to meet the singer and watch him rehearse "Heartbreak Hotel" and "Blue Suede Shoes." The studio was packed. Joining Elvis were his guitar player Scotty Moore, bass player Bill Black, drummer D. J. Fontana, the June Taylor Dancers, magicians, and the complete Dorsey band of at least 30 musicians. Let's not forget the publicity people, reporters, and an entourage of production staff. As I said in the preface to this book, what I learned about Elvis that day was that he permitted closeness. He wasn't shy to the camera. I was able to shoot him up close: during rehearsal, with the ring salesman, back at the Warwick Hotel, reading fan mail, and falling asleep before taking a shower. Closeness is the difference between being able to get a good photograph versus an ordinary one. I then followed him on his return to the theater, and to shoot his final performance.

ANNE FULCHINO VON DER POPMUSIK-ABTEILUNG des Schallplattenlabels RCA Victor fragte an, ob ich ein paar PR-Aufnahmen von Elvis Presley bei seinem Auftritt in der *Stage Show* machen könne, einer von Tommy und Jimmy Dorsey moderierten Musikshow. Meine ersten Worte waren: „Elvis wer?" Trotz dieser Reaktion machte ich mich auf ins Studio 50 von CBS, um den Sänger kennenzulernen und bei den Proben für „Heartbreak Hotel" und „Blue Suede Shoes" zu beobachten. Das Studio war brechend voll. An Elvis' Seite waren sein Gitarrist Scotty Moore, Bill Black am Bass, D. J. Fontana am Schlagzeug, die June Taylor Dancers, Zauberkünstler sowie die komplette Dorsey-Band von mindestens 30 Mann. Nicht zu vergessen die PR-Leute, Reporter und der ganze Produktionstross. Was ich an dem Tag über Elvis herausfand, war, dass er Nähe zuließ. Er kannte keine Kamerascheu. Ich konnte ihm mit dem Objektiv ganz nahe kommen: während der Proben, beim Gespräch mit dem Ringverkäufer, zurück im Warwick Hotel beim Lesen von Fanpost und als er einnickte, ehe er schließlich unter die Dusche ging. Nähe ist der Faktor, der entscheidet, ob man ein gewöhnliches Foto bekommt oder die Chance auf ein gutes hat. Danach folgte ich ihm zurück ins Fernsehstudio und fotografierte seinen Live-Auftritt.

ANNE FULCHINO, DU DÉPARTEMENT DE MUSIQUE POPULAIRE de RCA Victor, m'avait contacté pour réaliser quelques images promotionnelles d'Elvis Presley lors de sa prestation dans *Stage Show*, une émission de variétés animée par Tommy et Jimmy Dorsey. Ma première réaction fut: « Elvis qui ? » Je me rendis néanmoins au Studio 50 de la CBS pour le rencontrer. Il était en train de répéter « Heartbreak Hotel » et « Blue Suede Shoes ». Le studio était plein à craquer. Outre Elvis, il y avait là le guitariste Scotty Moore, le contrebassiste Bill Black, le batteur D. J. Fontana, les danseuses de la compagnie June Taylor, des magiciens et l'orchestre des Dorsey au grand complet, soit une trentaine de musiciens. Sans oublier les agents de publicité, les journalistes et toute l'équipe de production. Comme je l'ai observé dans la préface de ce livre, ce jour-là, j'ai pu constater qu'Elvis n'était pas farouche. L'objectif ne l'intimidait pas du tout. J'ai pu le mitrailler à loisir: pendant les répétitions, avec le marchand de bagues, dans sa chambre à l'hôtel Warwick, lisant des lettres d'admirateurs, s'endormant avant de prendre sa douche. La proximité fait toute la différence entre un bon portrait et un cliché ordinaire. Je l'ai ensuite accompagné jusqu'au théâtre pour le photographier sur scène.

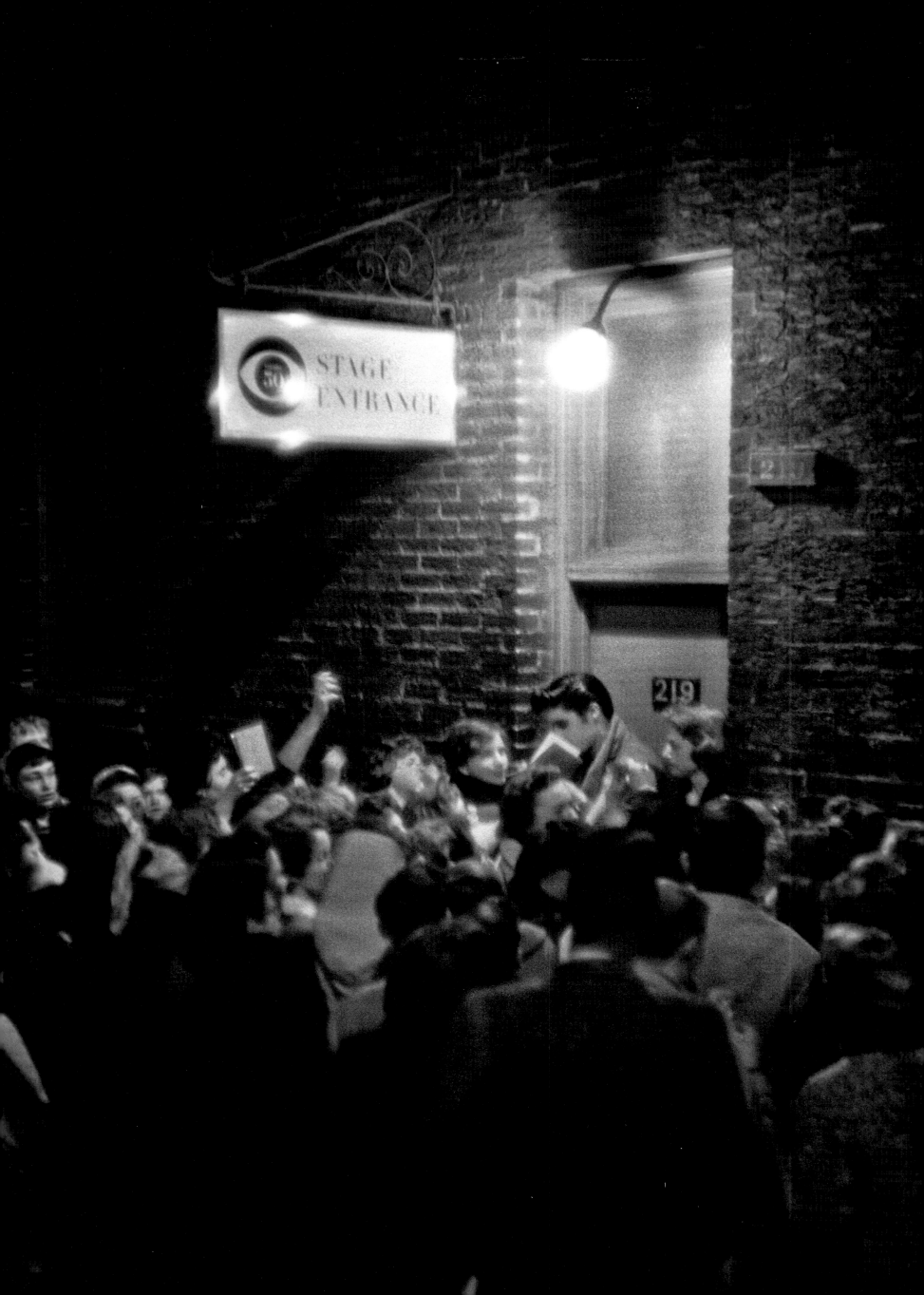

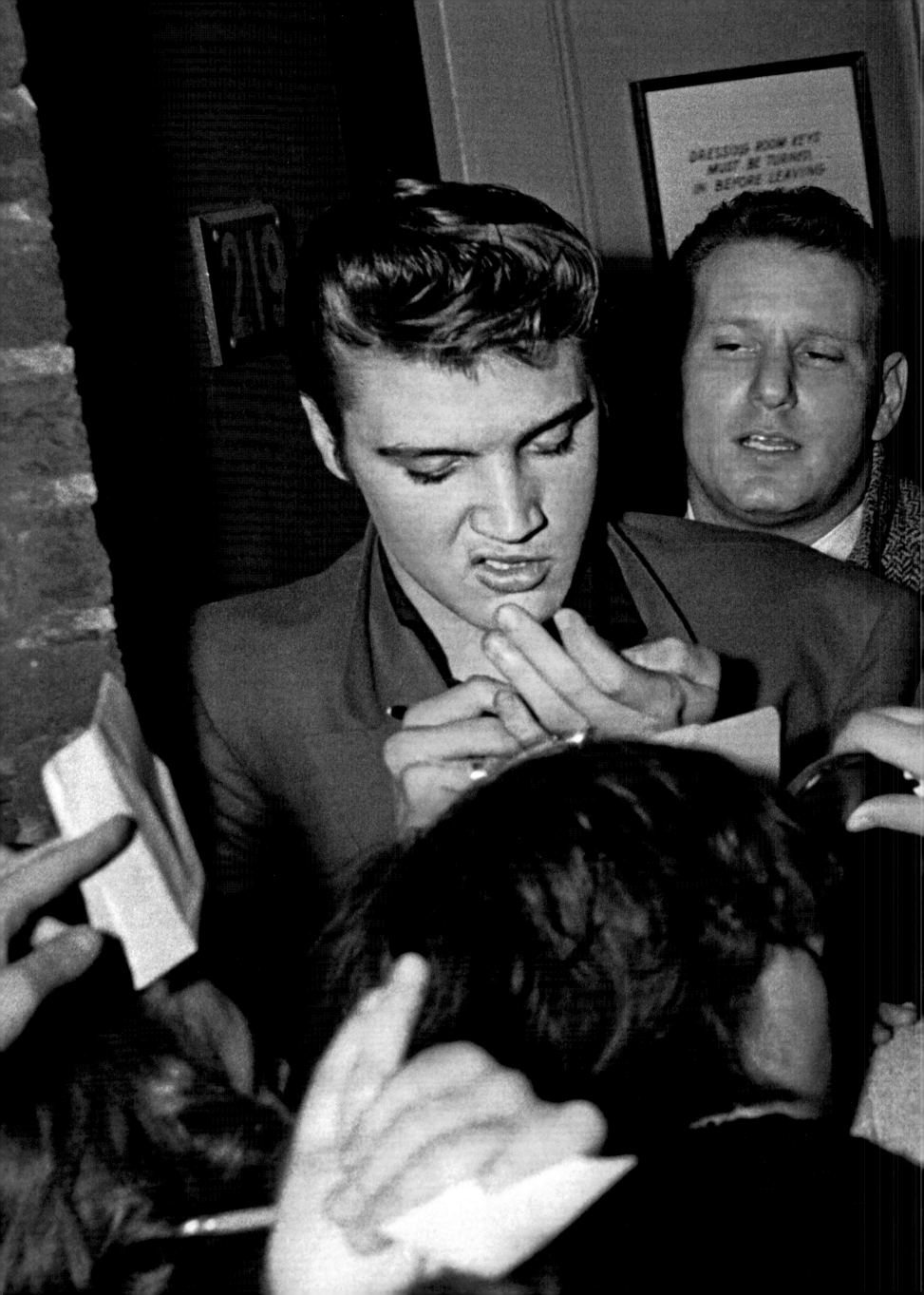

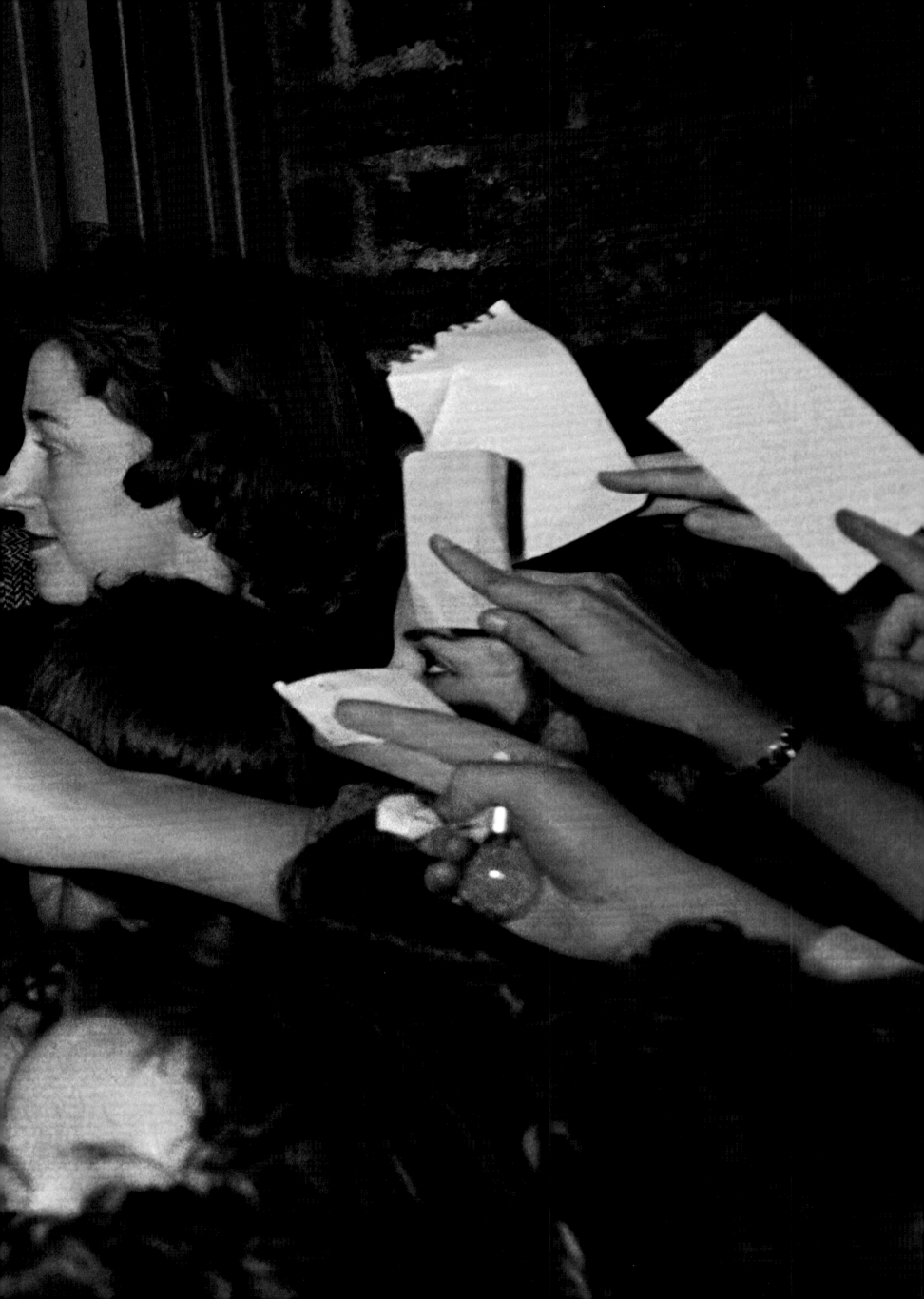

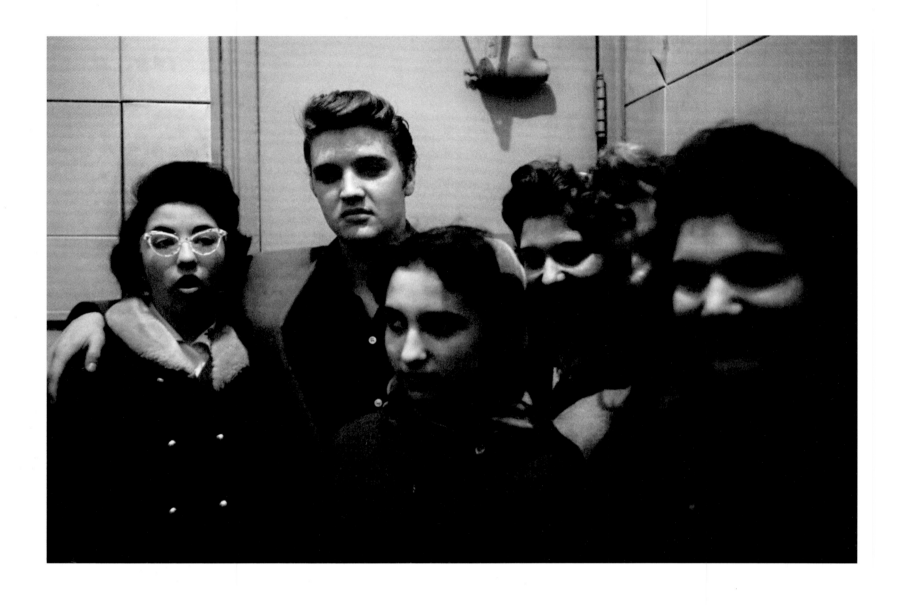

51 Stage door, CBS TV Studio 50, New York City.

PREVIOUS SPREAD Elvis delivers autographs and his trademark sneer to the crowd. First booked by producer Jackie Gleason to appear on the show on January 28, 1956, Elvis was so popular that five more appearances were lined up for February and March.

ABOVE & OPPOSITE Elvis was grateful for his fans, and enjoyed signing autographs, or putting his arms around some girls for a picture.

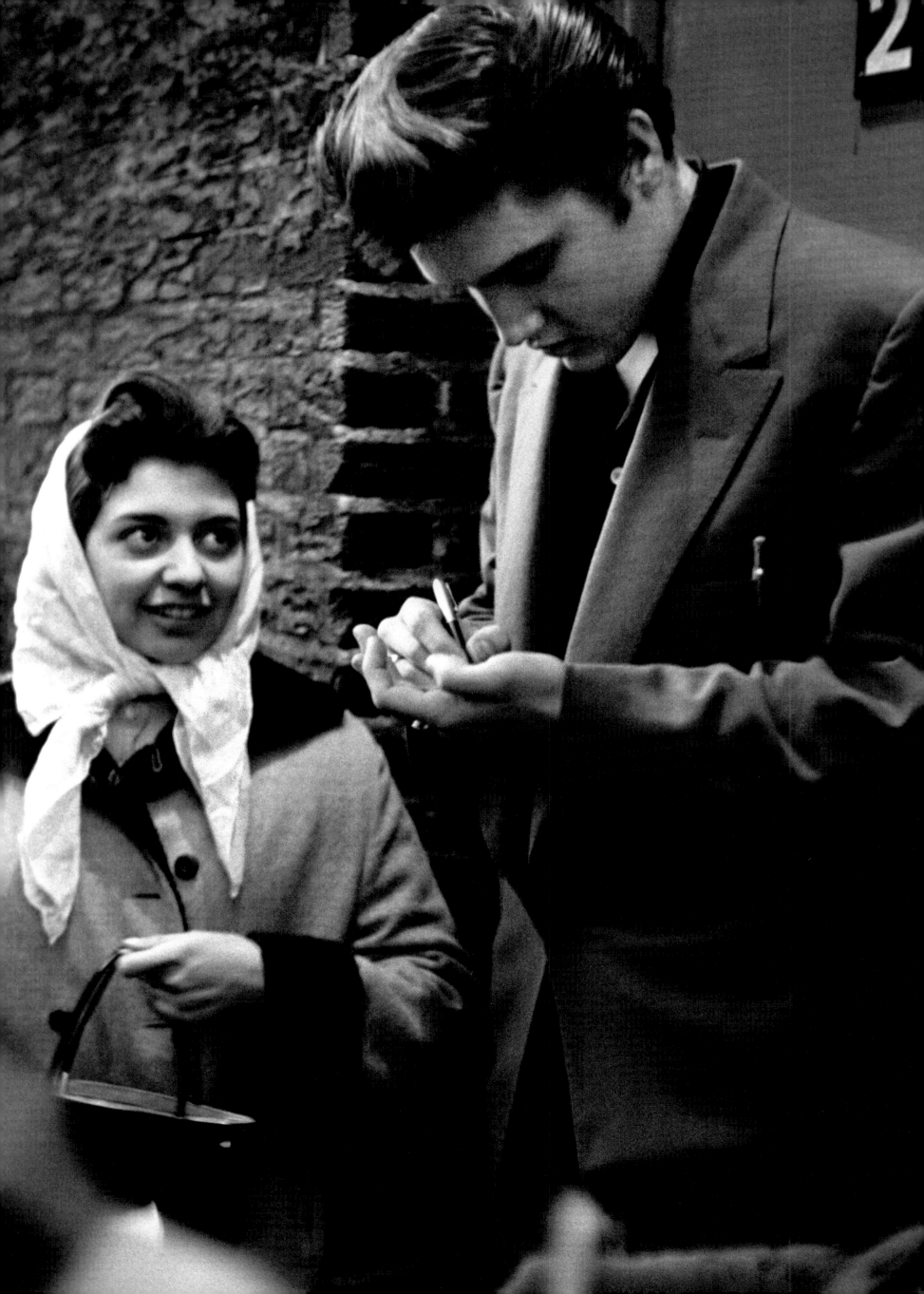

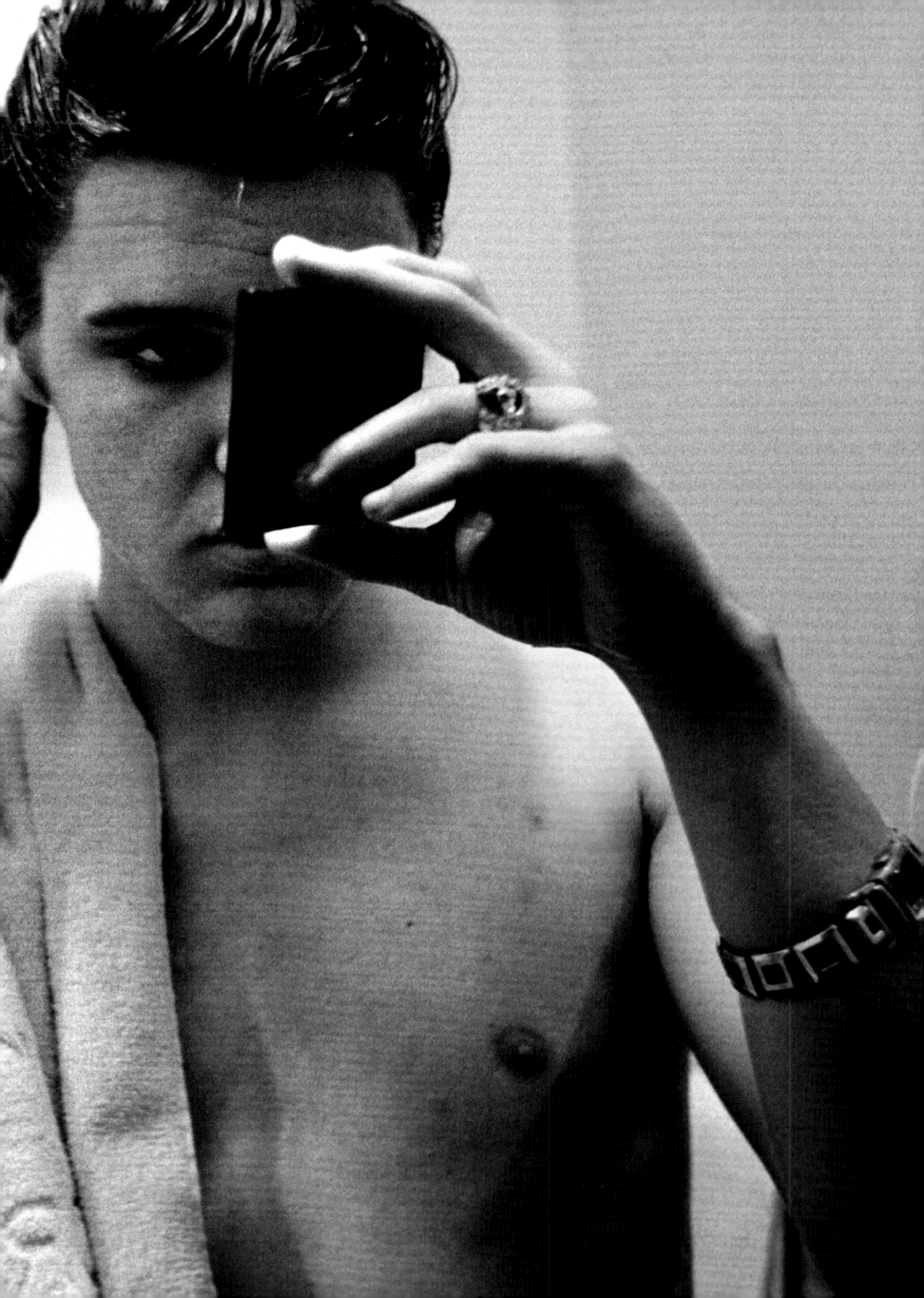

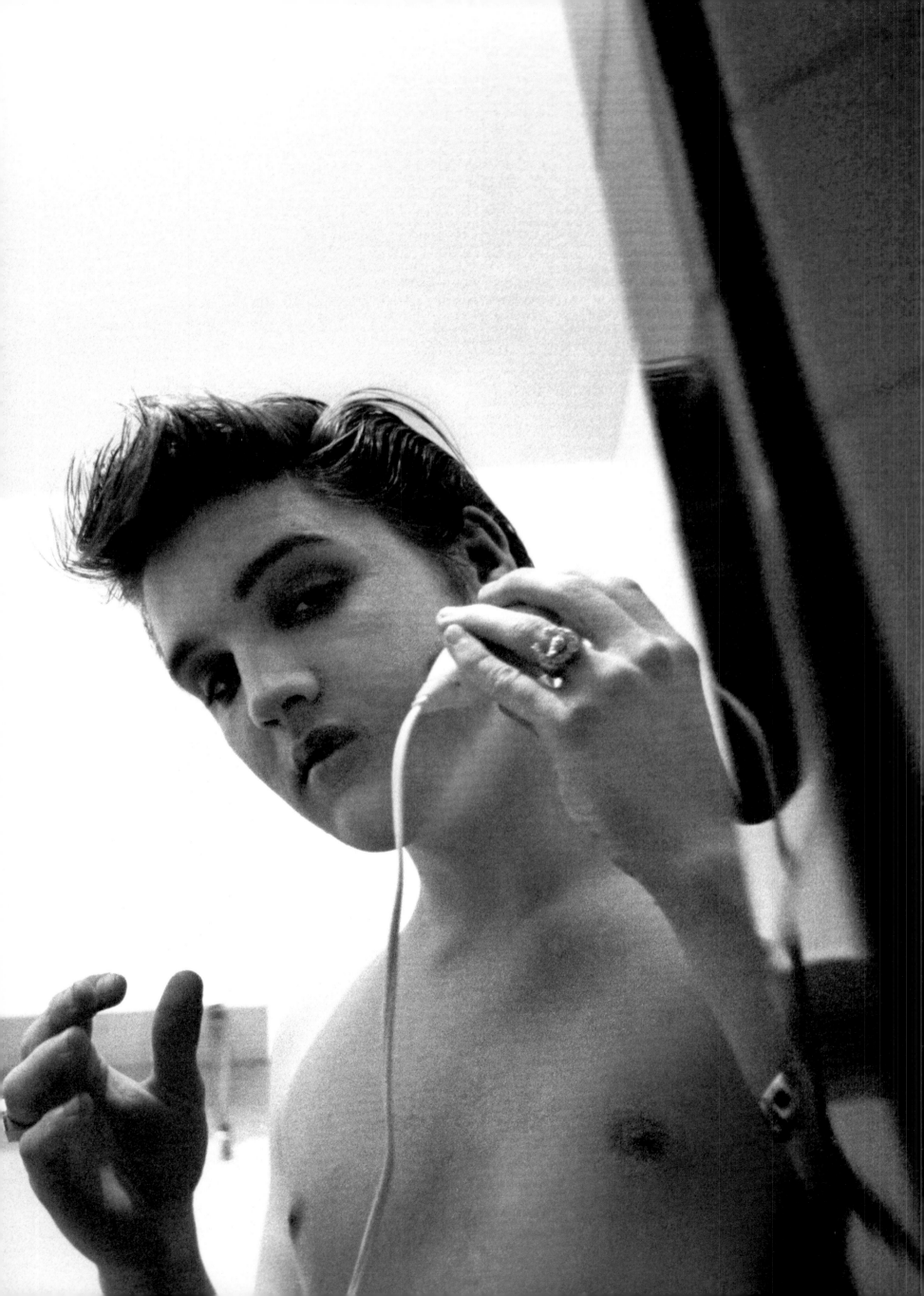

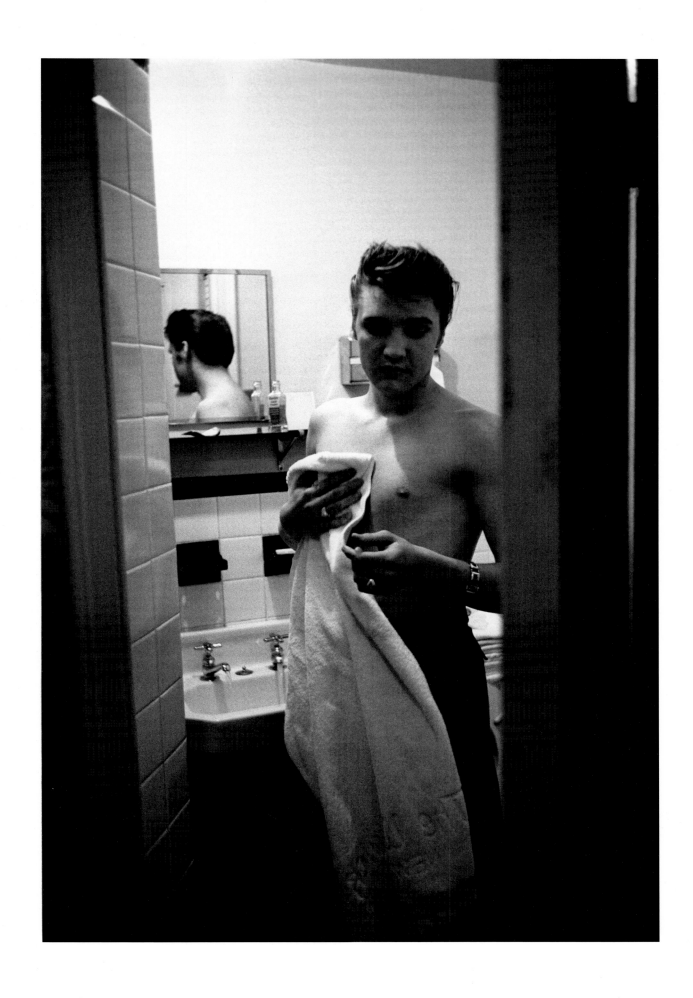

PREVIOUS SPREAD Washing up at the Warwick before leaving to perform live on *Stage Show*. With the help of a pocket mirror Elvis gives a final touch to his ducktail in the bathroom of his suite at the Warwick Hotel, New York City.

OPPOSITE & ABOVE The buzz of Elvis's Norelco electric razor wakes Wertheimer from a nap in the next room.

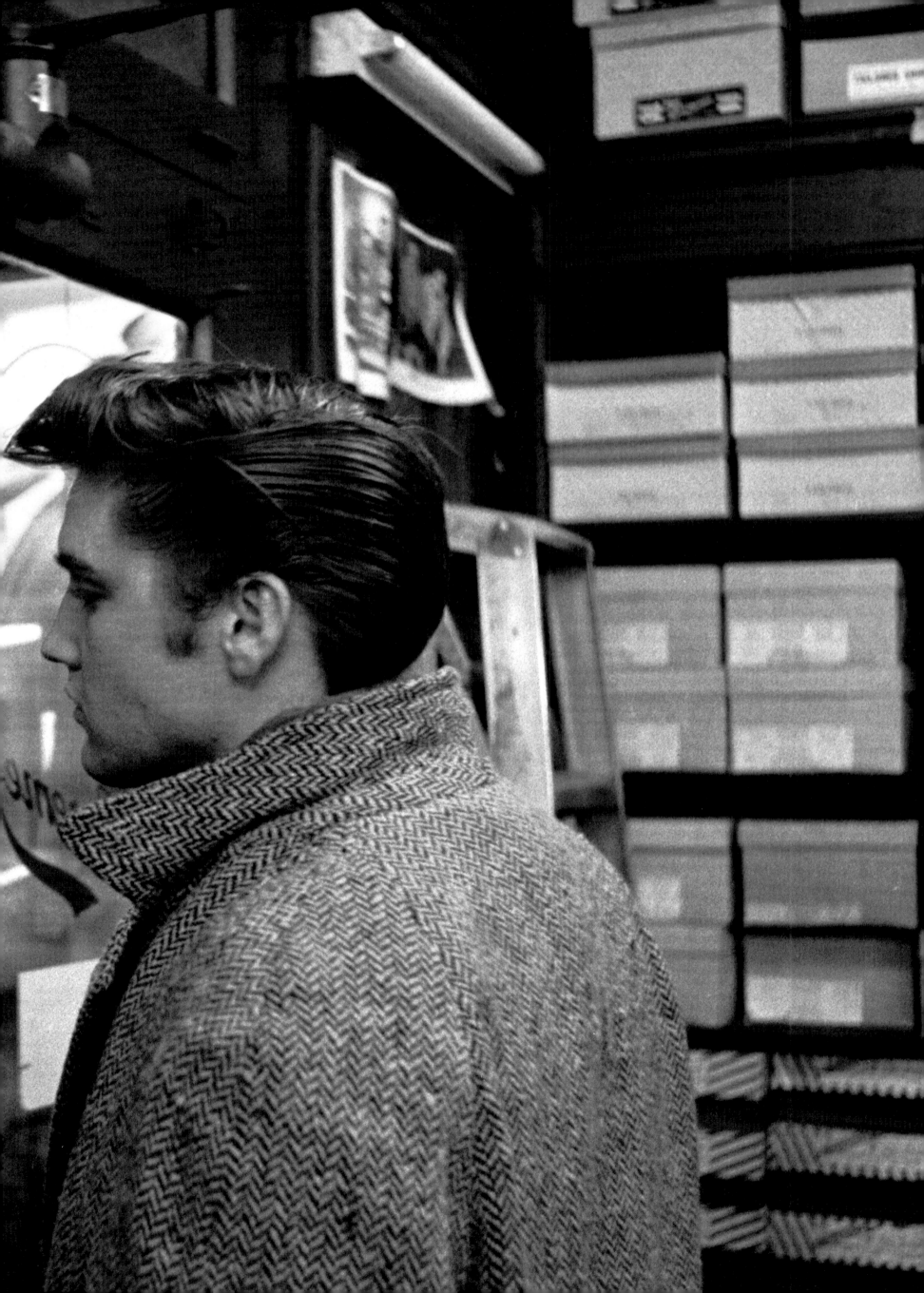

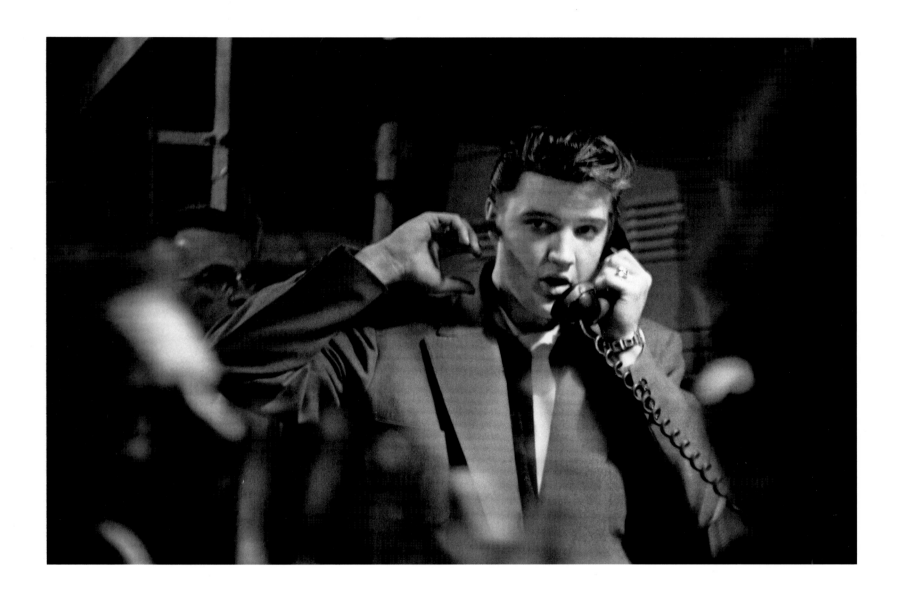

PREVIOUS SPREADS Shopping for shirts at the Supreme Men's Shop on Broadway, New York City; a celebrity-in-the-making studies the publicity photos on the changing room door.

OPPOSITE & ABOVE Backstage, CBS TV Studio 50.

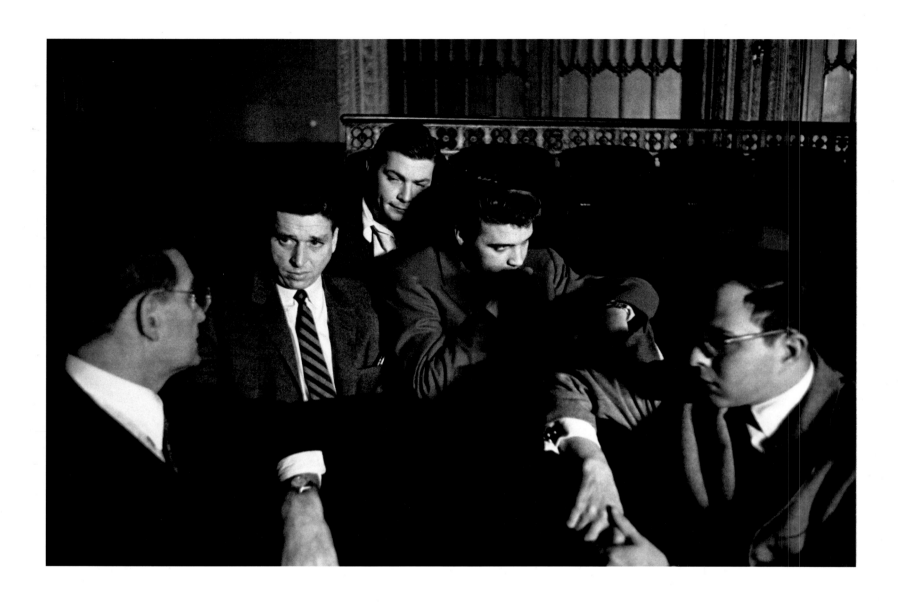

ABOVE Surrounded by reporters and agents in the CBS TV Studio 50 theater, Elvis awaits the director's call.

OPPOSITE An agent from William Morris looking on, Elvis holds hands with Anne Fulchino, the RCA Victor publicist who hired Wertheimer to photograph the young star.

FOLLOWING SPREAD Elvis gets made up for the dress rehearsal of *Stage Show*.

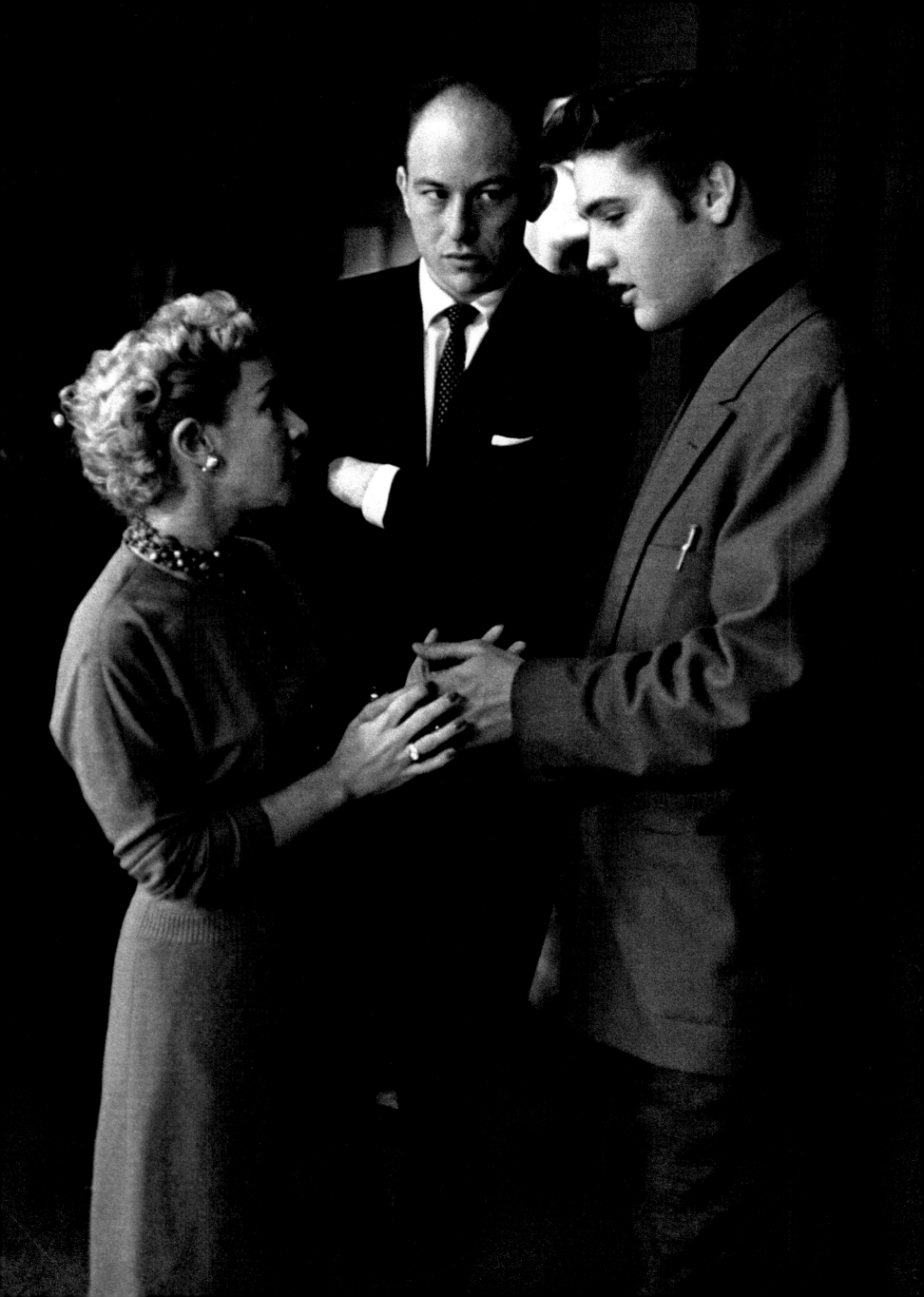

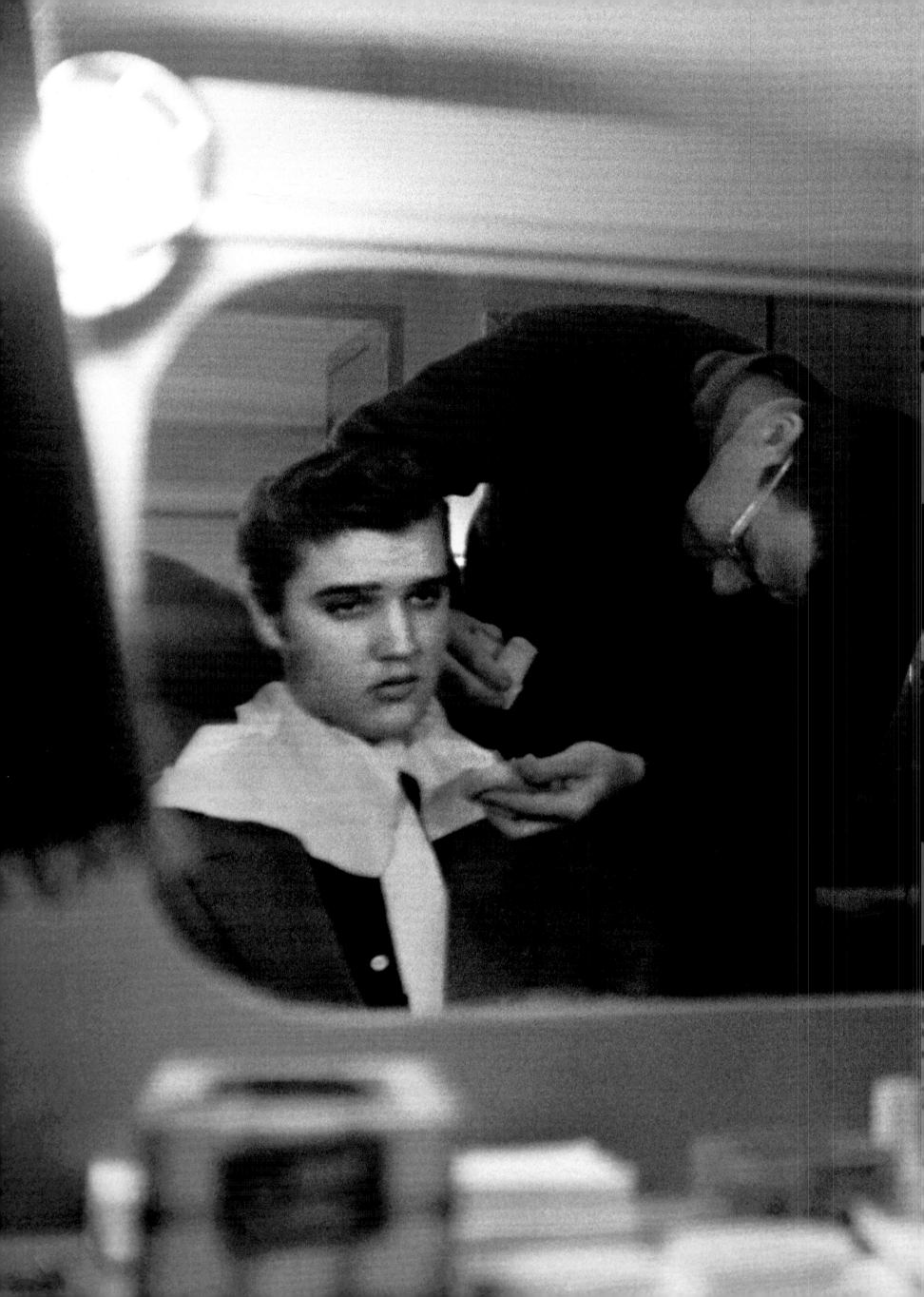

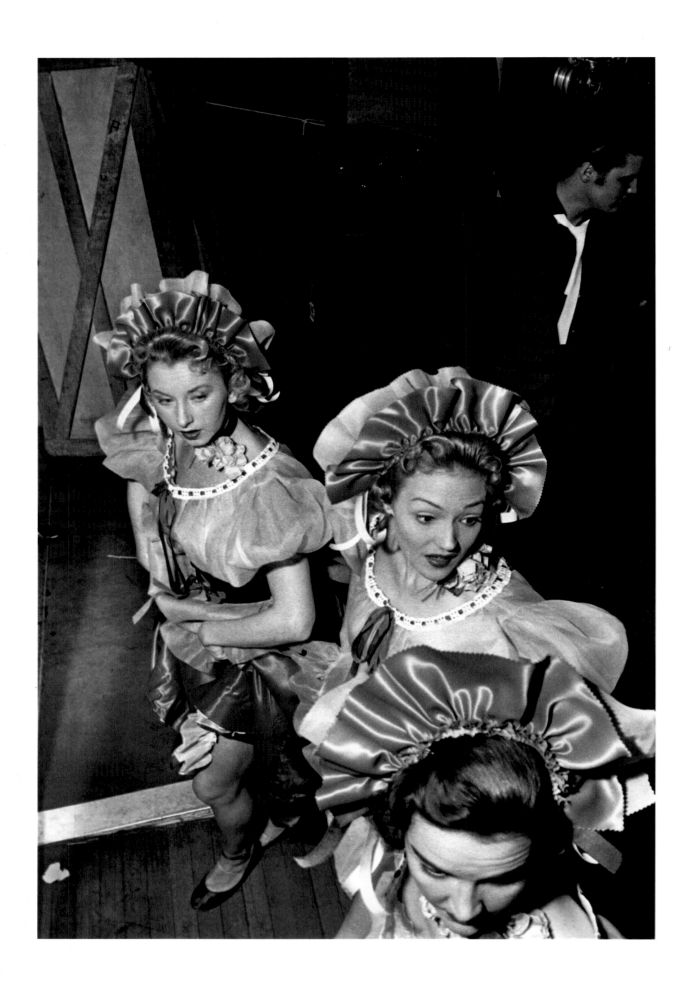

ABOVE The June Taylor Dancers, who were favorites of producer Jackie Gleason, backstage at *Stage Show*.

OPPOSITE Between the acts, Elvis gives the photographer a smile.

FOLLOWING SPREAD Cue cards set the pace during the run-through.

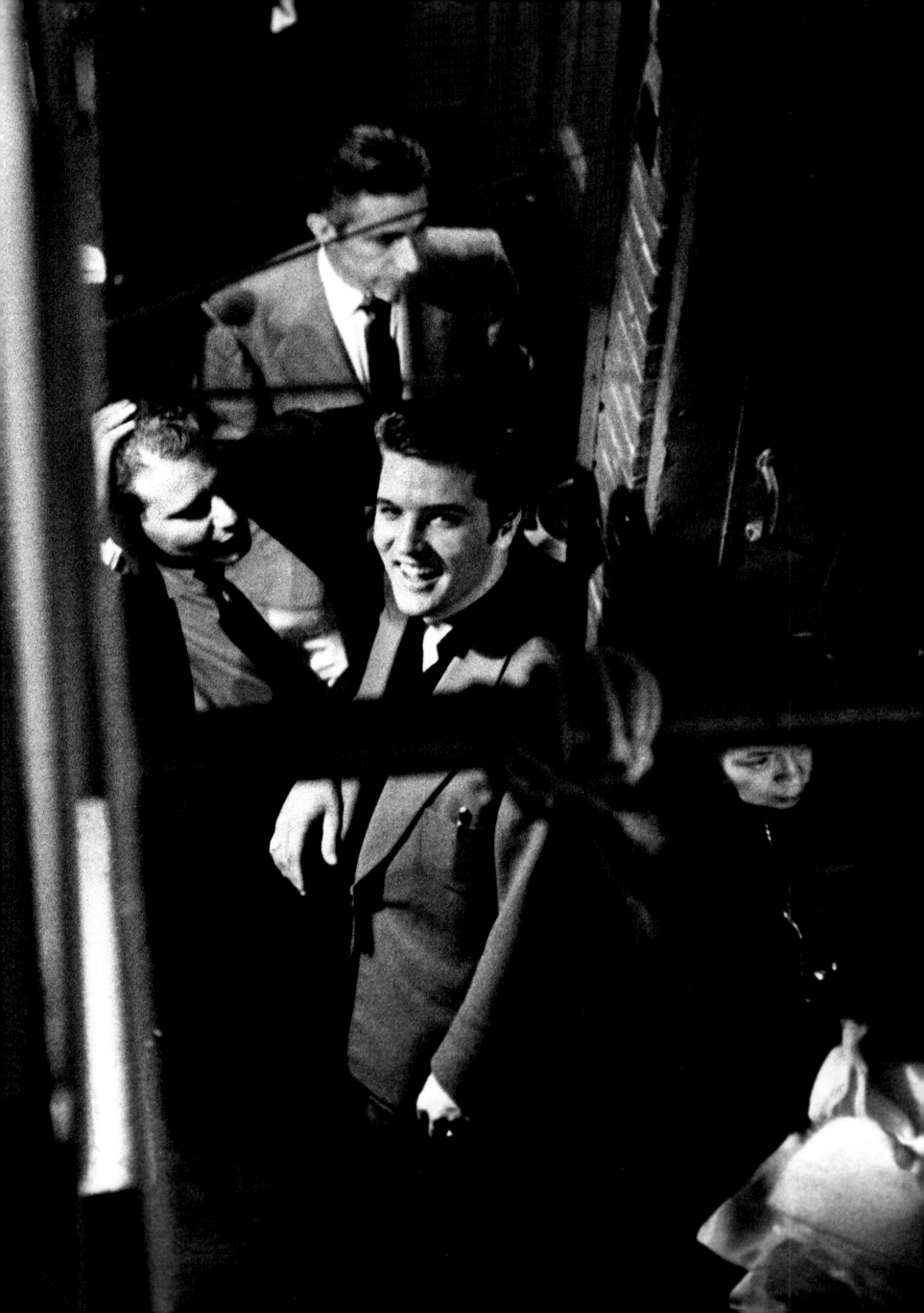

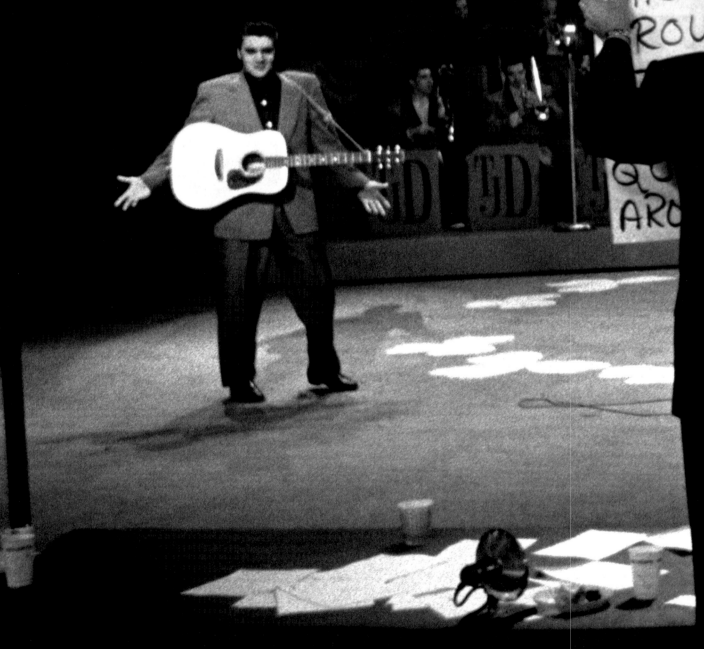

OPPOSITE *Stand By*, *Stage Show* rehearsal,
New York City, March 17, 1956.

FOLDOUT Still practicing, Elvis leads guitarist
Scotty Moore and the band through the set.

80-81 His necktie now on for the cameras and
live audience, Elvis performs "Heartbreak Hotel"
and "Blue Suede Shoes" with Scotty Moore,
Bill Black on bass, and D.J. Fontana on drums.

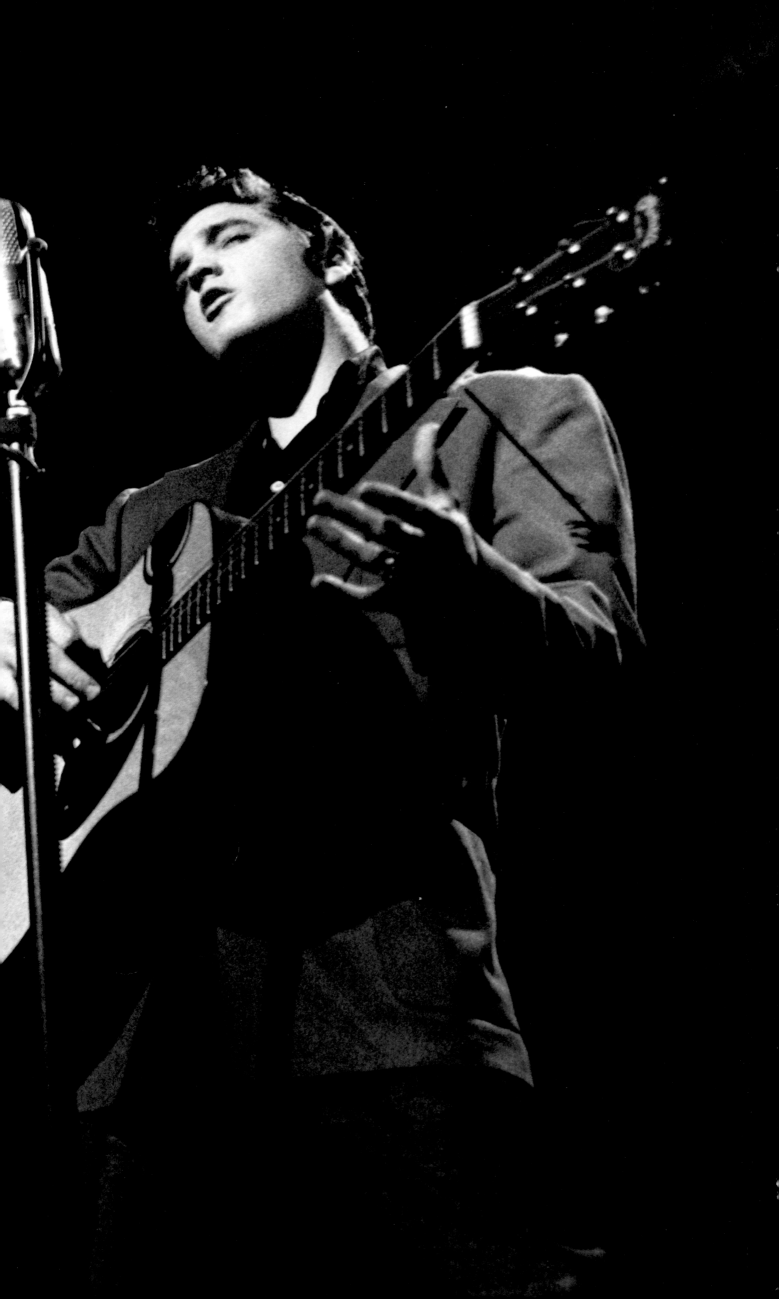

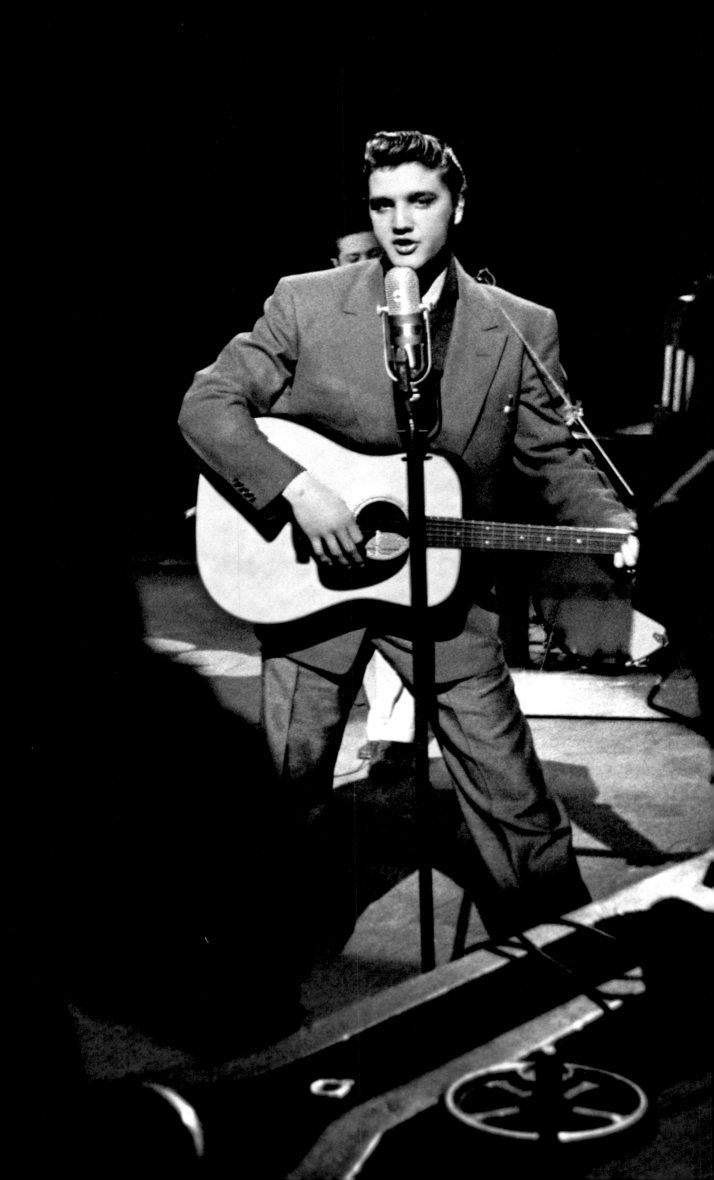

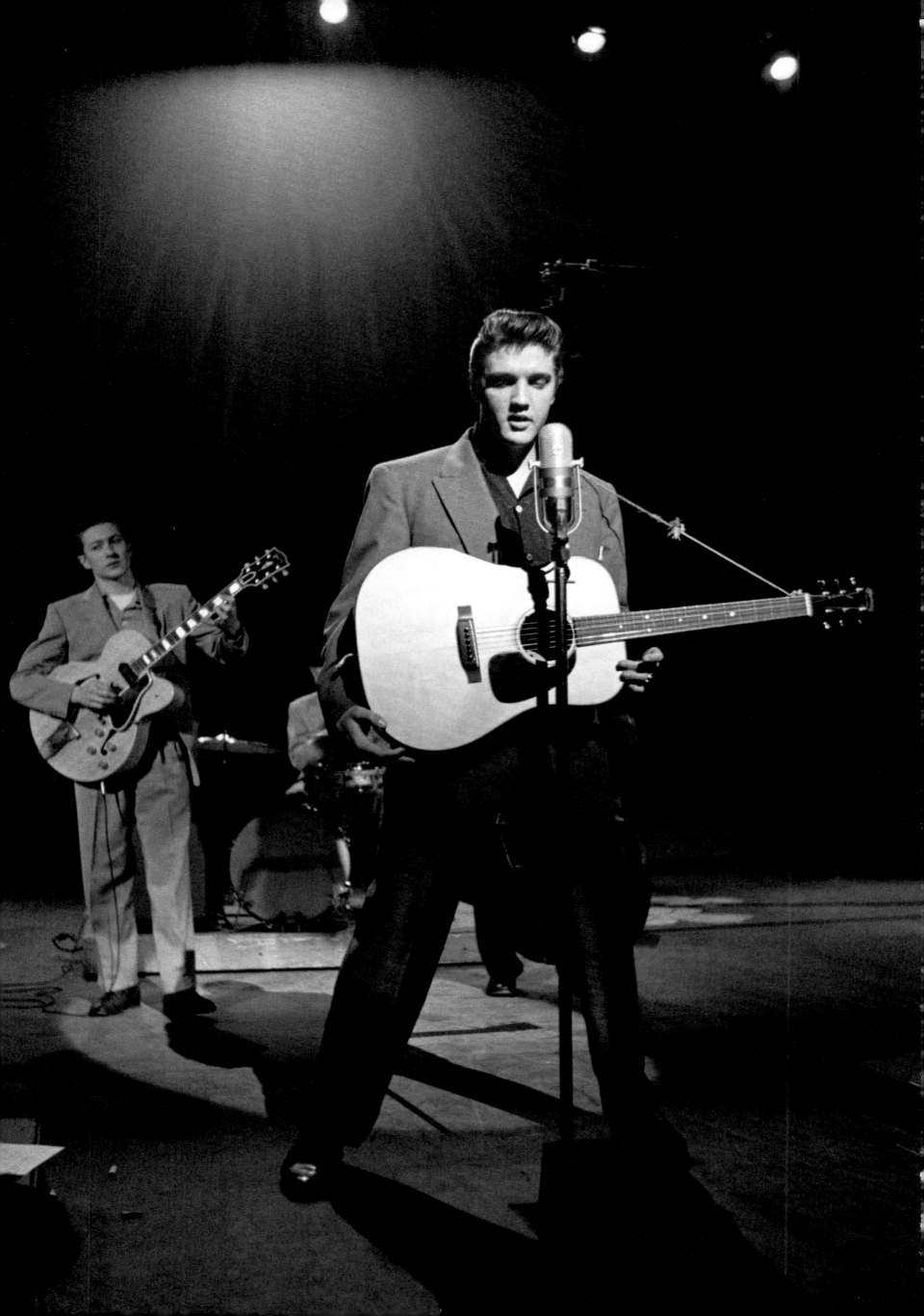

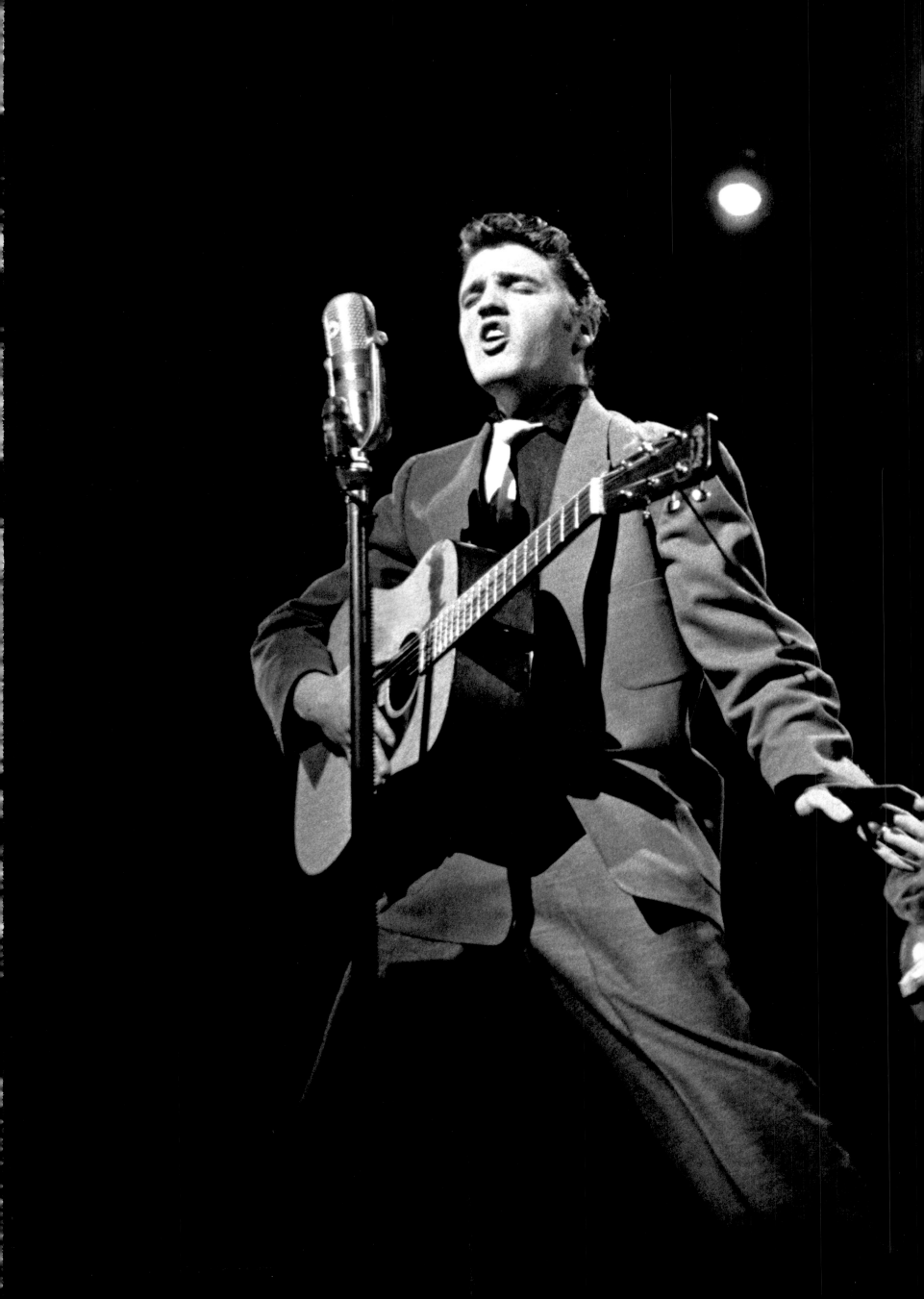

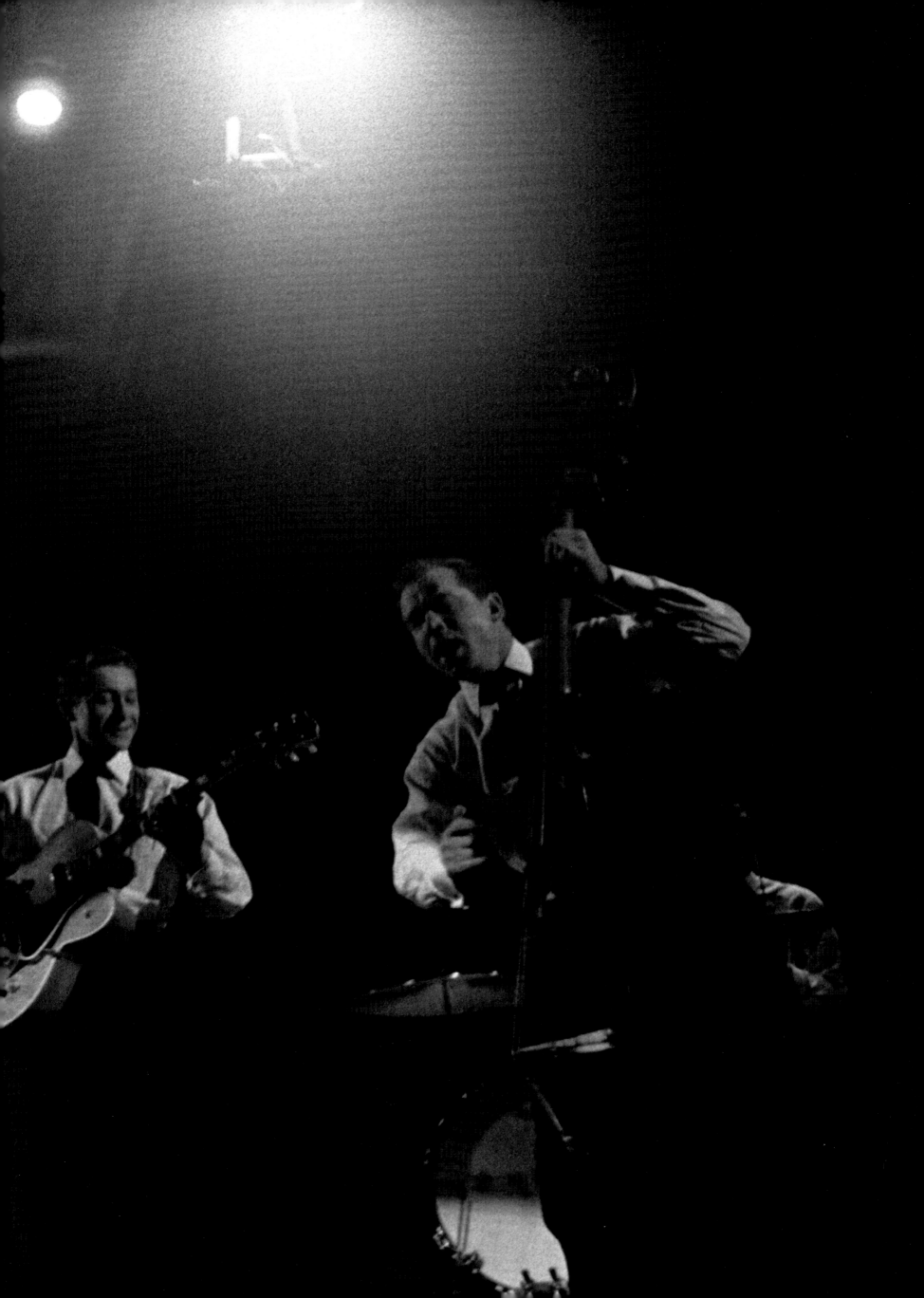

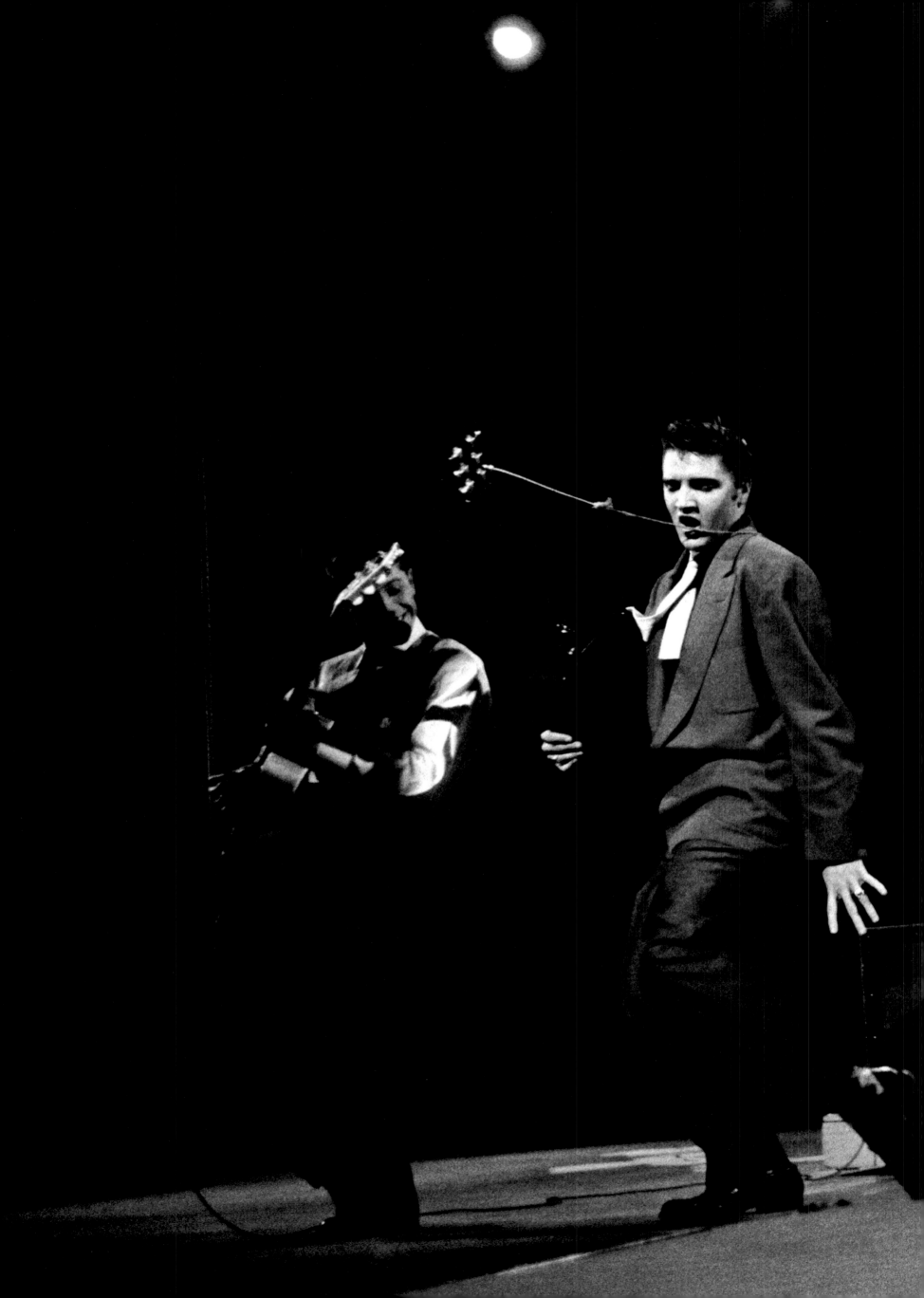

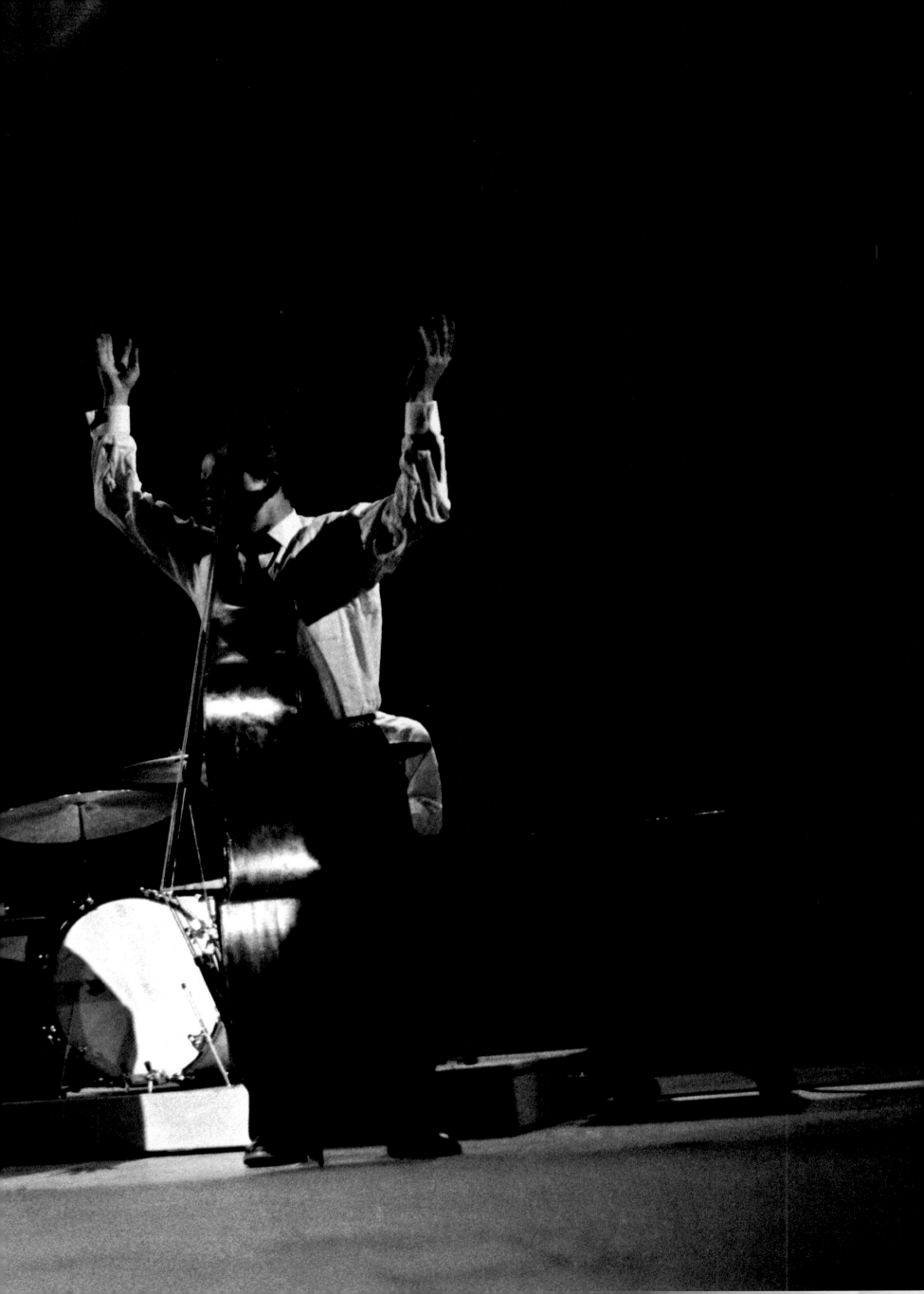

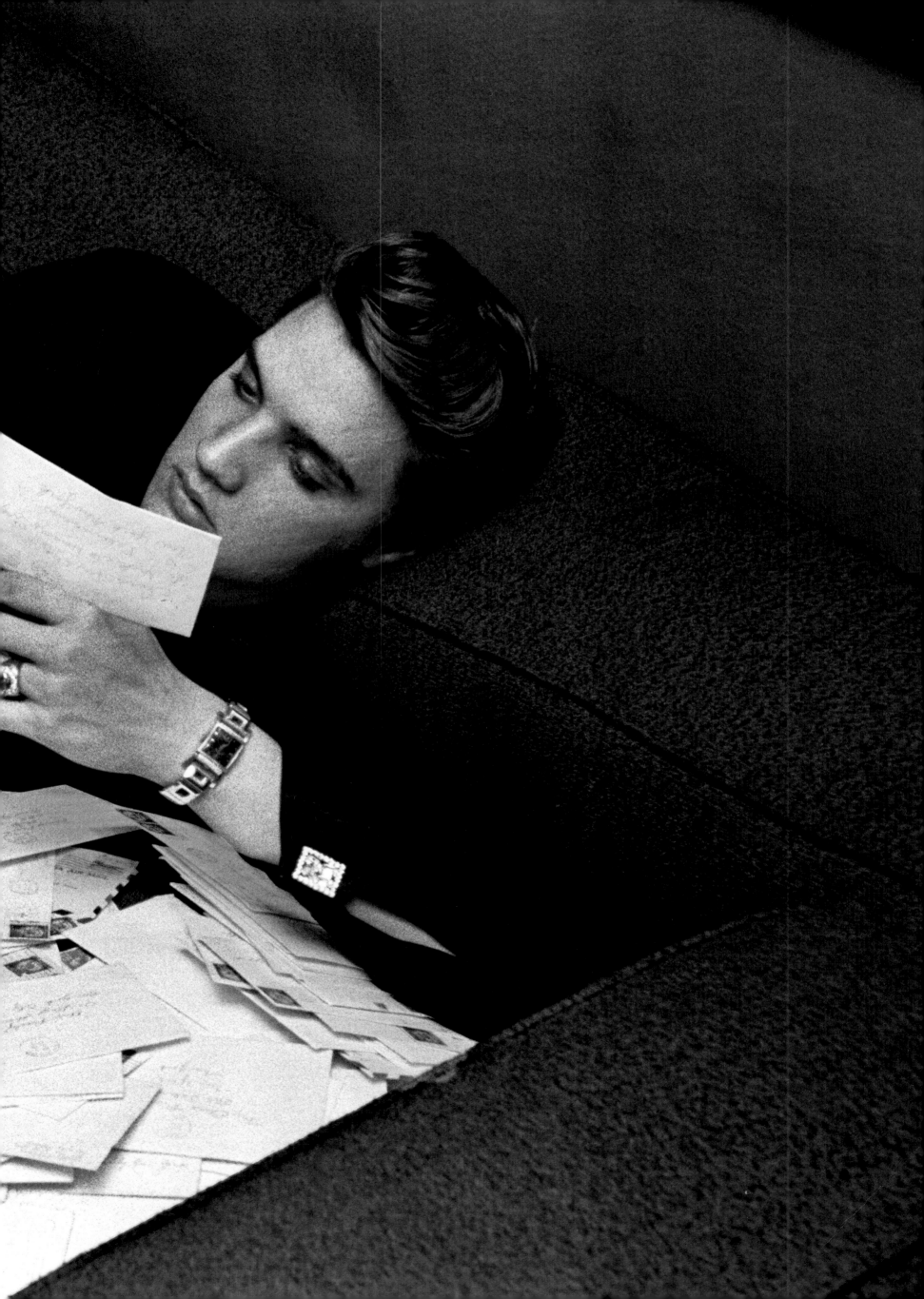

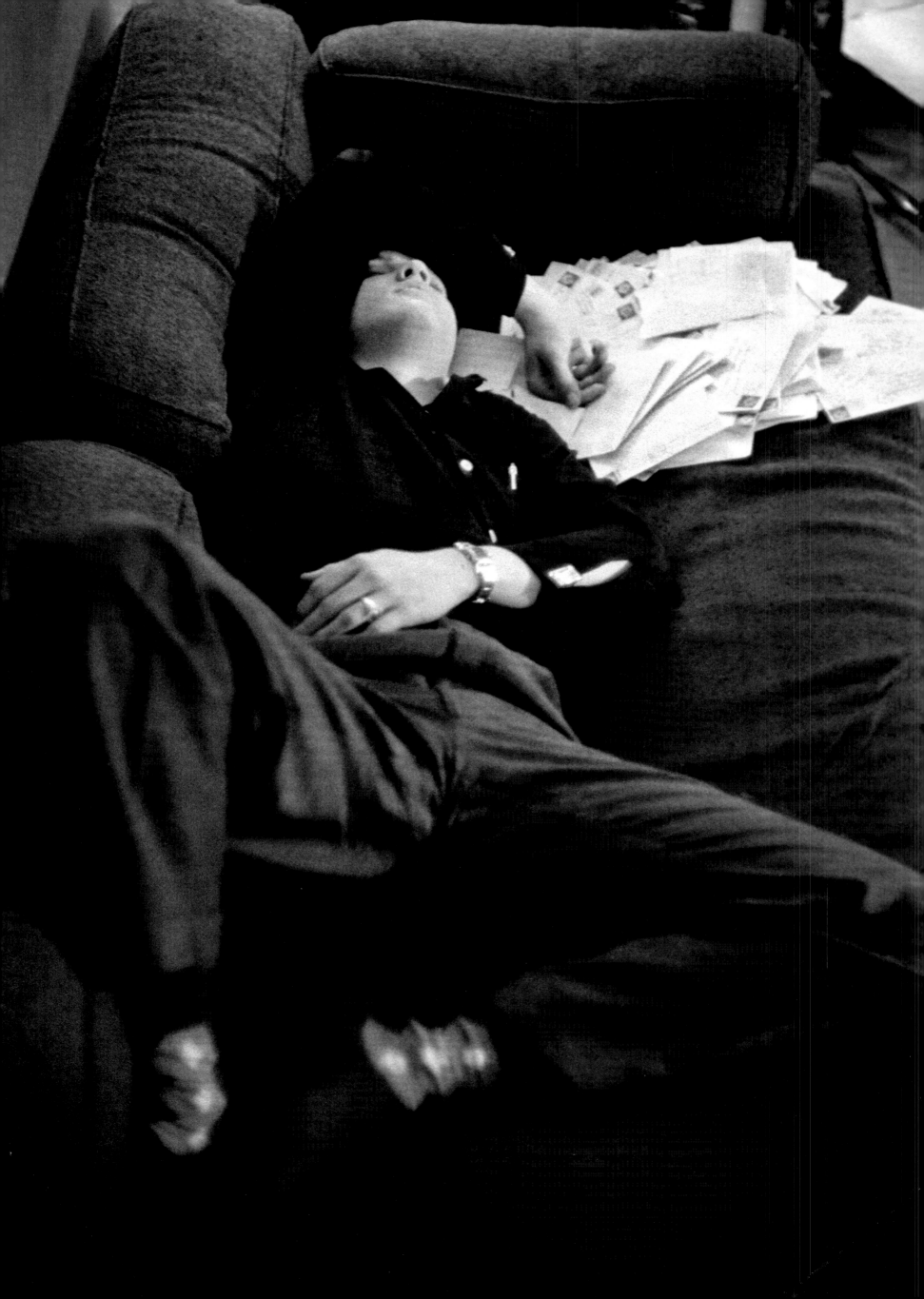

At the Warwick Hotel in New York City, he falls asleep on the couch, while reading—and on top of—his fan mail. The whole time I'm hovering over him—and he doesn't care that I'm three feet away from his nose—it doesn't bother him at all—he is the perfect subject.

Im Warwick Hotel in New York schläft er auf dem Sofa ein – auf der Fanpost, die er gerade liest. Ich hänge ihm die ganze Zeit auf der Pelle – und es macht ihm nichts aus, dass ich einen Meter vor seiner Nase bin – es stört ihn überhaupt nicht – er ist das perfekte Motiv.

Dans sa chambre de l'hôtel Warwick à New York, il s'endort sur le canapé en lisant le courrier de ses admirateurs. Il est couché sur les lettres. Je le mitraille. Il se fiche que je sois planté là, mon objectif à moins d'un mètre de son nez. Ça ne le dérange pas du tout. C'est le sujet idéal.

—ALFRED WERTHEIMER

PREVIOUS SPREAD "Dear Elvis, I love you…." Back at the Warwick between the rehearsal and live taping of *Stage Show*, Elvis begins to read the dozens of fan letters delivered to the hotel.

OPPOSITE A nap before the evening show.

THE NEW ELVIS PRESL

THE

STEVE ALL

SHOW

B

HU

NE

Y ON
EN

BROADCAST
THE
HUDSON THEATRE
JULY 1, 1956
NEW YORK CITY

WHEN I ARRIVED IN THE MIDTOWN MANHATTAN LOFT to photograph Elvis's rehearsal for NBC's *The Steve Allen Show*, he was in the corner of the studio, playing and singing gospel music on an upright piano, as Junior Smith, his sidekick, gopher, and cousin, watched over dutifully. Elvis would rather play music, to get people to gather round quietly and not disrupt his focus or engage him in small talk. The next day we would be off for a night of concerts in Richmond, Virginia, then back to New York City for the television show the following day. Some conservative church groups were making a fuss about Elvis's free style of moving below the waist, so Steve Allen's script was written to curtail any possible gyrations: Dressed in a tux, Elvis would start singing "Hound Dog" to a live basset hound, and continue with a ballad. Finally, in a debut that would help lead him into a successful acting career, he changed into a cowboy outfit for a comedy skit, "Range Roundup," where he appeared as Tumbleweed Presley, with Imogene Coca, Andy Griffith, and Steve Allen. Well, the strategy worked and *The Steve Allen Show* was able to keep the family television night "clean" and beat the ratings for *The Ed Sullivan Show* on CBS.

ALS ICH IN DAS LOFT IN MIDTOWN MANHATTAN KAM, um Aufnahmen von den Proben für *The Steve Allen Show* von NBC zu machen, saß Elvis an einem Klavier in der Ecke des Studios, spielte Gospellieder und sang dazu, während Junior Smith, sein Kumpel, Mädchen für alles und Cousin, den Aufpasser spielte. Anstatt sich in seiner Konzentration unterbrechen oder in Smalltalk verwickeln zu lassen, machte Elvis lieber Musik und ließ die Leute still um ihn herumstehen. Am nächsten Tag sollte Elvis Konzerte in Richmond, Virginia, geben, um am darauffolgenden Tag für den Fernsehauftritt wieder in New York zu sein. Einige konservative christliche Gruppen hatten Ärger wegen Elvis' freizügigen Hüftschwungs gemacht, deshalb wollte Steve allen alle möglichen Bewegungen drosseln: In einem Frack sollte Elvis mit dem Song „Hound Dog" beginnen und dann eine Ballade singen. Danach folgte der Auftritt als Tumbleweed Presley mit einem Cowboy-Outfit in dem Sketch „Range Round-Up", seiner erste Bühnenrolle mit Imogene Coca, Andy Griffith und Steve Allen, die mit dazu beitragen sollte, ihm den Weg zu einer erfolgreichen Karriere als Schauspieler zu ebnen. Die Strategie ging auf, und *The Steve Allen Show* blieb eine familientaugliche Abendshow mit besseren Quoten als *The Ed Sullivan Show* auf CBS.

QUAND JE SUIS ARRIVÉ DANS CE LOFT AU CŒUR DE MANHATTAN pour photographier les répétitions avant l'émission de la NBC, *The Steve Allen Show*, Elvis était en train de chanter et jouer des gospels sur un piano droit dans un coin de la pièce, sous le regard attentif de son cousin Junior Smith, qui était également son acolyte et factotum. Elvis préférait jouer de la musique entouré de gens l'écoutant en silence, plutôt qu'on brise sa concentration en lui parlant de tout et de rien. Le lendemain, il devait partir pour un concert à Richmond, en Virginie, avant de revenir à New York dans la foulée pour l'enregistrement de l'émission. Des groupes religieux conservateurs s'étaient offusqués de ses déhanchements provocants. Afin d'éviter toute controverse, Steve Allen avait soigneusement préparé chacune de ses apparitions: vêtu d'un smoking, Elvis devait d'abord chanter « Hound Dog » en s'adressant à un basset perché sur un piédestal, puis enchaîner avec une ballade. Ensuite, il enfilerait une tenue de cow-boy pour le sketch *Range Round-Up*, où il incarnerait Tumbleweed Presley aux côtés d'Imogene Coca, d'Andy Griffith et de Steve Allen. Ce petit numéro devait lancer sa carrière d'acteur. La stratégie d'Allen paya: son show respecta les normes de bienséance d'un programme familial et fit exploser l'audimat, battant l'indice de son concurrent sur CBS, le *Ed Sullivan Show*.

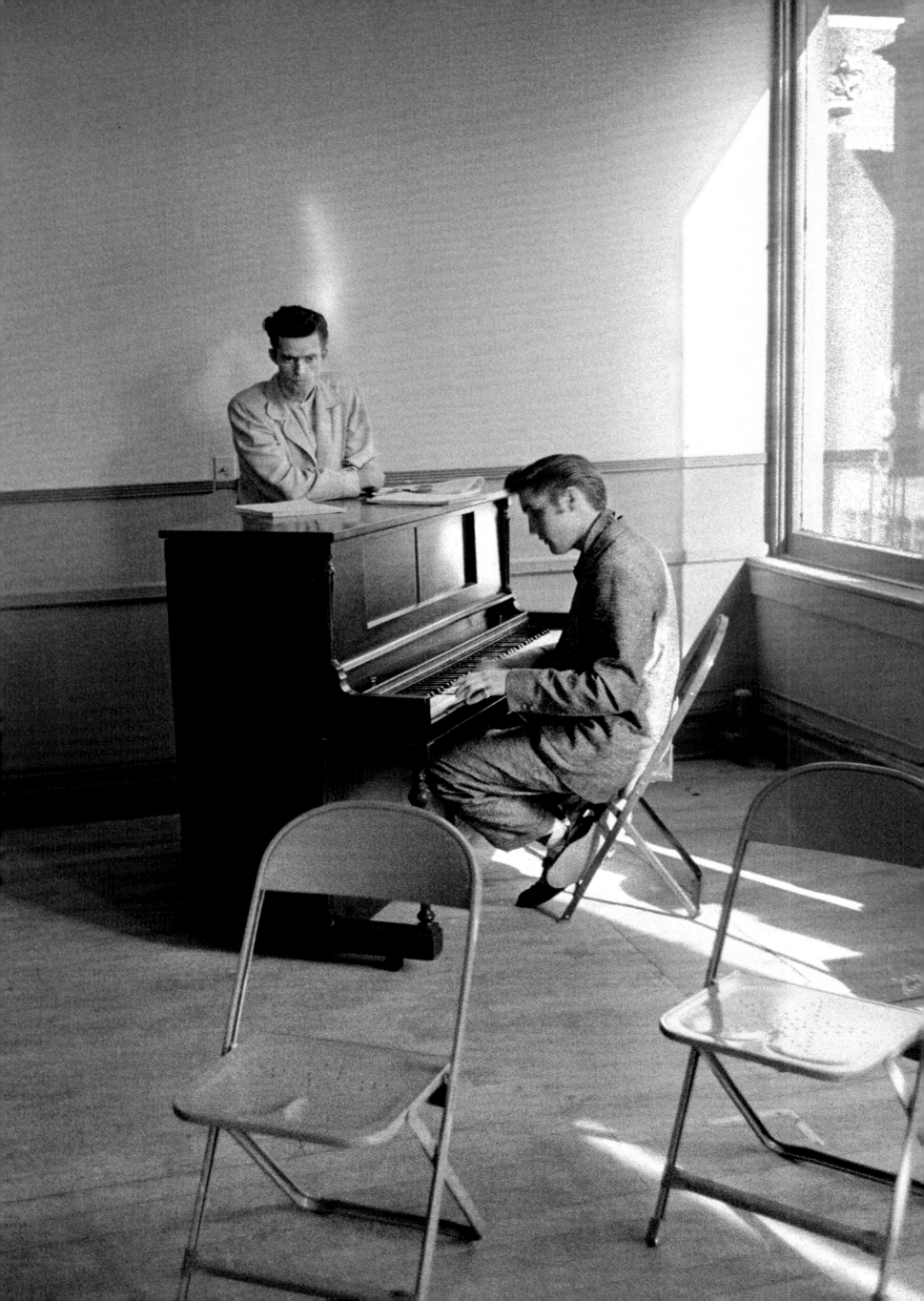

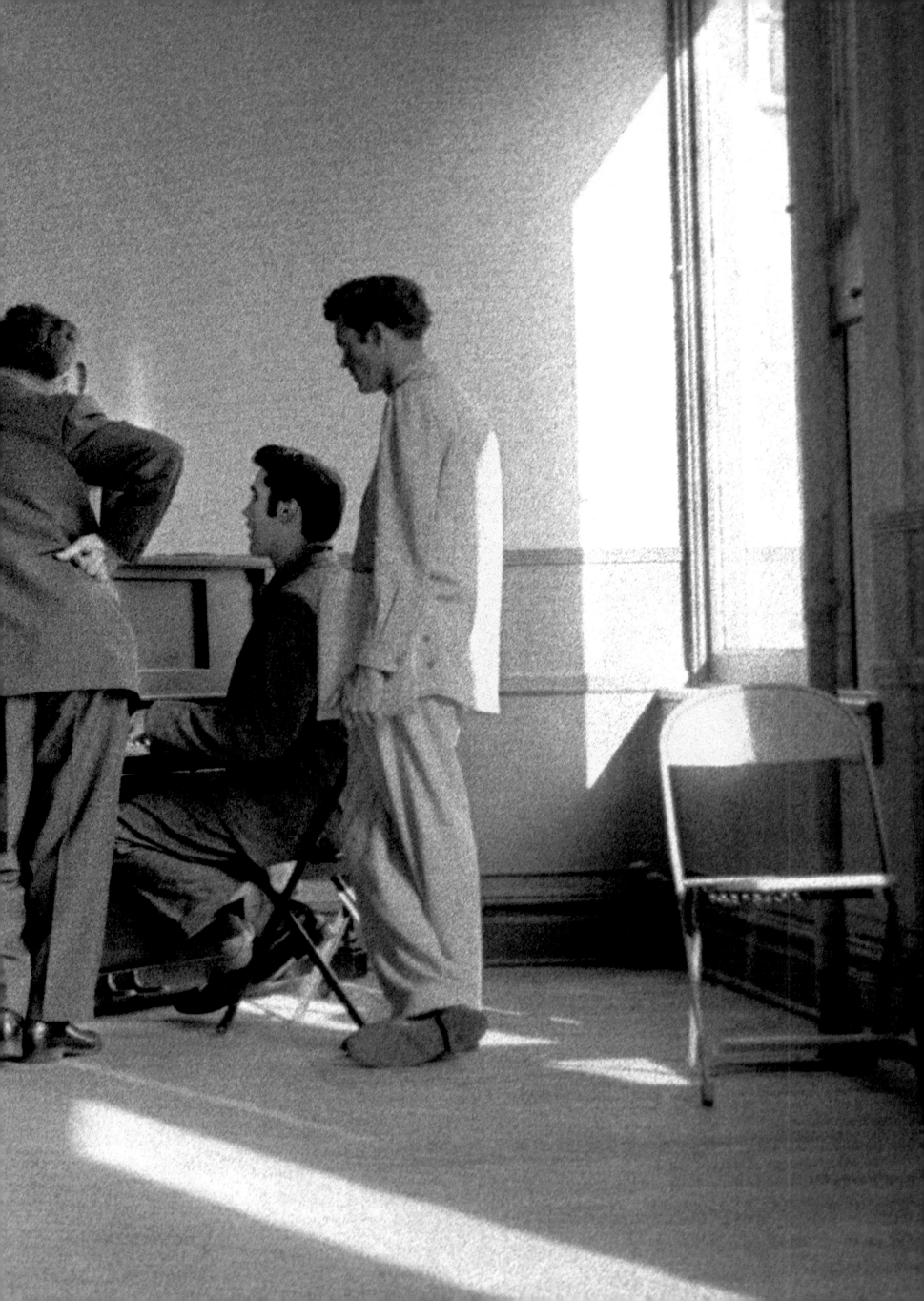

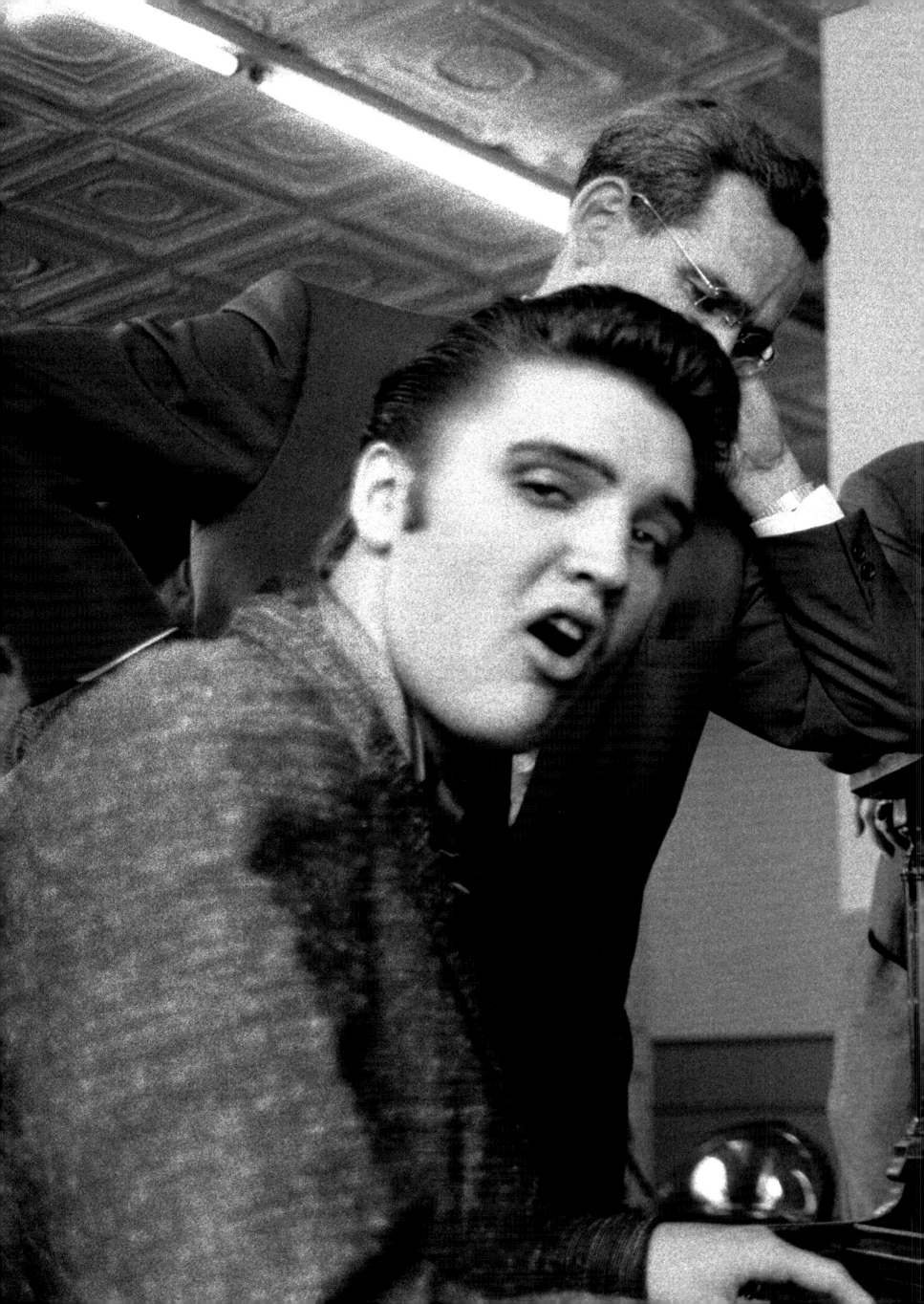

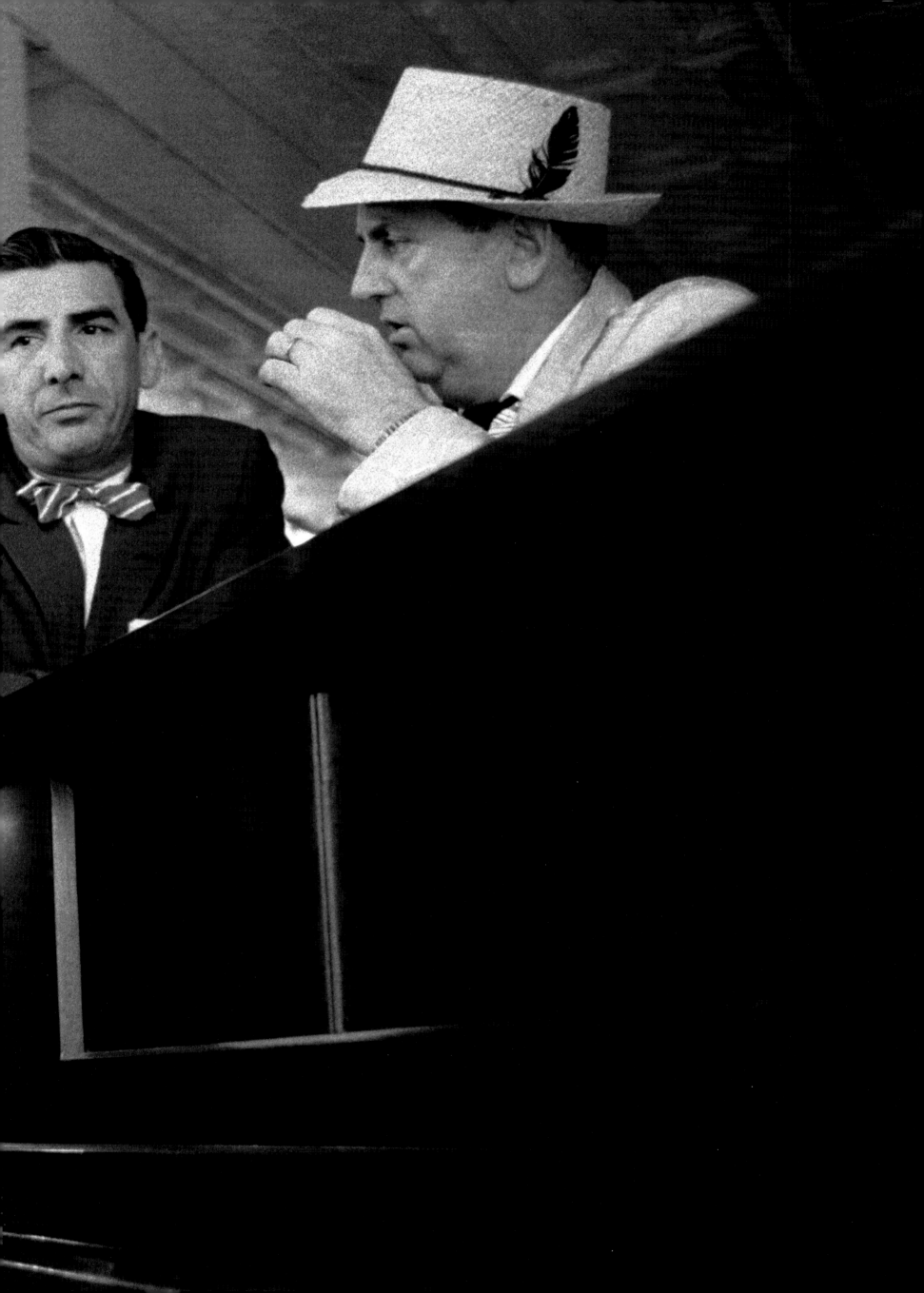

Without Elvis none of us could have made it.

Ohne Elvis hätte es keiner von uns geschafft.

Sans Elvis, aucun de nous n'aurait réussi.

—BUDDY HOLLY

My crushing ambition in life was to be like Elvis Presley.

Mein alles beherrschender Ehrgeiz im Leben war es, wie Elvis Presley zu sein.

Mon plus grand rêve était d'être comme Elvis Presley.

—JOHN LENNON

93 At the piano at a mid-Manhattan loft studio, Elvis waits for *The Steve Allen Show* script rehearsal to start with his cousin Junior Smith, June 29, 1956.

94-95 & OPPOSITE Elvis sings some gospel songs for his own pleasure while the "suits" look on.

PREVIOUS SPREAD Playing piano with television agents and manager, Colonel Tom Parker (in hat), standing by.

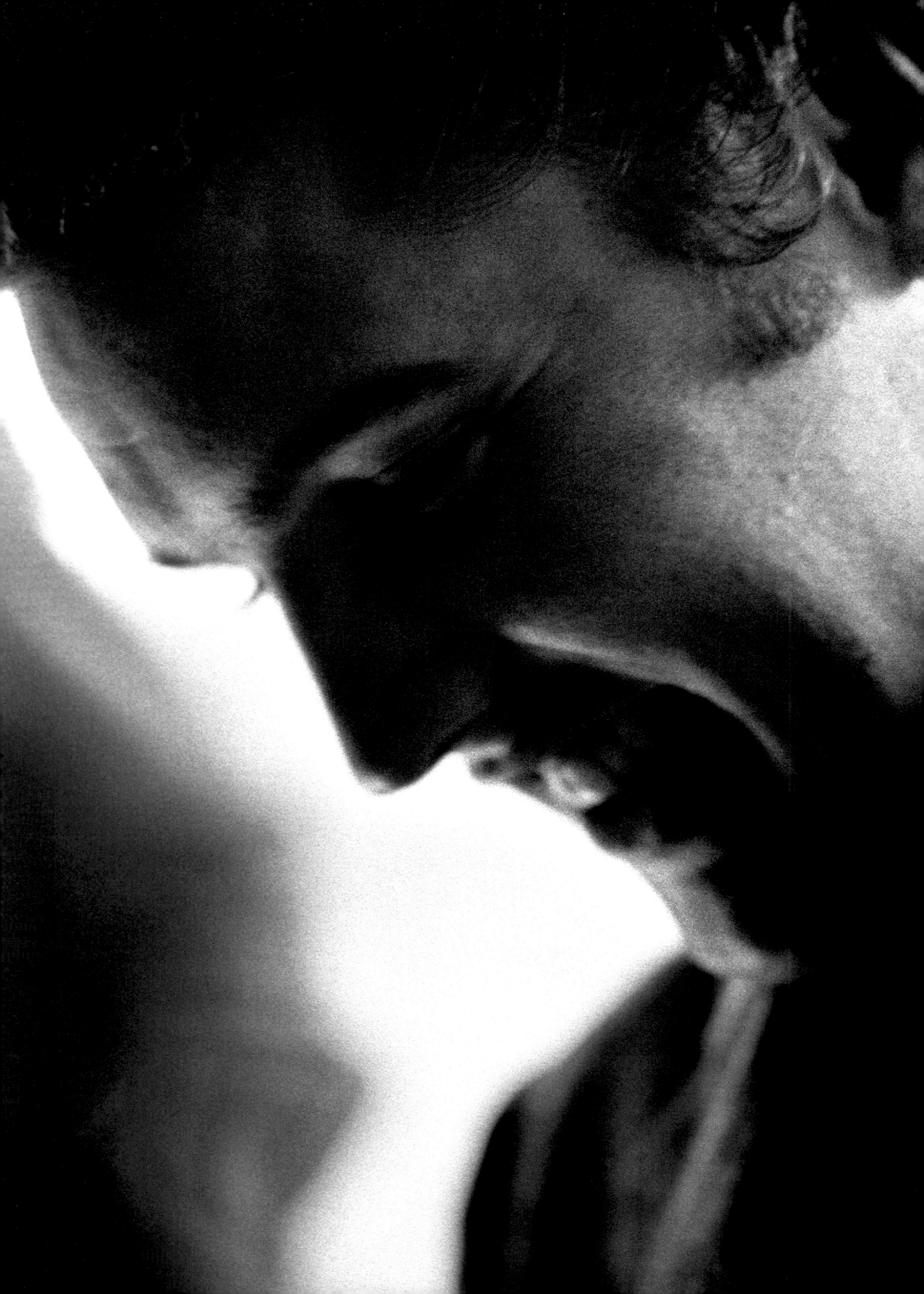

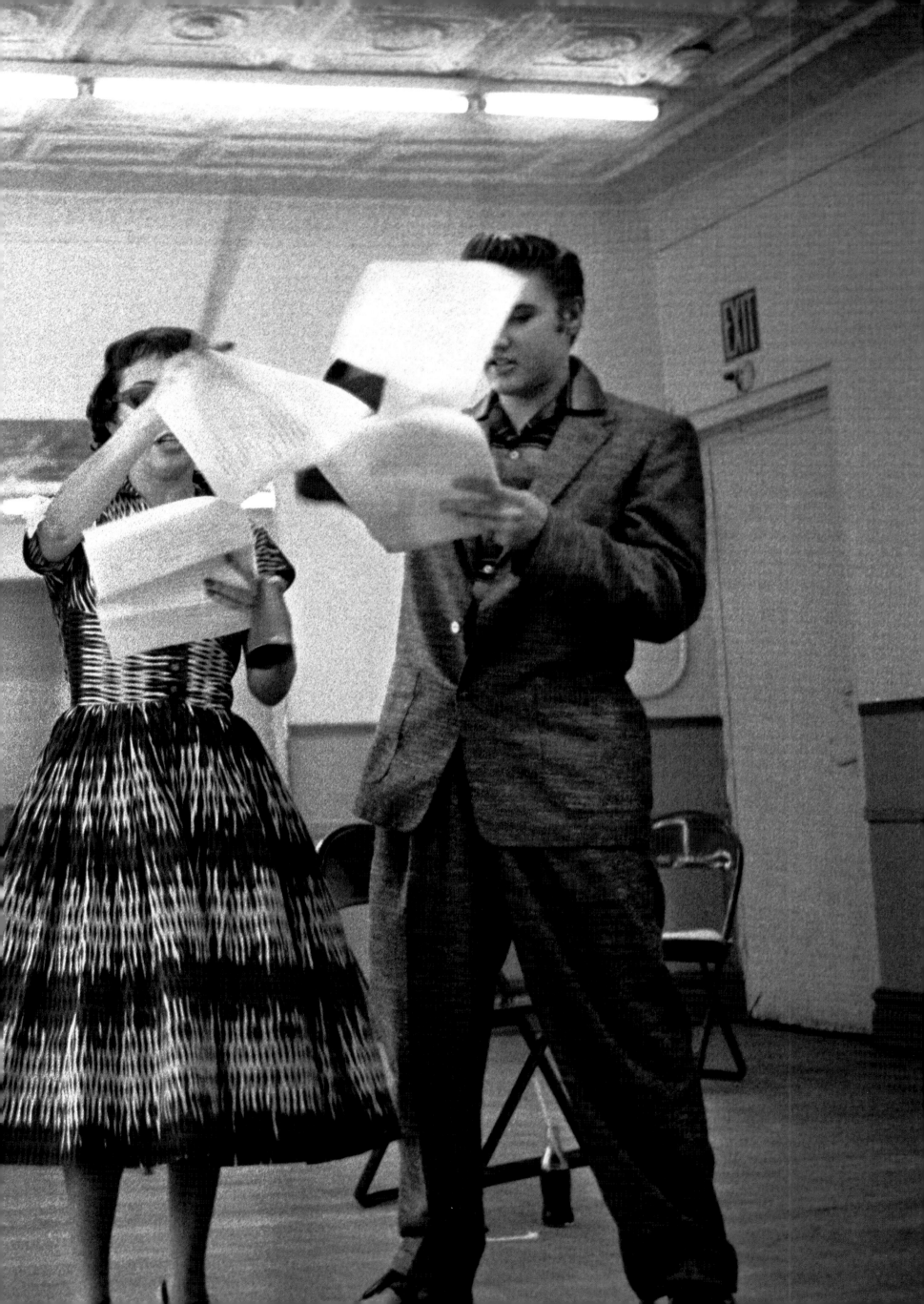

PREVIOUS SPREAD Rehearsals for the "Range Roundup"
skit with host Steve Allen (in glasses), Andy Griffith,
and Imogene Coca on June 29. Elvis and the band
will leave New York that evening for two shows at the
Mosque Theater in Richmond, Virginia.

OPPOSITE Bassist Bill Black looks for a cab at New York's
Penn Station on return to New York, July 1.

FOLLOWING SPREAD At a Penn Station newsstand, Elvis
picks up a paper with a front page story about a
mid-air collision of two planes over the Grand Canyon.

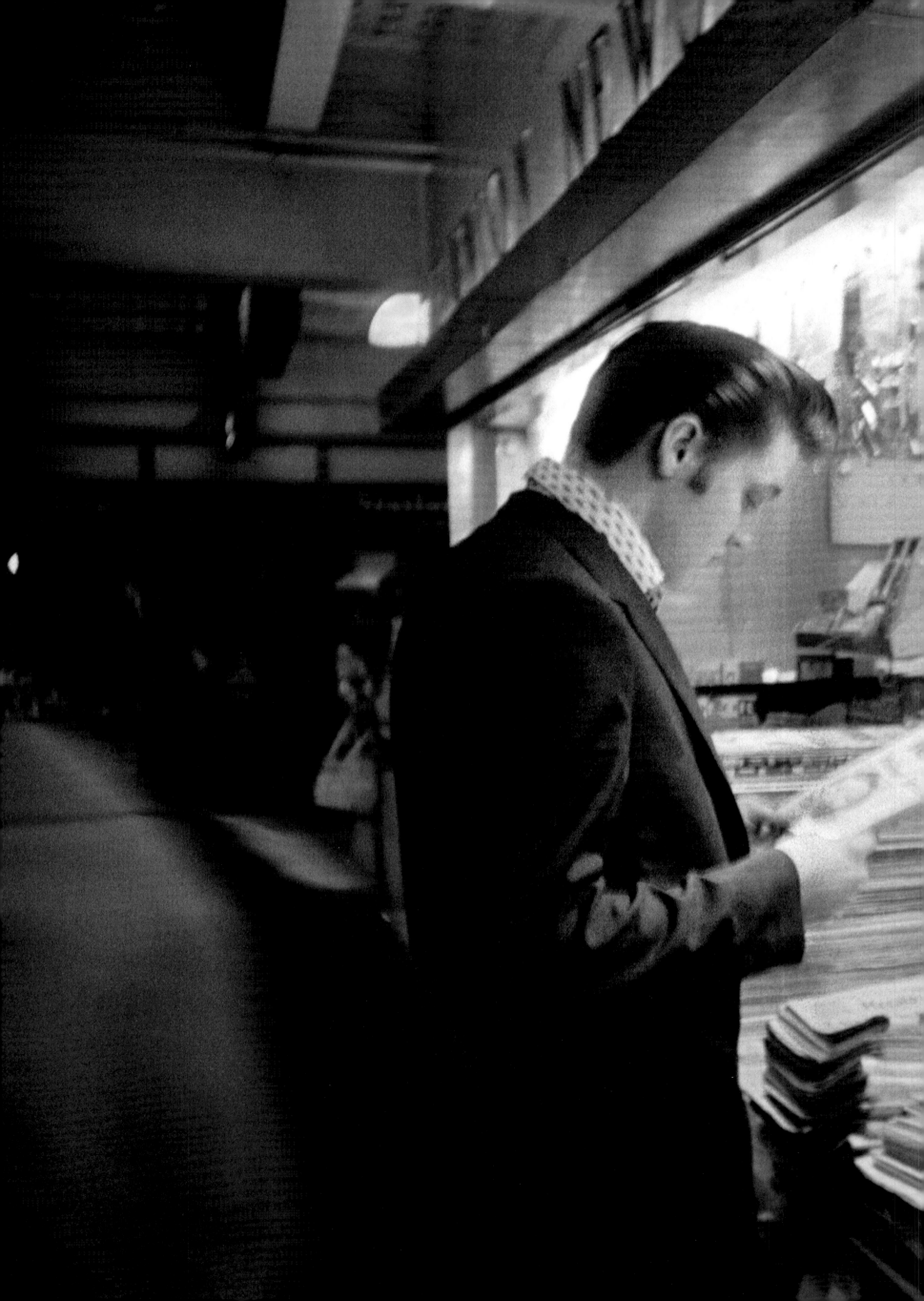

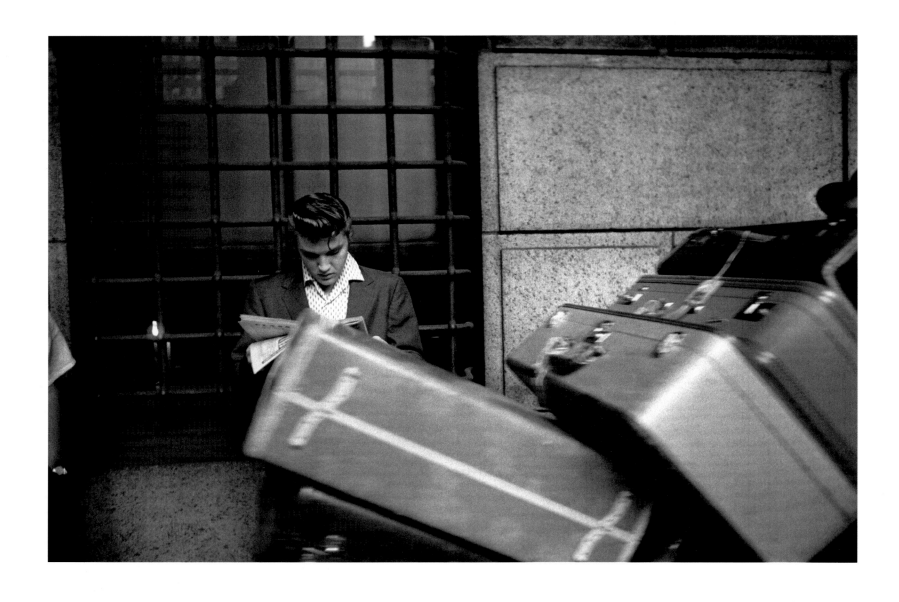

ABOVE & OPPOSITE "Two Airliners Missing. 128 Aboard."
Waiting for a cab, Elvis is absorbed by the story.
Earlier that year, Elvis's own tour plane made a
terrifying emergency landing between Amarillo,
Texas, and Nashville, Tennessee.

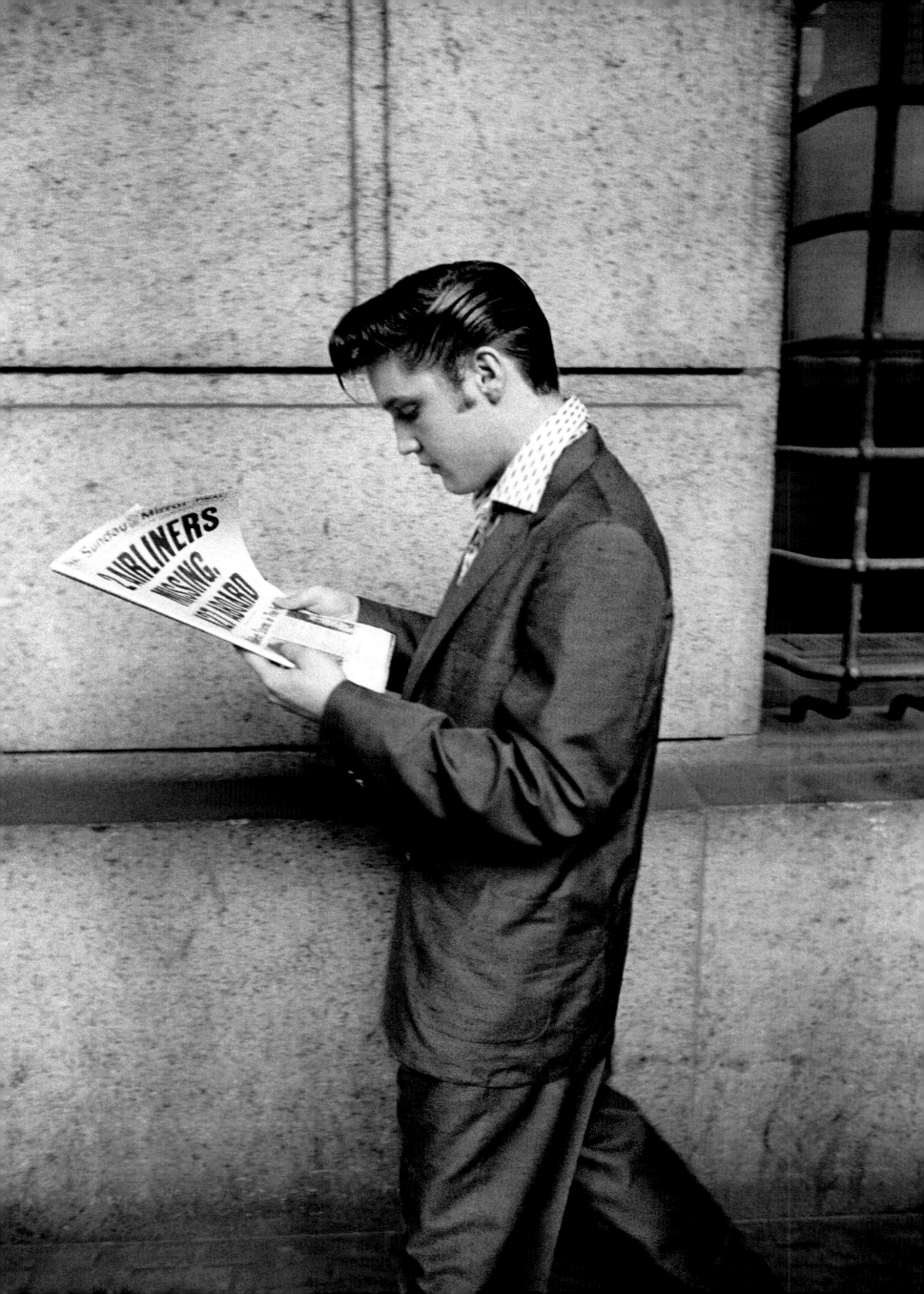

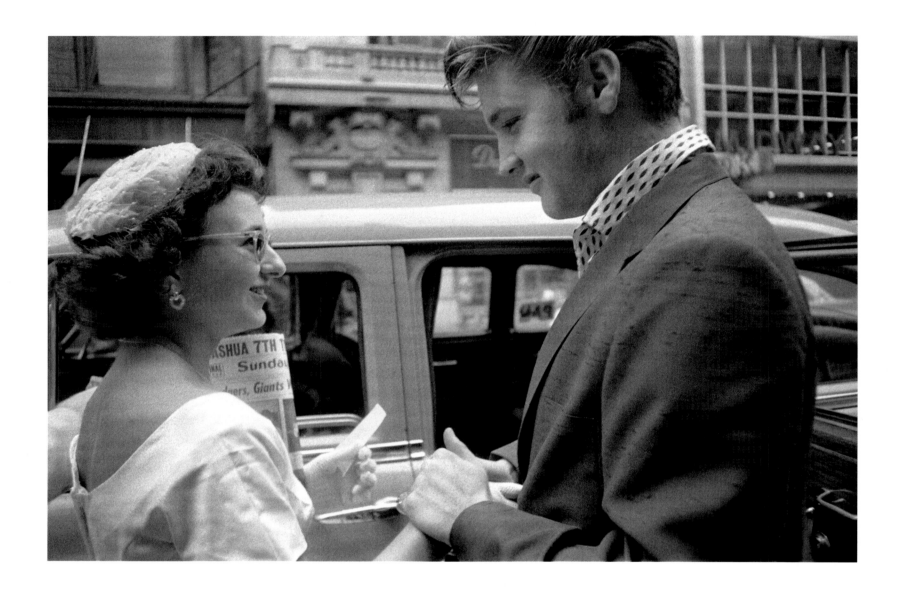

ABOVE & OPPOSITE Elvis arrives at the Hudson Theatre,
141 West 44th Street in New York City on July 1, where
The Steve Allen Show is to be broadcast that evening.
Outside, he is greeted by a girl in white, whose father
drove her in from Long Island. She breaks down in
tears when Elvis slips into the theater.

FOLLOWING SPREAD *Girls Behind Bars*, NBC Television,
the Hudson Theatre, New York City. 108

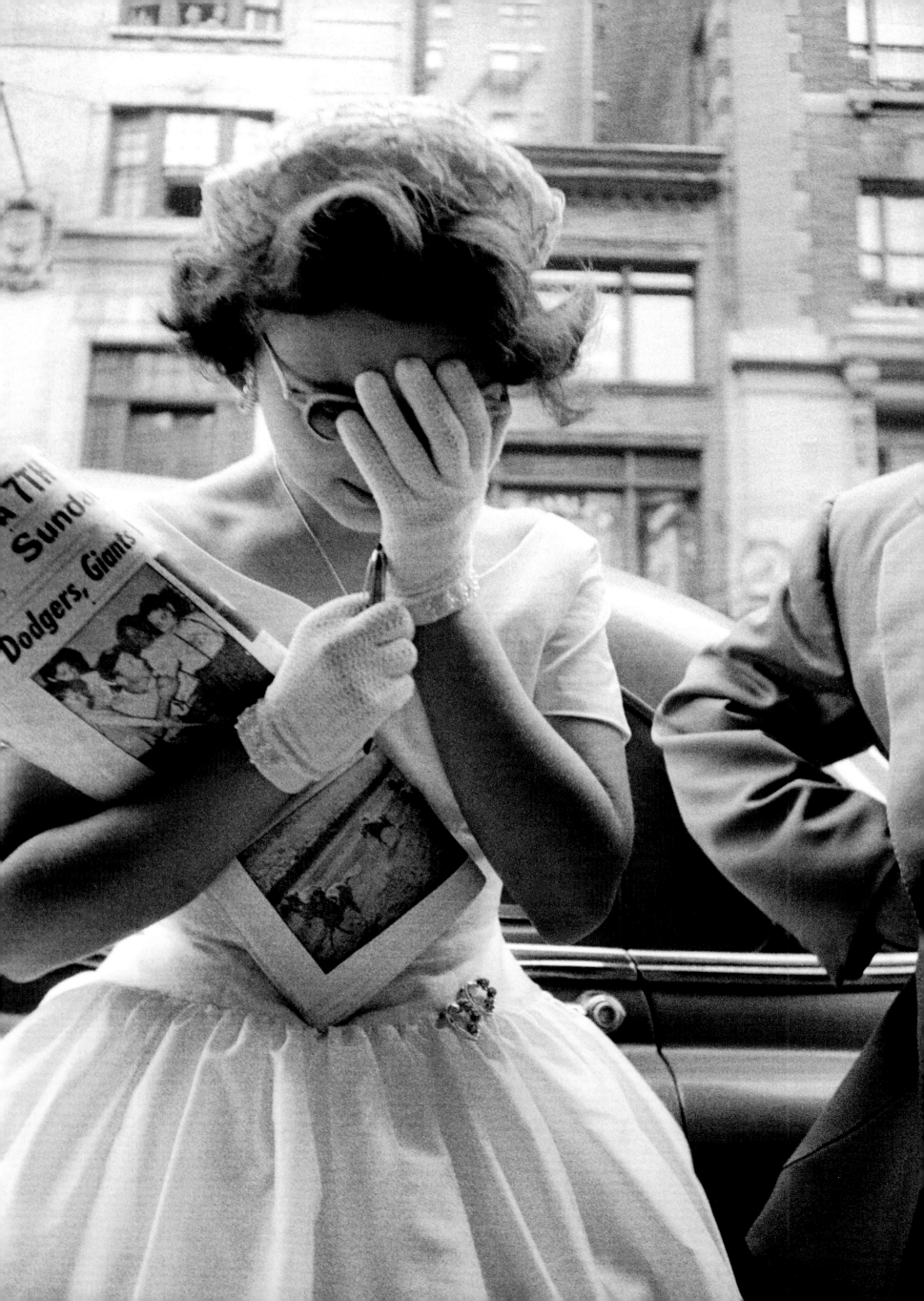

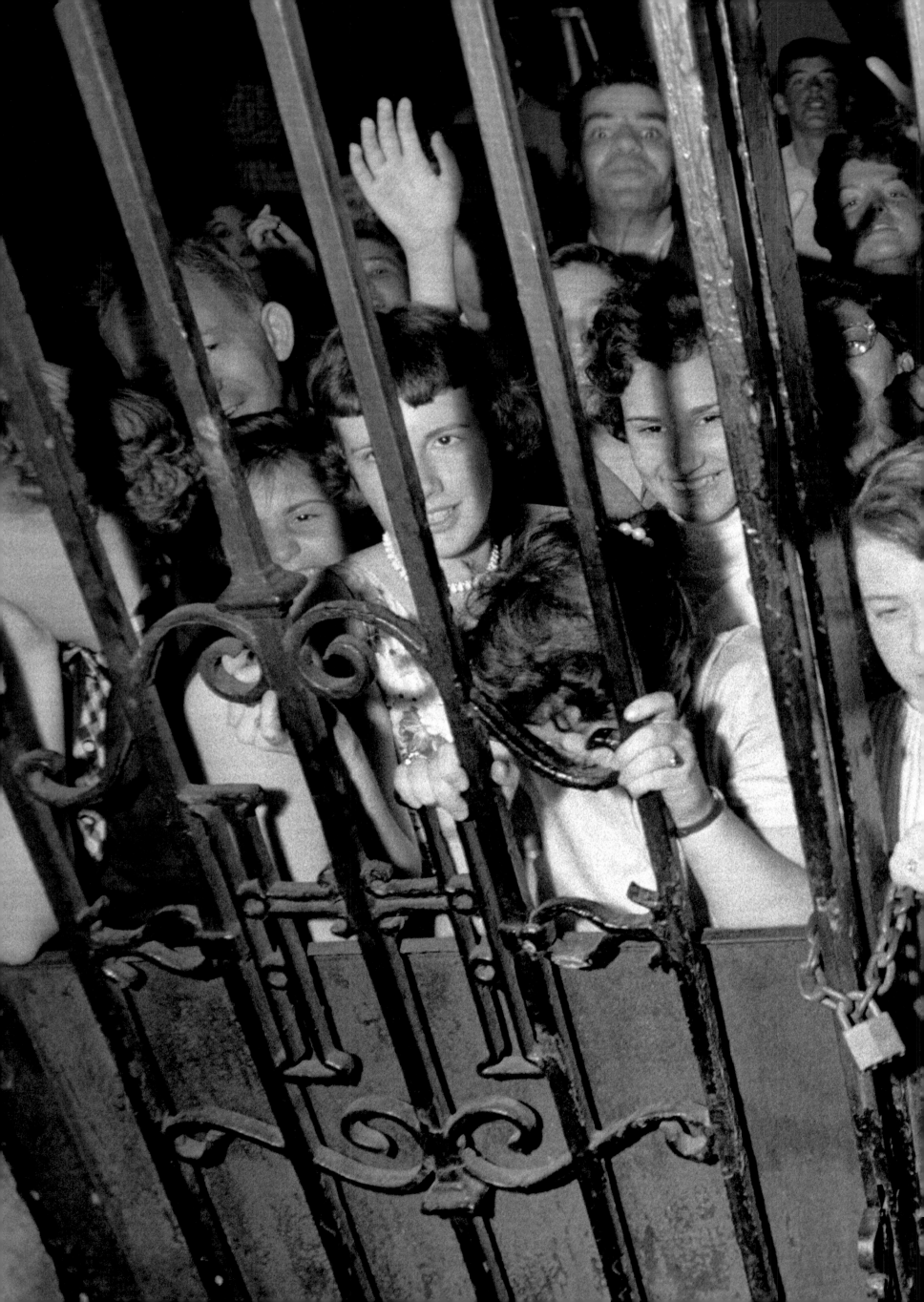

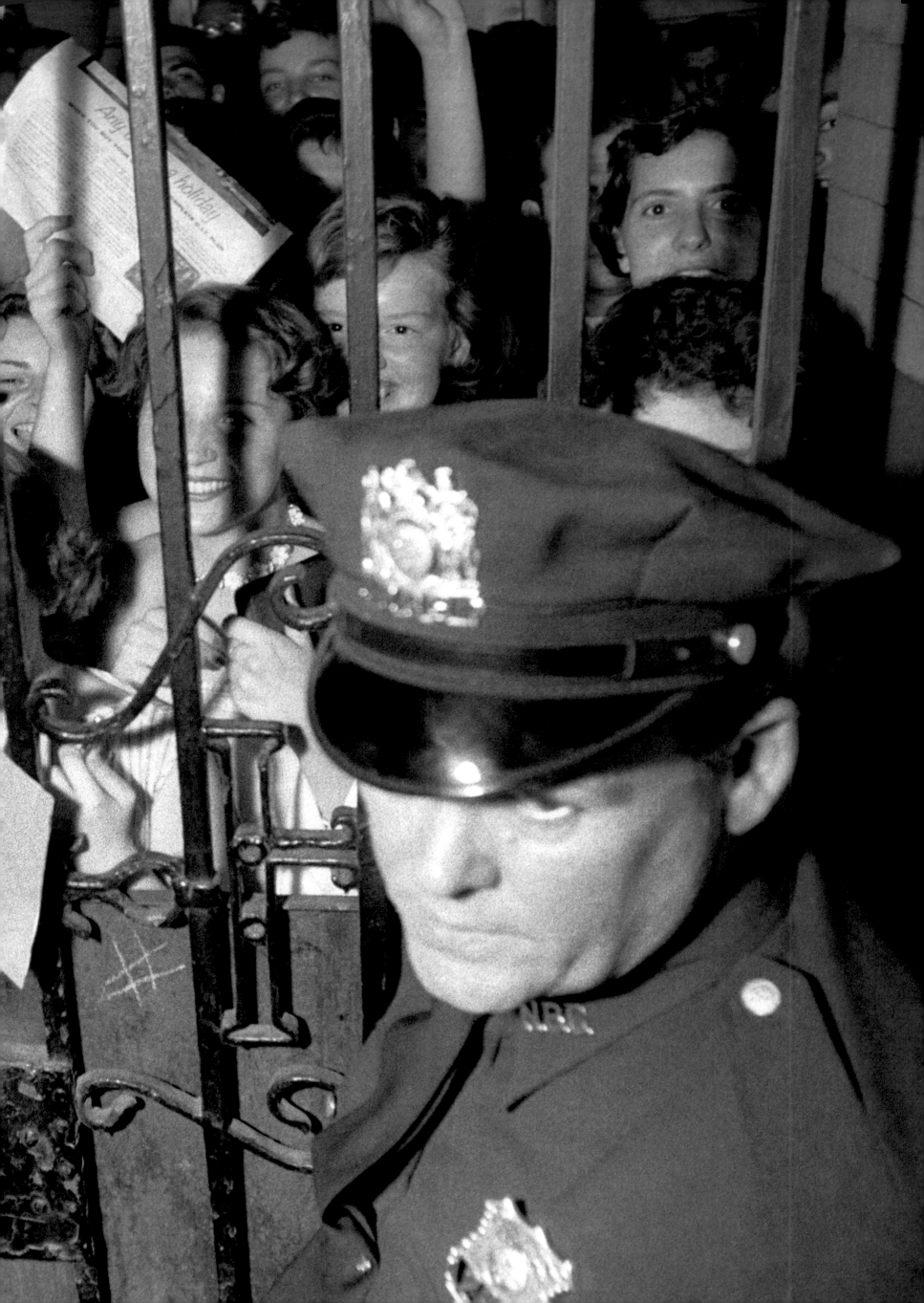

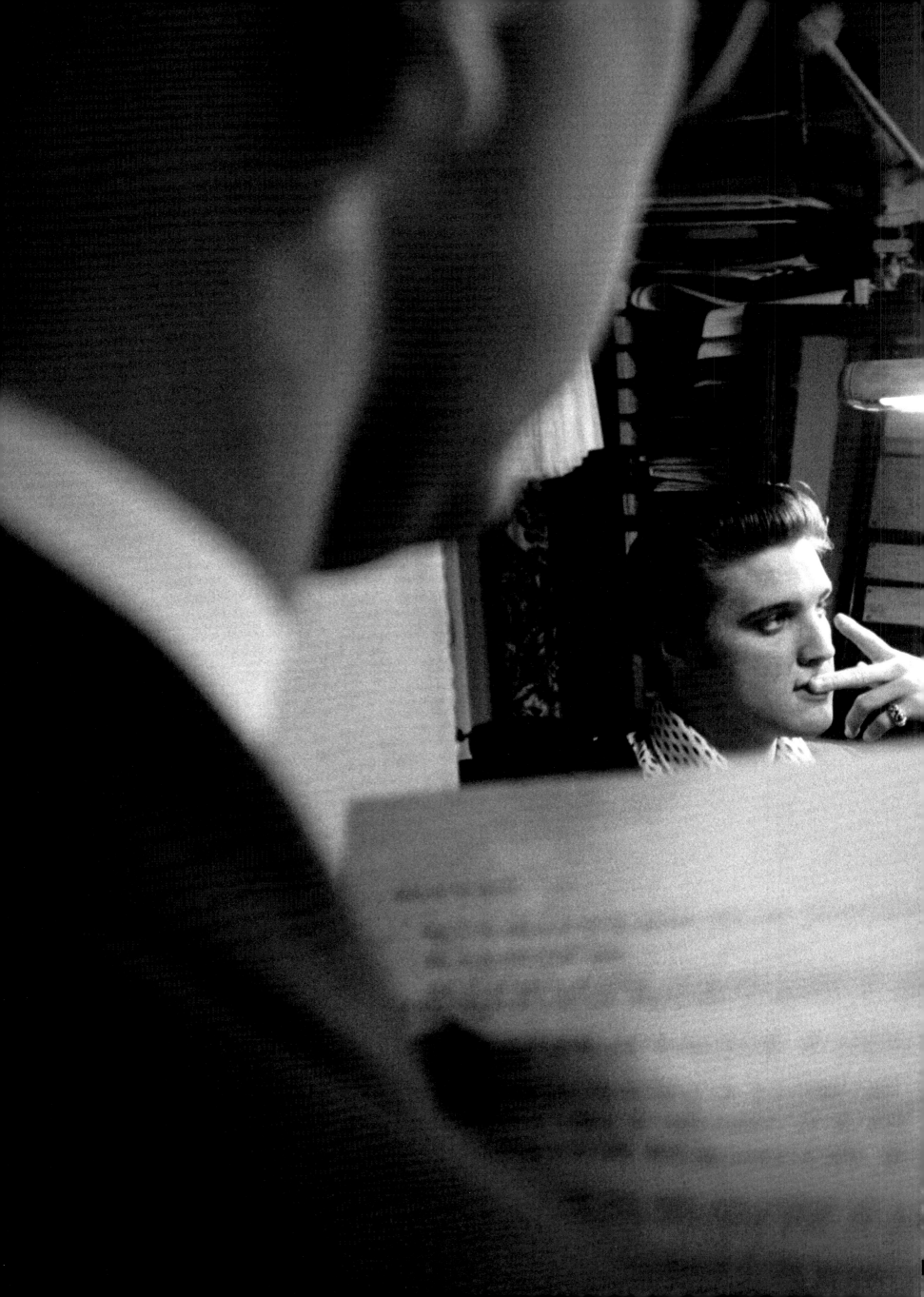

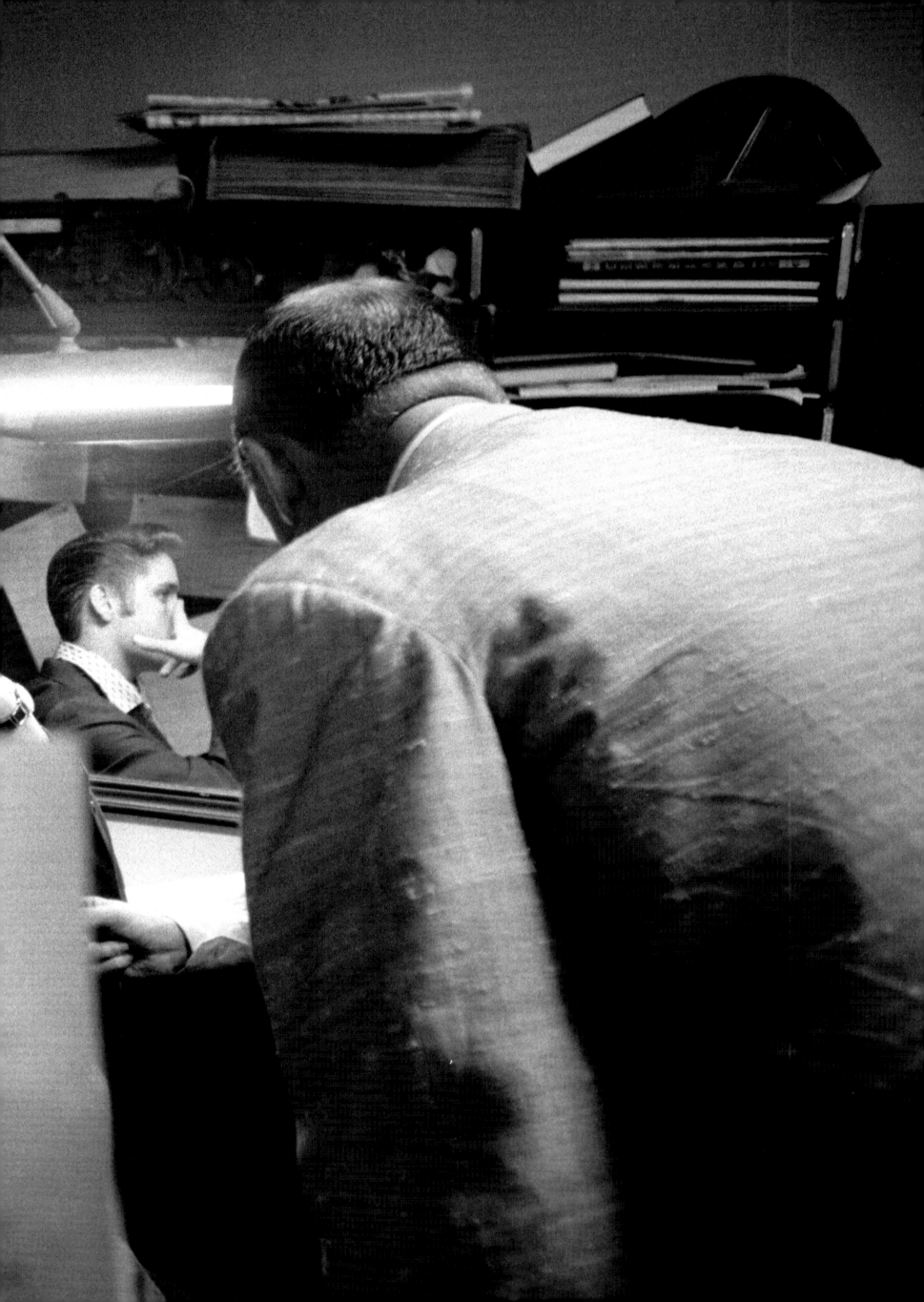

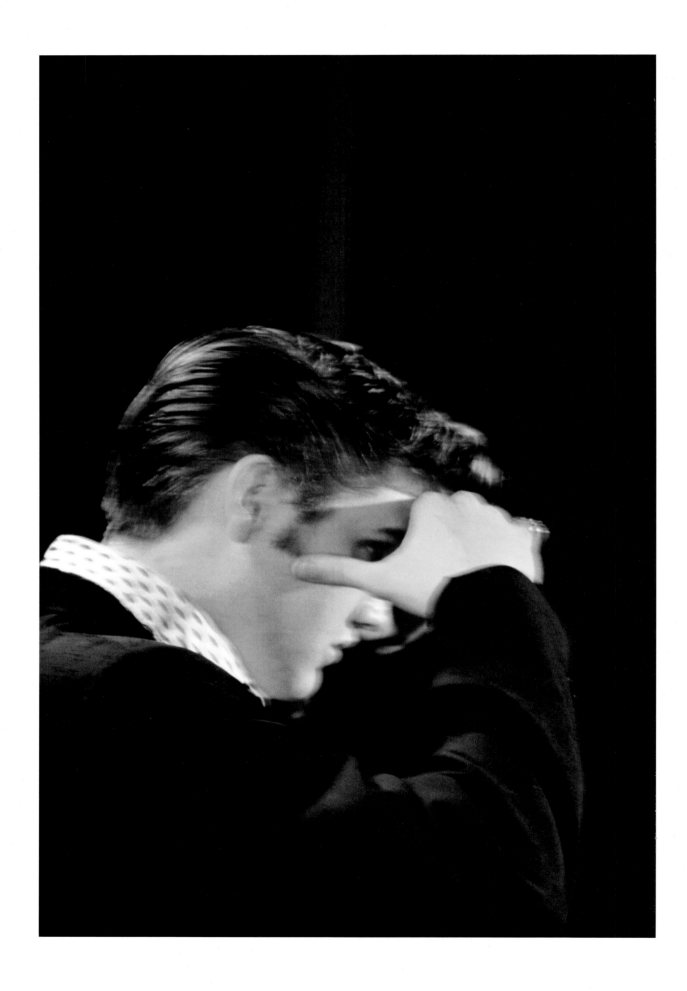

PREVIOUS SPREAD Backstage at the Hudson, awaiting a
press conference.

ABOVE Elvis shades his eyes from the bright studio
lights in rehearsal.

OPPOSITE NBC's boom man adjusts the microphone. 114

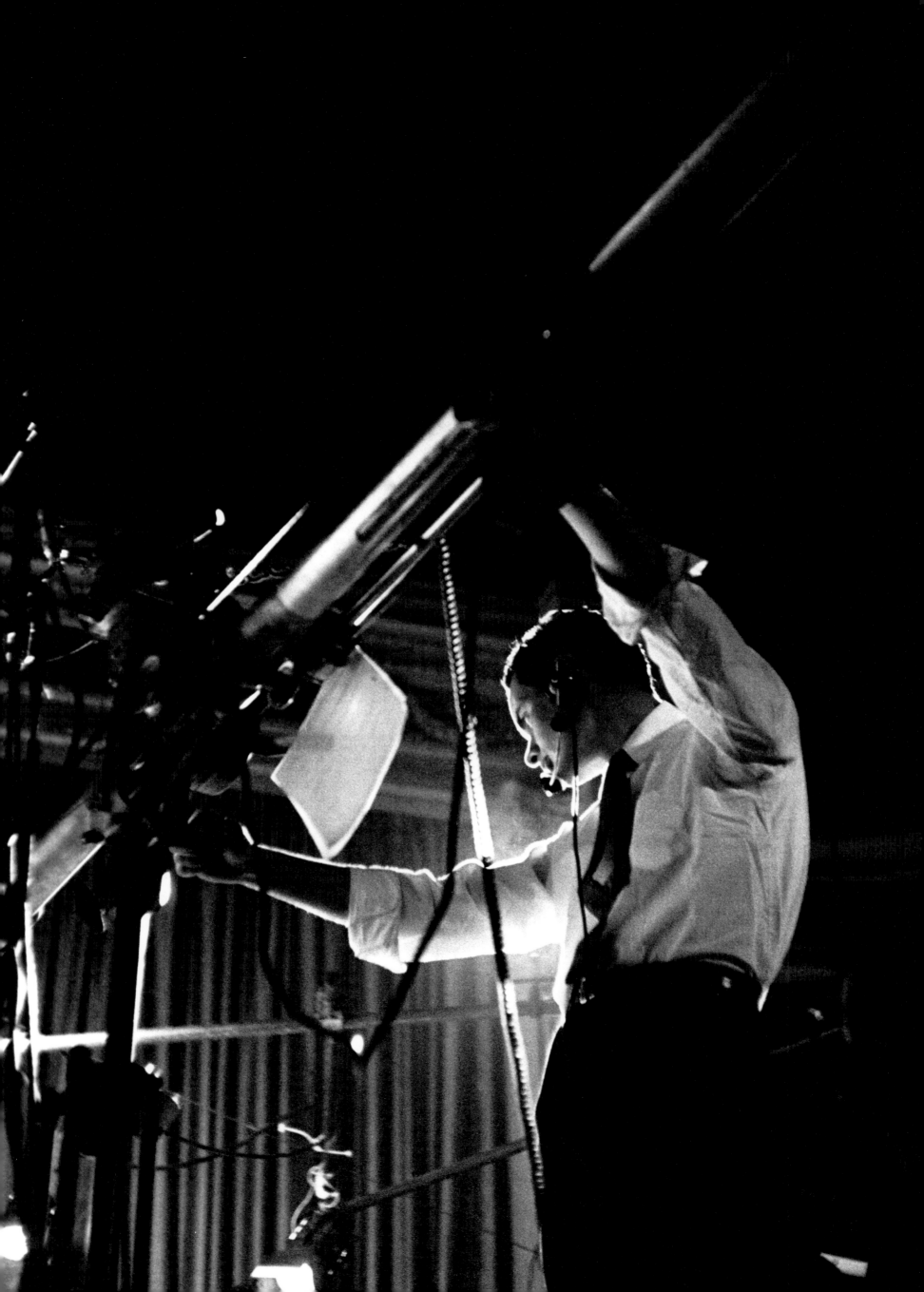

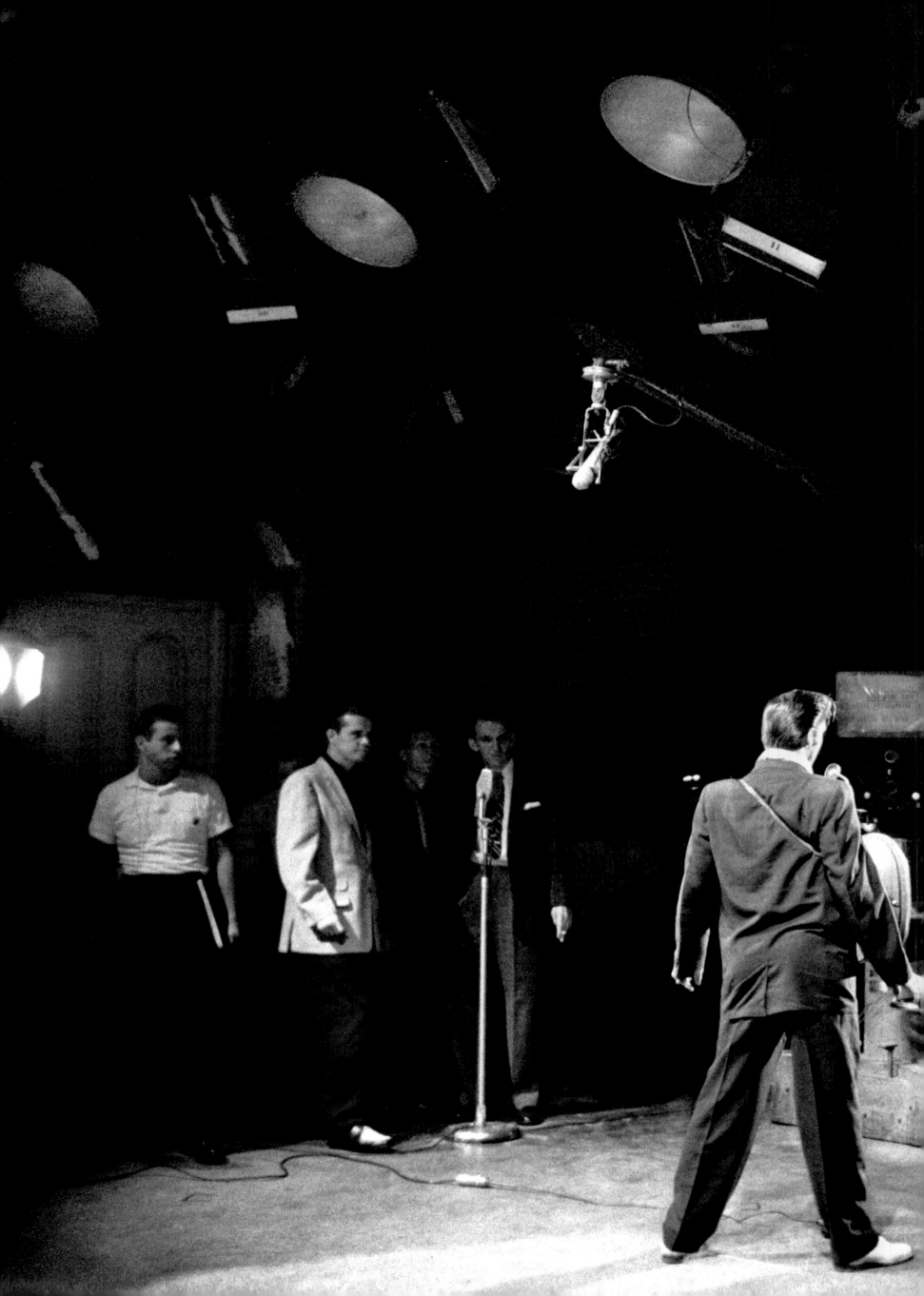

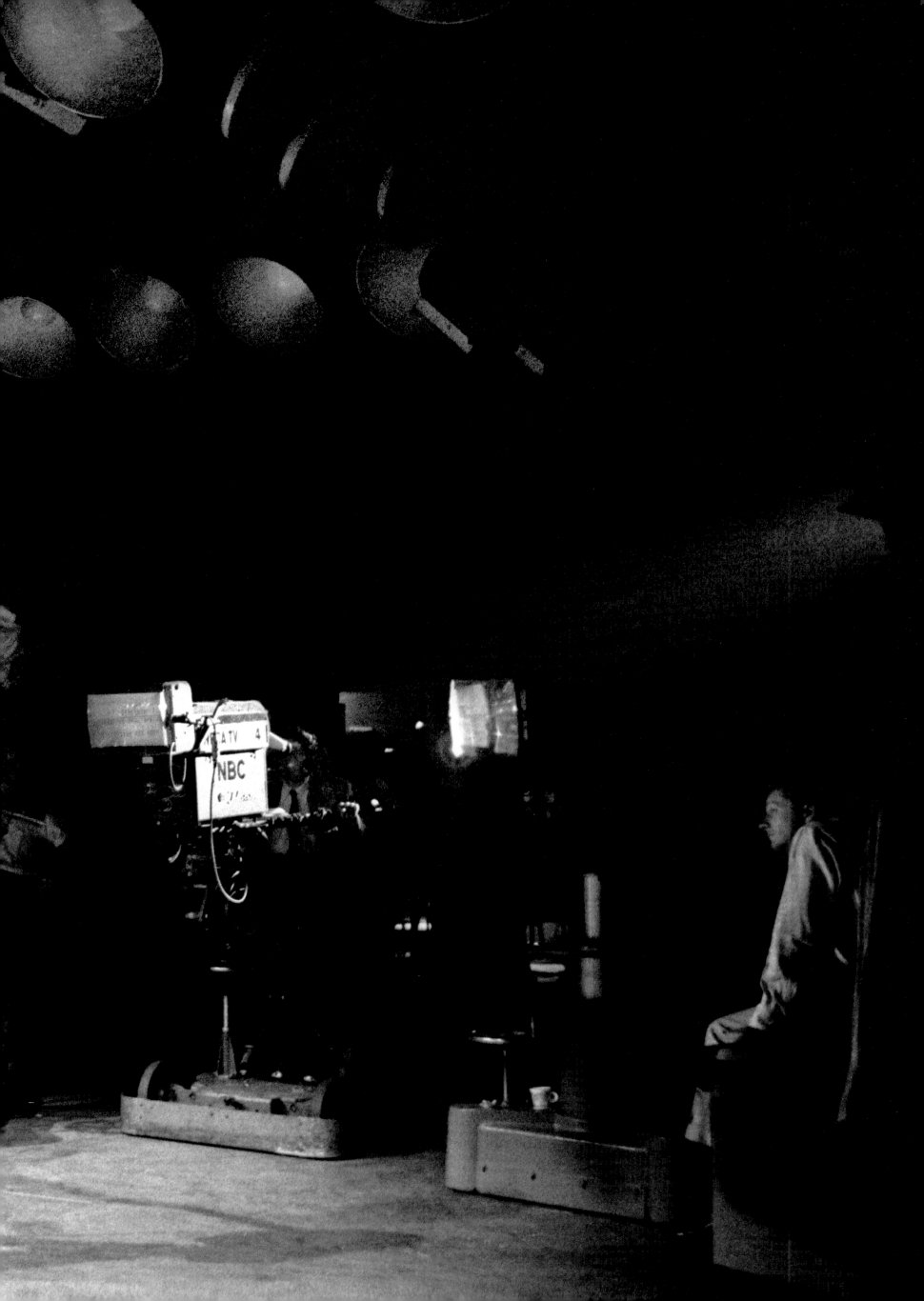

I don't feel I'm doing anything wrong…I don't see how any type of music would have any bad influence on people when it's only music. I can't figure it out…How would rock and roll music make anyone rebel against their parents?

Ich finde nicht, dass ich irgendwas Unrechtes tue … Ich kann mir nicht vorstellen, wie irgendeine Art von Musik einen schlechten Einfluss auf die Leute haben soll; es ist doch nur Musik. Ich versteh es einfach nicht … Wie soll Rock-and-Roll-Musik irgendwen dazu bringen, gegen seine Eltern zu rebellieren?

Je ne vois pas ce que je fais de mal… Comment un style de musique pourrait-il avoir une influence néfaste sur les gens ? Ce n'est que de la musique. Ça me dépasse… Pourquoi le rock'n'roll inciterait-il quelqu'un à se rebeller contre ses parents ?

—ELVIS PRESLEY
The Hy Gardner Show, July 1, 1956

PREVIOUS SPREAD Rear view of the rehearsal; background singers the Jordanaires stand by to the left.

118

OPPOSITE Portrait backstage, *The Steve Allen Show*.

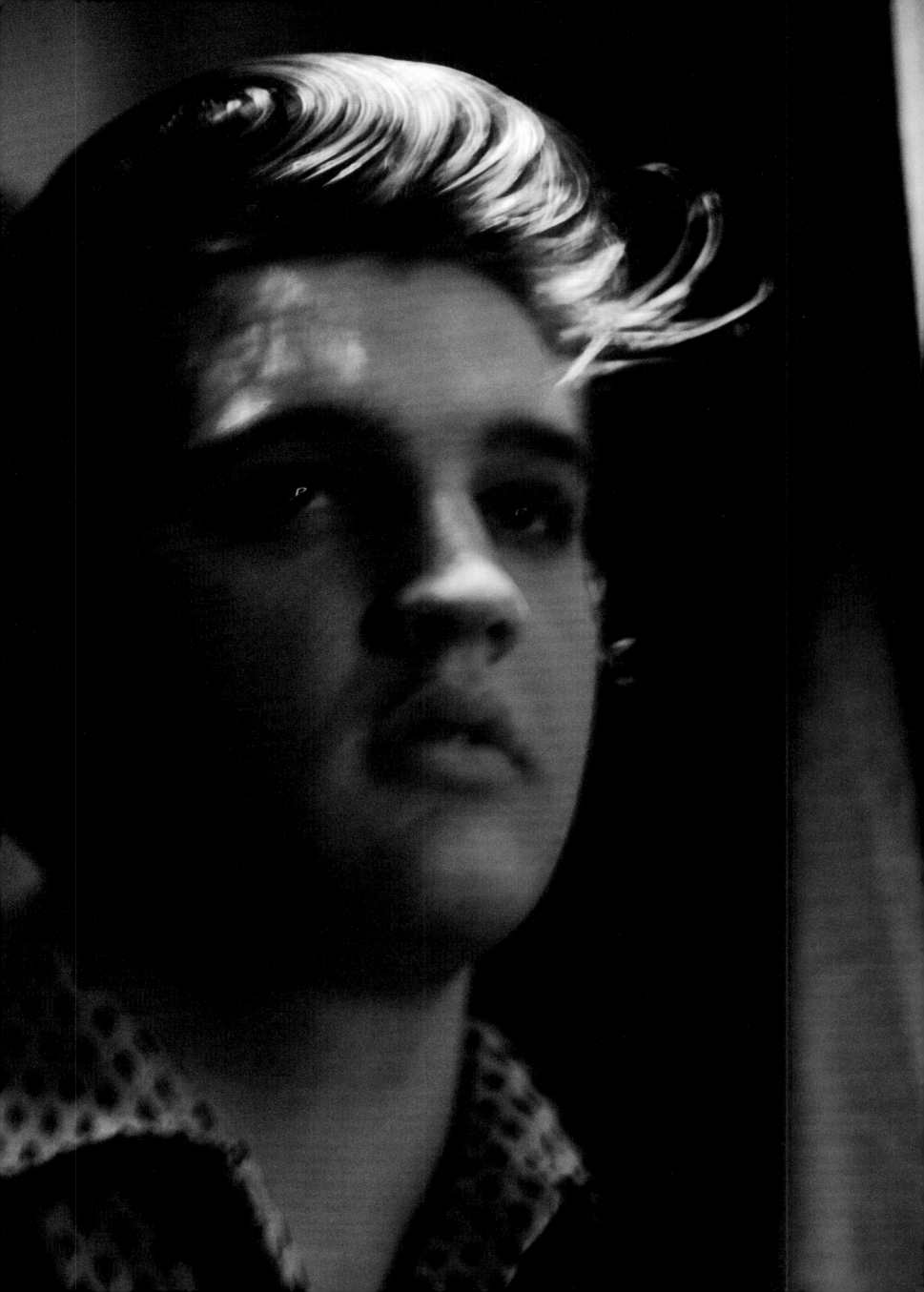

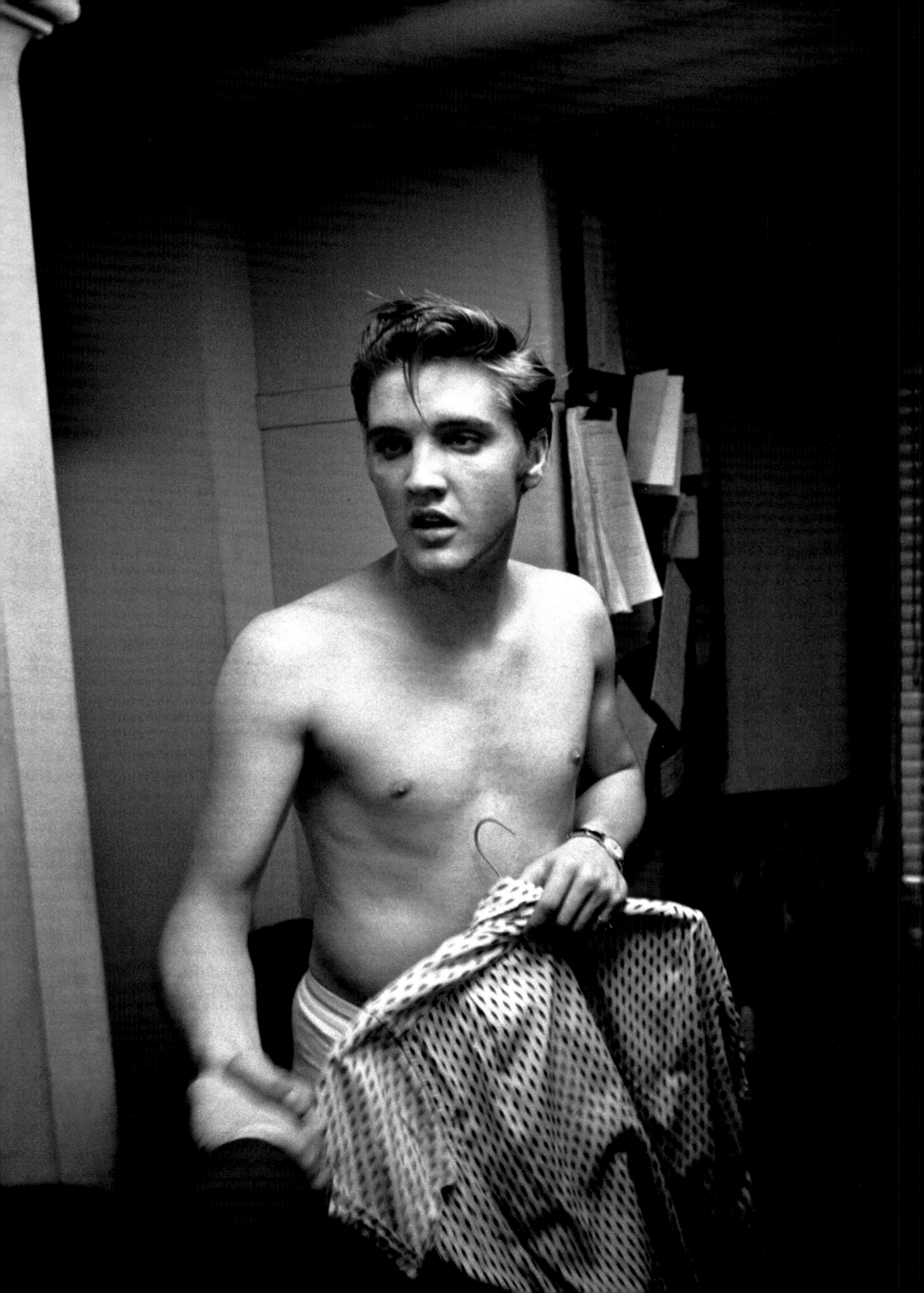

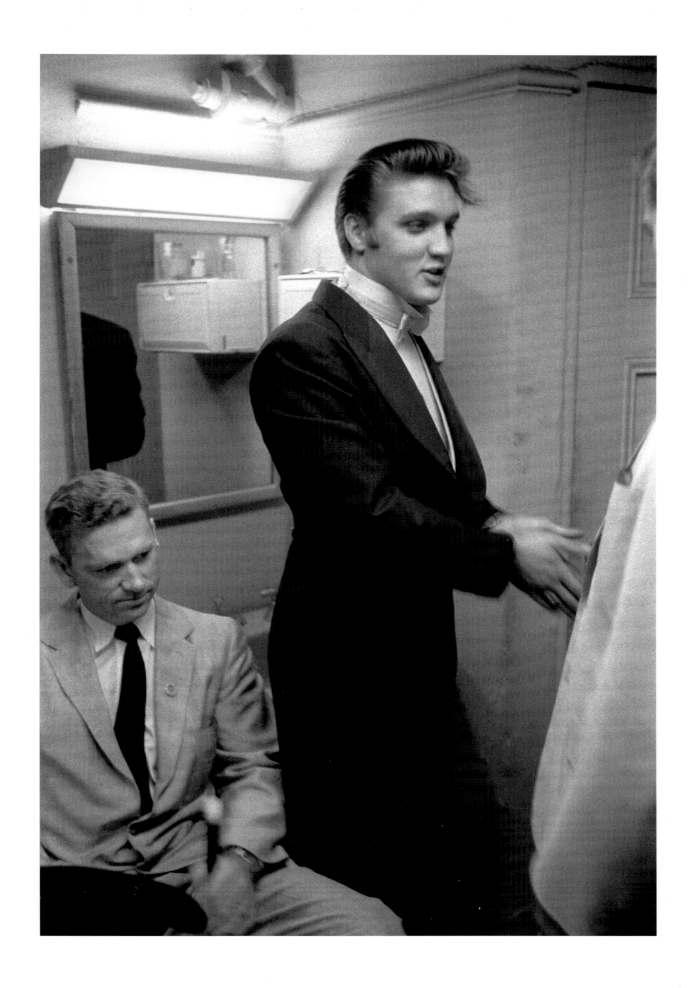

OPPOSITE & ABOVE Clothes make the man: Elvis changes out of his street garb into a blue shirt, tie, and tails, called for in the script. It's his first time wearing formal attire. To his left, Tom Diskin, assistant to Colonel Tom Parker.

FOLLOWING SPREAD Elvis's pompadour as seen from a stairwell.

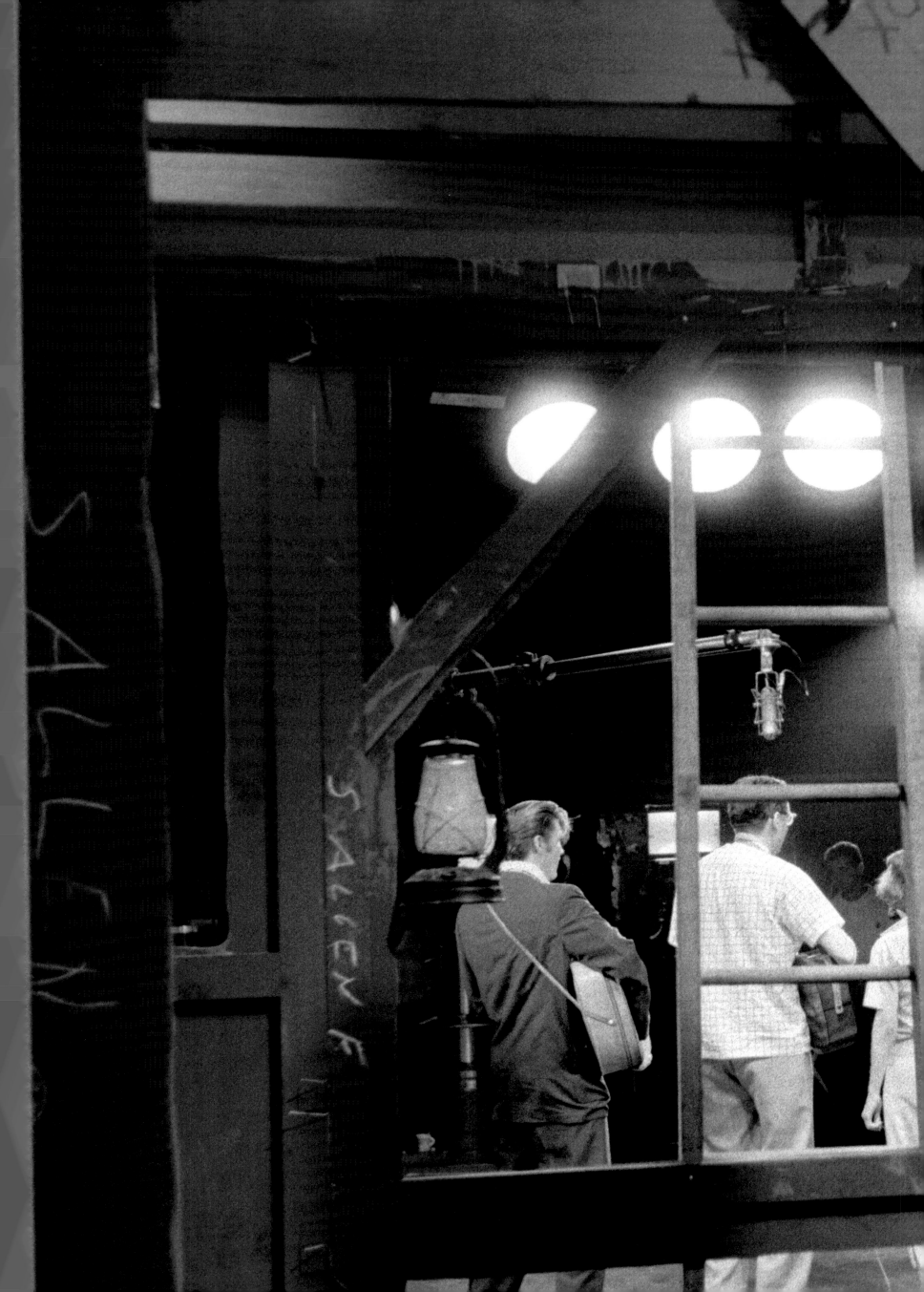

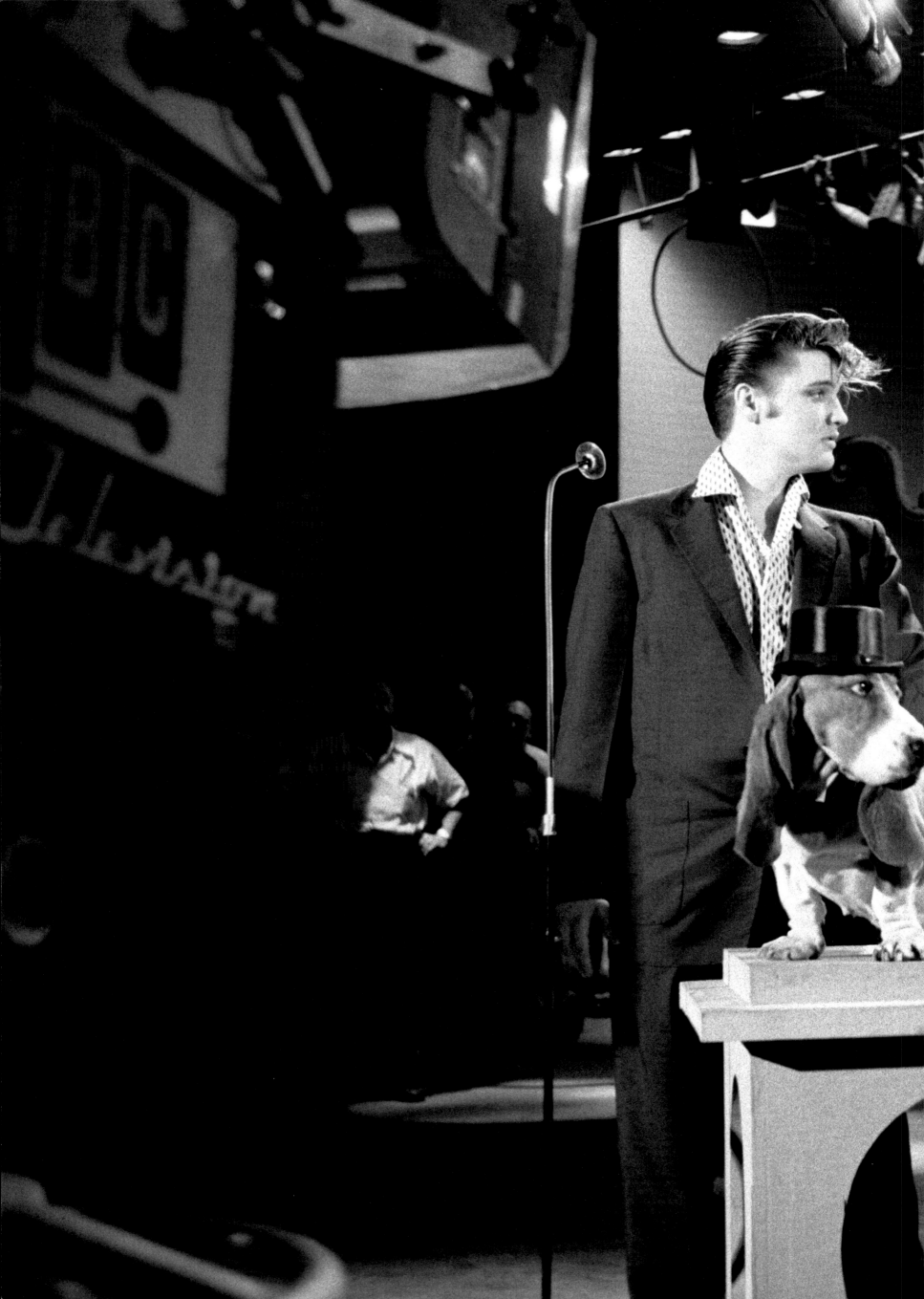

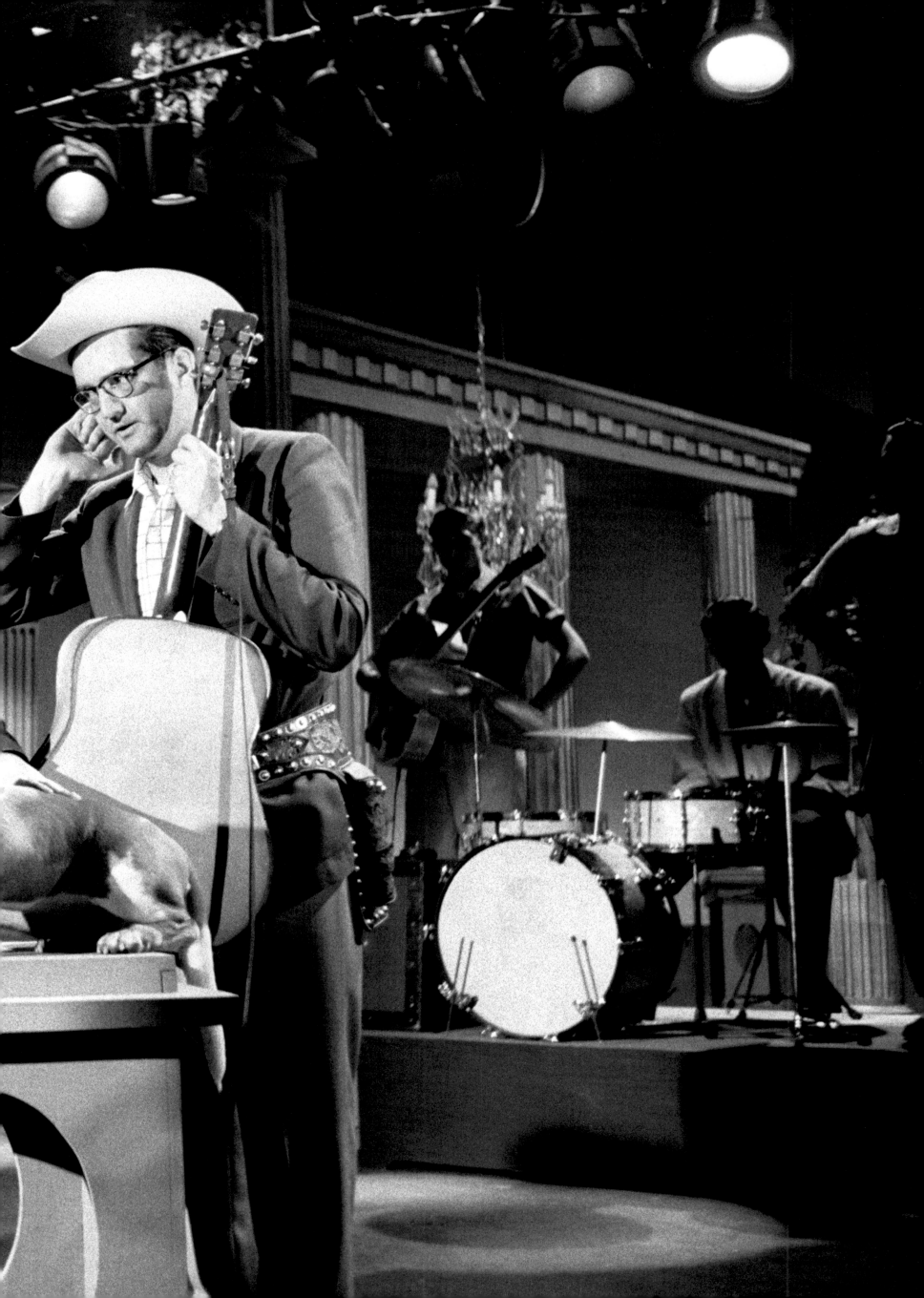

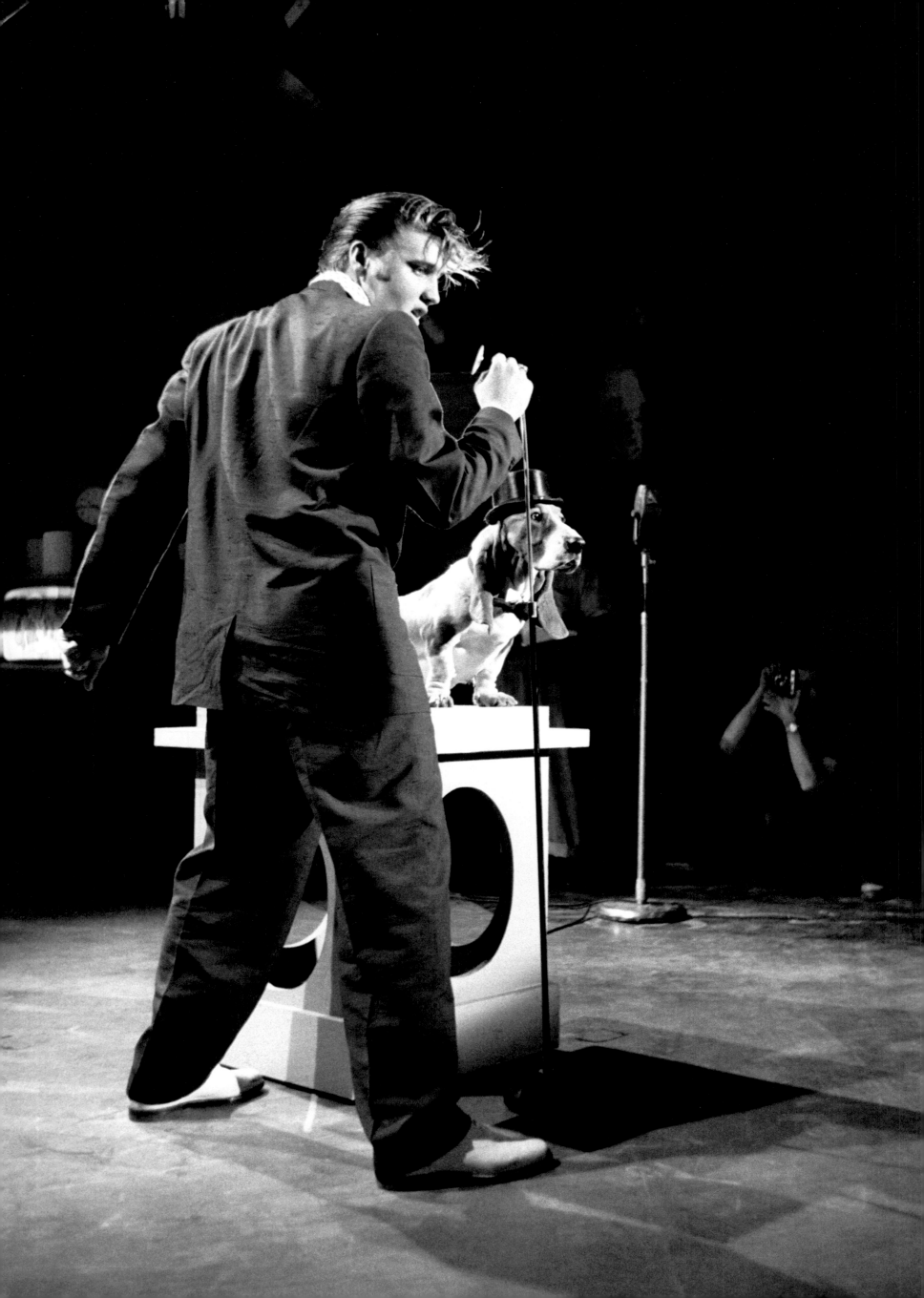

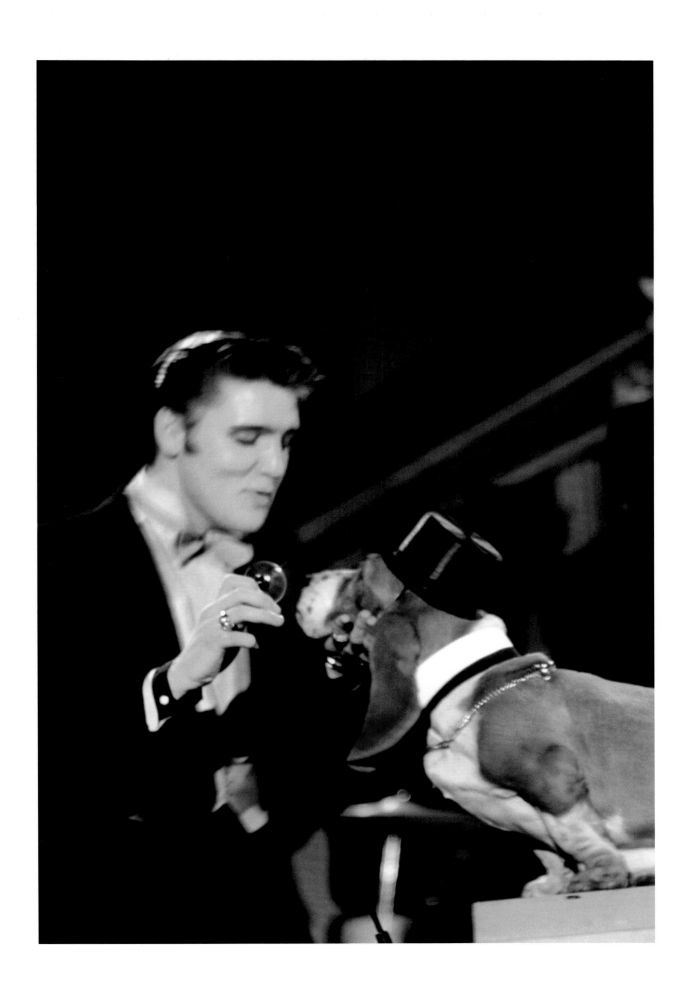

124-125 Behind the scenes on *The Steve Allen Show* set.

PREVIOUS SPREAD Following the singer's controversial, hip-thrusting, headline-grabbing performance of "Hound Dog" on *The Milton Berle Show* in June, host Steve Allen sets the tone by asking Elvis to sing to a live basset hound.

OPPOSITE & ABOVE "It's showbiz time": Elvis tries out "Hound Dog" in two rehearsals.

OPPOSITE Elvis leaves the stage after performing
"Hound Dog." This photo was shot from a stairwell
15 feet in the air, since Wertheimer's movements
were restricted on set during the taping of the show.

FOLLOWING SPREAD *Tumbleweed Presley*, in rehearsal,
The Steve Allen Show. This was Elvis's first non-singing
acting role on television, July 1, 1956.

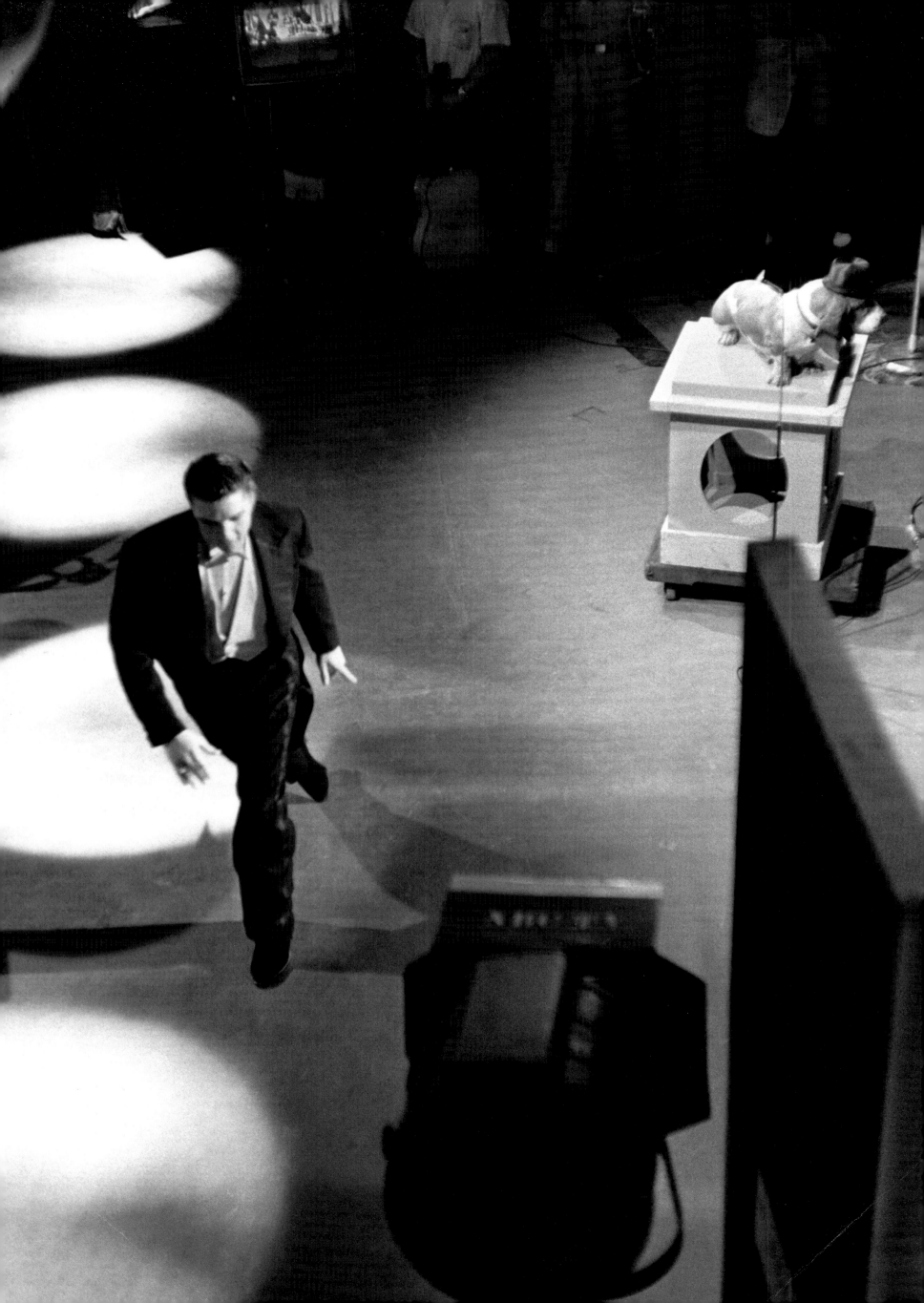

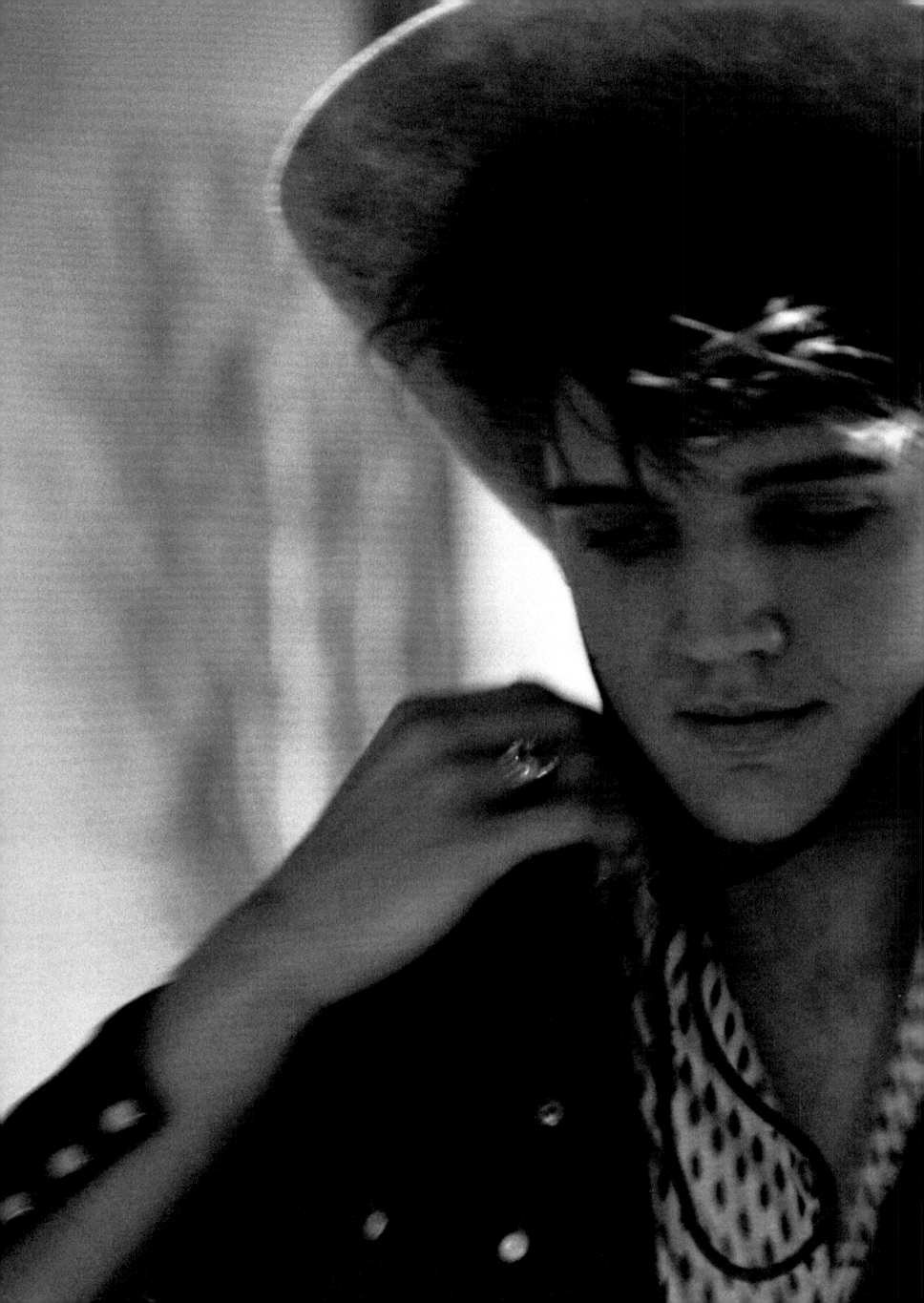

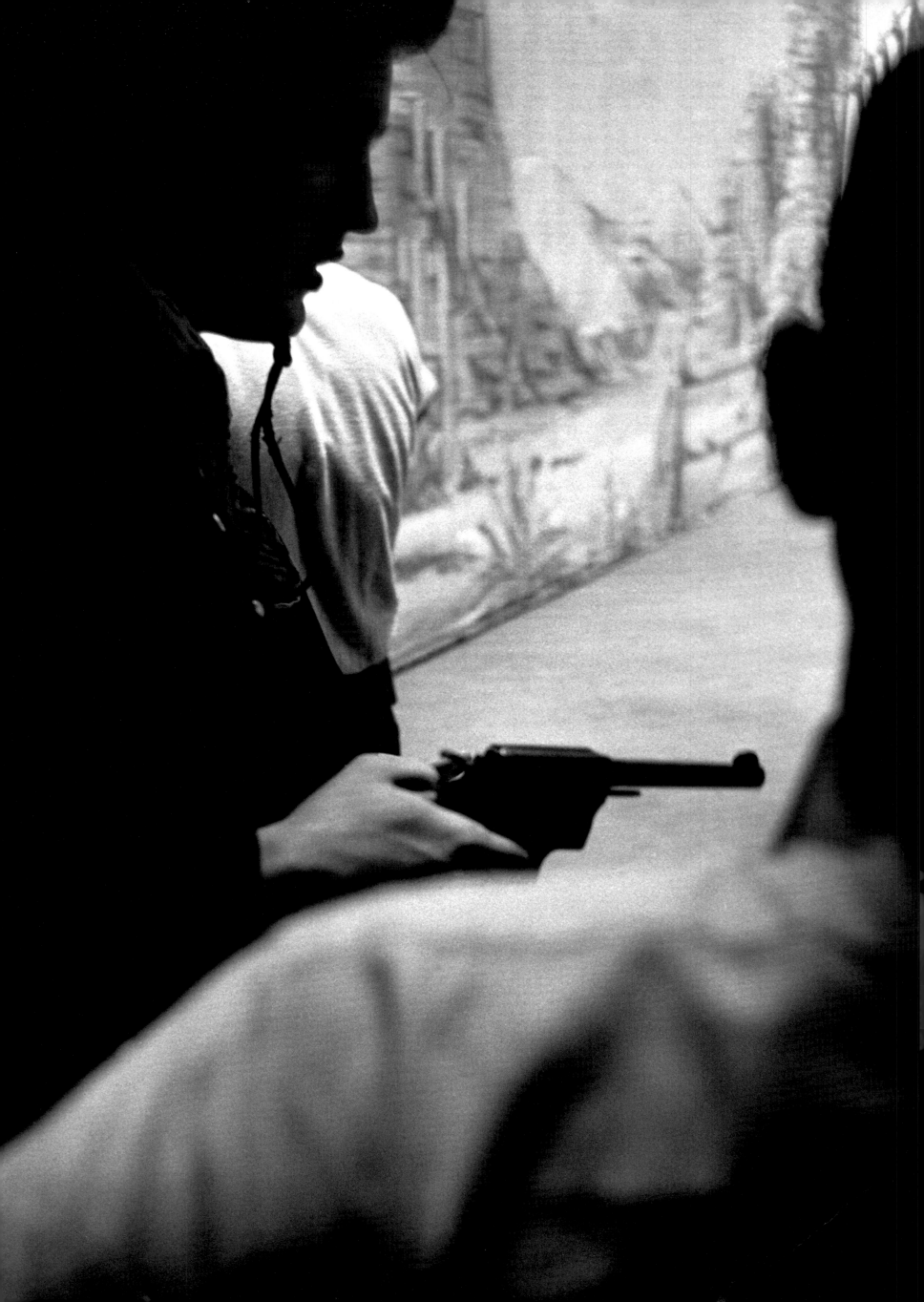

OPPOSITE Elvis practices with a six-shooter.

FOLLOWING SPREADS Dress rehearsal for the "Range Roundup" skit with Steve Allen, Andy Griffith, and Imogene Coca.

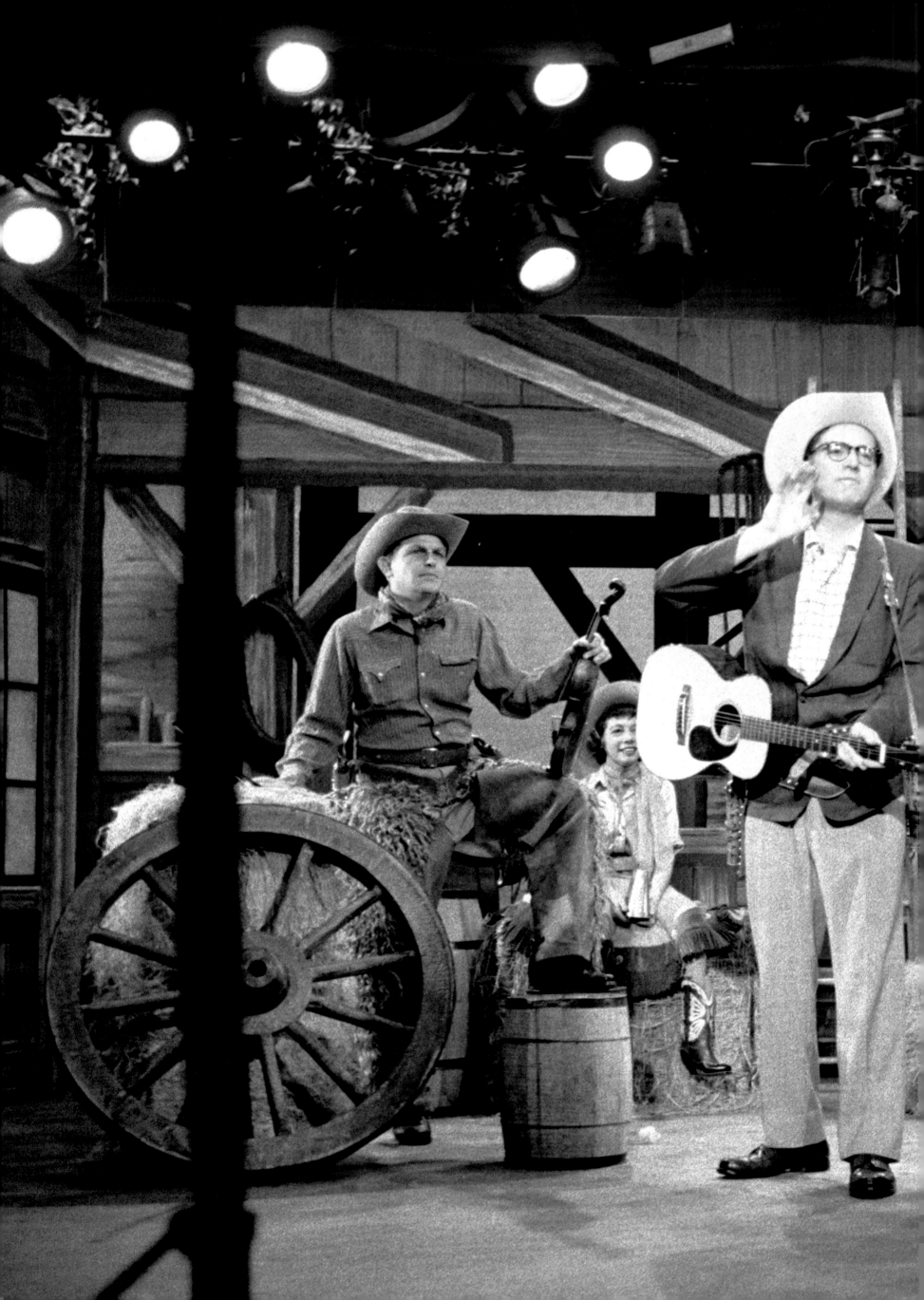

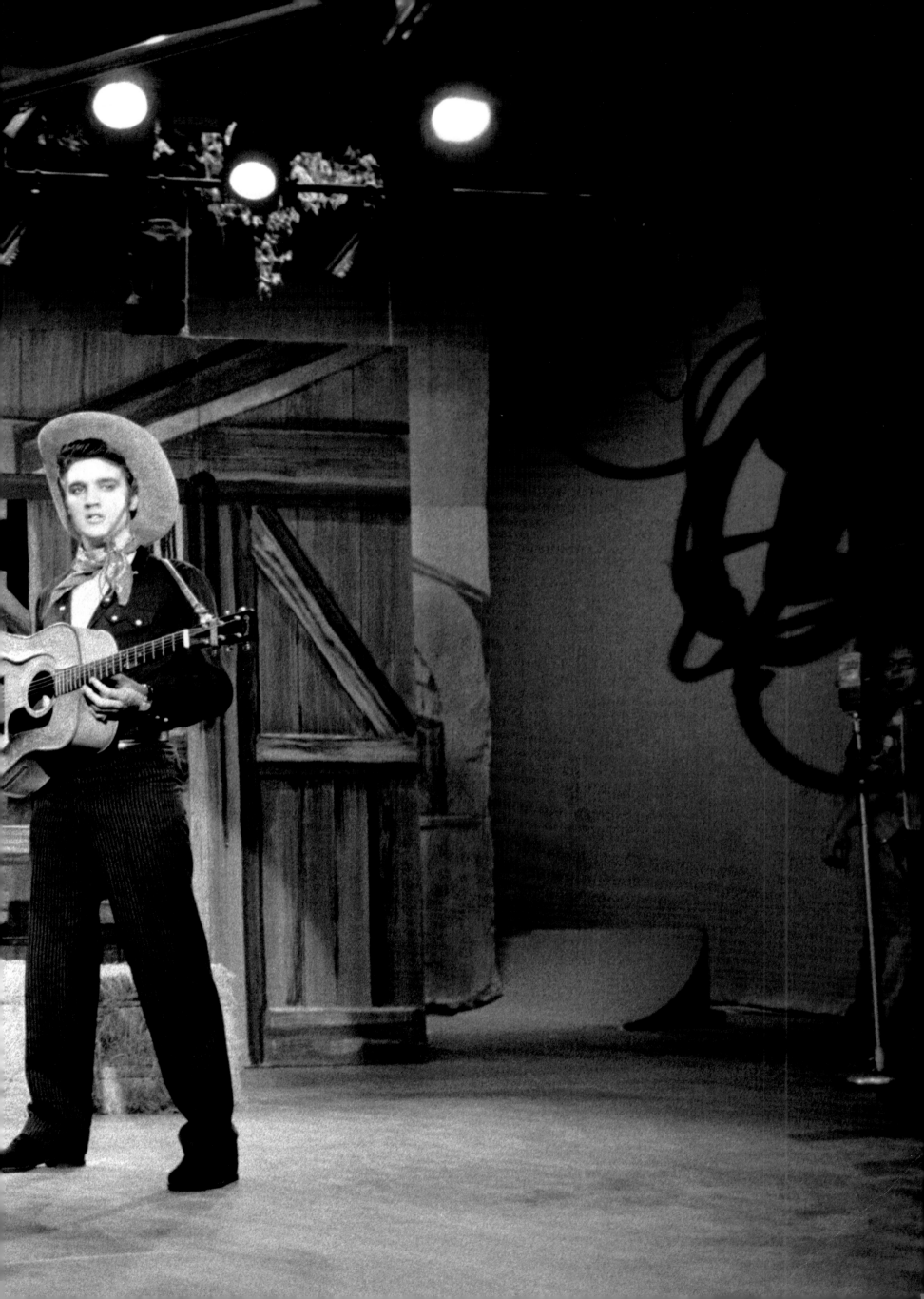

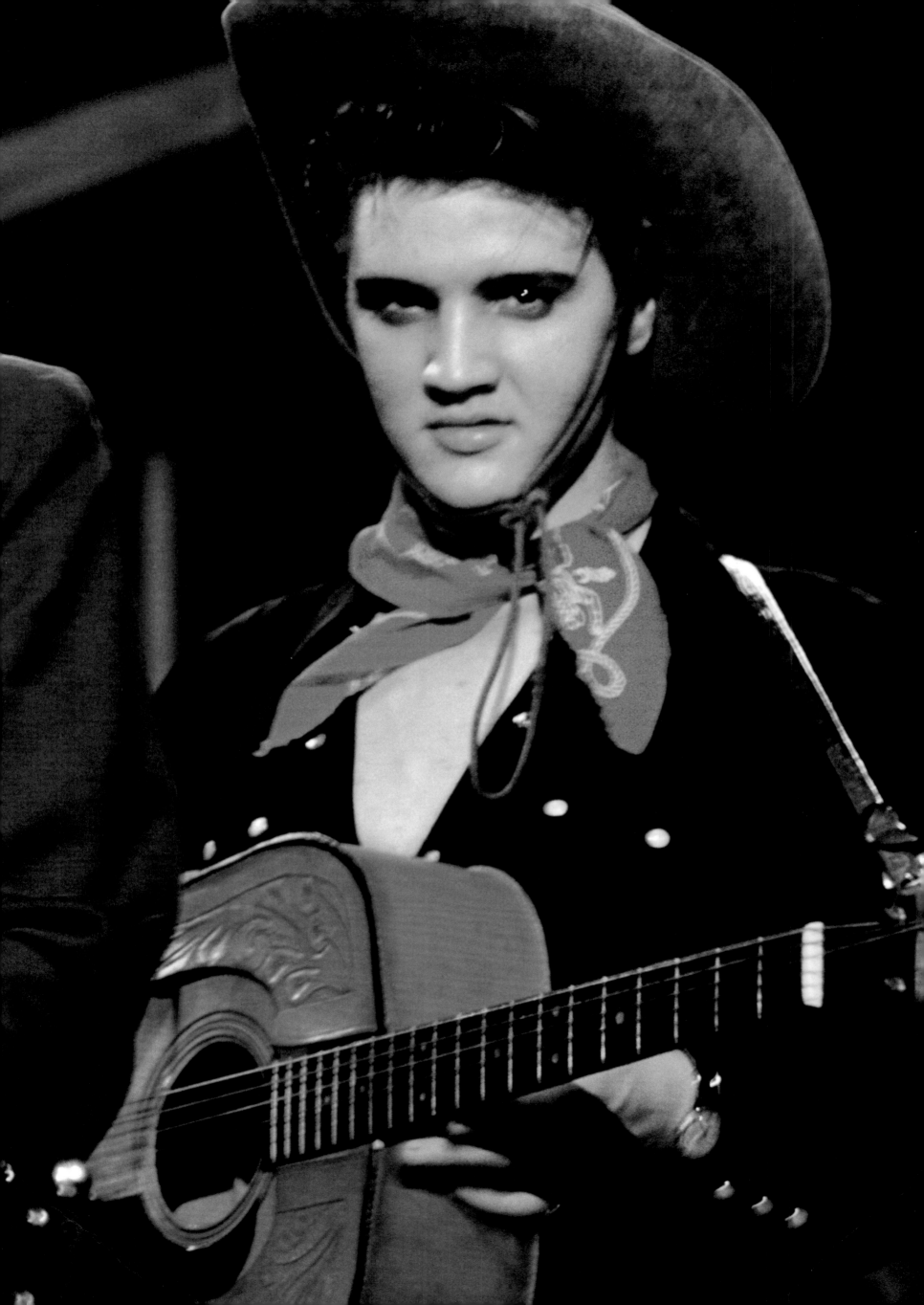

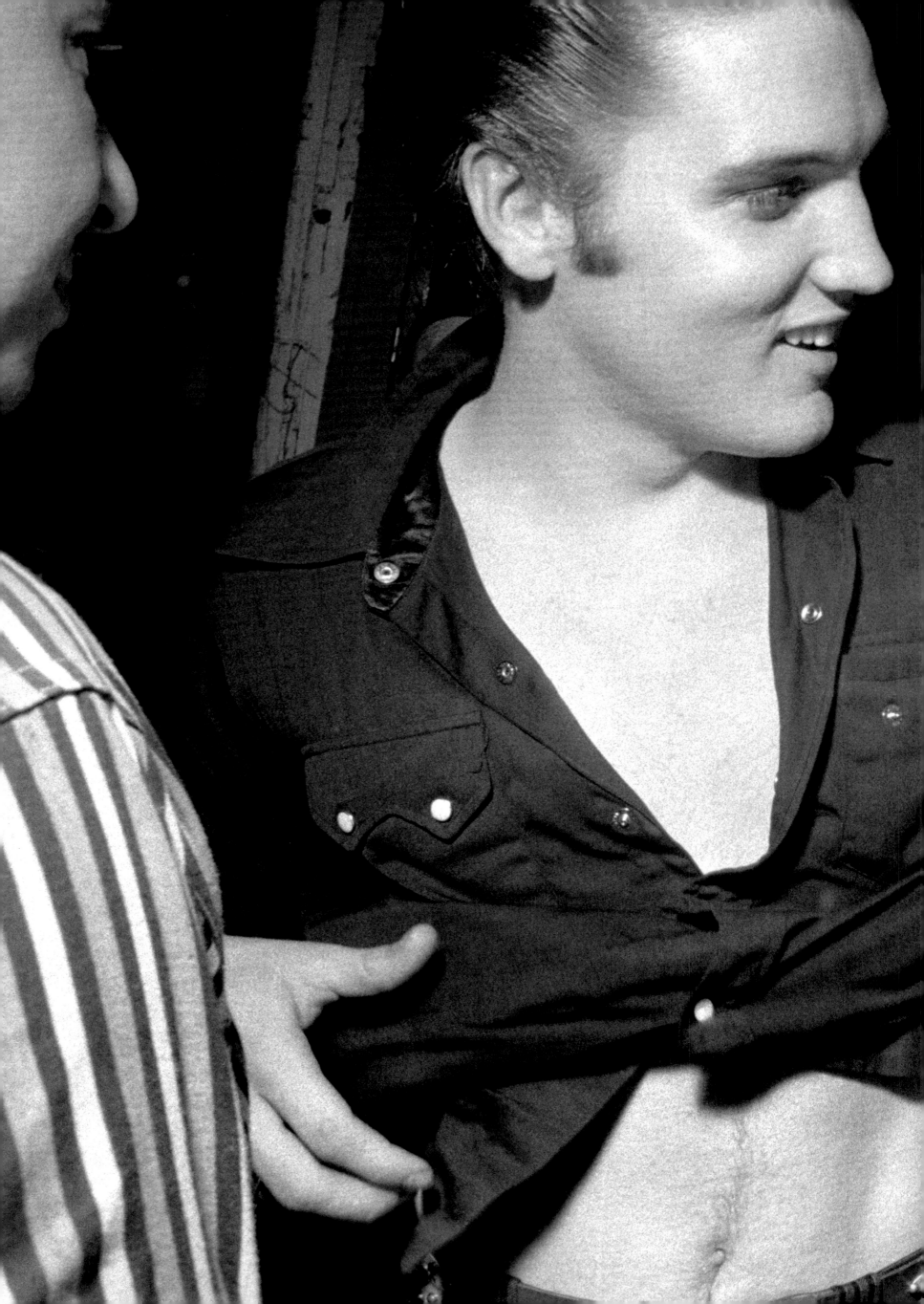

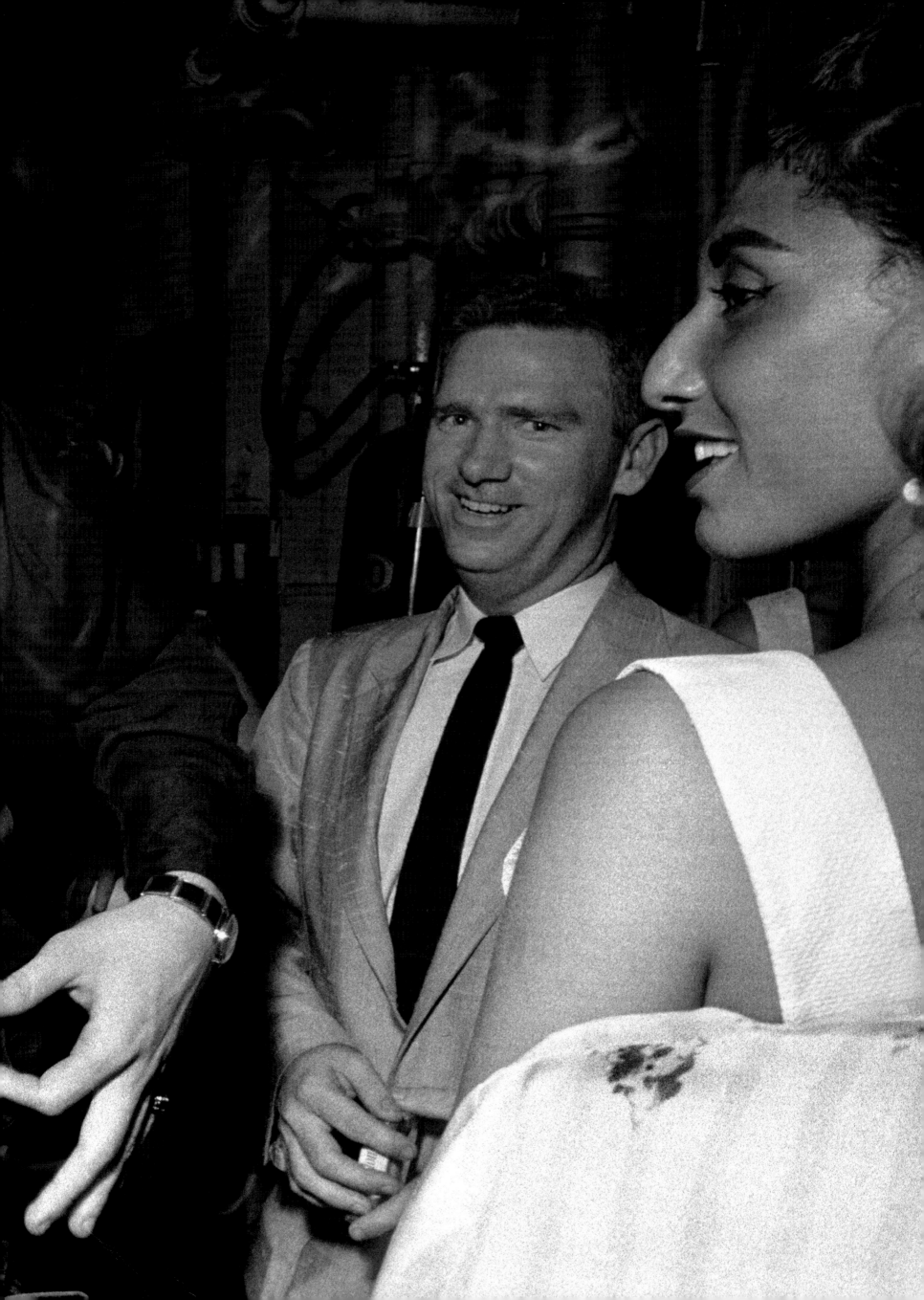

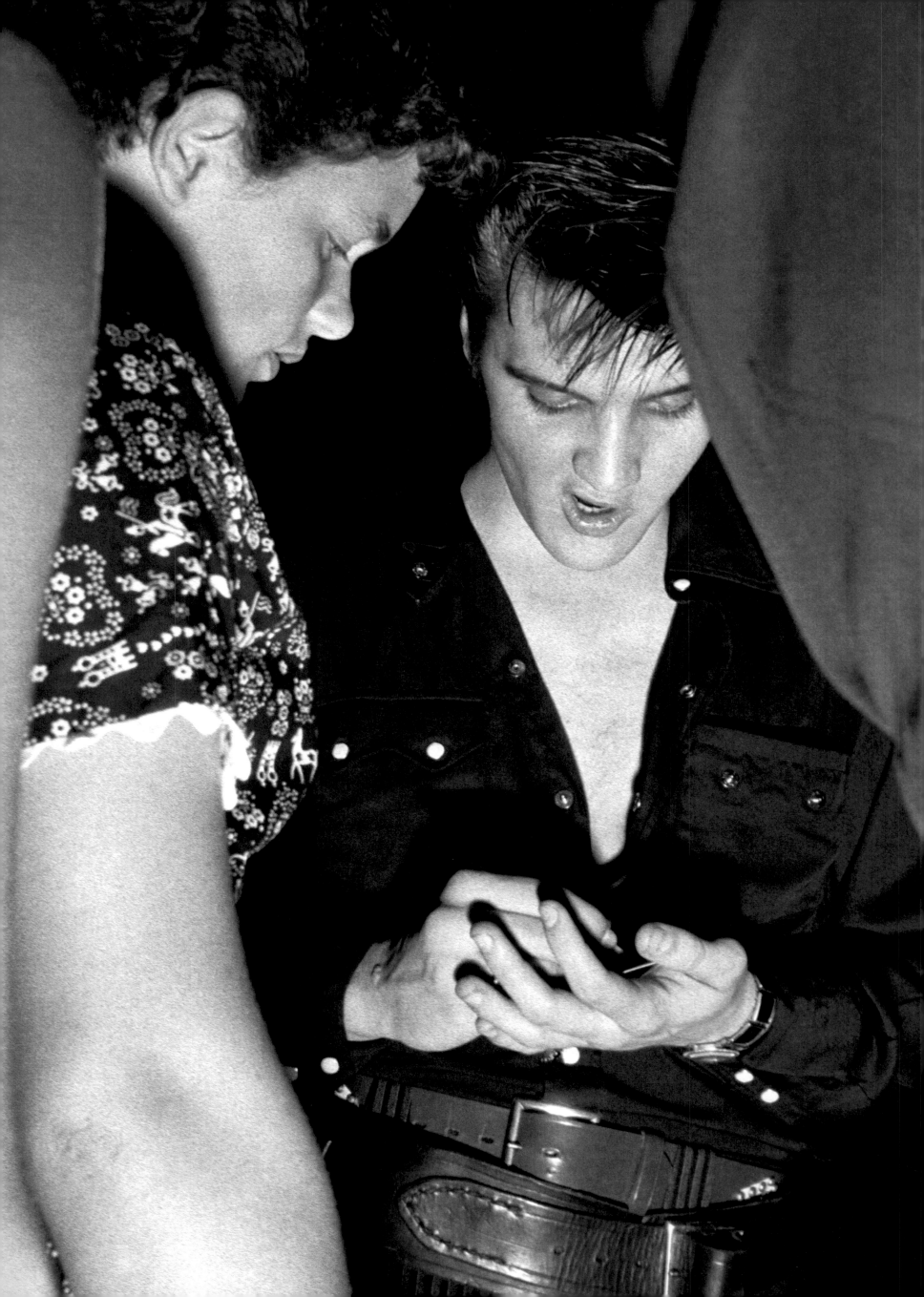

In his dressing room between shows, Presley still couldn't get away from his following. The fans, oblivious to the dressing and undressing members of the band, leaked through police at the doorway to get pictures, autographs or just to look. He signed autographs on pictures, notebooks, papers, legs, arms and foreheads.

Selbst in der Garderobe, zwischen den Auftritten, konnte Presley seiner Anhängerschaft nicht entfliehen. Ohne ein Auge für die anderen Mitglieder der Band, die sich dort an- und auszogen, schlüpften die Fans an der Polizei am Eingang vorbei, um ihre Fotos oder Autogramme zu bekommen oder einfach nur zu gucken. Er signierte Autogrammkarten, Notizbücher, Zettel, Beine, Arme und Stirnen.

Même dans sa loge entre deux apparitions sur scène, Presley ne pouvait échapper à ses admirateurs. Ces derniers, ne semblant pas remarquer les autres musiciens qui s'habillaient ou se déshabillaient, se glissaient entre les agents qui gardaient la porte pour le prendre en photo, obtenir un autographe ou juste le regarder. Il signait des autographes sur des photos, des cahiers, des papiers, des jambes, des bras et des fronts.

—KEN KENNAMER
Lubbock Avalanche Journal, April 11, 1956

PREVIOUS SPREAD While changing out of his clothes after the show, Elvis is easily distracted by a beautiful girl.

OPPOSITE An autograph after the "Range Roundup" performance.

IN PERSON

ELV
THE
MOSQ
THEATE

RICHMOND VIRGINIA JUNE 30TH 1956

BETWEEN THE REHEARSAL AND PERFORMANCE on *The Steve Allen Show*, Elvis took a train from New York to Richmond, Virginia, where he was to play two concerts of *The Elvis Presley Show*. My camera and I tagged along. When we arrived at the Jefferson Hotel, I watched him charm the ladies, from the elevator operator to the waitress to the mystery date who accompanied him, his cousins Junior and Bobby Smith, and myself in a cab to the Mosque Theater. During the first concert, while other acts were onstage, I briefly lost track of the singer, only to find him and his date at the end of a dark passageway. They were so intimately involved that I was invisible to them…but my camera froze the memory in a photograph known today as *The Kiss*. Elvis's electrifying performances that night ended with a flurry of screaming, crying fans and the final announcement: "Ladies and gentlemen, Elvis has left the building." It was the night of June 30, 1956, as Elvis headed back to New York to perform live on the nationally televised *Steve Allen Show*.

ZWISCHEN DER PROBE UND SEINEM AUFTRITT in der *Steve Allen Show* nahm Elvis den Zug von New York nach Richmond, Virginia, um dort zwei Vorstellungen der *Elvis Presley Show* zu geben; mit im Schlepptau: meine Kamera und ich. Bei der Ankunft am Jefferson Hotel beobachtete ich ihn dabei, wie er die Ladys bezirzte, von der Fahrstuhlführerin über die Kellnerin bis zu seiner rätselhaften Begleiterin. Bei der Taxifahrt zum Mosque Theater waren neben Elvis und mir auch seine Cousins Junior und Bobby Smith mit an Bord. Irgendwann im Verlauf des ersten Konzertes, als gerade andere Künstler auf der Bühne waren, verlor ich den Sänger kurzzeitig aus den Augen – nur, um ihn und seine Begleiterin schließlich am Ende eines dunklen Korridors wiederzuentdecken. Das Paar war so sehr miteinander beschäftigt, dass ich für die beiden unsichtbar war … doch meine Kamera verewigte die Erinnerung in einer Elvis-Fotografie, die heute als *Der Kuss* bekannt ist. Elvis' elektrisierender Auftritt an dem Abend endete in einem Tumult aus kreischenden Fans und einander in die Arme fallenden Mädchen, denen Tränen über die Wangen rannen, bis schließlich die Durchsage erklang: „Meine Damen und Herren, Elvis hat das Gebäude verlassen." An diesem Abend des 30. Juni 1956 war er auf dem Weg zurück nach New York, um in der landesweit ausgestrahlten *Steve Allen Show* aufzutreten.

APRÈS LA RÉPÉTITION ET AVANT L'ENREGISTREMENT du *Steve Allen Show* à New York, Elvis prit le train pour Richmond, en Virginie, où il devait donner deux concerts pour le *Elvis Presley Show*. Mon appareil photo et moi étions du voyage. En arrivant à l'hôtel Jefferson, je le vis faire son numéro de charme auprès des dames, de la liftière à la serveuse en passant par une mystérieuse blonde que je retrouvai plus tard dans le taxi qui nous emmena, Elvis, ses cousins Junior et Bobby Smith, et moi-même, au Mosque Theater. Au cours du premier concert, alors que d'autres artistes occupaient la scène, je l'ai perdu de vue un moment. Je l'ai retrouvé dans un escalier de service en pleine conversation intime avec la belle inconnue. Ils étaient trop occupés à se peloter pour remarquer ma présence et mon objectif a immortalisé ce qu'on appelle aujourd'hui *The Kiss*. La prestation survoltée d'Elvis s'acheva dans un vacarme tonitruant de cris et de larmes d'adolescentes. Le concert prit fin quand une voix annonça dans les haut-parleurs : « Mesdames et messieurs, Elvis a quitté les lieux. » C'était la nuit du 30 juin 1956. Elvis reprit aussitôt la route de New York car il devait se produire le lendemain soir dans l'émission télévisée *The Steve Allen Show*.

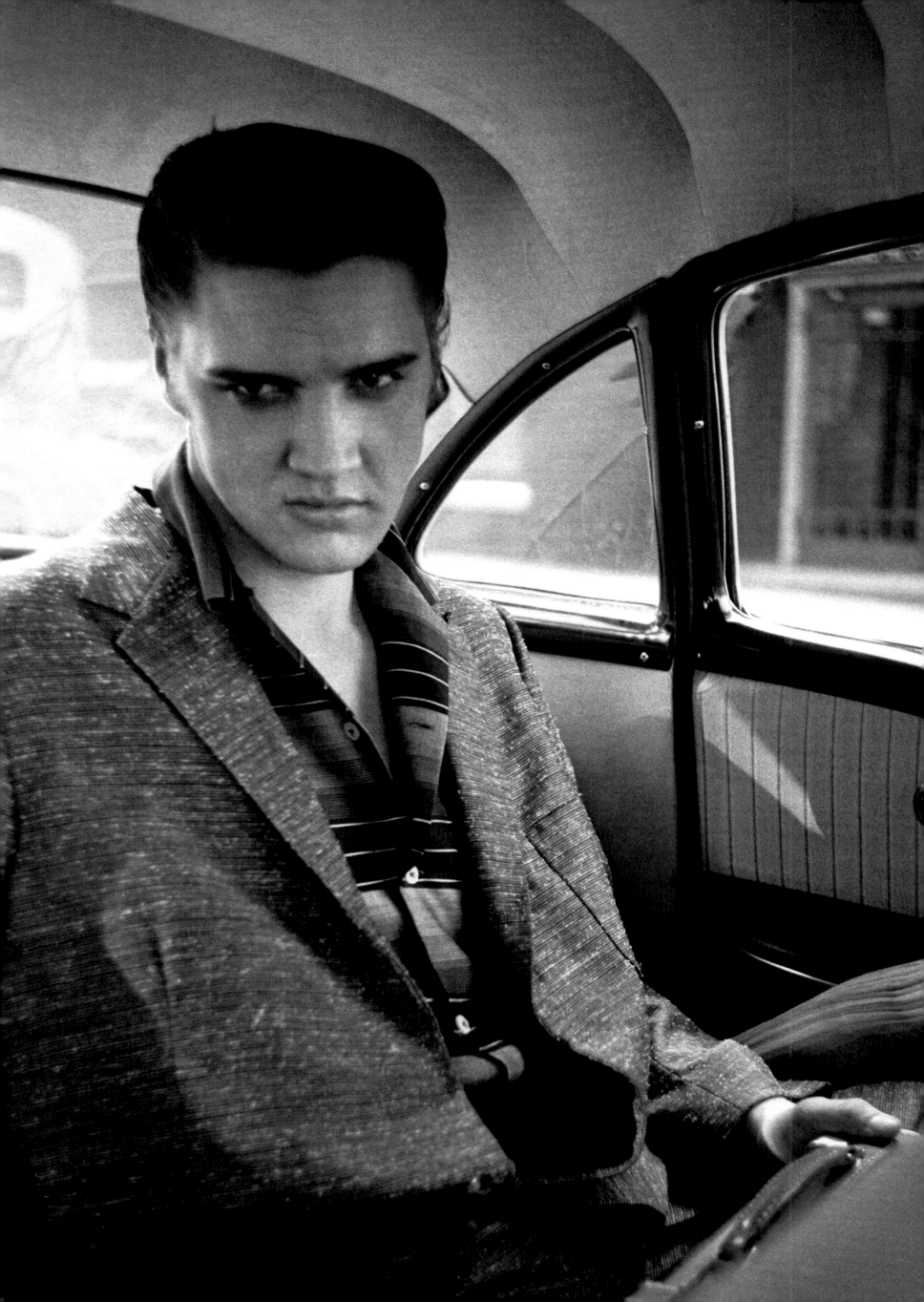

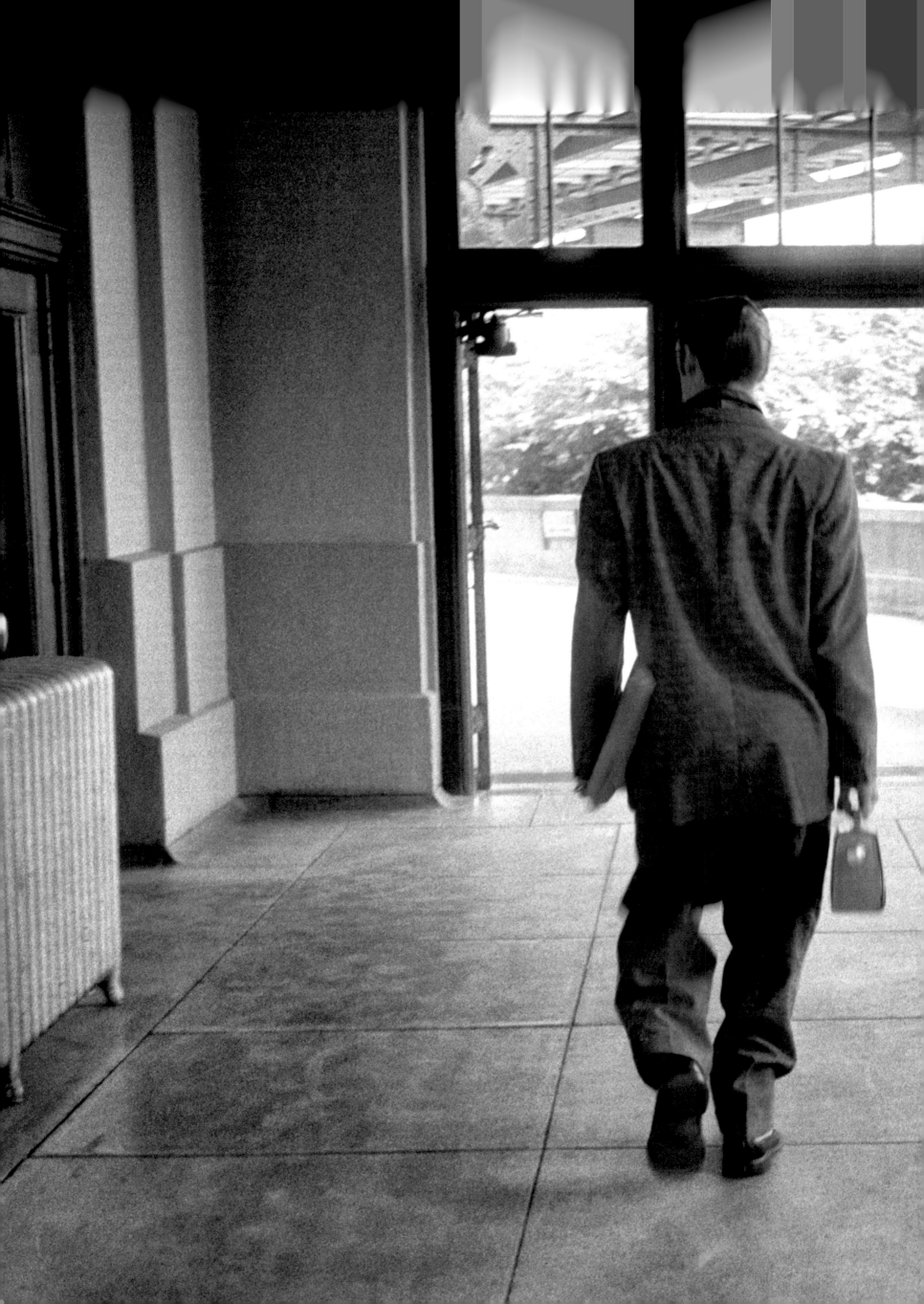

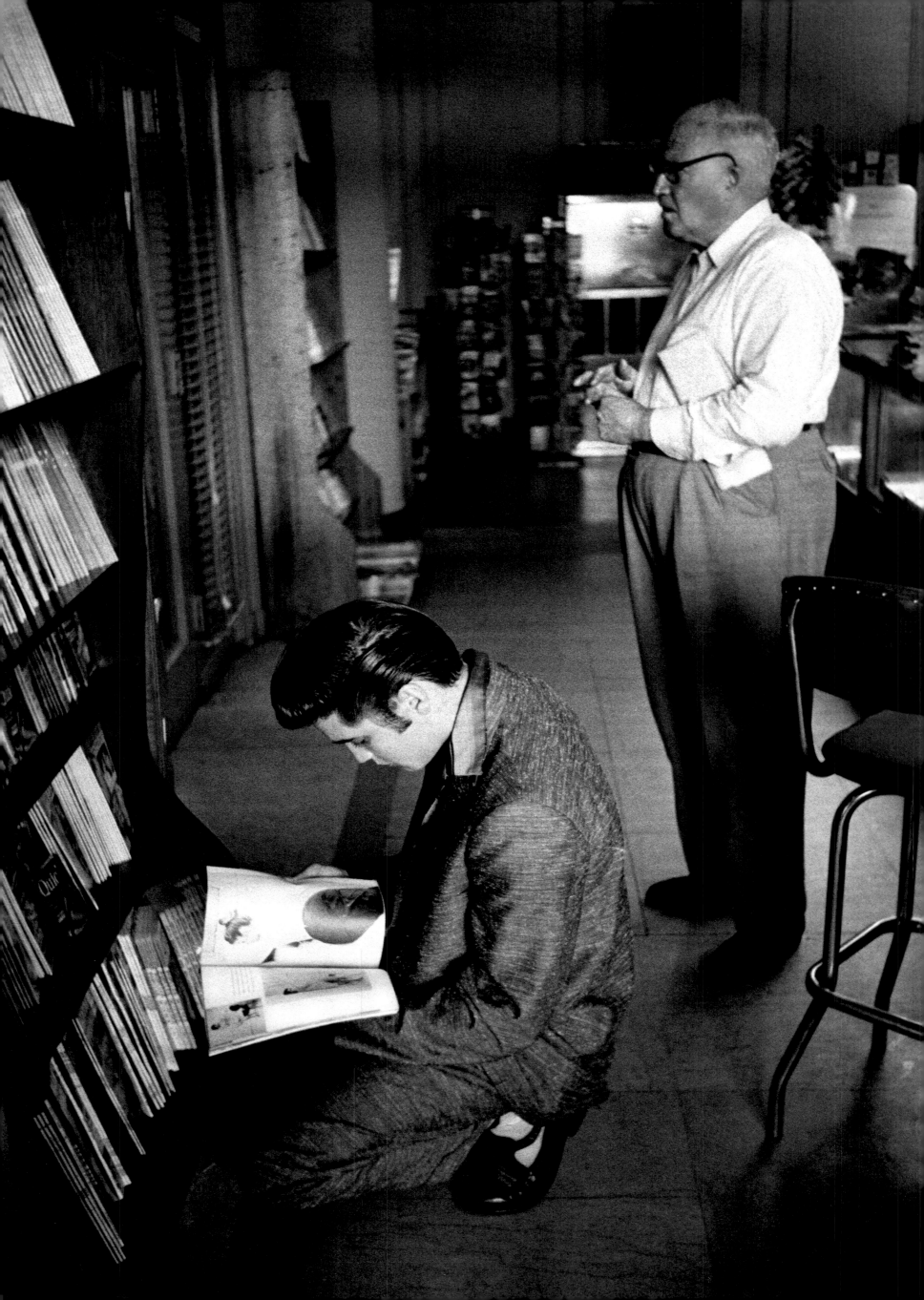

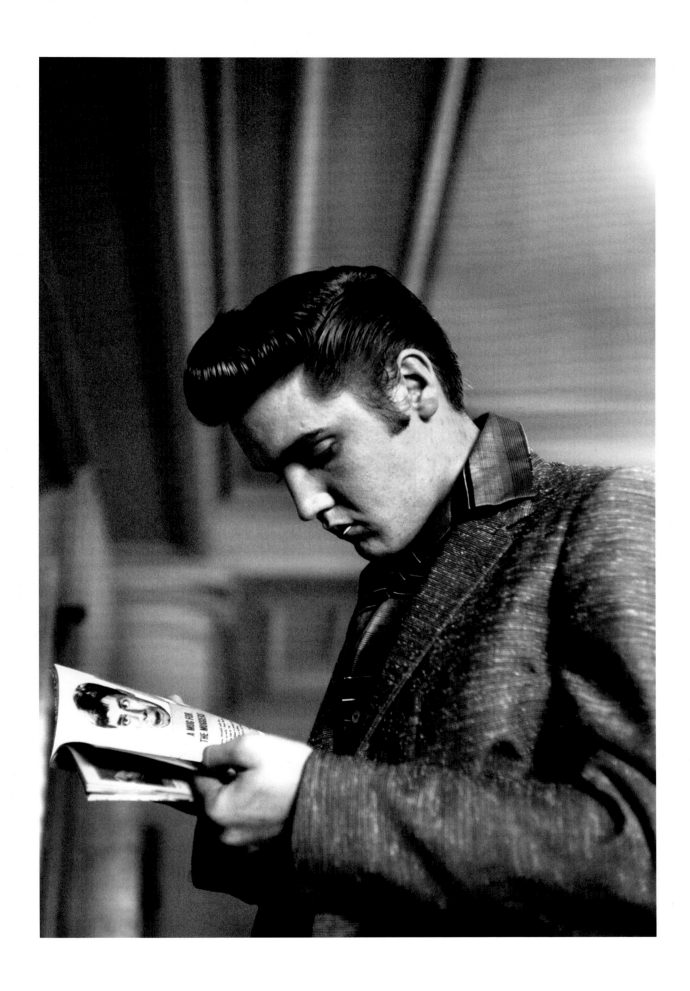

147 The Elvis stare, captured in the backseat of a taxi, Richmond, Virginia.

PREVIOUS SPREAD "Elvis the Pelvis" exits the Richmond train station. That night there will be two performances of the Elvis Presley show at the Mosque Theater.

OPPOSITE & ABOVE Elvis peruses the Jefferson Hotel coffee shop's magazine rack upon arrival.

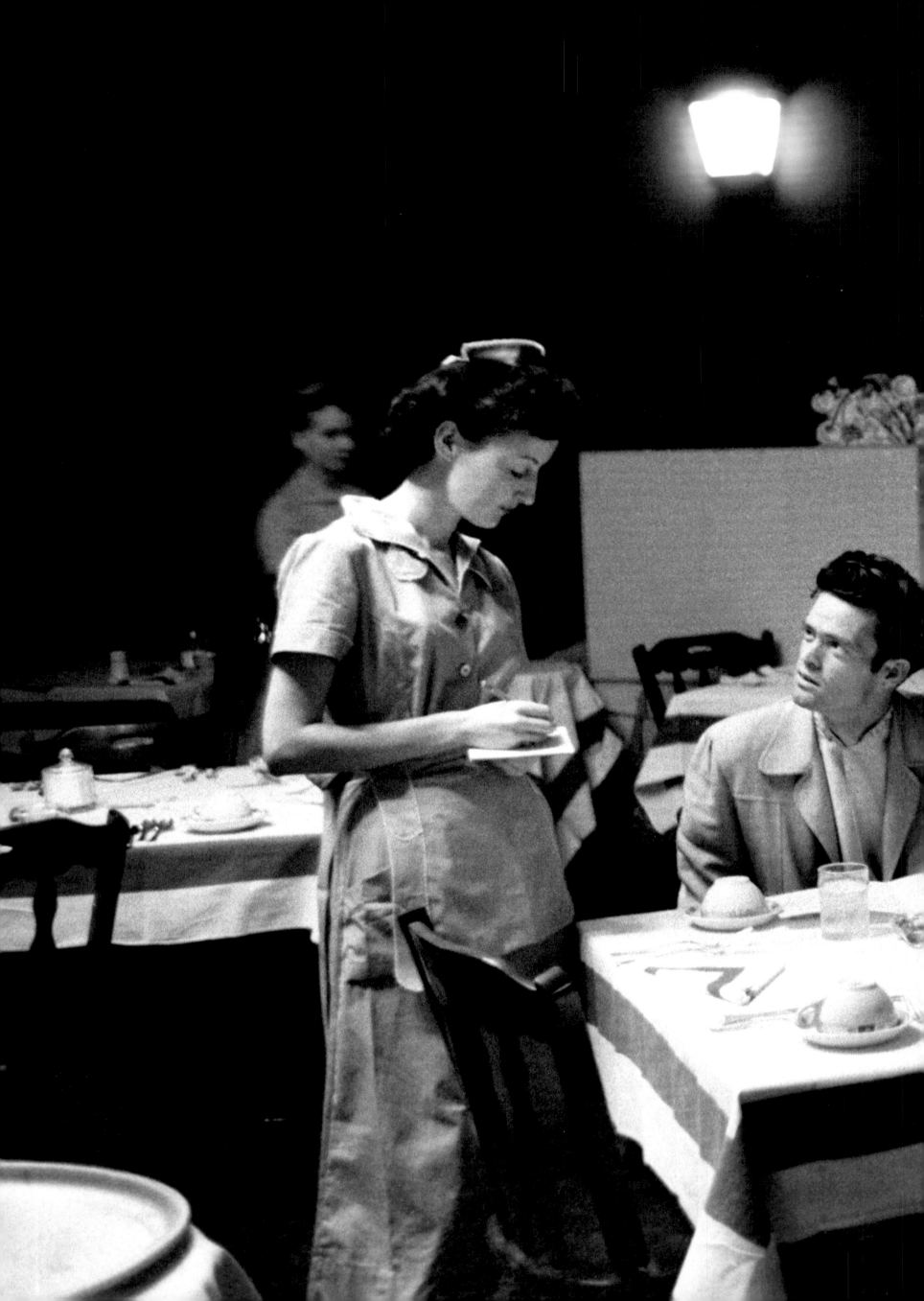

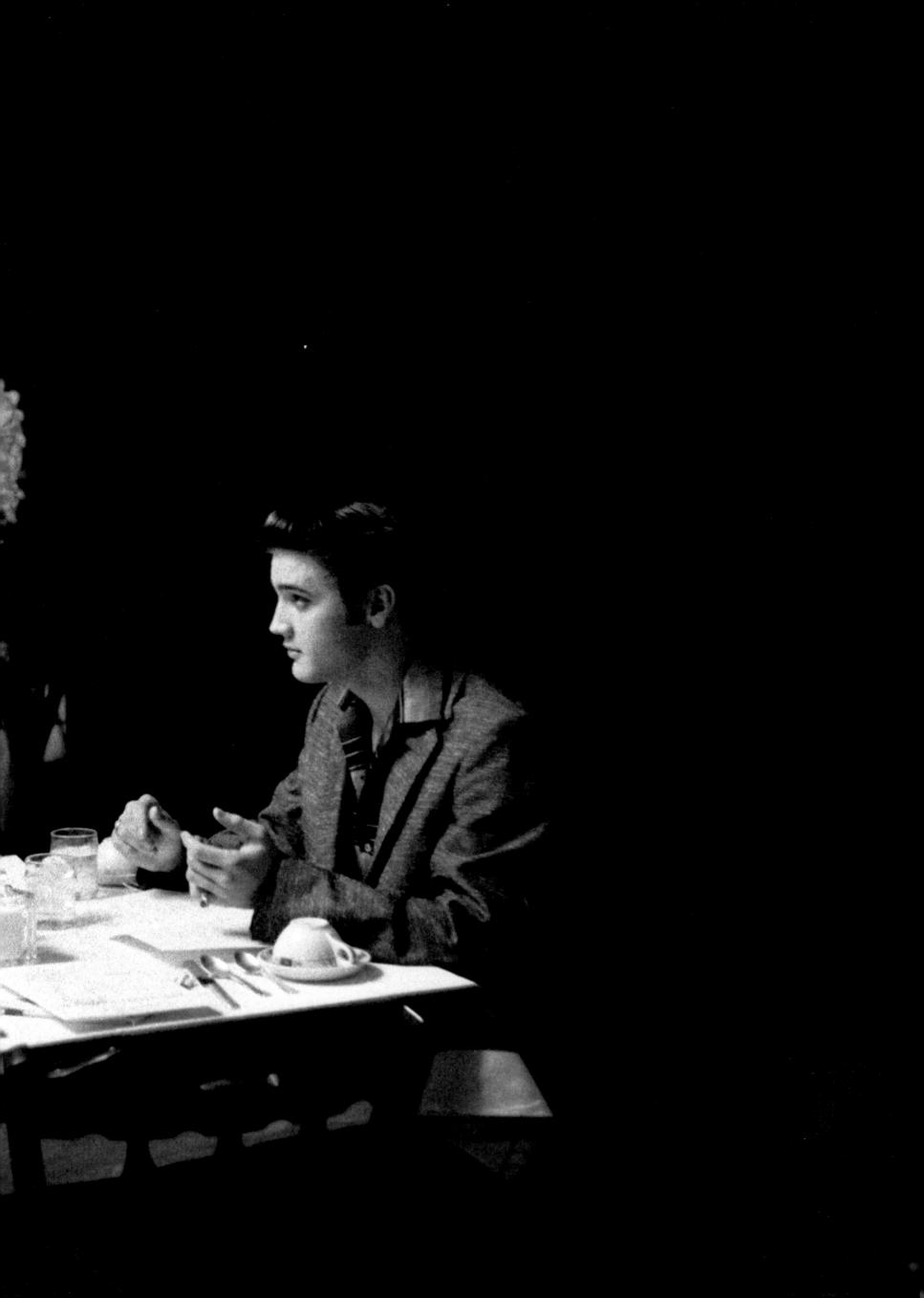

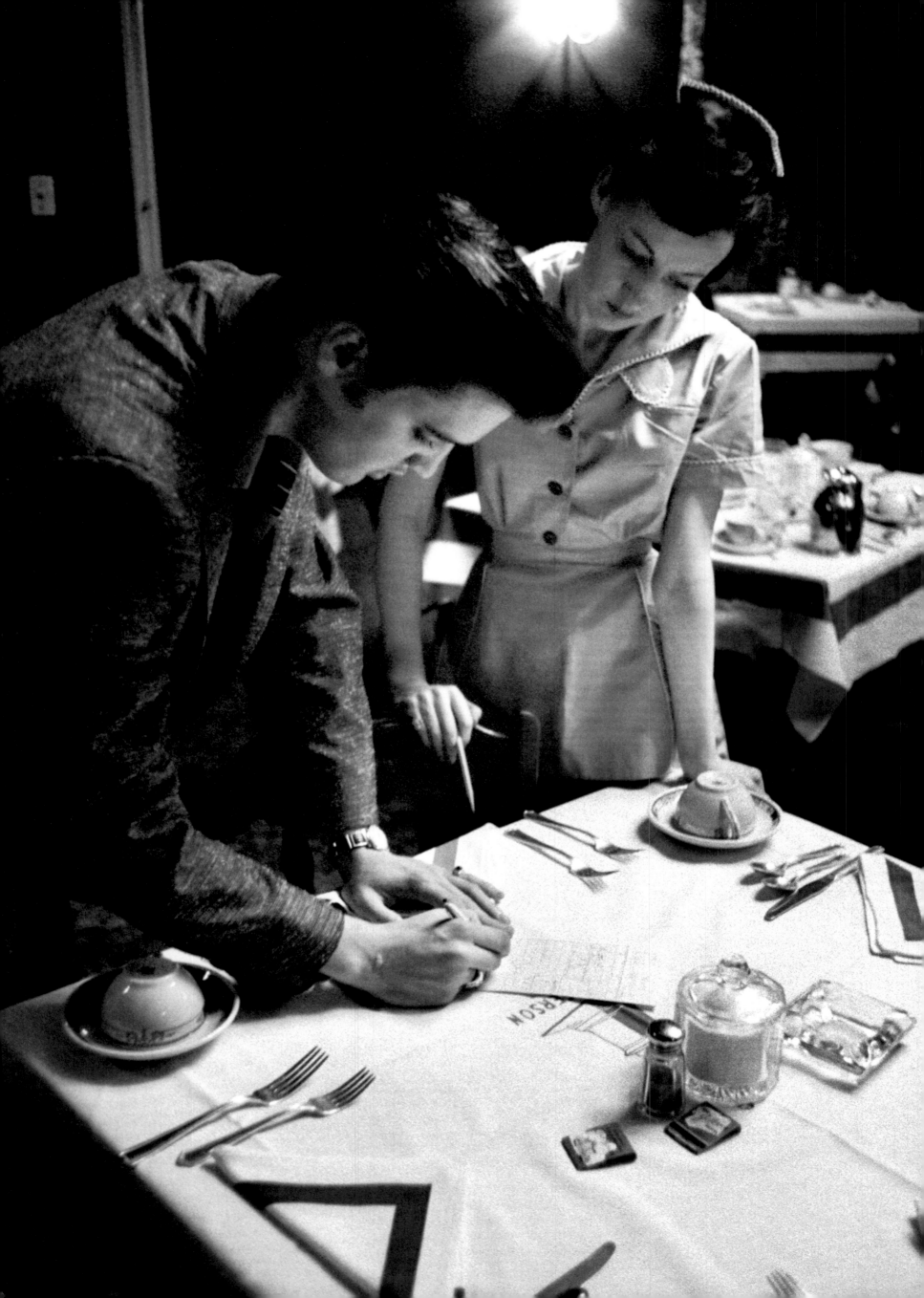

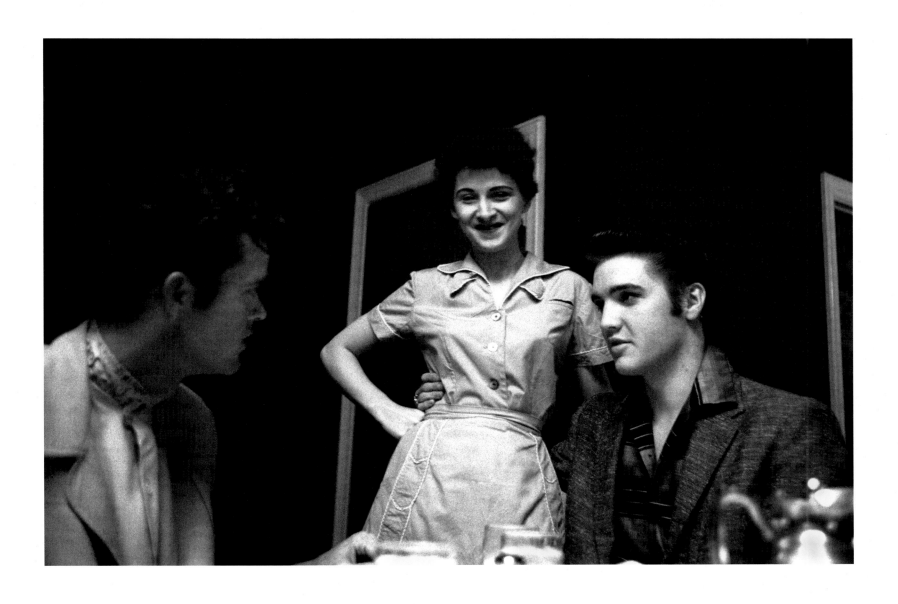

PREVIOUS SPREAD "Gentlemen, what would you like?" Junior Smith places his order while his cousin prepares to turn on the charm with a waitress at the hotel restaurant.

OPPOSITE Elvis charges the bill to his room at the Jefferson.

ABOVE Within 15 minutes of ordering his breakfast, Elvis has his arm around the waist of the delighted waitress.

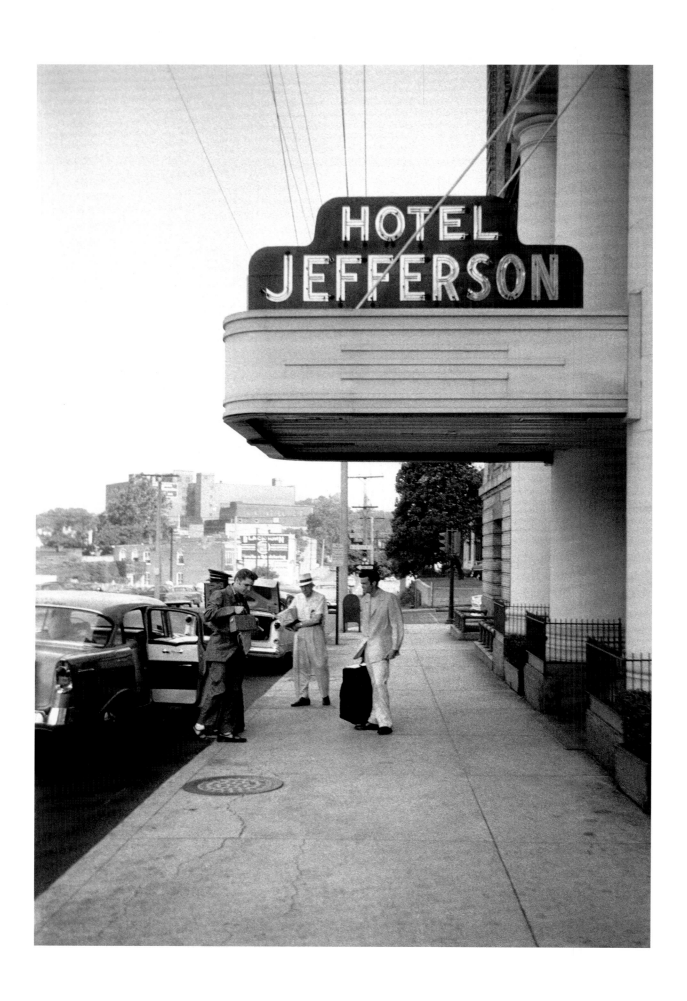

ABOVE & OPPOSITE Check-in at the Jefferson Hotel with
Junior Smith. Right, another of Elvis's cousins,
Gene Smith, carries the green jacket the singer will
wear for his second performance that night. His
date, Barbara Gray (formerly Bobbi Owens), has also
arrived from Charleston, South Carolina.

FOLLOWING SPREAD Elvis gets close to his date in the back
of a Richmond cab.

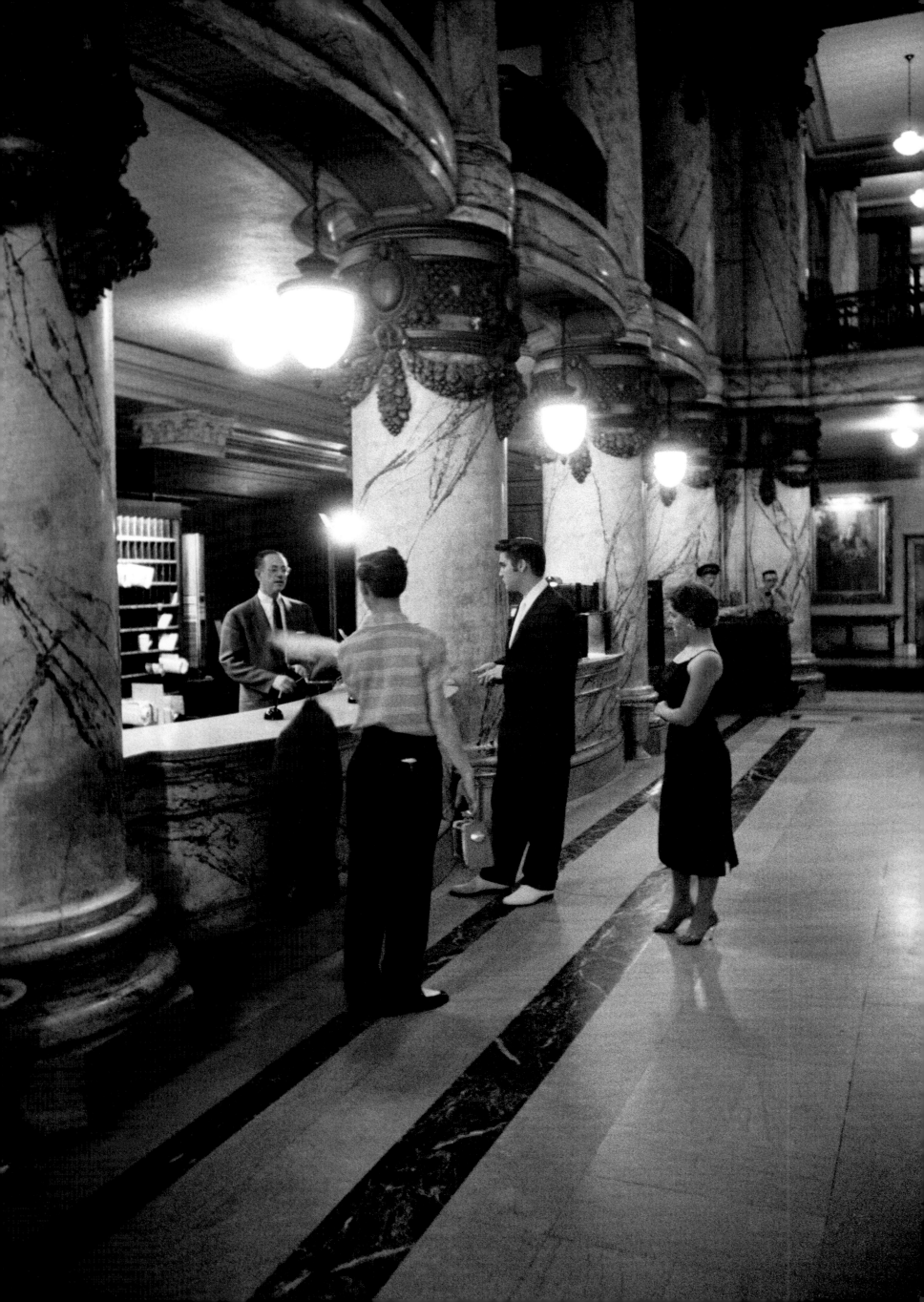

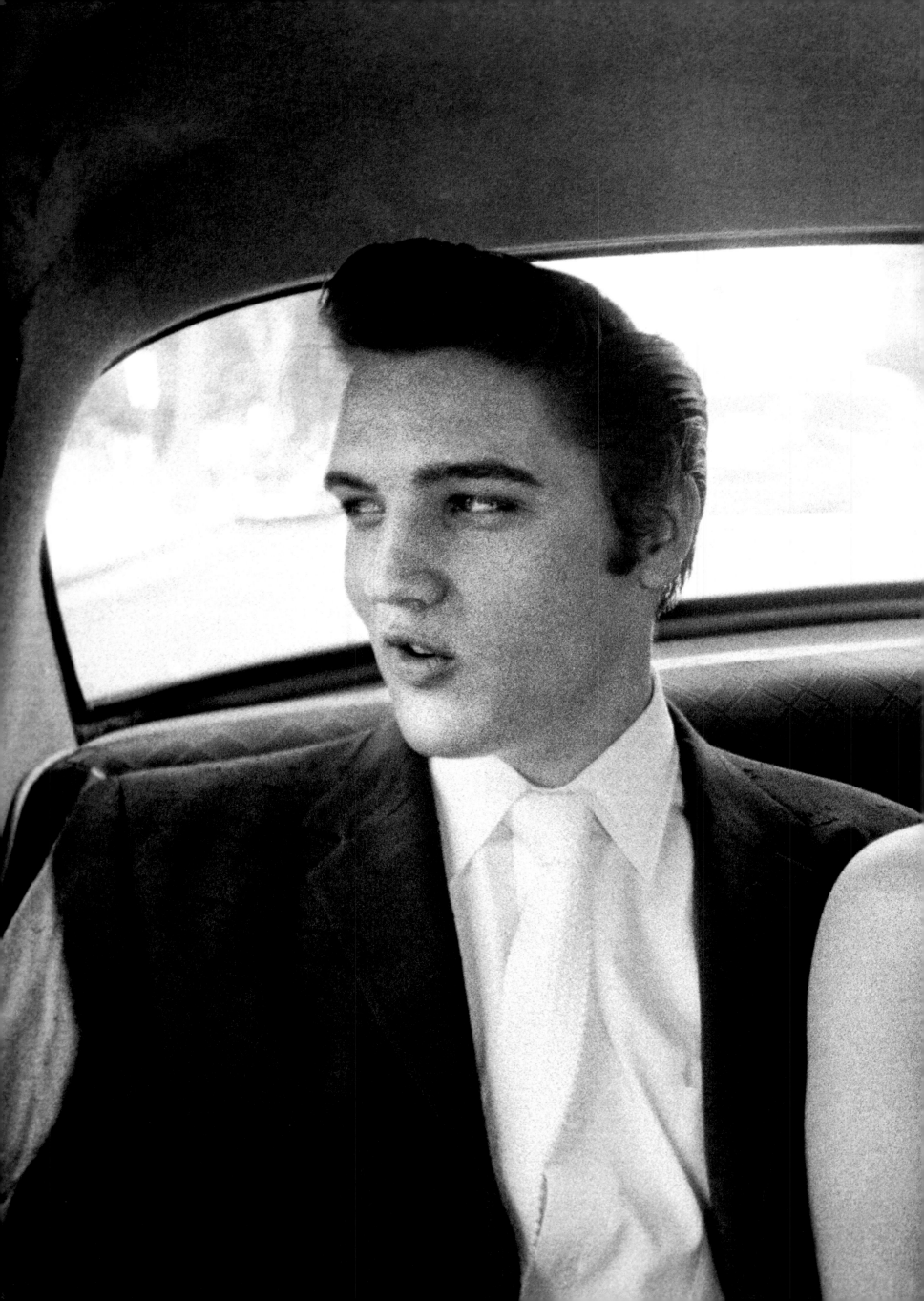

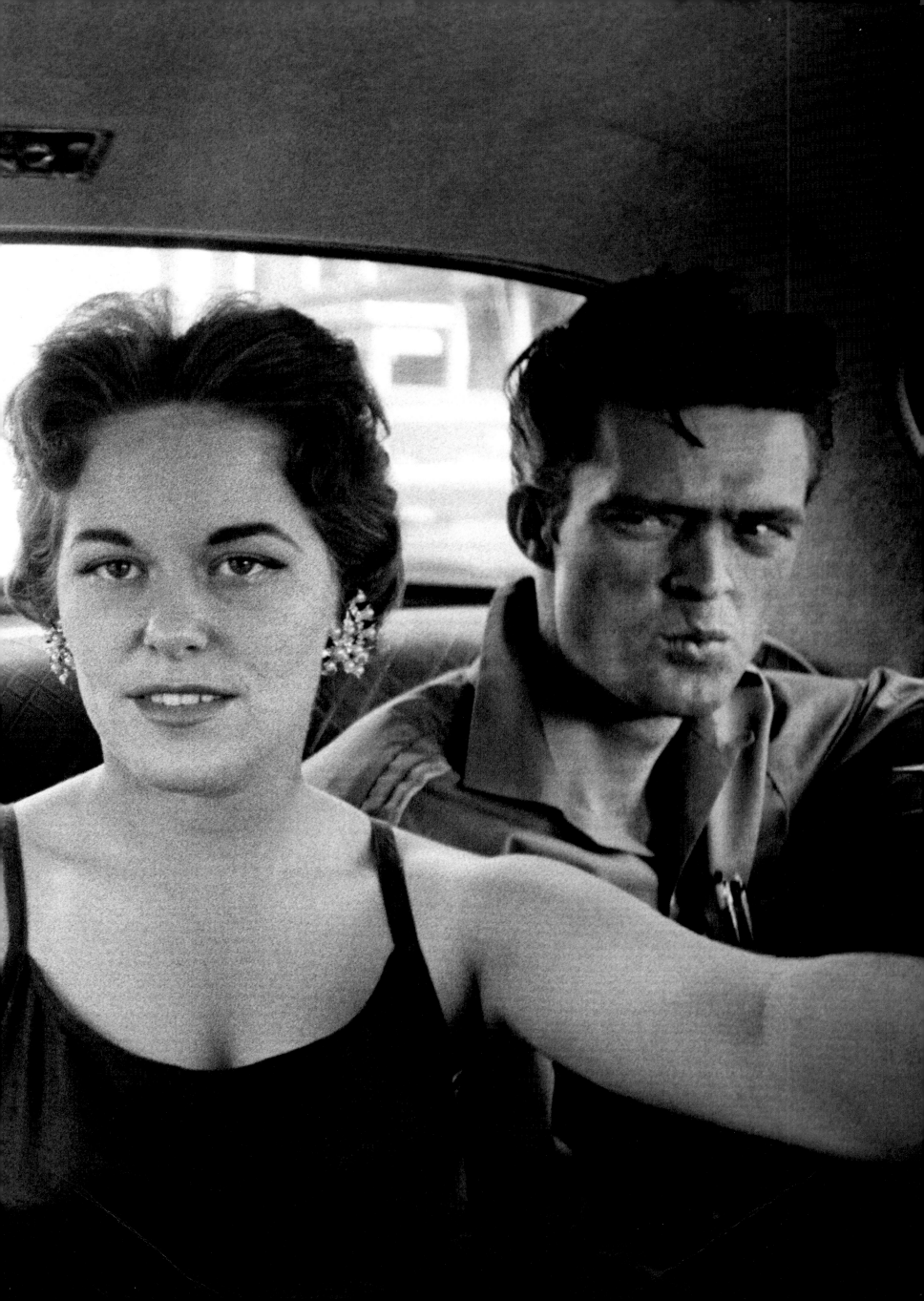

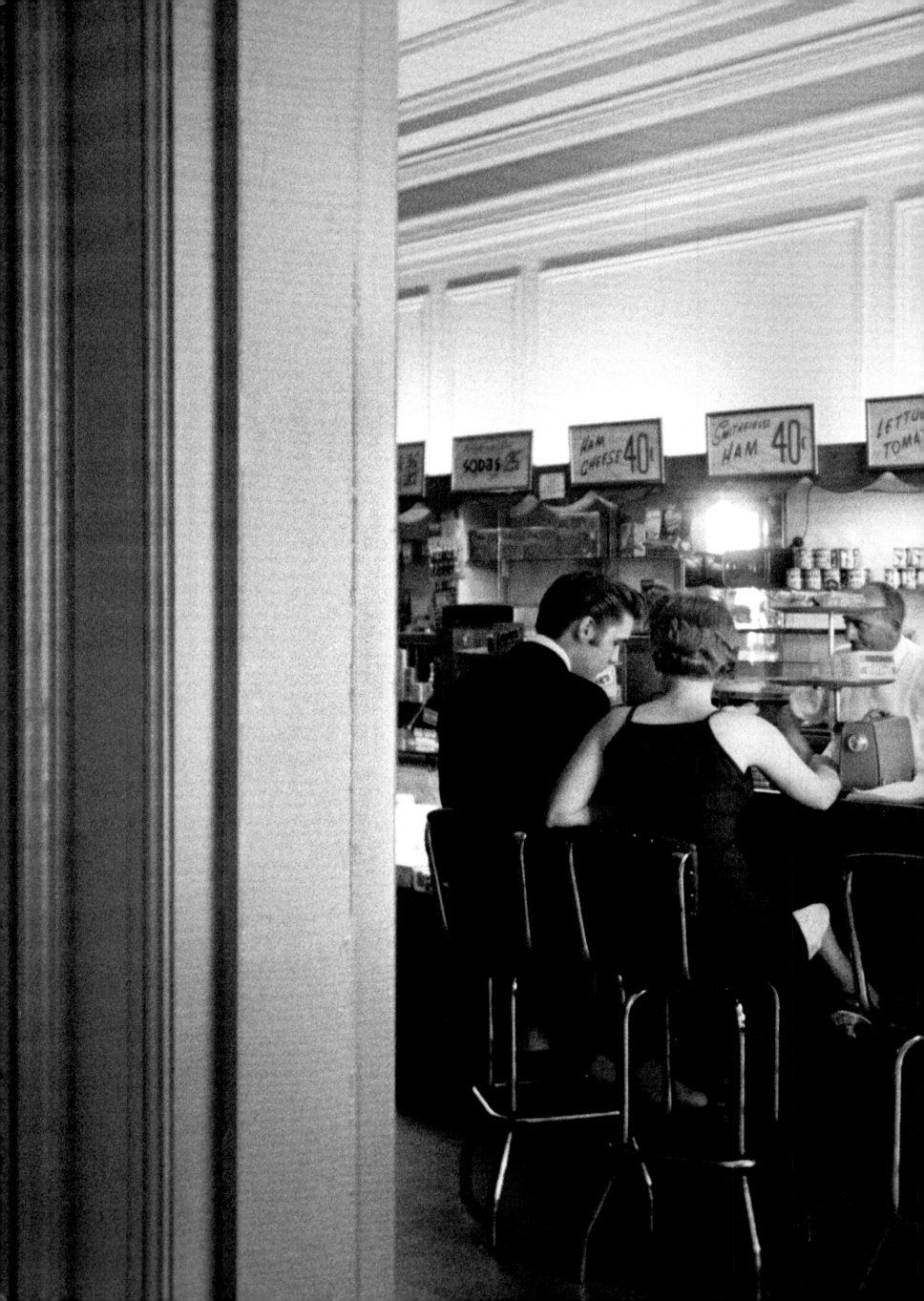

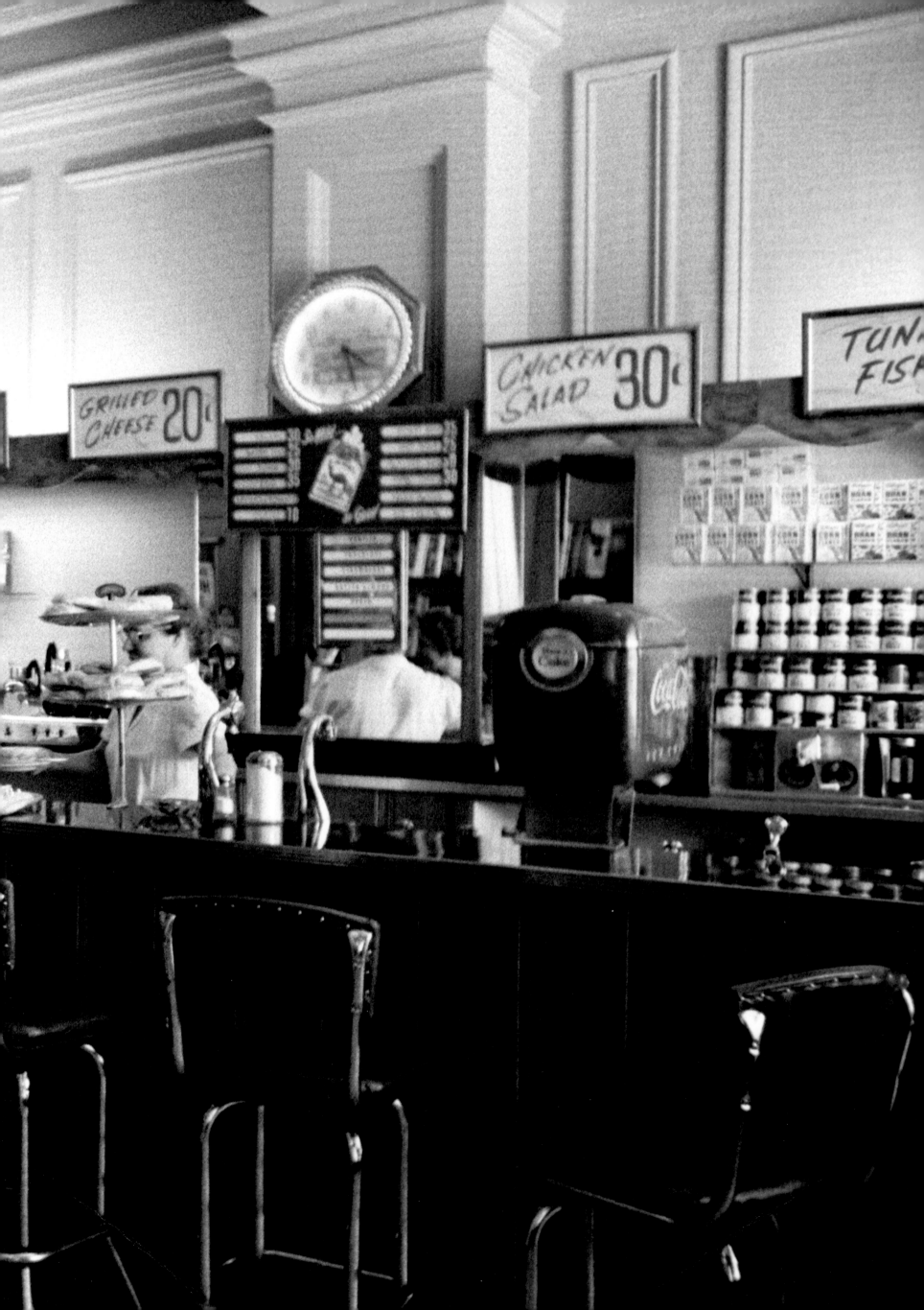

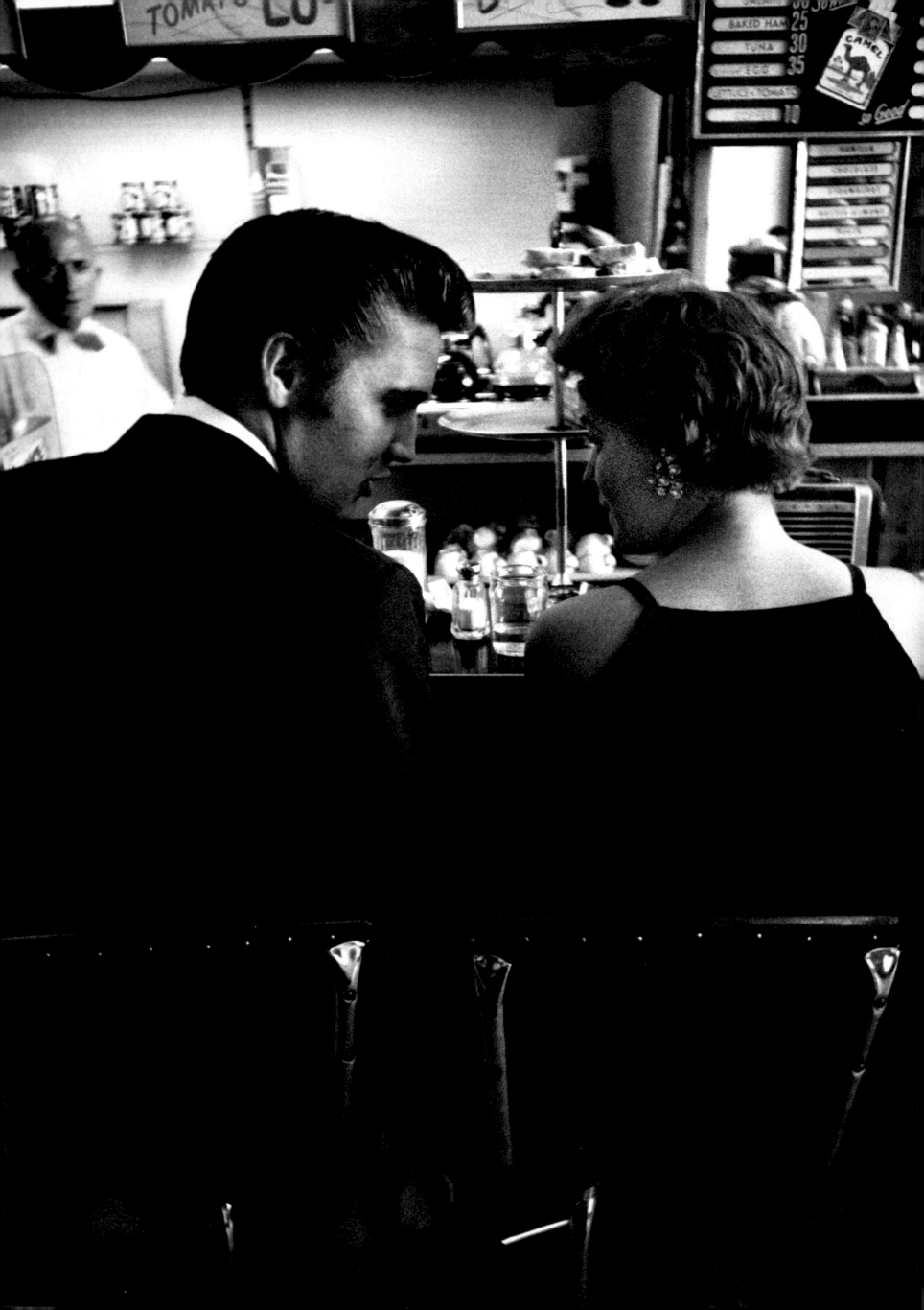

PREVIOUS SPREAD *Grilled Cheese 20 Cents*, Richmond, Virginia, June 30, 1956.

OPPOSITE Flirting with Barbara Gray at the Jefferson Hotel coffee shop.

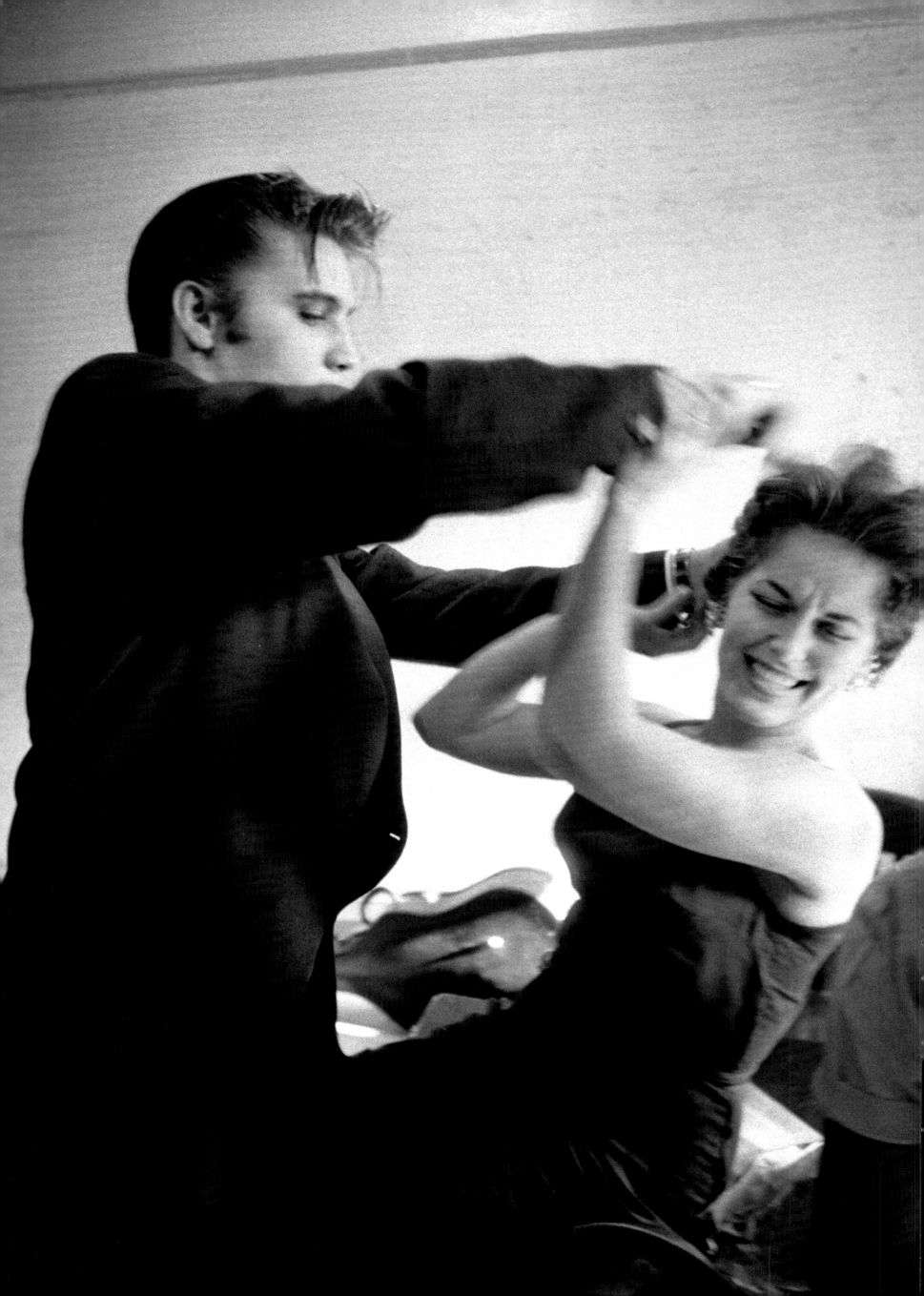

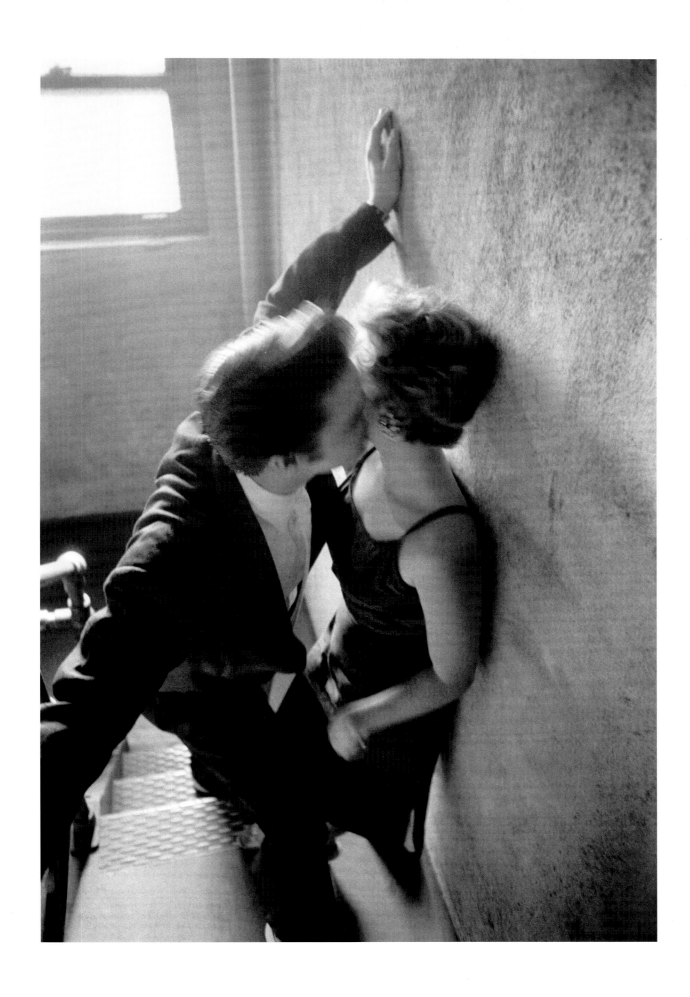

OPPOSITE At the Mosque Theater, where shows are scheduled that evening for 5 P.M. and 8 P.M. Elvis hated hairspray and decided to muss up Barbara's hair to prove it, much to her chagrin.

ABOVE The photographer finds his subject in the stairwell, making his move.

OPPOSITE *Hold Me Tight*, the Mosque Theater, June 30, 1956. Elvis performs with Barbara Gray while another act performs onstage. In order to capture the closeness between the couple, Wertheimer had to get close.

FOLLOWING SPREAD *The Kiss*, the Mosque Theater, June 30, 1956. Though perhaps Wertheimer's most iconic photograph, the identity of the woman remained unknown until she came forward in 2011, 55 years after the photo was taken.

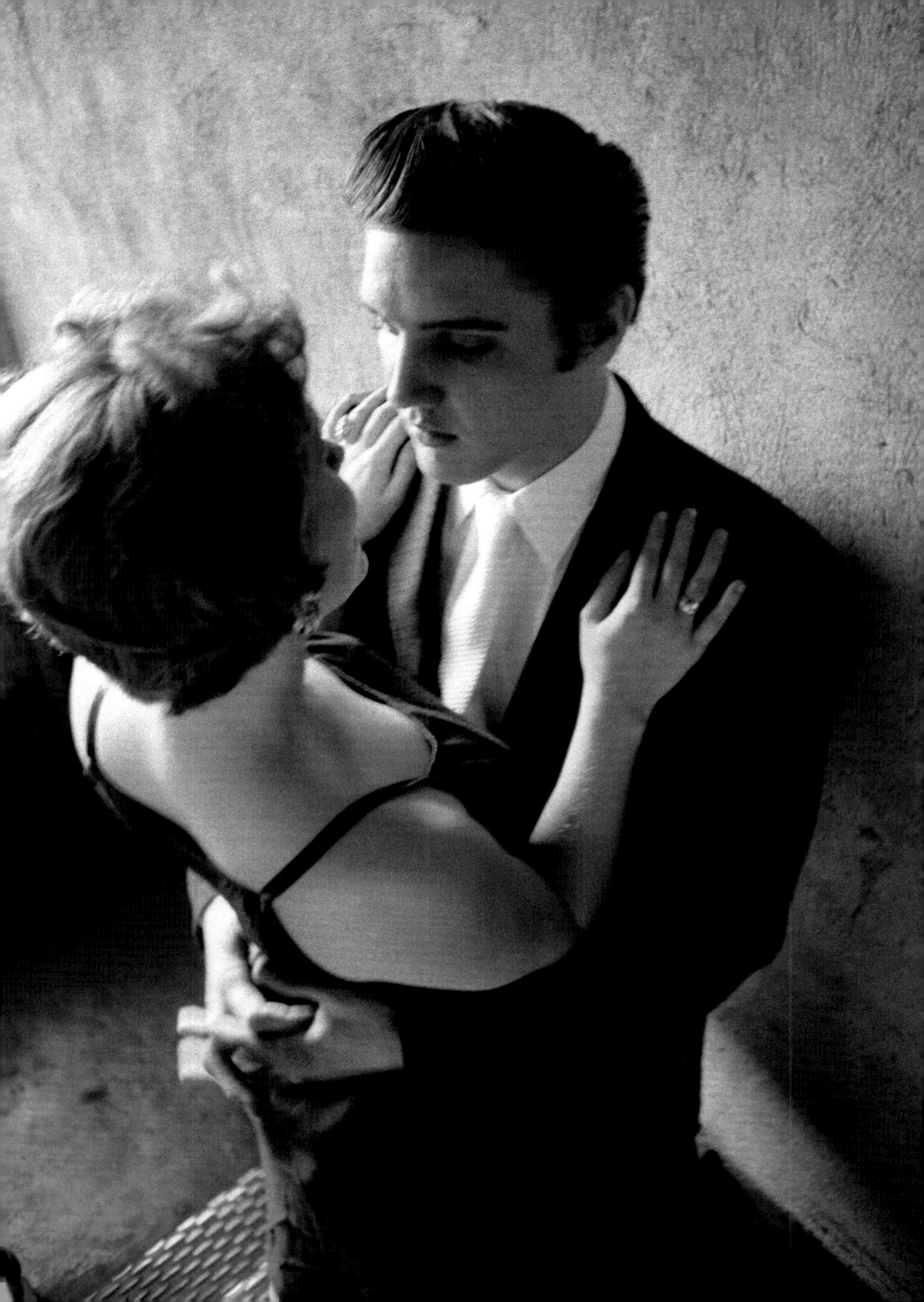

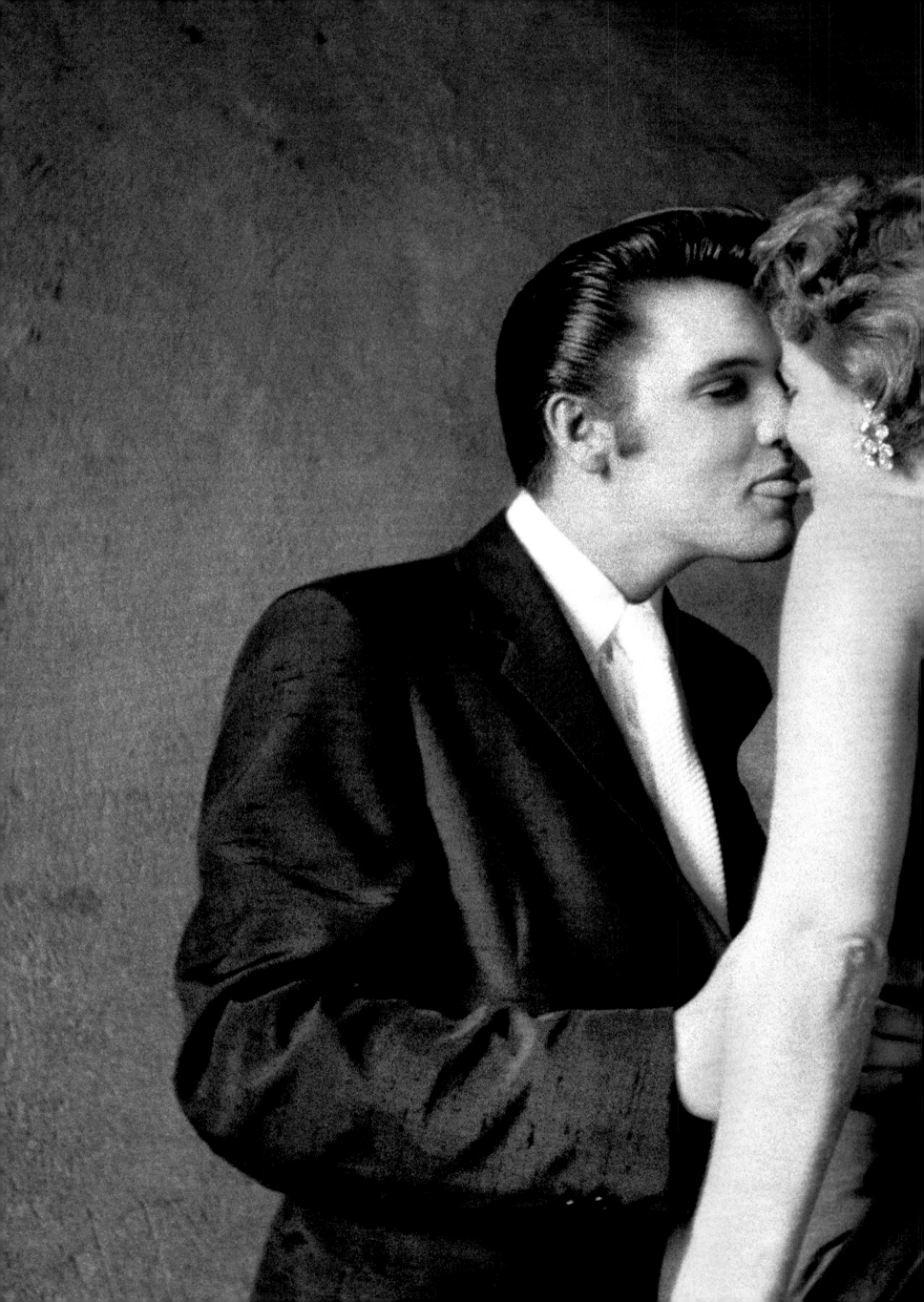

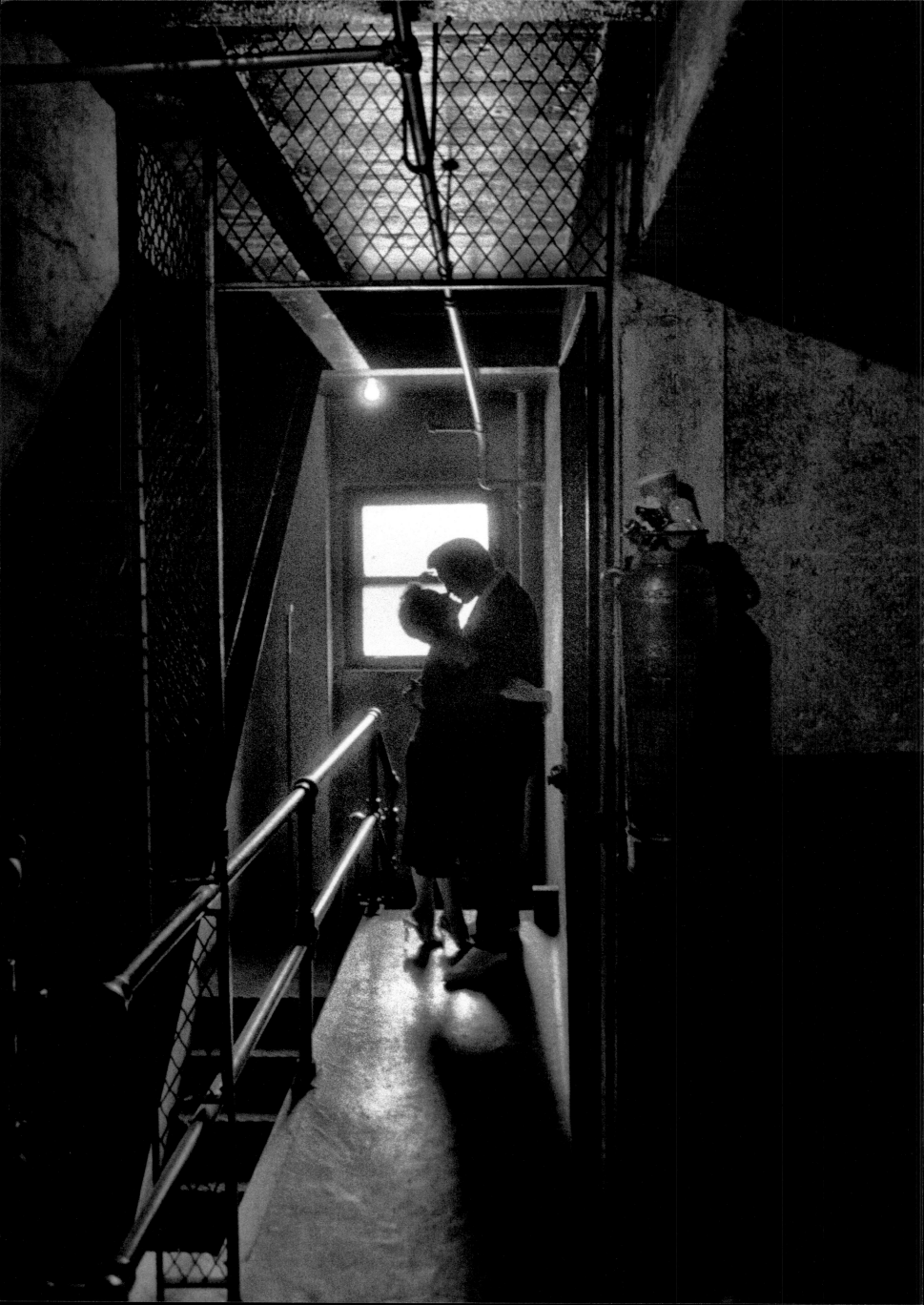

Maybe we had sparks…but I didn't know who he was. He was very silly. We were running around chasing each other and just being young.

Schon möglich, dass es zwischen uns geknistert hat … aber ich wusste nicht, wer er war. Er war sehr albern. Wir rannten herum und jagten einander nach und waren einfach nur jung.

Peut-être y a-t-il eu de la magie entre nous… je ne savais même pas qui il était. Il faisait le pitre. On se pourchassait dans les couloirs. On était simplement jeunes.

—BARBARA GRAY
"The Kiss Lady" on *The Today Show*,
August 8, 2011

OPPOSITE A last embrace before Elvis prepares to go onstage.

FOLLOWING SPREAD Junior Smith gives encouragement while Elvis combs his hair in the men's room of the Mosque.

171

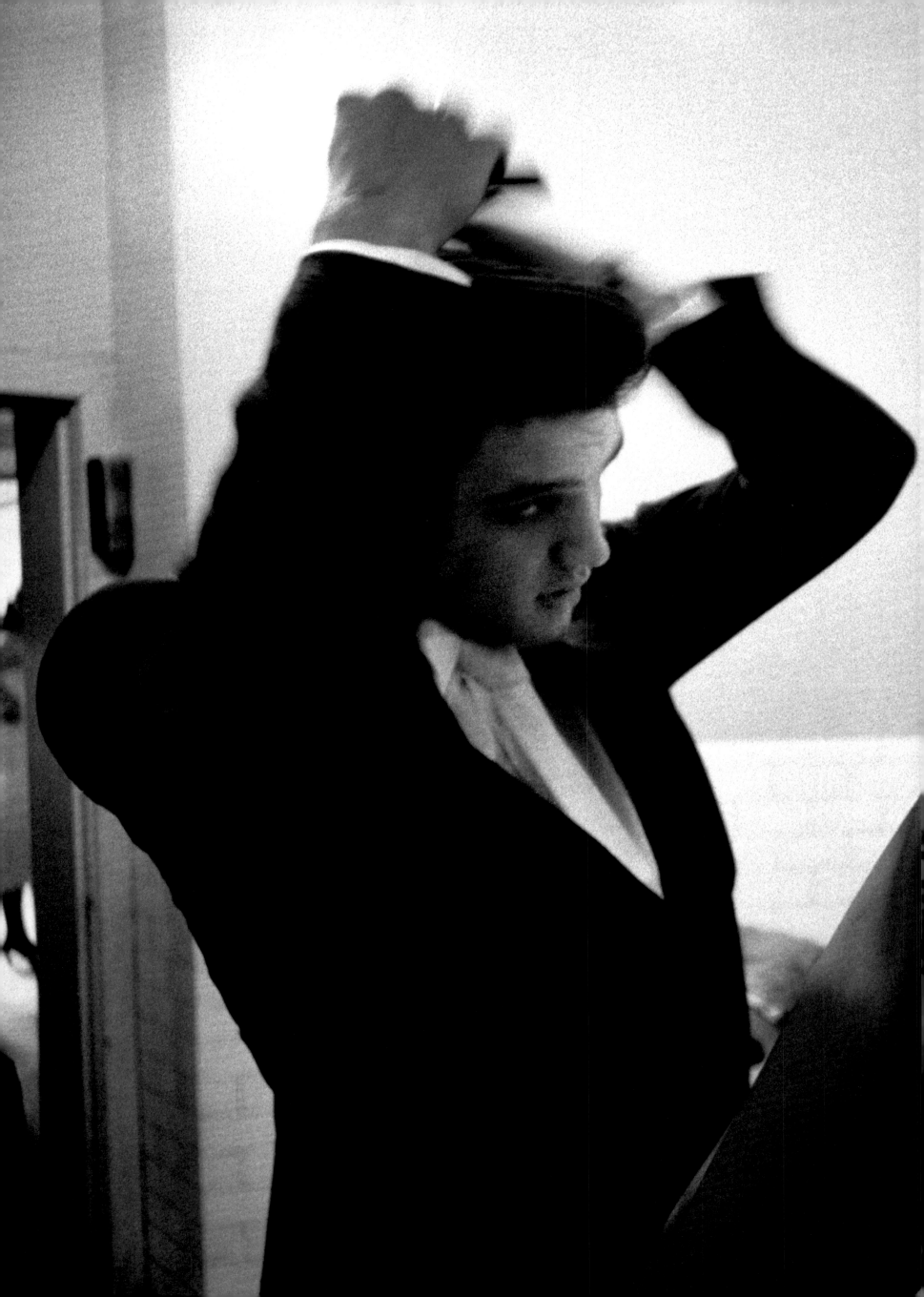

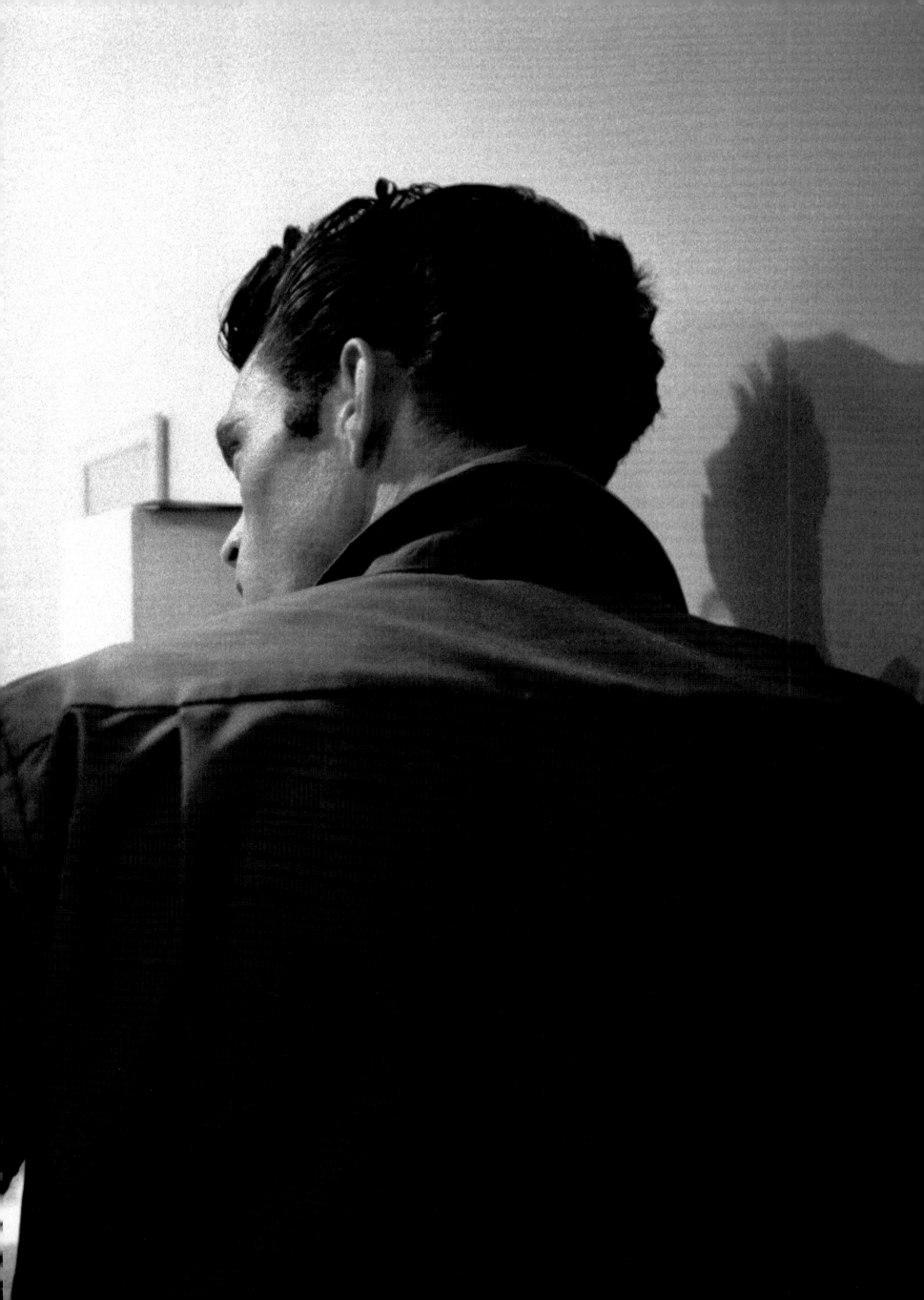

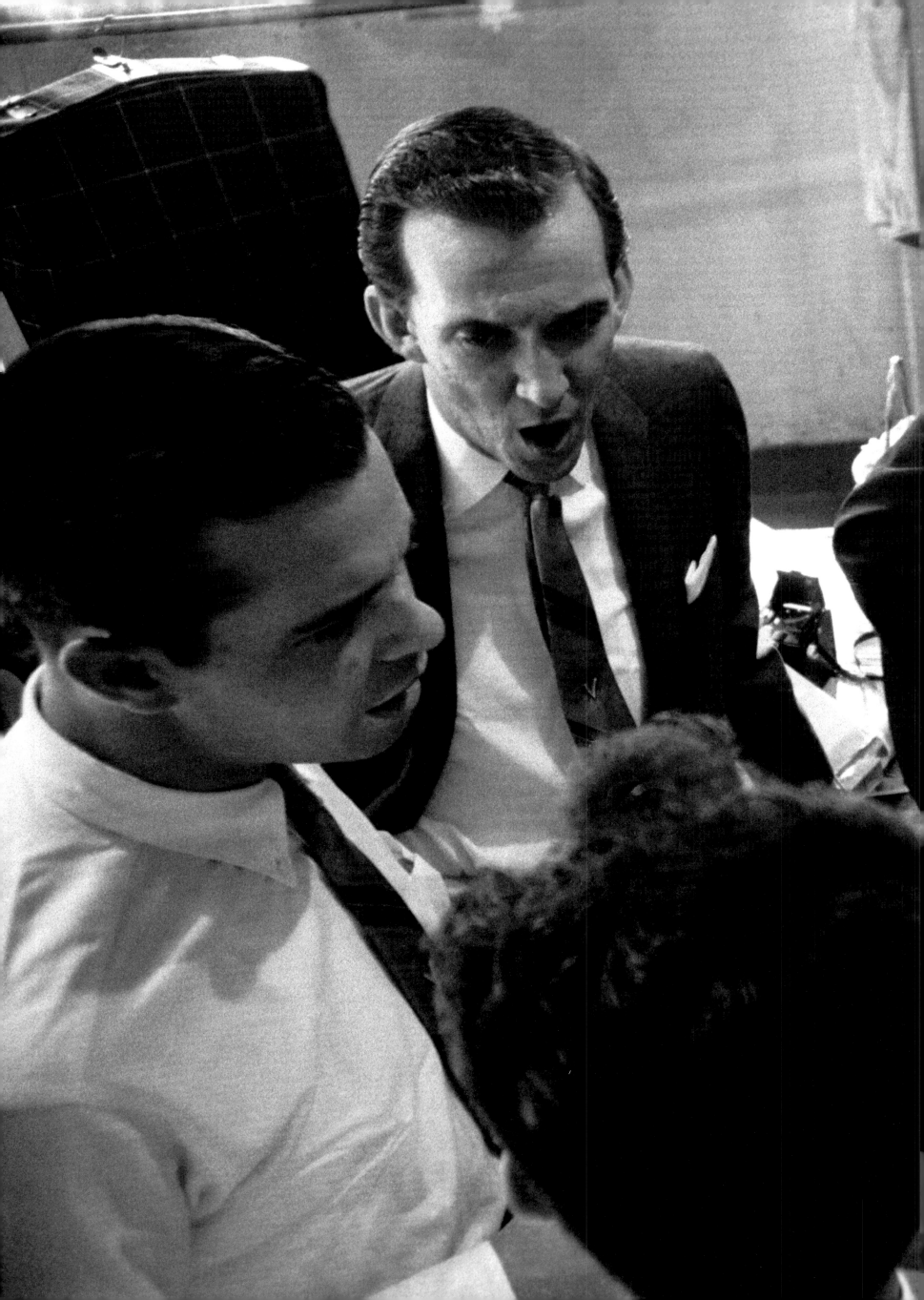

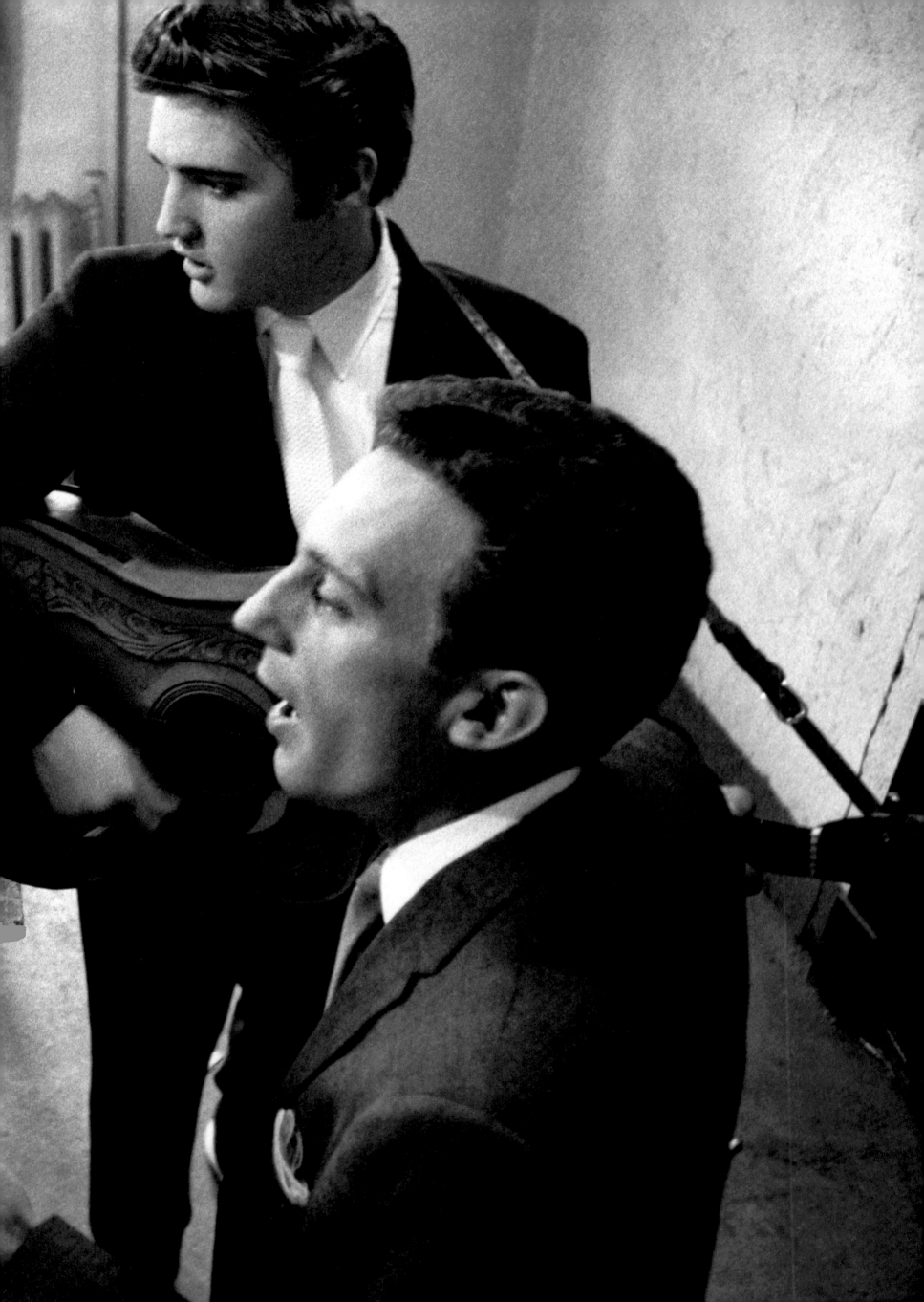

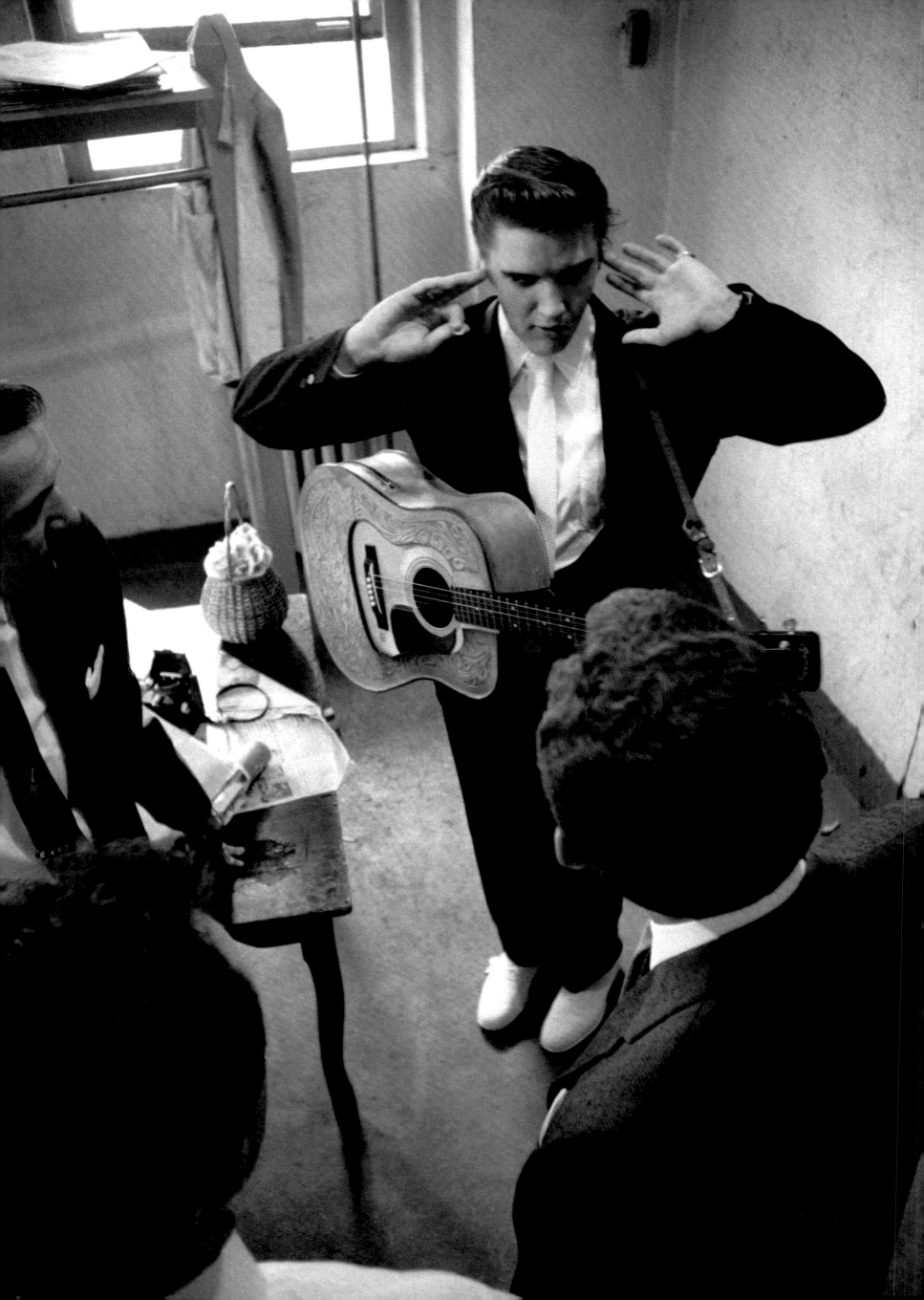

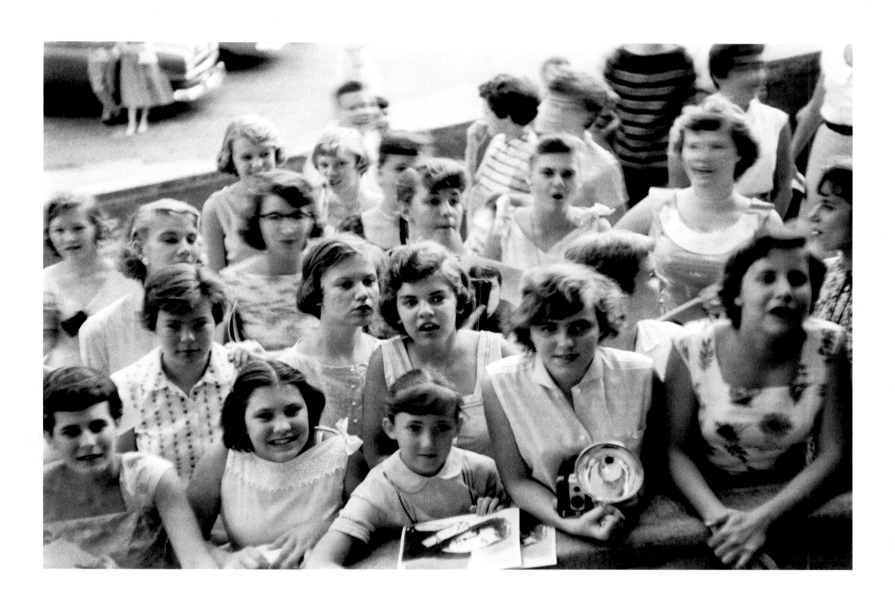

PREVIOUS SPREAD Elvis and the Jordanaires rehearse some of their songs in the green room.

OPPOSITE & ABOVE Rehearsal is interrupted by the high-pitched screams of fans outside. When Elvis opens the window and asks them to quiet down so he can concentrate, they comply.

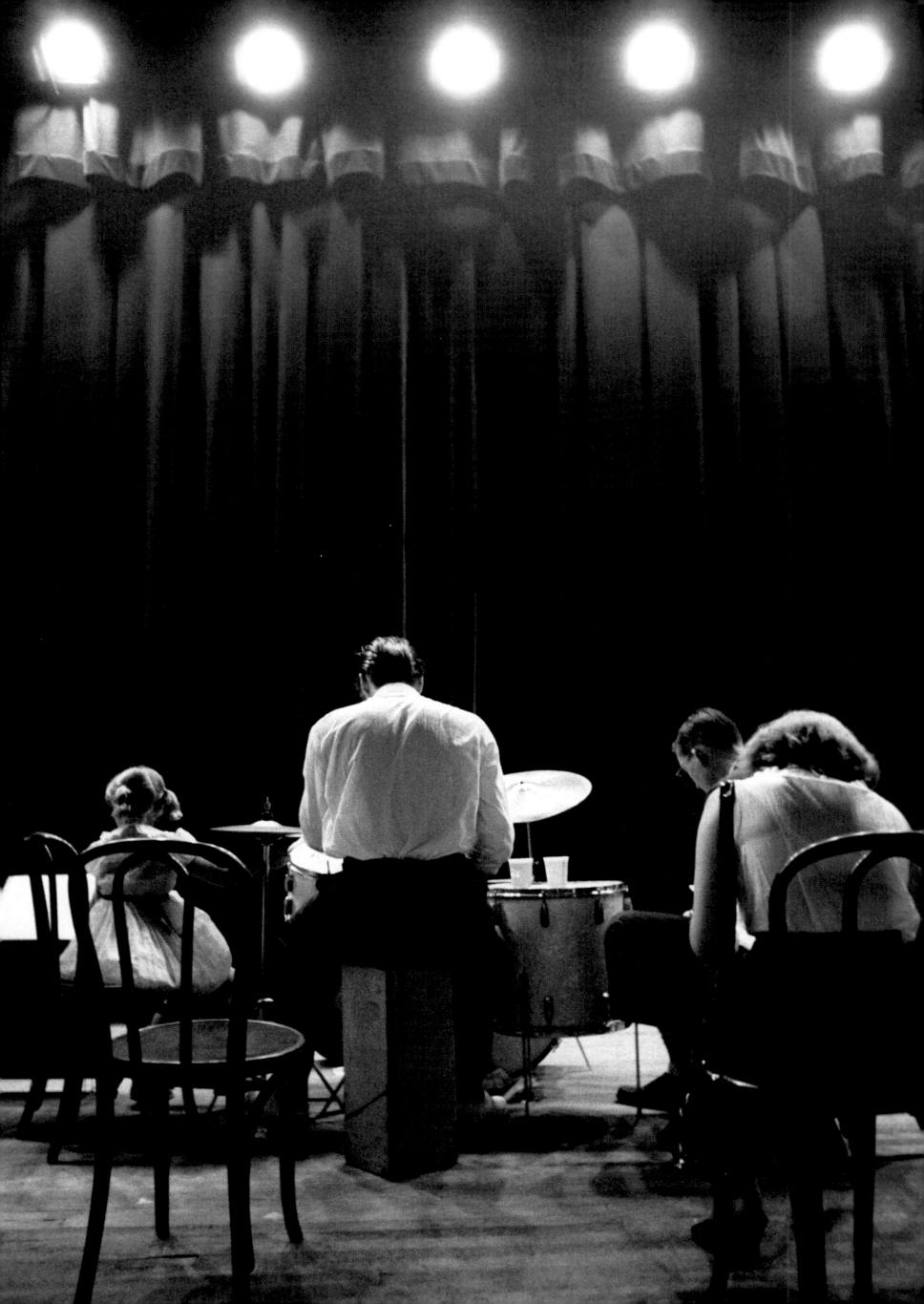

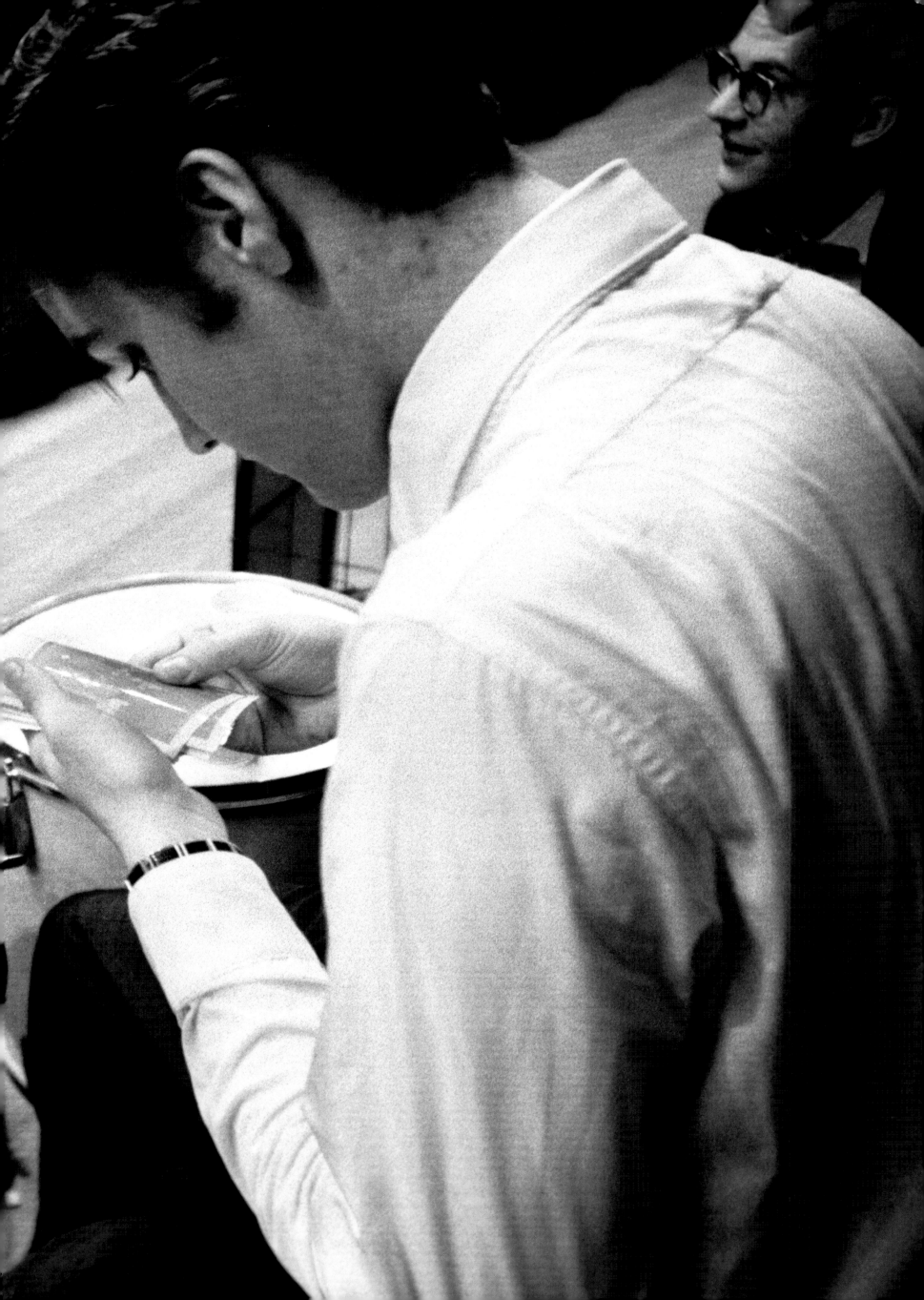

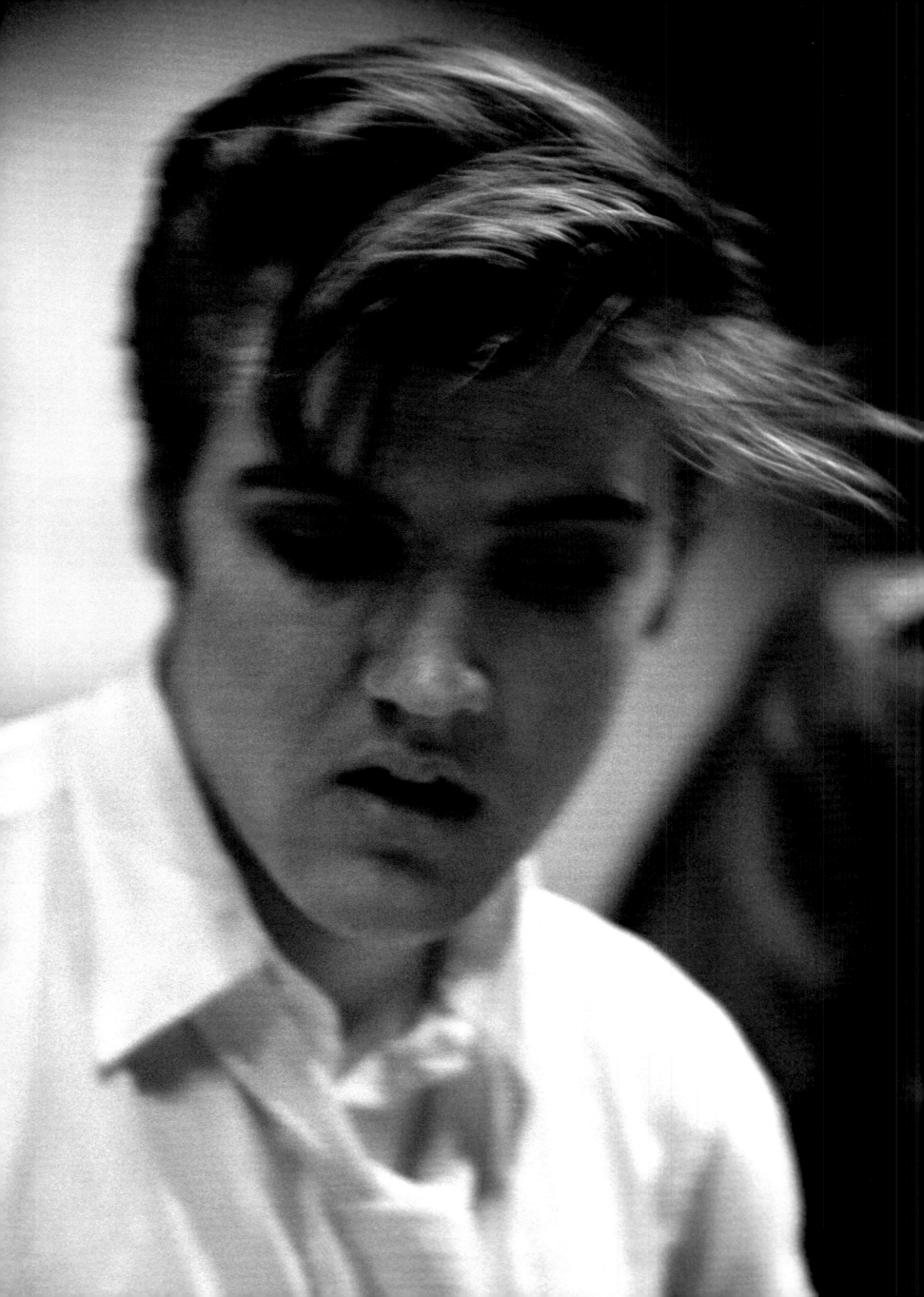

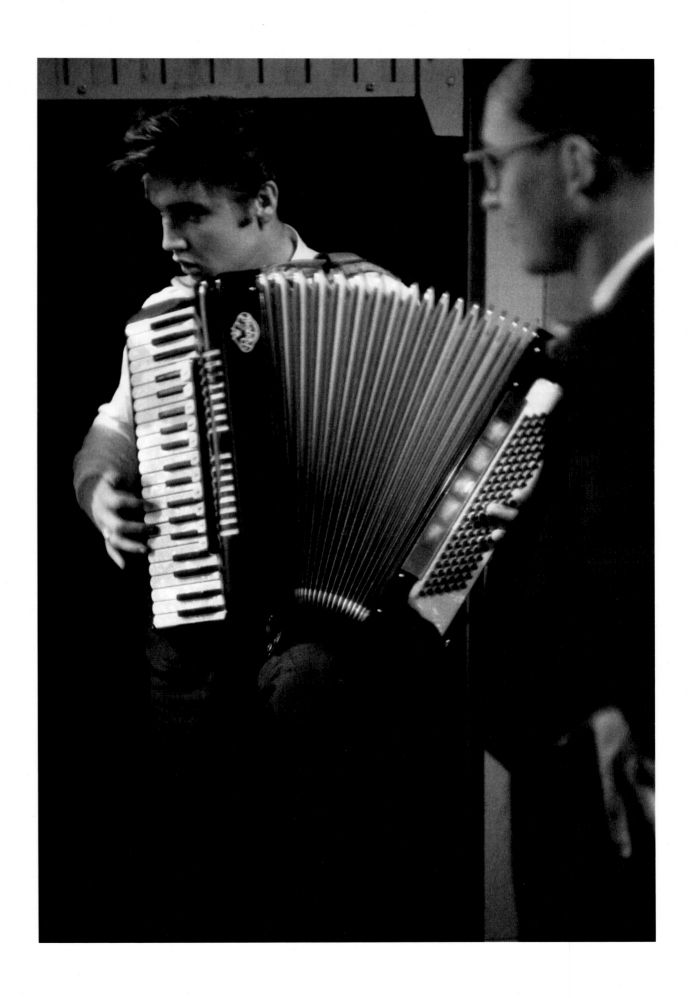

OPPOSITE Portrait in motion.

ABOVE Between shows, Elvis relaxes by playing an accordion. He found that when he had an instrument in his hands people left him alone.

FOLLOWING SPREAD His tooled-leather Martin strapped on, Elvis waits in the wings for the curtains to part.

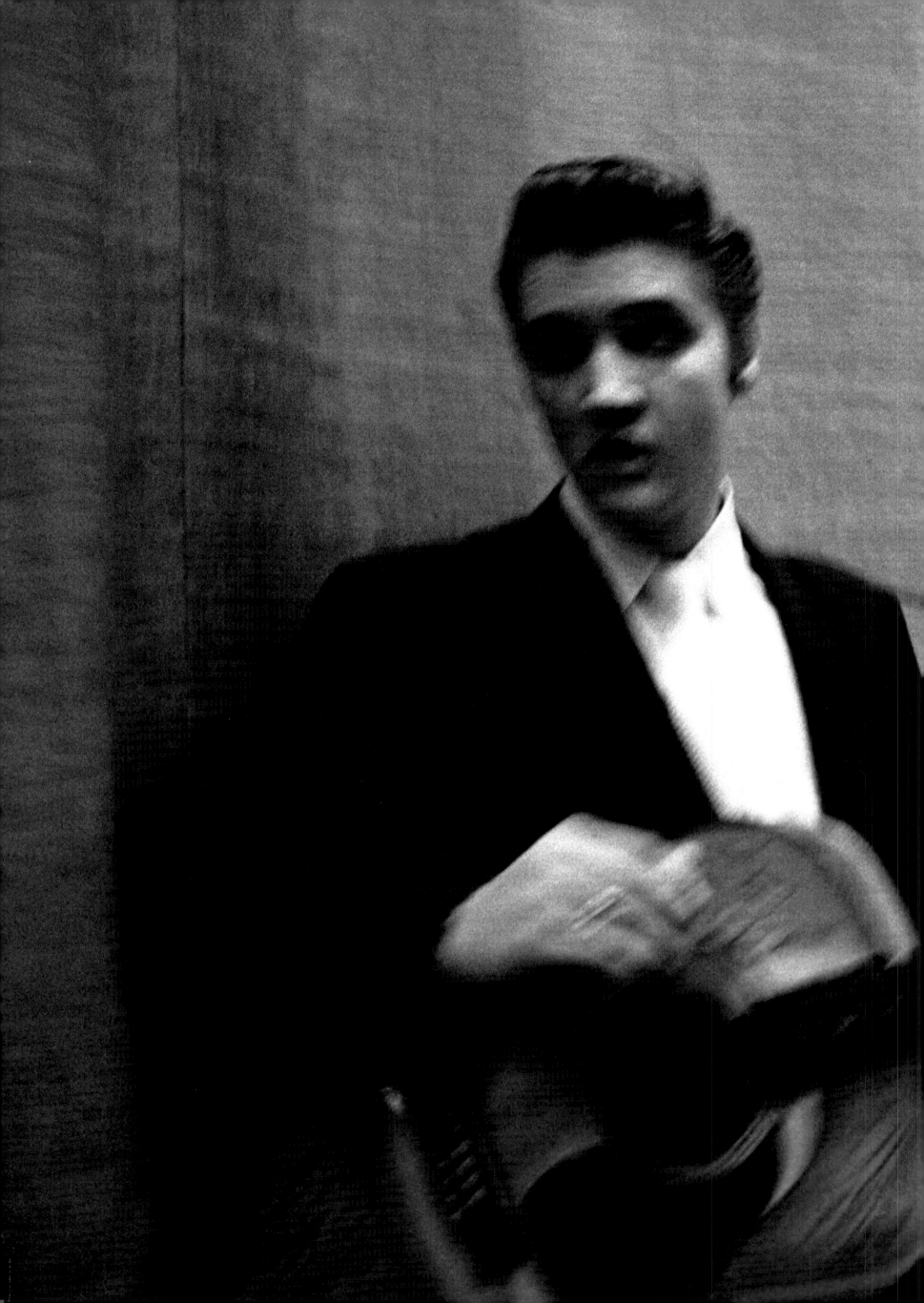

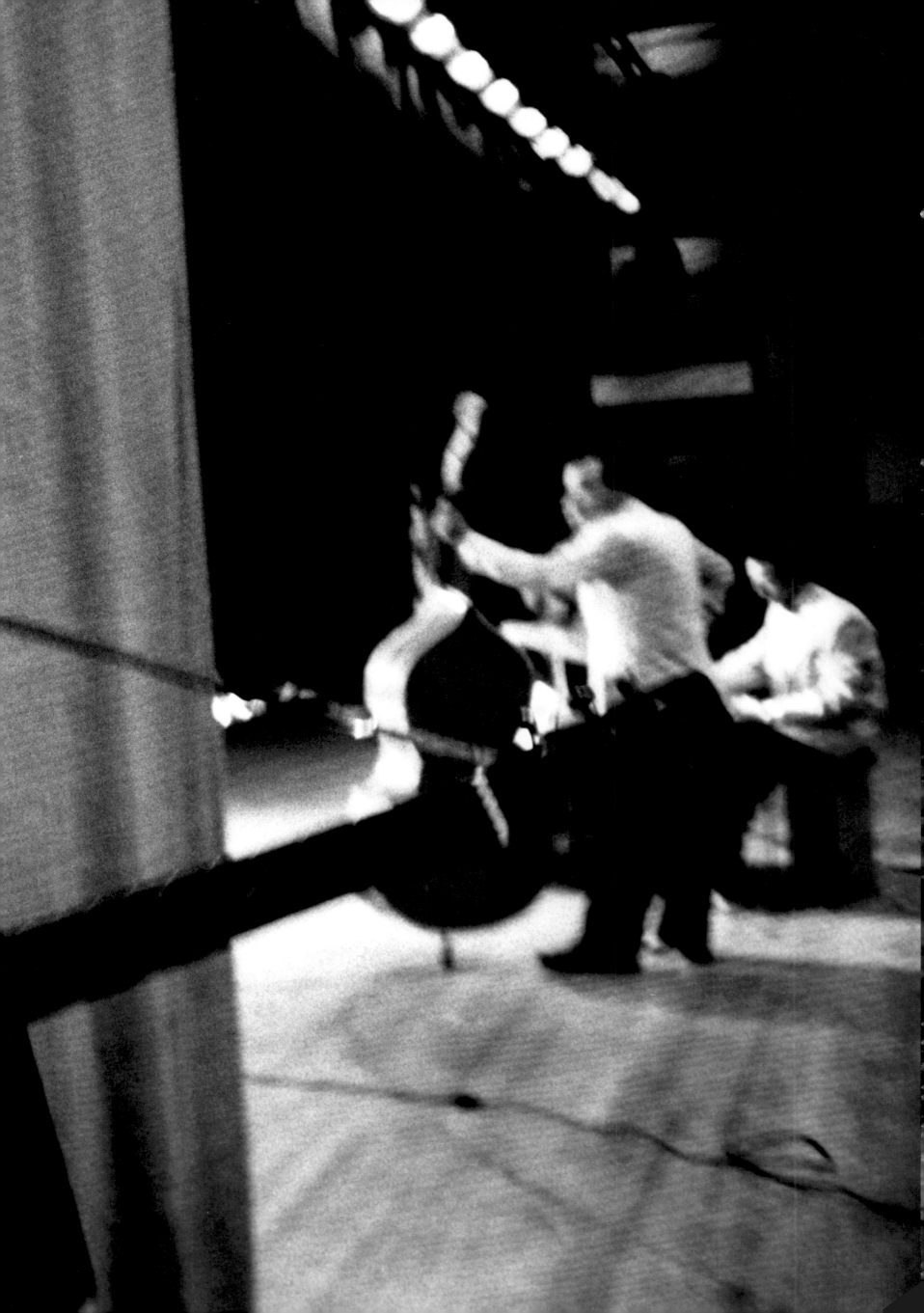

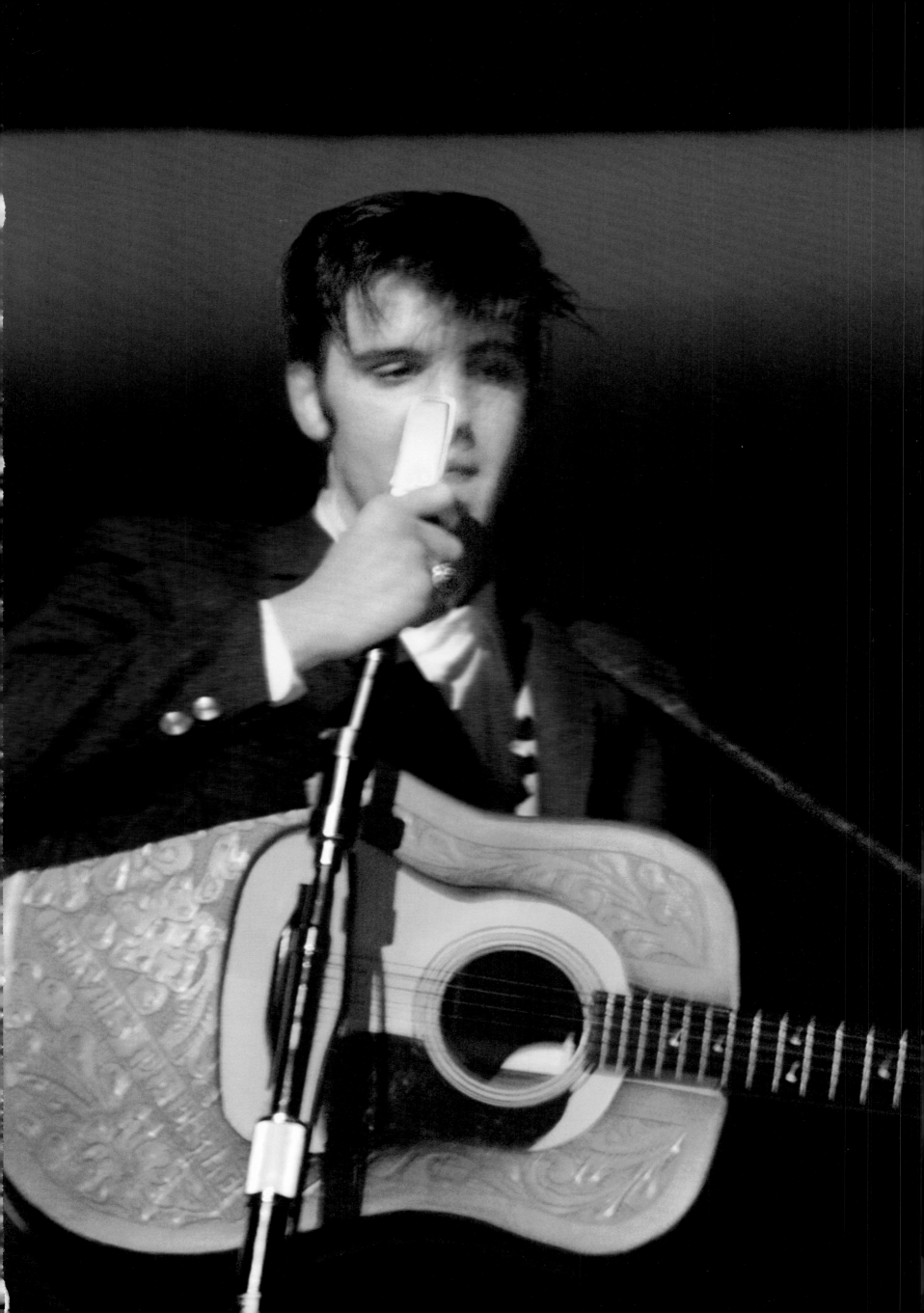

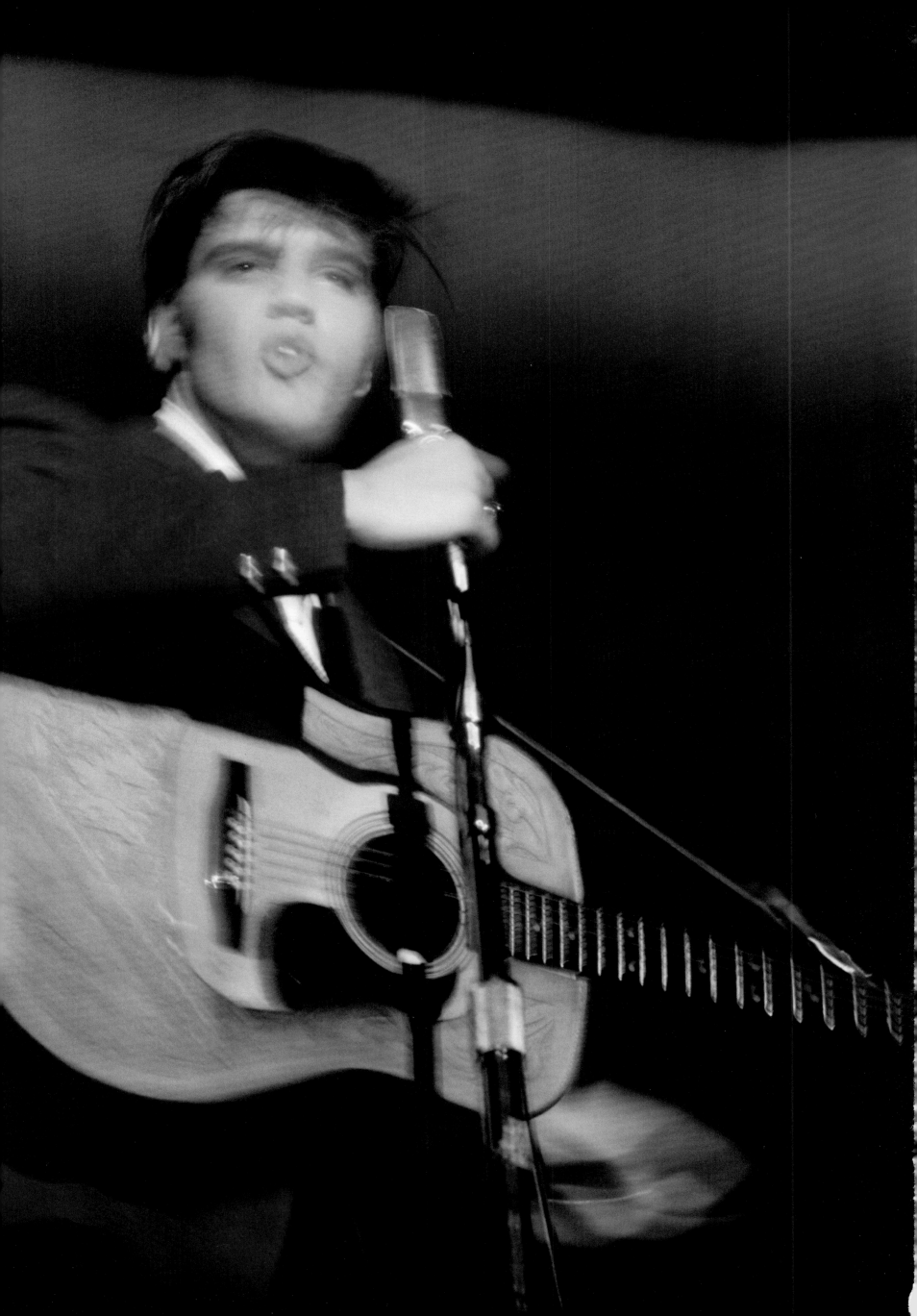

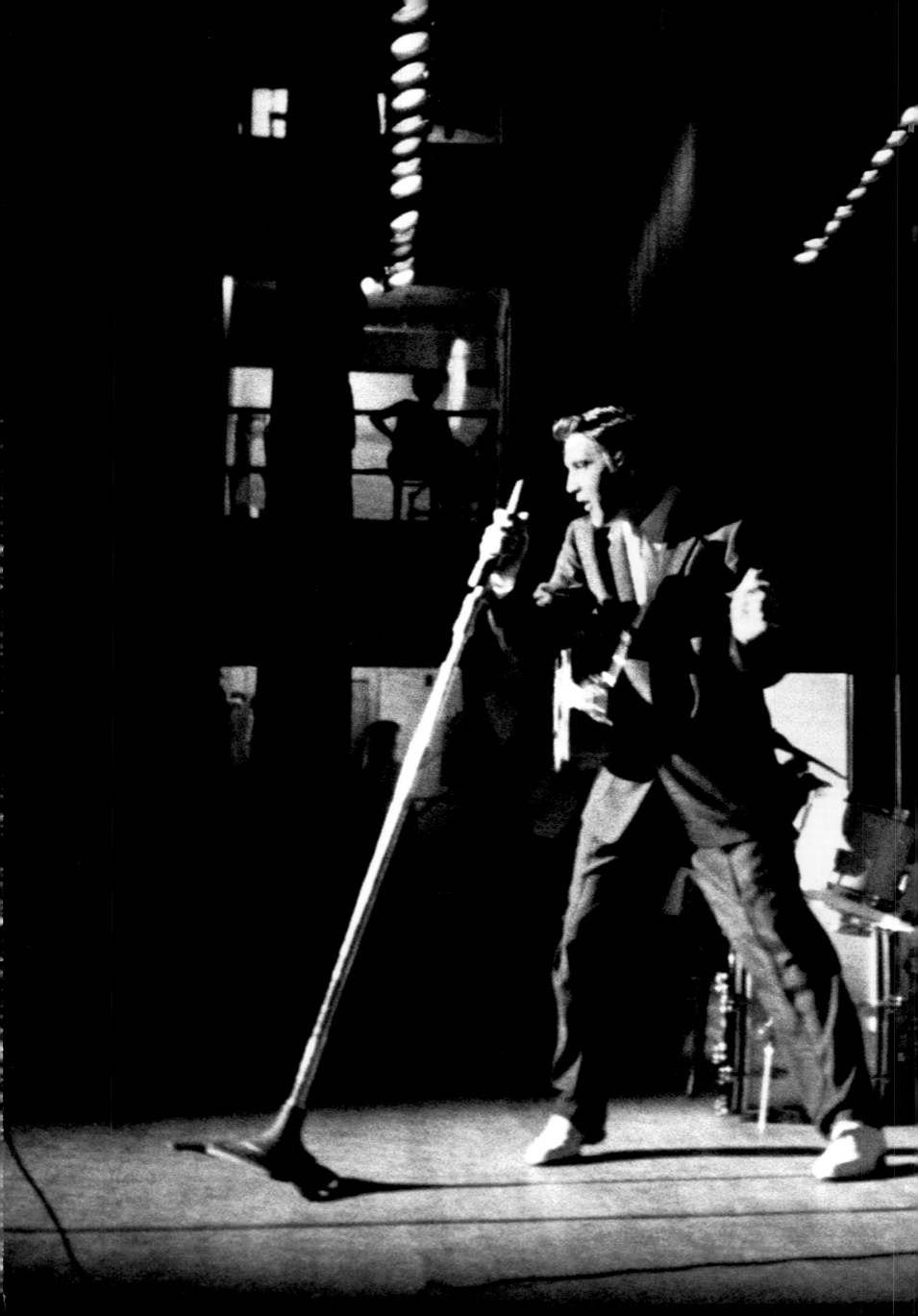

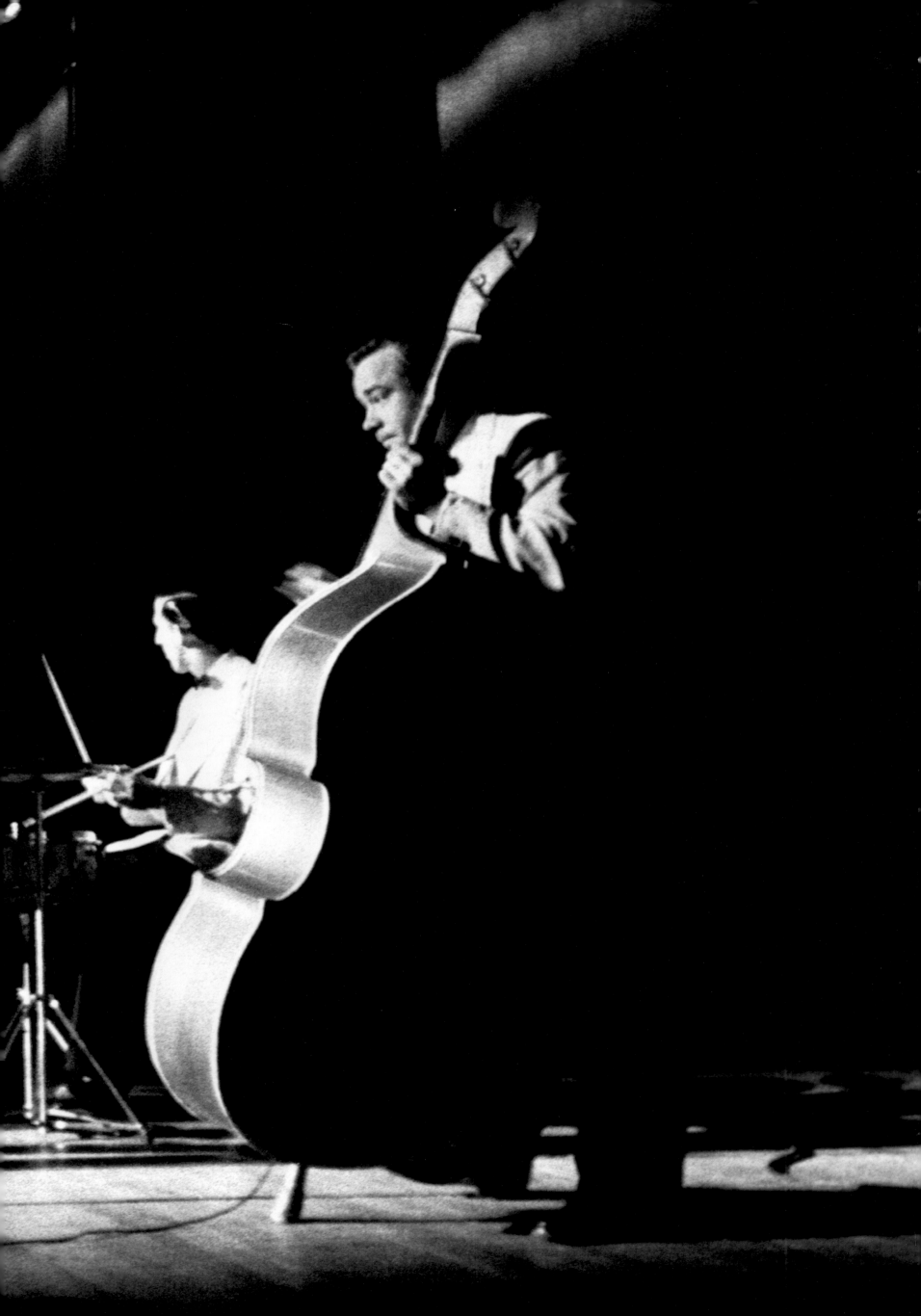

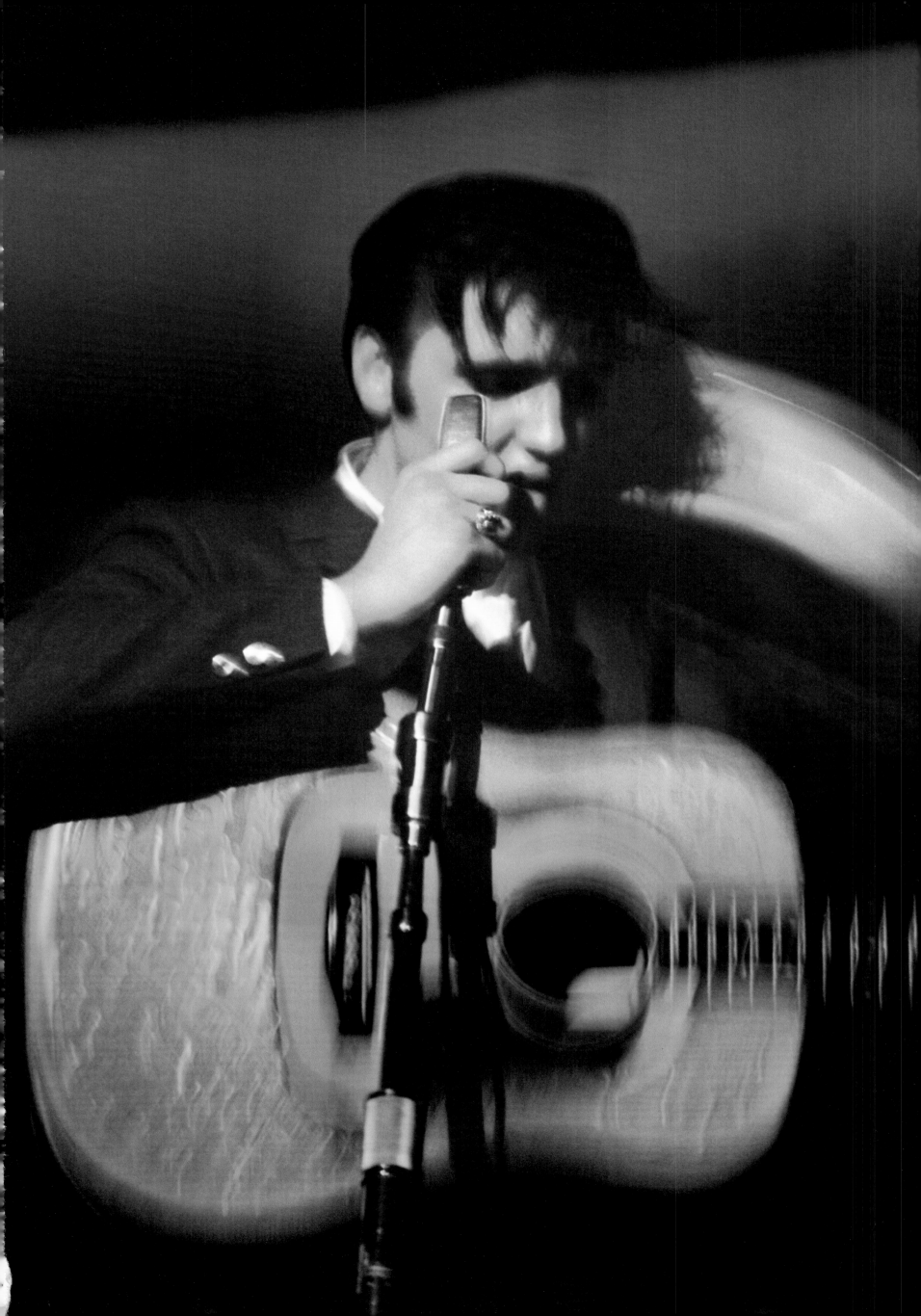

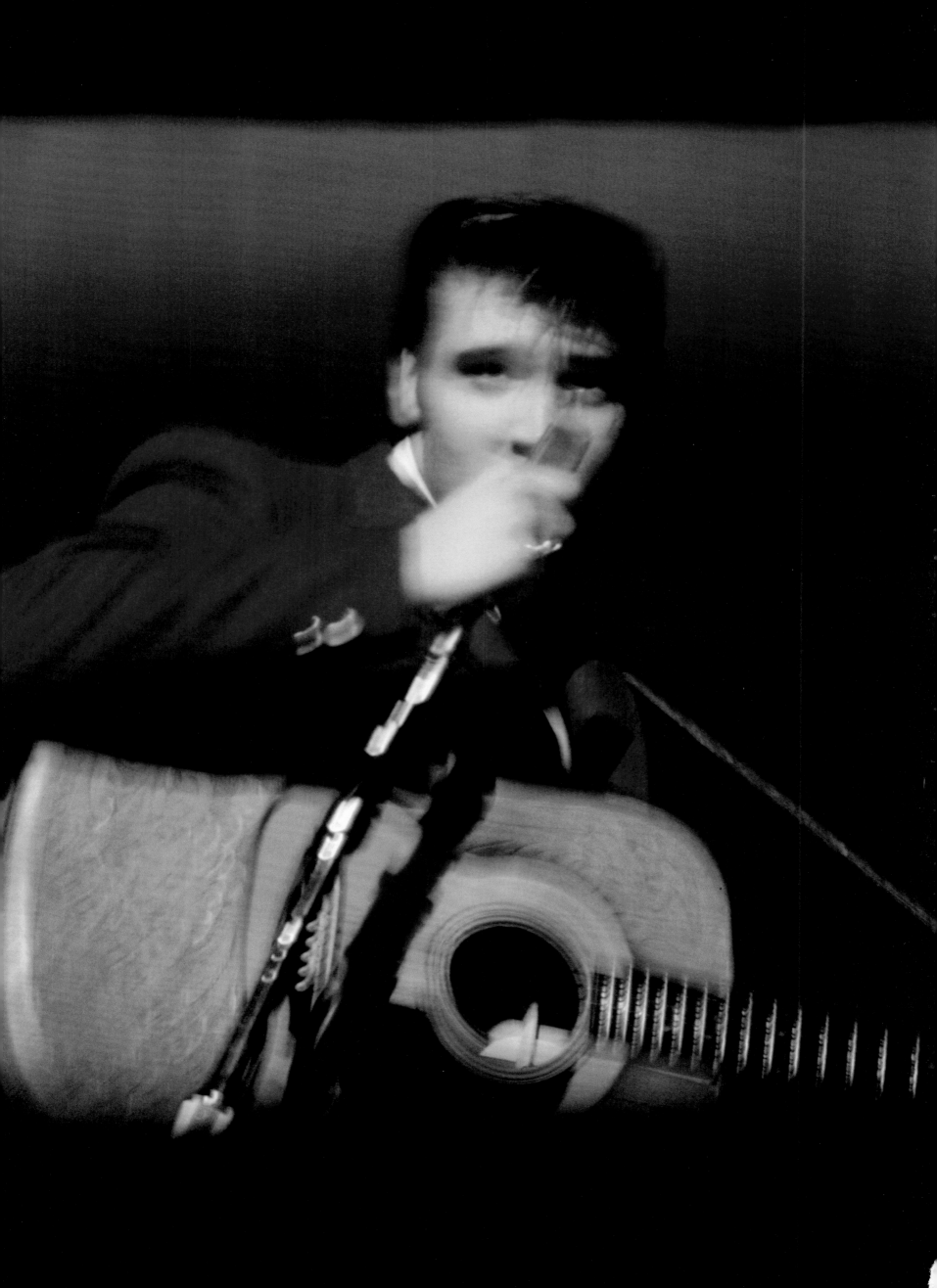

The Elvis Presley show comes alive on the
Mosque Theater stage with Scotty Moore on guitar,
Bill Black on bass, and D.J. Fontana on drums.

FOLDOUT Portrait studies in color: the 8 P.M. show at
the Mosque Theater.

OPPOSITE *Kneeling at the Mosque*, Richmond, Virginia,
June 30, 1956.

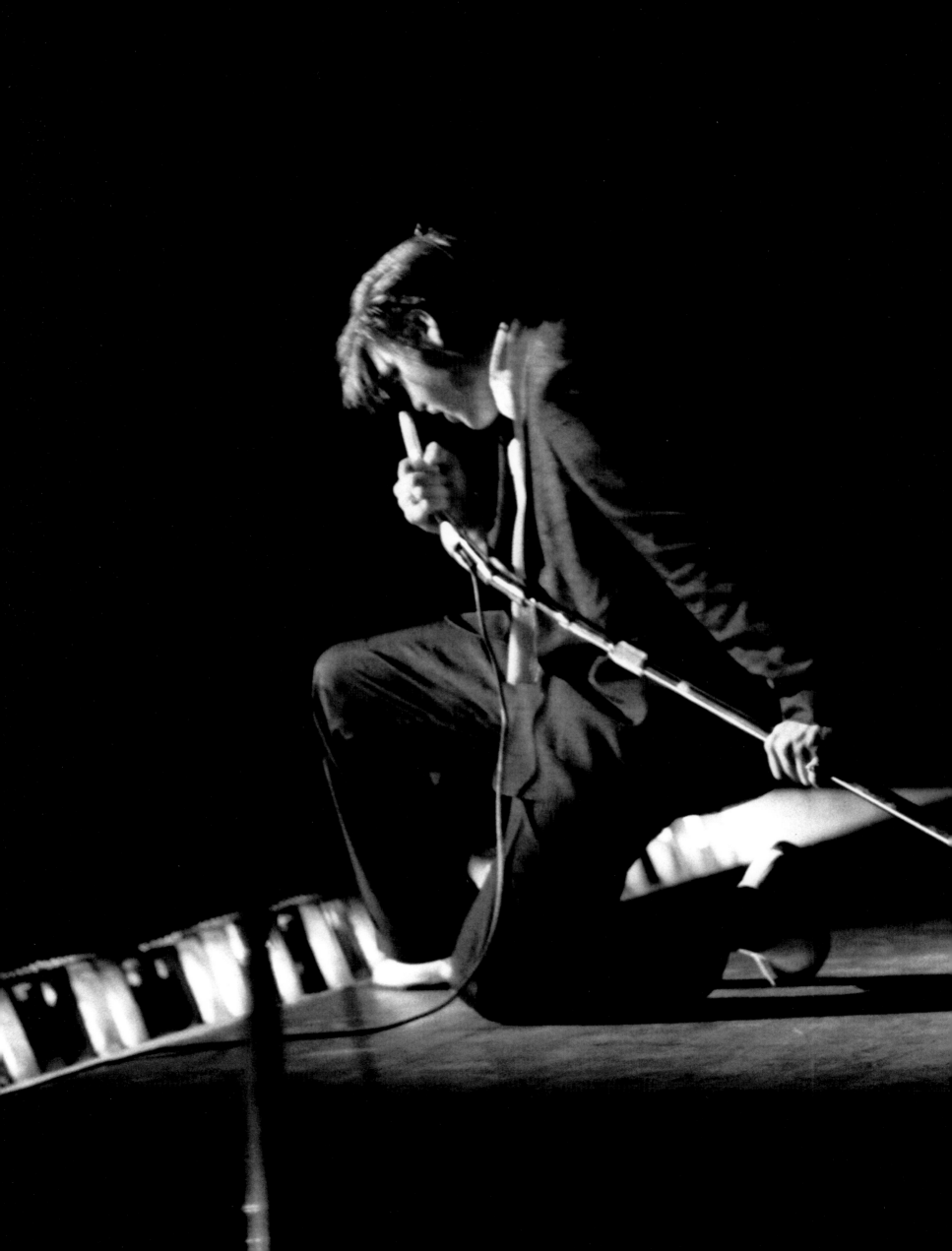

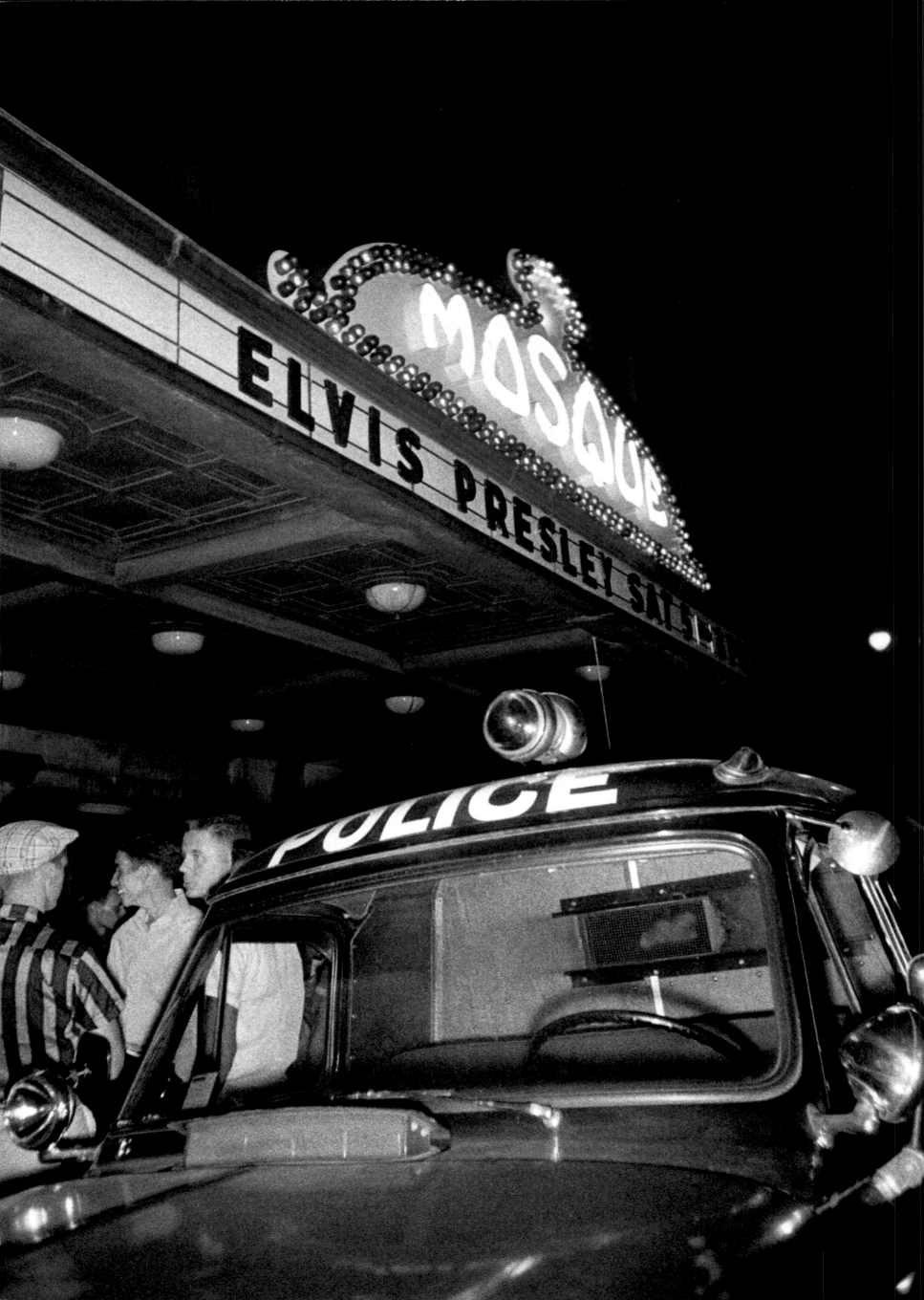

My pelvis had nothin' to do with what I do. I just get kinda in rhythm with the music. I jump around to it because I enjoy what I'm doin'—I'm not tryin' to be vulgar, I'm not tryin' to sell any sex, I'm not tryin' to look vulgar and nasty. I just enjoy what I'm doin' and tryin' to make the best of it.

Mein Becken hatte mit dem, was ich tu, nichts zu tun. Ich komm nur irgendwie in den Rhythmus mit der Musik. Ich hüpf dazu rum, weil ich Spaß hab an dem, was ich tu – ich versuch nicht, vulgär zu sein, ich versuch nicht, irgendwie Sex zu verkaufen, ich versuch nicht, vulgär und obszön auszusehen. Ich hab einfach Spaß an dem, was ich tu, und versuch, das Beste draus zu machen.

Mon pelvis n'a rien à voir là-dedans. Je me coule simplement dans le rythme de la musique. Si je saute dans tous les sens, c'est parce que je prends plaisir à ce que je fais. Je n'essaie pas d'être provocant, de vendre du sexe, d'avoir l'air vulgaire ou vicieux. J'aime ce que je fais et j'essaie d'en profiter au maximum.

–ELVIS PRESLEY
TV Guide interview, August 6, 1956

OPPOSITE "Elvis has left the building": the Mosque marquee after the show.

RESLEY

CTOR

10 1

RDING
SION
CITY - JULY 2, 1956

RCA VICTOR STUDIOS ON 24TH STREET

RCA VICTOR STUDIOS ON 24TH STREET in Manhattan was the site of Elvis's legendary recording session of "Hound Dog" and "Don't Be Cruel," which became his third and fourth gold records, along with "Any Way You Want Me." Junior Smith, the Jordanaires, Scotty Moore, D.J. Fontana, Bill Black, Shorty Long (an additional piano player), and Steve Sholes, the artist and repertoire man who had signed Elvis to RCA Victor—they were all there. At first Elvis had difficulty recording "Hound Dog." He just kept on moving off the fixed microphone, his voice fading in and out, until he ultimately adjusted to the studio's limitations. It still took about 20 takes for him to achieve his perfection. He was very absorbed in the process, choosing which songs to sing, how the arrangement for the band would go, and deciding which takes would stay and which would go. After a long day, Elvis and the group left the studio. This time there were no young girls; gathered on the sidewalk were a few blue-collar postal workers waiting for an autograph and small talk. His entourage then drove away in a white convertible into the darkness of the night.

RCA VICTOR STUDIOS IN DER 24. STRASSE in Manhattan war der Ort von Elvis' legendärer Aufnahmesession für „Hound Dog" und „Don't Be Cruel", die ihm die dritte und vierte Goldene Schallplatte bescheren sollten, zusammen mit „Any Way You Want Me". Mit von der Partie waren Junior Smith, die Jordanaires, Scotty Moore, D.J. Fontana und Bill Black, außerdem Shorty Long (ein zusätzlicher Mann am Klavier) und Steven Sholes, der Produzent, der Elvis für RCA Victor unter Vertrag genommen hatte. Bei der Aufnahme von „Hound Dog" gab es Probleme, weil Elvis sich immer wieder zu weit vom fest installierten Mikrofon wegbewegte und seine Stimme deshalb teils lauter, teils leiser zu hören war. Als er schließlich mit den Beschränkungen des Aufnahmestudios zurechtkam, sollte es immer noch 20 Takes dauern, bis er die für ihn perfekte Fassung gefunden hatte. Elvis war mit jeder Faser bei der Sache, entschied, welche Songs er singen wollte, welche Arrangements für die Band funktionieren würden, welche Takes bleiben konnten und welche rausflogen. Nach einem langen Tag verließen er und seine Leute das Studio. Diesmal hatten sich draußen auf dem Gehsteig keine jungen Mädchen versammelt, sondern ein paar Postarbeiter, die auf Autogramme und einen kurzen Plausch mit ihm warteten. Dann fuhren Elvis und seine Entourage in einem weißen Cabriolet in die dunkle Nacht davon.

CE FUT DANS LES STUDIOS DE LA RCA VICTOR, sur la 24ᵉ Rue à Manhattan, qu'eut lieu la légendaire séance d'enregistrement de «Hound Dog» et «Don't Be Cruel» (qui devinrent les 3ᵉ et 4ᵉ disques d'or d'Elvis). Ce jour-là, il enregistra également «Any Way You Want Me». Il était entouré de tous ses fidèles: Junior Smith, les Jordanaires, Scotty Moore, D.J. Fontana, Bill Black, Shorty Long (un pianiste supplémentaire); ainsi que de Steve Sholes, qui s'occupait alors des artistes et du répertoire à la RCA. Elvis eut du mal à enregistrer «Hound Dog» car il ne pouvait se retenir de se trémousser devant le micro fixe, ce qui rendait sa voix instable. Il finit par s'adapter aux contraintes du studio, mais il lui fallut néanmoins une vingtaine de prises avant d'atteindre la perfection. Il était très impliqué dans le procédé, choisissant ses chansons, les arrangements, décidant lui-même quelles prises conserver. Après une longue journée de travail, Elvis et son groupe quittèrent le studio. Cette fois, ce n'était pas une meute d'adolescentes qui l'attendait devant la porte, mais un groupe d'employés des postes voulant un autographe et échanger quelques mots. Puis Elvis et sa clique s'enfoncèrent dans la nuit à bord d'une décapotable blanche.

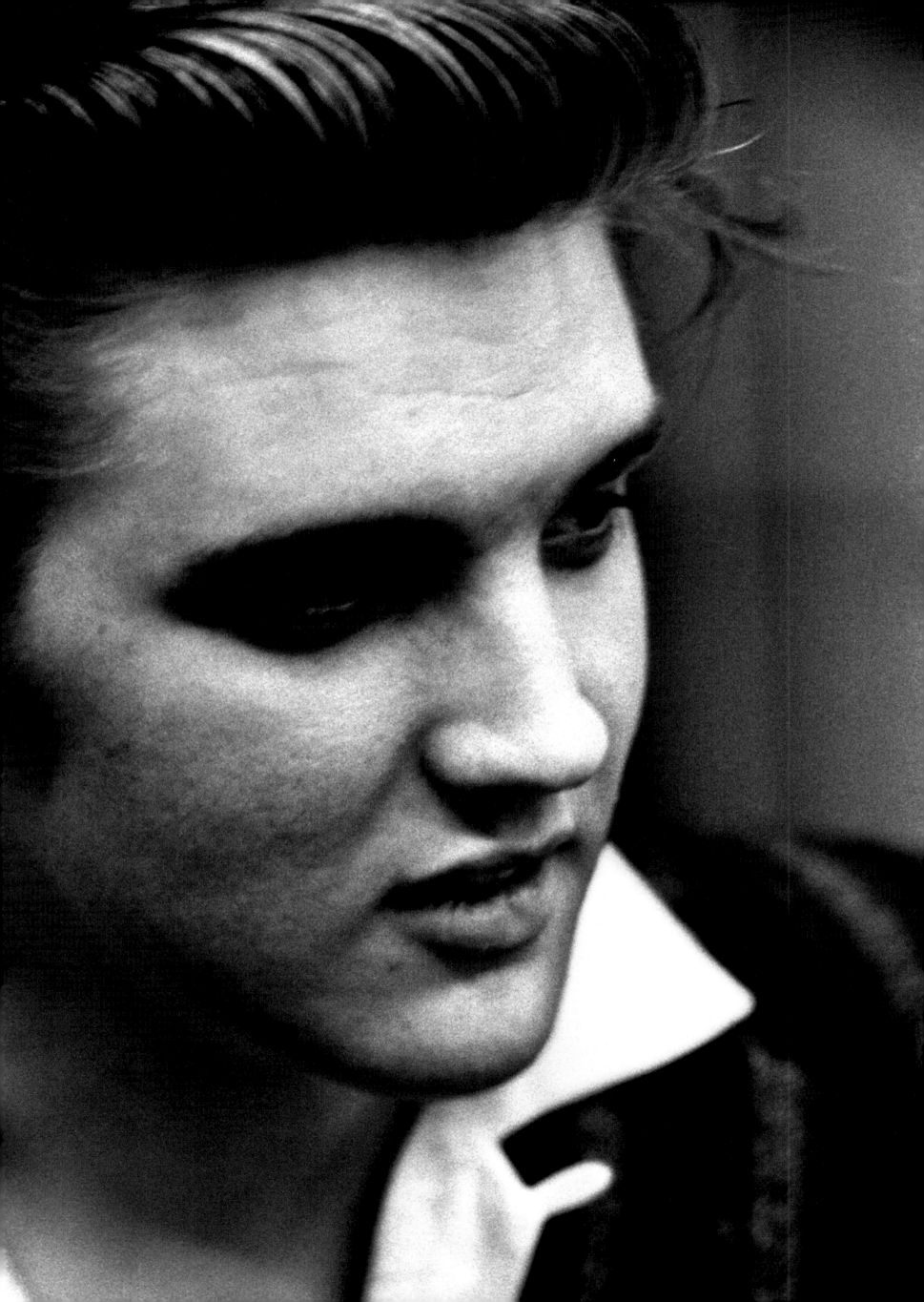

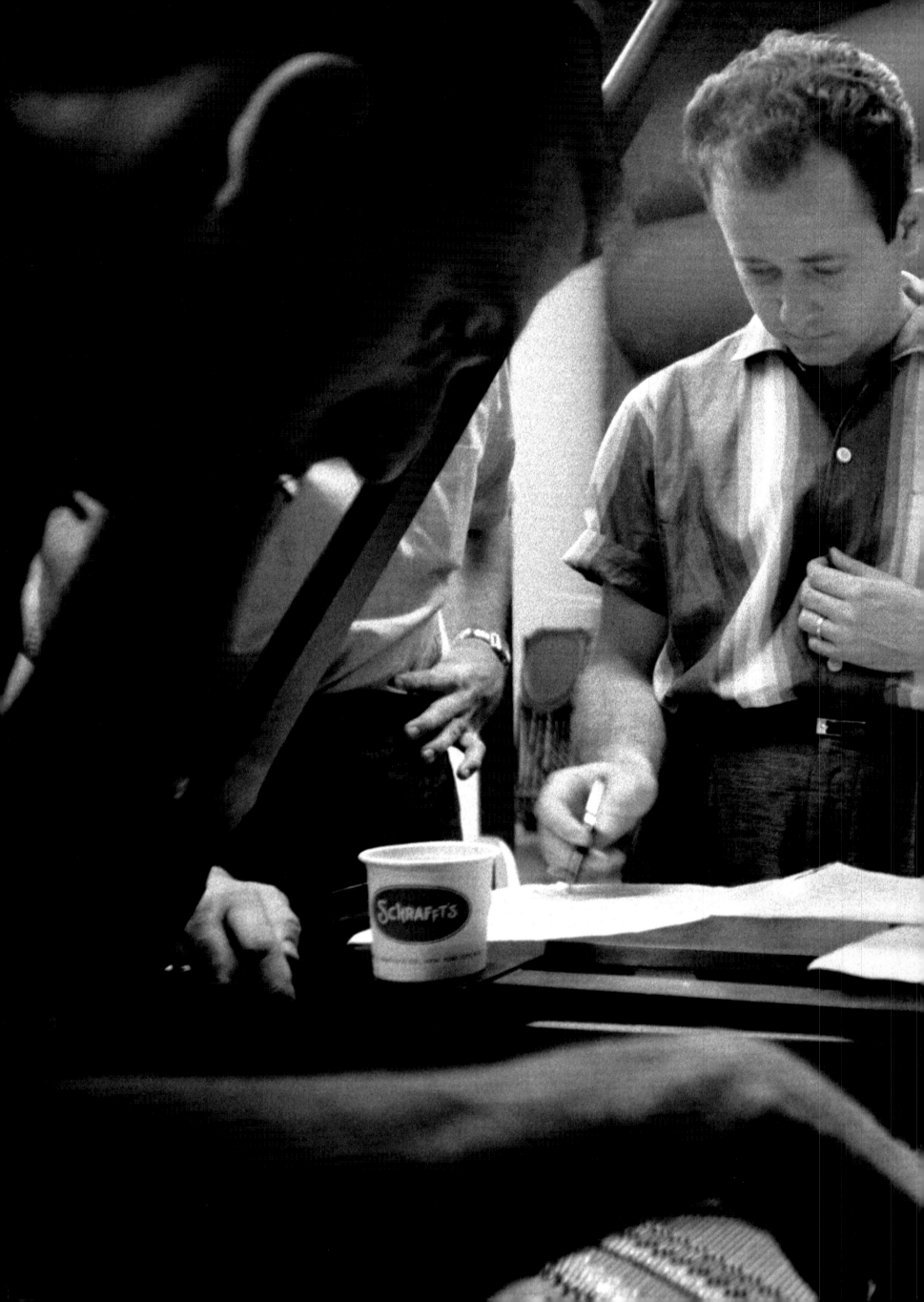

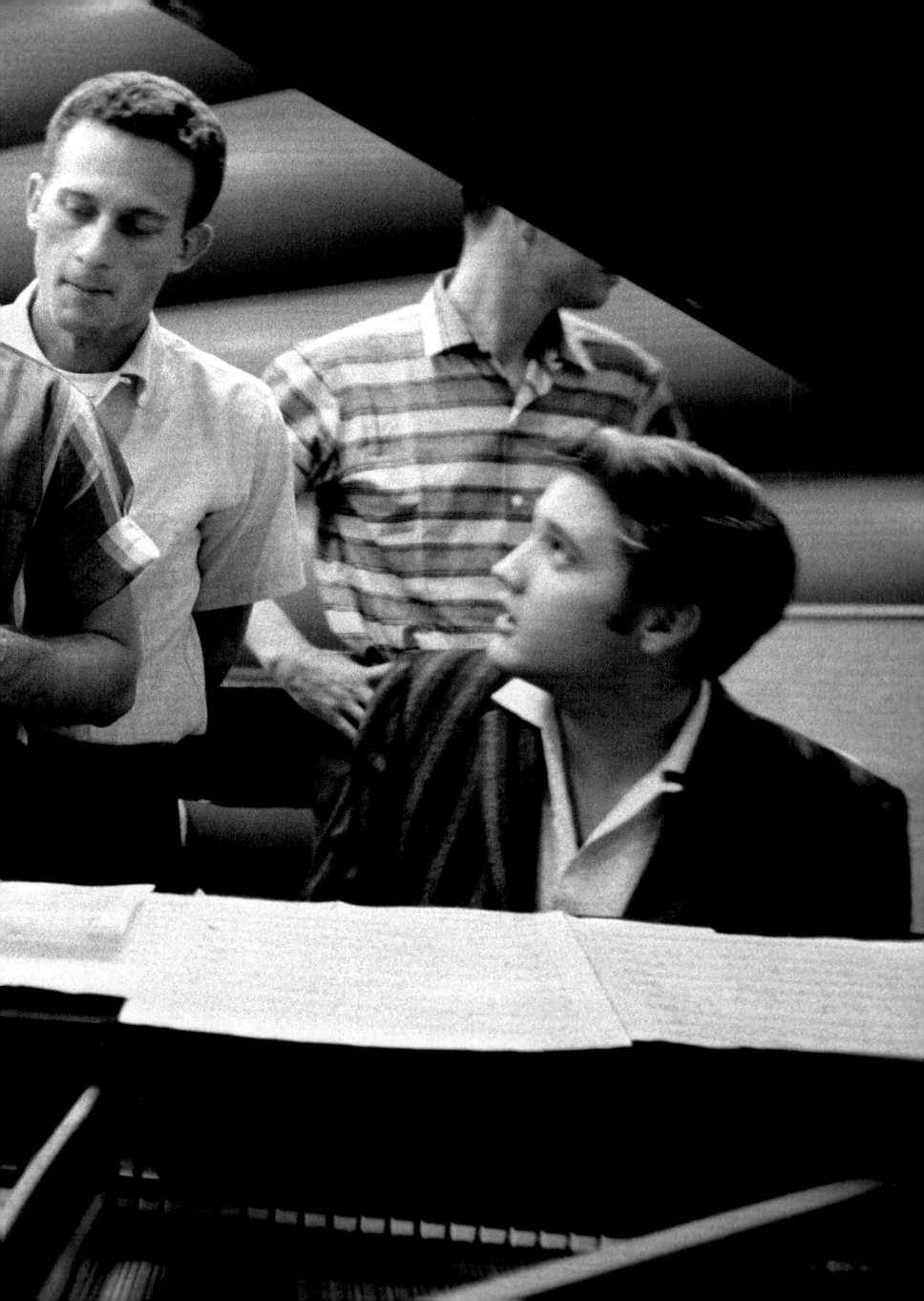

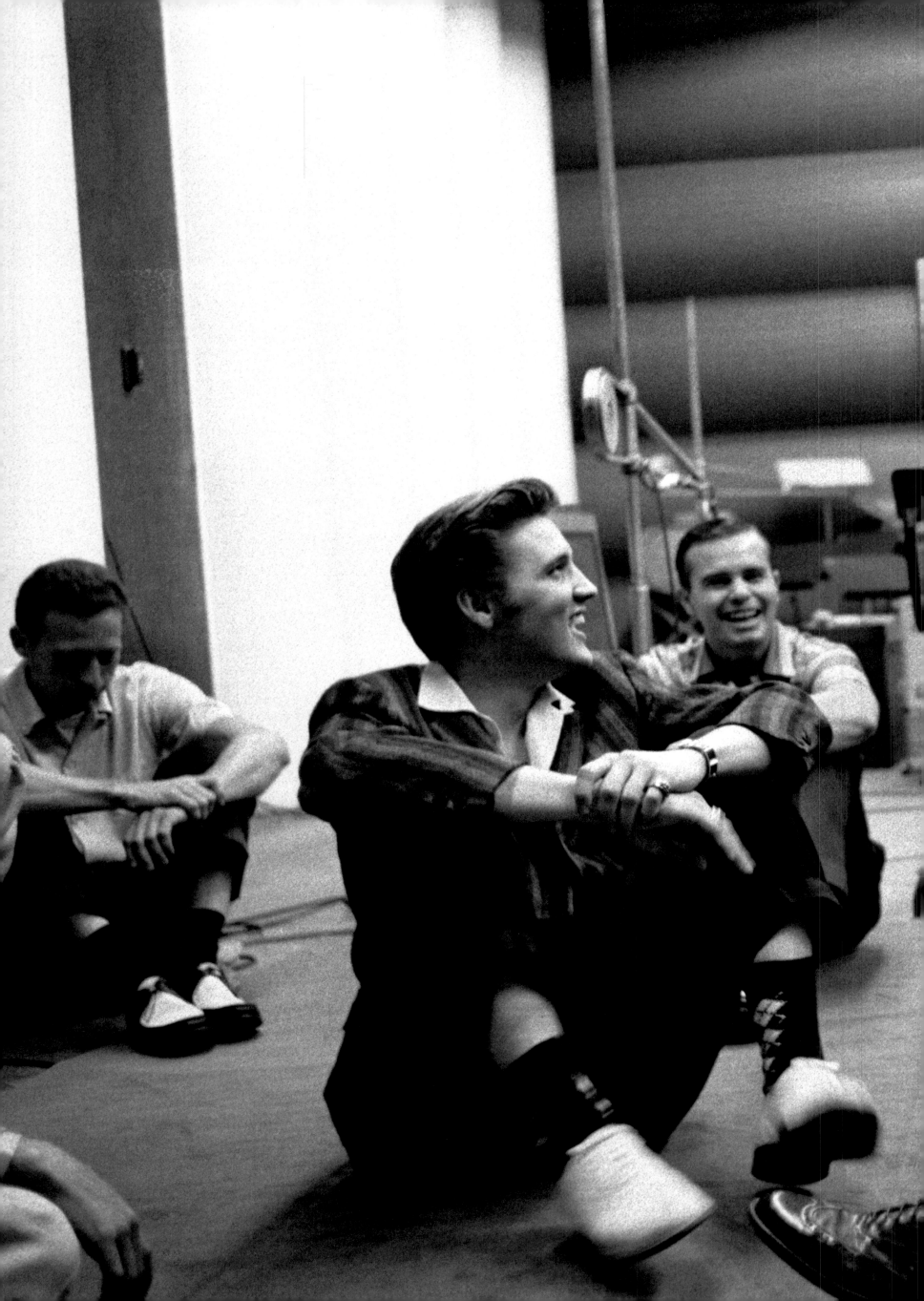

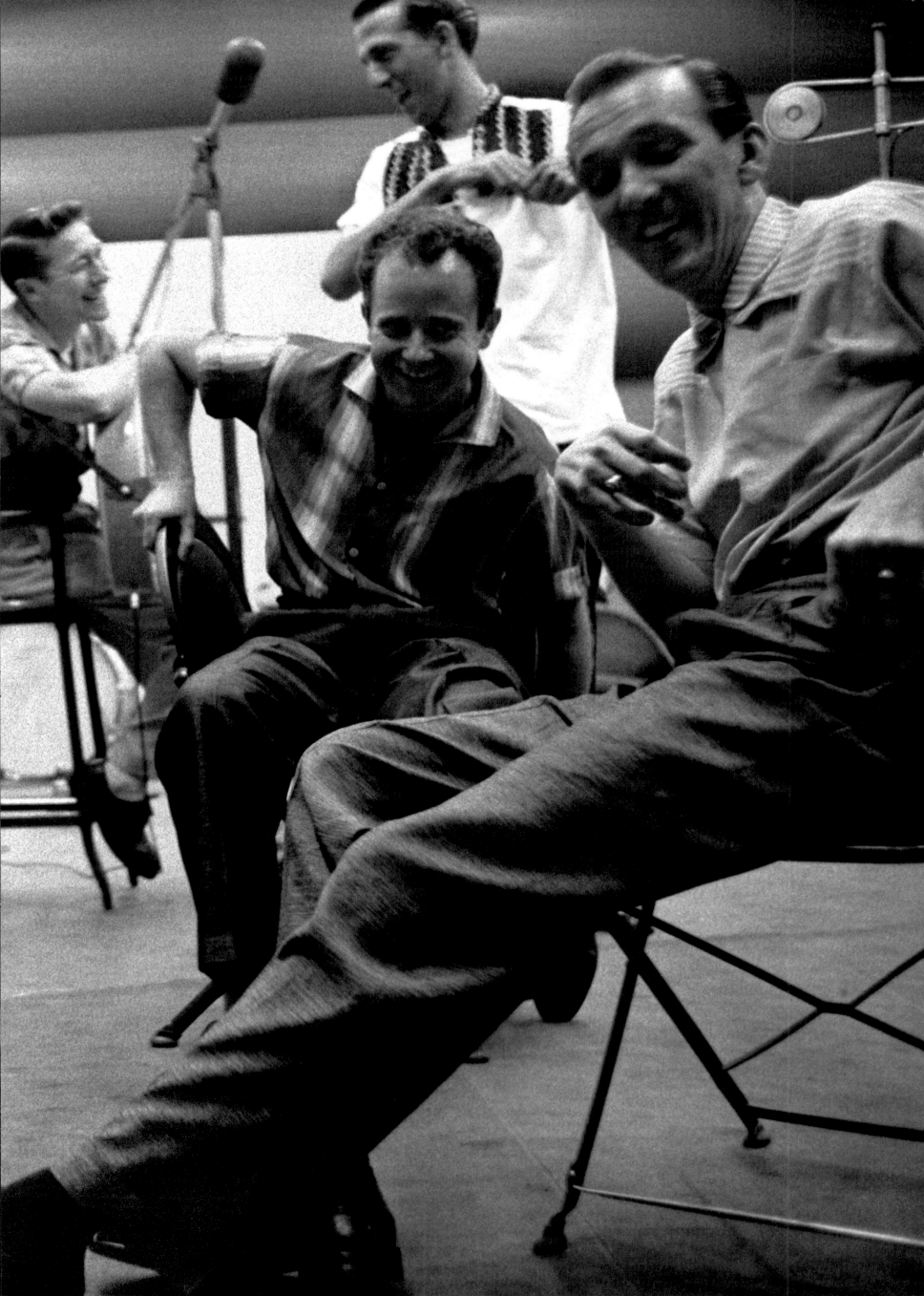

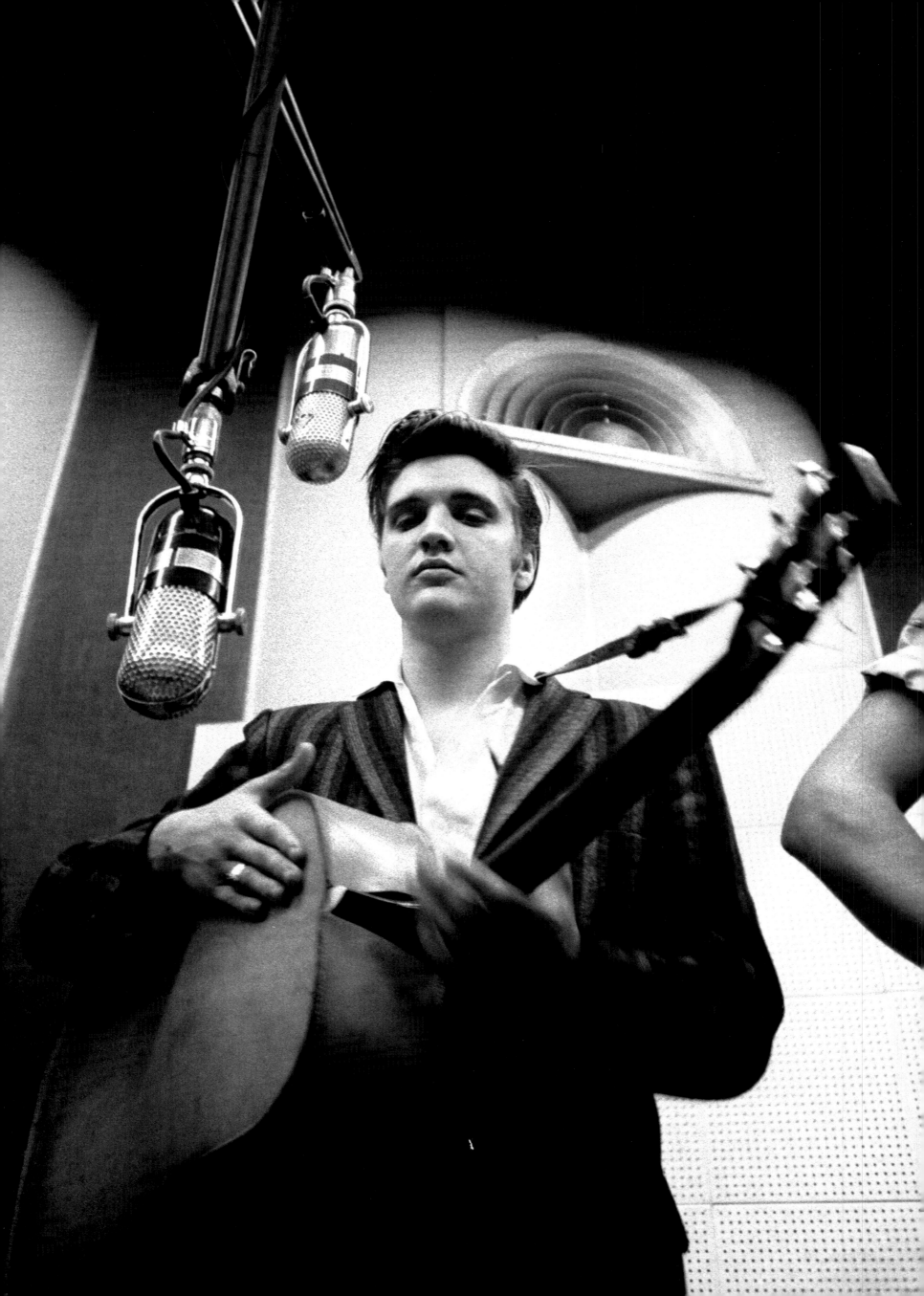

Elvis was one of those artists, when he sang a song, he just seemed to live every word of it. There's other people that have a voice that's maybe as great or greater than Presley's, but he had that certain something that everybody searches for all during their lifetime.

Elvis war so ein Musiker. Wenn der ein Lied sang, schien er einfach jedes Wort davon zu leben. Da gibt's andere, die haben Stimmen, die sind vielleicht genauso toll oder noch toller als seine, aber er hatte das gewisse Etwas, nach dem jeder sein ganzes Leben lang sucht.

Elvis était l'un de ces artistes qui, quand ils chantent, semblent vivre chaque parole de leur chanson. D'autres artistes ont une aussi belle voix que lui, voire plus belle, mais il avait ce petit plus indéfinissable que tout le monde recherche.

—JAKE HESS
Lead singer, the Statesmen Quartet

199 Portrait at the RCA Victor recording studio on East 24th Street, New York City, July 2, 1956. The session will begin with recording the A-side song, "Hound Dog."

200-201 Arranging a song with Gordon Stoker of the Jordanaires. When Presley heard the gospel quartet sing in Memphis in 1955 he told them, "If I ever get a recording contract with a major company, I want you guys to back me up."

PREVIOUS SPREAD Between songs, Elvis relaxes and cracks a joke.

OPPOSITE Twin microphones: the top one is for his voice, the bottom for his slap against the leather covering the guitar, and the song is "Don't Be Cruel."

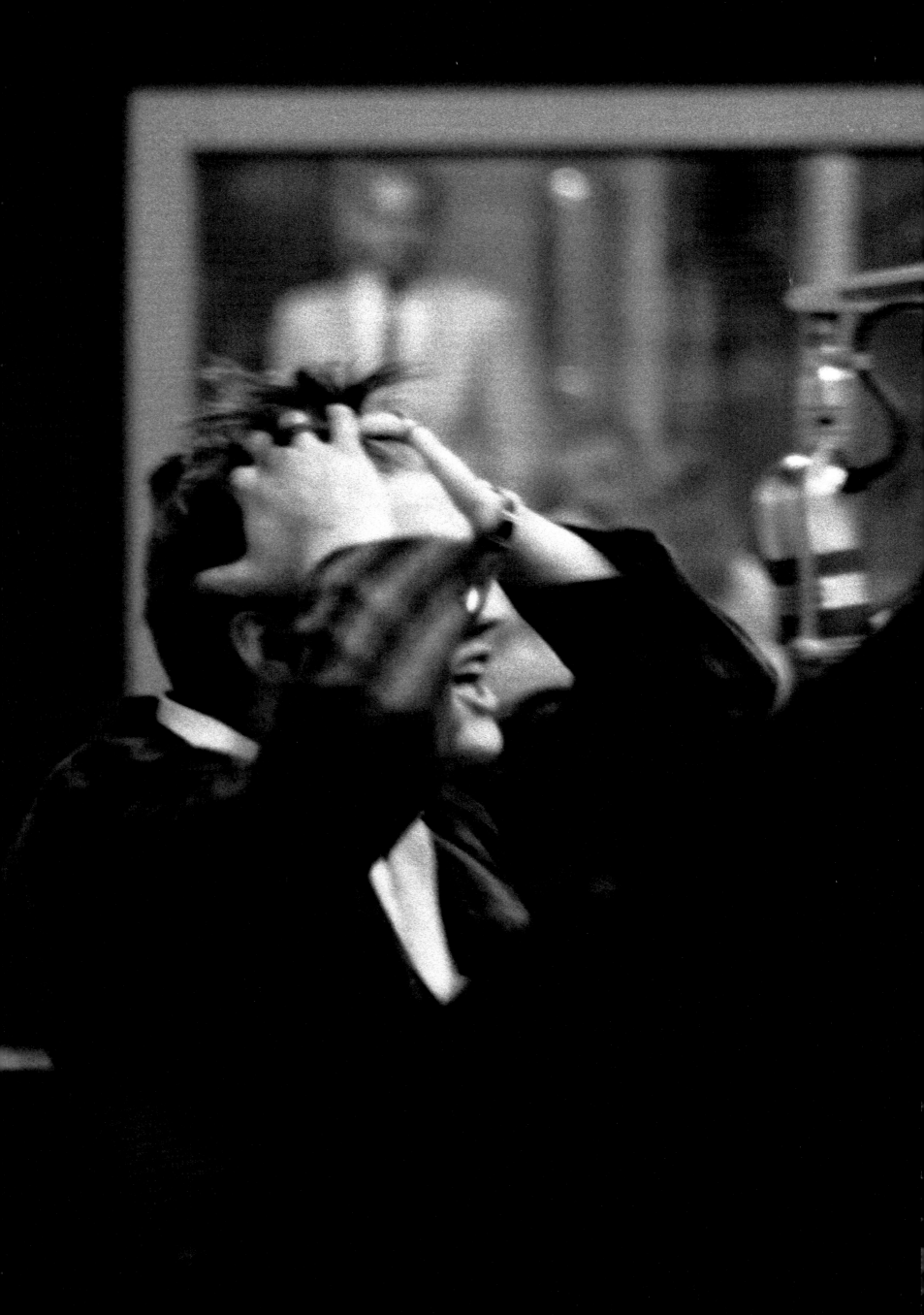

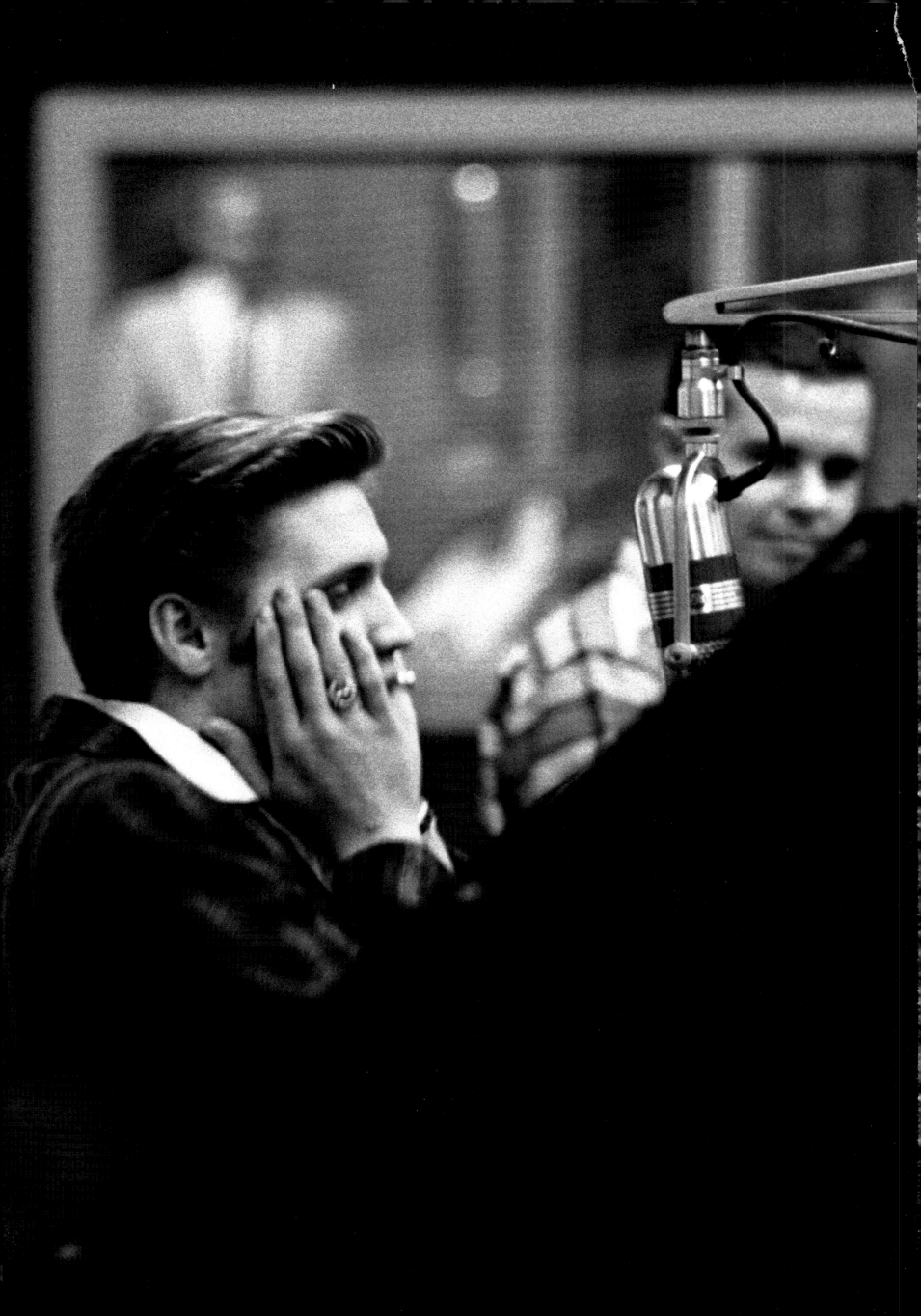

OPPOSITE *Don't Be Cruel*, RCA Victor Studio 1, July 2, 1956.

FOLDOUT One of several takes of "Hound Dog."

206

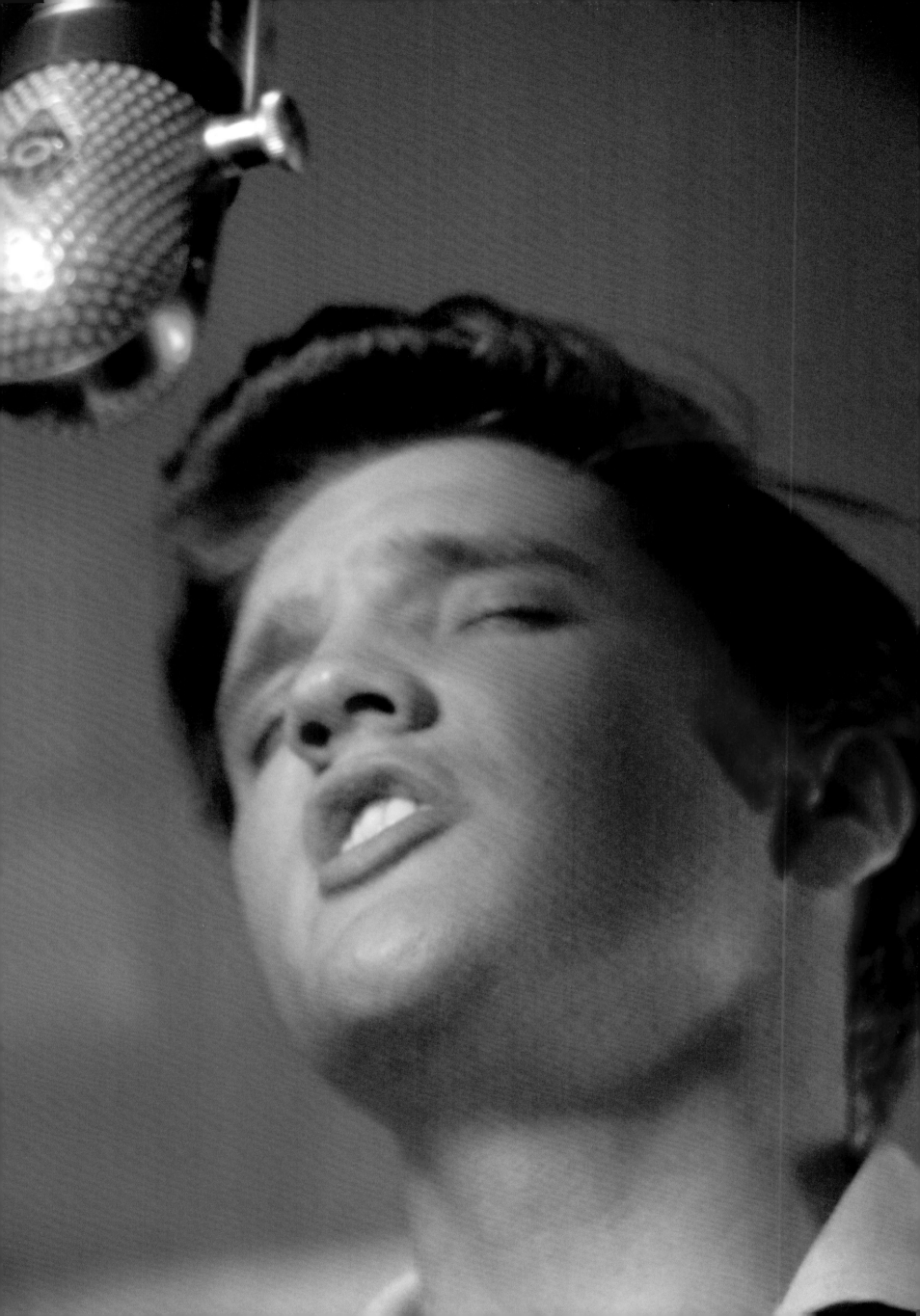

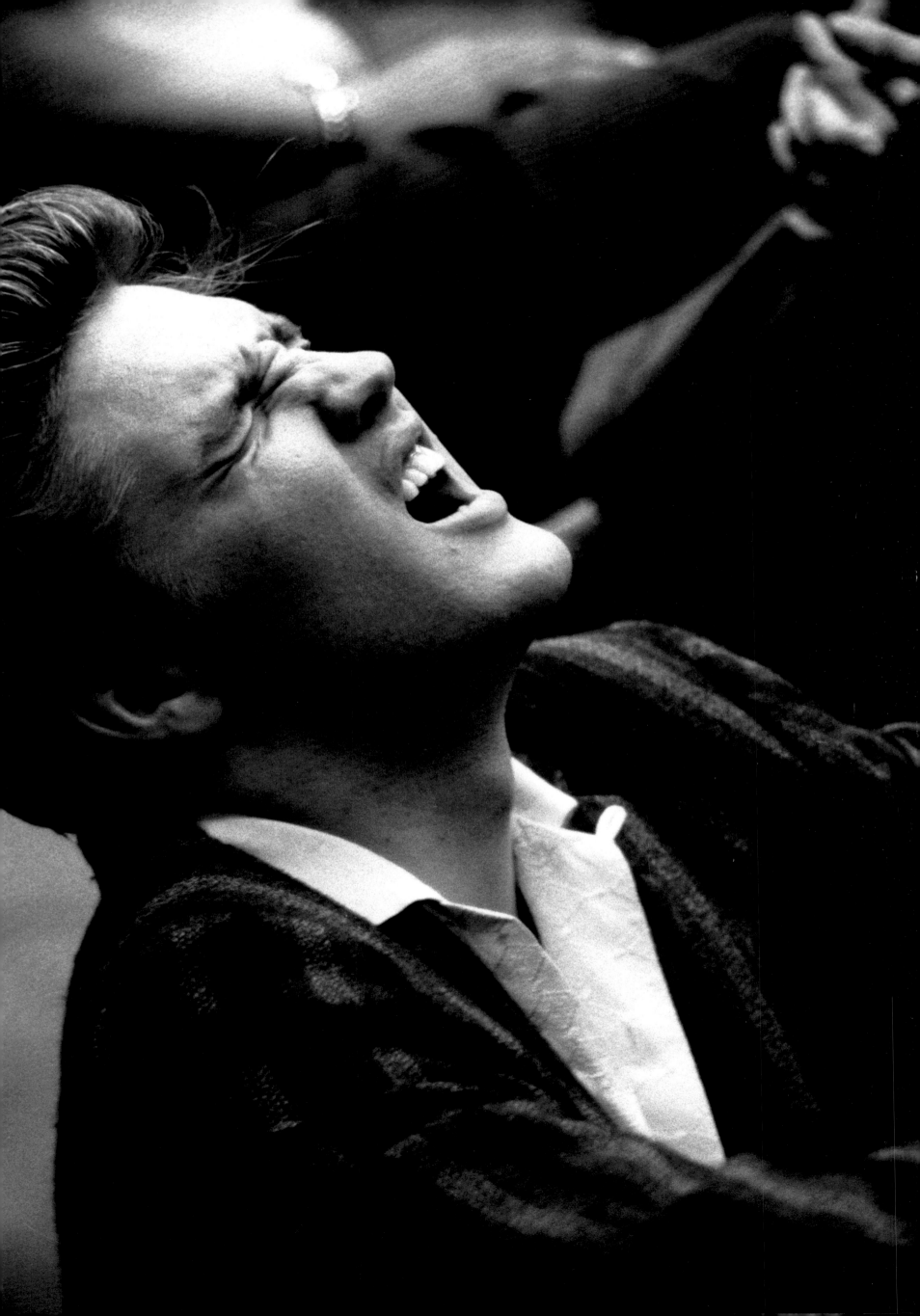

I never even thought of singing as a career. In fact I was ashamed to sing in front of anybody except my mother and daddy.

Ich dachte nie im Traum daran, Singen zu meinem Beruf zu machen. Ich habe mich eher geschämt, vor jemand anderem zu singen als meiner Mutter und meinem Daddy.

Je n'avais jamais envisagé de faire une carrière de chanteur. D'ailleurs, j'avais honte de chanter en public, sauf devant ma mère et mon père.

—ELVIS PRESLEY
Wink Martindale interview,
June 16, 1956

OPPOSITE "That's it, we've got it!" Elvis screams with delight, during a playback of "Hound Dog."

FOLLOWING SPREAD Lunch break with Hugh Jarrett, Junior Smith, Bill Black, and others.

213

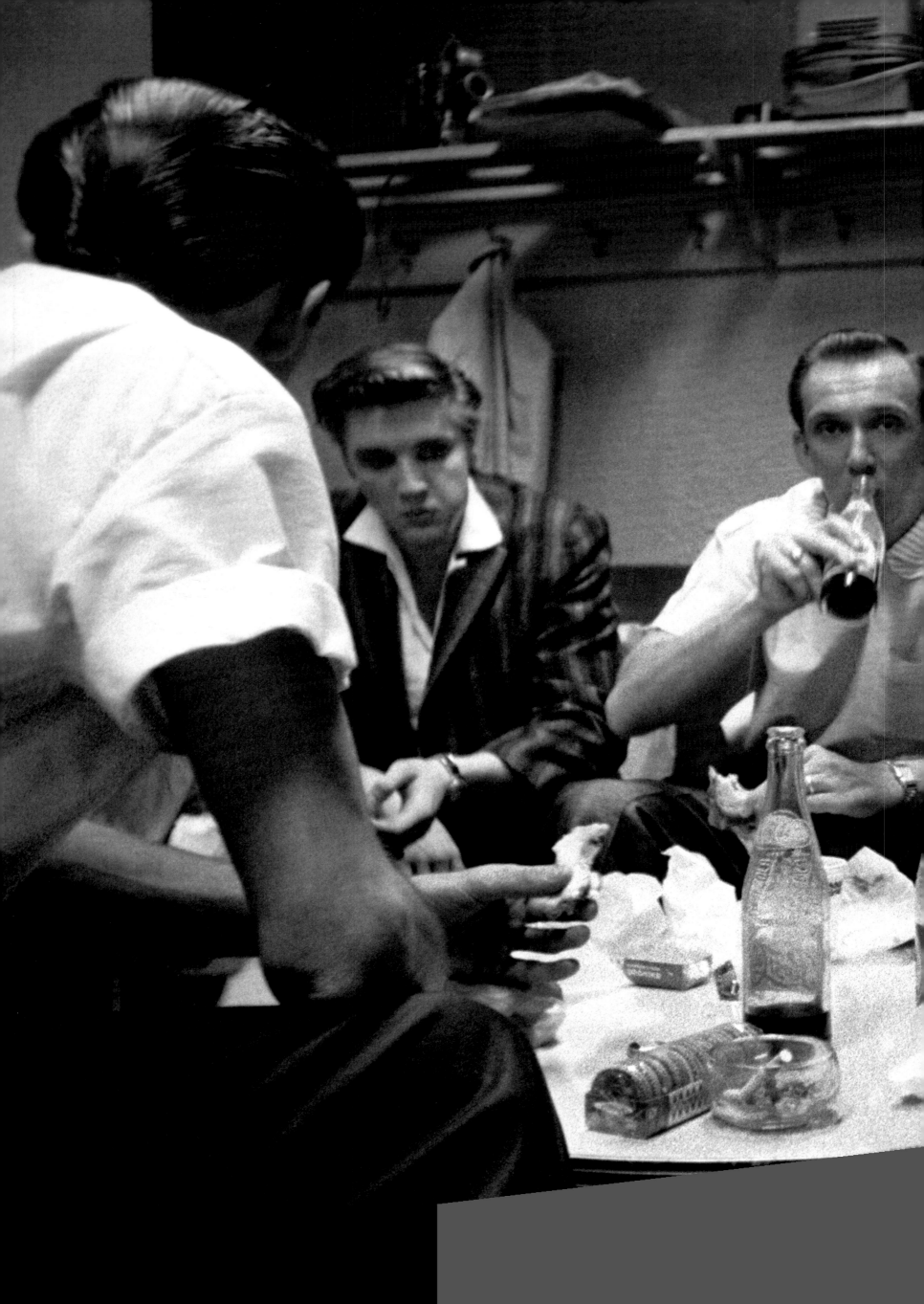

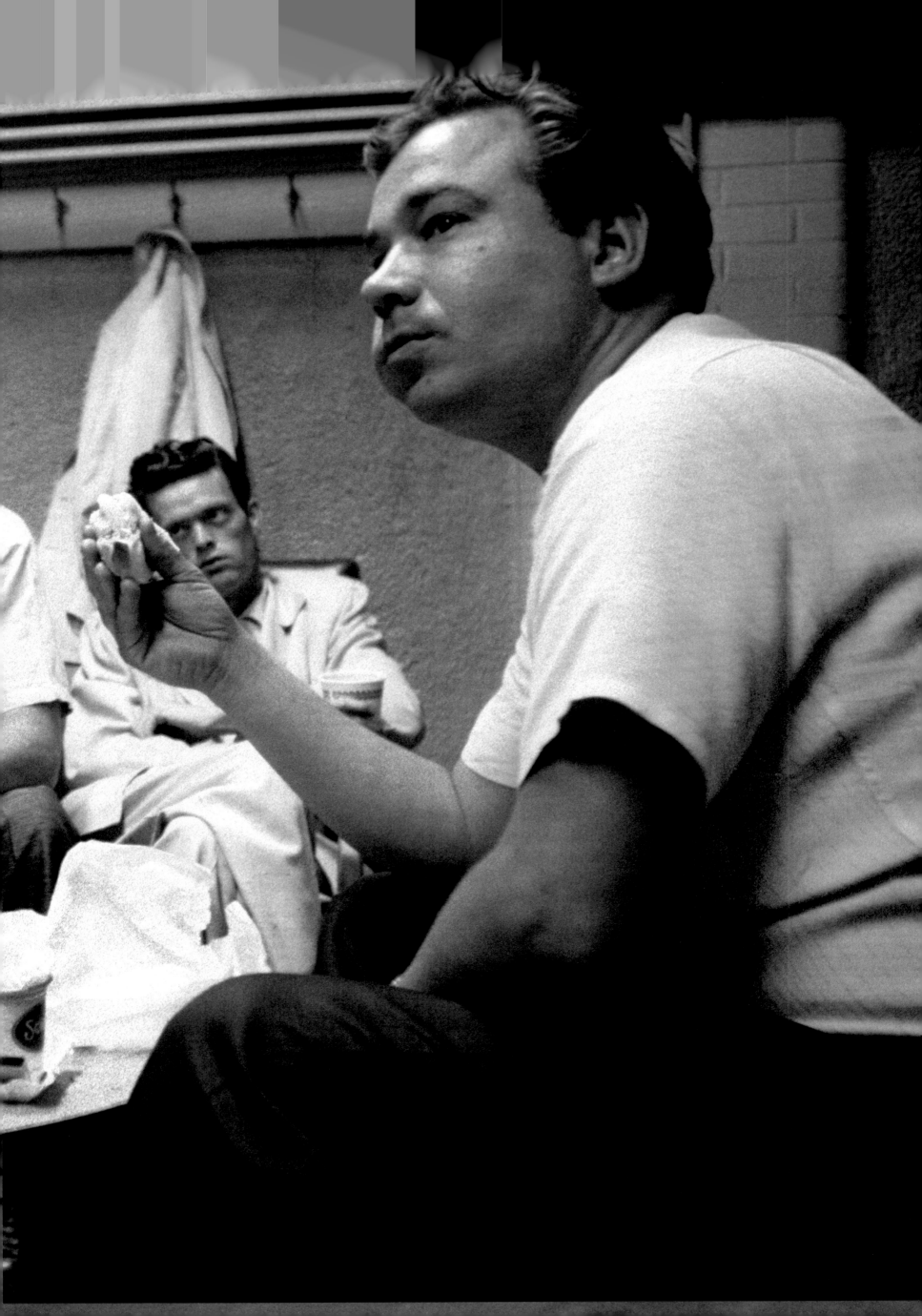

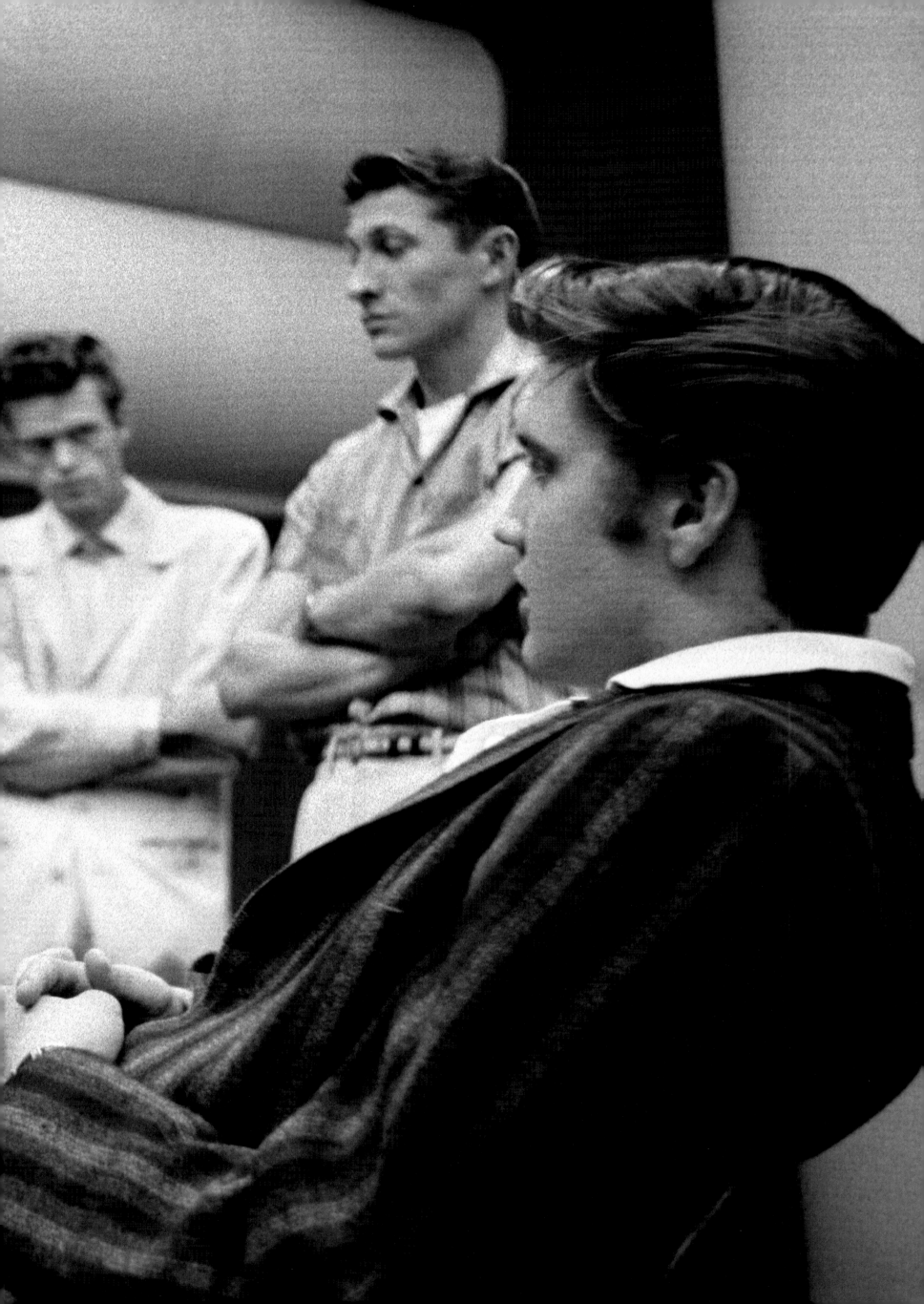

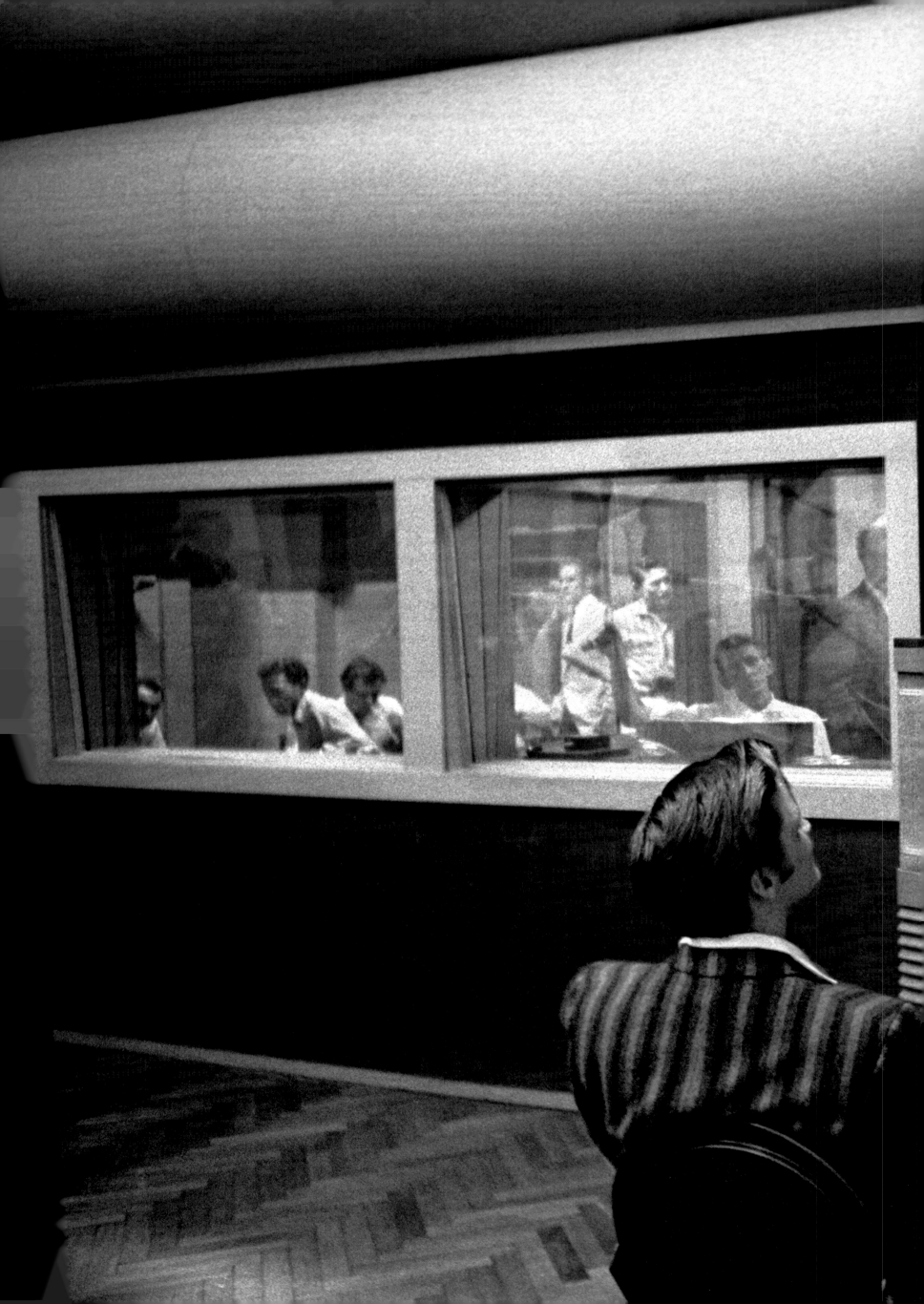

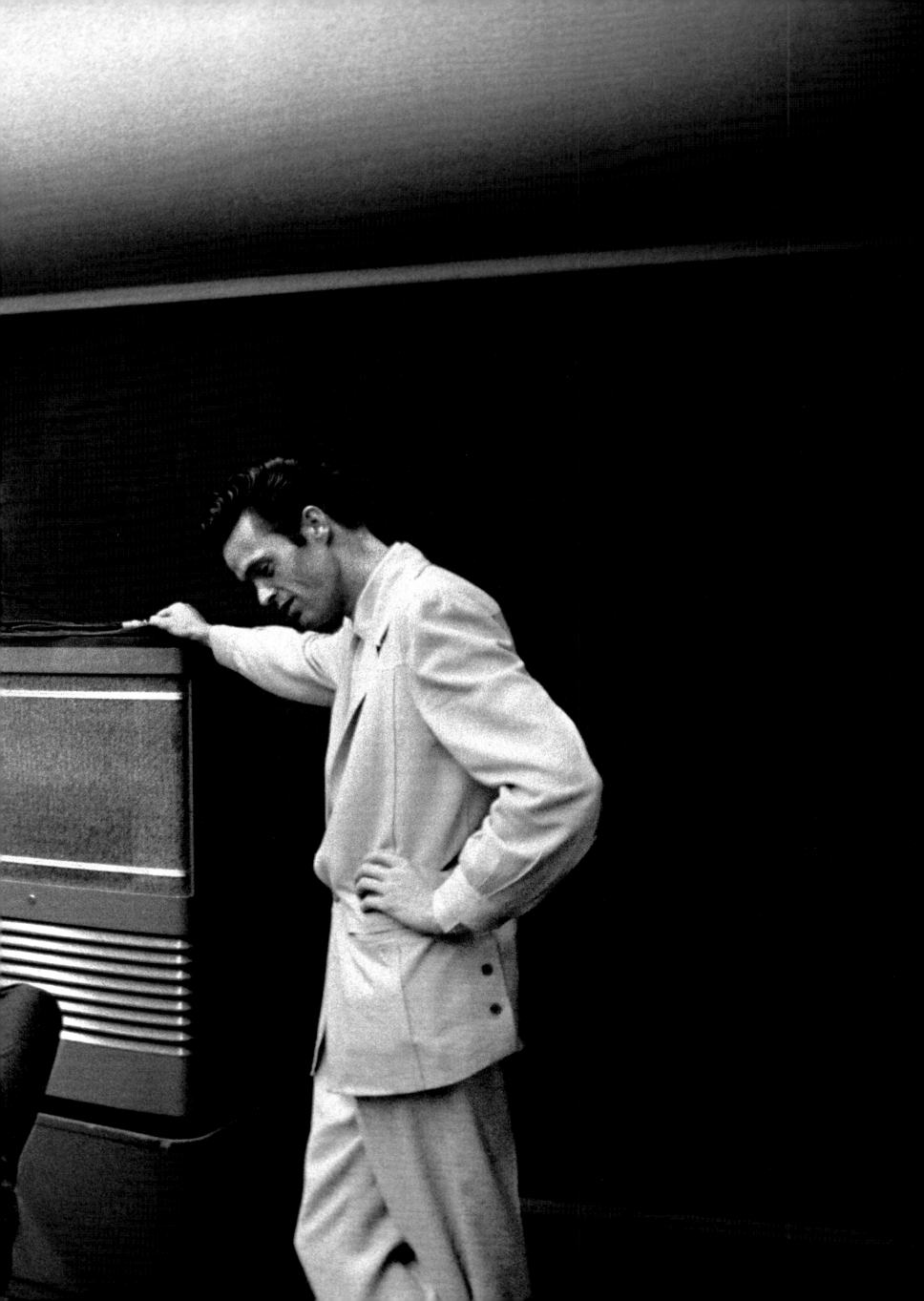

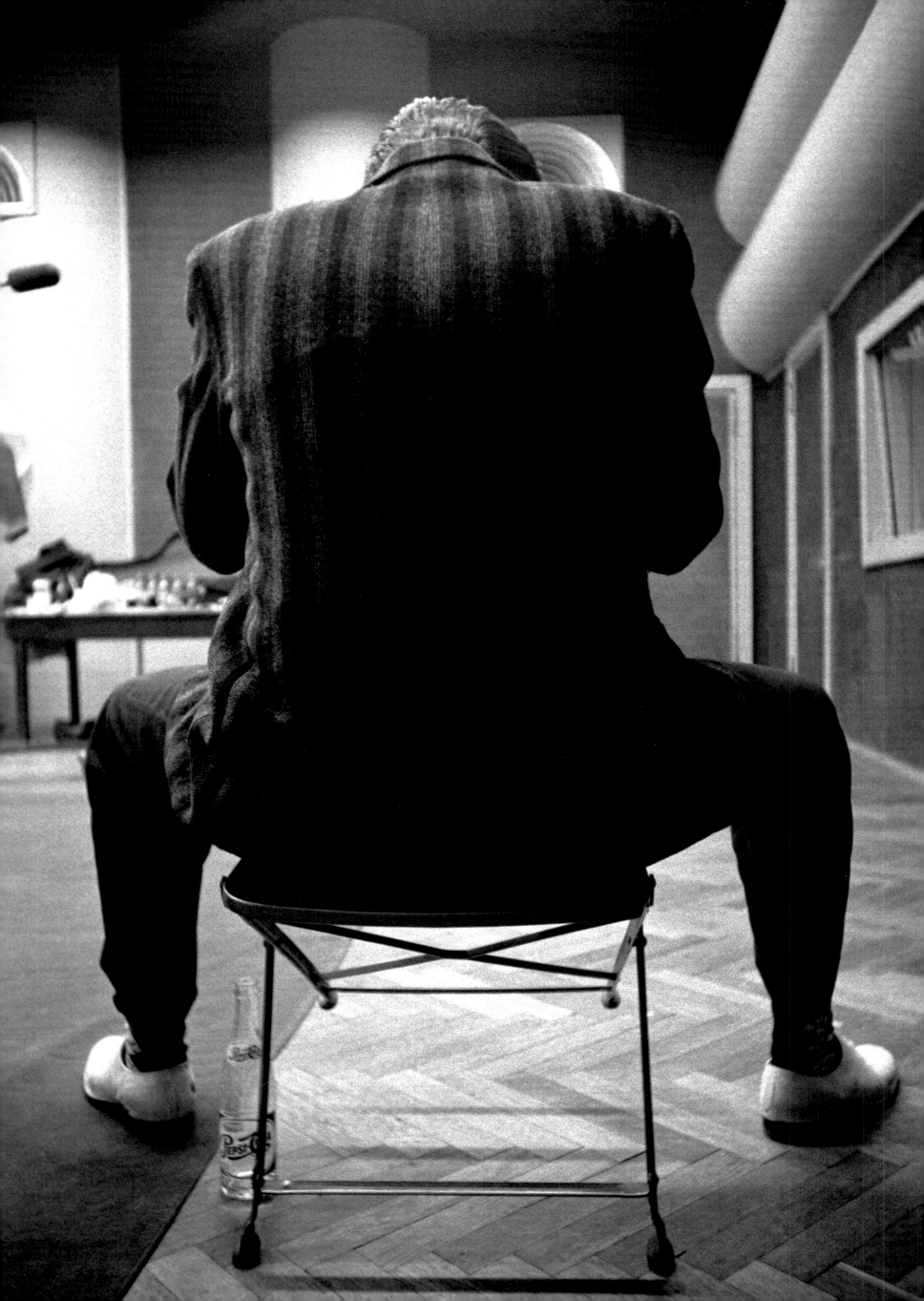

He was an integrator. Elvis was a blessing…He opened the door for black music.

Er stand für Integration. Elvis war ein Segen … Er öffnete der schwarzen Musik die Tür.

Elvis était un cadeau du ciel; il a favorisé l'intégration… et a ouvert la porte à la musique noire.

—LITTLE RICHARD

I better watch out. I believe whitey's pickin' up on things that I'm doin'.

Ich sollte besser mal aufpassen. Ich glaub, der Weiße hat kapiert, wie ich meine Sachen mache.

Il faut que je fasse gaffe. Le petit blanc empiète sur mes platebandes.

—MUDDY WATERS

PREVIOUS SPREAD Elvis and Junior Smith review playback of "Don't Be Cruel."

OPPOSITE Concentrating his efforts, Elvis listens to a playback of "Anyway You Want Me," the third song he recorded that day.

ELVIS PR

RETU

MEM

ABOARD THE

SOUTHERN RAILW

★

JULY 3-4, 1956

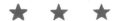

ON THE 27-HOUR TRAIN RIDE HOME from New York to Memphis, Elvis spent several hours repeatedly listening to quick acetate discs of the three final versions of his freshly recorded songs. When asked why he did not purchase a higher-quality record player, he remarked that he wanted to hear the songs the way his fans would. We transferred trains going west in Chattanooga, Tennessee, where Elvis flirted with girls and then had breakfast. Back on the train, I think Colonel Parker planted a giant stuffed panda bear knowing Elvis would find something to do with it to stir up some attention. Elvis in his boredom decided to pick up the panda, put it on his left hip, and proceeded to walk down the aisle to the other end of the car. I followed him discreetly with my camera. After drinking a cup of water, he asked some young girls if they were coming to his concert and they replied, "Who are you?" He said, "Elvis Presley." "How do we know that?" "You see that photographer over there? If I wasn't him do you think he would be taking my picture?" was his reply.

AUF DER LANGEN HEIMFAHRT MIT DER BAHN, die uns in 27 Stunden von New York zurück nach Memphis bringen sollte, brachte Elvis einige Stunden damit zu, sich immer wieder die tags zuvor aufgenommen Endfassungen seiner drei neuen Songs anzuhören, von denen schnelle Azetatplatten geschnitten worden waren. Auf die Frage, warum er sich nicht einen Plattenspieler mit besserer Tonqualität zulege, meinte er, dass er die Songs so hören wolle wie seine Fans. Beim Umsteigen in Chattanooga, Tennessee, flirtete Elvis mit ein paar Mädels herum und ging dann frühstücken. Als wir wieder im Zug saßen, hatte jemand, ich glaube, Colonel Parker, einen Riesenpanda aus Plüsch auf einen der Sitze gepflanzt, wohl wissend, dass Elvis schon etwas damit einfallen würde, um ein wenig Aufmerksamkeit zu erregen. In seiner Langeweile schnappte sich Elvis den Panda irgendwann, setzte ihn sich auf die linke Hüfte und ging damit den Gang hinunter bis ans Ende des Wagens. Ich folgte ihm diskret mit meiner Kamera. Nachdem er etwas getrunken hatte, fragte er ein paar junge Mädchen, ob sie zu seinem Konzert kämen, und sie fragten zurück: „Wer bist du denn?" Er sagte: „Elvis Presley." „Wer sagt uns, dass das stimmt?" „Seht ihr den Fotografen da drüben? Glaubt ihr, er würde Bilder von mir machen, wenn ich es nicht wäre?"

AU COURS DU LONG VOYAGE EN TRAIN de New York à Memphis (27 heures), Elvis passa plusieurs heures à écouter en boucle les trois versions finales qu'il avait enregistrées la veille sur des disques acétate. Quand on lui demanda pourquoi il n'achetait pas un tourne-disque de meilleure qualité, il répondit qu'il voulait entendre ses chansons dans les mêmes conditions que ses fans. Nous changeâmes de train à Chattanooga, dans le Tennessee, où il flirta avec des filles et prit son petit-déjeuner. De retour à bord, il trouva un panda en peluche sur son siège. Il avait sans doute été placé là par le colonel Parker qui se doutait qu'Elvis trouverait le moyen de s'en servir pour attirer l'attention. En effet, pour briser l'ennui, il cala la peluche contre sa hanche et se mit à déambuler dans la voiture. Je le suivis discrètement. Après avoir bu un verre d'eau, il demanda à des adolescentes si elles assisteraient à son concert. « Vous êtes qui ? » demandèrent-elles. « Elvis Presley. » « Qui nous dit que c'est vrai ? » « Vous voyez le photographe là-bas ? Si je n'étais pas Elvis, vous croyez qu'il me prendrait en photo ? »

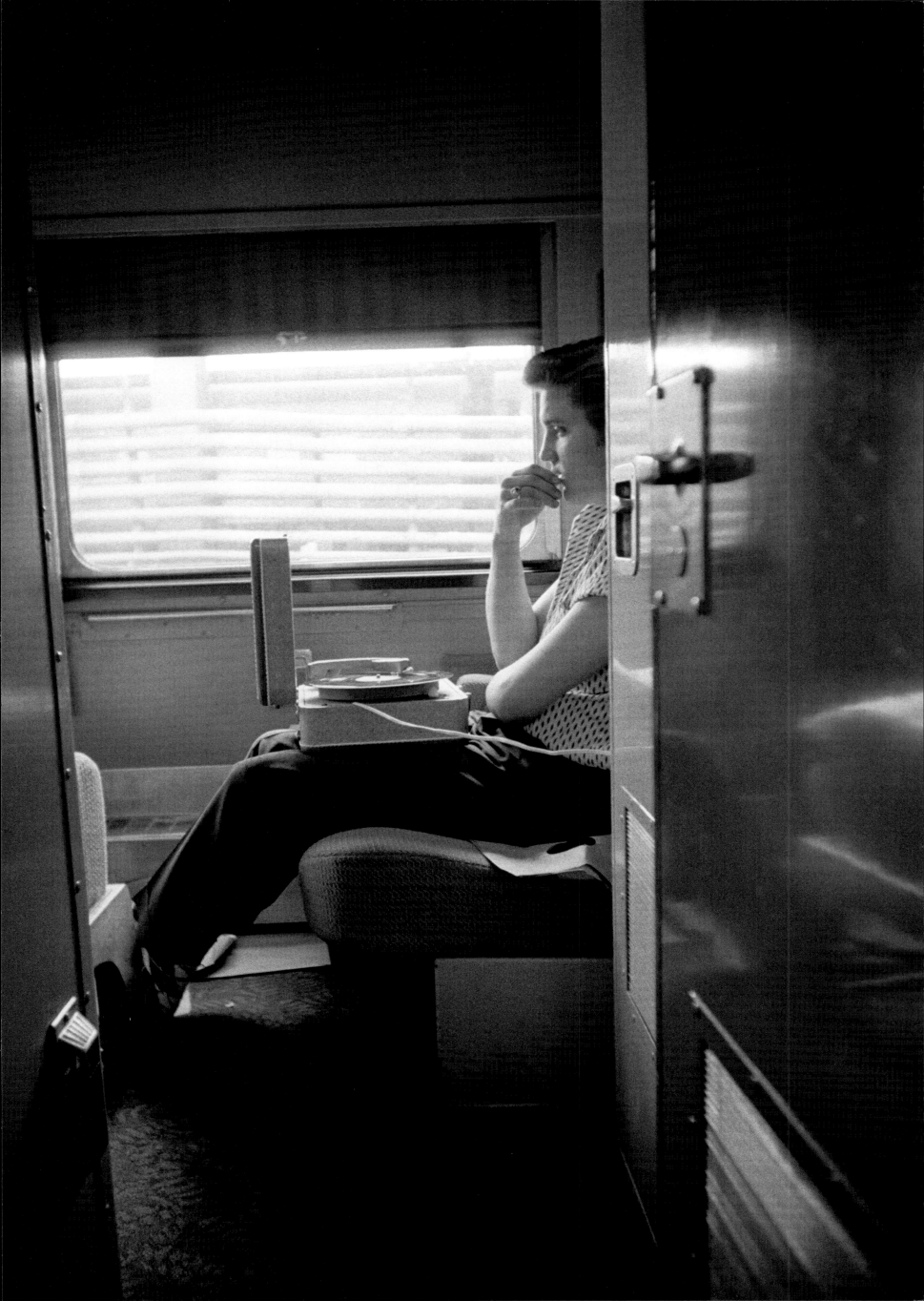

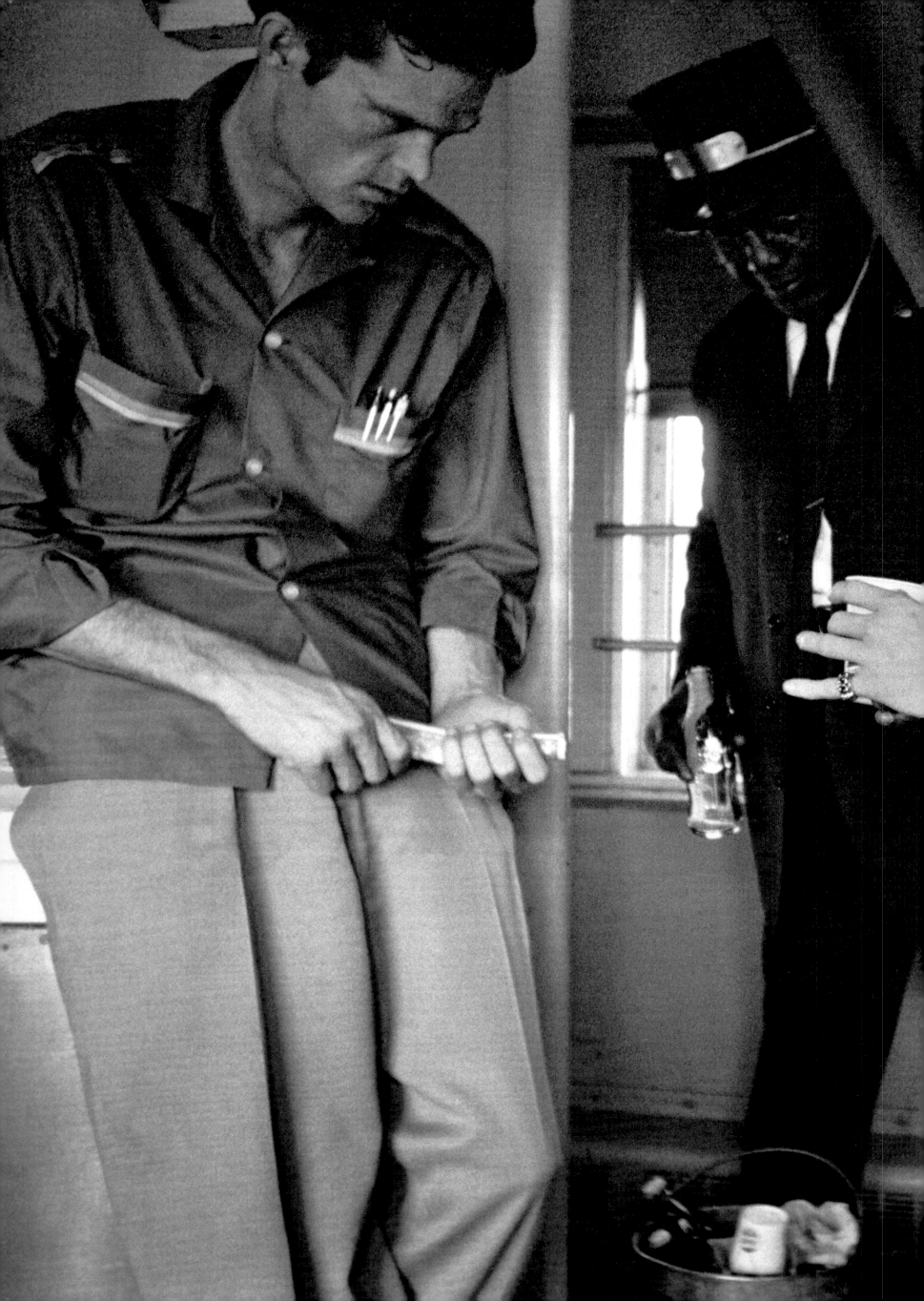

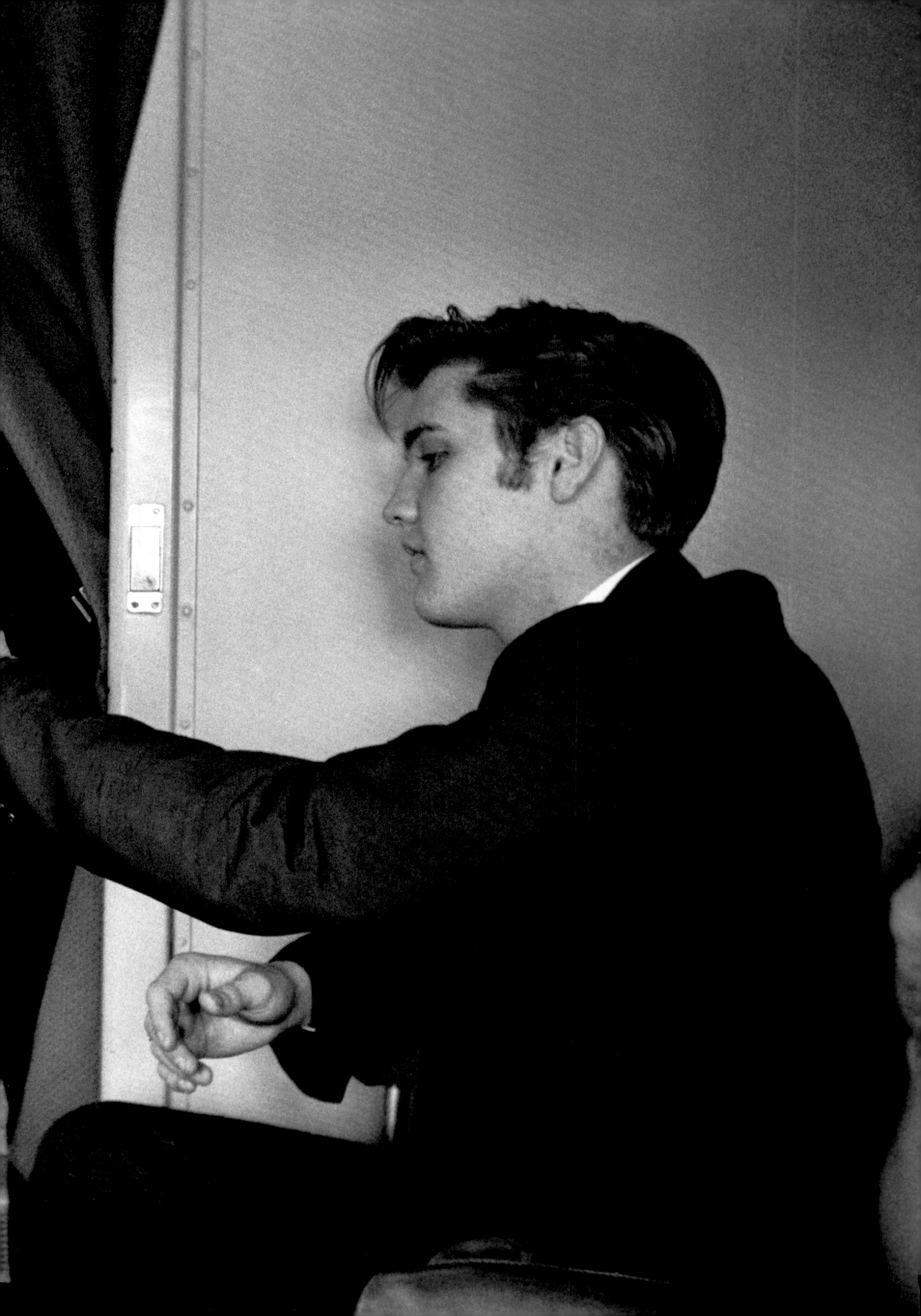

Elvis is a clean-cut, sincere, honest youngster who knows he is in the limelight but as yet is unspoiled. This six foot, blue eyed kid has his brown hair cut in a style that is his trade mark—a heavy mop over his forehead, a ducktail in the back, and sideburns. His nose is straight, a set jaw, and has a strong mouth. Yes, Madam, he is brutish and handsome.

Elvis ist ein feiner, anständiger, ehrlicher junger Mann, der weiß, dass er im Rampenlicht steht, aber bis jetzt noch unverdorben ist. Dieser 1,80 m große Junge mit den blauen Augen trägt seine dunkelblonden Haare in einem Stil, der sein Markenzeichen ist – eine dichte Tolle über der Stirn, einen Entenschwanz im Nacken und Koteletten. Seine Nase ist gerade, das Kinn energisch, und er hat einen ausdrucksstarken Mund. Ja, verehrte Leserin, er ist animalisch und attraktiv.

Elvis est un garçon honnête, sincère et soigné qui ne laisse pas le succès lui monter à la tête. Ce gamin d'un mètre quatre-vingts aux yeux bleus a une coupe de cheveux qui n'appartient qu'à lui: une épaisse mèche brune enroulée qui lui retombe sur le front, une raie derrière la nuque et des favoris. Il a le nez droit, la mâchoire ferme et une grande bouche. Oui, madame, il a un côté animal et il est séduisant.

—RUBY WOODS
Detroit Tribune, March 23, 1957

227 Aboard the train to Memphis, Elvis plays recordings from the RCA Victor session on an inexpensive portable record player to get a feeling for how his fans will hear the songs.

PREVIOUS SPREAD Junior Smith buys a soda for Elvis from the porter on the train.

OPPOSITE Even with his distinctive looks and recent shot to national fame over months of televised appearances, Elvis is still able to travel from New York to Memphis largely unrecognized.

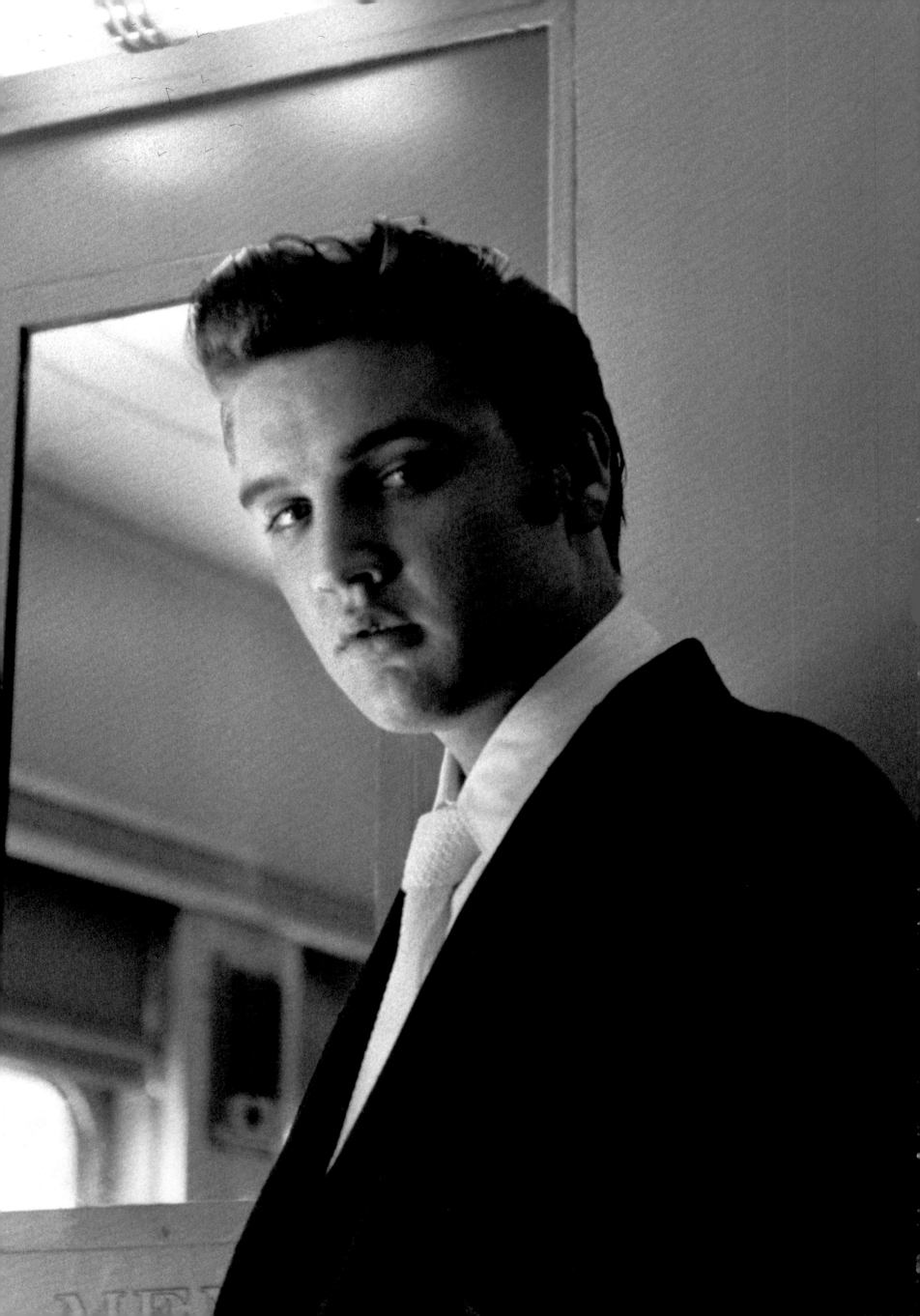

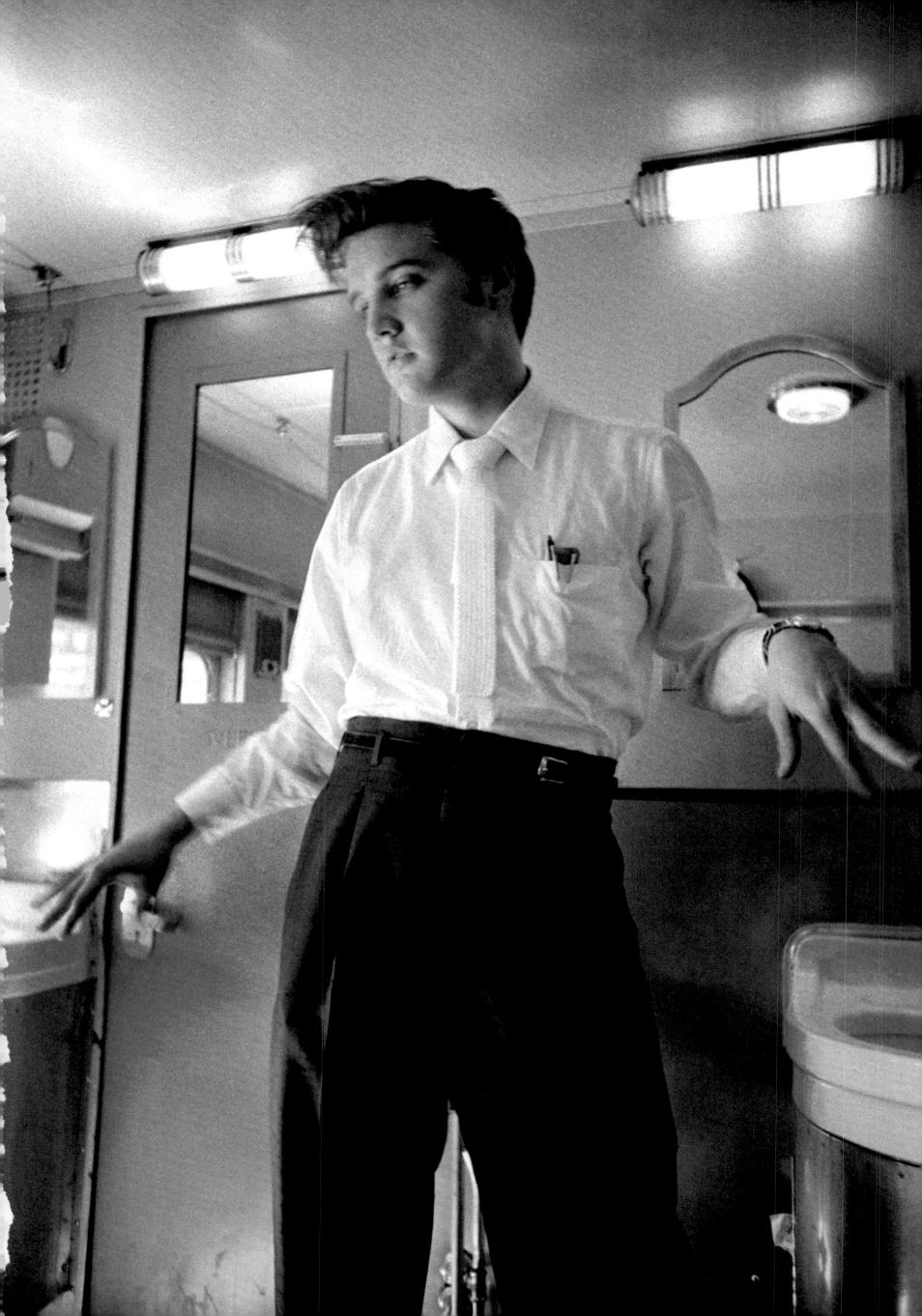

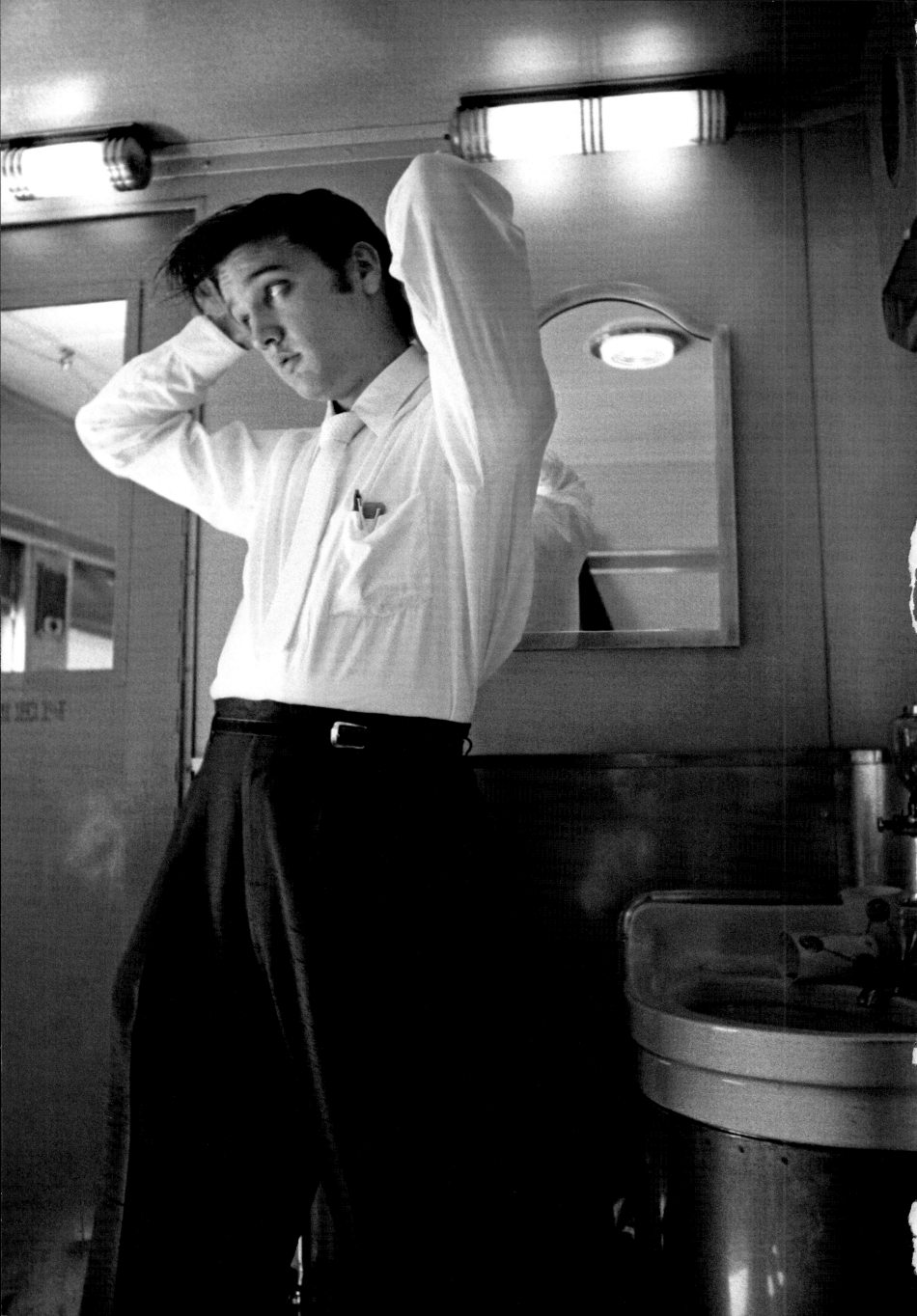

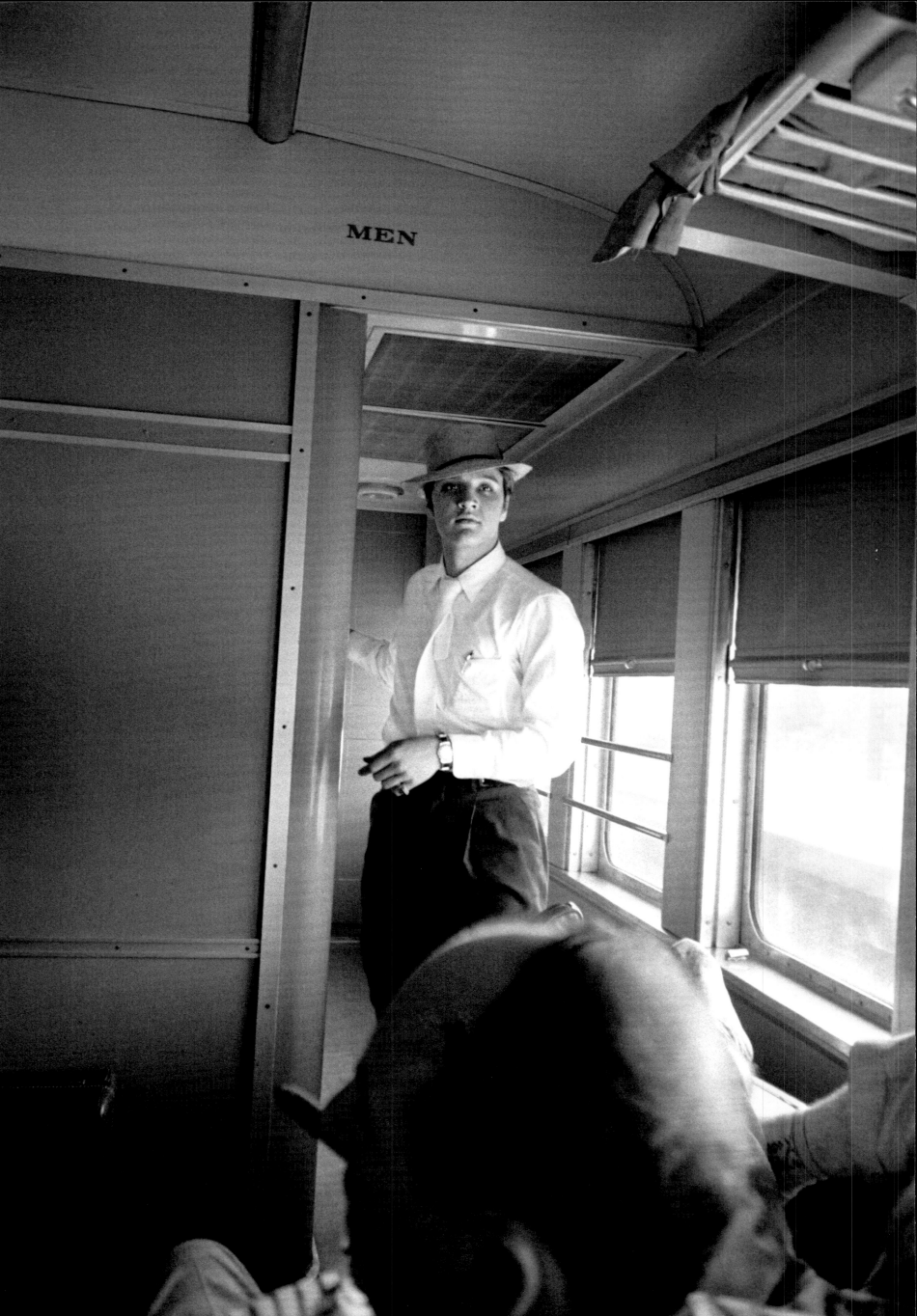

If Colonel Parker made Elvis Presley, then why didn't he make another one?

Wenn Colonel Parker Elvis Presley gemacht hat, warum hat er dann nicht noch einen gemacht?

Si c'est le colonel Parker qui a fait Elvis, pourquoi il n'en a pas fabriqué un autre?

—RICKY STANLEY
Elvis's stepbrother

FOLDOUT Wertheimer has complete access to his subject, even in the washroom, where the photographer will make one of his favorite Elvis images (far right): *No More Paper Towels*, the Southern Railway local train, New York to Memphis, July 4, 1956.

OPPOSITE Elvis dons Colonel Parker's hat in jest. The Colonel does not react.

237

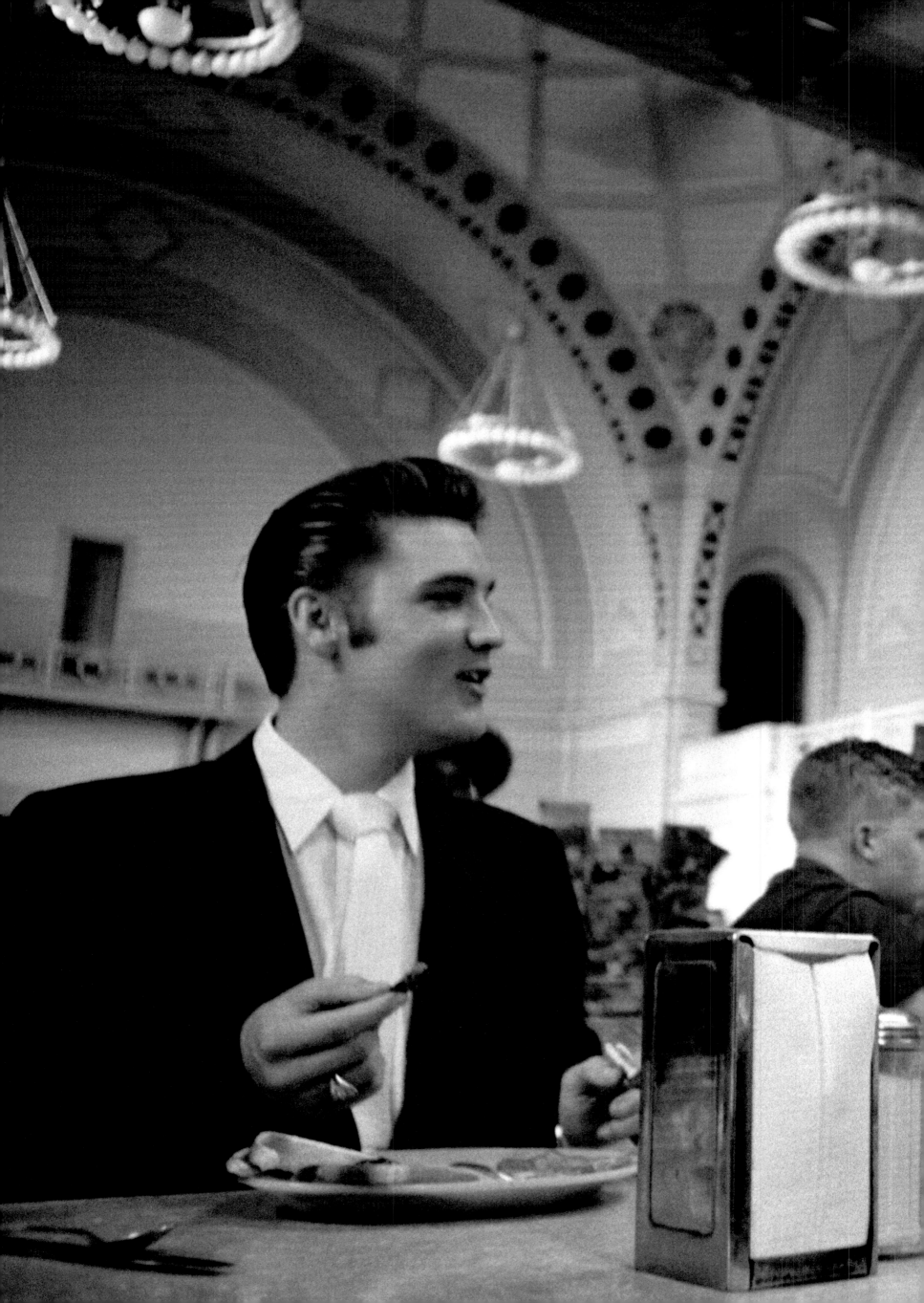

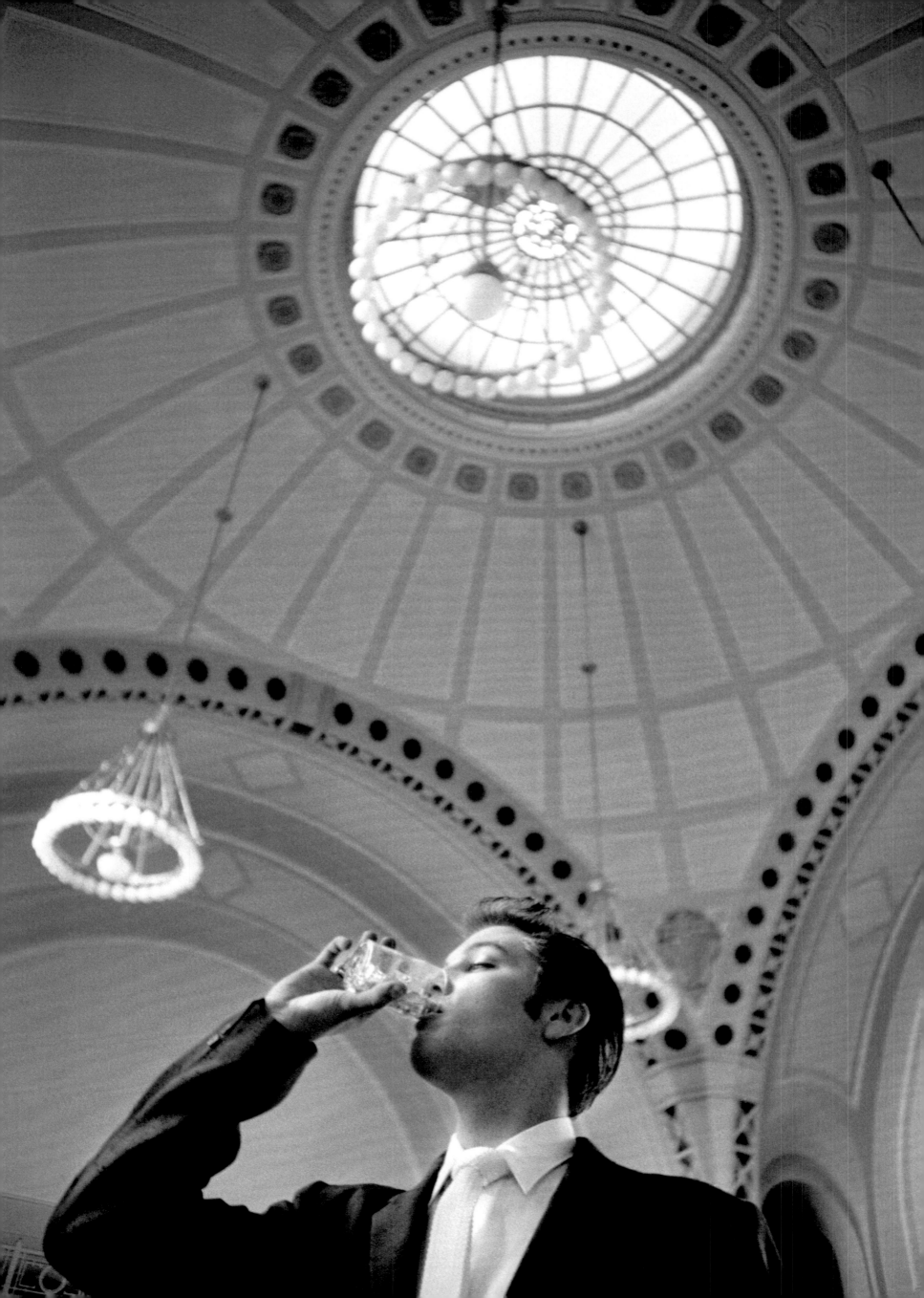

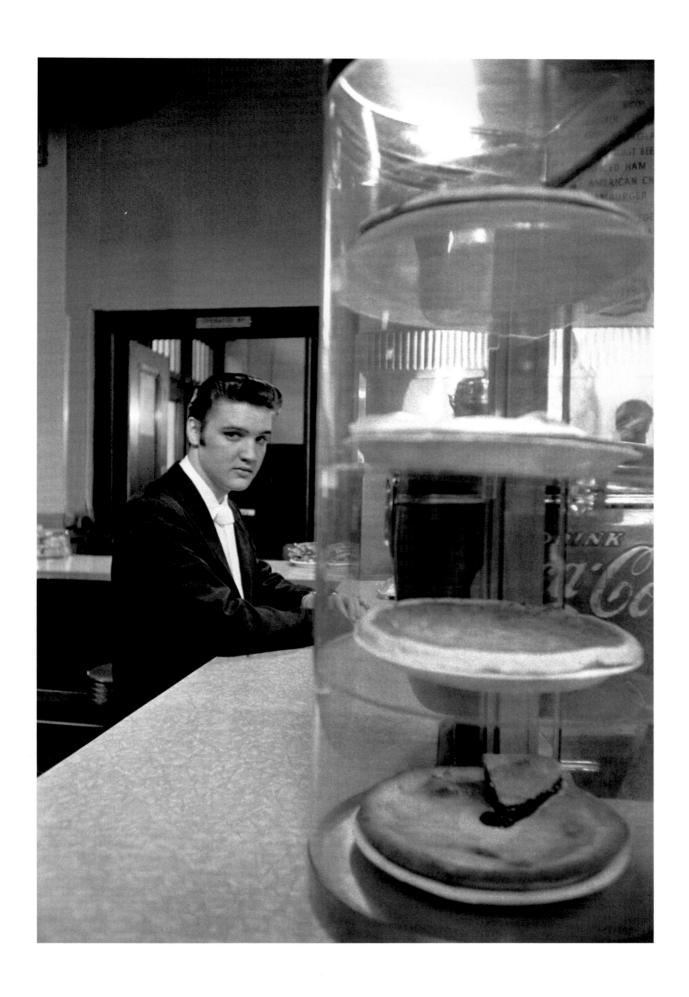

PREVIOUS SPREAD A stop for breakfast while changing trains in Chattanooga, Tennessee.

OPPOSITE Elvis finishes his drink at the coffee shop counter of the Chattanooga Terminal Station.

ABOVE *Apple Pie and Coke*, Chattanooga Terminal Station coffee shop, July 4, 1956.

OPPOSITE *Segregated Lunch Counter*, Chattanooga
Terminal Station, July 4, 1956. While Elvis awaits
his food, a woman orders a tuna fish sandwich
but cannot sit down.

FOLLOWING SPREAD *Lunchtime, Sheffield, Alabama,*
en route to Memphis, July 4, 1956.

242

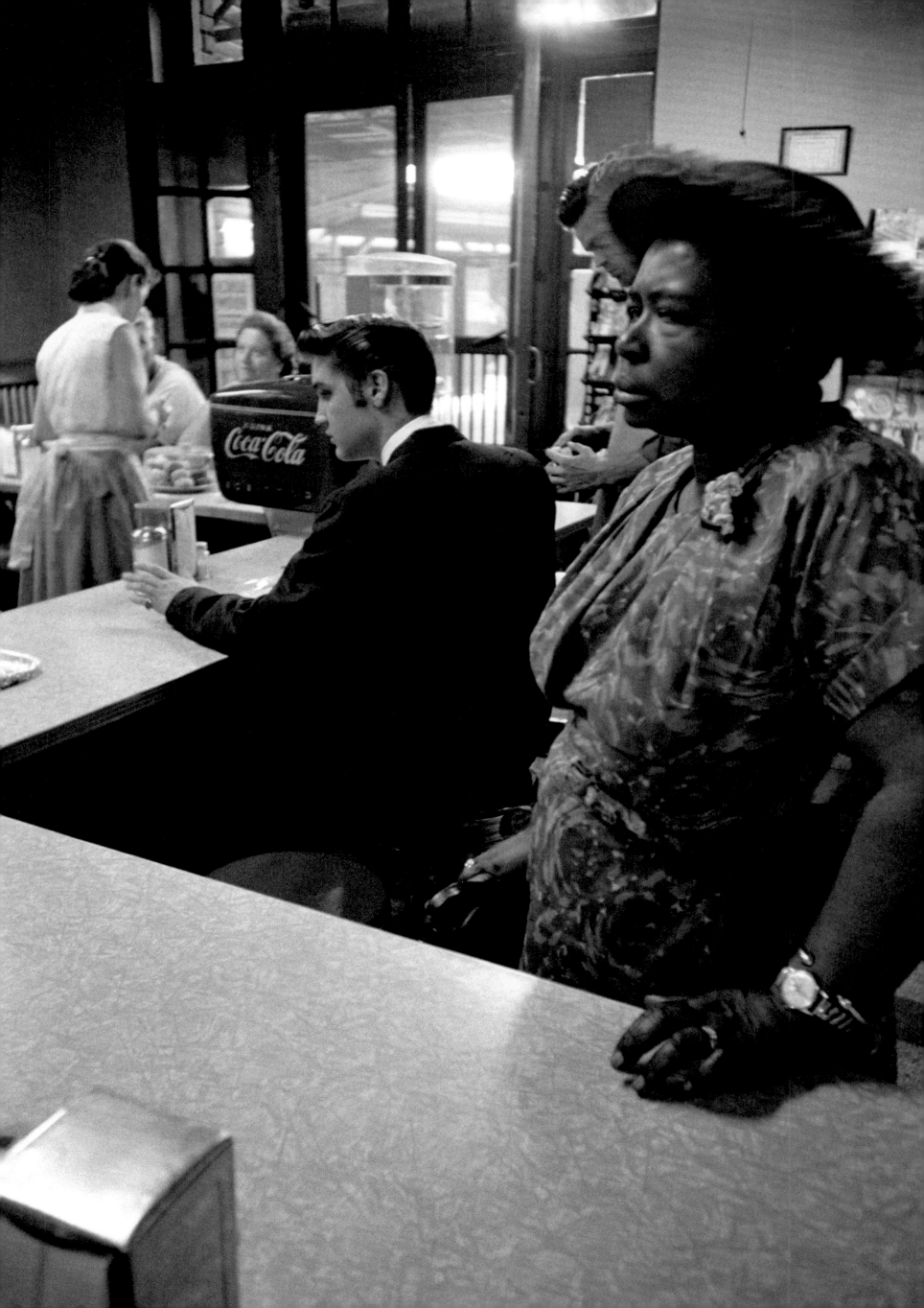

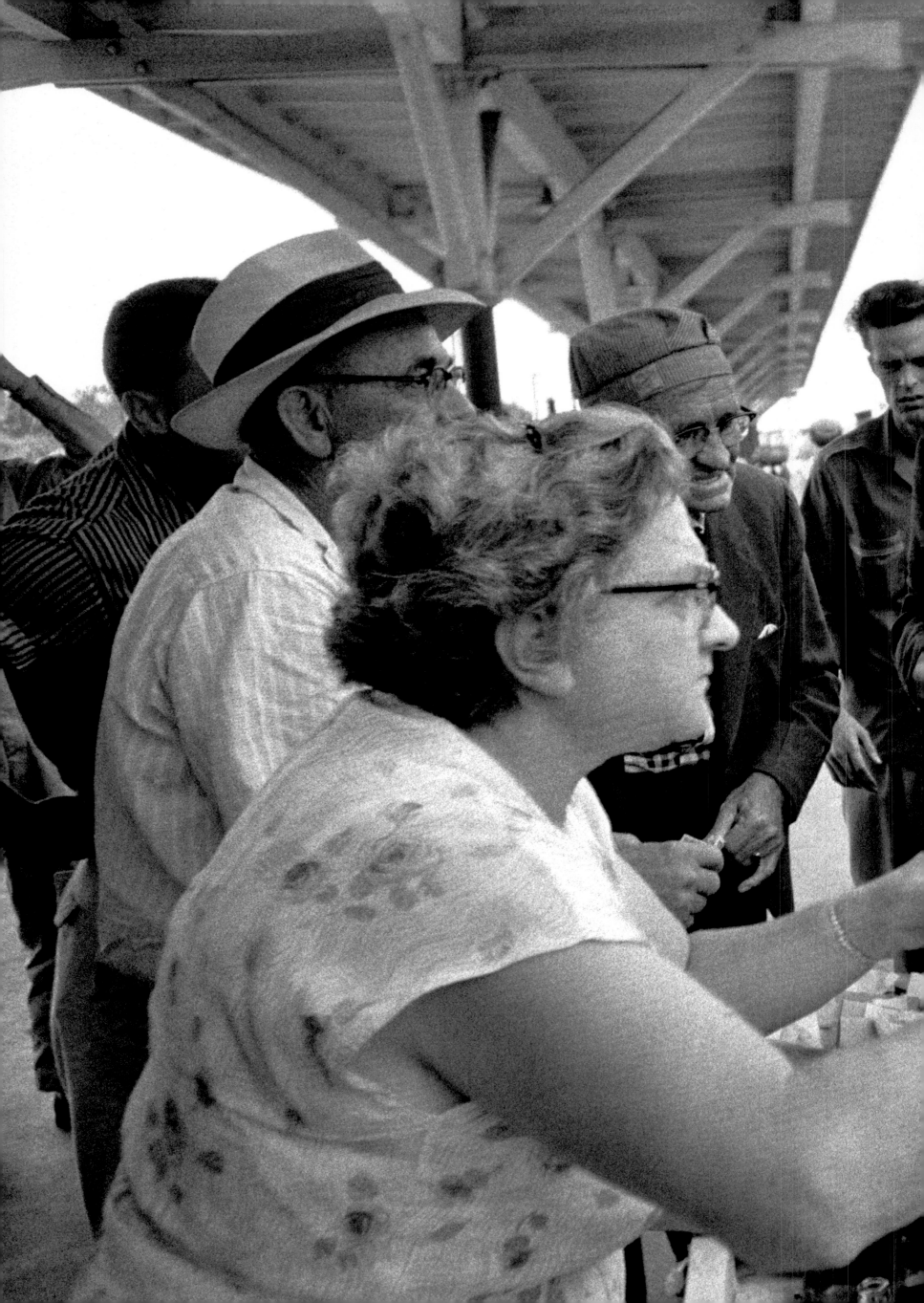

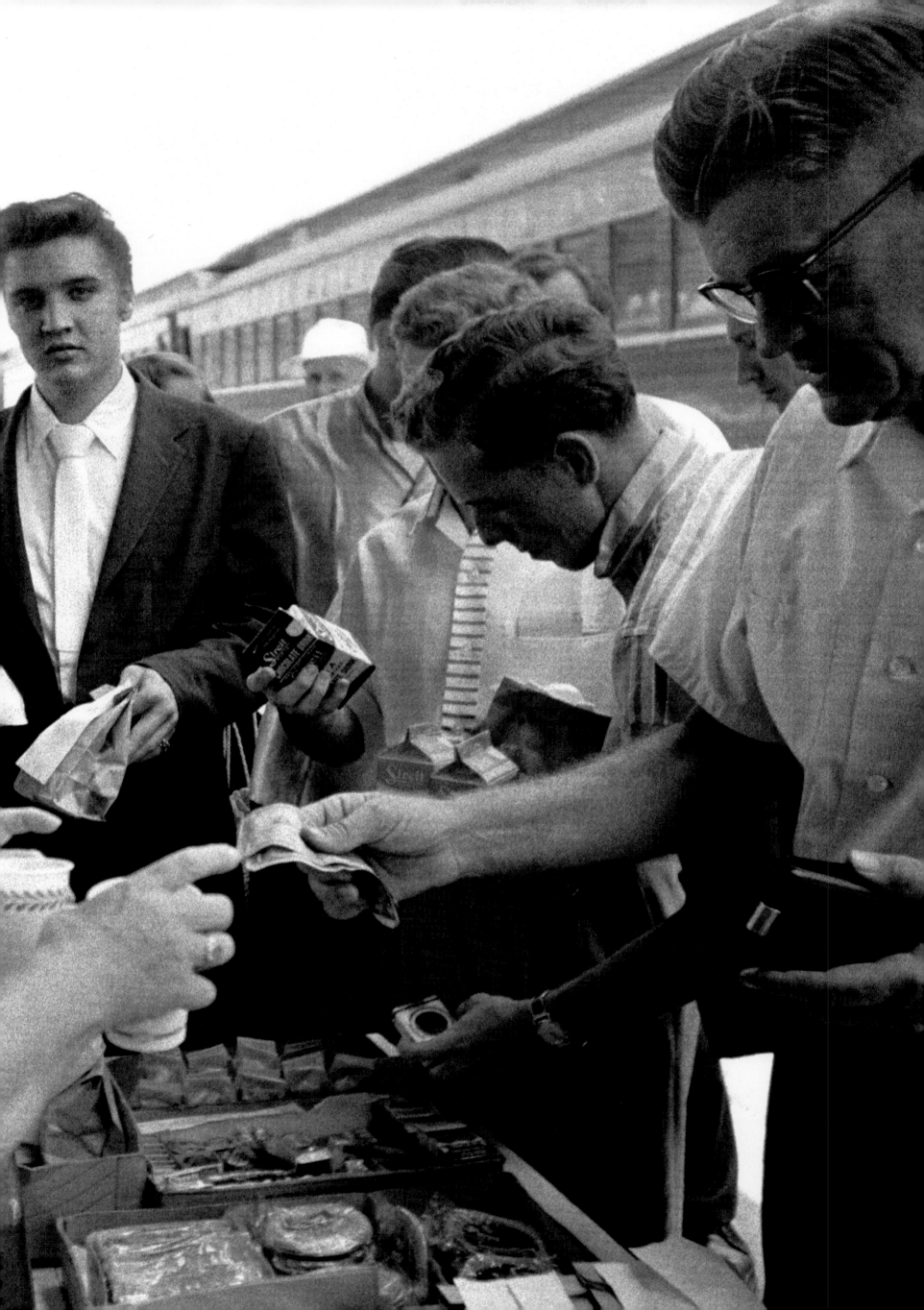

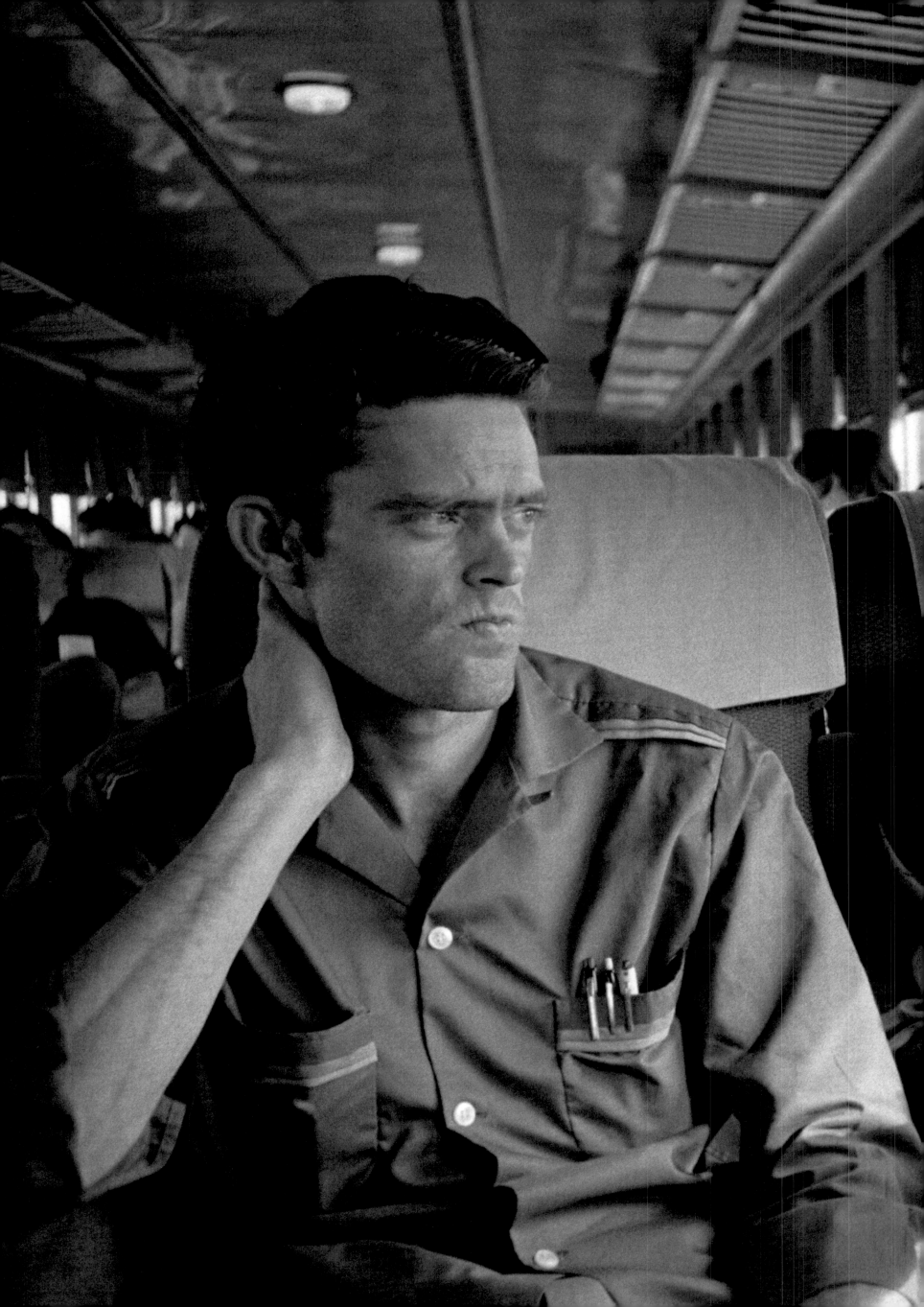

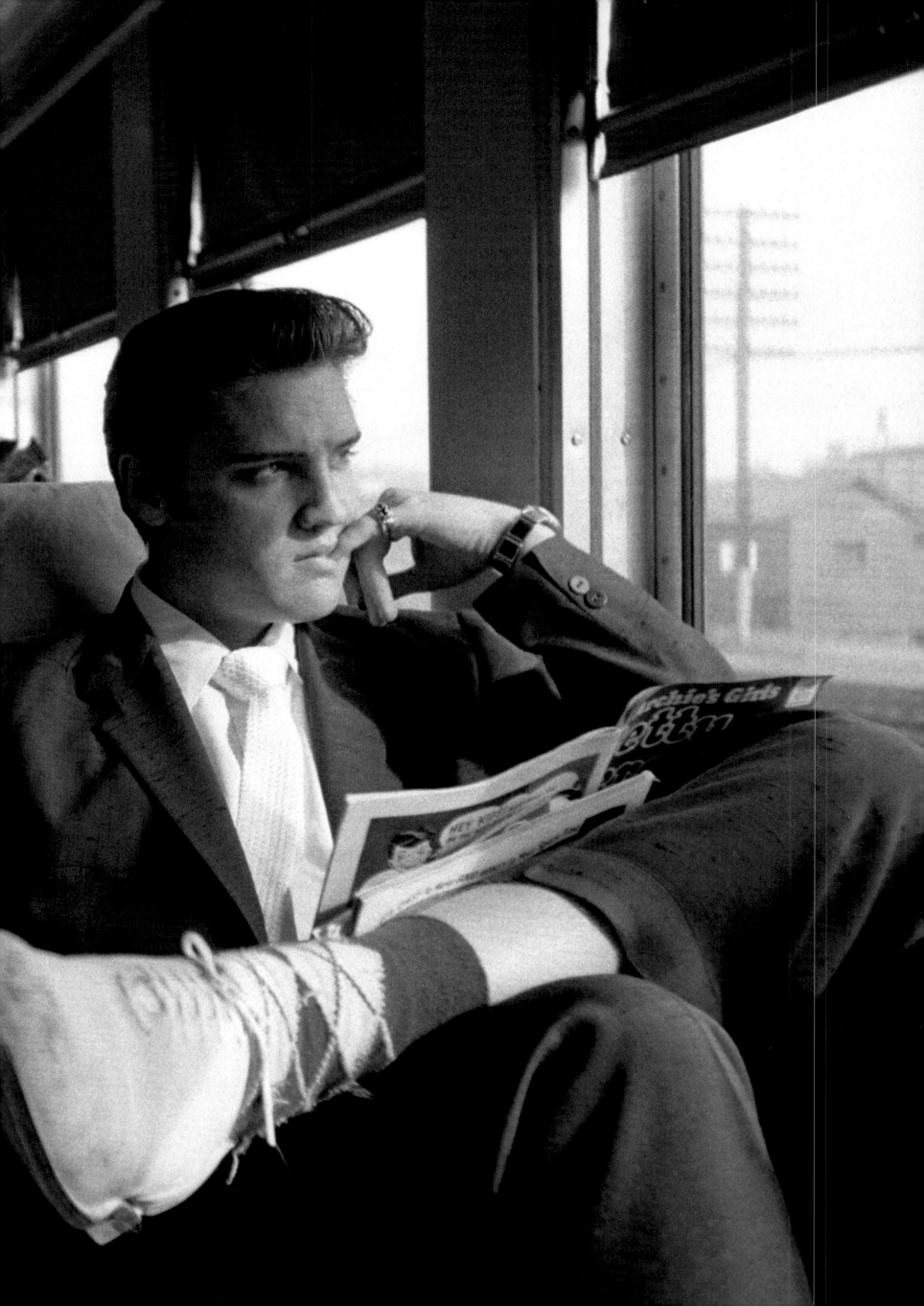

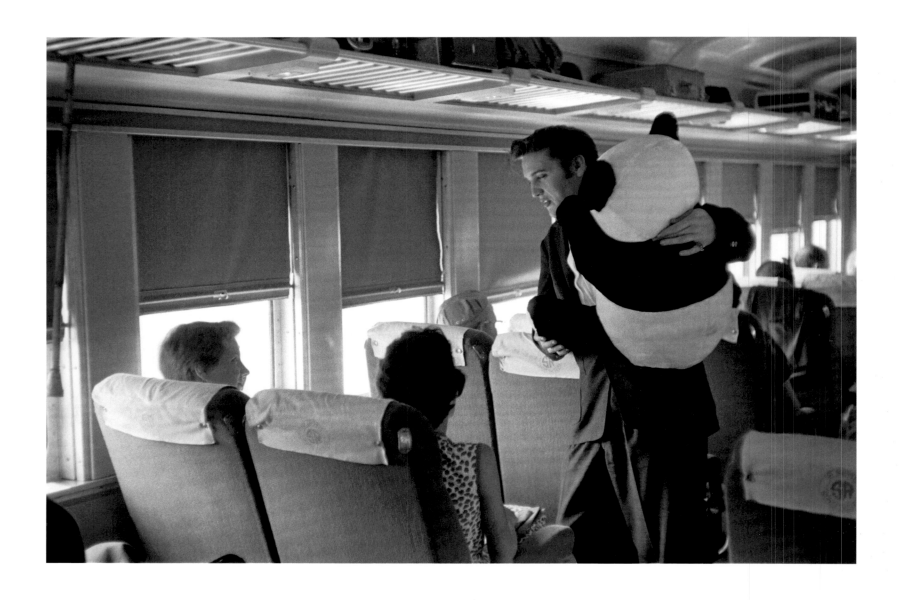

PREVIOUS SPREAD With Junior Smith, Elvis watches the view roll by when not reading *Archie* comics.

ABOVE "Are you coming to my concert tonight?" "Well, who are you?" "I'm Elvis Presley." "How do we know that?" "You see that photographer over there taking my picture? Would he be doing that if I wasn't Elvis Presley?"

OPPOSITE & FOLLOWING SPREADS A three-foot-tall stuffed panda arrives mysteriously the first day of the train ride, and rumor has it the Colonel is responsible.

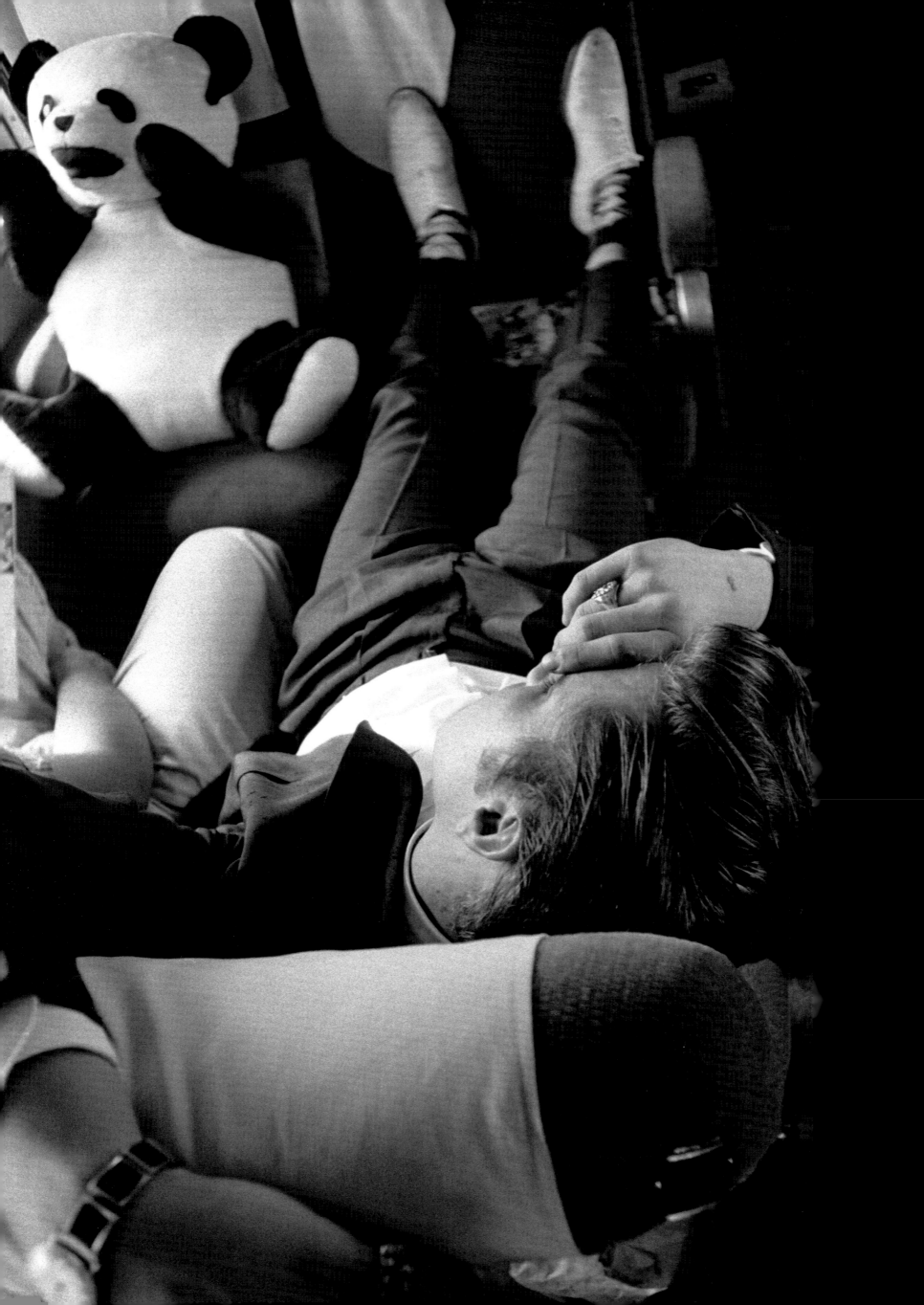

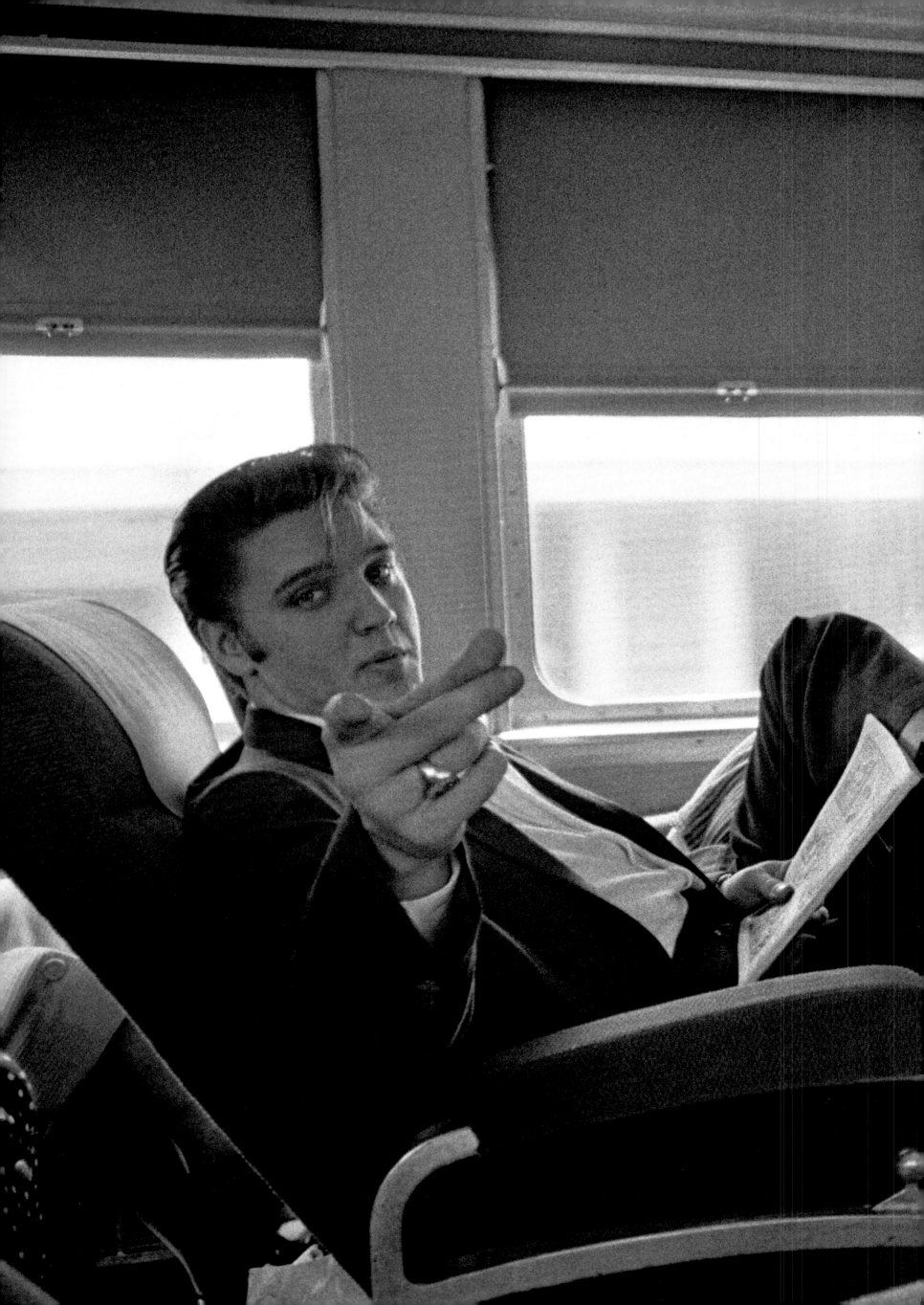

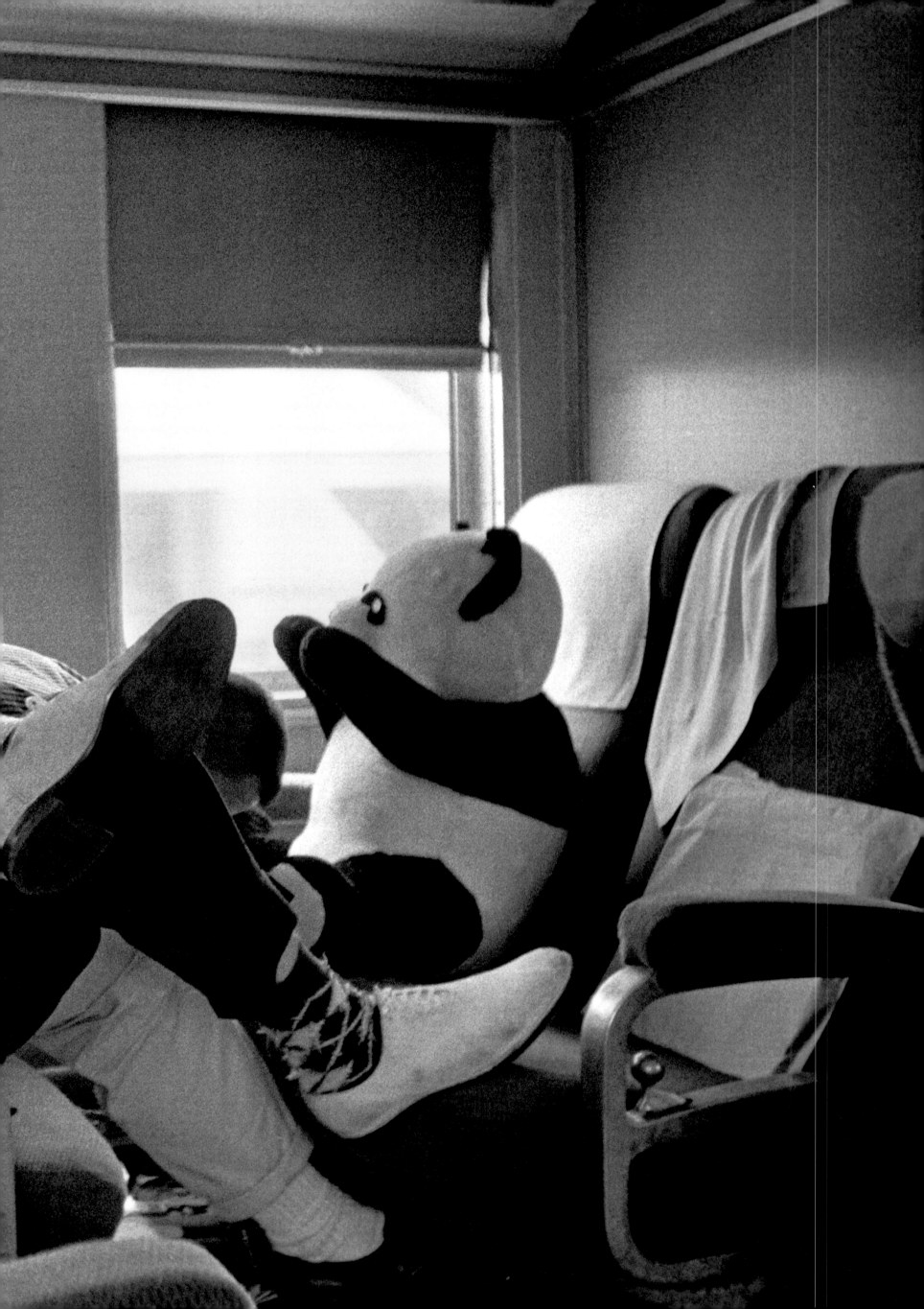

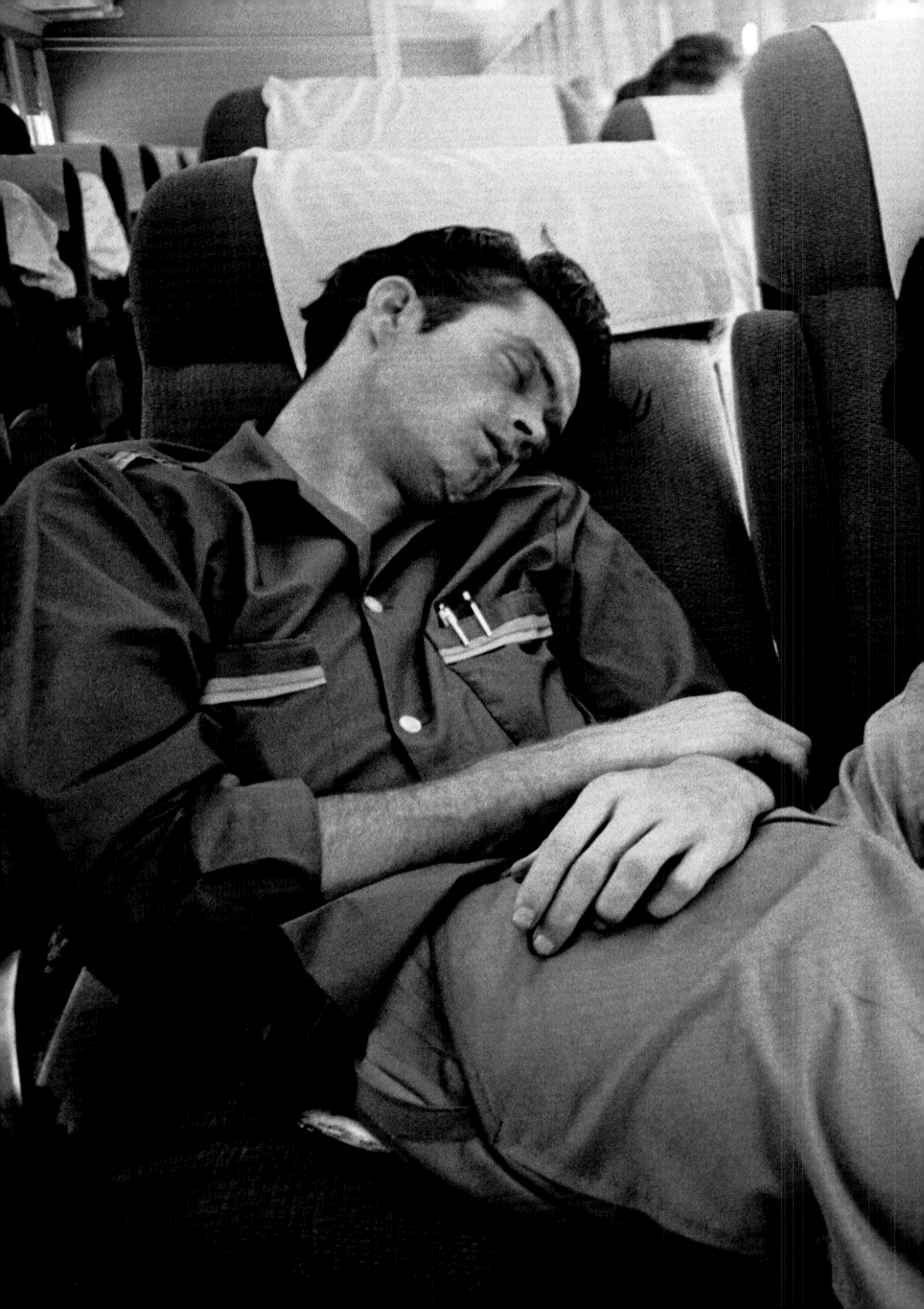

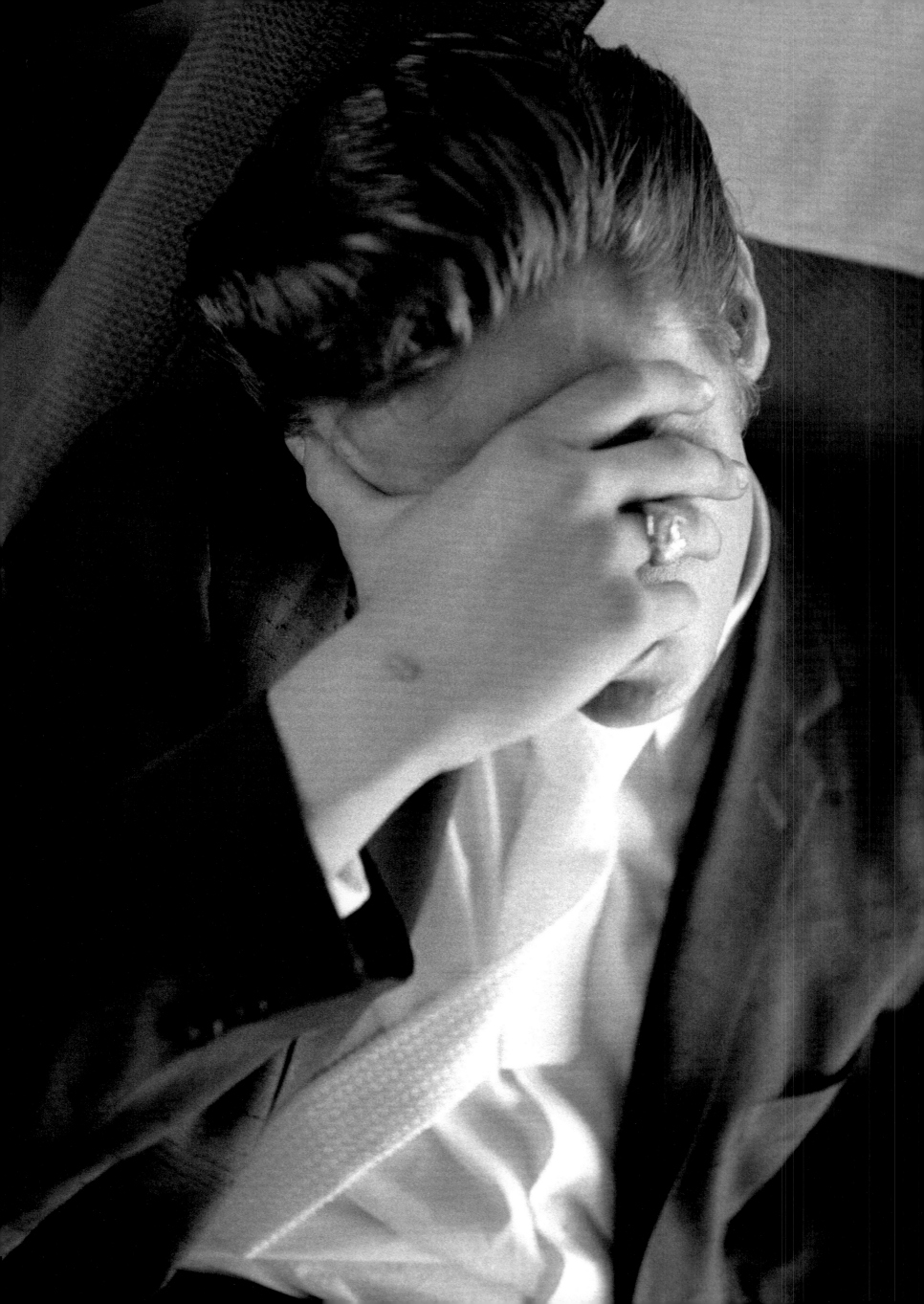

There were people that didn't like Jesus Christ. They killed him and Jesus Christ was a perfect man. And there's gonna be people that don't like ya regardless of who you are or what you do because if everybody thought the same way they'd be drivin' the same car, everybody'd be marryin' the same woman, and that wouldn't work out.

Es gab Leute, die Jesus Christus nicht mochten. Sie brachten ihn um, und Jesus Christus war ein vollkommener Mensch. Und es wird Leute geben, die dich nicht mögen, ganz egal, wer du bist oder was du tust, denn wenn alle gleich denken würden, würden sie alle das gleiche Auto fahren, jeder würde die gleiche Frau heiraten, und das würde nicht funktionieren.

Il y a des gens qui n'aimaient pas Jésus-Christ. Ils l'ont tué alors qu'il était parfait. Il y aura toujours des gens qui ne vous aimeront pas, qui que vous soyez ou quoi que vous fassiez, parce que, si tout le monde pensait pareil, on conduirait tous la même voiture, on épouserait tous la même femme et, ça, ça ne marcherait pas.

—ELVIS PRESLEY

OPPOSITE Elvis naps on the long ride, shading his eyes from the sunlight.

255

AS WE APPROACHED MEMPHIS, the Colonel had the conductor make a special stop at White Station, just outside Memphis. This allowed Elvis to take a shortcut to his family home at 1034 Audubon Drive and surprise them before the rest of us arrived. This would be one of the last times Elvis would walk down the street alone, like an ordinary person. There were around a hundred people from the neighborhood there to welcome Elvis home when I arrived, many teenage girls dressed in their holiday best. His mother, Gladys, greeted me, and I found the singer outside. After some confusion about getting his Harley started (it was out of gas) Elvis went for several rides, one with me on the back. I call these the best photographs I never got, because I ran out of film. Then Elvis decided to take a swim in the new pool with some of his cousins and friends. Six hours later the pool remained half filled (from a hose attached to the kitchen sink), and I finally got in, rather than keep shooting from above. The afternoon ended with Elvis and ex-girlfriend Barbara Hearn listening to his three new songs before he prepared for his concert that night at Russwood Park.

ALS WIR UNS ENDLICH MEMPHIS NÄHERTEN, ließ der Colonel den Schaffner kurz vor der Stadt einen außerplanmäßigen Stopp am Bahnhof White Station einlegen. So konnte Elvis eine Abkürzung zum Presley-Haus am Audubon Drive 1034 nehmen und seine Familie überraschen, ehe der Rest von uns eintraf. Es war wohl eines der letzten Male, dass Elvis eine Straße alleine entlangging, wie ein ganz normaler Mensch. Es waren an die 100 Leute aus der Nachbarschaft versammelt, um Elvis zu begrüßen, darunter viele Mädchen in ihren besten Sonntagskleidern. Ich wurde von Elvis' Mutter Gladys begrüßt und entdeckte den Sänger im Freien. Nach einigem Hin und Her, um die Harley zum Laufen zu bringen (der Tank war leer), drehte Elvis ein paar Runden, eine davon mit mir auf dem Sozius. Die Aufnahmen von dieser Fahrt bezeichne ich immer als die besten, die ich nie machen konnte, weil mir nämlich der Film ausging. Als wir zurückkamen, wollte Elvis mit ein paar von seinen Cousins und Kumpels ein Bad im neuen Pool nehmen. Der Pool war dank eines an der Küchenspüle angeschlossenen Gartenschlauchs nach sechs Stunden bis zur Hälfte gefüllt; ich stieg mit den anderen hinein und machte Fotos wie ich sie vom Beckenrand aus nicht hätte einfangen können. Der Nachmittag endete damit, dass Elvis und Barbara Hearn, eine ehemalige Flamme, sich die drei neuen Songs anhörten; dann begann er sich auf sein Konzert am Abend im Russwood Park vorzubereiten.

PEU AVANT D'ARRIVER À MEMPHIS, le colonel demanda au chef de train de faire un bref arrêt à White Station. Cela permit à Elvis de prendre un raccourci à travers champs et de surprendre sa famille au n°1034 d'Audubon Drive avant notre arrivée. Ce serait l'une des dernières fois qu'il pourrait marcher seul dans une rue, comme n'importe qui. Lorsque j'arrivai devant la maison de ses parents un peu plus tard, je découvris une centaine de voisins venus accueillir l'enfant prodigue, dont beaucoup d'adolescentes endimanchées. Je fus reçu par Gladys, la mère d'Elvis. Après plusieurs essais infructueux sur sa Harley (le réservoir était vide), ce dernier fit plusieurs tours du quartier, dont un avec moi assis à l'arrière. J'appelle ça les meilleures photos que je n'ai jamais prises, car je me suis trouvé à court de pellicule. Ensuite, Elvis voulut essayer la nouvelle piscine avec des cousins et des amis. Après six heures de remplissage (à l'aide d'un tuyau relié au robinet de la cuisine), elle était encore à moitié vide. Plutôt que de les photographier depuis le bord, je me mis à l'eau moi aussi. En fin d'après-midi, Elvis retrouva une ancienne petite amie, Barbara Hearn. Ils écoutèrent ses trois dernières chansons, puis il se prépara pour son concert à Russwood Park.

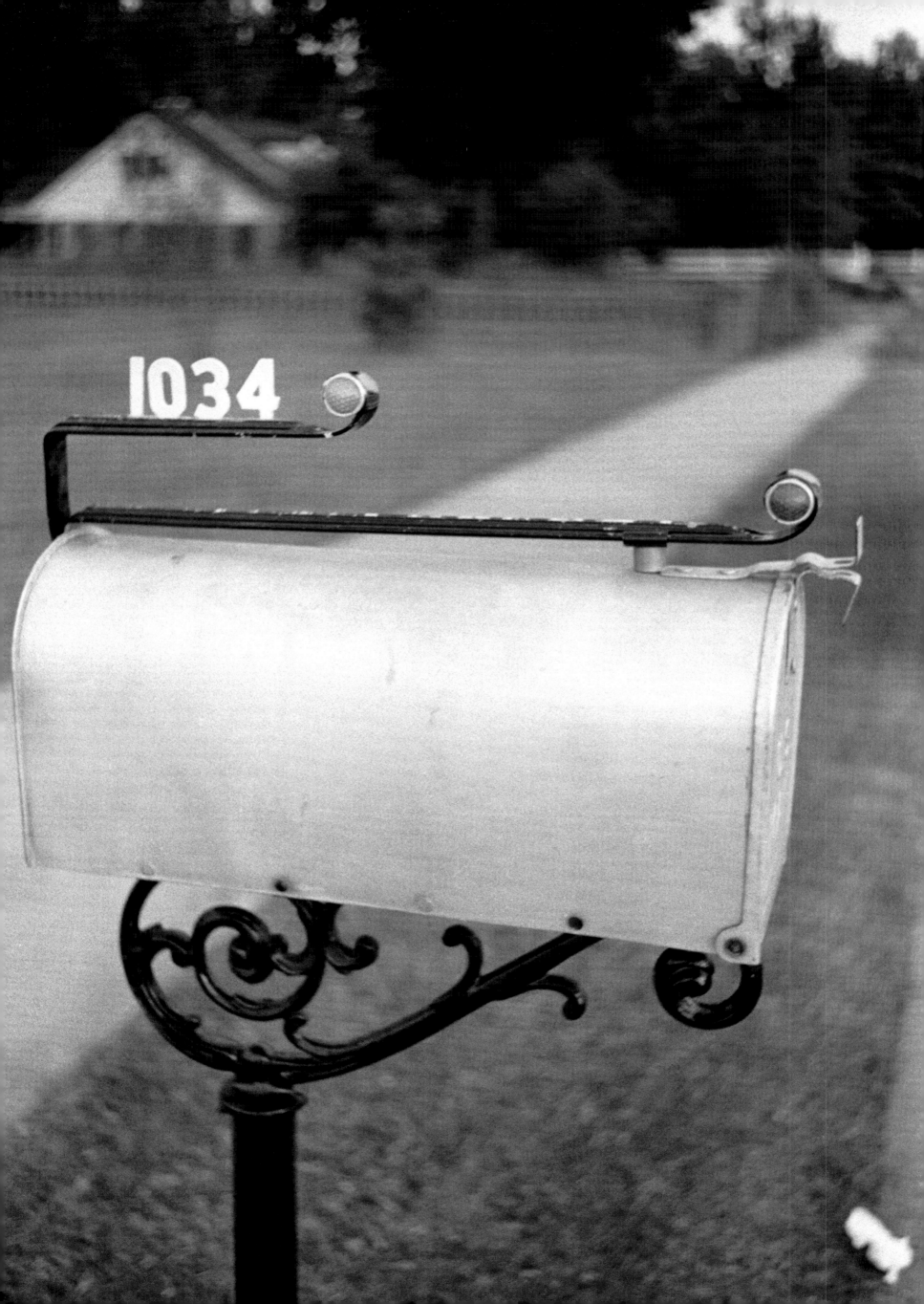

He had difficulty building true friendships, and I had that difficulty, too. I have a lot of friends, but I am just not a person who builds relationships easily. Elvis was the same way. He was just, innately, a loner.

Es fiel ihm schwer, echte Freundschaften aufzubauen, und mir fiel das auch schwer. Ich habe eine Menge Freunde, aber ich bin nicht der Typ, der leicht Beziehungen eingeht. Elvis war genauso. Er war einfach von Natur aus ein Einzelgänger.

Il avait du mal à nouer de vraies amitiés. J'avais le même problème. J'ai beaucoup d'amis, mais je ne suis pas quelqu'un qui se lie facilement. Elvis était pareil. C'était fondamentalement un solitaire.

—SAM PHILLIPS

PREVIOUS PAGE The mailbox at 1034 Audubon Drive, the Presley family home in Memphis, on the Fourth of July.

OPPOSITE Eager to get home, Elvis prepares to hop off the train a few minutes outside Memphis on an unauthorized stop arranged by Colonel Tom Parker.

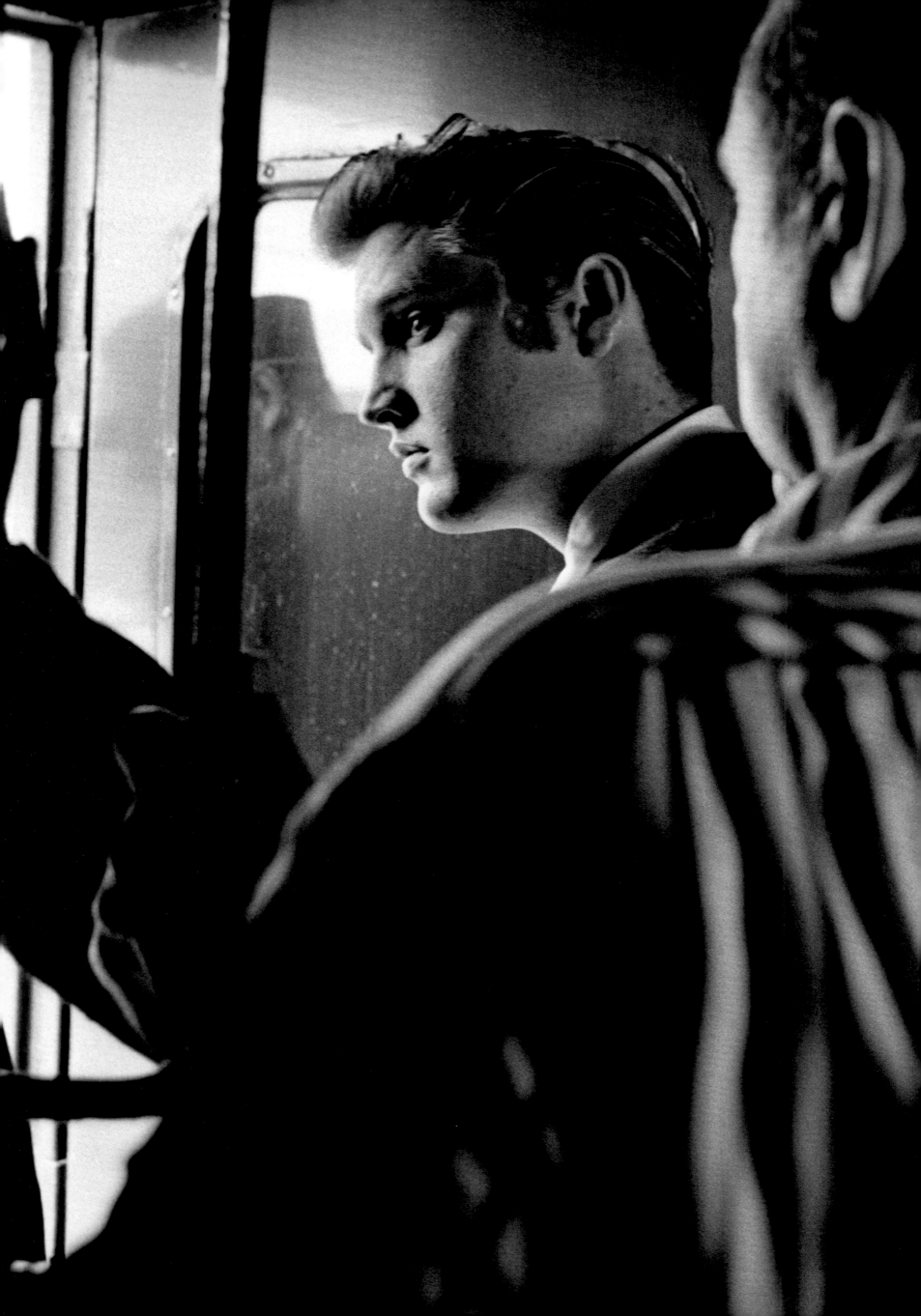

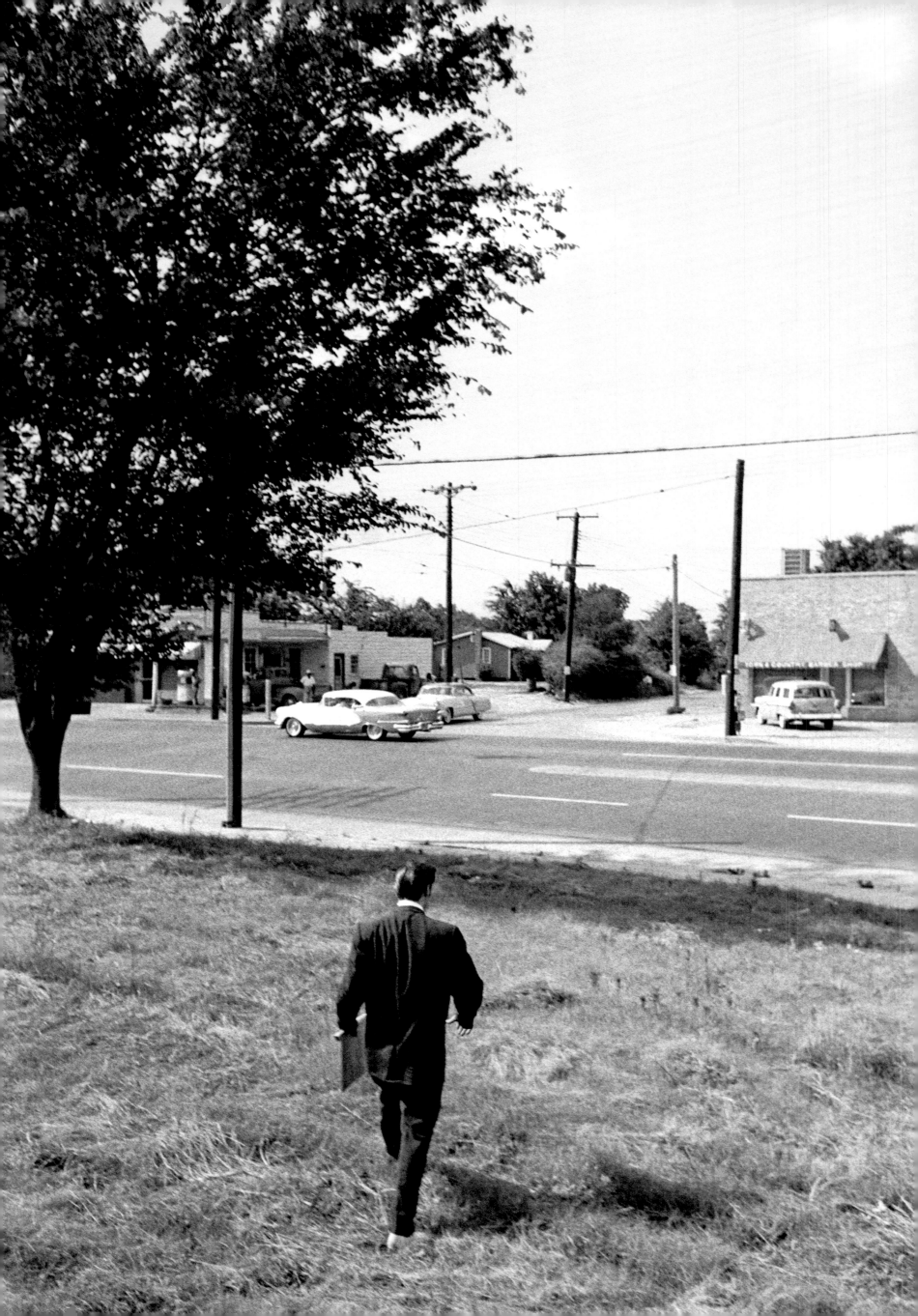

OPPOSITE By stopping at the White Station rather than going on to Memphis Central Station and taking a taxi back to the suburbs, Elvis is able to save an hour getting home to see his family.

FOLDOUT Now off the train at White Station, he waves to the Colonel, Wertheimer, and the conductor; gets directions; and travels down the street alone, probably the last time he can do so in his lifetime.

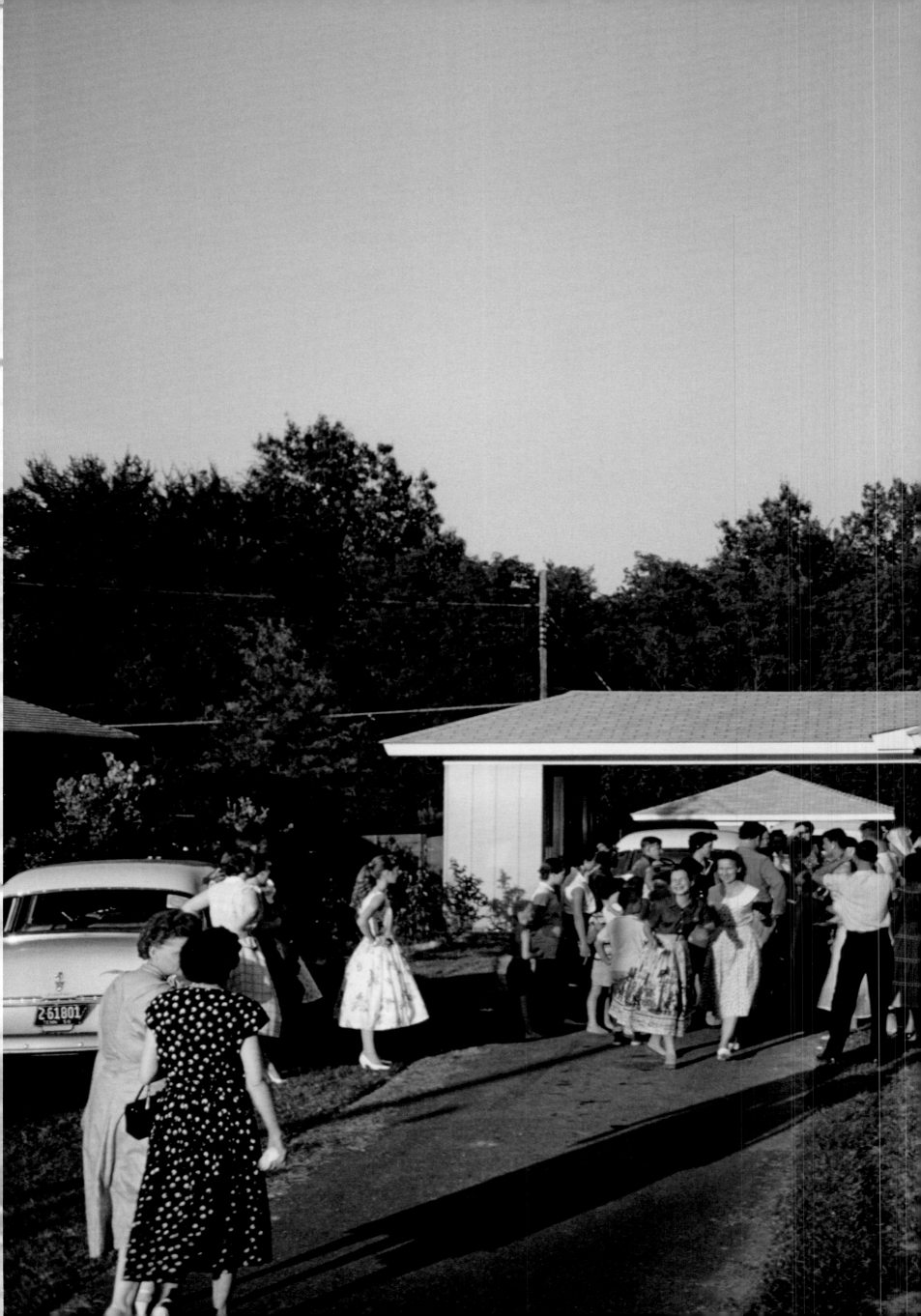

When he was hardly four he'd tell me: 'Don't worry, baby. When I'm grown up I'll buy you a big home and two cars. One for you and Daddy and one for me.' All his life he'd say out loud what he was going to do for us…And you know, I believed him.

Er war noch keine vier, da erklärte er mir: ‚Mach dir keine Sorgen, Kleine. Wenn ich groß bin, kauf ich dir ein großes Haus und zwei Autos. Eins für dich und Daddy und eins für mich.' Sein Lebtag lang hat er immer laut gesagt, was er einmal für uns tun wird … Und, wissen Sie, ich habe ihm geglaubt.

Il avait à peine quatre ans qu'il me disait déjà : «T'inquiète pas, ma petite maman, quand je serai grand je t'achèterai une grande maison et deux voitures. Une pour papa et toi, et une pour moi.» Il n'arrêtait pas d'annoncer à voix haute tout ce qu'il ferait pour nous… Et vous savez quoi ? Je l'ai toujours cru.

—GLADYS PRESLEY
New York Daily News interview,
September 23–27, 1956

PREVIOUS SPREAD Home sweet home, 1034 Audubon Drive. Gladys and Vernon Presley have moved in to the ranch-style house, which was purchased by their son for the family for $40,000, only months earlier. In 1957 the family will move to Graceland.

OPPOSITE *No Gas in the Tank*, Elvis on his Harley-Davidson, wondering why it won't start, Memphis, Tennessee, July 4, 1956.

FOLLOWING SPREAD Friends and neighbors gather in the yard as Elvis tries to get his Harley running. Once they discover no gas in the tank, someone volunteers to get a Jerrycan of gasoline.

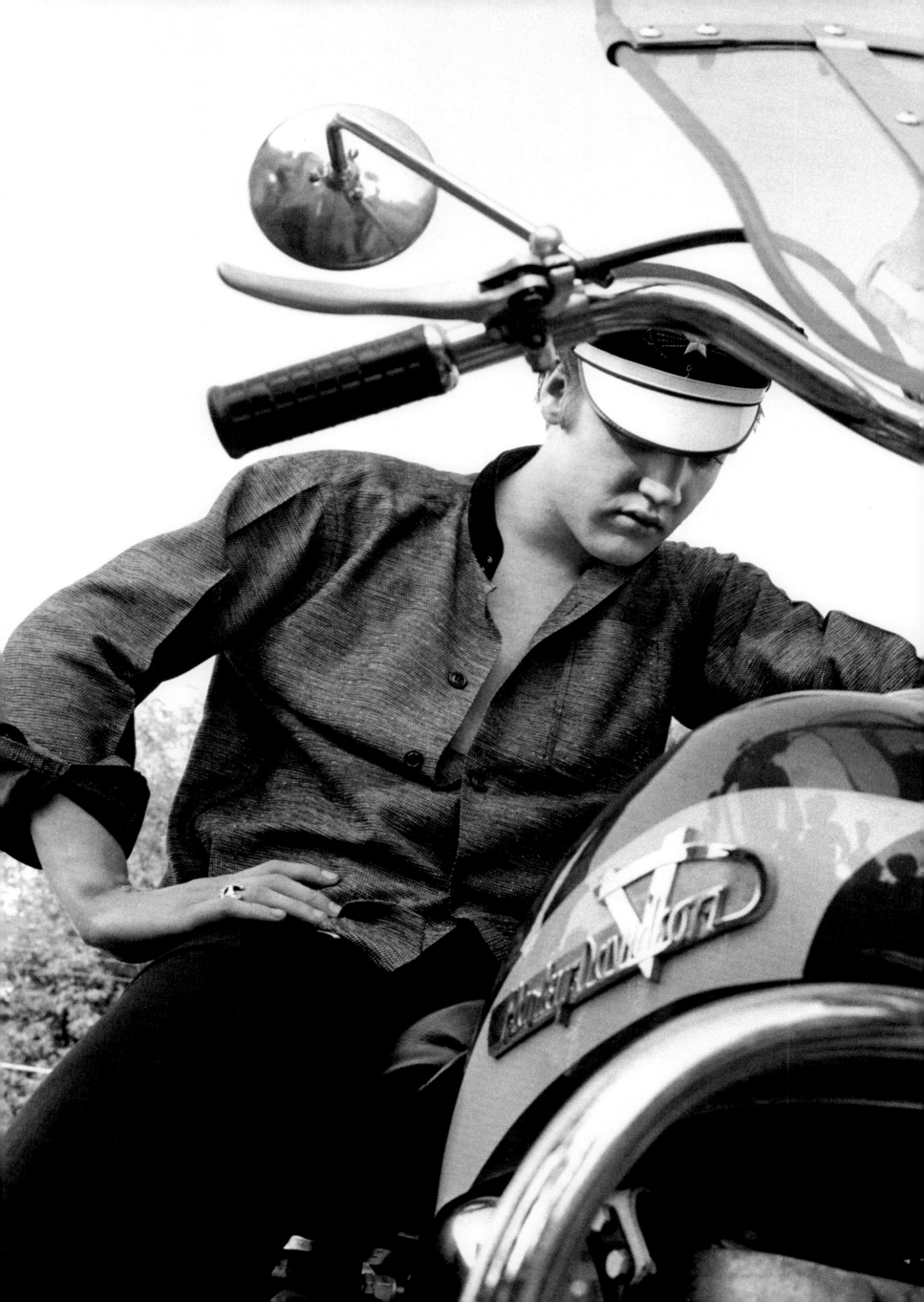

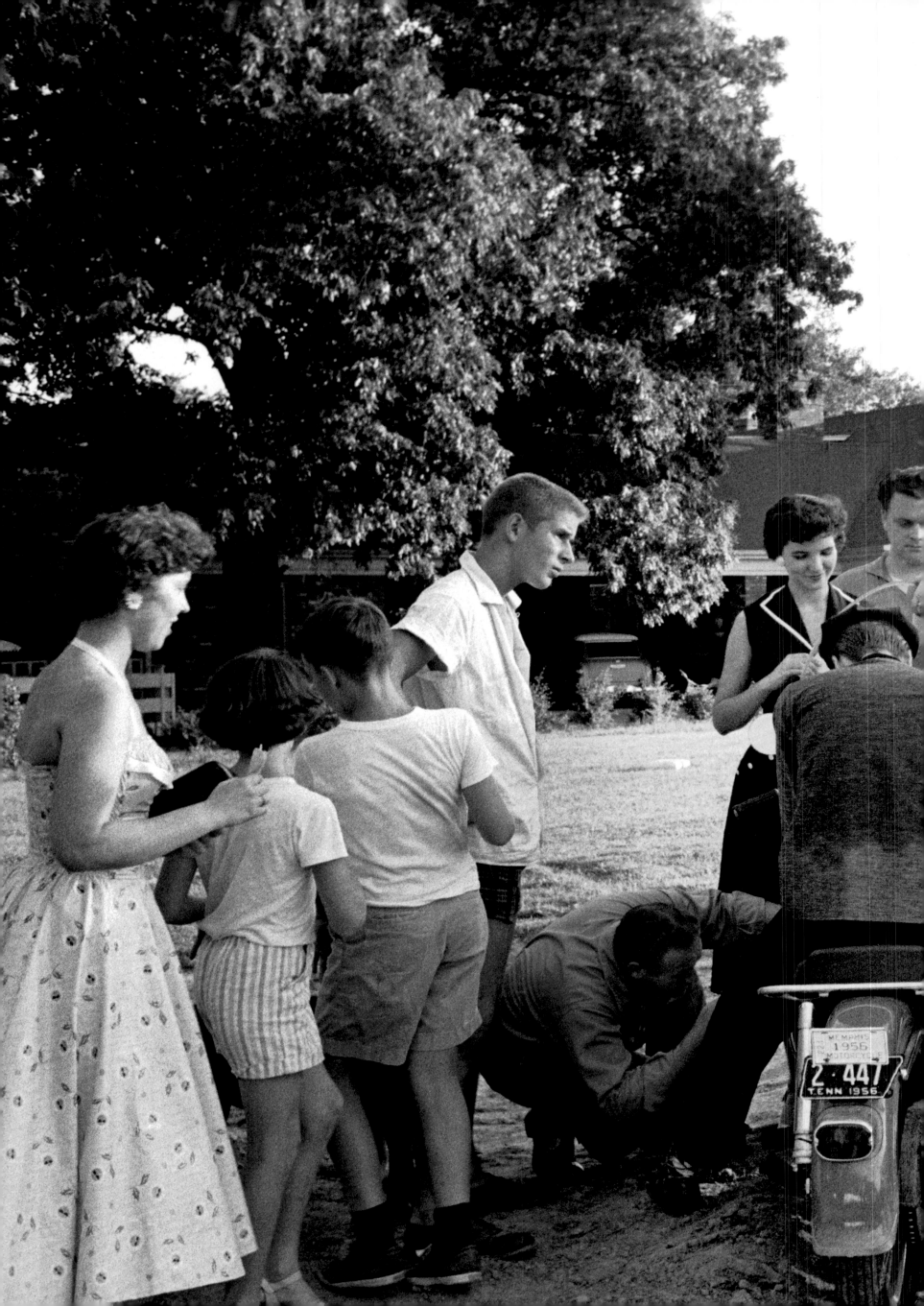

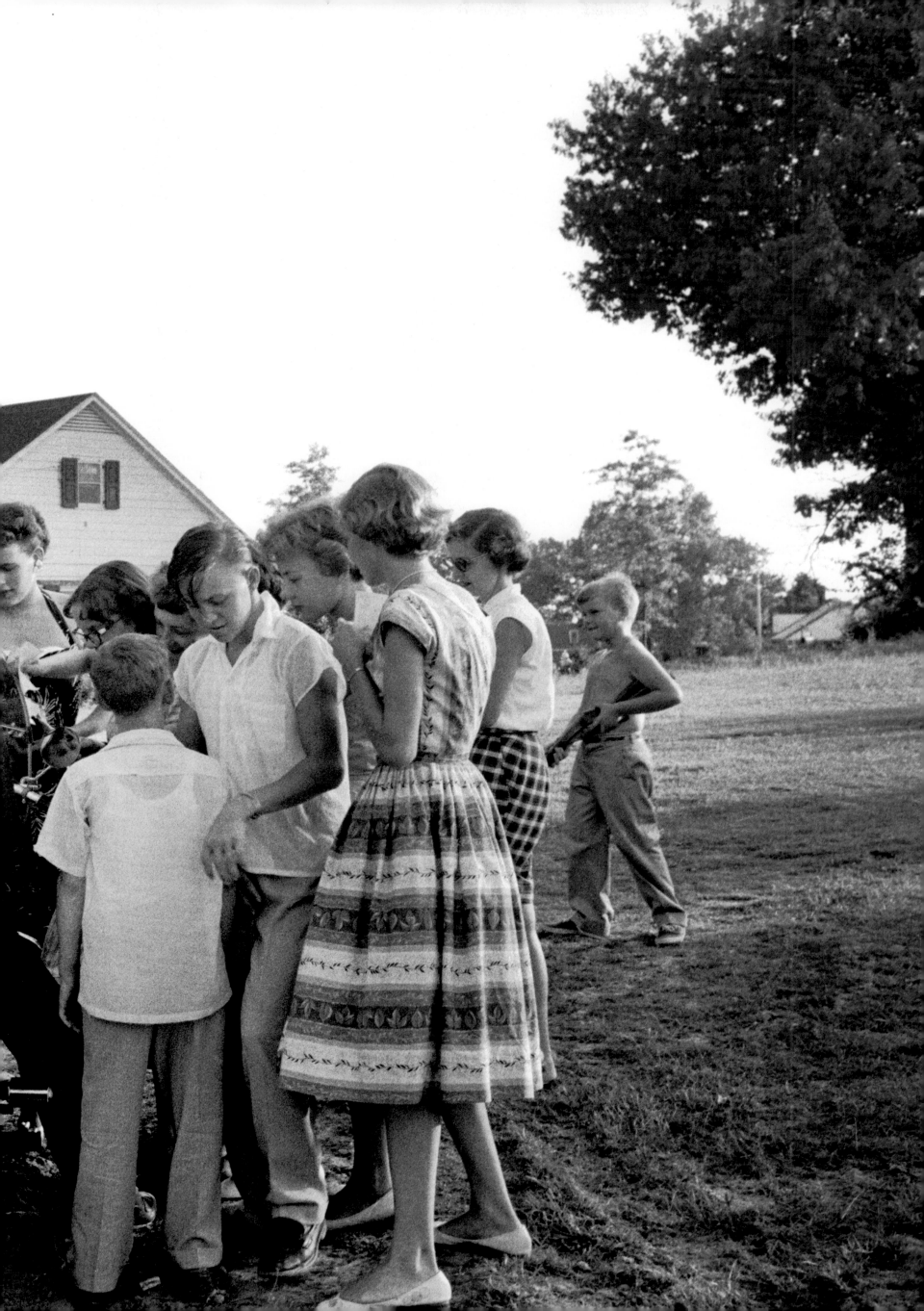

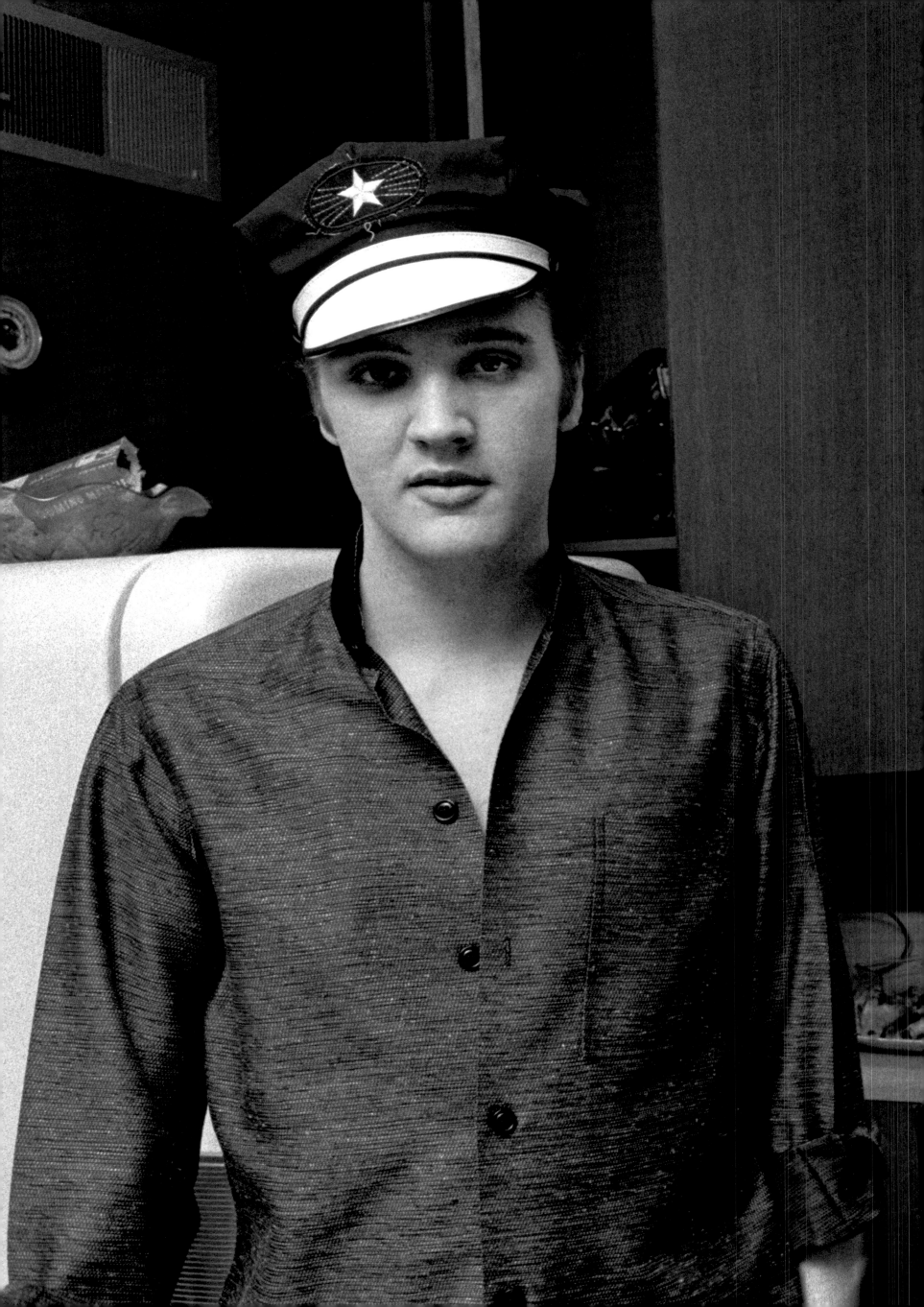

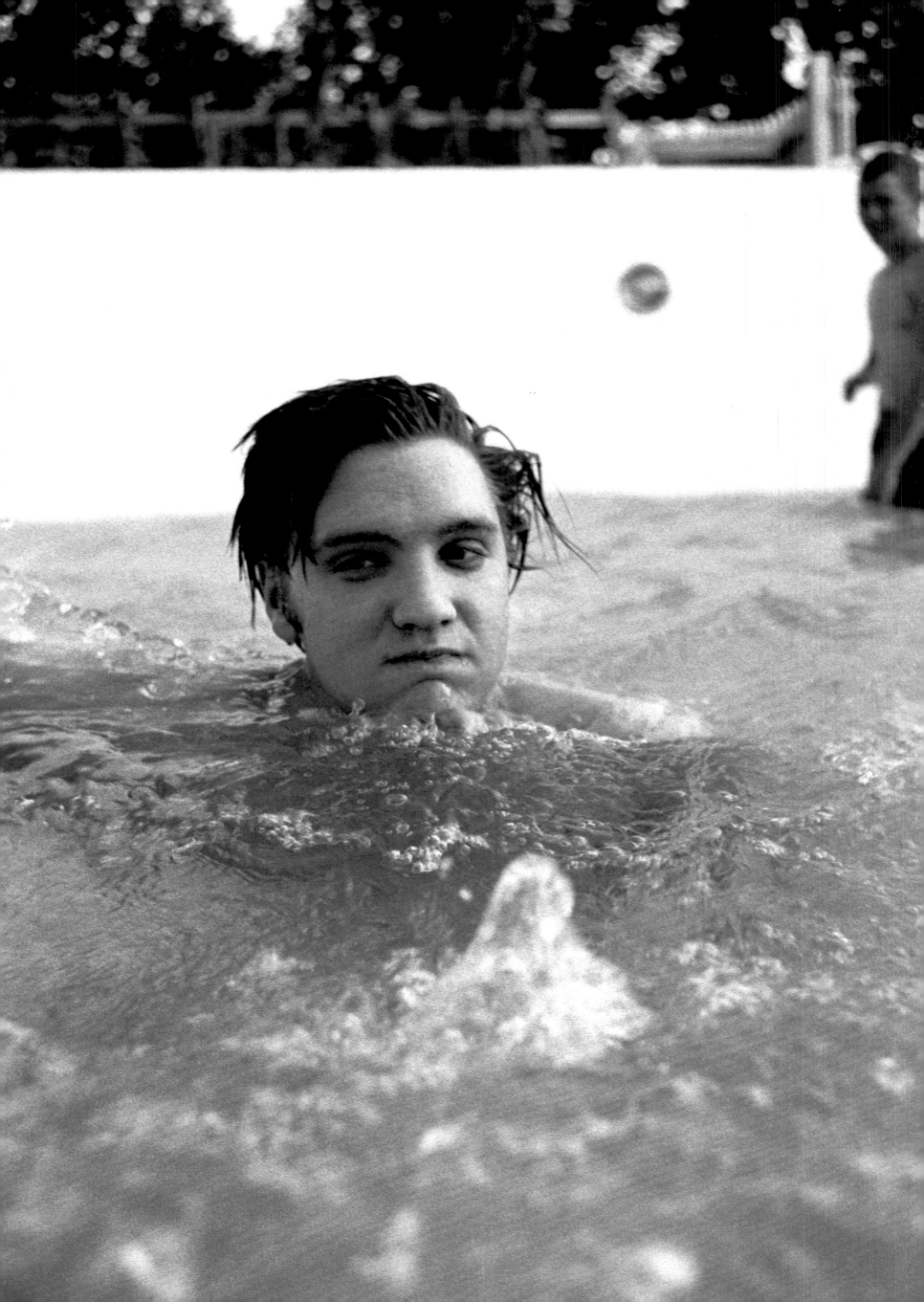

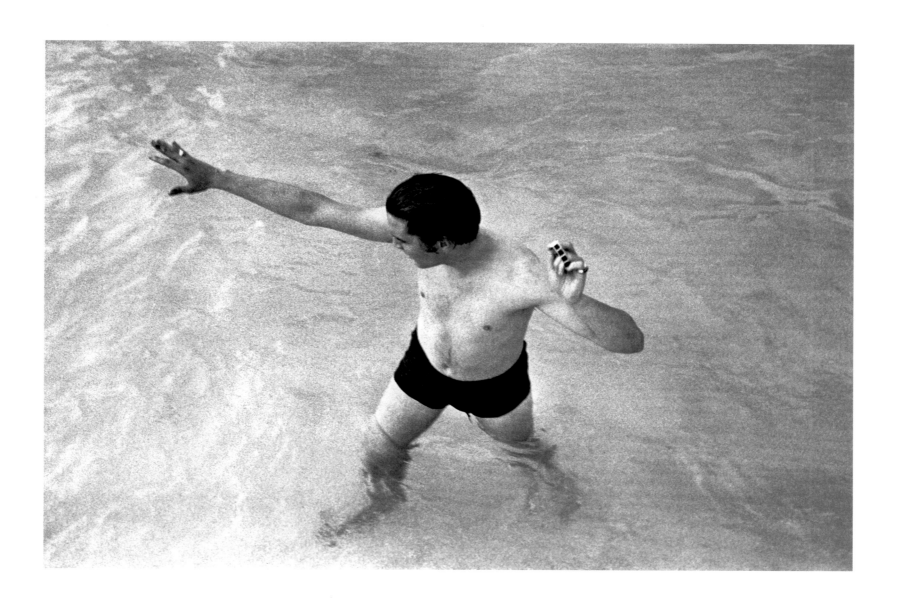

281

PREVIOUS SPREAD Since the valve is stuck, the pool is filled
for hours with a garden hose attached to the kitchen
sink. Six hours in, the pool is not even half full.

OPPOSITE & ABOVE "Hey, Ma!" Elvis calls to his mother
to take his watch, which he has forgotten to remove
before jumping into the pool.

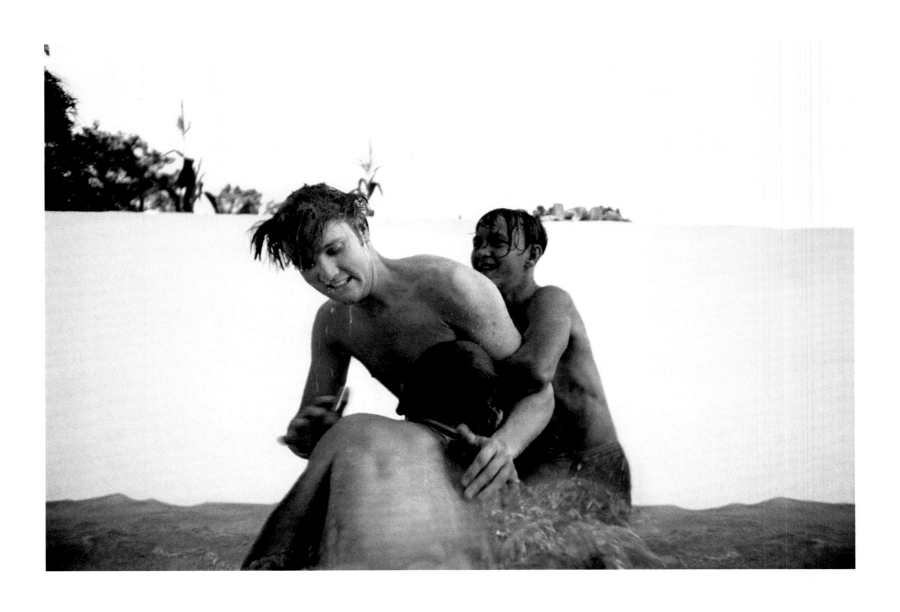

ABOVE Much to his delight, Elvis horses around in the pool with his younger cousin Billy Smith and another cousin.

OPPOSITE Elvis takes a moment to catch his breath before going into the house.

FOLLOWING SPREAD Elvis enjoys a Pepsi in the rec room with his cousins Billy and Bobby Smith.

282

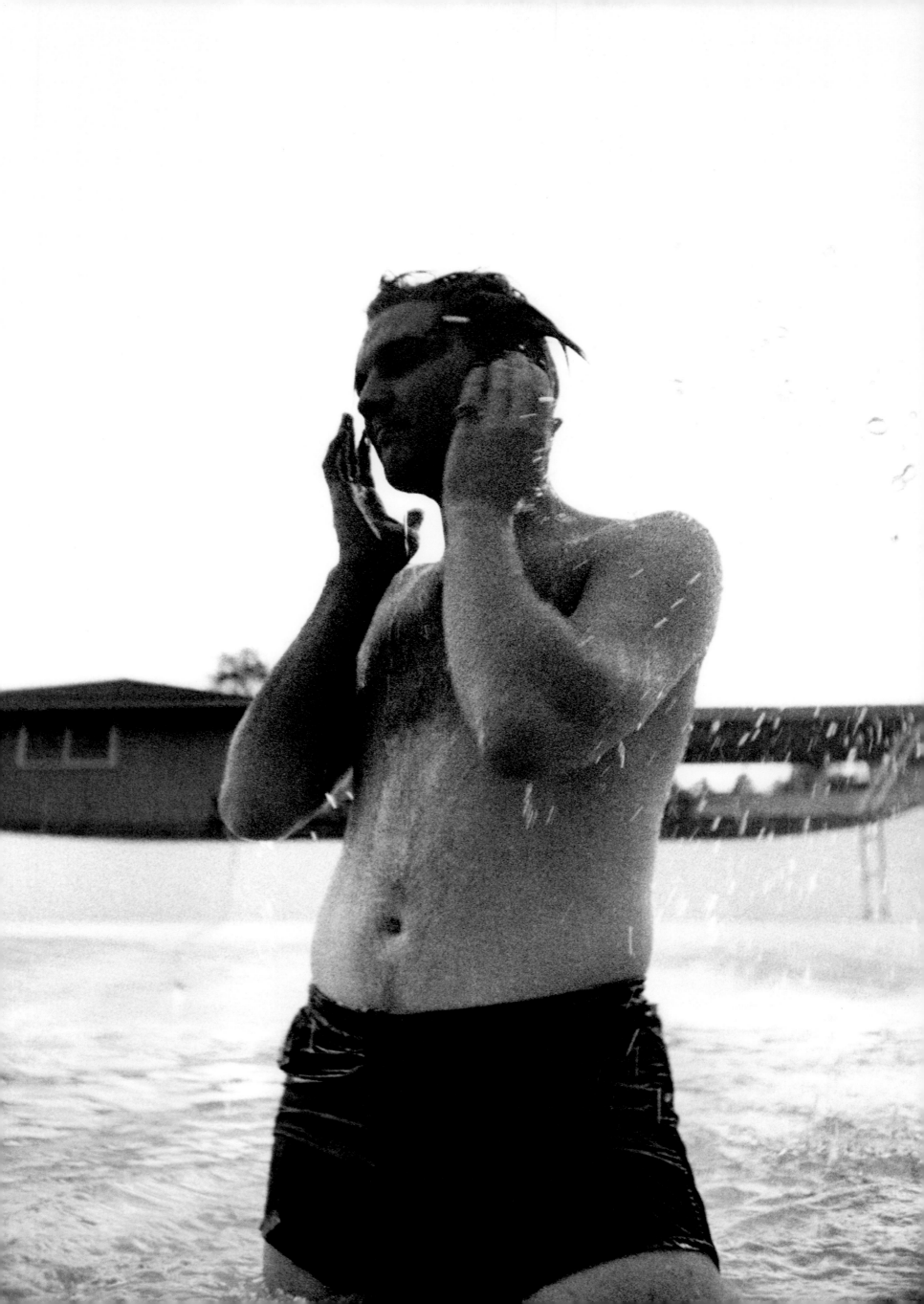

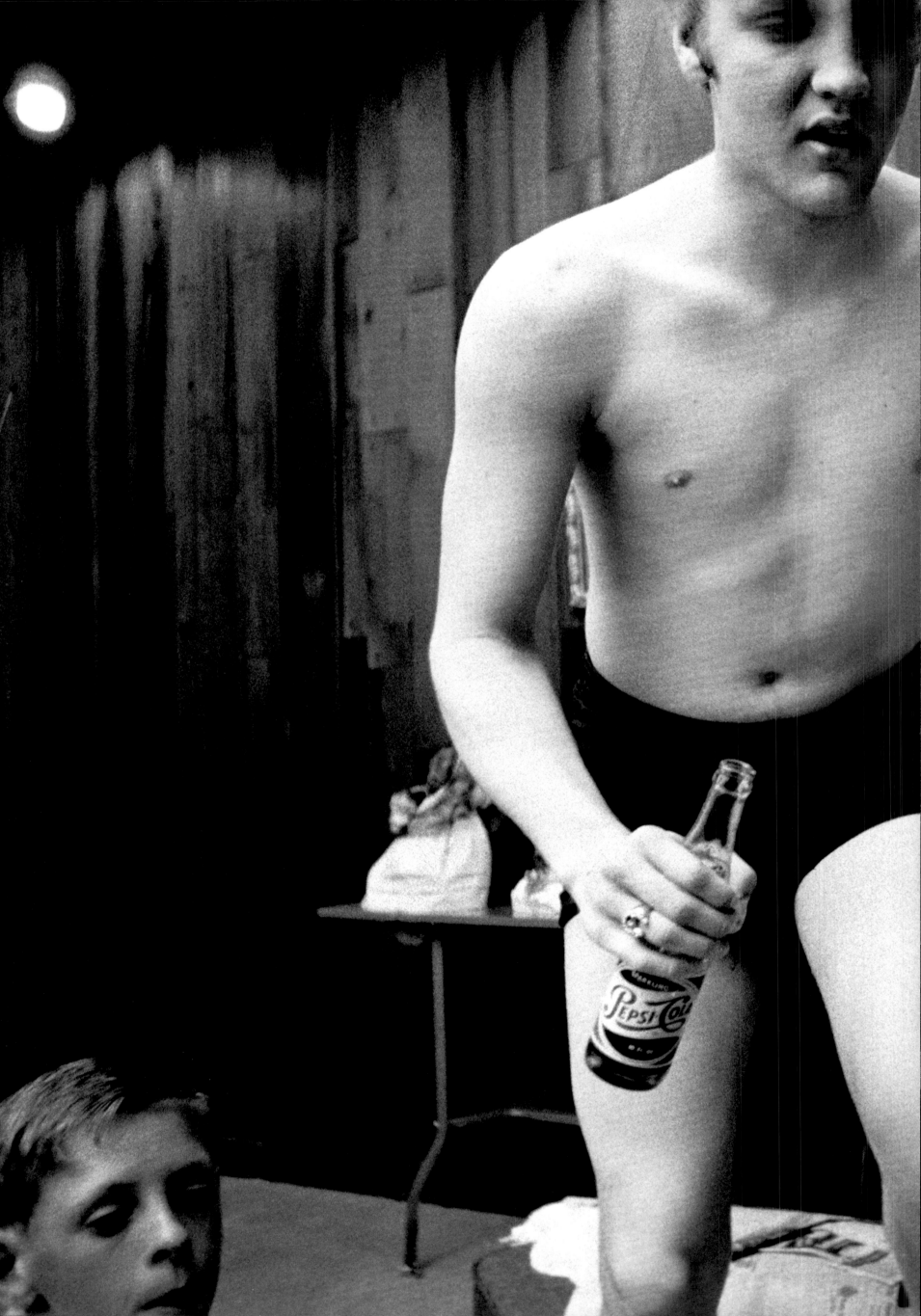

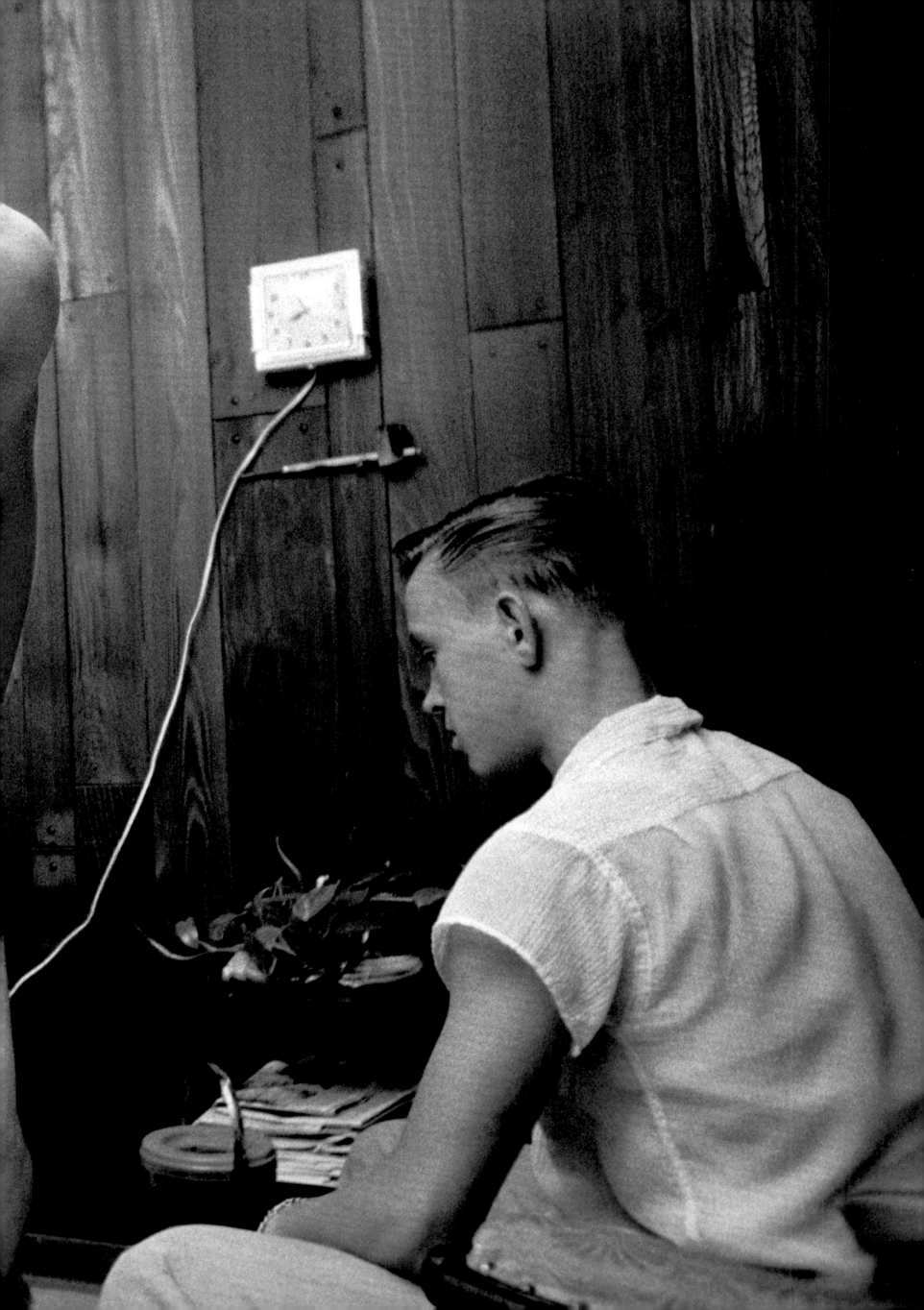

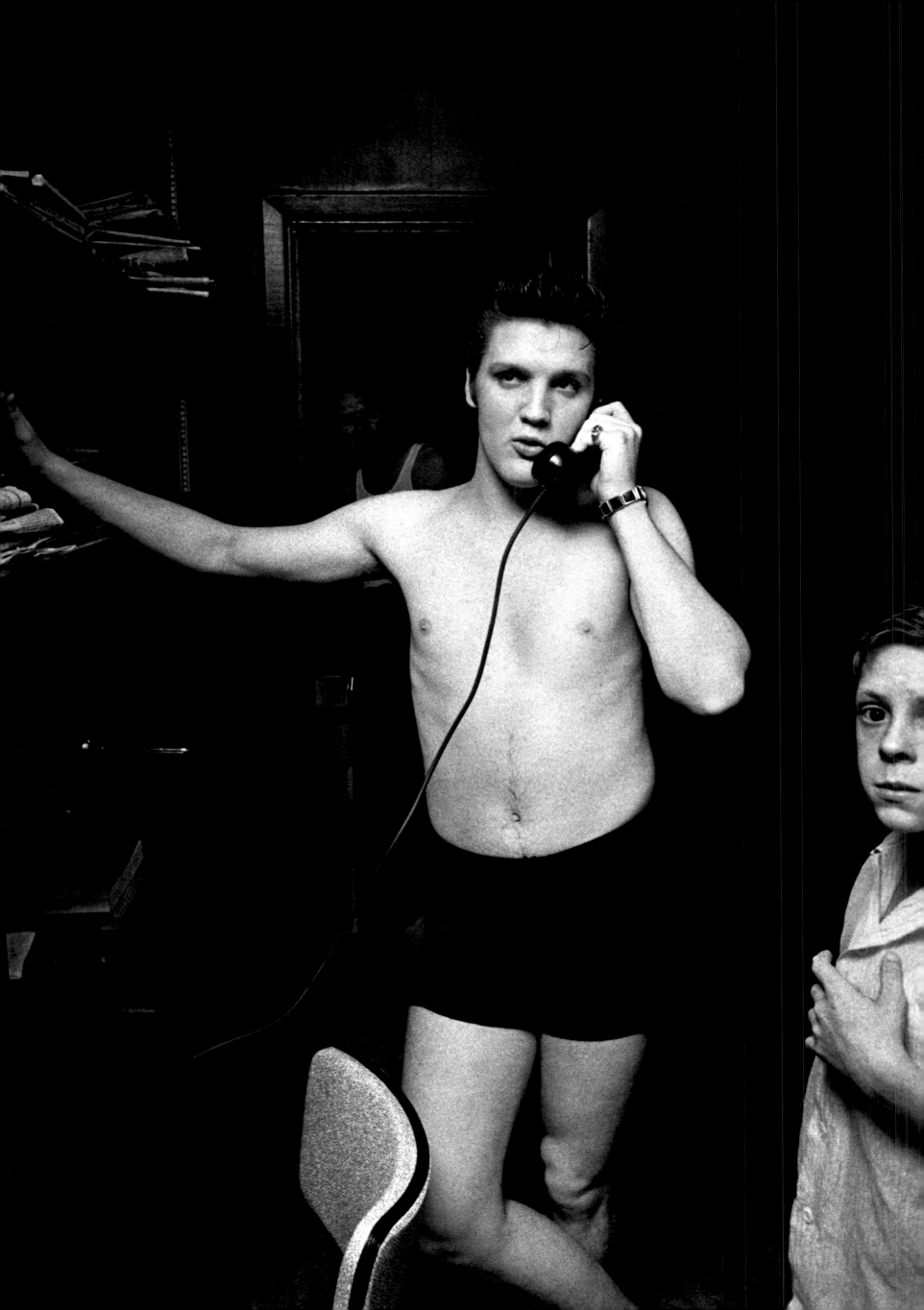

Just ask the boy from Tupelo.
He's the king and he oughta know...

Frag einfach den Jungen aus Tupelo.
Er ist der King, und er weiß, wieso ...

Vous n'avez qu'à interroger le petit
gars de Tupelo. C'est le roi, alors il
devrait savoir...

—EMMYLOU HARRIS
"Boy From Tupelo," 2000

OPPOSITE Talking on the phone at home, his dad in the
background shaving.

FOLLOWING SPREAD Before the concert at Russwood Park,
Elvis relaxes on the back patio with his family and
turns to give the photographer his patented stare.

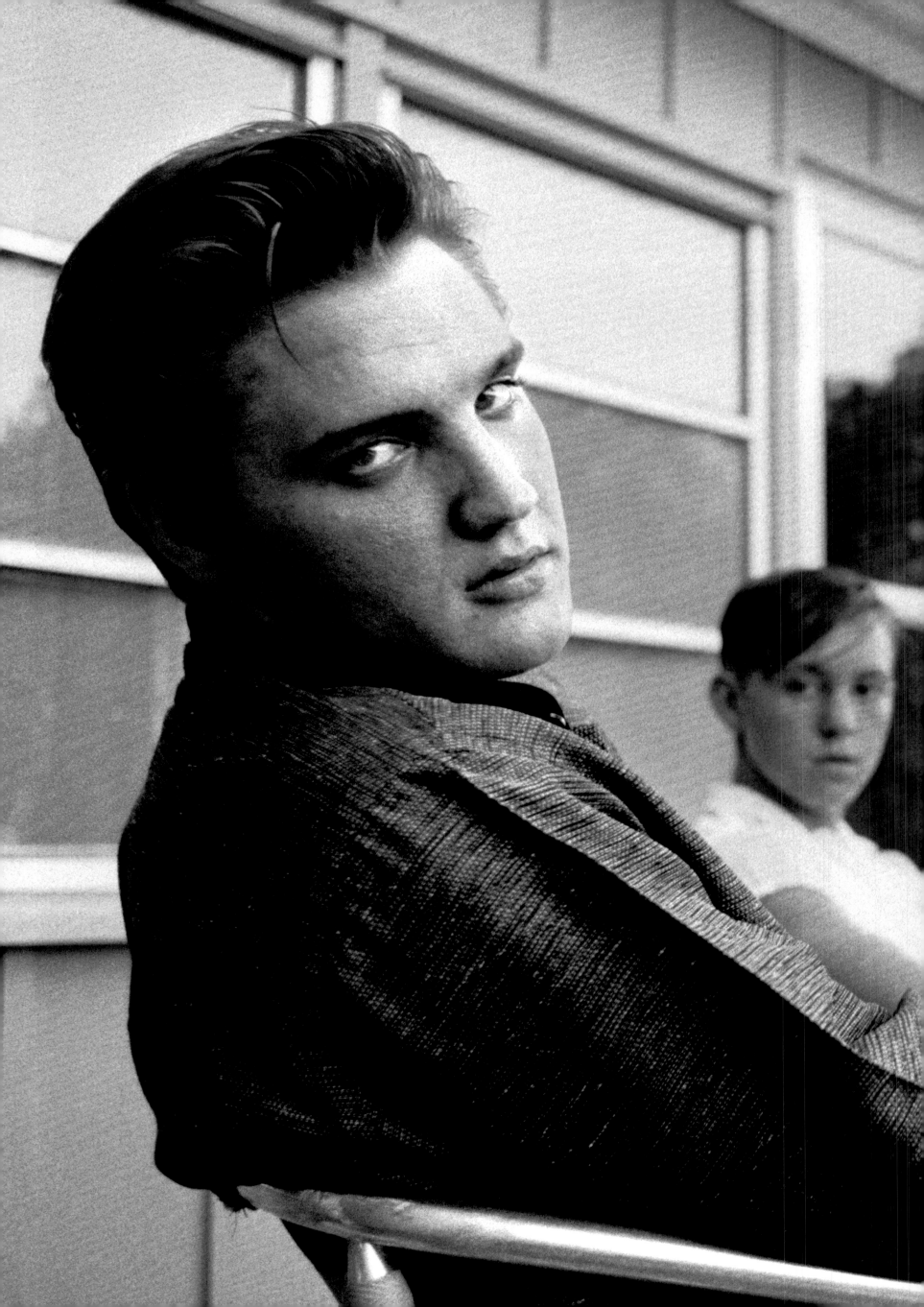

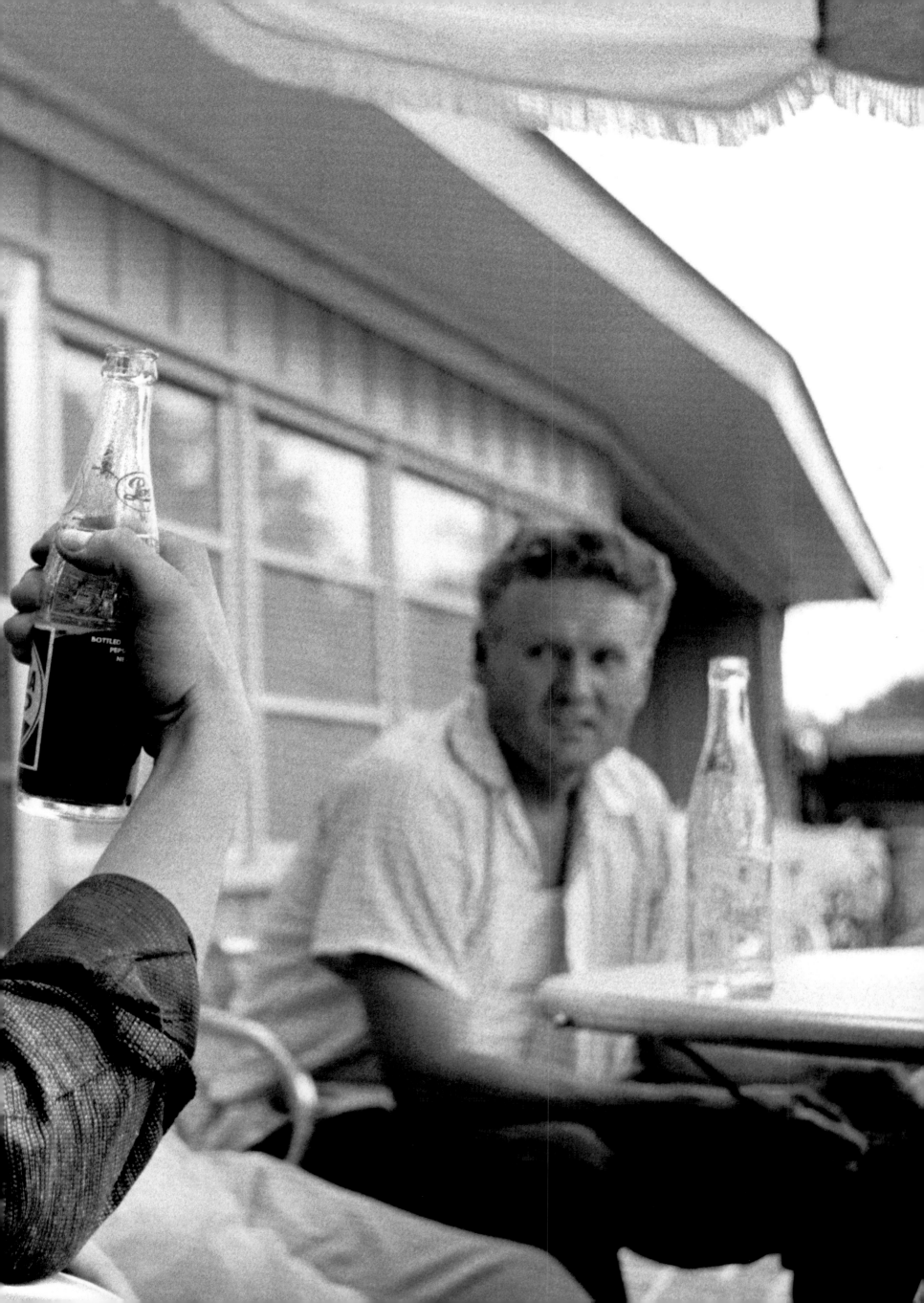

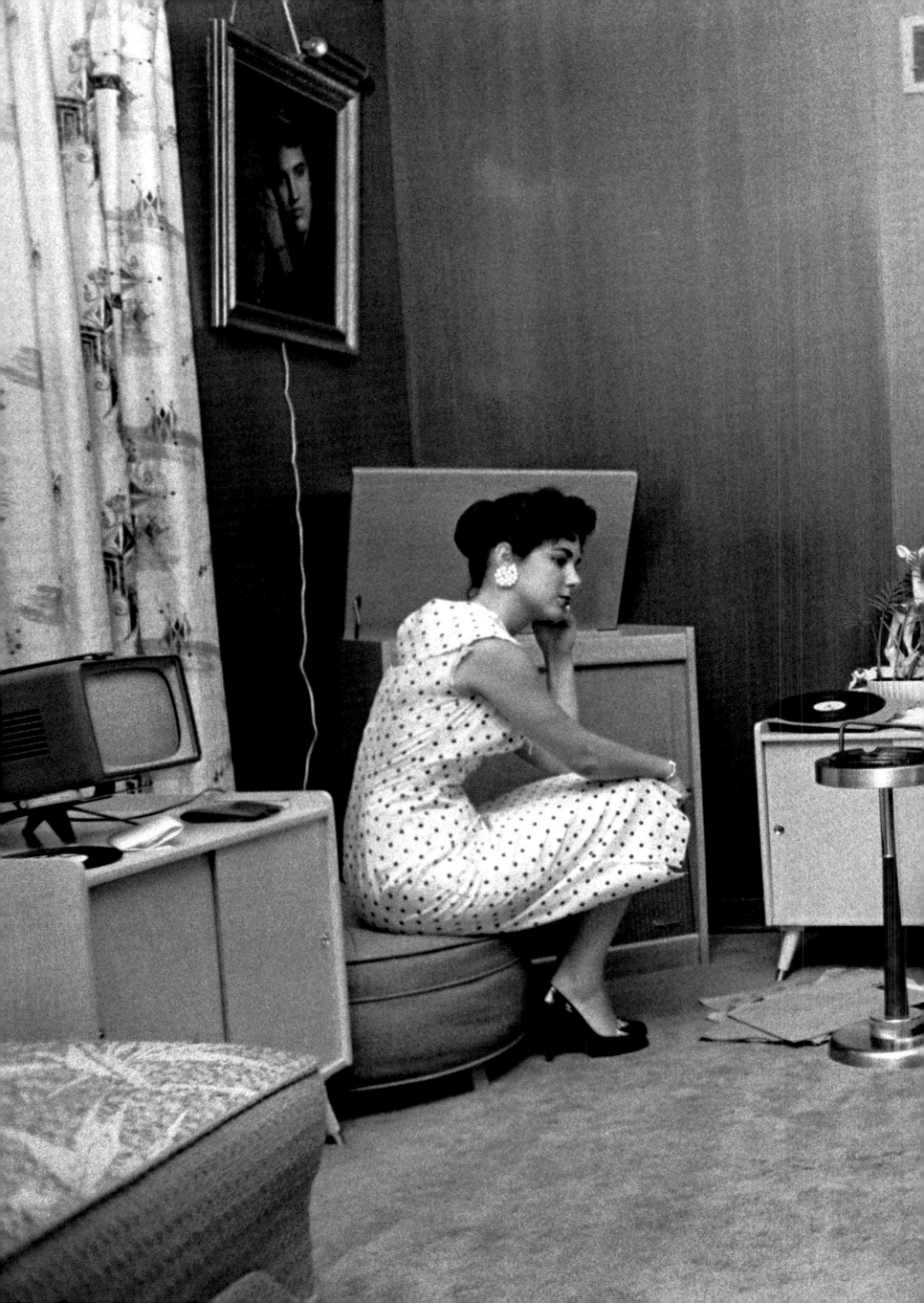

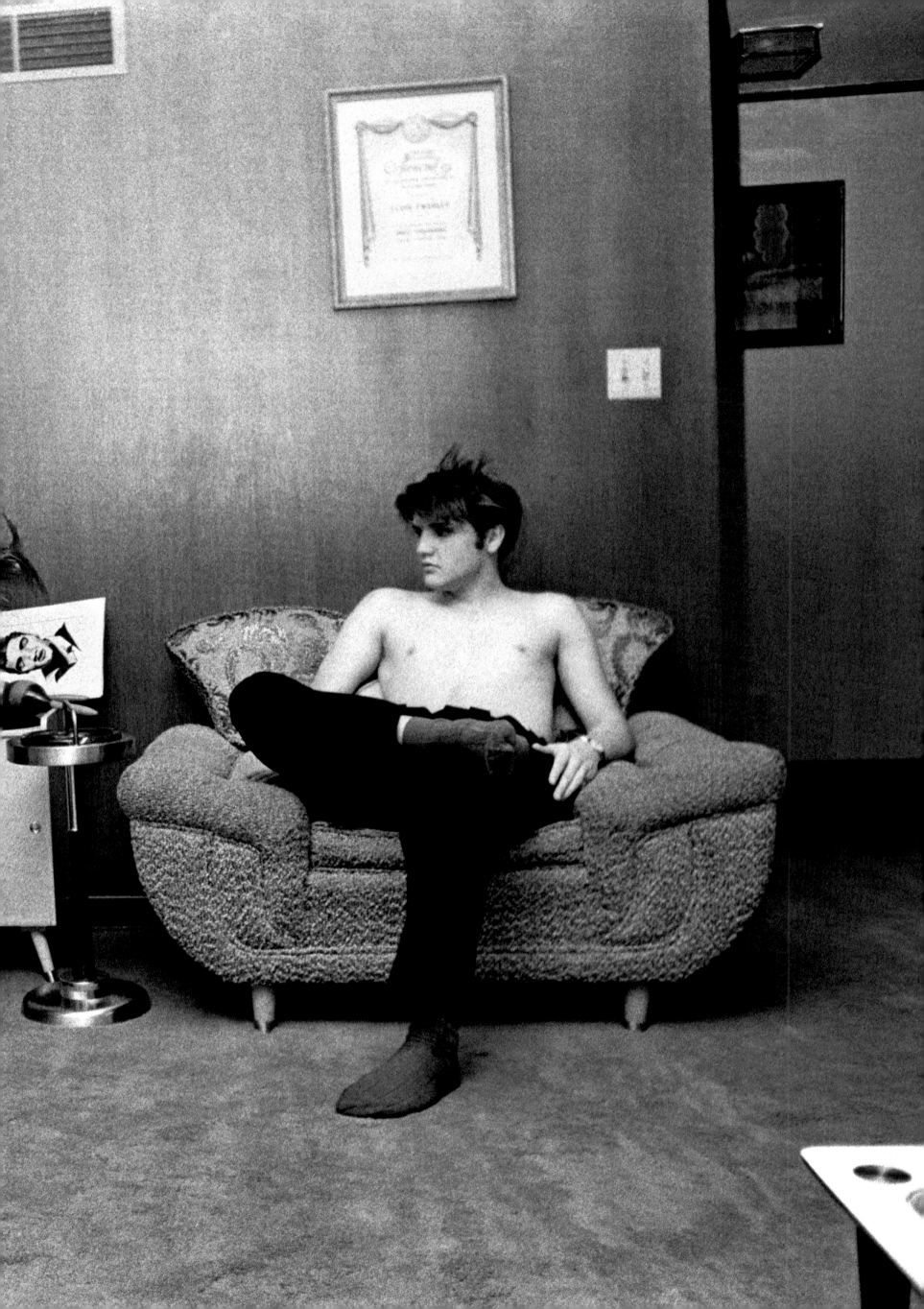

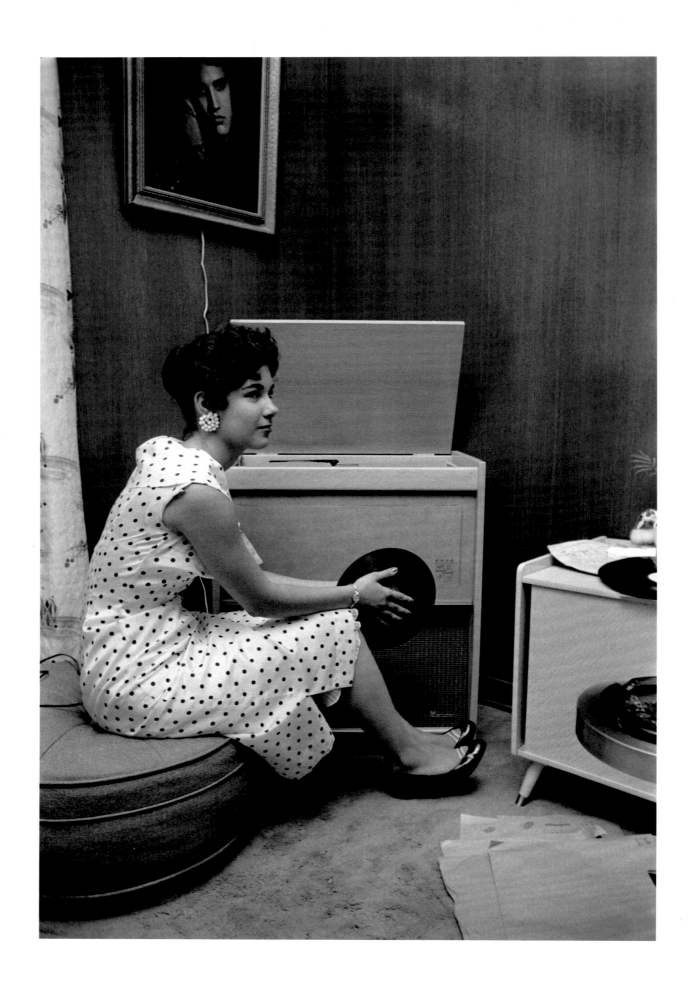

PREVIOUS SPREAD & ABOVE High school sweetheart Barbara Hearn comes by the house before the concert, and listens to the quick acetate discs from the RCA Victor session a few days earlier.

OPPOSITE Elvis asks her for a dance to see if the songs are "danceable."

292

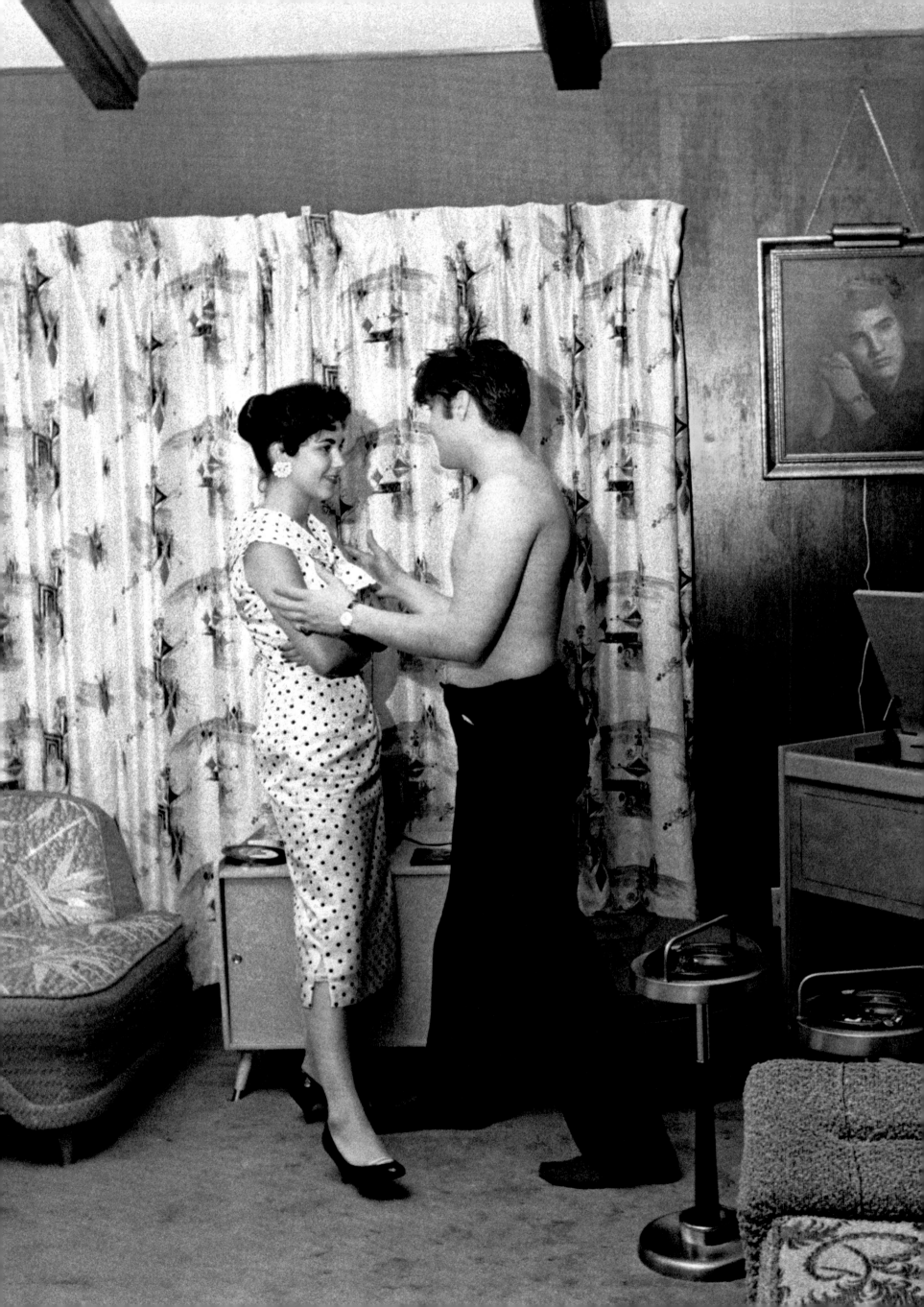

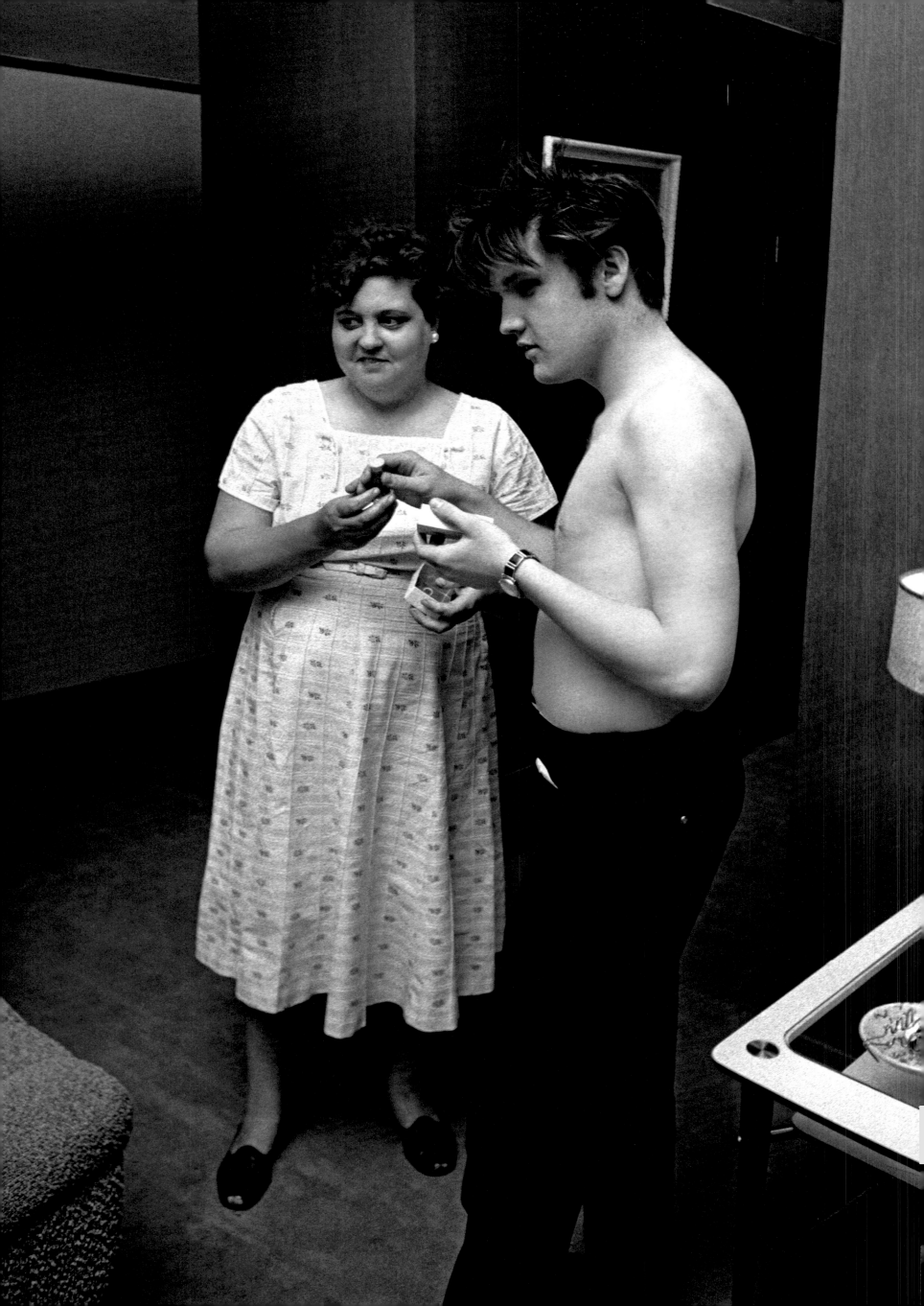

He loved his work, loved his music, loved his guitar, loved gospel music, and loved his mother.

Er liebte seine Arbeit, liebte seine Musik, liebte seine Gitarre, liebte Gospelmusik und liebte seine Mutter.

Il adorait son travail, il adorait sa musique, il adorait sa guitare, il adorait le gospel et il adorait sa mère.

—JOHNNY CASH

THE STAR OF STARS

LIVE

Elvis

★ RUSSWO

MEMP

JULY

➡ TICKETS

RINGSIDE
DONATION

$2.75 OR MORE

GRANDSTAND
DONATION

$1.50 OR MORE

DIAMO
DOOR

ELVIS'S OWN P

★ RING - GOLD

★ THE SHOW OF SHOWS ★ ★ ★

resley

IN CONCERT

OD PARK ★

HIS ★ TN

, 1956

★ SURPRISE
GUESTS

D RING
RIZE! ★
ONAL & INITIALED
H 14 DIAMONDS ★

THE

JORDANAIRES

ELVIS PERFORMED THAT EVENING at Russwood Park in Memphis, a baseball stadium converted into a concert venue that would hold up to 14,000 fans. All the proceeds from the concert went to the Scimitar Newspaper Milk Fund for poor children. Elvis, the Colonel, and I got a ride to the stadium with the sheriff in his police car. Escorted by the local police and Navy Shore Patrol, Elvis took the stage dressed all in black. Alluding to his scripted performance on *The Steve Allen Show* in which he sang to a live hound dog while wearing a tux, Elvis told the audience in Memphis, "Tonight you're going to see what the real Elvis Presley is all about." He proceeded to sing and gyrate and carry on all over the stage, to the delight of the crowd. Little did I know, as I got on the late-night train to New York that night, that it would be another two years before I would see Elvis again.

ELVIS TRAT AN DEM ABEND im Russwood Park in Memphis auf, einem zur Konzertarena umfunktionierten Baseballstadion, das Platz für bis zu 14 000 Fans bot. Sämtliche Erlöse aus dem Konzert gingen an den Milchfonds für arme Kinder, den die Lokalzeitung *Memphis Press-Scimitar* ins Leben gerufen hatte. Elvis, der Colonel und ich fuhren mit dem Polizeichef in einem Streifenwagen zum Stadion. Eskortiert von Vertretern der örtlichen Polizei und der Wasserschutzpolizei betrat Elvis, ganz in Schwarz gekleidet, die Bühne. In Anspielung auf seinen Auftritt nach dem Drehbuch für die *Steve Allen Show*, wo er einen Frack tragen und einen leibhaftigen „Hound Dog" in Gestalt eines Bassets hatte ansingen müssen, erklärte Elvis dem Publikum in Memphis: „Heute Abend werdet ihr sehen, wie der echte Elvis Presley tickt." Dann legte er los und fegte zum Entzücken der Menge singend und hüftkreisend über die Bühne. Im Anschluss an den Auftritt bestieg ich den Nachtzug nach New York und sollte Elvis erst zwei Jahre später wiedersehen.

CE SOIR-LÀ, ELVIS SE PRODUISIT à Russwood Park, un stade de base-ball converti en salle de concert à ciel ouvert pouvant accueillir 14 000 fans. Tous les bénéfices seraient reversés au fonds Scimitar Newspaper Milk pour les enfants défavorisés. Elvis, le colonel et moi fûmes conduits au stade dans la voiture du shérif, escortés par la police locale et la patrouille côtière. Elvis était entièrement vêtu de noir. Faisant allusion à sa prestation dans le *Steve Allen Show,* où il chantait en smoking face à un basset, il déclara à la foule: «Ce soir, vous allez voir le vrai Elvis Presley.» Puis il se mit à chanter, à se déhancher et à gambader sur toute la scène pour le plus grand plaisir du public. Après le concert, je pris le train de nuit pour New York. Je ne devais revoir Elvis que deux ans plus tard.

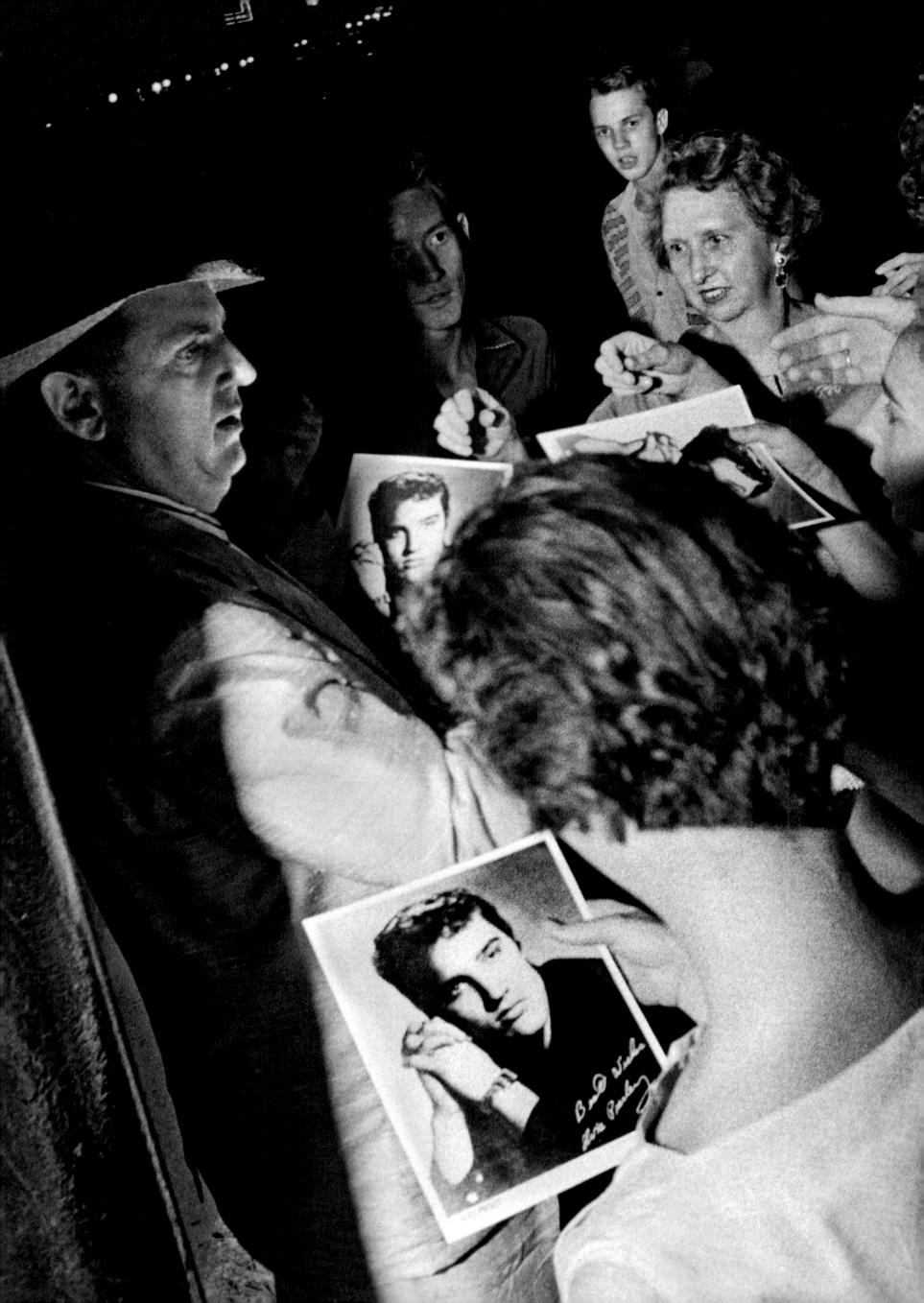

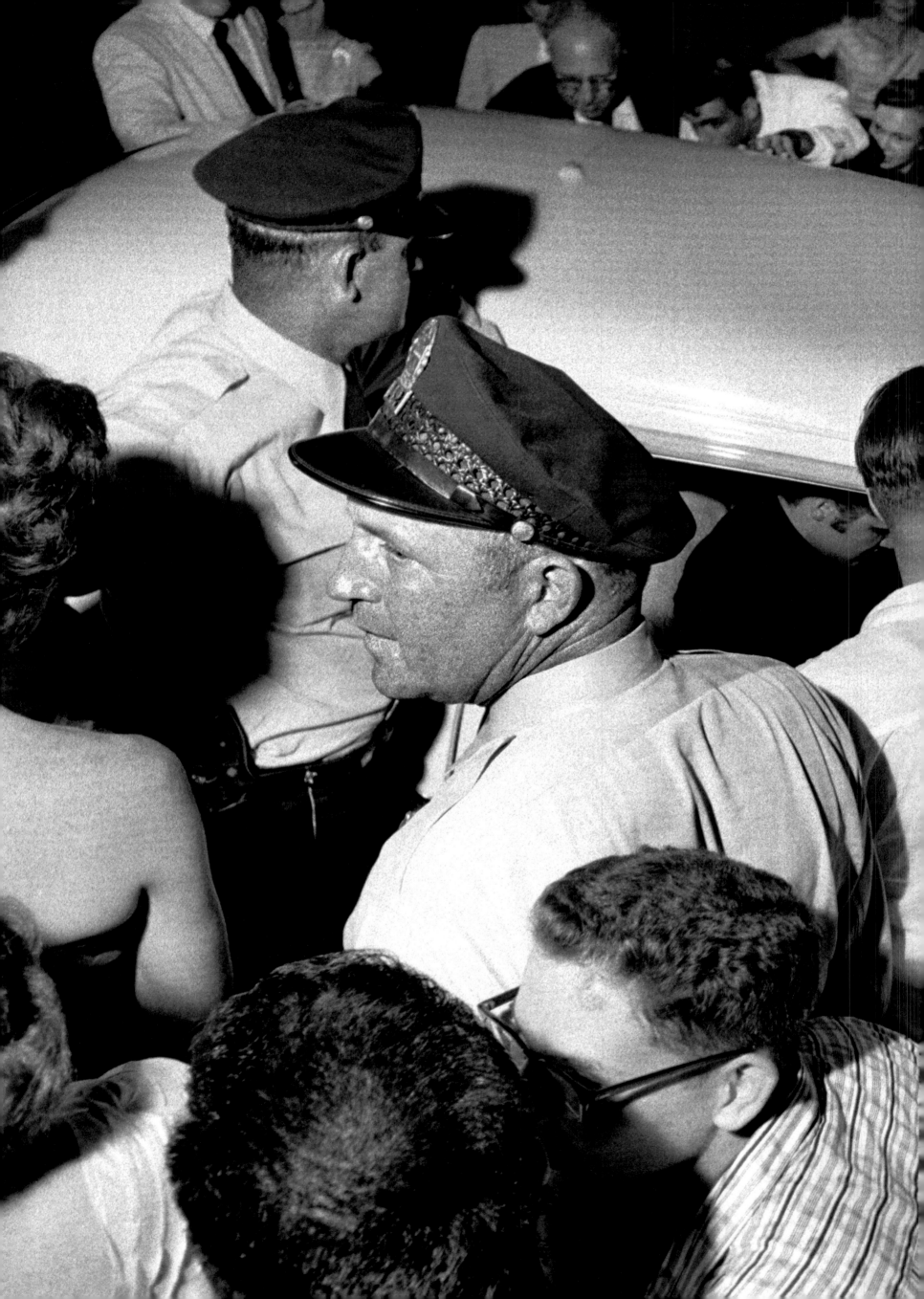

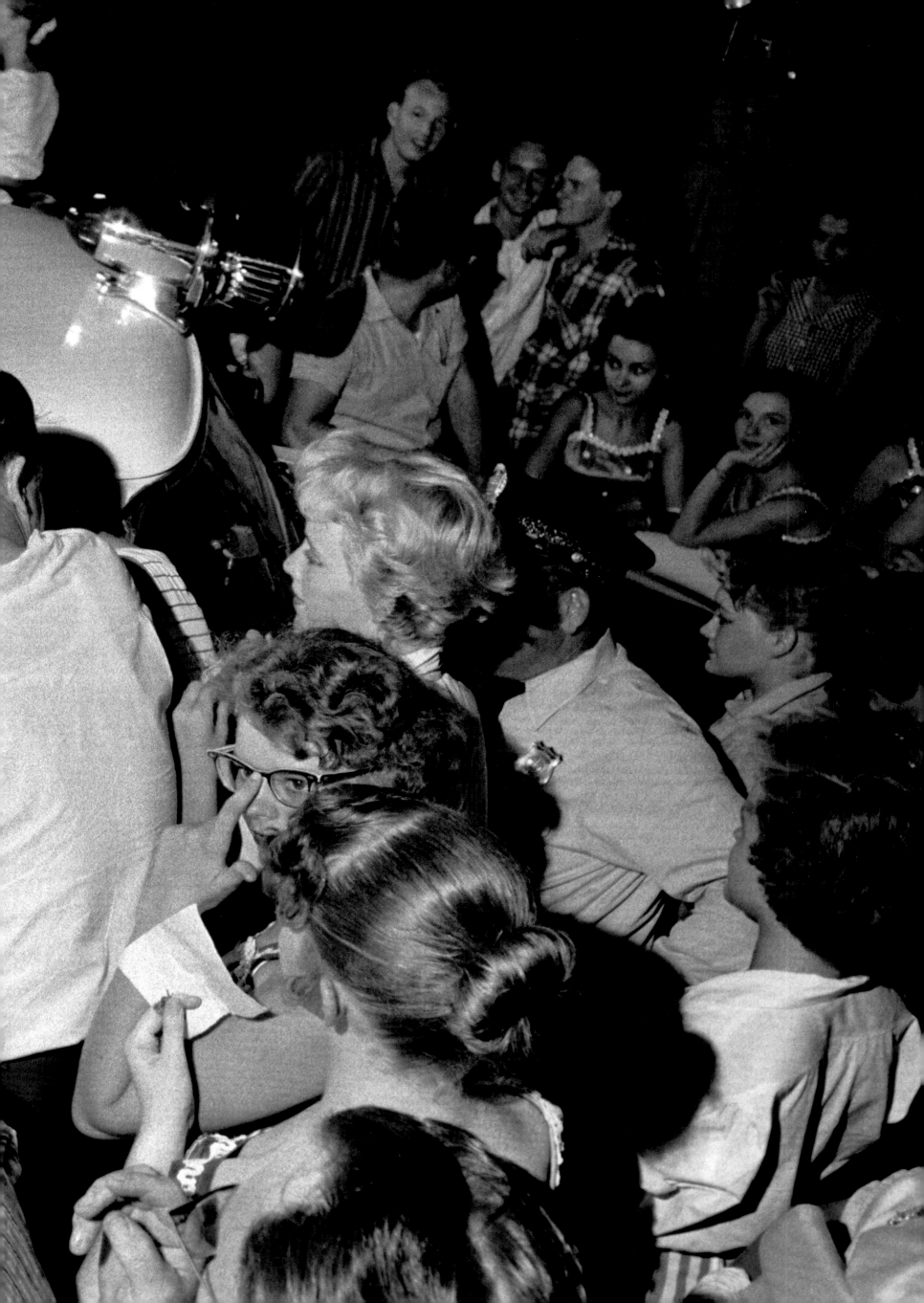

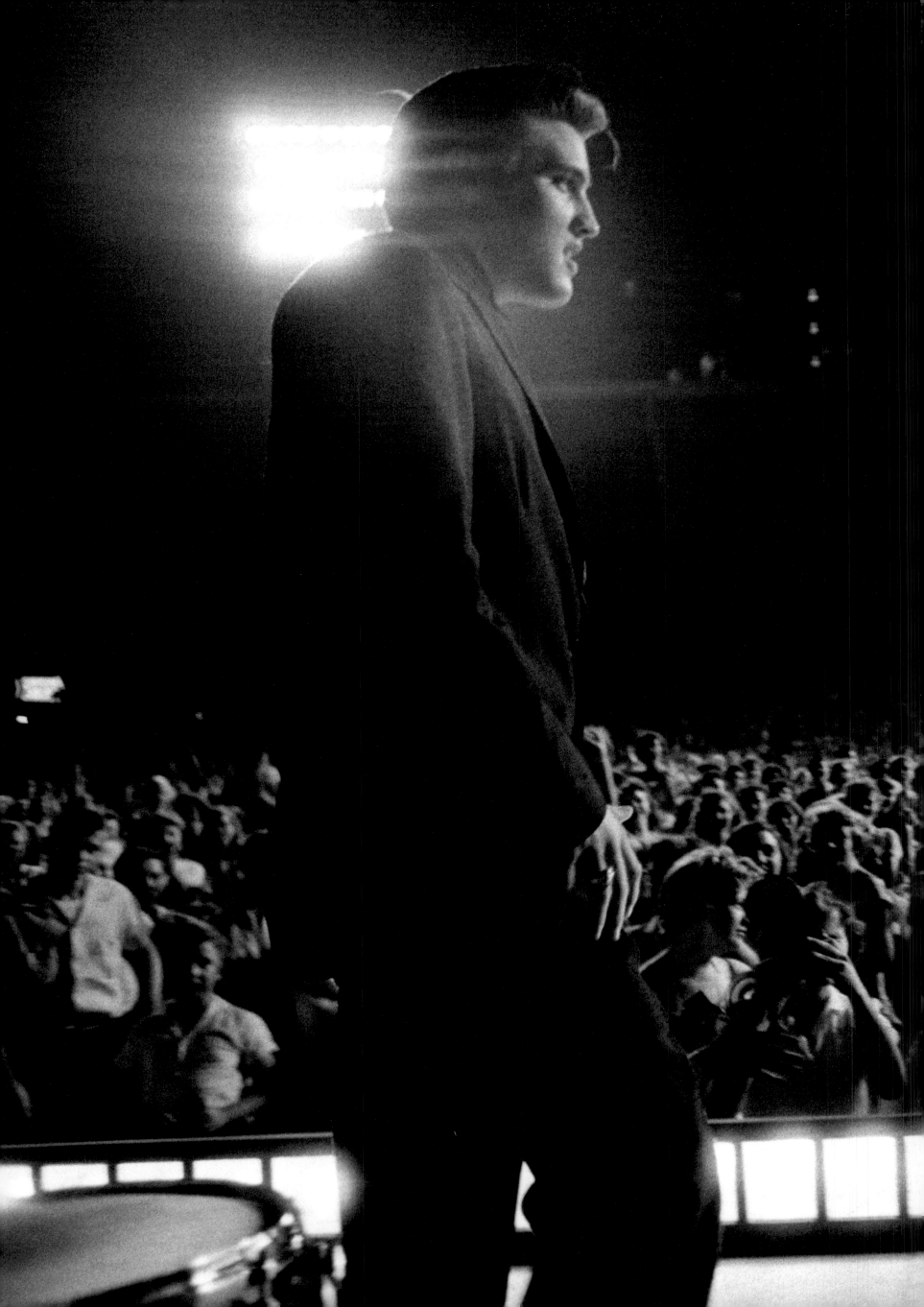

Elvis is a no-talent performer riding the crest of a wave of mass hysteria…He's drawing an average of two thousand kids a show and most of them are girls. Elvis can't sing, can't play the guitar.

Elvis ist ein untalentierter Interpret, der auf der Welle einer Massenhysterie reitet … Er lockt durchschnittlich 2000 Jugendliche pro Auftritt ins Konzert, und die meisten davon sind Mädchen. Elvis kann nicht singen, kann nicht Gitarre spielen.

Elvis est un musicien sans talent qui surfe sur une vague d'hystérie collective... Il attire environ deux mille gosses par concert et la plupart sont des gamines. Elvis ne sait pas chanter; il ne sait pas jouer de la guitare.

—HERB ROWE
Miami Herald, August 4, 1956

299 Colonel Parker sells autographed photos for a dime apiece before the Russwood Park show, which was a concert to benefit the Cynthia Milk Fund and the Variety Club's Home for Convalescent Children.

PREVIOUS SPREAD A sheriff's police car pushes Elvis through the crowd.

OPPOSITE Elvis takes the stage wearing all black except for his tie and his socks (both red).

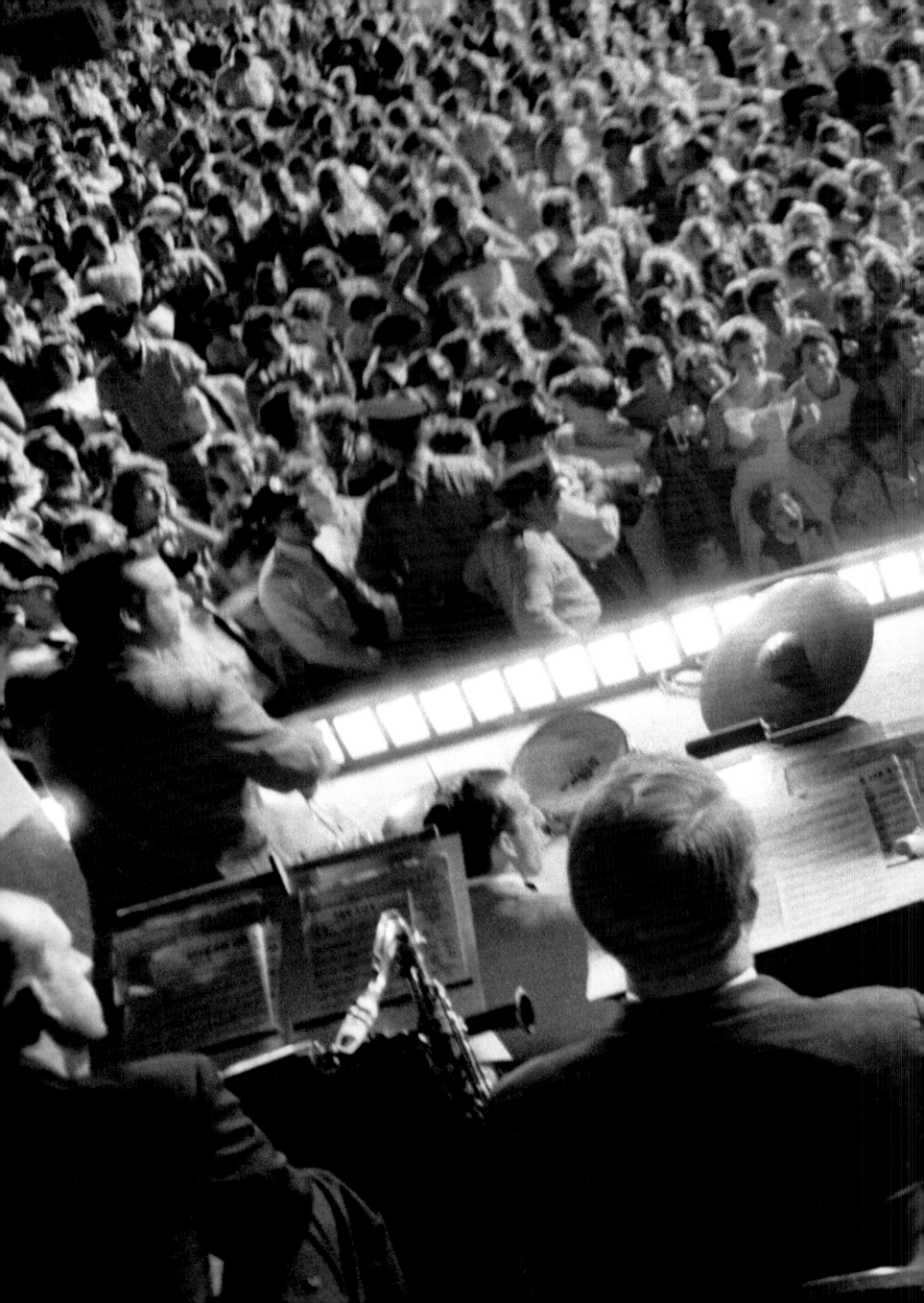

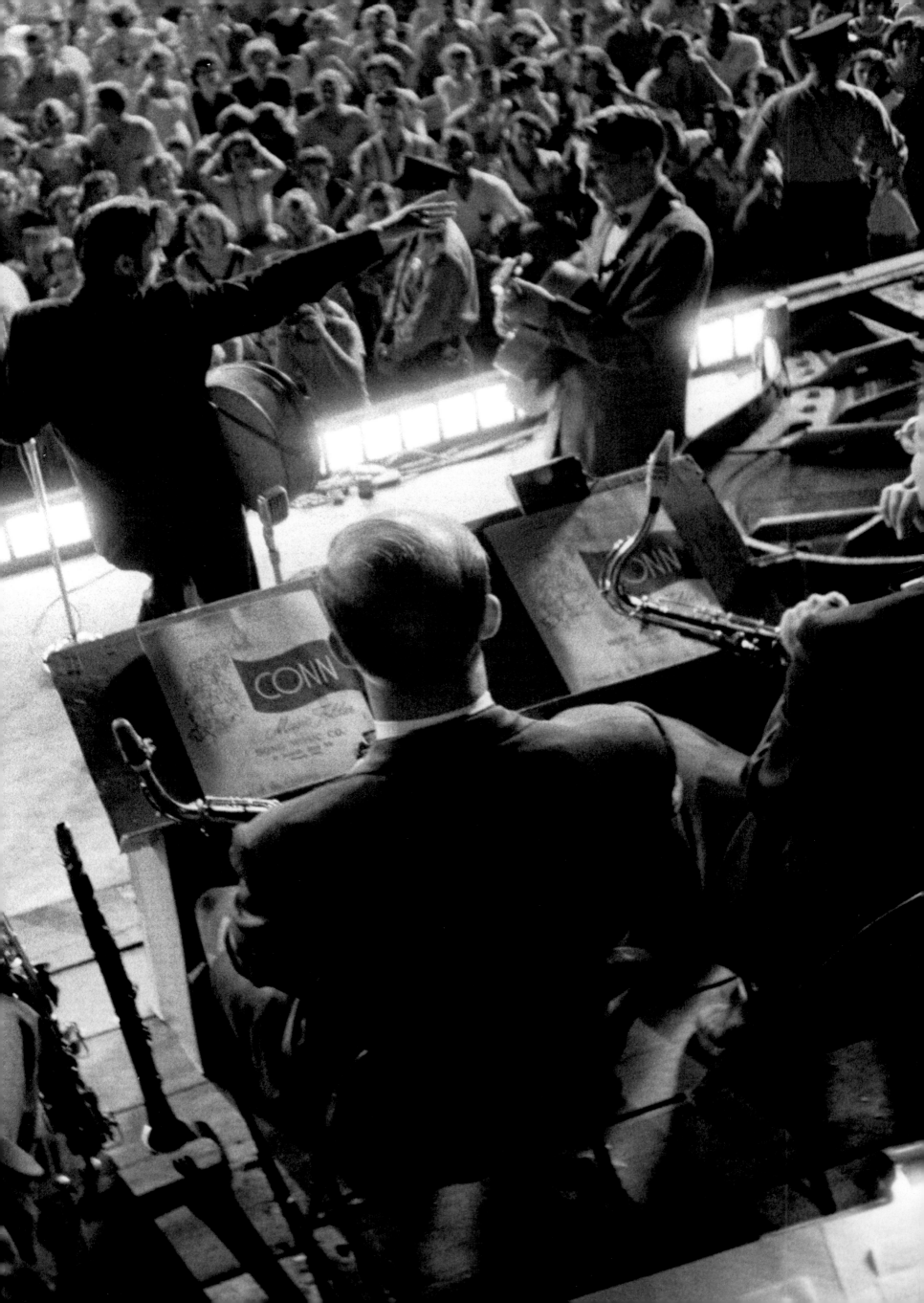

PREVIOUS SPREAD Referring to his tightly scripted performance on *Steve Allen*, Elvis readies the audience: "Tonight you're going to see what the real Elvis Presley is all about." Then he proceeds to gyrate all over the stage to their delight.

OPPOSITE *Starburst*, Russwood Park, Memphis, Tennessee, July 4, 1956. A lucky accident, a flashbulb goes off in the crowd at the very moment the shutter of Wertheimer's camera opens, creating a magnificent spray of backlight.

FOLLOWING SPREAD Elvis gets warmed up, a phalanx of officers protecting him from the crowd.

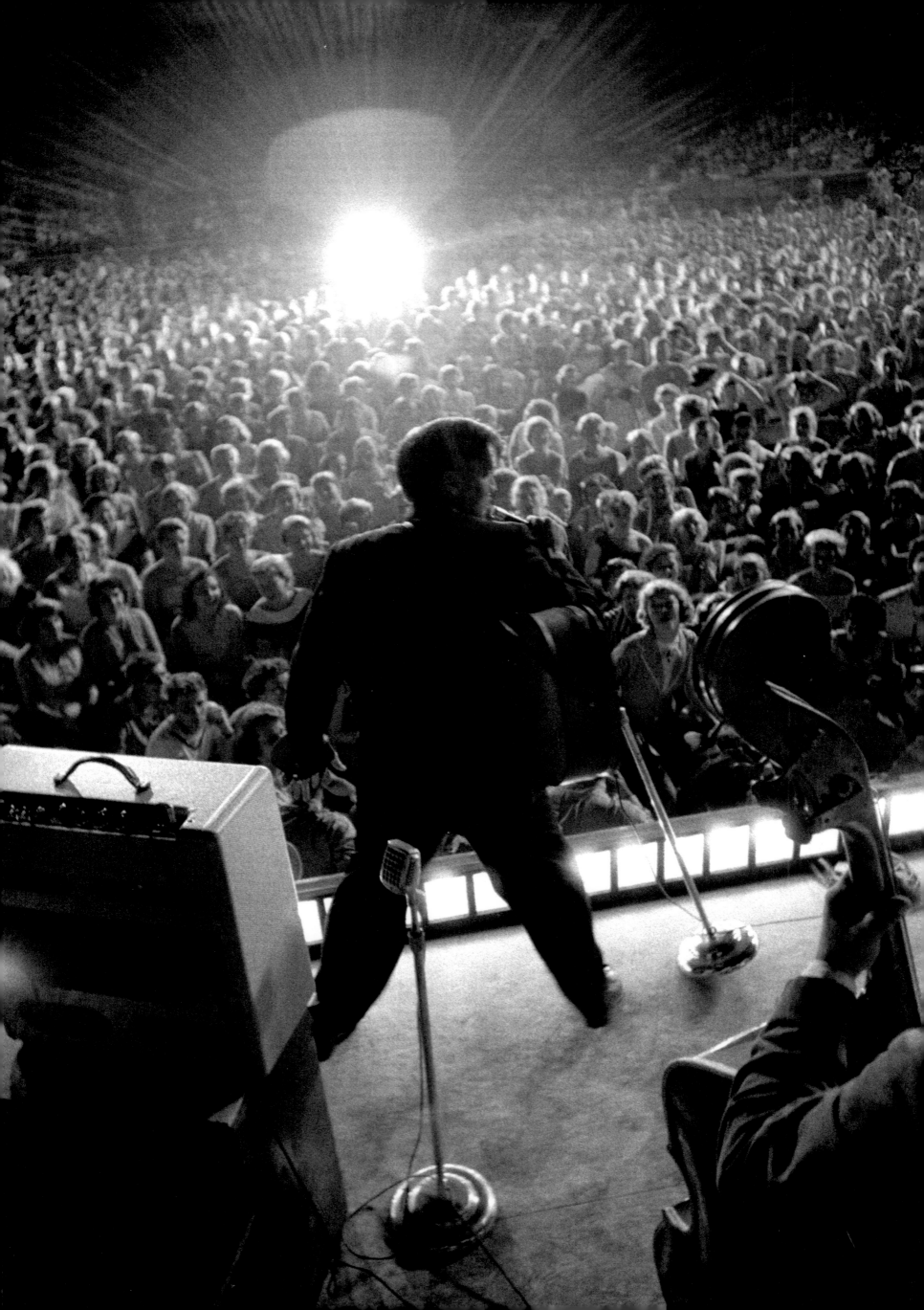

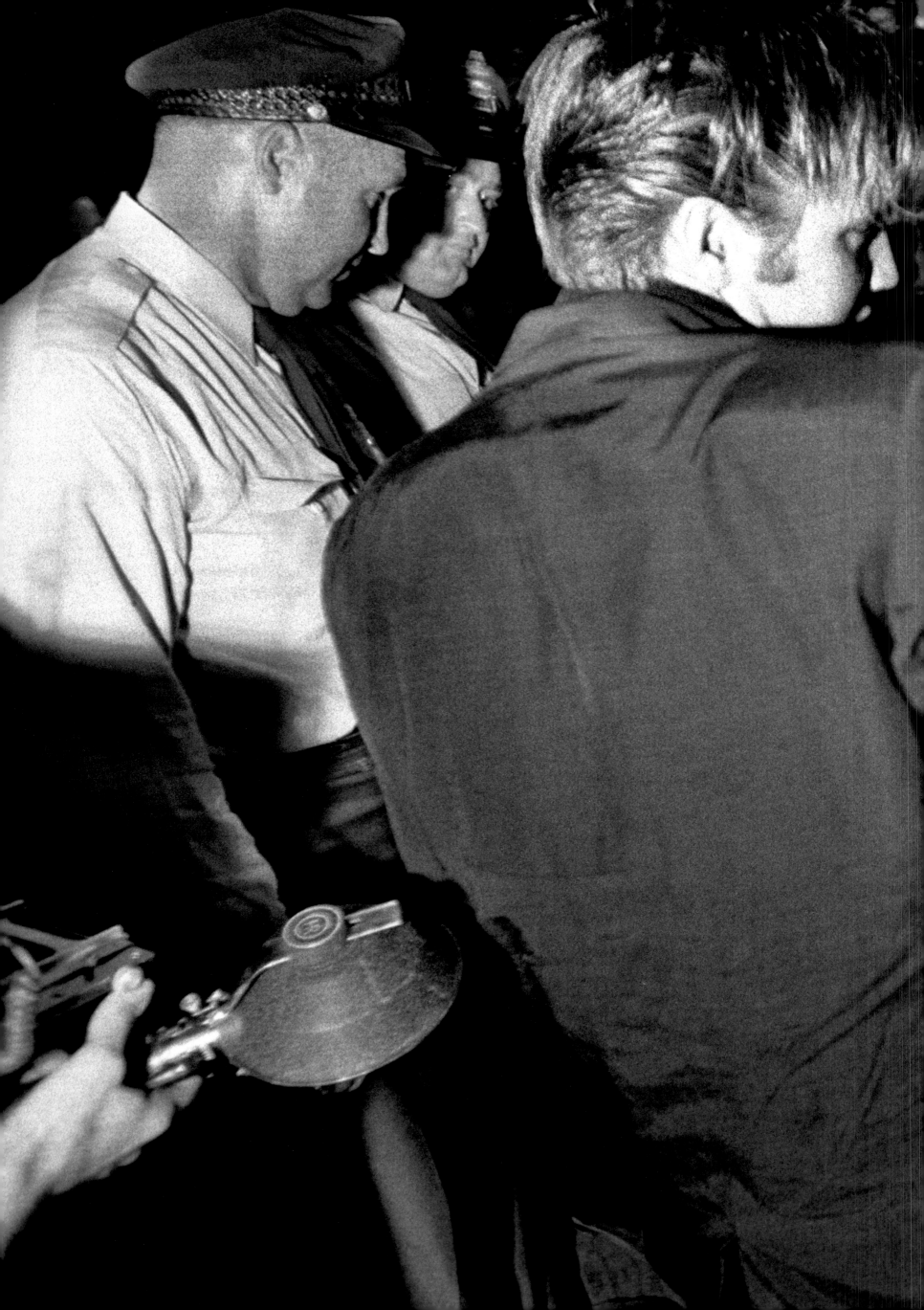

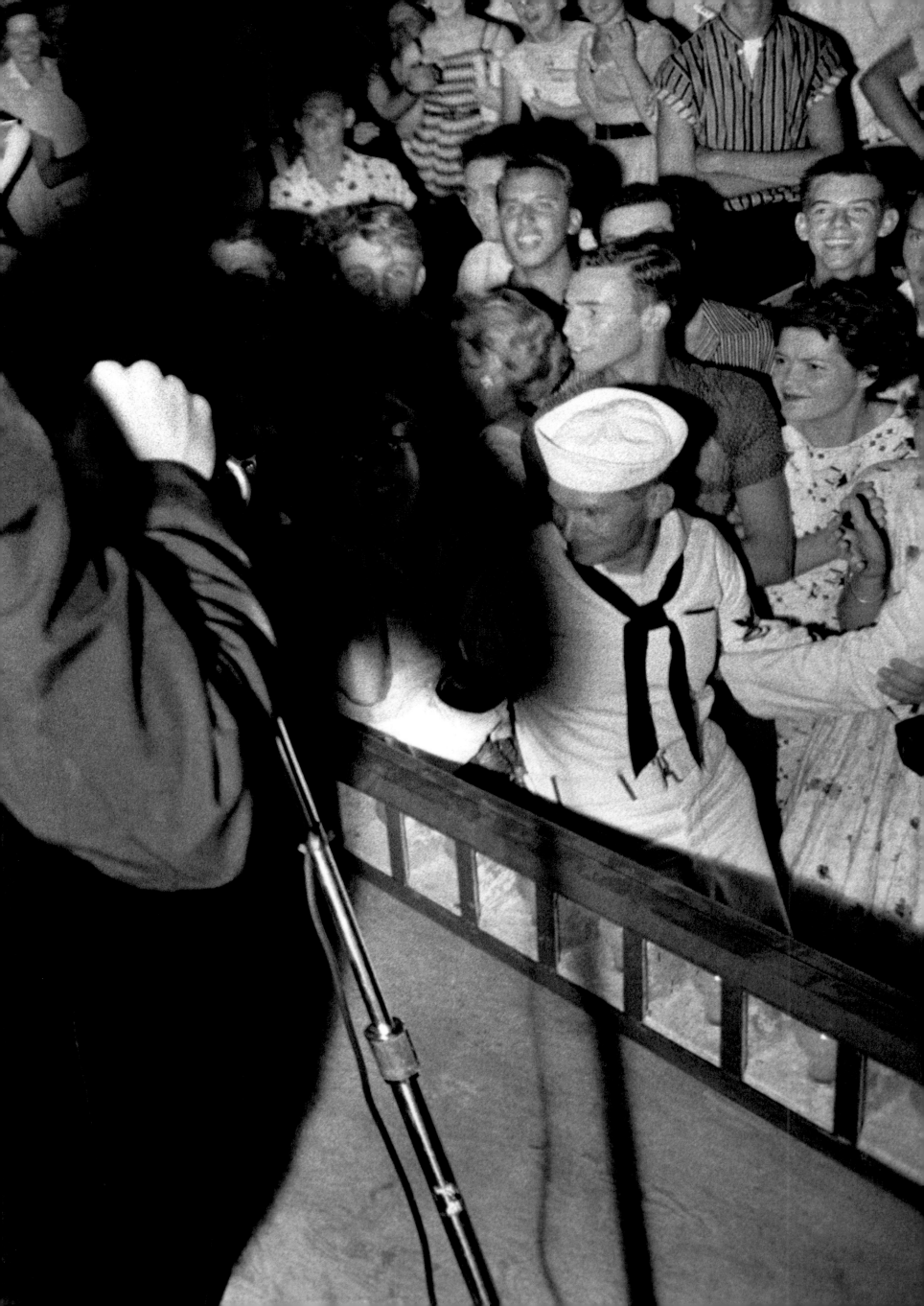

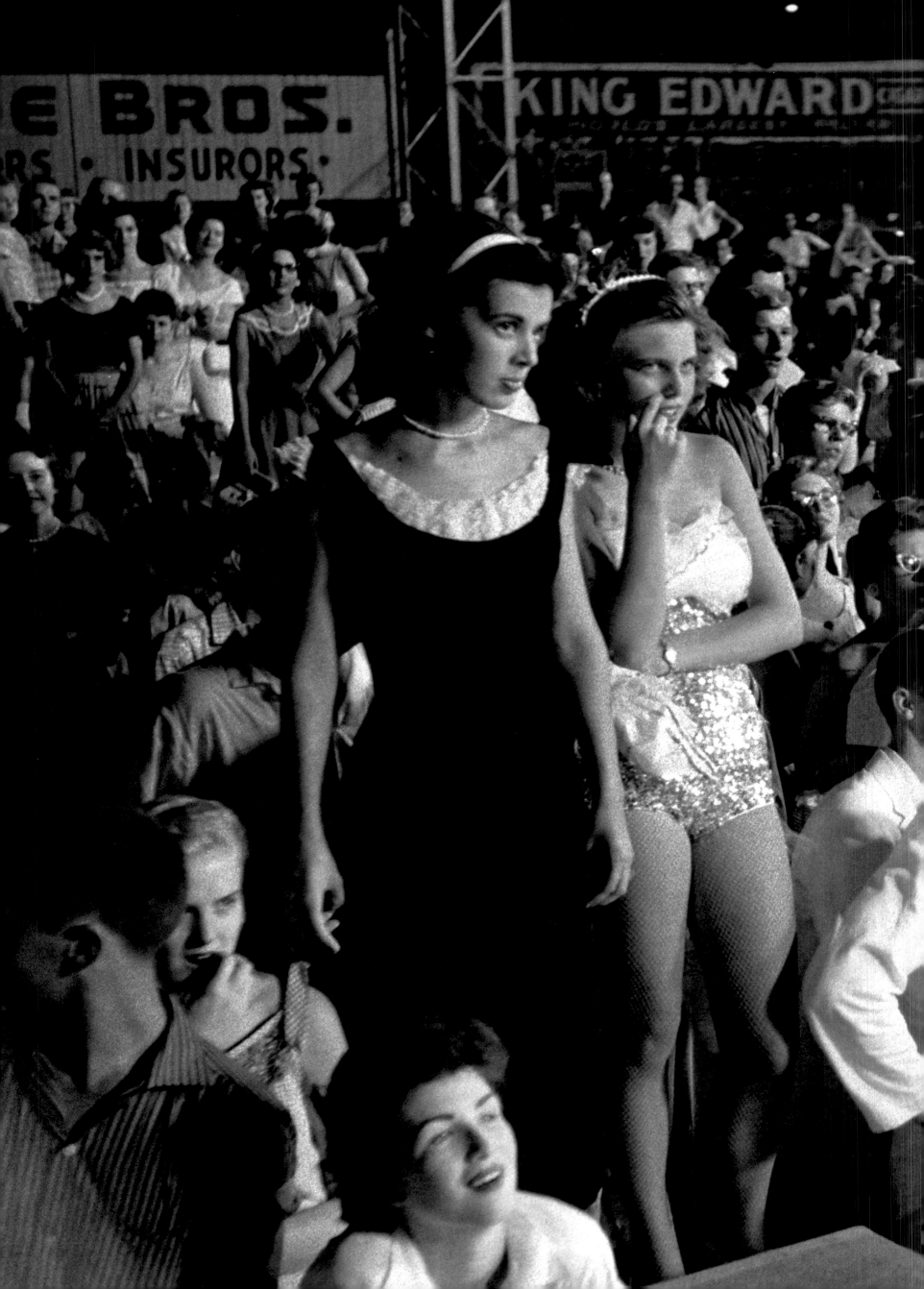

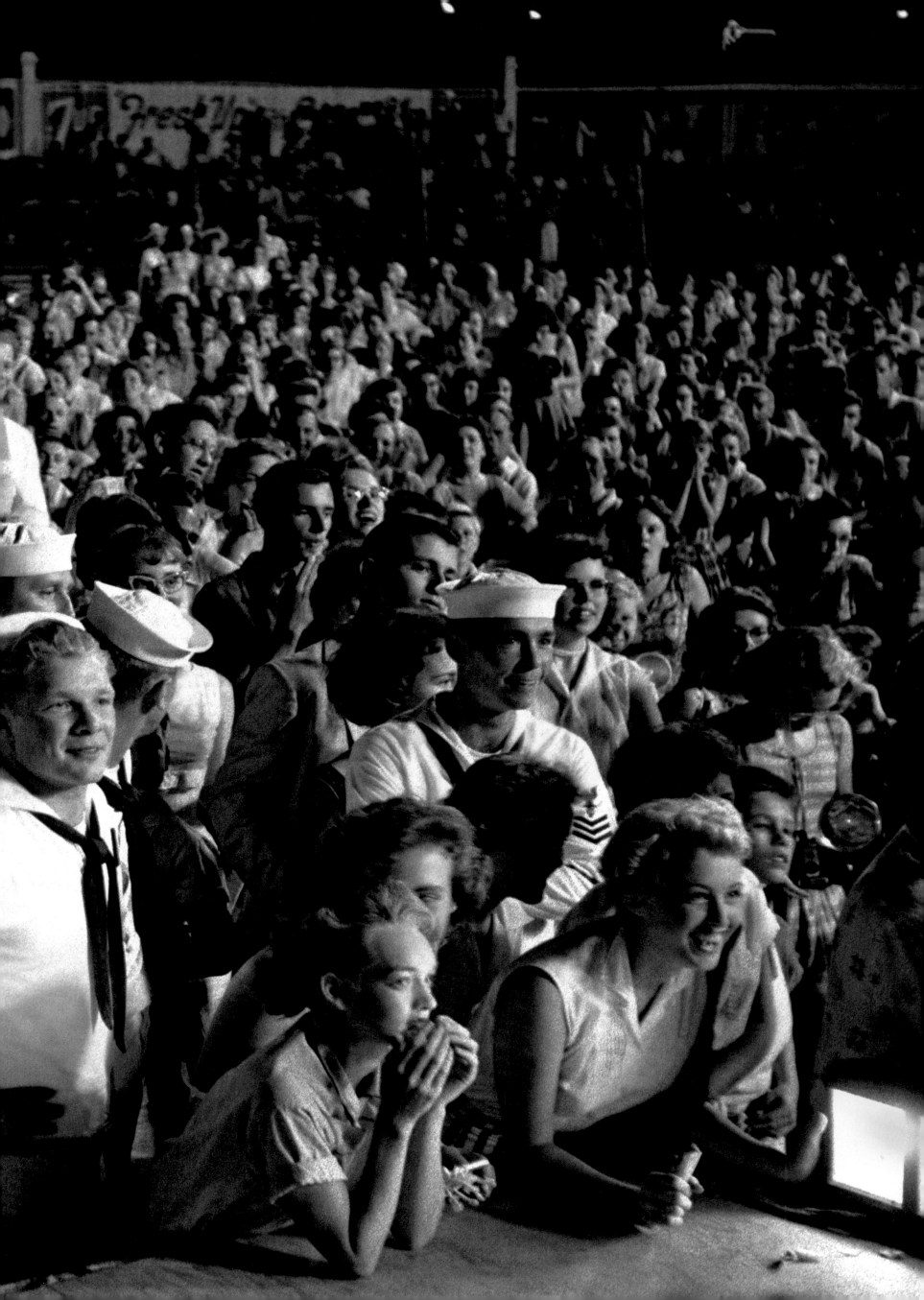

There's a big difference in singing on a record and singing for an audience. People can stay home and listen to records on the radio or phonograph and it doesn't cost 'em anything. But when they pay their money to come out and see you at a personal appearance, these people want to see a show.

Es ist ein großer Unterschied, ob man auf einer Platte oder für ein Publikum singt. Die Leute können zu Hause bleiben und im Radio oder auf dem Plattenspieler Musik hören, und es kostet sie nichts. Aber wenn sie Geld bezahlen, um ins Konzert zu kommen und dich bei einem Auftritt zu sehen – dann wollen sie eine Show sehen.

Il y a une grande différence entre chanter pour un disque et chanter pour un public. Les gens peuvent rester à la maison et écouter les disques à la radio ou sur leur phonographe, et ça ne leur coûte rien. Mais lorsqu'ils paient pour sortir et vous voir en chair et en os, alors ils veulent voir un vrai spectacle.

—ELVIS PRESLEY
Elvis Answers Back magazine, August 28, 1956

PREVIOUS SPREAD The next day, newspapers reported the Russwood crowd to number 14,000.

OPPOSITE Over 100 performers were on stage that night for the benefit show, including tap dancers and baton twirlers.

313

PVT. P[R]

SA[

BROOKLYN ★ ARMY ★

PORT OF EMBAR[

SEPTEMBER 2[

RESLEY
ILS
ERMINAL
KATION
2, 1958

A LITTLE LESS THAN A YEAR AFTER Elvis entered the U.S. Army, he arrived at the Brooklyn Army
Terminal Port of Embarkation sporting a crew cut and normal sideburns, ready to do occupation duty as a
soldier in Germany. A terrible and life-changing incident had happened five weeks earlier when his beloved
mother, Gladys, passed away. It was announced that Private Presley was not being treated differently
from other soldiers; however, he held a press conference in front of approximately 250 media people with
recruiting posters hanging behind him prior to shipping out. I was warned by Anne Fulchino that Colonel
Parker was going to be there—but I reassured her that I had nothing to fear. When I was at the podium he
squeezed in beside me. After a moment he looked me in the face and said, "Wertheimer! Taking any good
pictures?" And I said, "Always, Colonel, always," and he replied, "Very good, keep it up." Colonel Parker was
always thinking ahead, providing the bandleader with sheet music of Elvis's hits, especially those from
Sun Records. The Army band played many of Elvis's early songs as the *USS Randall* troop ship sailed out
of New York Harbor with 6,000 soldiers aboard. That was the last time I ever saw him.

NUR KNAPP EIN JAHR NACH seiner Einberufung in die US Army kam Elvis mit Crewcut und kurzen
Koteletten am Armeehafen in Brooklyn an, bereit, seinen Dienst als Besatzungssoldat in Deutschland zu
leisten. Fünf Wochen zuvor war seine geliebte Mutter Gladys gestorben – ein für ihn traumatisches Ereignis,
das sein Leben verändern sollte. Von offizieller Seite wurde verkündet, dass der Soldat Presley in keiner
Weise anders behandelt würde als jeder andere Soldat; trotzdem gab Elvis eine Pressekonferenz vor unge-
fähr 250 Medienvertretern, an der Wand hinter sich Werbeplakate der US Army. Anne Fulchino hatte
mich vorgewarnt, dass Colonel Parker anwesend sein würde – aber ich versicherte ihr, dass ich nichts zu
befürchten hätte. Als ich beim Podium stand, quetschte er sich neben mich. Nach einer kurzen Pause sah
er mich an und sagte: „Wertheimer! Werden es gute Bilder?" Und ich sagte: „Aber immer, Colonel, immer."
Und er: „Sehr schön, weiter so!" Colonel Parker, der stets vorausdachte, hatte den Leiter des Musikkorps
mit Noten zu allen Elvis-Hits, speziell aus der Sun-Records-Zeit, versorgt. Und so kam es, dass die Militär-
kapelle viele der frühen Elvis-Songs spielte, als der Truppentransporter *USS Randall* mit 6 000 Soldaten
an Bord aus dem New Yorker Hafen auslief. Damals sah ich ihn zum letzten Mal.

MOINS D'UN AN APRÈS avoir été appelé sous les drapeaux, Elvis se présenta au port d'embarquement
du terminal militaire de Brooklyn avec une coupe de cheveux réglementaire et ses favoris rasés, prêt
à effectuer son service militaire en Allemagne. Cinq semaines plus tôt, un drame avait bouleversé sa vie :
il avait perdu Gladys, sa mère adorée. Bien que le première classe Presley soit censé être traité comme
n'importe quel autre soldat, il tint une conférence de presse devant environ 250 journalistes, avec, derrière
lui, des affiches de recrutement. Anne Fulchino m'avait prévenu que le colonel serait dans les parages, mais
je l'avais assurée n'avoir rien à craindre. Alors que je me trouvais au pied de l'estrade, il joua des coudes
pour se faufiler à mes côtés. Me regardant dans les yeux, il me demanda : « Wertheimer ! Vous prenez de
bons clichés ? » « Comme toujours, mon colonel », ai-je répondu. « Très bien, continuez ! » Le colonel Parker
avait toujours une longueur d'avance sur les autres : il avait fourni au chef de musique des partitions de
tubes d'Elvis, notamment ceux de Sun Records. Lorsque l'*USS Randall* quitta le port de New York avec
6 000 soldats à son bord, la fanfare joua d'anciennes chansons d'Elvis au lieu de la musique militaire tradition-
nelle. Je ne devais jamais le revoir.

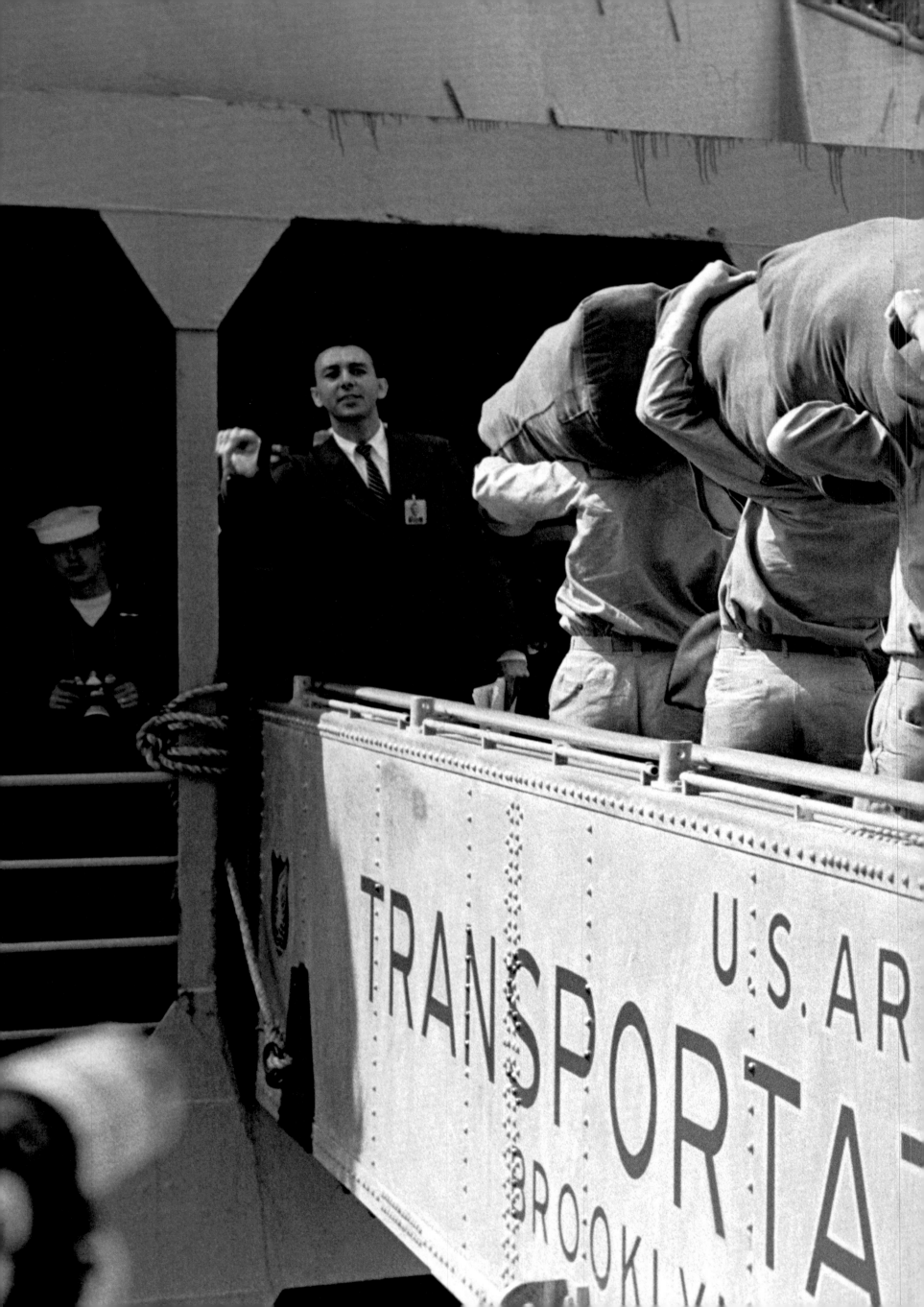

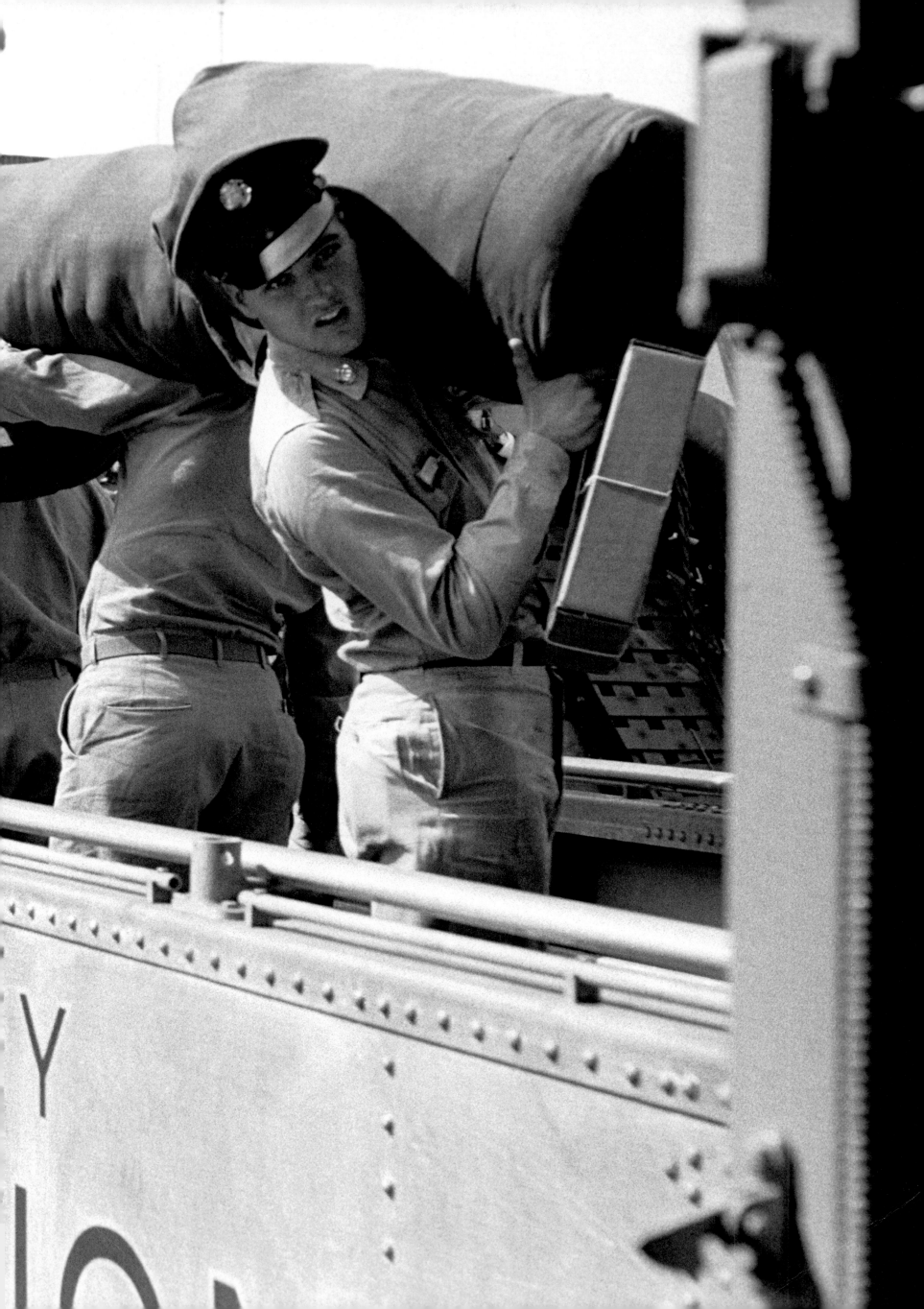

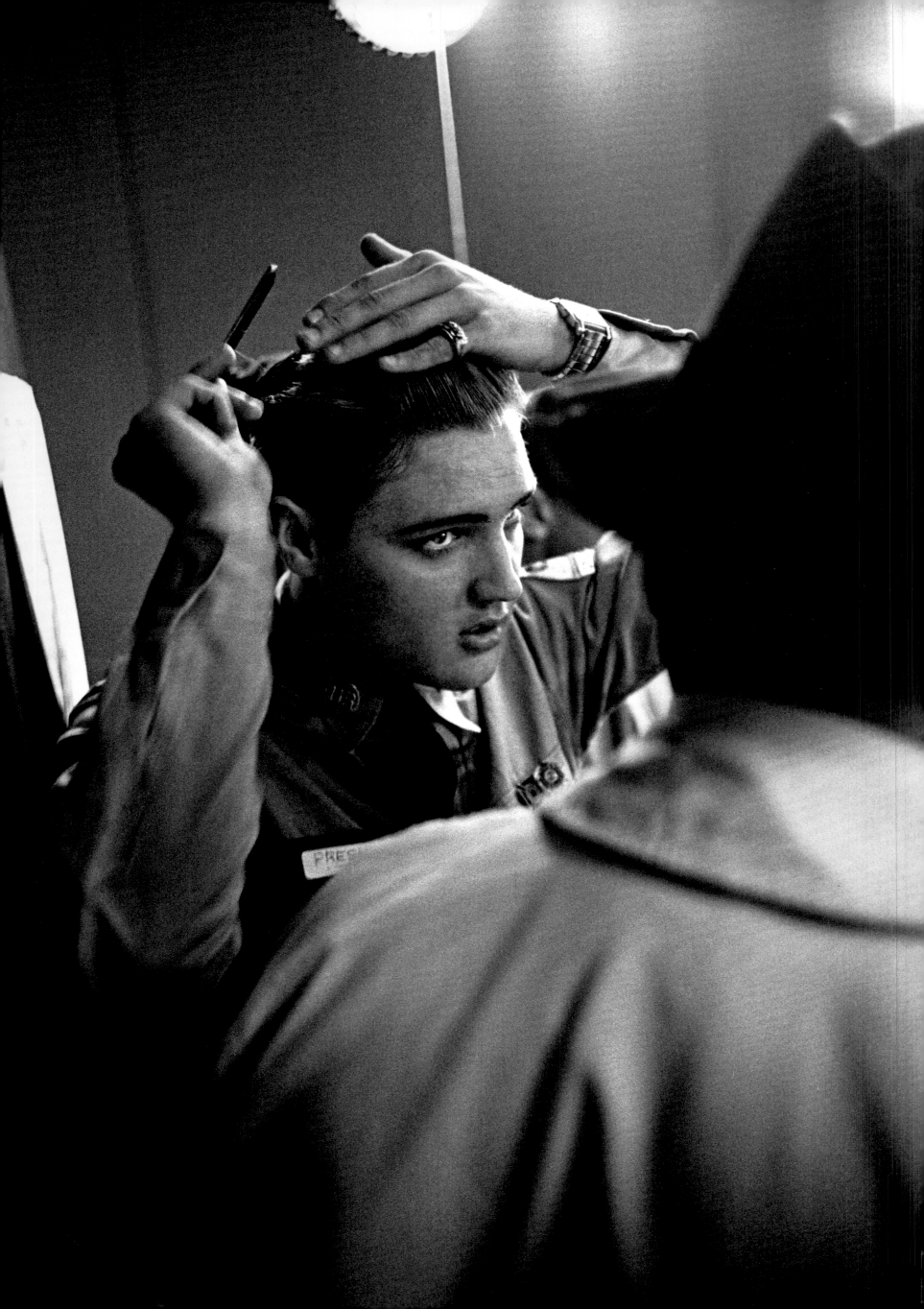

Pvt. Elvis Presley departed yesterday with 1,170 members of the Third Armored Division for an eighteen-month tour of duty in Germany. The entertainer said that if rock 'n' roll music died out during his stay in service, he would give up singing and try to become a good actor.

Der Rekrut Elvis Presley lief gestern mit 1170 Angehörigen der Dritten Panzerdivision zu einem 18-monatigen Dienst-einsatz in Deutschland aus. Der Unterhaltungskünstler sagte, dass er, falls Rock-and-Roll-Musik während seines Aufenthalts in der Armee aussterben sollte, das Singen aufgeben und versuchen wolle, ein guter Schauspieler zu werden.

Le première classe Elvis Presley est parti hier avec 1170 autres membres de la troisième division blindée pour une période de service de dix-huit mois en Allemagne. Le musicien a déclaré que si le rock'n'roll disparaissait pendant son absence, il abandonnerait le chant et tenterait de devenir un bon acteur.

—THE NEW YORK TIMES
September 23, 1958

317 & PREVIOUS SPREAD "Could we try that once more?" Elvis and fellow soldiers of Company D 1st Battalion 32nd Armor, 3rd Armored Division walk the gangplank of the *USS Randall* at the Brooklyn Army Terminal Port of Embarkation.

OPPOSITE Combing his GI haircut.

FOLLOWING SPREADS The Colonel (Tom Parker) and the commanding general (in civilian clothes) accompany Elvis at his press conference, where he answers questions from television news interviewers about his deployment.

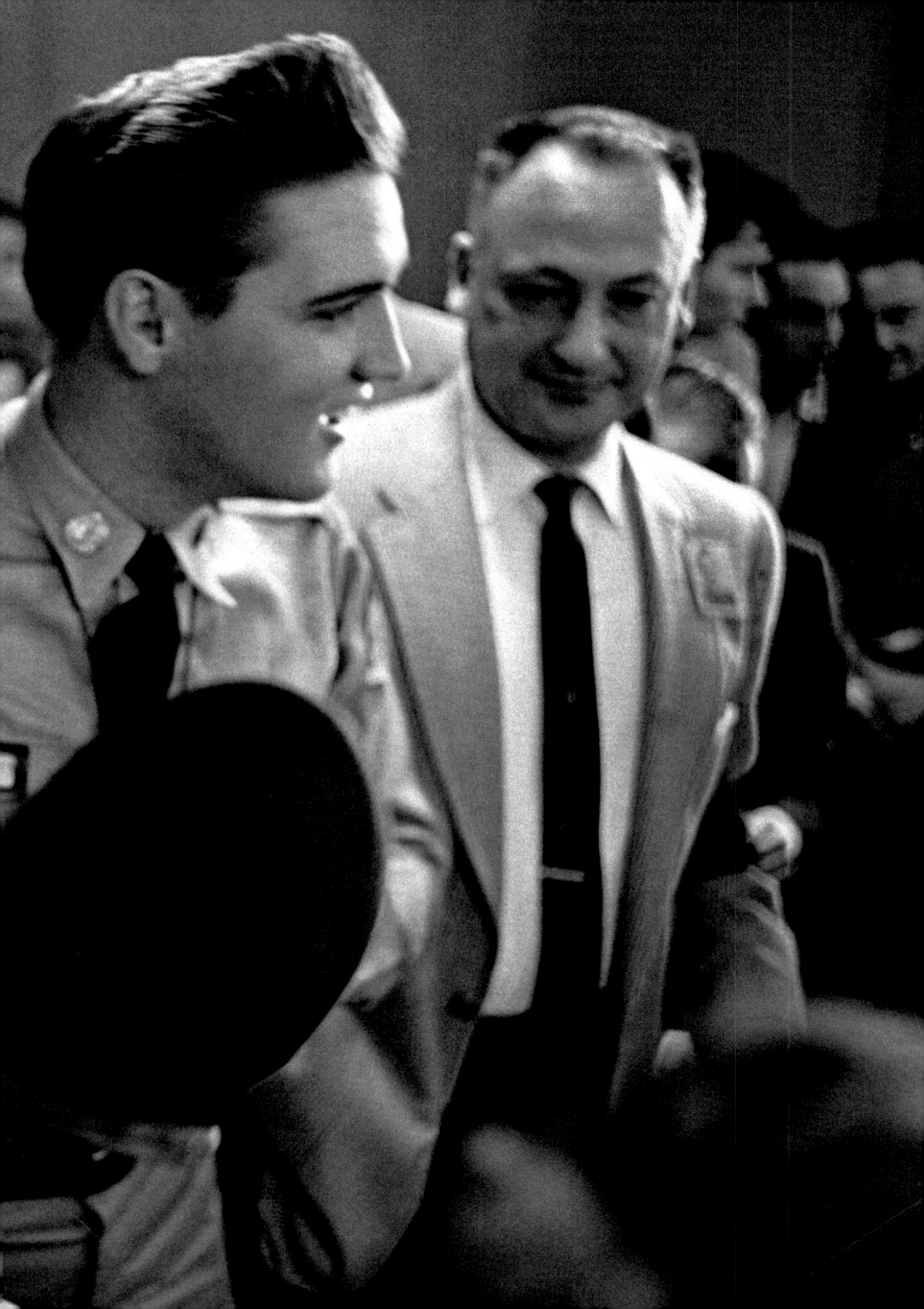

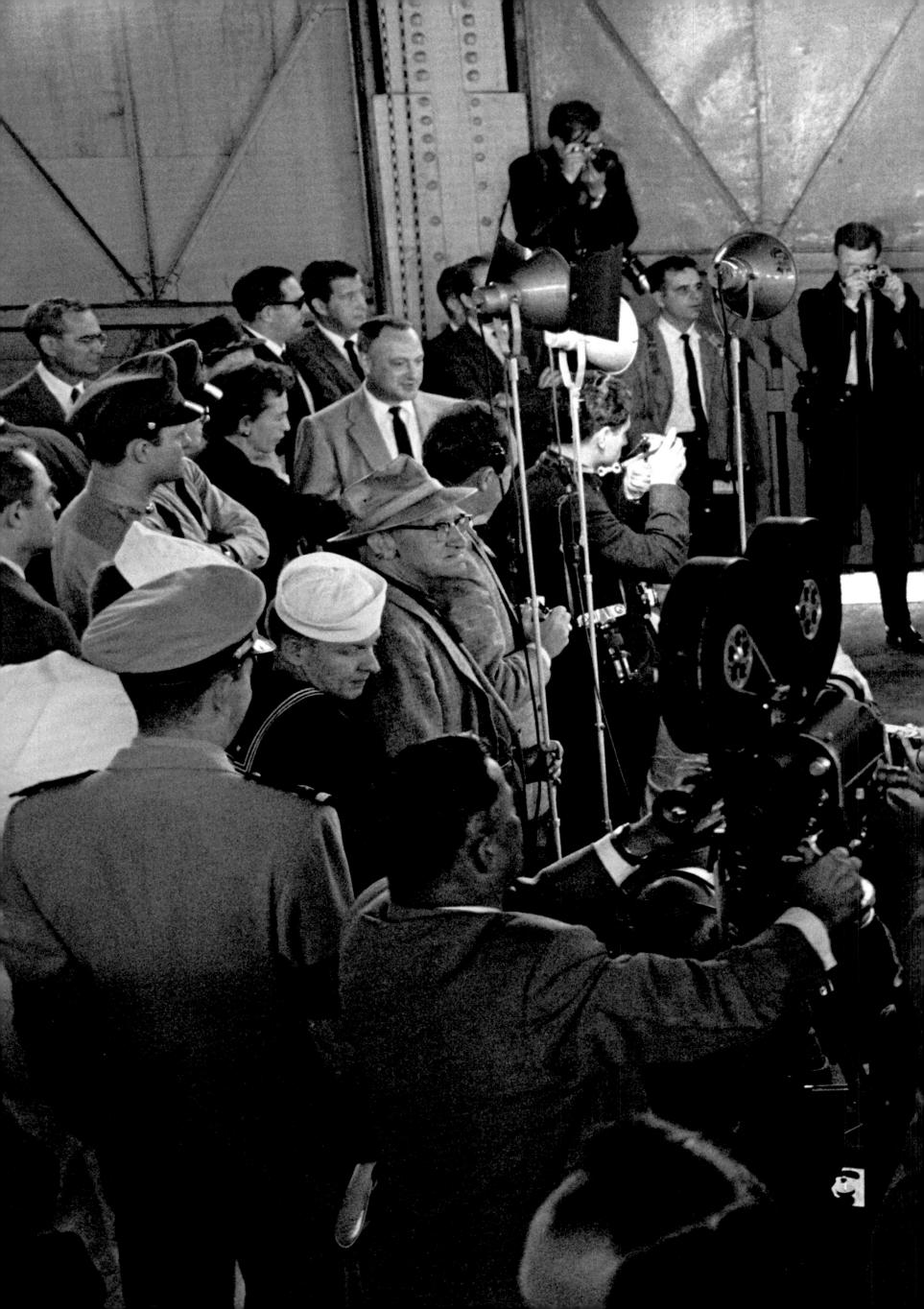

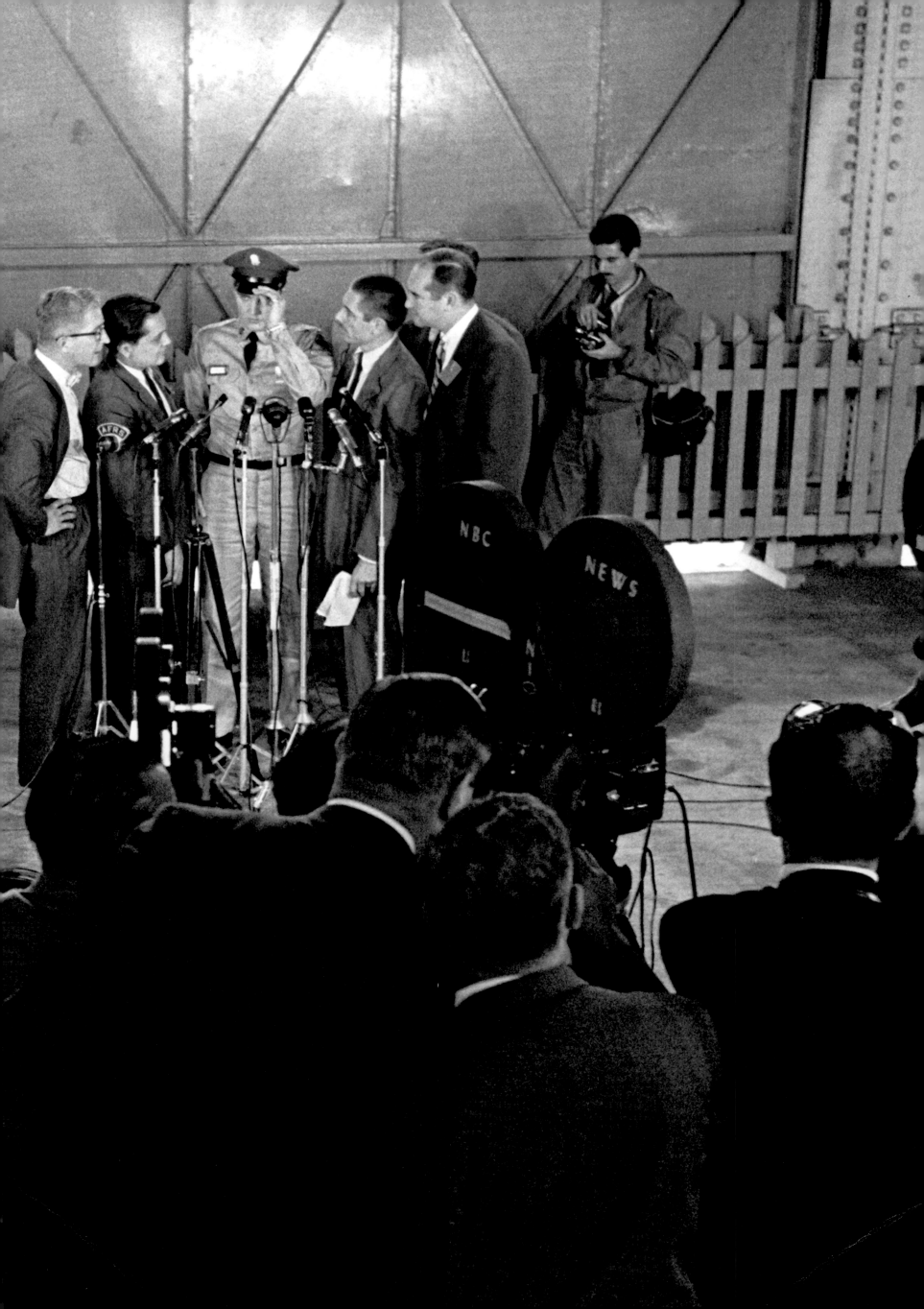

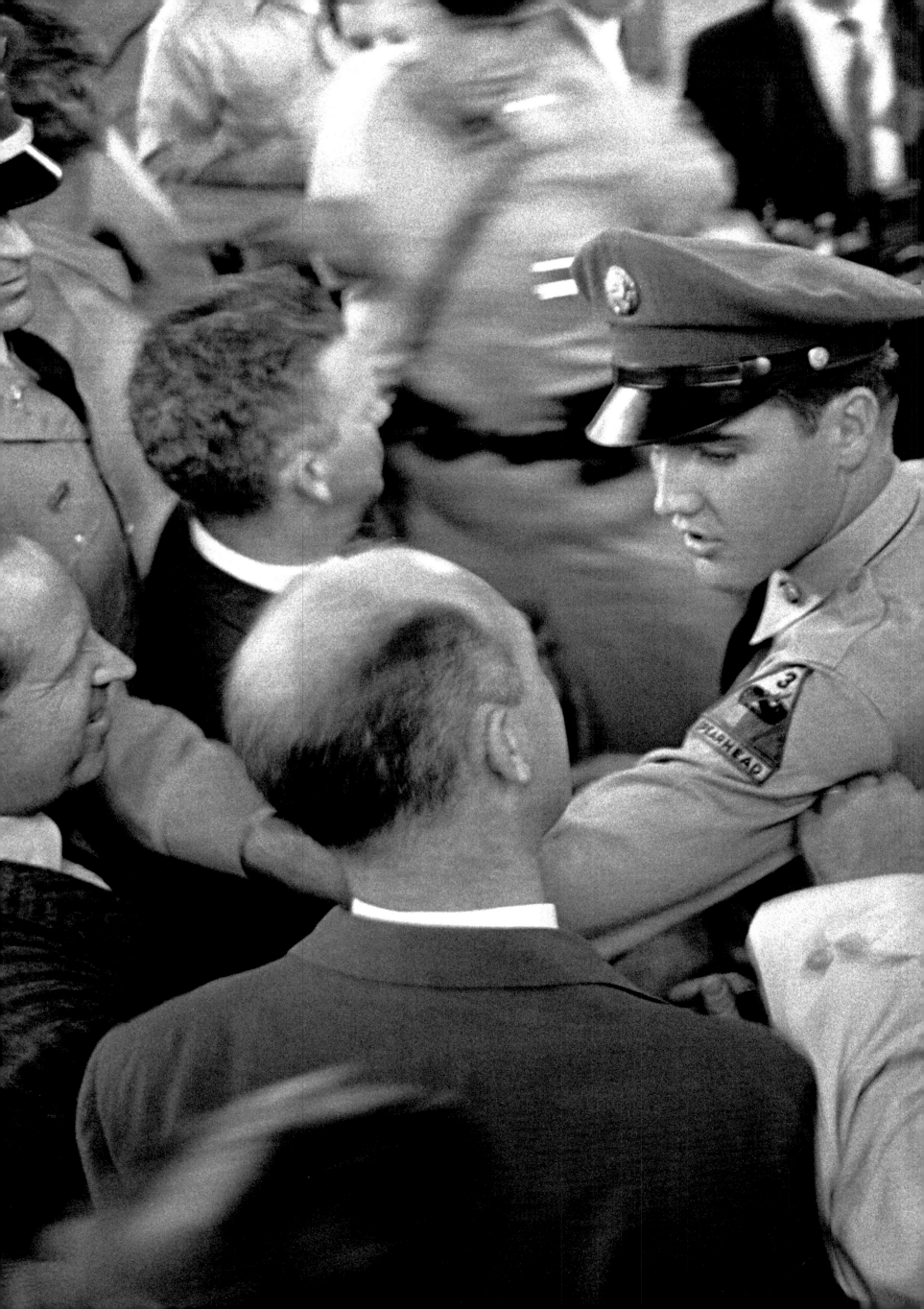

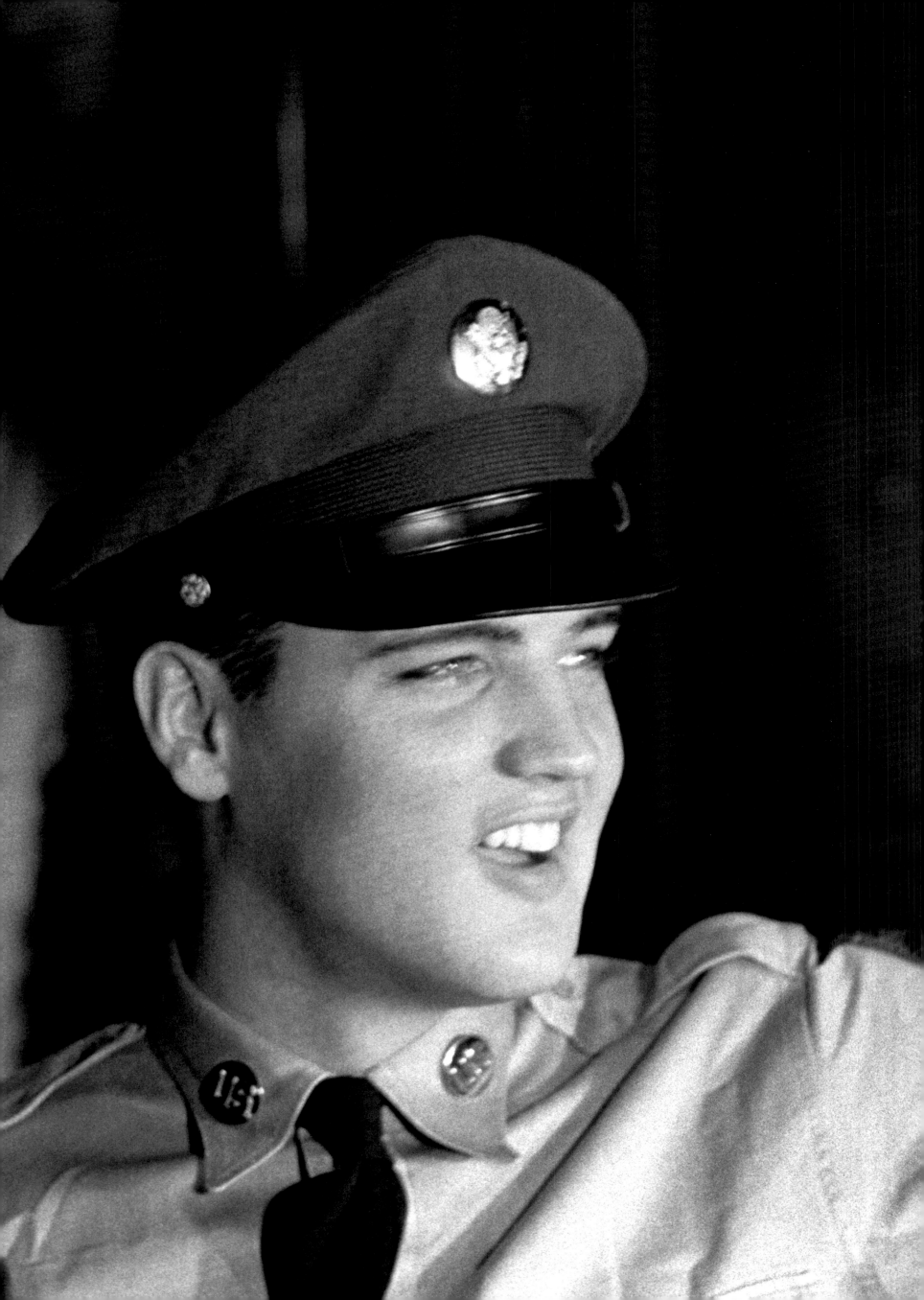

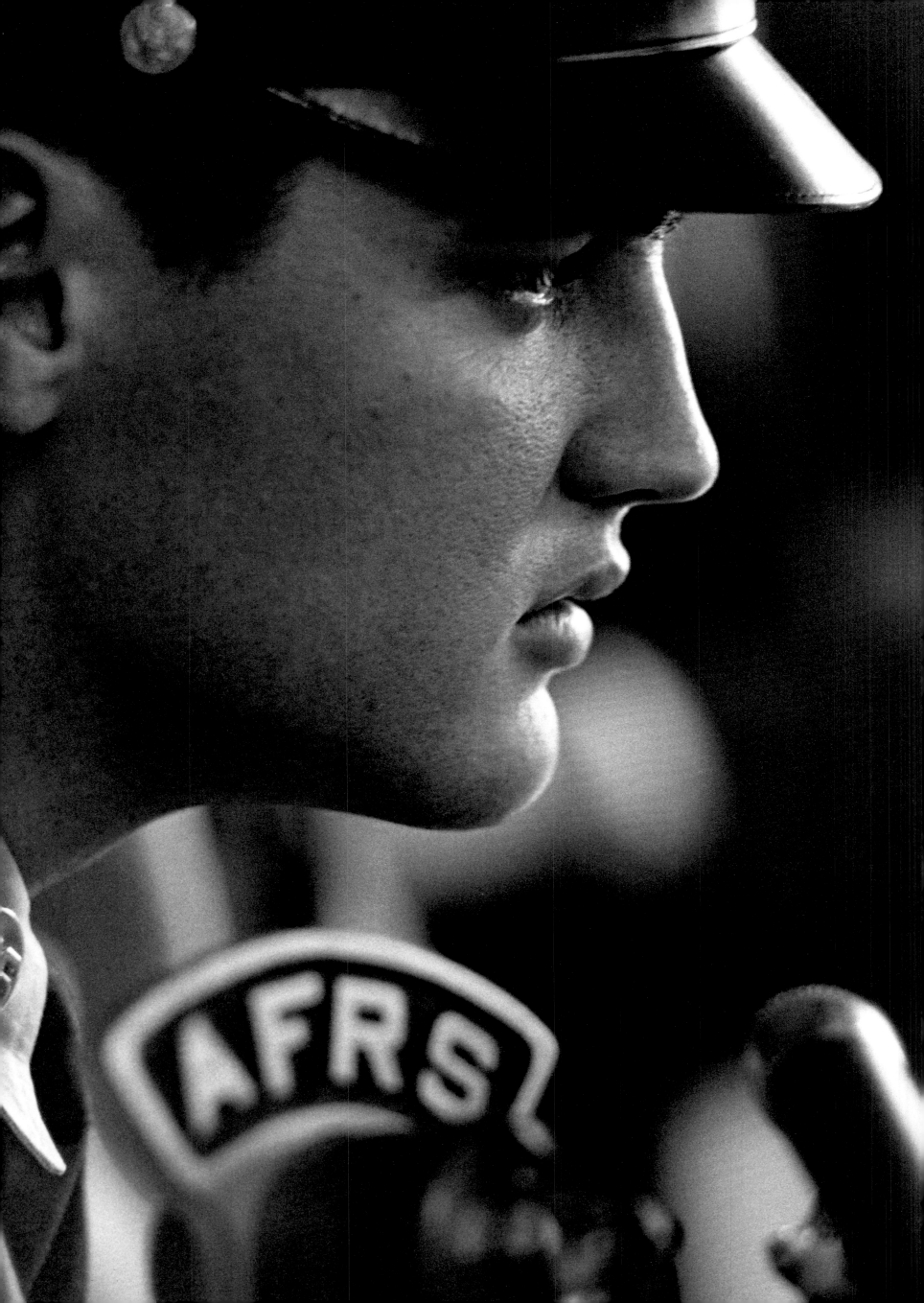

It's rare when an artist's talent can touch an entire generation of people. It's even more rare when that same influence affects several generations. Elvis made an imprint on the world of pop music unequaled by any other single performer.

Es ist selten, dass ein Künstler mit seinem Talent eine ganze Generation anrühren kann. Es ist sogar noch seltener, wenn dieser Einfluss über mehrere Generationen anhält. Elvis prägte die Welt der Popmusik in einem Maß, wie es keinem anderen Interpreten gelang.

Il est rare que le talent d'un artiste touche toute une génération de gens. C'est encore plus rare quand son influence se fait sentir sur plusieurs générations. Elvis a laissé son empreinte dans le monde de la musique populaire comme aucun autre artiste.

—DICK CLARK

326-327 Colonel Tom Parker literally pushes Elvis closer to the gangplank of the troop ship *USS Randall* on the day of departure.

PREVIOUS SPREAD *Private Presley*, Brooklyn Army Terminal Port of Embarkation, September 22, 1958.

OPPOSITE Elvis holds forth on the Armed Forces Radio Service, broadcasting his departure for Friedberg, Germany.

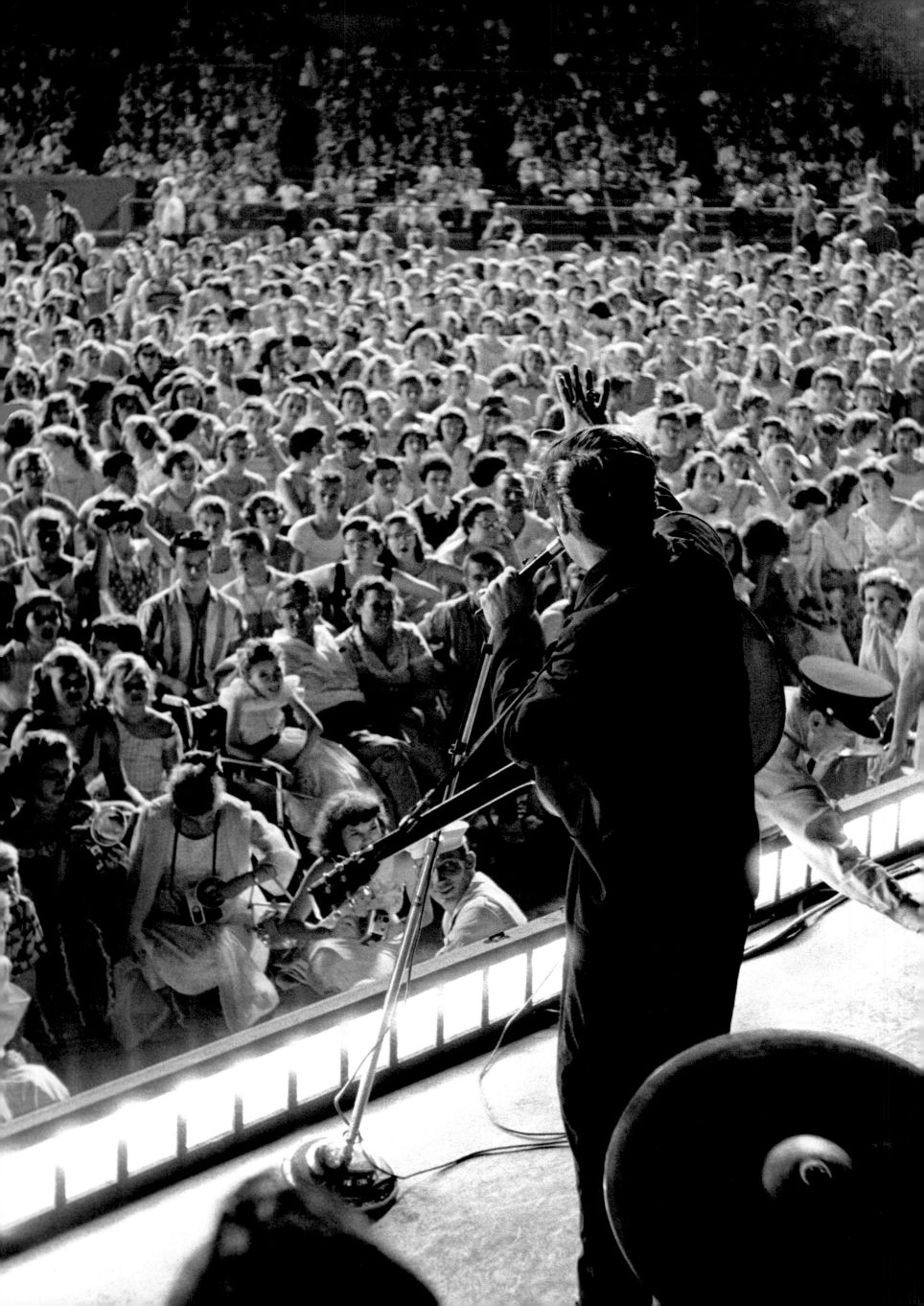

Just Another Assignment

CHRIS MURRAY

"Alfred Wertheimer got great pictures. Like Elvis, by embracing spontaneity, by prizing feeling over mere technique, he found something new in familiar forms, and the result is work that can stand gloriously on its own, unaffected by the eddying tides of fashion or the shifting sands of time." —**PETER GURALNICK**

IT WAS A HOT SUMMER NIGHT in Memphis on July 4, 1956. A 21-year-old Elvis Presley had just returned home from a trip to New York City, where he had made several appearances on national television shows and recorded "Hound Dog," "Don't Be Cruel," and "Any Way You Want Me" at RCA Victor's Studio 1. "Hound Dog" and "Don't Be Cruel" would soon be released as A- and B-sides of a 45-rpm record ready to explode on radio airwaves. Elvis was to perform that evening in Russwood Park, a stadium in Memphis. The crowd was buzzing and in a mood of great anticipation, excited to see their hometown boy who had gone north and "made it big."

Photographer Alfred Wertheimer, just 26 years old himself, accompanied Elvis to his concert. The sheriff arrived at the Presley home in his police car. Elvis sat in the middle of the front seat, in between the sheriff and his manager, Colonel Tom Parker. Wertheimer sat in the backseat alone. When they arrived, Wertheimer photographed Elvis moving through a surging crowd that was trying to get as close to him as possible.

The air was electric when a black-clad Elvis took the stage, backed by Scotty Moore on the guitar, Bill Black on bass, and D.J. Fontana on drums. 14,000 people were on hand to celebrate this new liberating and thrilling music performed by one of their own. Alluding to the stiff script he'd followed just a few days earlier on *The Steve Allen Show*, he told the Memphis audience, "Tonight, you're going to see what the real Elvis is all about." What followed was a mesmerizing, no-holds-barred performance. The fans loved

it, and Wertheimer photographed it all. Within a few short months, Elvis Presley would soon be the most talked-about entertainer in the world.

Alfred Wertheimer's photographs of Elvis Presley are a unique visual record of the most exciting and influential performer of our time. They capture Elvis at the quintessential moment of his explosive appearance onto the cultural landscape, and no photographer ever again had the kind of access to the star that Wertheimer experienced. Wertheimer has described his photographs as "the first and last look at the day-to-day life of Elvis Presley." Apart from Elvis's own recordings from this period, Wertheimer's photographs are the most compelling vintage document of the singer in 1956, a very special year for a young man from Memphis who was about to shake up the world. They are an extraordinary record of how these two storytellers' lives came together, a 21-year-old singer on the verge of fame and fortune crossing paths with a 26-year-old photographer about to document a legend.

AT THE AGE OF SIX, in 1936, Alfred Wertheimer left Germany with his father, Julius, his mother, Katy, and his brother, Henry. Julius was a kosher delicatessen butcher with a little shop in Coburg, Germany. After leaving their home behind, young Alfred and his family came to New York City and after several moves rented an apartment at 842 Nostrand Avenue in Brooklyn. Julius got a job at Carmel Kosher Provision, and the Wertheimer family settled in to a new life in America.

Wertheimer graduated from high school in 1947 and spent a year at City College studying drawing before being accepted at Cooper Union, a school of art and engineering in Manhattan. Cooper Union was tuition-free, and he describes himself as "one of the lucky 90," as only 90 students were admitted that year. At Cooper Union, Wertheimer took

332 Benefit concert at Russwood Park, Memphis,
Tennessee, July 4, 1956.

334

his first photographs with a camera Henry had given him. Using available light, he photographed his classmates and teachers, and was delighted to see his photos published in the school newspaper.

In 1951 Wertheimer graduated with a major in advertising design, and the following year he was drafted into the U.S. Army, where he worked as a military photographer from 1952–54. While in basic training, he became the first and only photographer to cover a unit's transition from civilian life to military or GI (government issue) property. At the end of the 16 weeks, he put together what he felt was a good portfolio showing what it took to go from a civilian to a soldier. He presented it to the captain of his company with the hope of influencing him to change his job title from a mortar base plate carrier. The captain complimented his work, and Wertheimer said, "I appreciate that, sir. Is there any possibility of you changing my job classification to that of photographer?" The captain said that would require the general's approval, which was soon granted.

After finishing his service in 1954, Wertheimer returned to New York City, where he found a job with fashion photographer Tom Palumbo, who worked on assignment for *Harper's Bazaar* magazine under the legendary art director Alexey Brodovitch. Wertheimer learned much under Palumbo, developing film, printing photographs, setting up and cleaning the studio, keeping track of negatives and his music library, assisting at shoots, and going to the color lab for processing.

After about a year, he started his own business as a freelance photographer. Though he worked independently, he shared studio space with a group of photographers at Dave Linton's studio at Third Avenue and 74th Street. His good friend Paul Schutzer, a talented photojournalist, also worked there and introduced Wertheimer to the publicist at RCA Victor's pop record division, Anne Fulchino. Fulchino hired him to photograph RCA acts

 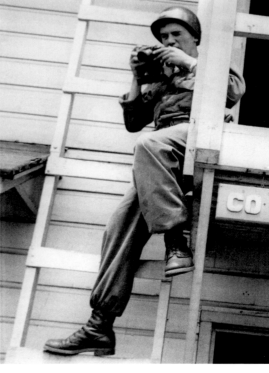

OPPOSITE & ABOVE Basic training, U.S. Army, Fort Dix, New Jersey, 1953. Wertheimer's (above) photographs were the first to document the 16-week basic training session that would turn a civilian into a soldier.

like Perry Como, Lena Horne, Julius La Rosa, Arthur Rubinstein, Nelson Eddy, Jeannette MacDonald, and others. In March 1956 she asked him to come take some pictures of RCA's latest acquisition. While Wertheimer had never heard of this new singer, in just a few months the whole world would know the name Elvis Presley.

ALFRED WERTHEIMER HAS OFTEN SAID, "My photographs speak for themselves." That they resonate so splendidly is a result of his awareness and sensitivity as a skilled photographer, qualities that complemented his charismatic subject, Elvis Presley. For no matter who else he photographed in the years to come, including his later work as a documentary cameraman for television, no assignment would ever come close to matching the Elvis job. About his experience revealing Elvis's environment and how he lived in it, Wertheimer has remarked, "I was a reporter whose pen was a camera."

Steeped in the distinguished tradition of photojournalists, Wertheimer embraced an aesthetic that was simultaneously classic yet innovative. Wertheimer was not a rock-and-roll photographer. After all, that genre of photography did not even exist yet. However, his photographs of Elvis would set a standard for all photographers who would go on to document musical artists.

In 1958 Elvis Presley was drafted into the U.S. Army and reported to the draft board on South Main Street in Memphis, Tennessee, for his physical on March 24. A few days later, Elvis was assigned to the Second Armored Division at Fort Hood, Texas. After his basic training, advanced tank training, and basic unit training, he was ready to ship out to Germany and join a scout platoon called Company C. On Friday, September 19, he boarded a troop train in Killeen, Texas, headed to the Brooklyn Army Terminal Port of Embarkation, and arrived in New York at 9 a.m. on Monday, September 22.

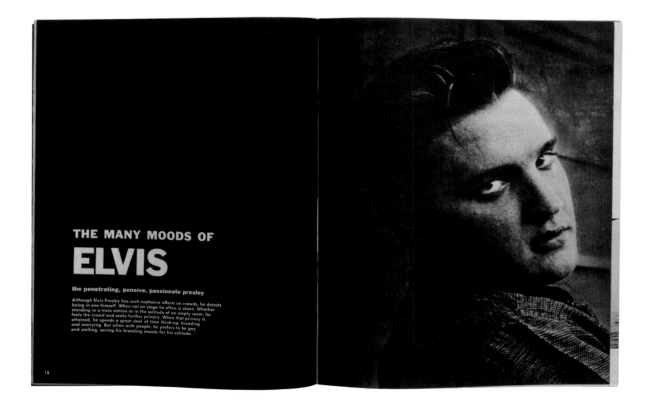

ABOVE Interior, *The Amazing Elvis Presley*, September 1956. Produced by Alfred Wertheimer under the imprint Renal Corporation, the fanzine sold 400,000 copies at 35 cents apiece.

Elvis Presley was at the height of his fame when he was drafted. Like many young men, he was anxious about leaving behind friends, family, and career, but more significantly, he was still deeply affected by the loss of his beloved mother, who had died just five weeks before he was to ship out from New York. Although his father and grandmother were going to accompany him to Germany, Elvis was clearly unsettled. Considering all of the changes of the past three years and his incredible rise to fame and fortune, Elvis had a lot on his mind. This day in Brooklyn was surely a turning point in his life.

When Alfred Wertheimer arrived at the Brooklyn Army Terminal to photograph Elvis shipping out, he was not the only photographer this time. There were dozens of photographers, film and TV crews, and reporters on hand. But Wertheimer knew Elvis, his entourage, the Colonel, and the representatives from RCA Victor. Having served in the Army only a few years earlier, Wertheimer was familiar with that environment and photographed the events surrounding the embarkation with an insider's point of view. These photos of Elvis's departure tell the story of that day and are the last photographs Wertheimer ever took of Elvis.

To some, Elvis's departure in 1958 marks the end of the most exciting and compelling period of his career as a performer and musical artist. Wertheimer's 1956 photographs of Elvis documented that golden period for us all. These last photos of Elvis shipping out are Wertheimer's good-bye to the Elvis he knew.

Wertheimer's photographs capture Elvis at a crossroads of culture. Elvis went on to unprecedented fame and fortune as a musical artist, but it is Alfred Wertheimer's photographs that remind us of a time in America when a young man from Mississippi could change the world with a song. These photographs of Elvis Presley are without a doubt the most important and compelling images ever taken of the greatest rock-and-roll icon of all time. No other photographer has ever come closer to catching Elvis Presley's magic than Alfred Wertheimer.

WERTHEIMER CONTINUED TO WORK as a freelance photographer after taking his last photographs of Elvis Presley on September 22, 1958. Throughout the late '50s he photographed Eleanor Roosevelt, Perry Como, Nina Simone, Paul Anka, Nelson Eddy, and many others, and shot for magazines like *Life*, *Pageant*, and *Paris Match*. "But some of the best assignments are my own assignments," Wertheimer says. And his fondness for being the "fly on the wall" led to photo essays on religious sects in New York (Sweet Daddy Grace's United House of Prayer for All People, Hasidim, Jehovah's Witnesses) and life inside Bellevue Psychiatric Hospital. "I'm basically a curious person, and want to know how things evolved and why," he says. "And I like to do it visually."

But by the early '60s he was no longer interested in making still pictures. In 1964 he became a cameraman and filmmaker for Granada TV in the UK. Producing segments for the weekly show *World in Action* took him from Bolivia on a hunt for Che Guevara to Harvard and Yale, where professors were doing research on flying saucers. In 1969 he was hired as one of the principal cameramen on the Mike Wadleigh film *Woodstock*. The straight man in a sea of 300,000 hippies, he shot the famous mudslide scene. More

Pickin' Out
a Tune

12 *ask Elvis*
WHAT IS YOUR GREAT-
EST AMBITION?

You know it's funny how things
are sometimes. Take a fine
dramatic actor, for instance.
He should be real happy. What
does he say? He'd like to do
comedy — and comedians want to
play dramatic roles. Well, I'm
a singer — I'd also like to be
a dramatic movie actor. That's
been my dream since I was a kid.
Sure I love singing, and I'd
love to be an actor. The com-
bination of
the two in a
movie just
suits me fine. ©T. C. ©BUBBLES INC. .S.A.
© 1956 ELVIS PRESLEY ENTERPRISES—ALL RIGHTS RESERVED

prepared than the rest of the crew, Wertheimer had arrived on location with his own equipment. When he noticed that Wadleigh had rented every Éclair camera in New York City for the job, the idea for a new business began to form in his mind...

He soon bought a Steenbeck editing machine, then another, and before he knew it he had 28 Steenbecks and a staff of four to service them in a 12,000-square-foot office in midtown Manhattan. Catering to networks such as CBS News and ABC Sports, Cinergy Communications became the go-to place for many creative cinematographers and editors of that time, including documentary filmmakers like Ken Burns. Wertheimer ran the business for 20 years, but as digital technology began transforming the filmmaker's world, he decided to sell his analog Steenbeck business and return to photography.

In the early '90s Wertheimer began to focus for the first time on his vast archive of personal photographs, publishing books of his work and exhibiting his photographs of Elvis Presley, starting with a one-man show at my gallery in Washington, D.C., Govinda Gallery. His work has been exhibited at the Fondation Cartier pour l'art contemporain in Paris; the Rock and Roll Hall of Fame and Museum in Cleveland, Ohio; the Experience Music Project in Seattle, Washington; Domus Artium in Salamanca, Spain; and the Jule Collins Smith Museum in Auburn Alabama. And Wertheimer's exhibition, *Elvis at 21*, co-organized by the Smithsonian Institution and Govinda Gallery, has traveled to 14 museums, including the Grammy Museum in Los Angeles and the National Portrait Gallery in Washington, D.C.

ABOVE Elvis trading cards produced by Colonel Tom Parker, using Wertheimer's photographs, released June 29, 1956.

OPPOSITE Time to play a few gospel songs before rehearsal for *The Steve Allen Show*, June 29, 1956.

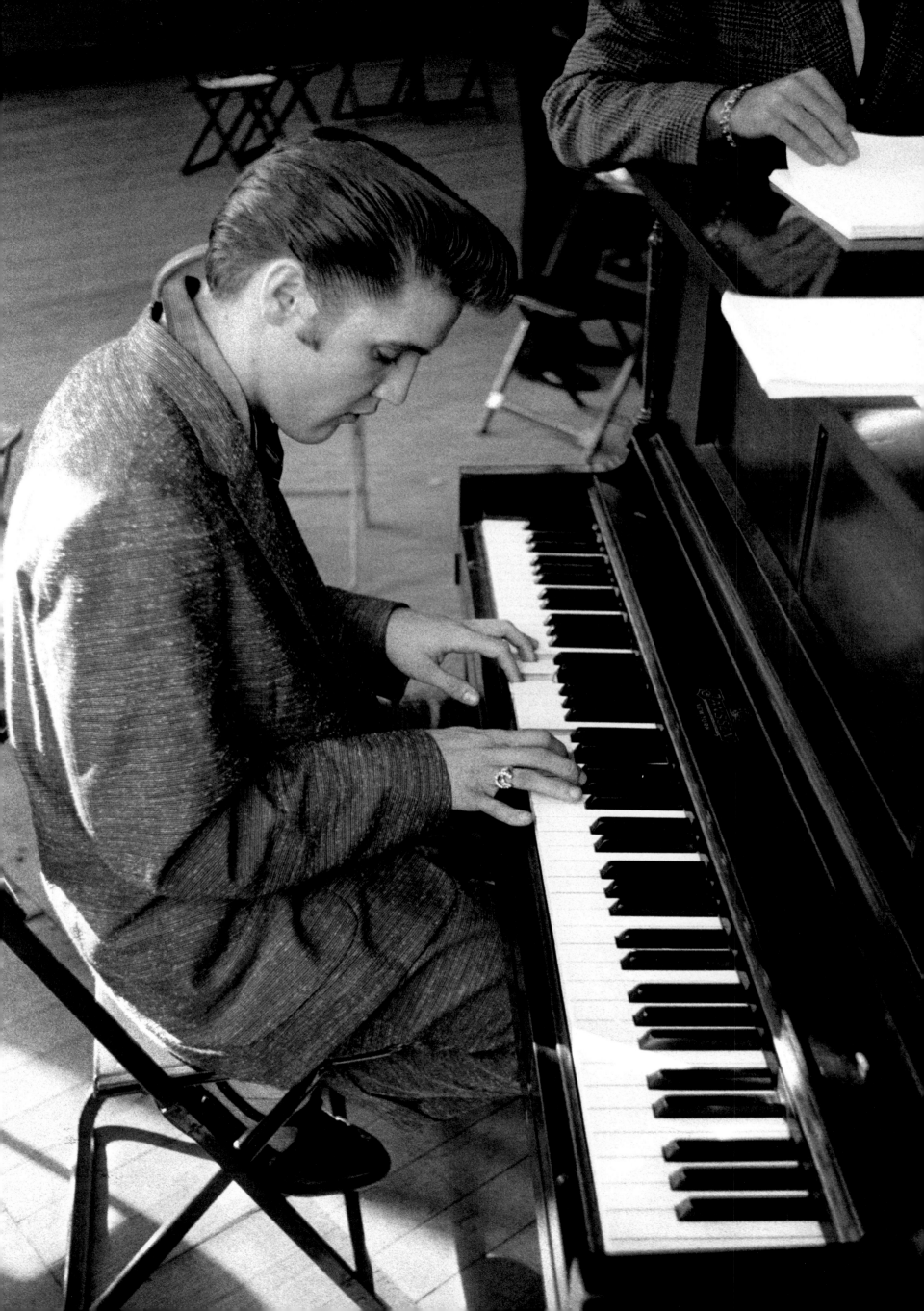

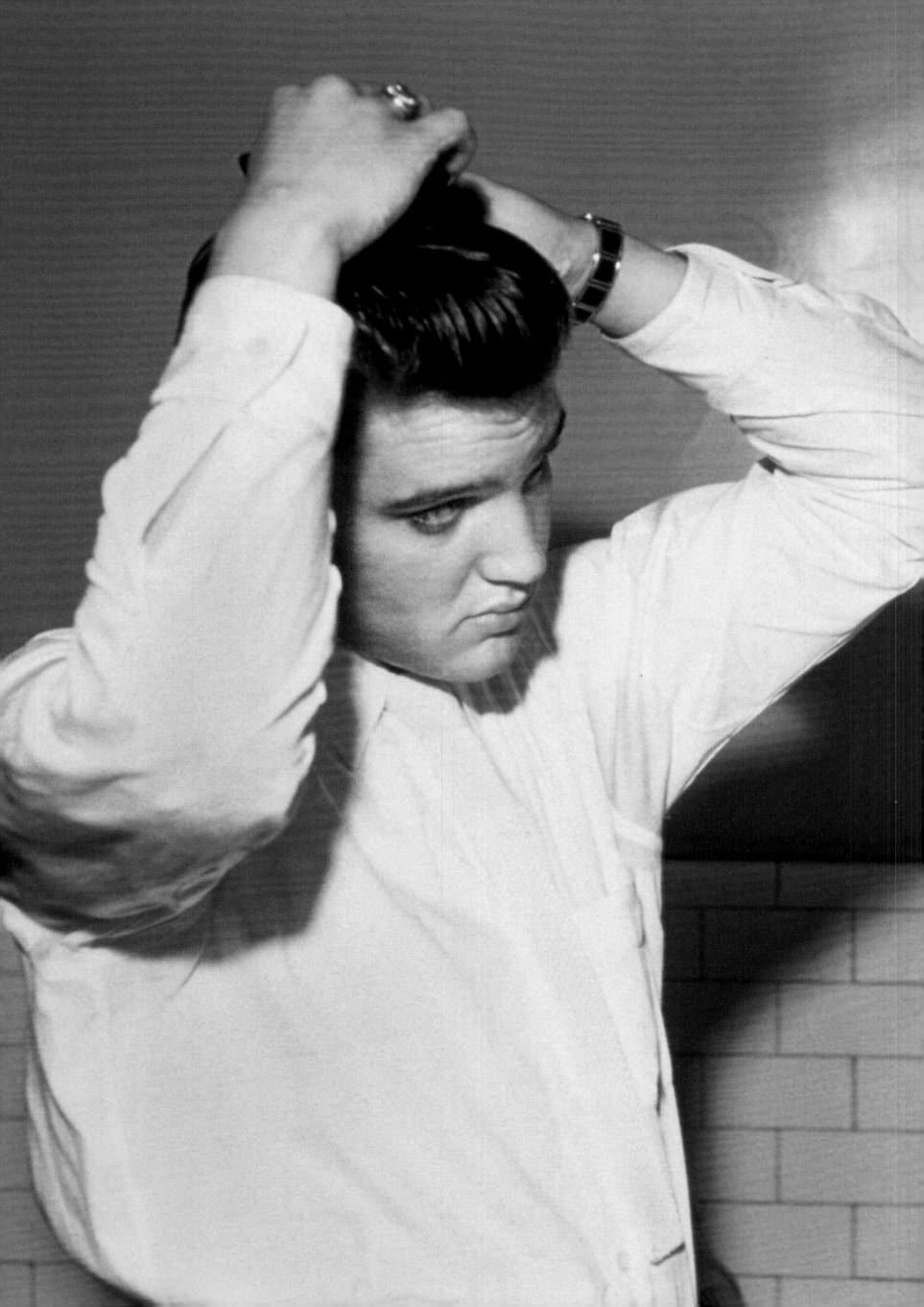

Ein Auftrag unter vielen

CHRIS MURRAY

"Alfred Wertheimer gelangen großartige Bilder. Weil er, genau wie Elvis, Spontaneität schätzte und Gefühlen den Vorrang gab vor reiner Technik, entdeckte auch er in vertrauten Formen etwas Neues, und das Ergebnis ist ein Werk, das in seinem Glanz alleine stehen kann, unberührt von den turbulenten Strömungen der Mode oder dem steten Mahlstrom der Zeit."
—PETER GURALNICK

ES WAR EIN HEISSER SOMMERABEND, der 4. Juli 1956, in Memphis. Elvis Presley, 21 Jahre alt, war eben erst aus New York heimgekehrt, wo er Auftritte in mehreren landesweit ausgestrahlten Fernsehsendungen absolviert und im Studio 1 von RCA Victor die Songs „Hound Dog", „Don't Be Cruel" und „Anyway You Want Me" aufgenommen hatte. „Hound Dog" und „Don't Be Cruel" sollten bald darauf als A- und B-Seiten einer 45er-Single veröffentlicht werden und sich explosionsartig über den Äther verbreiten. An diesem Abend stand für Elvis ein Konzert im Russwood Park, einem Baseballstadion in Memphis, auf dem Programm. Die Menge war aufgeheizt und brannte vor Erwartung, den Jungen aus ihrer Heimatstadt zu erleben, der nach Norden gegangen und „groß rausgekommen" war.

Der Fotograf Alfred Wertheimer, selbst gerade einmal 26 Jahre alt, begleitete Elvis zu seinem Auftritt. Der Polizeichef fuhr mit dem Streifenwagen vor dem Haus der Presleys vor. Elvis saß vorne in der Mitte, zwischen dem Polizeichef und seinem Manager Colonel Tom Parker, Wertheimer alleine hinten im Fond. Bei der Ankunft fotografierte Wertheimer Elvis auf seinem Weg durch die wogende Menge, die so nahe wie möglich an ihn heranzukommen versuchte.

Die Luft war wie elektrisiert, als Elvis, ganz in Schwarz gekleidet, die Bühne betrat, in seinem Rücken Scotty Moore an der Gitarre, Bill Black am Bass und D.J. Fontana am

Schlagzeug. 14 000 Menschen standen bereit, um diese neuartige, so befreiende und aufregende Musik zu feiern, die einer der ihren zum Besten gab. In Anspielung auf seinen streng reglementierten Auftritt in in der *Steve Allen Show* wenige Tage zuvor erklärte Elvis dem Publikum in Memphis: „Heute Abend werdet ihr sehen, wie der echte Elvis tickt." Was folgte, war eine mitreißende Show, die keine Drehbuchschranken kannte. Die Fans waren begeistert, und Wertheimer hielt das ganze Geschehen in Bildern fest. Nur wenige Monate später sollte Elvis Presley der meistbeachtete Unterhaltungskünstler der Welt sein.

Alfred Wertheimers Elvis-Fotografien sind einzigartige Bilddokumente über den aufregendsten und einflussreichsten Interpreten unserer Epoche. Sie fangen exakt den Moment ein, in dem Elvis' Stern explosionsartig über der kulturellen Landschaft erschien, und nach diesem Augenblick sollte niemals wieder ein Fotograf die Art von Zugang zu dem Star haben, wie er sich Wertheimer eröffnete. Wertheimer selbst beschreibt seine Bilder als „ersten und letzten Blick auf das Alltagsleben von Elvis Presley". Abgesehen von Elvis' eigenen Plattenaufnahmen aus dieser Zeit sind Wertheimers Aufnahmen die faszinierendsten noch erhaltenen Zeugnisse des Sängers im Jahr 1956 – einem ganz besonderen Jahr für einen jungen Mann aus Memphis, der im Begriff war, die Welt aufzurütteln. Sie liefern einen außergewöhnlichen Beleg dafür, wie sich die Wege dieser beiden Geschichtenerzähler kreuzten, der eines 21 Jahre alten Sängers an der Pforte zu Ruhm und Reichtum und der eines 26-jährigen Fotografen, der sich anschickte, eine Legende zu dokumentieren.

ALFRED WERTHEIMER WAR SECHS JAHRE ALT, als er mit seinem Vater Julius, seiner Mutter Katy und seinem Bruder Henry 1936 Deutschland verließ. Julius, ein koscherer Metzger, hatte bis dahin ein kleines Feinkostgeschäft in Coburg betrieben. Nachdem sie

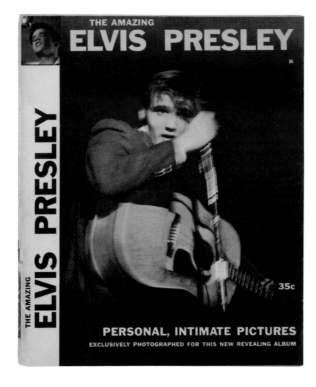 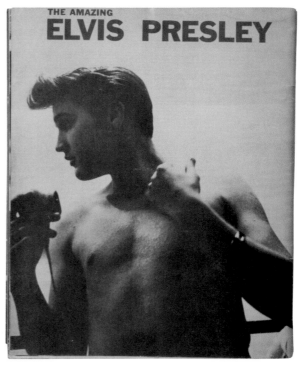

340 Elvis combs his hair in the men's room of the Mosque Theater, which was used as a dressing room for all of the male performers of the Elvis Presley show, Richmond, Virginia, June 30, 1956.

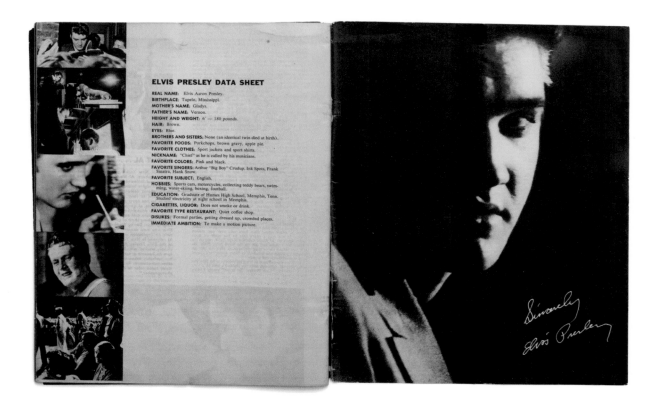

ihr Zuhause verlassen hatten, kamen der kleine Alfred und seine Familie in New York an, wo sie nach mehreren Zwischenstationen eine Wohnung in der Nostrand Avenue 842 in Brooklyn bezogen. Julius fand eine Anstellung bei dem Lebensmittelhändler Carmel Kosher Provision, und die Familie Wertheimer richtete sich in einem neuen Leben in Amerika ein.

Nach seinem Highschool-Abschluss 1947 besuchte Wertheimer ein Jahr lang Zeichenkurse am City College, ehe er 1948 an der Cooper Union aufgenommen wurde, einer privaten Hochschule für Kunst und Ingenieurwissenschaften in Manhattan. Die Cooper Union verlangte keine Studiengebühren, und Wertheimer bezeichnet sich selbst als „einen der glücklichen 90", da in jenem Jahr nur 90 Studenten eine Zulassung für die begehrte Hochschule erhielten.

An der Cooper Union machte Wertheimer seine ersten Aufnahmen mit einer Kamera, die ihm sein Bruder Henry geschenkt hatte. Die Fotografien von seinen Mitstudenten und Dozenten, für die er mit vorhandenem Licht arbeitete, wurden zu seiner Freude in der Hochschulzeitung veröffentlicht.

1951 schloss Wertheimer sein Grafikdesign-Studium ab und wurde im Jahr darauf in die US Army eingezogen, wo er von 1952 bis 1954 als Militärfotograf arbeitete. Während seiner Grundausbildung dokumentierte er als erster und einziger Fotograf, wie sich eine Einheit von Zivilisten in GIs, Armeeangehörige, verwandelte. Am Ende der 16 Wochen stellte er aus dem Material ein Portfolio zusammen, das in seinen Augen gut veranschaulichte, was dazugehörte, um vom Zivilisten zum Soldaten zu werden. Er präsentierte es seinem Hauptmann in der Hoffnung, damit für sich einen anderen Dienstgrad als den eines Bodenplattenträgers der Mörserkompanie herausschlagen zu können. Der Hauptmann lobte seine Arbeit, und Wertheimer sagte: „Das freut mich zu hören, Sir. Sehen Sie denn irgendeine Möglichkeit, mich in den Dienstrang eines Fotografen zu versetzen?"

OPPOSITE & ABOVE Front cover, back cover, and interior spread, *The Amazing Elvis Presley*, September 1956, with photographs by Wertheimer.

Der Hauptmann antwortete, dass derlei der Zustimmung des General bedürfe, die bald darauf erteilt wurde.

Nach Ableistung seines Wehrdienstes kehrte Wertheimer 1954 zurück nach New York, wo er eine Anstellung als Assistent bei Tom Palumbo fand, einem Modefotografen, der für die Zeitschrift *Harper's Bazaar* unter deren legendärem Artdirektor Alexey Brodovitch arbeitete. Wertheimer lernte viel bei Palumbo – er entwickelte Filme, machte Abzüge, baute die Sets auf und putzte das Studio, verwaltete das Negativarchiv und Brodovitchs Musiksammlung, assistierte bei den Shootings und kümmerte sich um die Weiterbearbeitung im Farblabor.

Nach etwa einem Jahr machte er sich als freier Fotograf selbstständig. Er arbeitete zwar unabhängig, teilte sich aber Atelierräume mit einer Gruppe anderer Fotografen in Dave Lintons Studio an der 3. Avenue Ecke 74. Straße. Auch sein guter Freund Paul Schutzer, ein talentierter Fotojournalist, arbeitete dort und machte Wertheimer mit der PR-Chefin der Popabteilung von RCA Victor, Anne Fulchino, bekannt. Sie engagierte ihn für Aufnahmen von RCA-Künstlern wie Perry Como, Lena Horne, Julius La Rosa, Arthur Rubinstein, Nelson Eddy, Jeannette MacDonald und anderen. Im März 1956 bat sie ihn, ein paar Bilder von RCAs jüngstem Neuzugang zu machen. Zwar hatte Wertheimer noch nie von diesem neuen Sänger gehört, doch innerhalb weniger Monate sollte die ganze Welt den Namen Elvis Presley kennen.

ALFRED WERTHEIMER SAGTE OFT: „Meine Fotografien sprechen für sich selbst." Dass sie es auf so brillante Weise tun, ist auf seine Wahrnehmungskraft und Empfindsamkeit als erfahrener Fotograf zurückzuführen – Qualitäten, die genau zu seinem charismatischen Motiv Elvis Presley passten. Und wen er in den folgenden Jahren auch aufnahm, sei es

als Fotograf oder als Kameramann für das Fernsehen: An den Elvis-Auftrag sollte kein anderer Job mehr herankommen. Im Rückblick sagte Wertheimer über die Erfahrung, Elvis' Umfeld und Lebensalltag abgelichtet zu haben: „Ich war ein Reporter, und mein Stift war eine Kamera."

Fest in der hehren Tradition des Bildjournalismus verwurzelt, verfolgte Wertheimer eine Ästhetik, die klassisch und innovativ zugleich war. Obwohl er kein Rock-and-Roll-Fotograf war – ein fotografisches Genre, das zu der Zeit noch nicht einmal existierte –, setzten seine Elvis-Aufnahmen einen Standard für alle Fotografen, die fortan Musikinterpreten mit der Kamera begleiteten.

1958 erhielt Elvis Presley seinen Einberufungsbescheid und meldete sich am 24. März zur Tauglichkeitsprüfung bei der zuständigen Dienststelle in der South Main Street in Memphis. Wenige Tage darauf wurde er der Zweiten Panzerdivision in Fort Hood, Texas, zugeteilt. Nach der Grundausbildung, einer Spezialausbildung zum Panzergrenadier und allgemeinem Gefechtsdienst war er bereit, nach Deutschland überzusetzen und sich dort einem als „Company C" bezeichneten Aufklärungszug anzuschließen. Am Freitag, den 19. September, bestieg er in Killeen, Texas, den Truppenzug Richtung New York und kam am Montag, den 22. September, um 9 Uhr morgens am Armee-Verladehafen in Brooklyn an.

Elvis Presley stand auf dem Gipfel seines Ruhms, als er zum Wehrdienst eingezogen wurde. Wie vielen jungen Männern war auch ihm bange davor, seine Freunde, Familie und Karriere zurückzulassen, doch was ihn wesentlich schwerer belastete, war der Verlust seiner geliebten Mutter, die nur fünf Wochen vor seiner geplanten Abreise aus New York gestorben war. Obwohl sein Vater und seine Großmutter ihn nach Deutschland begleiteten, war die Welt für Elvis eindeutig aus den Fugen geraten. In Anbetracht all der Veränderungen der zurückliegenden drei Jahre und seines unfassbaren Aufstiegs zu

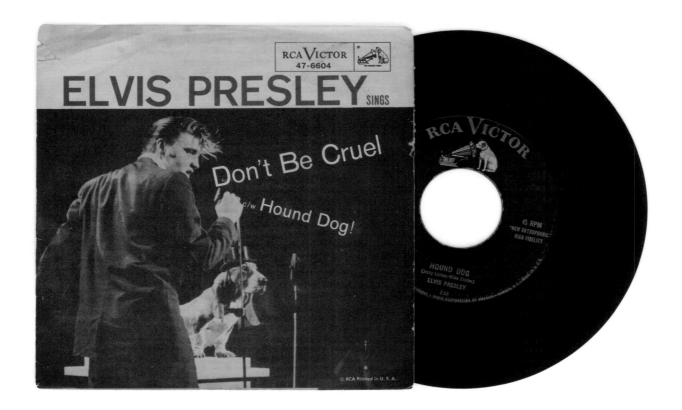

345

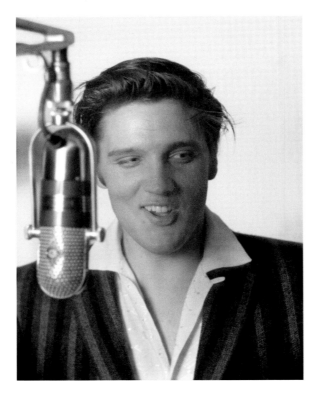
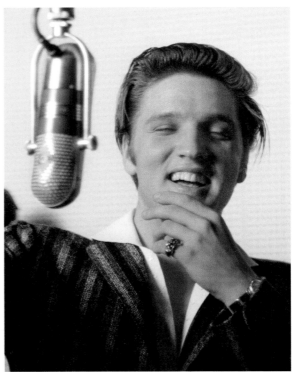

Ruhm und Reichtum lag ihm vieles auf der Seele. Jener Montag in Brooklyn markierte definitiv einen Wendepunkt in seinem Leben.

Dieses Mal war Alfred Wertheimer, als er am Verladehafen in Brooklyn ankam, um Elvis' Abfahrt zu fotografieren, nicht mehr der einzige Vertreter seiner Zunft. Zu Dutzenden standen Pressefotografen, Reporter, Film- und Fernsehteams bereit. Doch Wertheimer kannte Elvis, seinen Begleittross, den Colonel und die Vertreter von RCA Victor. Da er selbst nur wenige Jahre zuvor seinen Wehrdienst abgeleistet hatte, war Wertheimer mit dieser Umgebung vertraut und fotografierte die Geschehnisse rund um die Verschiffung von der Warte eines Insiders. Seine Bilder von Elvis' Abschied erzählen die Geschichte dieses Tages und sind die letzten Aufnahmen, die Wertheimer von Elvis machte.

Elvis' Abreise nach Deutschland im Jahr 1958 markiert nach Ansicht einiger das Ende der aufregendsten und faszinierendsten Phase seiner künstlerischen Karriere. Die Fotografien, die Alfred Wertheimer im Jahr 1956 von Elvis Presley machte, dokumentieren diese goldenen Zeiten für uns alle. Mit seinen letzten Aufnahmen vom GI Presley beim Auslaufen aus dem New Yorker Hafen sagte Wertheimer dem Elvis, den er kannte, Lebewohl.

Mit seiner Kamera fing Wertheimer Elvis an einem Wendepunkt der Kultur ein. In der Folgezeit erlangte Elvis als Musikinterpret nie da gewesenen Ruhm und Reichtum, doch Alfred Wertheimers Bilder führen uns eine amerikanische Ära vor Augen, in der ein junger Mann aus Mississippi mit einem Lied die Welt verändern konnte. Diese Fotografien von Elvis Presley sind ohne Zweifel die wichtigsten und fesselndsten Bilder, die von der größten Rock-and-Roll-Ikone aller Zeiten jemals gemacht wurden. Es sollte keinem anderen Fotografen mehr gelingen, den Zauber von Elvis Presley annähernd so einzufangen wie Alfred Wertheimer.

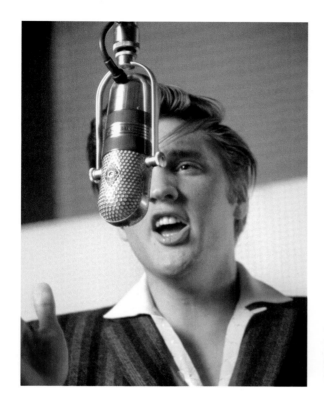
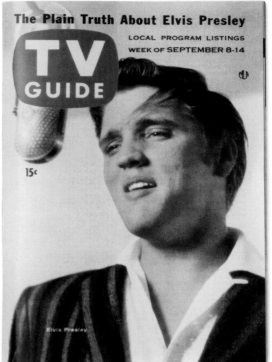

NACH DEN LETZTEN AUFNAHMEN, die er am 22. September 1958 von Elvis Presley

gemacht hatte, arbeitete Wertheimer zunächst weiter als freier Fotograf. Während der
späten 1950er-Jahre fotografierte er viele berühmte Persönlichkeiten wie Eleanor Roosevelt,
Perry Como, Nina Simone, Paul Anka oder Nelson Eddy und arbeitete für Zeitschriften
wie *Life*, *Pageant* und *Paris Match*. „Doch einige der besten Aufträge sind meine eigenen
Aufträge", sagt Wertheimer. Sein Faible dafür, die „Fliege an der Wand" zu sein, führte
zu Fotoreportagen über Sekten in New York (die von Sweet Daddy Grace gegründete
Glaubensgemeinschaft United House of Prayer for All People, die Chassidim, die Zeugen
Jehovas) oder den Klinikalltag im Bellevue Psychiatric Hospital. „Ich bin im Grunde ein
neugieriger Mensch und will herausfinden, wie sich bestimmte Phänomene entwickelten
und warum", erklärt Wertheimer. „Und das tue ich gern auf visuellem Weg."

Doch mit Beginn der 1960er-Jahre verlor er das Interesse daran, unbewegte Bilder zu
machen. 1964 begann er als Kameramann Dokumentationen für den britischen Fernseh-
sender Granada Television zu drehen. Die Produktion von Beiträgen für die wöchentliche
Sendung *World in Action* führte ihn über die Jagd nach Che Guevara in Bolivien bis nach
Harvard und Yale zu Professoren, die über fliegende Untertassen forschten. 1969 wurde
er als einer der Haupt-Kameramänner für Mike Wadleighs Woodstock-Film engagiert.
In einem Meer aus 300 000 Hippies stehend, war er der Mann, der die berühmte Schlamm-
partie filmte. Wertheimer erschien besser vorbereitet am Drehort als der Rest der Crew,
denn er hatte seine eigene Ausrüstung dabei. Als er feststellte, dass Wadleigh für den
Auftrag jede verfügbare Eclair-Kamera in New York gemietet hatte, kam ihm eine neue
Geschäftsidee.

Bald darauf legte Wertheimer sich einen Steenbeck-Schneidetisch zu, dann den nächs-
ten, und ehe er sichs versah, betrieb er mit vier Mann Belegschaft an 28 Steenbecks
ein gut 1000 Quadratmeter großes Studio in Midtown Manhattan. Seine Firma Cinergy

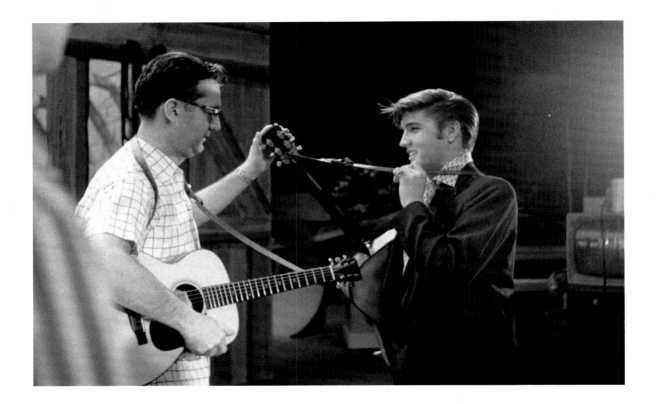

Communications, die Sender wie CBS News und ABC Sports belieferte, wurde zur angesagten Adresse für viele kreative Kameraleute und Cutter der damaligen Zeit, unter ihnen Dokumentarfilmer wie Ken Burns. Wertheimer führte die Firma 20 Jahre lang, doch als die Digitaltechnik die Branche zu verändern begann, beschloss er, seinen analogen Steenbeck-Betrieb zu verkaufen und zur Fotografie zurückzukehren.

In den frühen 1990er-Jahren widmete sich Wertheimer erstmals intensiver seinem eigenen, umfangreichen Fotoarchiv, veröffentlichte Bildbände mit seinen Arbeiten und stellte seine Elvis-Aufnahmen aus, beginnend mit einer Einzelausstellung in meiner Galerie, der Govinda Gallery in Washington, D.C. Weitere Ausstellungsstationen waren die Fondation Cartier pour l'art contemporain in Paris, die Rock and Roll Hall of Fame and Museum in Cleveland, Ohio, das Experience Music Project Museum in Seattle, Washington, das Domus Artium in Salamanca, Spanien, und das Jule Collins Smith Museum in Auburn Alabama. Zudem reiste die von der Smithsonian Institution und der Govinda Gallery mitorganisierte Wertheimer-Ausstellung *Elvis at 21* zu 14 verschiedenen Museen, darunter das Grammy Museum in Los Angeles und die National Portrait Gallery in Washington, D.C.

PREVIOUS SPREAD Elvis at the microphone, RCA Victor Studio 1, July 2, 1956. The September 8–14 issue of *TV Guide*, featuring one of Wertheimer's portraits from that historic session, was the first of many Elvis covers for the publication.

ABOVE Rehearsal for *The Steve Allen Show*, July 1, 1956.

OPPPOSITE Elvis bows to the applause of a studio audience at the end of a performance on *Stage Show*, March 17, 1956.

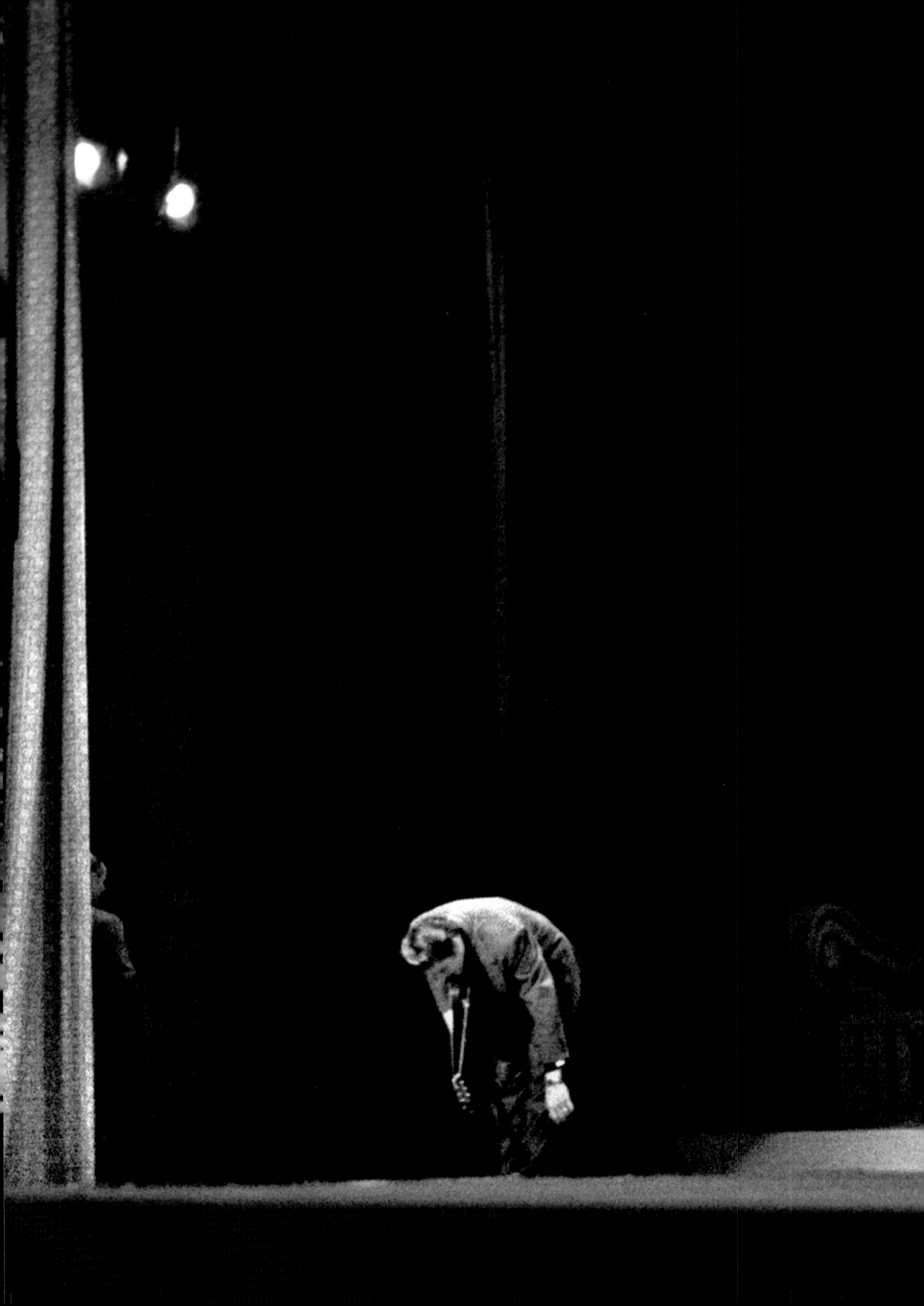

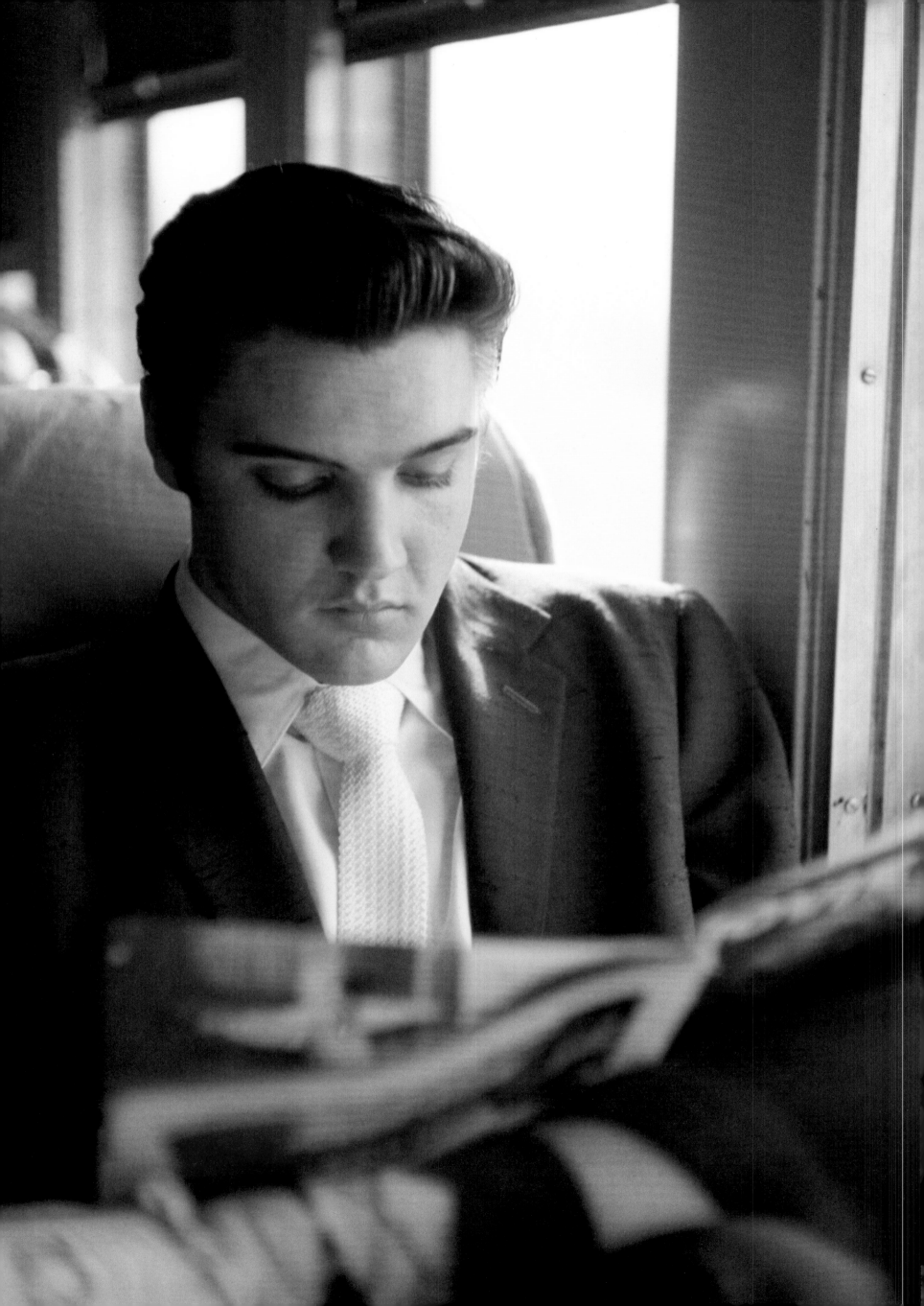

Rien qu'une commande de plus

CHRIS MURRAY

« *Les photos d'Alfred Wertheimer sont superbes. Comme Elvis, il privilégiait la spontanéité, laissant l'émotion primer sur la technique pure. Cela lui a permis de montrer des formes familières d'une manière inédite et de réaliser une œuvre qui se suffit à elle-même, indifférente aux changements de modes et aux aléas du temps qui passe.* » —**PETER GURALNICK**

C'ÉTAIT UNE CHAUDE NUIT D'ÉTÉ à Memphis, le 4 juillet 1956. Elvis Presley, âgé de vingt et un ans, venait de rentrer chez lui après un séjour à New York où il avait fait plusieurs apparitions dans des émissions télévisées et avait enregistré « Hound Dog », « Don't Be Cruel » ainsi qu'« Any Way You Want Me » dans le Studio 1 de la RCA Victor. « Hound Dog » et « Don't Be Cruel » sortiraient bientôt en face A et B d'un 45 tours qui inonderait les ondes radiophoniques. Ce soir-là, Elvis devait se produire à Russwood Park, un stade de Memphis. Une foule compacte l'attendait fébrilement, excitée à l'idée de voir un enfant du pays parti tenter sa chance au « Nord » et ayant fait un tabac.

Le photographe Alfred Wertheimer, à peine âgé de vingt-six ans lui-même, accompagnait Elvis ce soir-là. Le shérif se présenta chez les Presley dans sa voiture de fonction. Elvis prit place à l'avant, entre le shérif et son manager, le colonel Tom Parker. Wertheimer s'assit seul sur la banquette arrière. Lorsqu'ils arrivèrent devant le stade, il photographia le chanteur essayant de se frayer un chemin dans la cohue de tous ceux qui tentaient de l'approcher.

Elvis, tout vêtu de noir, grimpa sur scène dans une atmosphère survoltée. Il était accompagné par Scotty Moore à la guitare, Bill Black à la contrebasse et D.J. Fontana à la batterie. 14 000 personnes s'étaient déplacées pour écouter cette nouvelle musique exaltante créée par l'un des leurs. Faisant allusion à sa prestation strictement contrôlée quelques jours plus tôt dans l'émission *The Steve Allen Show*, Elvis annonça au public de

Memphis: «Ce soir, vous allez voir de quoi est capable le vrai Elvis.» Fidèle à sa promesse, il se déchaîna sur scène, donnant un concert mémorable. Ses fans étaient aux anges et l'objectif de Wertheimer n'en perdit pas une miette. Quelques mois plus tard, le monde entier ne parlait plus que d'Elvis Presley.

Les photographies d'Alfred Wertheimer constituent un témoignage visuel unique, saisissant sur le vif le chanteur le plus passionnant et influent de notre temps. Elles le montrent au moment clef de son irruption sur la scène culturelle. Aucun autre photographe n'a pu l'approcher d'aussi près. Wertheimer a décrit ses propres images comme «le premier et dernier regard sur la vie quotidienne d'Elvis Presley». Au-delà des enregistrements réalisés par Elvis à cette époque, les photos de Wertheimer représentent les documents les plus fascinants sur l'Elvis de 1956, une année déterminante pour le jeune chanteur de Memphis sur le point d'ébranler le monde. On y voit également comment se sont croisées les vies de ces deux conteurs: le chanteur de vingt et un ans à l'aube de la gloire et de la fortune, et le photographe de vingt-six ans sur le point d'immortaliser une légende vivante.

EN 1936, ALORS ÂGÉ DE SIX ANS, Alfred Wertheimer quitta l'Allemagne avec son

père, Julius, sa mère, Katy, et son frère Henry. Julius tenait une petite boucherie casher à Cobourg, en Bavière. Laissant tout derrière elle, la petite famille débarqua à New York où, après plusieurs déménagements, elle loua un appartement au numéro 842 de Nostrand Avenue à Brooklyn. Julius trouva du travail à la Carmel Kosher Provision, et la famille Wertheimer s'installa dans sa nouvelle vie américaine.

Alfred termina le lycée en 1947 et étudia le dessin au City College avant d'être accepté à la Cooper Union, une école supérieure d'art et d'ingénierie à Manhattan. L'enseignement

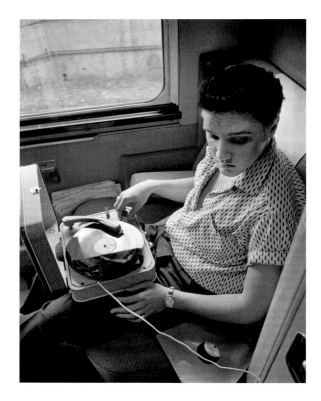 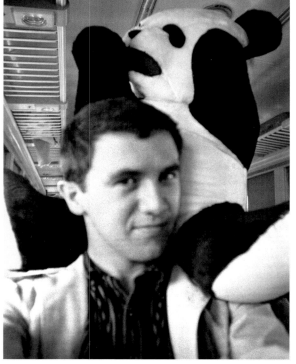

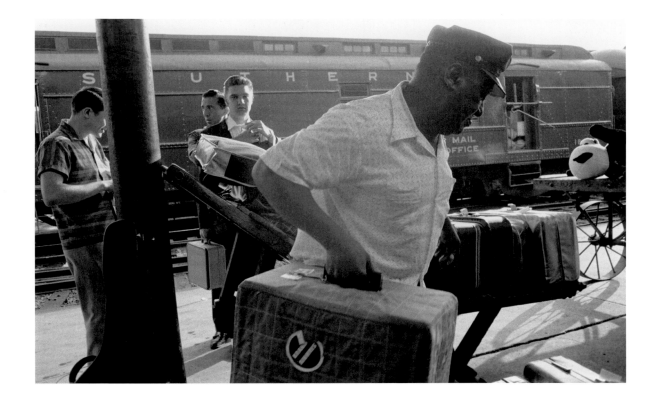

était gratuit et il se décrivit lui-même comme « l'un des quatre-vingt-dix chanceux », car seuls quatre-vingt-dix étudiants furent admis cette année-là. Avec un appareil offert par Henry, Wertheimer prit ses premières photos : il photographia ses camarades et ses professeurs en utilisant la lumière naturelle et eut la joie de voir ses images publiées dans le journal de l'école.

En 1951, Wertheimer obtint son diplôme en design publicitaire. L'année suivante, il fut appelé sous les drapeaux. Il servit comme photographe militaire de 1952 à 1954. Pendant qu'il faisait ses classes, il devint le premier et unique photographe à couvrir la transition d'une unité de la vie civile à la vie de GI. Au terme de seize semaines, il assembla ce qu'il considérait être un bon portfolio de son travail et le présenta au capitaine de sa compagnie dans l'espoir de changer l'intitulé de son poste : porteur de plaques de base de mortier. Après avoir reçu les compliments de son supérieur, il lui demanda : « Serait-il possible d'avoir le statut de photographe ? » Le capitaine répondit qu'il lui fallait l'aval du général, qui le donna rapidement.

Lorsqu'il fut libéré du service militaire en 1954, Wertheimer rentra à New York où il trouva un job chez le photographe de mode Tom Palumbo. Ce dernier travaillait régulièrement pour le magazine Harper's Bazaar, alors sous l'égide du légendaire directeur artistique Alexey Brodovitch. Wertheimer appris beaucoup auprès de Palumbo, développant des négatifs, imprimant des tirages, installant et nettoyant le studio, classant ses négatifs et sa discothèque, assistant aux prises de vue et se rendant au laboratoire photographique pour le traitement des couleurs.

Un an plus tard, il se lança en free-lance. Bien que travaillant seul, il partageait un espace de travail avec un groupe de photographes au studio Dave Linton, sur la Troisième Avenue et la 74ᵉ Rue. Son ami Paul Schutzer, un talentueux photojournaliste, y travaillait également et lui présenta la responsable de la publicité du département de musique

ABOVE A porter transfers the band's bags at the Chattanooga Terminal Station. Behind, drummer D.J. Fontana adjusts Elvis's tie.

populaire de RCA Victor, Anne Fulchino. Cette dernière l'engagea pour photographier des concerts de vedettes de la RCA dont Perry Como, Lena Horne, Julius La Rosa, Arthur Rubinstein, Nelson Eddy, Jeannette MacDonald. En mars 1956, elle lui demanda de prendre quelques images de la dernière recrue de la RCA. Wertheimer n'avait jamais entendu parler du jeune chanteur mais, quelques mois plus tard, le monde entier connaîtrait le nom d'Elvis Presley.

ALFRED WERTHEIMER A SOUVENT DÉCLARÉ : «Mes photos parlent d'elles-mêmes.»

Son habileté et sa sensibilité de photographe se sont parfaitement accordées au charisme de son sujet, ce qui explique l'impact de ces images aujourd'hui encore. Tout au long de sa carrière, qu'il photographie des célébrités ou filme des documentaires pour la télévision, il ne connaîtrait plus jamais une mission comme celle de suivre Elvis Presley, montrant son environnement et la manière dont il vivait au jour le jour. Il a observé plus tard: «J'étais comme un journaliste avec un appareil photo en guise de stylo.»

Imprégné de la noble tradition du photoreportage, Wertheimer développa une esthé-tique à la fois classique et innovante. Ce n'était pas un «photographe rock'n'roll». D'ailleurs, ce genre de photographie n'existait pas encore. Néanmoins, son travail sur Elvis établit un standard pour tous ses confrères amenés à photographier des chanteurs et musiciens.

En 1958, Elvis Presley fut appelé sous les drapeaux. Le 24 mars, il se présenta devant le conseil de révision sur South Main Street à Memphis, dans le Tennessee, afin d'effec-tuer ses examens médicaux. Quelques jours plus tard, il apprit qu'il était affecté à la seconde division blindée à Fort Hood, dans le Texas. Après avoir fait ses classes et avoir été formé à la conduite de chars d'assaut, il fut déclaré prêt à partir pour l'Allemagne, où il devait rejoindre la Company C, un peloton d'éclaireurs. Le 19 septembre, il monta à bord d'un train à Killeen, au Texas, qui le conduisit au terminal d'embarquement militaire de Brooklyn, où il arriva à 9 h du matin le lundi 22 septembre.

Lors de son incorporation, Elvis Presley était au sommet de sa gloire. Comme de nombreux jeunes conscrits, il était angoissé à l'idée de quitter ses amis, sa famille et

ABOVE Stuffed animals, gifts from fans, at the house on Audubon Drive, Memphis, Tennessee.

d'interrompre sa carrière. Plus important encore, il était très affecté par la mort de sa mère, décédée cinq semaines avant son embarquement à New York. Même si son père et sa grand-mère avaient décidé de l'accompagner en Allemagne, il était fortement perturbé. Il fallait ajouter à cela tous les bouleversements qu'il avait connus au cours des trois dernières années et son ascension vertigineuse vers la célébrité et la fortune. Cette journée à Brooklyn marquait donc un grand tournant dans sa vie.

Cette fois, lorsqu'Alfred Wertheimer arriva au terminal militaire de Brooklyn, il n'était plus seul. L'événement était couvert par des dizaines de photographes, d'équipes de télévision et de journalistes. Toutefois, Wertheimer connaissait déjà Elvis, son entourage, le colonel et les représentants de RCA Victor. Ayant lui-même effectué son service militaire quelques années plus tôt, il connaissait bien ce milieu et photographia l'embarquement des troupes avec l'œil d'un initié. Ses photos d'Elvis racontent l'histoire de ce jour-là. Ce sont les dernières que le photographe ait prises de la star.

Pour certains, le départ d'Elvis pour l'Allemagne en 1958 marque la fin de la partie la plus fascinante et excitante de sa carrière de musicien et d'artiste de scène. Les photographies que Wertheimer prit en 1956 documentent cette période dorée ; celles de l'embarquement d'Elvis à Brooklyn sonnent comme un adieu à l'Elvis qu'il avait connu.

Les images de Wertheimer saisissent Elvis à un croisement des cultures. Par la suite, celui-ci poursuivit sa carrière musicale pour atteindre une renommée et une fortune sans précédents mais les clichés d'Alfred Wertheimer nous rappellent une époque où un jeune homme venu du Mississippi pouvait changer le monde avec une chanson. Ce sont sans conteste les images les plus importantes et captivantes jamais prises de la plus grande légende du rock'n'roll de tous les temps. Aucun autre photographe n'a su aussi bien restituer la magie d'Elvis Presley.

ABOVE The pink Cadillac in the driveway was a gift to Gladys Presley, who didn't drive.

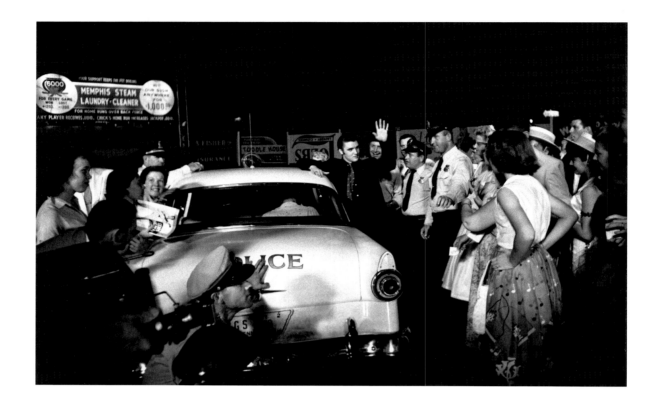

APRÈS LE 22 SEPTEMBRE 1958, Wertheimer poursuivit sa carrière de photographe

free-lance, réalisant des portraits d'Eleanor Roosevelt, de Perry Como, de Nina Simone, de Paul Anka, de Nelson Eddy et de bien d'autres. Il travailla pour des magazines tels que *Life*, *Pageant* et *Paris Match*. « Mais certains de mes meilleurs projets sont ceux que j'ai décidés par moi-même », déclare-t-il. Son don de se faire « aussi petit qu'une souris » lui permit de réaliser des essais photographiques sur des sectes à New York (La maison de prière de tous les peuples de Sweet Daddy Grace, les hassidim, les témoins de Jéhovah) et sur la vie à l'intérieur de l'hôpital psychiatrique de Bellevue. « Je suis fondamentalement curieux. Je veux savoir comment et pourquoi les choses se passent, et j'aime le faire visuellement », explique-t-il.

Au début des années soixante, la photographie cessa de l'intéresser. En 1964, il devint caméraman et réalisateur pour la chaîne télévisée Granada au Royaume-Uni. Ses reportages pour l'émission hebdomadaire *World in Action* le conduisirent aussi bien en Bolivie à la recherche de Che Guevara qu'à Harvard et Yale, où des chercheurs étudiaient les soucoupes volantes. En 1969, il fut recruté comme caméraman principal pour le film de Mike Wadleigh, *Woodstock*. Entouré de 300 000 hippys, il filma notamment la fameuse scène des glissades dans la boue. Mieux préparé que les autres membres de l'équipe technique, Wertheimer était venu avec son propre matériel. Lorsqu'il remarqua que Wadleigh avait loué toutes les caméras Éclair disponibles à New York pour l'occasion, l'idée d'un nouveau business prit forme dans son esprit.

Il acheta une table de montage Steenbeck, puis une autre et, bientôt, il en possédait vingt-huit, ainsi qu'une équipe de quatre monteurs pour les faire fonctionner dans un local de plus de 1000 m² au cœur de Manhattan. Travaillant pour des chaînes comme CBS News et ABC Sports, Cinergy Communications devint un lieu incontournable pour de nombreux cinéastes et monteurs de l'époque, notamment pour des documentaristes

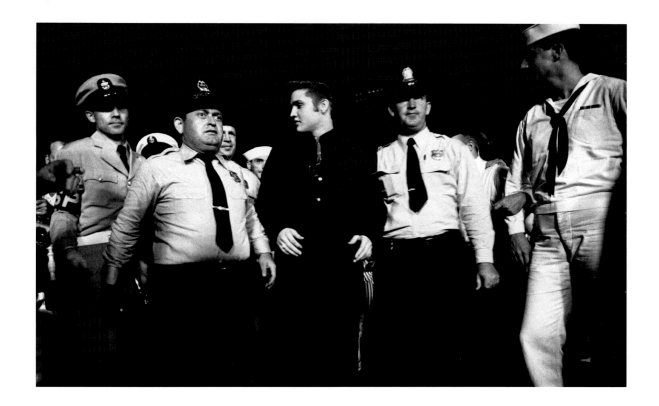

tels que Ken Burns. Wertheimer dirigea la société pendant vingt ans puis, quand la technologie numérique commença à transformer le monde de l'image, il la vendit pour se consacrer de nouveau à la photographie.

Au début des années quatre-vingt-dix, il commença à se pencher pour la première fois sur ses propres archives considérables, publiant des livres et exposant ses photos d'Elvis Presley. Sa première exposition eut lieu dans ma galerie à Washington, la Govinda Gallery. Depuis, son travail a été présenté à la Fondation Cartier pour l'art contemporain à Paris, au Rock and Roll Hall of Fame and Museum à Cleveland (Ohio), au Experience the Music Project Museum de Seattle (Washington), au Domus Atrium de Salamanca (Espagne) et au Jule Collins Smith Museum à Auburn (Alabama). Son exposition *Elvis at 21*, produite par la Smithsonian Institution et la Govinda Gallery a été montrée dans quatorze musées, dont le Grammy Museum de Los Angeles et la National Portrait Gallery de Washington, DC.

OPPOSITE & ABOVE Elvis arrives for his show at Russwood Park with an escort from local police and Navy Shore Patrol, July 4, 1956.

ACKNOWLEDGMENTS

Many thanks to the pioneers of photography who inspired me by their example. Amongst them are Nicéphore Niepce, Louis Daguerre, William Fox Talbot, Mathew Brady, Eadweard Muybridge, Lewis Hine, Jacob Riis, Alfred Stieglitz, Edward Steichen, Erich Salomon, the Roy Stryker Farm Security Administration of the 1930s, Dorothea Lange, Margaret Bourke-White, Henri Cartier-Bresson, Alfred Eisenstaedt, Robert Capa, Gordon Parks, W. Eugene Smith, David Douglas Duncan, Irving Penn, Sebastião Salgado, Sergei Eisenstein, and Vsevolod Pudovkin.

One of my favorite sayings is attributed to John Lennon: "Life is what happens to you while you're busy making other plans." Well, that is so true in my case. I am sure my dear mother, Katy Wertheimer, would agree. I commend her foresight and tenacity in asking her uncle in America, Joseph Kaltenbacher, to send the proper papers so our family could migrate during the dangerous pre-WWII times in Nazi Germany. My father, Julius; brother, Henry; and I then left my birth home in Coburg on an eight-day transatlantic boat trip, landing on U.S. soil on July 2, 1936. Who would have thought that 20 years later, through a set of unforeseen circumstances, I'd be in a position to make my most iconic photographs of Elvis Presley, just as he was crossing the threshold of his fame in 1956.

The link that originally connected me with Elvis started with my friend Paul Schutzer, photojournalist. He introduced me to Anne Fulchino, head of RCA Victor Records Publicity Department, who hired me to photograph Elvis Presley.

There are many others who have helped to bring this book project to its conclusion. I owe you all a debt of gratitude for your contributions.

My education, besides endless hours of self-teaching, was the New York City Public School system, starting with PS 138 in Brooklyn. I was fortunate to attend Cooper Union School of Art, Architecture and Engineering, where I spent many an evening in the Camera Club darkroom developing black-and-white film and making enlarged prints. Robert Gwathmey, my drawing teacher, made us all buy the best sable brushes, and then told the class to use the stick end to draw the model: "If you are an artist, you can create with anything." Both he and Josef Breitenbach, photography teacher, left their impressions on me as a student hungry to learn the arts.

Gratitude goes to my friend and agent Chris Murray of Govinda Gallery in Washington, D.C., for his collaborative work and vision in sponsoring several of my one-man shows. Chris brought this book project to the attention of Benedikt Taschen, who enthusiastically agreed to undertake the most complete and lavish documentation of the Wertheimer Collection of Elvis images taken in 1956 and 1958. Much appreciation to our focused editor Nina Wiener, who kept me on target and always moving forward, as well as the rest of the TASCHEN team, including art director Josh Baker; designer Anna-Tina Kessler; production director Frank Goerhardt; production manager Stefan Klatte; editor Kathrin Murr; copyeditors Doug Adrianson, Craig B. Gaines, and Anna Skinner; and Eric Schwartau, Mallory Farrugia, Michael Martinson, and Winny Woo, who provided additional support. Thanks as well to the team at Hatch Show Print, who kept the flavor of the 1950s in their poster designs.

I would like to expressly acknowledge the Smithsonian Institute Traveling Exhibitions Service (SITES); producer Marquette Folley, for a memorable exhibit at the National Portrait Gallery, Washington, D.C.; David Adamson, who exquisitely reproduced in giant digital format the 56 prints of the *Elvis at 21* traveling exhibit; and all the fans who have attended and will attend my exhibit—past, present, and future.

My nieces, Pamela Wertheimer and Heidi Wohlfeld; her husband, Michael, and children, Rachel and Joseph; my sister-in-law, Renee, and her twin brother, Wolfe: Thank you for keeping our family connected while I was secluded in my Elvis world.

Well-deserved thanks goes to Gavin Christopher, my guide to the ever-complex digital world of computers; to Spiro Carras, consultant, filmmaker, and friend; to skilled analogue photo printers Yetish Yetish; Laurent Girard, Junko, and the crew at Griffin Editions Lab, NYC.

Much thanks to the savvy women who gave me their "TCB wisdom, clarity, brevity, and quality": Georgina Galanis and Lynda Gregory, both loyal friends and persevering colleagues.

And to my tireless in-house Cinergy Communications production crew; Milciades Buritica, my right hand for licensed products, and his wife, Ana; Sonam Tsering from Rebkong, who crossed the Himalayas (on foot, no less!), to end up here in my studio, hand-spotting each of my Elvis prints; and Diane Kantzoglou, whose *snip by snip* keeps me looking fine.

To those with whom I shared love and affection, and for their endless patience… You know who you are: Therese, Josephine, Elsie, and Susan.

To Carol Butler of EPE Licensing, Robert Dye, Jonathan and Galete Seiden, and to the lovely Priscilla Presley, who visited my home and expressed great interest in my photos of Elvis, taken when she was only eleven years old.

Agents who have advised and helped me along the way: Milton Newborn of Topix, Barbara Cox of Photokunst, Robert Pledge and Jeffrey Smith of Contact Press Images. Etheleen Staley and Taki Wise of Staley Wise Gallery, NYC; Jim Mones, director of the New York Times Photo Archives; and Jill Furmanovsky of Rockarchive, UK.

I am remembering my mentor, Charles Reiche of Scope Associates, who taught me so much about printing black-and-white images. Roland Mitchell, responsible for much of the developing of the negatives of my Elvis Collection; Moneta Sleet and G. Marshal Wilson, with whom I shared space at David Linton Studio—all steered me to many a good story. A word must be mentioned for longtime friends along the way: Howard Leichman and Tom Palumbo, the fashion photographer, for my first job after my discharge from the U.S. Army.

To Gladys and Vernon Presley, for opening their home to me on July 4, 1956, and even loaning me spare bathing trunks that allowed me to jump into the pool for those up close and personal shots of their son. Elvis's manager Colonel Tom Parker and RCA Victor's A&R man Steve Sholes, who allowed me full access when Elvis recorded two of his biggest hits, "Hound Dog" and "Don't Be Cruel."

If I unwittingly omitted you from my list of thanks, please forgive me.

Finally, Elvis has definitely not left the building where I reside…I thank him for his trust in permitting such closeness with my camera, and sharing his life in such a generous, unflinching way.

—ALFRED WERTHEIMER, 2013

I have so much gratitude for the opportunity to work with Alfred Wertheimer. Assisting him with publications and exhibitions has been not only a thrilling experience for me, but has been the best professional relationship that one could hope for. I can't thank enough Nina Wiener at TASCHEN for guiding this book to publication. My thanks to Benedikt Taschen, a visionary publisher who brings so much quality and excitement to the cultural imagination. I am ever grateful to Priscilla Presley for her generous and charming spirit. When looking at Alfred Wertheimer's photographs together, Priscilla showed me things that I had never seen before in the photos. Thank you to my long time associate Bob Santelli for his introduction to this book and for his enthusiasm for Alfred Wertheimer's photographs. Special thank to Michael Meyer and Kim Pappaterra for their constant support. To Vivienne Foster, my assistant at Govinda Gallery while working on this book, and to all Govinda Girls—past, present, and future. Thanks to my beautiful and talented wife, Carlotta, for her constant support. My appreciation to the wonderful team at SITES, with whom I organized *Elvis at 21: Photographs by Alfred Wertheimer*, as well as to the Experience Music Project in Seattle; the Jule Collins Smith Museum in Auburn, Alabama; Domus Artium in Salamanca, Spain; the Cartier Foundation Museum in Paris; and the Rock and Roll Hall of Fame and Museum in Cleveland, for their exhibitions of Alfred Wertheimer's photographs of Elvis Presley. And most of all, my appreciation to Elvis Presley, the greatest rock and roller of all time.

—CHRIS MURRAY, 2015

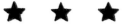

COVER *Stage Show* New York City, March 17, 1956. Poster design by Hatch Show Print.

1 Portrait at the Jefferson Hotel coffee shop lunch counter, Richmond, Virginia, June 30, 1956.

2 & BACK COVER *Going Home*, July 4, 1956, aboard the Southern Railway local train to Memphis, Tennessee.

7 Elvis's Martin guitar, with a tooled leather cover, stands upright against the wall during the recording session of "Hound Dog" and "Don't Be Cruel," RCA Victor Studio 1, New York City, July 2, 1956.

360 As the *USS Randall* pulls out into New York Harbor a screaming fan expresses her dismay that "Elvis has left the country," September 22, 1958.

All photos and text © Alfred Wertheimer unless otherwise noted. All Rights Reserved.
www.alfredwertheimer.com

"Just Another Assignment" © 2015 Chris Murray.
"Elvis: The Life and Legacy" © 2015 Robert Santelli.

The original letterpress poster art throughout this book was created by Hatch Show Print in Nashville, Tennessee, by designers Jennife Bronstein, Carl Carbonell, and Jim Sherraden, with project management by Celene Aubry.

EACH AND EVERY TASCHEN BOOK PLANTS A SEED!
TASCHEN is a carbon neutral publisher. Each year, we offset our annual carbon emissions with carbon credits at the Instituto Terra, a reforestation program in Minas Gerais, Brazil, founded by Lélia and Sebastião Salgado. To find out more about this ecological partnership, please check: www.taschen.com/zerocarbon
Inspiration: unlimited. Carbon footprint: zero.

To stay informed about TASCHEN and our upcoming titles, please subscribe to our free magazine at www.taschen.com/magazine, follow us on Twitter and Facebook, or e-mail your questions to contact@taschen.com.

© 2015 TASCHEN GmbH
Hohenzollernring 53, D-50672 Köln, Germany
www.taschen.com

Editor: Nina Wiener, Los Angeles
Layout and design: Anna-Tina Kessler, Los Angeles
Editorial coordination: Kathrin Murr, Cologne; Florian Kobler, Berlin
Production: Frank Goerhardt and Stefan Klatte, Cologne
German translation: Julia Heller, Munich
French translation: Philippe Safavi, Paris

ISBN 978-3-8365-5907-2
Printed in Italy